To my exceptional family: my parents, Vera and Mac;
sisters Stephanie and Joanne; nieces Brooke, Victoria, and Alexandra;
precious grandnephew Theo Max; and, of course, Scott and Stan,
without whom I wouldn't be who I am today. I love you all.

And to my other family, the 92Y, a New York treasure.
Thanks to their love and support, this series and book are in your hands.

FASHION LIVES

FASHION ICONS WITH FERN MALLIS

RIZZOLI
NEW YORK

New York · Paris · London · Milan

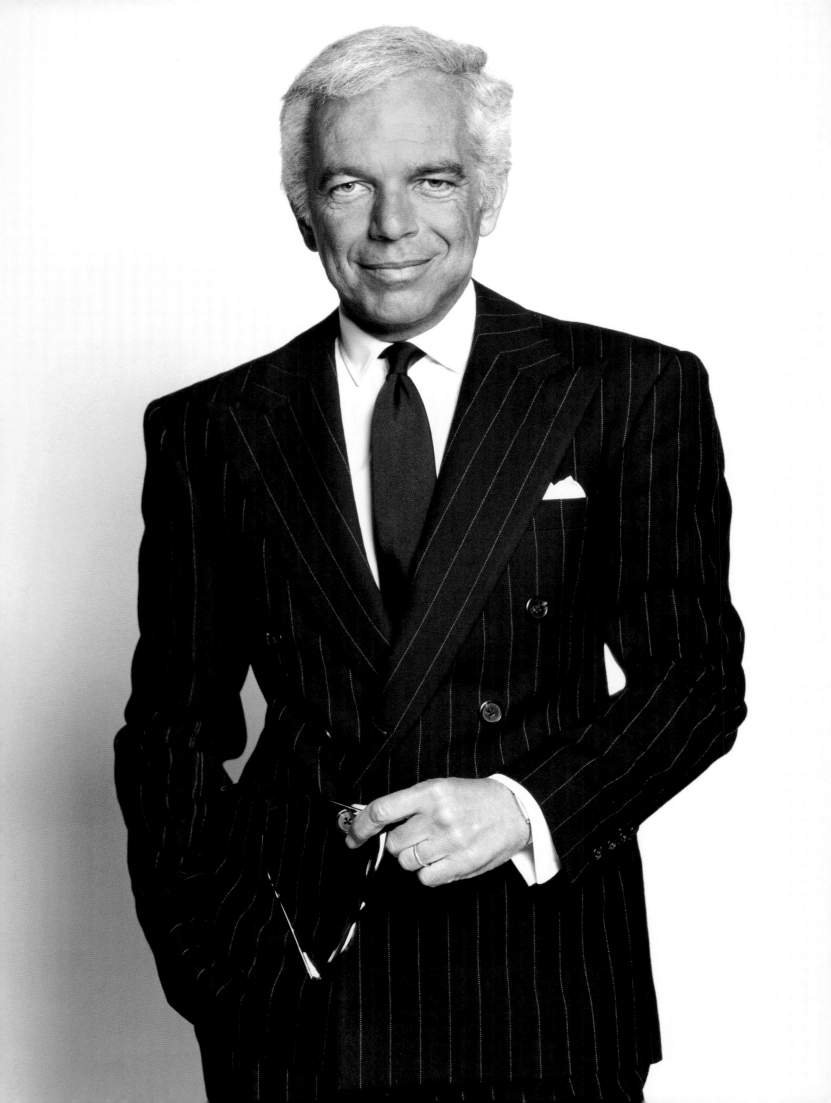

FOREWORD

Fern Mallis is a woman who doesn't sit still. I learned that firsthand in 1991, when she was made executive director of the Council of Fashion Designers of America, and I was on the board. She wasted no time infusing her new role and the organization with the energy and passion that defines who she is. Fern understood the power of the fashion industry and mobilized the CFDA's full support behind the most meaningful programs, including scholarships to benefit aspiring designers and fundraising for AIDS. In 1994, knowing my personal commitment to the fight against breast cancer, Fern, on behalf of the CFDA, asked me to lead the charge in launching their vital commitment to that cause. With my design team, we created a simple T-shirt emblazoned with the blue and black target symbol of the Fashion Targets Breast Cancer campaign and were invited by First Lady Hillary Clinton to launch its powerful message at the White House. The sale of that simple shirt jumpstarted a campaign that, twenty years later, has raised over $100 million to support breast cancer research, education, and patient care through charities around the world.

Fern's fervor for elevating American fashion to its rightful place in art and culture has always been at the heart of her mission. Through the now legendary and global 7th on Sixth events, she organized and centralized Fashion Week in New York City, a seminal event in unifying the seasonal collections of the American design community. Since her decade of contributions at the CFDA, and later at IMG, she has taken on many other important roles to further that cause, traveling the world organizing events, creating international marketing and communication platforms, and, most importantly, mentoring and encouraging the passion of students.

Though her name is not on a label, Fern Mallis has made her own mark on the world of American fashion. Her amazing energy and passion and respect for the art of fashion and those who craft and celebrate it have been her life's work. Over the last three years, Fern, now with her own international consulting firm, has presided over her innovative series— *Fashion Icons with Fern Mallis* at New York's prestigious 92nd Street Y. She has sat down one-on-one with designers, fashion editors, and photographers and allowed them to share their stories in their own personal ways. Those stories woven together in this book constitute an important part of fashion's history and inspire its future. — **Ralph Lauren**

TABLE OF CONTENTS

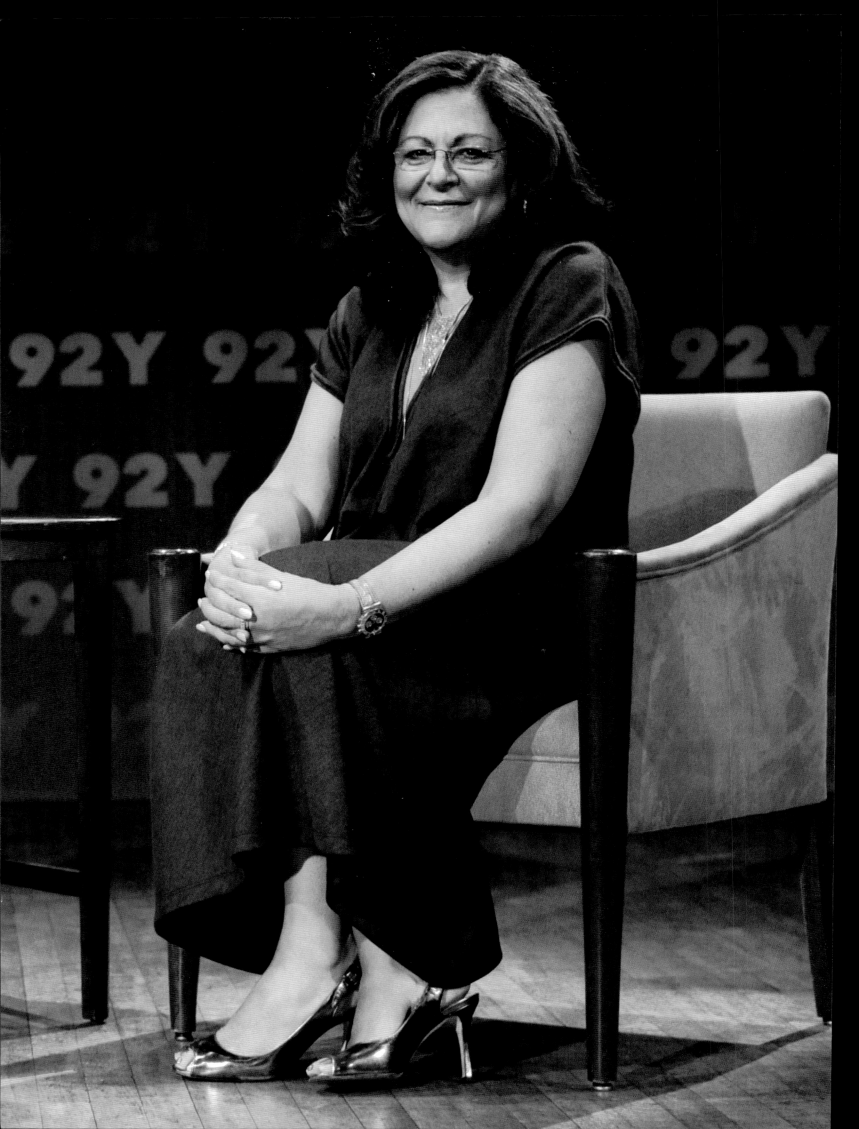

INTRODUCTION

Four years ago, I had come to a crossroads in my life and career. After being in the spotlight for twenty years, running Fashion Week in New York and beyond, I made the decision to leave my position as senior vice president of IMG Fashion and one of the most exciting, visible jobs in the business.

I didn't have a plan. I asked myself, what do I do next? How do I "reinvent" myself? Can I ever top my last job? Am I still relevant? Will I matter anymore if I'm not doling out time slots for fashion shows? These were some of the insecurities I was feeling. I needed to think and reflect, not something I was accustomed to doing. I was always go, go, go. So I thought hard about my career. Here's the story about how I got from East 65th Street in Brooklyn to a life-changing "gig" on 92nd Street and Lexington Avenue in Manhattan.

The fashion industry is in my DNA. My father was a salesman who sold women's scarves. My uncles worked in the Garment Center as well. I would go to work with my dad every chance I could when I was a child. I loved seeing the fabrics and colors and being surrounded by the hustle and bustle of the people, energy, and excitement of fashion. I also started reading his copies of *Women's Wear Daily*—the bible of the industry—and that became a lifelong habit.

My long and varied career in fashion and design began by winning a "guest editor" contest at *Mademoiselle* magazine in 1969, when I graduated from the University of Buffalo. I ended up spending six years there. I went on to become the fashion director at Gimbel's East—anyone remember Gimbel's? Shortly after that, I opened my own PR firm and for more than ten years I worked with some of the greatest clients in the architecture and design world before I joined the International Design Center New York. At IDCNY I organized and galvanized the entire industry and created groundbreaking events working with Massimo and Lella Vignelli, I.M. Pei, Gwathmey Siegel Architects, and many others. At that time, while a founding board member of Design Industries Foundation Fighting AIDS (DIFFA), I was very proud to produce memorable fundraisers for the fight against AIDS and the Partnership for the Homeless.

In 1991, after reading in *WWD* about the CFDA's search for a new executive director, I threw my hat in the ring for the position at the Council of Fashion Designers of America. I basically snuck in as the last candidate to be considered in their search, and I was offered the job on my birthday, March 26, 1991. The office was tiny—no staff, just lots of old file cabinets. I loved having the opportunity to shape, lead, and reinvent this organization, along with its newly elected president, Stan Herman.

The CFDA office grew, staff was hired, a new iconic logo was designed, programs flourished, scholarships and benefits were created, the awards gala was expanded, and so much more. But the creation of 7th on Sixth—with the mission to organize, centralize, and modernize

the American runway shows in tents in New York's Bryant Park, was the most exciting and exhilarating part of my job. At the time, it was an experiment, an adventure, and a risk. Would multiple designers show here? Will the media embrace it and take it seriously? Would retail buyers come and like it? Can we attract sponsors and raise the money to pull it off? Will it work? Will it last? New York Fashion Week in Bryant Park was a game changer for the American fashion industry, and, ultimately, the international fashion industry as well. For me, it was a challenge, an accomplishment, and a defining moment of my career.

Ten years later, when CFDA sold 7th on Sixth to IMG, the global sports and event management company, I assumed the newly created position of senior vice president of IMG Fashion. We created fashion weeks in L.A., Miami, Mumbai, Berlin, and cities around the world. I traveled the globe and met many amazing, creative people—not just designers, but models, stylists, publicists, producers, photographers, corporate leaders, editors, journalists, volunteers, and interns and everyone in between. Fashion is truly a collaborative business and to pull off a successful show takes a village… a very cool, chic village.

During this time I got to see firsthand from the front row what worked, what didn't, who triumphed, and who failed. But more importantly, I learned and watched how hard this industry works, the dedication and commitment that it takes to succeed season in and out, over and over again. No one is an overnight success. There is a price to pay for fame and fortune. But the respect and admiration I have for these people sustain me and bring me joy.

I decided to leave IMG Fashion in 2010 after a decision was made to move the shows out of Bryant Park, which had been home to Fashion Week for eighteen years. As we were planning our last season in Bryant Park, I saw clearly that the shows in those tents were my baby. But they had grown up—and were anxious to move on—and so was I. It was time for someone else to manage Fashion Week's next phase at Lincoln Center. I felt in my bones it was time, and I had always paid great attention to my gut instincts. In retrospect, I think my timing was impeccable.

I needed time to breathe and "smell the roses." But I continued to think, what's next? Could I work for any one designer or company when essentially I worked for them all? Could I go back to a nine-to-whenever job?

And then came the coffee phase of my life…

"What are you doing now?" "Can we meet for coffee?" "What's next for you?" "How about a cup of coffee?" "…Are you okay?" "Can we meet for coffee? I'd like to pick your brain." "I have an idea I'd like to run by you, can we meet for coffee?" I had coffee coming out of my ears. I just wish I had bought shares in Nespresso, which seemed to have become my de facto office. Never Starbucks.

Ironically, it was over a cup of tea with my great friend photographer Timothy Greenfield-Sanders that the journey to 92nd Street began. He suggested I meet his pal Betsy Berg,

Clockwise from top:
Fern Mallis at four years old;
Fern working at *Mademoiselle*
magazine, early 1970s;
Fern with her family, 1955

This page: Fern Mallis at the Ralph Lauren show in the Bryant Park tents, November 1995. Opposite: Fern at her fortieth birthday party with her sisters, Stephanie and Joanne, and their mother, Vera

who represented people for speaking tours and conferences. He thought I had a great story to tell and knew she could be helpful.

Betsy and I met for lunch and instantly hit it off. She suggested I meet with her friend and neighbor Susan Engel, who heads up programming for New York City's oldest and most prestigious cultural community center—the 92nd Street Y. Betsy said she knew they were interested in bringing fashion to 92Y, and needed the right person to facilitate. Of course I knew the Y—as it's affectionately called in NYC. Their programs have featured everyone from presidents, prime ministers, Nobel Prize winners, authors, musicians, and film stars to a wide variety of talented, topical, newsworthy people, all at the top of their game being interviewed by noteworthy personalities. The 92Y is a beloved New York institution. Of course I was interested.

I spent twenty years championing designers and the work they do—giving validity to a profession often maligned as silly and irrelevant. But I'd always felt that these amazingly talented people—the rock stars of our world—never really had the opportunity to tell their stories. Many people think that anyone can be a successful designer, but most don't have a clue, or know that successes and failures, ups and downs, are the hallmarks of many great careers. I thought, how great would it be to get some of the most iconic designers and friends I've worked with to share their stories on stage with me? And so we named the series *Fashion Icons* and the asks went out...

My dear friend, Norma Kamali, one of the most talented designers in the world, was my first guest. We were like old pals gabbing and catching up on my living room sofa. Next came Calvin. When I asked him at the start of our interview, "Why are you here and talking to me?" he responded with his admiration for 92Y, and then said, "Because you asked me and I'm thrilled to be here for you." His answer meant more to me than I could ever express. When Donna called Calvin from her car on the way to the Y and asked him, "What am I getting myself into?" He said, "Relax, you're going to love it." And that's how it all began.

I love asking these influential personalities how they became who they are. I'm curious about their families and pets and birth signs. I want to know about where, when, and what they were exposed to that gave them the ideas, vision, and chutzpah to do what they do. And most especially, what their creative process is like. They're not a "brand"; they are people who have struggled and persevered. Some of them had dysfunctional families and great or not-so-great business partners. They are not all happy stories, and clearly, I wasn't the only one who was fascinated by their journeys.

The 92Y was thrilled with *Fashion Icons* as it brought them an entirely new audience with programs successfully selling out many times over, and it became the building block of the reinvention of my career. I'm as proud of this series as anything I've ever accomplished. As more interviews followed with industry friends and legends, the accolades poured in. I've been gratified by the support this series has received from the fashion press and social media. In this new age of instant communication, Tweets, Instagrams, and Facebook posts fueled the Internet, further spreading their stories.

These conversations are intimate, informative, friendly, funny, and poignant and are played out in front of capacity crowds of over nine hundred people in a majestic concert hall. In addition, a worldwide audience watches via Livestream—and together we laugh, cry, and gasp at their revelations, and admire, applaud, and respect their talent and their journeys.

Fashion Icons has brought me focus, purpose, passion, happiness, and yes, relevance. Many other projects and clients have since poured in, including broadcasting these interviews on my radio show "Fashion Insiders with Fern Mallis" on the SiriusXM Stars channel.

I don't drink nearly as much coffee anymore, and this phase of my life is exciting and unpredictable—just the way I like it. I let the universe deliver, and it has… it delivered this book.

And so, the conversations continue. Enjoy these journeys.

NORMA KAMALI

I am thrilled to be hosting this new series at the 92nd Street Y. When the Y approached me about a series we named Fashion Icons—to bring to this audience the stories of our iconic designers and how they became who they are—I said yes, because fashion is such an important part of our city and our culture. I also said I want to start with Norma Kamali, because she is an American icon. She's a treasure and I love her dearly. Norma, come on out and I'll finish the rest of the introduction when you're here. Norma and I have been friends, I'm afraid to say, for about forty years. And we don't look that old, right? Norma is truly one of the most original designers in the world. She's created more iconic clothing than anyone. When I mentioned to people that Norma was my first guest, everybody said, "Oh my God, she's amazing." She's one step ahead of everybody. Clearly known for the most influential swimsuits in the world, the sleeping-bag down coat, her sweatshirt collections, her innovative use of Lycra, her modern vintage looks, the athletic-inspired collections, and now her 3-D clothing collection. She is also a social media maven, way ahead of everybody in our industry. She's added a wellness café to her business and her life. She knows more about olive oil than anybody. The Norma Kamali swimsuit Farrah Fawcett wore on her famous poster was inducted into the Smithsonian. And now I'm very proud to say, she's the first guest of the Fashion Icons with Fern Mallis series at the 92nd Street Y.

FERN MALLIS: Let's start at the beginning so we can all learn about how Norma became this extraordinary Norma that she is. You were born on June 27, 1945, which makes you a Cancer. Describe where you grew up. What were your parents like? Were they creative people? Were they supportive?

NORMA KAMALI: I grew up in New York, in New York City public schools. I was born in New York Hospital. I'm as New York as you can get. There's not very many of us, but I'm very proud of that. And I grew up in a house especially influenced by a mother who could do anything. She could paint. She could make clothes that were extraordinary. She could do costumes. She could cook anything. There wasn't anything she couldn't do, and I thought that was normal. I thought everybody's mother was that way. I was just imitating my mother and expecting that I should be able to do everything. So I'm very grateful to that kind of an upbringing. As eccentric as it might have been, it certainly is the core of who I am and the great fortune I had to be in a house where anything you wanted to do was certainly a possibility.

When did you know that you wanted to be a designer? When did it occur to you that was a career you could actually pursue?

Well, I grew up through the 1950s and early '60s. It was *Mad Men* dressing time. And I never really got that. I never looked good in those clothes. I never was the coordinated hat-gloves kind of person. I wanted to be a painter, and my mother stressed that I would have to pay rent soon. She insisted that I find another career path. I was fortunate to get a scholarship to FIT, and I had a painting scholarship opportunity at NYU. But I went to FIT and I had anatomy classes, and I kept studying, thinking that I would still be a painter.

I really didn't like FIT. I was studying illustration, and I thought all these design students were just the worst. They were so obsessed with the superficial. I just decided to get a job at an airline and travel, because I wasn't finding a job that I liked. I got a job in an office, working on the very first computers that were used commercially.

For what airline?

For Northwest Orient Airlines. I learned how to use a UNIVAC computer in the 1960s. My comfort with the computer world was very easy. I adapted easily because I learned early on how much information you can get through the UNIVAC. I found myself in London in the early 1960s. I was there every weekend for twenty-nine dollars round-trip. I realized that I did like fashion after all. It was very expressive. It was very creative.

Those were the days of Biba and Mary Quant.

Yeah, and that was when I decided that I really did want to do this. I opened my store on East 53rd Street. For two hundred and eighty-five dollars a month, I might add. It was a basement store, granted, but it was good.

You said, "I want to open a store, and I'm going to make clothing"? How did you do that?

I brought back clothes from Biba and Bus Stop and some of the designers at the time. Then I opened the store, and I did it with my ex-husband at the time. He was a student and he sold in the store. I started making clothes—when I wasn't at the airline—at night. I realized that I could actually do this, and I was really enjoying it. I was so lucky early on that a top editor for *Harper's Bazaar*, Ray Crespin, lived right down the street, and my good fortune was that she actually looked down into the basement window. I would do anything to get people to look down.

Good editors have to look down all the time.

She actually pulled an outfit. It was the first time that had ever happened. I knew very little about what all that was about. She had Hiro, who was an extraordinary photographer for *Harper's Bazaar* at the time, shoot photos. I had a full-color page of a snakeskin patchwork jacket and spats. It was just beyond what I could ever imagine. And it really was a great kind of signal to me that I should keep trying. That was one of those lucky things that happen that get you going.

You did a lot of leather clothing. It was very rock-and-roll, kind of hippie leather, right?

In the 1960s, early '70s, it was basically a costume party. I loved every minute of it. And I attracted a lot of music people, men and women. I dressed everyone. I started to get this kind of cult, underground reputation. And when that happens, you have to know when to reinvent yourself.

But who were the mentors or people whom you would bounce ideas off and say was it time to change?

Actually, I didn't know whom to ask. I was very young and I thought I knew everything. Now I know I know nothing. But then I knew everything, so why would I ask anybody? Instinctively I knew that I needed to build a reputation for quality clothes, for tailored clothes, and a different look. And it was like starting all over again. We moved to a second-floor store on Madison Avenue, and there were no stores on the second floor on Madison at the time. So now we had to get everybody to look up. And I had the good fortune of having an incredible friend, Bob Currie. He was really so helpful in getting people to look up. He would do the most extraordinary window displays. And he would actually steal things from the street.

This page, clockwise from top right: Norma Kamali as a teenager, 1969; Norma Kamali, 1964; Patchwork snakeskin, 1967. Following page: Bob Currie dressing a mannequin for the windows of Henri Bendel

Signs?

He'd add traffic signs, anything. He was outrageous. He was the best window designer.

Bob was best known for his many years at Henri Bendel when it was on 57th Street, the original Gerry Stutz Bendel days. It was an adventure. Every Thursday night you went to 57th Street to watch Bob install the windows. It was theater. And they were magic. They told a story and were brilliant. He was, without question, one of the most creative geniuses of our time.

He was my best friend. And I miss him. I miss him a lot.

We all do.

He worked with Avedon for many years. It was also a very creative time in the city. It was before AIDS, and everything you saw was new. Everything was original. I miss that—the sense of things being original.

It's remarkable when you have those experiences of actually seeing something for the first time, and seeing something new that just goes boing.

Pow.

It's that aha moment.

It's inspirational and makes you want to do original things.

Absolutely. So now you were on the second floor. Where on Madison Avenue was that?

It was 67th and Madison. We were right down the street from Halston and Sassoon. It was a hot spot. I was still a cult kind of designer. I wasn't known across the country or around the world, for sure. It was a very inventive, creative time. A lot of the things that I did then have held up through time. There's something to looking at your career and seeing what worked and what didn't. The things that didn't are so embarrassing. What were you thinking? But then there were things that hold up, and I decided, because it's fashion, I'm not going to dispose of it. I think one of my most popular swimsuits is one that I designed in 1974. I still do it. And every year, it's photographed in a major magazine as if I just did it. So some things hold up.

Well, every year there are new readers and new customers.

Yes, you're absolutely right.

And for the people who bought it way back then, it probably doesn't fit anymore.

Well, maybe they should get a new one.

Okay, so you're building a business. Whom do you hire? What do you start to look for? You have to find a factory. You have to find patternmakers. You have to find salespeople. How do you do it?

I knew I had to learn how to make patterns. I had to learn how to sew. I had to learn how to do what I wanted to tell other people what to do. One of the great joys I have in designing is making patterns. I still do it today. I do most of my swimwear patterns. And I feel very good that I can. Learning early on how to do it helped me be a better designer.

When you do the patterns now, is that in a CAD program on computer?

No.

Why not?

Well, I love draping and I love making patterns and I like the process of it. I like touching, being at the cutting table. I'm in a happy place when I'm doing that. I love computers, but that's not what I do when it comes to the creative process.

So would you say that part of the process is when you feel most like a designer?

Yeah. I've never done drugs and I've never gotten high—

Even all those years we were at Studio 54 together?

Yes, never. Never. I have never smoked pot. I never did anything, but I got high. I swear, I really feel like I still get high on seeing what I wanted to happen is actually happening. And I'm so much better at it now. Actually, I'm really good at it now. I never want to give up that high. I love it. I'm addicted to it, obviously.

Well, that's the best kind of high to be addicted to. Let's go to the sleeping-bag coats, since you can't say your name without somebody saying, "The sleeping-bag coat, the down coat, the jacket." Tell us how that came about.

I was camping with a bunch of friends, including Bob Currie. I was going through a period of time with my hippie-dippie boyfriend. I [had] separated from Eddie Kamali, and we would take his Volkswagen van and go camping and canoeing. It was the time of the year where it was starting to get cold. And, of course, if you want to relieve yourself, you go in the woods. I just was so cold in the middle of the night, I took my sleeping bag with me and ran into the woods. As I was doing it, I thought, this has to be a coat. Growing up in my mother's house, you just made things out of anything, so it was part of my DNA. I came back and I cut up my sleeping bag. I wore it that winter. And then I just bought a ton of sleeping bags, and it started.

Did you go to a sporting goods store?

Yeah, and I just started making coats out of sleeping bags. And then it finally evolved to just making a pattern and getting high-tech fiberfill and the lightest-weight fillers that could be still rolled up as a sleeping bag. The doormen at Studio 54 wore the sleeping-bag coats and then everybody wanted them. After 9/11, there was a period of time when I just closed the company. I was devastated. You saw me crying on the steps of St. Patrick's. I was a mess. I just couldn't function. But one day I went back to the building and I thought I would pick up the voicemails. And one voice message after another was somebody asking for a sleeping-bag coat. It was September, kind of muggy and really not cold out. And there were so many requests for sleeping-bag coats that I had everybody come back. We just

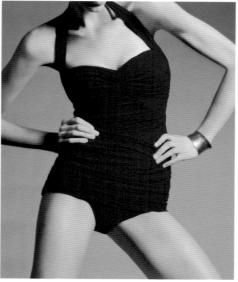

This page, left to right: Norma Kamali and friend in a sleepingbag coat, early 1980s; OMO Norma Kamali bathing suit. Opposite, left to right: Farrah Fawcett wearing a Norma Kamali oversize sweatshirt; Farrah Fawcett in Norma Kamali swimwear, 1970s. Following spread: Clothing from Norma Kamali's 1981 sweatshirt collection

cut up anything we had into coats. We sold the largest number of sleeping-bag coats ever during that period of time.

Wow.

Yeah. And so the sleepingbag coat is still in my collection today, and it will continue to be. It serves a function and it keeps people warm. And I wear it every year.

Any estimate of how many you've sold in your career?

I couldn't even calculate it.

So, now bathing suits. You're the most influential swimsuit designer. Why are they all named after men?

Well, they're named after specific men, baseball players.

So Bill is... ?

Well, Bill is actually my brother. He helped me start the swimsuit company in the first place, so the most famous suit is actually named after him. But Matsui is Matsui. We have one for almost every Yankee. I thought it would be a good tribute to the guys. Swimwear is not like fashion. It's like lingerie, and certain categories ride the edge of fashion. They are influenced a little bit by fashion, but they really have a different purpose in a woman's life. They are so much a part of her psyche. The kind of swimsuit you put on—does it empower you or does it objectify you? It's that fine line in deciding what you're going to wear. Do you have an athletic body? Are you rounder? It's a very complicated category. But it's the first category I did for wholesale. I don't know how I even went further with it, because it's the most difficult. But it's my favorite. And I think swimwear can last forever if it's a good suit. Right now, because of the Farrah Fawcett kind of buzz that's going around, we've had so many requests for that suit. And so I did it again, and I look at it and I think, why not? It looks so great. It's so simple.

How did that suit get on Farrah? Was that a stylist who picked it out?

No, no, no. First of all, stylists are a new phenomenon. Could you imagine Jimi Hendrix having a stylist? Farrah Fawcett was a customer. I remember after she did the poster, she came to the store. I said, "What made you pick that suit?" And she said she just went on a shoot with a photographer, and whatever she had in her closet she stuffed in her bag. That was the suit she put on when the poster was shot. It's a very simple suit, and it has nothing

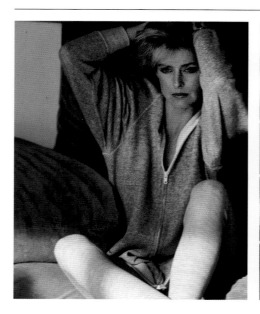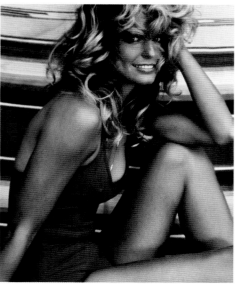

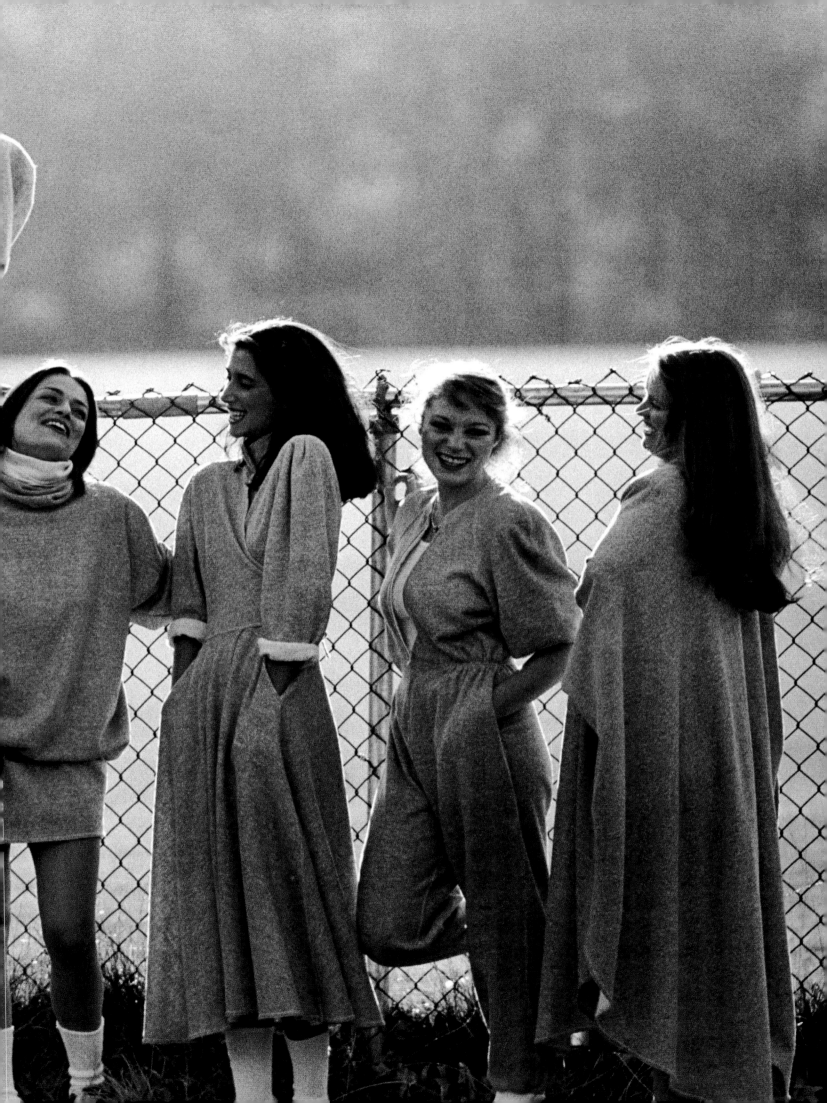

to do with the success of the poster, believe me. Farrah Fawcett—and I've seen so many celebrity women, beautiful women, that have shopped through the years—truly, in her prime, was an extraordinarily beautiful example of an American woman. I think her smile and her persona would sell anything. I was really lucky that she had my swimsuit on. Simply that.

Okay. Sweatshirts. That's another thing that Norma just did. She took a good old sweatshirt that everybody lives in and turned that into an unbelievable fashion collection.

It was a time in the 1980s when the idea of casual clothing hadn't really settled in. People were pretty dressed up to do most anything. Casual clothing is the way we live now, but not so much then. I always put on a sweatshirt when I got out of the pool. So I thought I would do some sweatshirt pieces when I was doing cover-ups for my swimsuit collection and then I ended up doing gowns and dresses and pants, and I couldn't stop. I had this collection in gray sweatshirt, and I'd never seen anything like it before. I didn't know what to do with it. I was copied a lot by department stores, because nobody really knew who I was or where the ideas were coming from. I needed help. So I called Michael Coady at *Women's Wear Daily*. He said, "You need to sign a license agreement, fast." I had no idea what a license agreement was. I asked somebody, "What do you ask for?" And they said, "You want a percentage and a minimum guarantee." The first person I met with was Sidney Kimmel from Jones. He came in and said, "I understand it's really great—*Women's Wear Daily* said I had to do something with you. Can we talk business?" I said, "I would like this for a minimum guarantee, and I would like this for the royalty." And he said yes. And we did it. In two weeks we were in business.

So did you think you didn't ask enough, if it happened so quickly?

No, it was actually pretty good. I was so lucky, so lucky. There were lines around the block in the department stores, our store. It was very, very new in the marketplace. And we had a huge success for quite a few years. It was in sync with the mood for casual dressing. We might have gone too far over in the other direction. I apologize for the shoulder pads that I put in there. Please accept my apology.

Just take them out. But they served a time and a purpose.

Yes, they did.

They were very empowering. Okay, let's go to the Wellness Cafe and the wellness concept, because that's become a really important part of not only your collections and business, but your life. Was there a cathartic moment when that bulb went off?

It's back to 9/11 again. I was moved in every way you could think. Well, what am I doing? This is a world that will never be the same again, and is what I do for a living valid? What we're eating and how we're living is going to be so much more important. I didn't really know how to manifest that into anything, except I knew that I needed to do something. I grew up in a home where olive oil was really part of the culture. My mother was Lebanese and my father was Basque, and there was olive oil everywhere. We had olive oil to be regular. We had olive oil in our hair. I started to get interested in olive oil again, and I met someone who wanted to bring olive oil to the states. Top, high-end olive oil. We joined together to create this collection of the best olive oils in the world from the best orchards. We have an extraordinary collection of products. The whole idea of the Wellness Cafe evolved from there. I stopped eating processed foods, and I feel so good and so healthy as a result of it. I've incorporated juices and soups and smoothies, all raw, into the café. Our environment

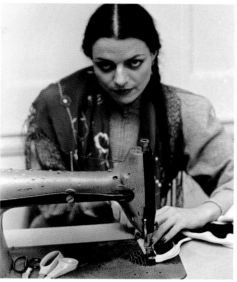

Left to right: Portrait of Norma Kamali, New York, 1977; Norma Kamali at work in her studio, New York, February 10, 1982

[and] the food we eat are affecting our well-being, and we need to take steps to keep our immune systems strong. So, instead of an ordinary toothpaste, you might want to have—

Not olive oil.

Yes, ma'am. Actually, it's quite good. Fern, behave. Oils actually pull bacteria out of the membranes in your mouth and sinuses. There is a tooth soap that actually has cinnamon and some natural oils, and you brush your teeth with it. And your teeth will never feel cleaner. You'll wake up with the best morning breath you can possibly have. It's actually very healthy for you, too. We have events at the Wellness Cafe, like an acupuncturist who is extraordinary in balancing your body. I asked him if it was true that you could have acupuncture facelifts, and he said yes. I have to admit, I go every week for acupuncture, full body, and lots of needles in my face.

Well, it's working. Somebody's in a closet aging somewhere for you. Okay, the other thing that everybody said when I mentioned you was social media and marketing. I remember when I was at CFDA, and everybody was getting on computers and websites and emails. There were so many designers who never even had a website and couldn't figure out the first thing to do about that. Many of them seemed completely disinterested in going that route or embracing any of that technology, which, we know now is something you can't escape from. I think you were one of the first people who understood that. And it could be that old airline experience that helped you do [it], but you embraced that with the barcoding and all of the different ways you made technology integral to your business. It's seamless.

Well, I enjoy it. It's the way I like to think. When I heard about the barcodes, I thought, how incredible. I could have barcodes by every outfit in my window and in the shop, and people could scan it, and, using "Try Before You Buy," have it sent straight to their homes. They'd have forty-eight hours to try it. How convenient. The barcoding is just part of the culture of our business. Who knew that that would be a great thing? So it's still kind of like discovering and innovating, but it's the most exciting time in my lifetime now. It's far more exciting than the 1960s, which were revolutionary.

This is a different revolution.

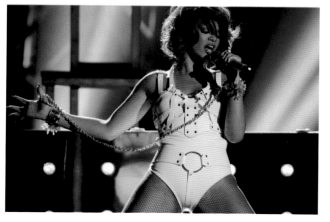

Clockwise from top left: Model Tatjana Patitz wearing Norma Kamali's black boned bandeau and matching shirred bikini bottom; OMO swimsuit featured in *Vogue*, July 2011; Rihanna performing during the 2011 Billboard Music Awards wearing Norma Kamali swimwear

This is huge. This is mind-blowing. I'm so happy to be alive now and to be participating in this.

How much time do you spend on Facebook and email and Twitter? Do you have a Tweeter in the office, or are you it?

I'm not a Twitterer because I like doing a blog. I do *Note from Norma* every week, and it's a way that I can tell a story about what's going on. We had two women soldiers who were stationed in Afghanistan who were going on a break in Kuwait, and they sent away for swimsuits. So the girls in my office said, "Isn't this great?" And I said, "Well, we can't charge them. Just send them the swimsuits." I sent them a note saying, "I want you to have these as a gift, but I really want to see a picture of you in them and a picture of you in uniform." And they were amazing. They were gorgeous. So I introduce different things like that in my *Note from Norma*. We are Tweeting and we have our Facebook page. It's part of the culture of the company. But I'm not going to tell you I'm at the airport, just getting on a plane to do whatever. It's not going to happen.

So we're not going to know where you're going to be after this?

I'm afraid not, no. And I can't imagine why you would want to know.

What blogs or websites do you read to stay current?

My personal favorites happen to be about wellness. There's so much new information about fitness, health, and beauty from real experts. I'm obsessed with those.

How big is your e-commerce business?

Well, in proportion to our retail business, it's now probably going half and half.

Who are some of the best celebrity customers you've had? Who do you think speaks your clothing?

From the beginning until now, I think I've been very fortunate. People remember Raquel Welch in her heyday, and she wore my clothes all the time. Here is a woman who's no bigger than I am. We're exactly the same height, except she's built a little differently. And when we would go out to dinner, people would say, "You look like Raquel Welch." But when she would put on a dress, she was blown up into this bigger-than-life person. I found her very impressive in that way. I also thought Jackie Bassett was really quite beautiful, and I enjoyed dressing her. Cher has been a great customer. Madonna wore a lot of my clothes. And now, obviously, Beyoncé and Rihanna and all of those girls are customers. I think a great story is, Lady Gaga placed an order for some ridiculous amount online and under another name.

The order came in from Lady Gaga?

No, another name. It was obvious that it was a tremendous amount of money for someone to be shopping online, and it turned out that it was Lady Gaga. She's been a really good customer of ours ever since. I think one of the interesting things about the time I've been in this business is all these generations that have been wearing my clothes. In Lady Gaga's last video, she's wearing her mother's wedding gown that I made.

Oh, how fabulous.

And she talks about it, so I'm not talking out of school. And the promo for the video, she's wearing one of my new swimsuits.

It's multigenerational. So, is there a celebrity out there that you always wished you would've dressed and never did? Anybody?

No. I've seen really beautiful women wearing my clothes. I can even say Jackie Kennedy

Left to right: Norma Kamali, 1981; Norma Kamali, 1987

bought clothes from me. And so I've been very lucky that way.

Have you dressed Mrs. Obama?

No, I haven't. But I feel like, if you don't want to wear my clothes, I don't want you to wear my clothes.

What continues to inspire you? When you see something, what do you do? Do you draw? Do you sketch? Do you take pictures?

In design, we're thinking all the time. I see a light fixture, well, maybe that can be something. Or that pattern could work nicely into a collection. It's stuff that stores up. And then, when you create the collection, it somehow comes out into something else, if you're being creative and not mimicking something. I think the inspiration for me is new technology in fabrics and the way clothing is made. Can this piece of clothing heat your body and cool it? Can it change the dynamic of your metabolism? And can it affect your health? Can it do acupuncture? That's an area I'm going to really want to explore.

Which designers do you admire the most? And why?

I think—and it's going to sound maybe not the expected—but I think someone like Ralph Lauren. You know Ralph. And he's got a really great company based on his authentic philosophy. And so I really respect him. I think he's fantastic. And he's successful, because he's valid and authentic.

Fair enough. I'm going to ask you an important question. Why isn't Norma Kamali a gigantic business, like some of these designers? Like Ralph? You're an authentic. You should have stores all over the world and be a huge, huge business. Is it part of your Cancer trait or your rooster sign that holds you back?

I don't see it as being held back, actually.

Well I don't mean held back, but you know what I mean.

I've been the owner of my own company since 1967. I'm still in business. I've seen a lot of people come and go. I've been able to do anything I want whenever I want, as long as I can pay the rent. I've had the ultimate freedom to do films, to do architecture, to do furniture, anything. I've never had to talk to a board to tell me I could or I couldn't. I love the freedom to be creative. I'm not sure that being the wealthiest, biggest company has been my goal,

but it doesn't mean it may not be in the future. I never close the door to it. In my career, the freedom to be creative in any area I want was more important. I think success can be measured in lots of different ways. I want to be creatively expressive and enjoy every day. And I still do, so that's a pretty good thing.

That is a pretty good thing. Is there a Norma Kamali business without Norma?

I think there's a culture that I've created that's very defined and definite. I think that culture can exist without Norma. I think there's a possibility for that culture, the Norma Kamali culture or the Kamali Kulture, to exist without me.

What is—or what was—the most integral part of your life at OMO?

At On My Own? When my husband and I split, going on my own was a huge, huge thing. I had ninety-eight dollars, which was interesting funding for a new company, to say the least. And I really didn't know what I was going to do, except a lot of people were very supportive and I was very lucky. And so going on my own in the 1970s was, I thought, a personal experience. But when I did that, and certain people started to write about it, I received a slew of letters from women who were also thinking that maybe they should be on their own. I was a poster girl for this movement for a little while. I didn't know that I really wanted to be the poster girl for it, because I couldn't figure out what I was doing myself. But I think On My Own was a very big, important step for me. It was probably one of the most difficult things that I'd ever done. And I did it when I was twenty-nine, thirty—in that age when women are at a big crossroad.

What is your most humbling experience to date?

Ugh, they happen all the time, unfortunately. I'm humbled every day. It's by something that is just so big and so awesome, and you think it's impossible that this can be, and you realize how small you are in the world. I think it's very important to understand that nothing is that big or that great or that important. There's always something more dramatic and more important. To keep that balance is key.

What's the most important advice you would give to people who want to follow in your footsteps?

You have to really like to work a lot. You have to like to work weekends and late nights. You have to have passion for what it is you're doing and feel grateful to have the opportunity. I feel that I have a very fortunate life. I'm doing everything I love every day. It doesn't mean it's a perfect day and doesn't have problems, but I have been blessed with this great opportunity. So if you feel that way, and you want to maximize every day, you don't mind what comes with it. And follow your own footsteps—don't bother about mine. You'll have more fun in your own footsteps.

And what is next on your agenda? What other things are still on the bucket list you haven't crossed off yet?

Unfortunately for my staff, they're always afraid after a weekend that I'll come in with too many ideas. I always believe in the theory that you could have twenty ideas and throw them up on the wall, and what sticks you play out. I like having a lot of ideas. That's the fun part of it, not repeating. I like trying something if it's never been done before. It has that much more appeal.

So I think we should end on thinking of things that have never been done before. Thank you, Norma. [APPLAUSE]

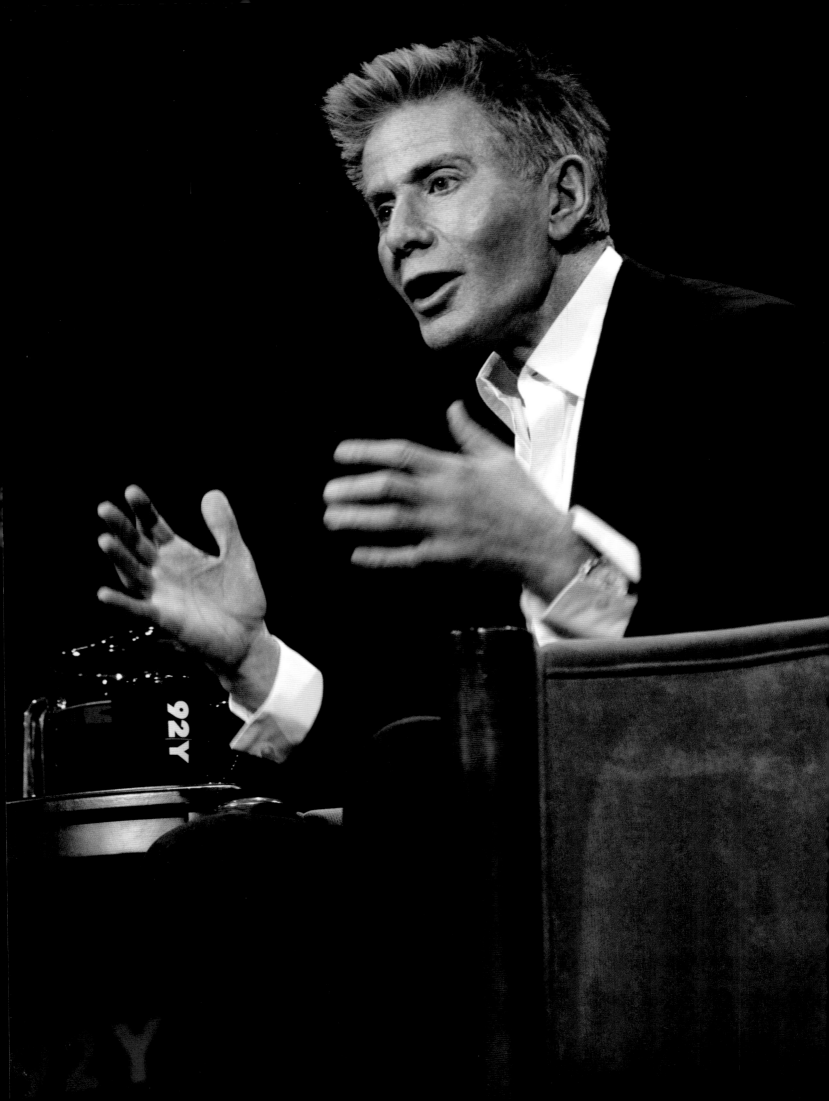

CALVIN KLEIN

Calvin Klein is clearly the most recognizable fashion brand in the world. He has, over forty years, broken every rule and boundary. And he didn't push the envelope—he created new ones, all to communicate his very focused vision and to sell jeans, fragrances, underwear, collection clothes, watches, tabletop, flatware, sheets, sunglasses, and more. Ladies and gentlemen, let us welcome the one and only Calvin Klein.

FERN MALLIS: Okay, so the first question I have for you is, why are you here and talking to me?

CALVIN KLEIN: Good question. I was here twelve years ago and did this once before for the Y. This is such a great place, such an important organization. I did it with Charlie Rose then. And you asked me and I'm thrilled to do this for you. Most of the time I speak at universities. I do a lot of work with FIT [the Fashion Institute of Technology] and talk with the young people who are studying to be designers, businessmen, marketing people, anything that I've been involved with. Tonight I'm here to speak to your audience and happy to be with you.

You were born on November 19, 1942. Do you know the way a Scorpio is described? What you see is only one-third above the surface, the rest is two-thirds hidden below. And I know Calvin doesn't care about horoscopes, but you do surround yourself mostly with Scorpios.

Well, it's all just coincidence. I worked with a group of people, and that was the most exciting part of all the work that I've ever done, the collaboration. And oddly enough, there were a handful of people who were very close to me who were Scorpios, so it was kind of testy at times. But we were all on the same page. We all thought about pushing the envelope and creating something exciting.

Well, you certainly did. So, let's find out how you did that. Let's start at the very beginning. Let's go to the Bronx. I know you didn't grow up in a white minimal apartment in the Bronx. So, what was that like? What were your parents like? What did they do?

Well, my mother would paint the apartment every few months. And I'd come home and say, "God, it's burgundy now." I hated the way the place looked. I mean I just couldn't bear it. But my parents were wonderful people. As my mother once said, "Don't ever forget you're a product of your father and me."

How true.

I am, I know that, and they encouraged me, both of them, to study and to continue my work. Growing up was actually a wonderful experience.

So I guess it was the burgundy in the apartment that helped you to think you could design something better. How did you know that fashion was a career that you could have? How did you start to pursue that?

Well, for one thing, my father was a businessman and my mother managed to spend all of his money. It was clothes. She loved clothes. And she was very subtle about everything. If she had fur, it would be fur-lined coats. You wouldn't see the fur on the outside. She loved neutral colors, tweeds. And she would sketch. She was good at that, actually. My grandmother,

her mother, was a dressmaker for a designer on Seventh Avenue and then opened up her own little shop. I was very close to my grandmother.

So then you decided you would go to school to study fashion?

I always knew I would go into fashion. I knew from the time I was five that this is exactly what I wanted to do. I always went to great public schools in New York and was in special art classes. I drew all the time. I knew what high school I was going to go to, which was Art and Design on 57th Street. From Art and Design I went to FIT to study fashion.

Did you graduate from FIT?

Yes.

Did you save all your sketches?

No, I never saved any of it. I didn't think about it that way. But what I did save were the clothes—all the clothes that we made since 1968, all the samples. I have an archive of all the photography, film, and commercial work that we did. And that I retained when I sold the company.

That was very smart. We'll come back to that. But where? Is it in New York, this archive of all the clothes? And can people access it, students or academics?

Not yet. The archives are still housed in the building where my offices are. The design studios use them.

When you decided to go to fashion school and study in FIT, what did your family and friends back in the Bronx think of that decision? Were they supportive?

My best friend, Barry Schwartz, who became my business partner, always supported it. He was absolutely great. Most people didn't understand. They were playing baseball and I was going to art classes.

Coming from the Bronx, going to FIT, being a designer—was that considered a gay profession?

No, I don't think anyone thought about straight/gay. Ralph Lauren grew up in the same neighborhood, and Ralph always dressed in sort of a peculiar way. I was the edgy one. I wanted to look like some tough guy, like James Dean. And Ralph looked like he was [in] some foreign country. I remember him distinctly as I was growing up.

Were you friends, or you just knew who Ralph was?

No, no. He is a little older than I am. [LAUGHTER] I grew up in a very Jewish, intellectual environment. People cared about education, music, art, culture. Being gay or straight was never an issue.

When did you get married—your first marriage?

I'm so bad with years.

Was it right after school?

Yes, it was after FIT. My first wife and I were seeing each other for a few years before that. We got married and shortly after had my daughter, who's here tonight, whom I'm very proud of, who is very successful in her own right.

So what was your first fashion job out of school, where you started working?

The first real job was designing coats and suits. I mean I wouldn't say designing. I was employed as a sketcher. It was for Dan Millstein, a typical garment-center company at that time. And he had what we called morning sickness. Until he smoked his first cigar, which was around noon, he was a nightmare. Whatever I sketched, it was never good enough

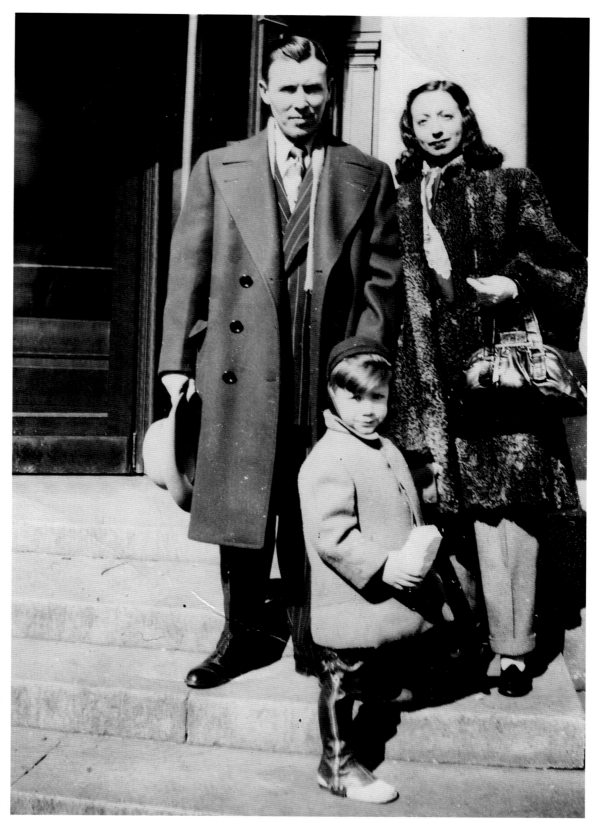

Clockwise from top right: Calvin at nine years old, with his parents, Flo and Leo Klein; Calvin Klein and his business partner, Barry Schwartz, 1975; Marci, Jane, and Calvin Klein, 1971

until after he had a little cigar, and then of course everything was fine. It was a good learning experience. But I knew then that I wanted to have my own company at some point. I don't know why, but I always had the sense. Maybe it came from my dad being in his own business. I always had the sense that I wouldn't be understood and I would have to do it myself.

When you were working for Millstein, I think that was your first trip to Paris, wasn't it? And there's a funny story about some people trying to sell you some clothes there.

Well, at that time, American manufacturers and designers went to Paris for inspiration and would go to the shows. They would have to buy one or two couture pieces as the entrance fee. Mr. Millstein called me in one day, and he said the consensus of opinion seems to be that [I] should meet us next week in Paris. And I just said, "Would you mind if I go tomorrow?" And off I went. That was the beginning of a great, wonderful experience.

Can you tell me about somebody who was trying to sell you some clothes off the rack in Paris?

Back then, we went to see Valentino, who, with Giancarlo [Giammetti], was showing his clothes on a hanger. He had a model, and he would show us the clothes in a tiny room at the Queen Elizabeth Hotel. It was his beginning too.

Extraordinary. So in 1967 you decided you had to have your own business. Who did you go to for advice to do that and set it up? I mean, you don't just wake up and start a business one morning. What did you do?

I just decided that while I was on a job—and it was a different job—that I could make some samples. And I discussed this with a couple of buyers from New York stores. Make these samples at night and on weekends, and then I would leave my job and the buyers promised to buy the clothes. The people that I worked for found out what I was doing, and they fired me before I quit. So I took a little room at a little hotel that had showrooms for manufacturers that made clothes in the South or the West Coast. It was called the York Hotel. I'm sure it doesn't exist anymore. My little room was opposite the elevator. And sure enough, one Thursday, the elevator door opened. I was sitting in my tiny little showroom with my rack of three coats and four dresses, and a man walked in, introduced himself, and said that he was the general merchandise manager from Bonwit Teller. I showed him the clothes. He said, "I'll have the buyer down here tomorrow, and then on Saturday, you will come up and show the clothes to the president of the store." Her name was Mildred Custin. And he said, "You will then have been discovered." I promise you, that's exactly what happened. The buyer loved the clothes. The next day, I had an appointment up at Bonwit Teller. My little showroom was on Seventh Avenue and 37th Street. Bonwit's was on Fifth Avenue and 56th, I think. And being this crazy perfectionist, I didn't want to crease any of the clothes in a taxi, so I wheeled a rack uptown. Unfortunately, one of the wheels broke. So it was a nightmare getting the clothes up there. Finally, I was up in her office at the top of the building, and they would say, "Ms. Custin just entered the store." "Ms. Custin's now in the elevator." And I'm dying. And she comes in, I show her the clothes, [she] doesn't smile and says, "Mr. Klein, I will pay you twenty dollars more for each piece that you're showing me— just make the production look exactly the way these samples look." And that was it. They wrote a fifty-thousand-dollar order.

Which was what you projected for the year. And who was your first call?

I thought if I did fifty thousand for the year it would be great. Now mind you, this is 1968. So,

I called Barry, my business partner. I had the talent, he had the money. He took the money out of the cash register from his supermarket. I called him and said, "Are you sitting down?" And he said yes. And I said, I just got a fifty-thousand-dollar order from Bonwit Teller. And he said, "Who's Bonwit Teller?" In the grocery business, it's about peas and beans. So that was the beginning. I like to tell this story to students because the great thing about the fashion business—and I believe it still today—is that word caught on like fire. People were coming immediately. They heard what was happening and they wanted to see the clothes and everyone wanted to buy. And so we started off really well.

So that confirmed that you and Barry were not going to go into the supermarket business together.

Months before I started the business, there was a terrible tragedy in his family. His father was murdered in his store. Both of our parents were in the same business. And he said to me, "Why don't we become partners? I'll give you half the business. We'll open up lots of stores, and we will be the next A&P," or whatever the big chain was. I was married. Marci was like a year old, or two years old. I knew this would mean security. I thought he and I would be successful. The idea of a business partnership with a close friend seemed ideal. I went to my parents, which I rarely did because I always thought I knew it all. I was sure that my mother would say, "Don't you dare go into the supermarket grocery business." And I thought my father would say, "Do it, this is a great opportunity." My dad, instead, said, "I never really understood exactly what you're studying all these years, but I have a feeling if you don't see it through, you will be unhappy all your life." I left their apartment on cloud nine, and I thought, wow, that did it for me.

That's some of the best advice you ever got.

It is the best advice I ever got.

So, when you had this collection and you took it up to Bonwit's, did you already have that perfect Calvin Klein logo? Did you design it?

Maybe—I've discussed this with Norma Kamali, whom I know you interviewed here. Norma grew up wearing camel-hair classic coats and gray flannel, and everything she hates. I grew up in an environment that was very baroque, and I always loved simplicity and purity. So the clothes were that at the time. The label—everything—had to be pure, minimal, and strong.

So you picked the typeface?

I worked with an art director. She was really wonderful at the time. Bea Feitler. I don't know if she was at *Vogue* or *Bazaar* back then. I've worked with some of the greatest art directors, photographers, cinematographers. And that's part of what's been so wonderful about the work that I've done, is it isn't just about clothes. It's—

It's the world.

—the whole world of style and then communicating the style to the world.

But did you know you were creating a brand? Did the word "brand" mean anything to you then?

I didn't think of it in terms of a brand. I always managed to separate myself from the name of the company. But I knew I wanted to create something that would go on long after I was personally involved with it. And I was just intrigued by the idea of doing other things. It started very early [with] advertising. Back then, and I think Anna Wintour is in the audience, the magazines would come to designers and say, it's now time for you to advertise, and we

will do it for you. And I always thought, how could they possibly do something like that? How can they communicate what I have to say better than me? And so I always got involved in areas that maybe American designers, or even European designers, hadn't experienced before.

With the in-house agencies?

With the marketing, with everything.

So after your collection, the first licensing and classification or category you went into was jeans, way back before a lot of people did jeans. How did that deal happen?

Those were the Studio 54 days. I was on my way to Frankfurt for a fabrics fair. And it was about four o'clock in the morning, and some man came up to me and said, "Would you like to put your name on blue jeans, on denim?" I called Barry when I was on my way to the airport and I said, "You know, there's something interesting about this." I said I love the idea of designing jeans, because then it was Lee, Levi, and Wrangler. I liked the idea of reaching a lot of people. With the clothes that I was making, because of the prices, you could reach very few people. And so I thought this would just be really interesting and fun, and we made an arrangement to start that company.

And that was with Puritan [Fashions] and Carl Rosen, who was Andrew Rosen's father.

Andrew used to work for us. And I'm so proud of what he's accomplished. His dad was a really cool guy. He was in the dress business. They knew nothing about jeans. All I kept saying was "Trust me. Just trust me." And Carl did. Then we were doing so much business that I said I think if we really want to reach people in the jeans world, we should be on TV.

Which was revolutionary.

Print's one thing and television's another. I said it's going to cost a lot of money. He said okay.

Fifteen-year-old Brooke Shields, who put on the jeans and helped put you on the map in a bigger way. Who did the creative and the shoots for that, and the copy?

I did a lot of work with Dick Avedon. I went to Dick and told him what I wanted to do, and he introduced me to Doon Arbus, Diane Arbus's daughter, who's brilliant and a great writer. And the three of us would do a lot of drinking, staying up very late, and deciding who the cinematographer should be. We just worked on it until we got it.

And you got it.

I worked with all the photographers and directors pretty much the same way. I just felt this passion that I knew what I wanted to say. I had to find the right people to help me convey that message.

You all heard the most famous of Brooke's lines with that campaign, but I'm just going to read you three of the others because they really are wonderful to remember. So, in addition to "Do you know what comes between me and my Calvins? Nothing." "Reading is to the mind what Calvins are to the body." "I've got seven Calvins in my closet. If they could talk, I'd be ruined." And, "Whenever I get some money I buy Calvins, and if there's any left, I pay the rent." They were great campaigns. But since you had all of that in you—I'm diverting you for a second—did you ever feel the need, as Tom Ford did, to make a movie?

No.

That campaign with Brooke was the beginning of probably a few decades for you of sexually provocative ads, which also led to you adding underwear to the Calvin Klein empire. Tell us how the underwear came about.

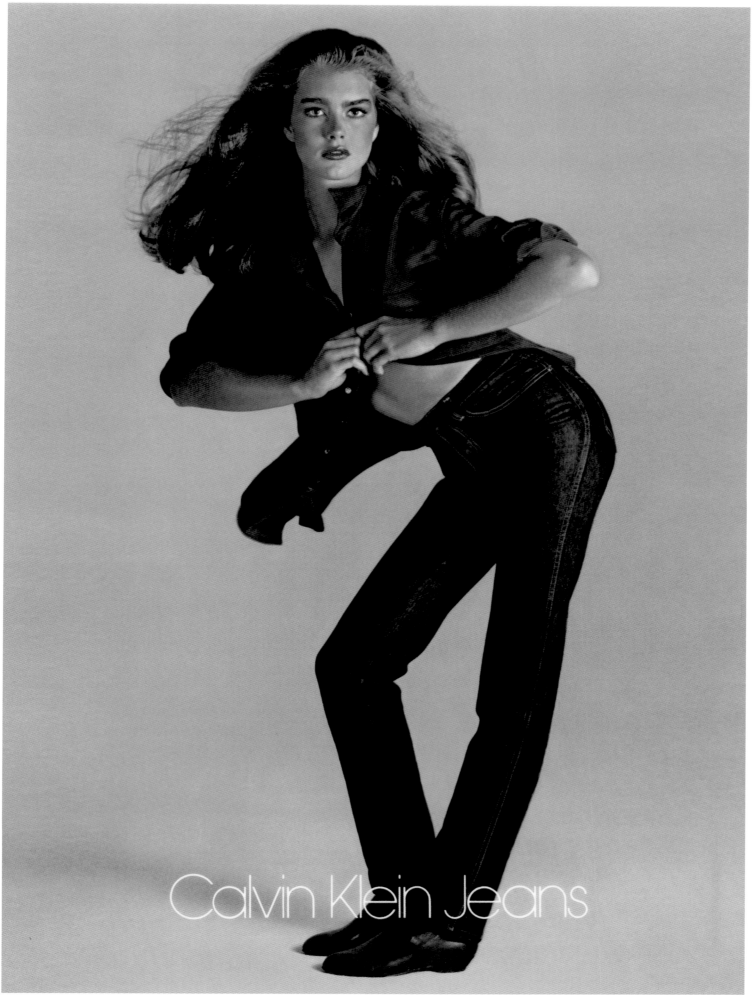

Calvin Klein Jeans

Photograph by Richard Avedon

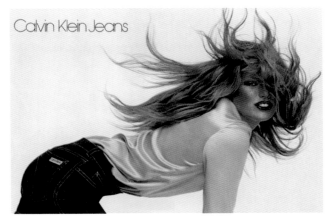

Calvin Klein Jeans

Pages 36–37: Calvin Klein making a personal appearance in Tokyo, 1979. Page 39: Brooke Shields, Calvin Klein Ad, November 1980. Photograph by Richard Avedon. This page, clockwise from top: Calvin Klein Jeans advertisement featuring Patti Hansen, by Charles Tracy; Calvin Klein men's underwear advertisement, by Bruce Weber; Calvin Klein underwear advertisement, by Bruce Weber; Calvin Klein with models from his Resort 1983 ready-to-wear collection, New York, August 5, 1983

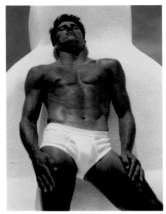

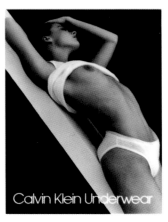

Calvin Klein Underwear

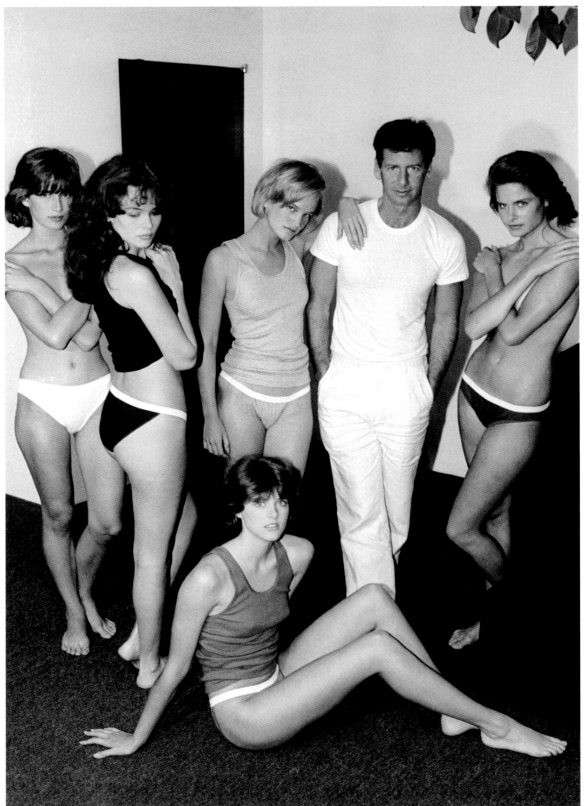

My second wife, Kelly, worked with me in the design studio for a long period of time. And she was greatly responsible for the idea of us doing underwear. She and I worked on it together. And ck One, the fragrance—we didn't want to use the word "unisex," but it was a fragrance for women and men. The underwear was the same idea. Kelly would often wear my white shirts. She would borrow things from me.

She wouldn't wear your underwear.

She didn't wear my underwear. But I thought it would be really sexy to see women in something that reminded me of men's underwear. And it worked.

Do you wear Calvin Klein underwear?

I still wear it. I wear other people's underwear, too, because I still want to check out the competition.

The underwear also started some of the most important outdoor billboards and big advertising campaigns, with your very first male model, the Olympic pole-vaulter, starting a crime wave in New York. Do you want to tell us about that?

I used to live uptown and I'd drive down Broadway to get to 39th Street, and I thought, billboards. The size of them. And they seemed so powerful. Patti Hansen was the great beauty of the time—this was probably around 1980. And I had someone shoot her on her hands and knees when she had this incredible mane of hair. That was the first billboard on Broadway. People were really upset. And now these things seem so tame.

You made them upset for years.

That Patti thing, on her hands and knees, didn't win me a lot of friends. But I believed in reaching people, especially if we're making products that a lot of people can afford to buy. So then I did a shoot with Bruce Weber. Bruce and I are really good friends. We did it in Greece. That's when we introduced the underwear. He did a photograph that's really iconic of this young triathlete in front of a sculpture, which is kind of phallic. We put the image on bus stop shelters all over the city and the country. People were breaking the glass and stealing the posters. Of course, the publicity from all of this was always great. We never did any thinking that we were going to cause controversy or that—we were trying to get publicity out of it. I think if you start off that way, you get nothing. We just thought about creating something that would be exciting, that would push the envelope but not be vulgar. And it was certainly sensual, sexual. I worked with the best people in the business.

In 1984, the Calvin Klein business projected an eighteen-to-twenty-million-dollar business in underwear. And it went up to seventy million dollars in a year. So I guess sex sells. Dare I ask you how you decided on these models? Could you imagine those go-sees?

Well, for one thing, as much as I like modeling agencies, I would hire people to scout and send me Polaroids in Europe, all over the US. I didn't want to just use someone whom everyone was using. And so I would have people scout, and then I'd go through hundreds and hundreds of Polaroids and bring people in if I thought they were interesting. I'd have to fall in love for five minutes. That's what happened with Obsession.

Now, we're going to get there in a second.

Okay. But I always chose the model, hairstylist, makeup, every aspect of the shoot.

Well, for the underwear, though, there's one shoot that you didn't pick and that also helped launch that as an incredible worldwide business. And that was before there was paid product placement in movies. In 1985, there was a little film called *Back to*

the Future. **And that certainly secured the boxer shorts a permanent place in history. As Lea Thompson said to a time-traveling Michael J. Fox, "Just relax, Calvin. You have a big bruise on your head." And "I've never seen red underwear before, Calvin." "Why are you calling me Calvin," he asked. "Well, isn't that your name? Calvin Klein? It's written on your underwear." You told me you'd never seen that movie.**

I never saw the movie. But a very close friend of mine, David [Geffen], was in the film business, and he was at a screening at Steven Spielberg's house. He called me right after the screening, and he said, "You are not going to believe what I've just seen." He said it's going to be a huge hit. I found it embarrassing.

It was a brilliant film moment. But I also heard that that became a problem for your daughter, Marci, when she was at Brown.

Well, she was quoted once—I don't know if it was *Time* or *Newsweek*. She's involved with comedy; *Saturday Night Live* she's been producing and *30 Rock* she produced. She said something to the effect of, "Every time I go to bed with some guy, I'm looking at my dad's name on their underwear." I said to my psychiatrist at the time, "I don't think that's very funny." He said, "Lighten up."

You were always looking for new people to put in these campaigns. You had an up-and-coming Marky Mark or Mark Wahlberg, Josie Borain, Lisa Taylor, and a waifish model named Kate Moss. This was also at a time when everybody was becoming very self-conscious about their bodies. That's partially what I think you addressed in all of that imagery.

The reason for Kate and this whole group of young women that I found that someone named "waifs" was because before that, a lot of the women were having implants in their breasts. They were doing things to their buttocks. I mean, it was getting out of control. And there was something so distasteful about all of that. I wanted someone who I thought was natural, always thin. But I was looking for the complete opposite of that glamour type that came before Kate and a lot of others.

But also the male models. You put forth to the world an image of bodies that was somewhat attainable, somewhat not. I mean, those bodies made a lot of people either go to the gym or go to the shrink.

Well, that is a problem. For one thing, I've always been about physical fitness. I've been in the gym forever. I want to be in as good shape as possible. When you make clothes, and you want to sell clothes, you want to put them on the best bodies you can find. We were doing lots of things that would show skin. I found models who probably took steroids. Young boys and men grew up looking at these billboards and all this advertising that we were doing with male models who had bodies that you just couldn't get naturally, and that is a real issue. It's almost like females with anorexia and looking at fashion models. For the male, it's the opposite. They want to be bigger than they can be.

Well, you made most of these models and performers famous by including them in your campaign. How do you feel today about everybody who's using celebrities to make their campaigns famous? What's your take on the fashion-celebrity obsession?

It's never been my thing, because then it's about the celebrity. I wanted what I was selling to be about the clothes or the fragrance, not about some celebrity. But celebrities on magazine covers sell magazines. It's valid and it works, but it was just not for me.

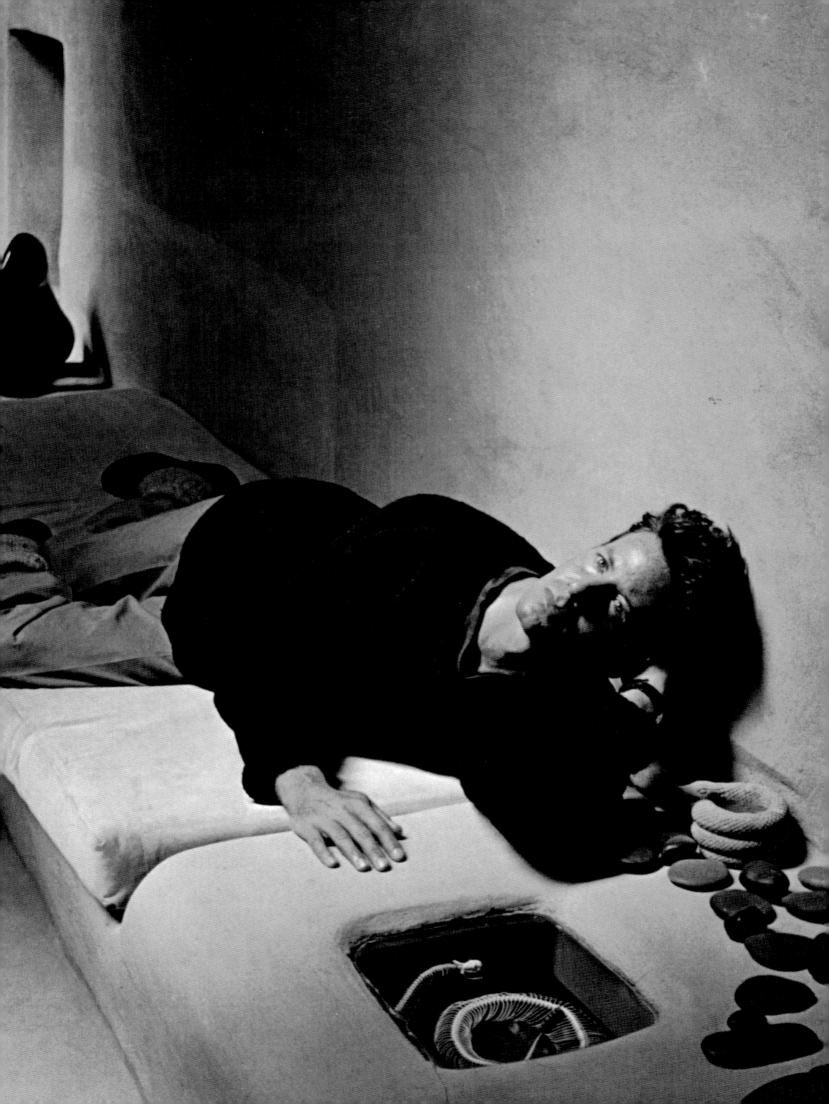

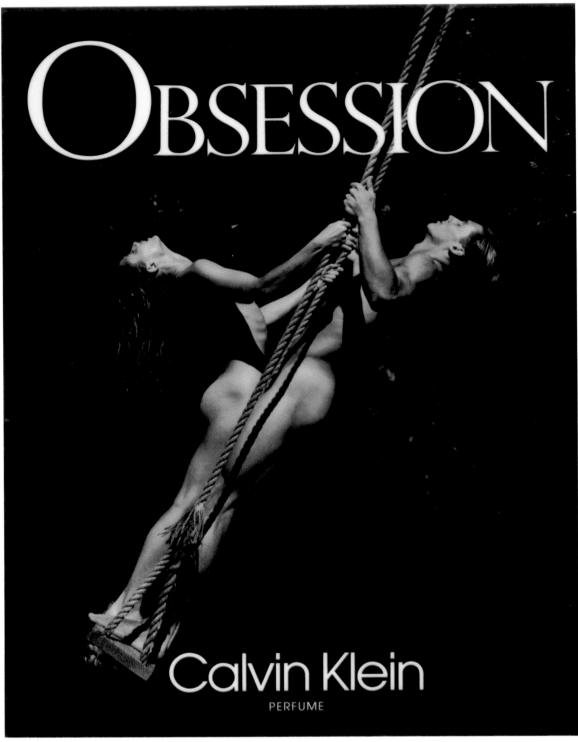

OBSESSION

Calvin Klein
PERFUME

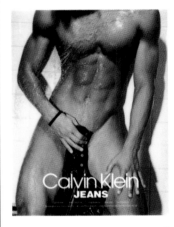

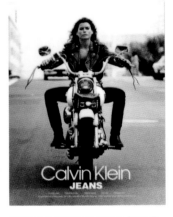

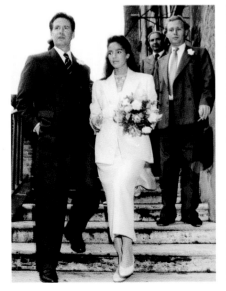

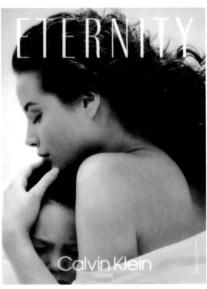

ETERNITY

Calvin Klein

Previous page: Calvin Klein in Sante Fe, New Mexico, at Georgia O'Keefe's house. This page, clockwise from top left: Calvin Klein Obsession advertisement, by Bruce Weber; two Calvin Klein jeans advertisements, by Bruce Weber; Calvin Klein Eternity advertisement, by Bruce Weber; Calvin and Kelly Klein on their wedding day, in Rome on September 26, 1986.

Just wasn't your thing. But you were obsessed with something, which caused you to create a fragrance named Obsession.

Well, I was obsessed about everything.

That works.

Every time I worked on a fragrance, I would have two or three writers giving me names. We had done marketing studies about the direction that the fragrance business was going. It was going romantic or green, woodsy, outdoorsy, or sexual. Then I would apply that marketing, that direction, to my life. Then I would have to find the people to pull it together and represent that. And with Obsession, I was going through some magazine and I saw the [word] "obsession," and I said that's it. I knew in a second because it reminded me of myself, of my friends who were obsessed with work, success. It's instinct. I get an emotional reaction—something happens to my body—when I see a photograph or clothes or a word, and I know that it's right.

And where did you see the word "eternity"?

Kelly and I were not married yet, but very much in love. The Duchess of Windsor had passed away and there was a sale of her jewelry at Sotheby's. There was a catalogue, and we were going through it. And sure enough, there was a ring that the duke had given to her, a diamond band. It was called an eternity ring. That was it.

You got that gut feeling.

I got the gut feeling, and Kelly got more than the ring.

She got pretty fabulous pearls, if I remember correctly. You did something very groundbreaking with *Vanity Fair* in 1991.

Well, I actually started before that. I was on a shoot with Bruce Weber in Santa Fe, and I used to do a lot of my own styling. I don't know if other designers did it, or if they do it, or if they even care. But I would like to arrange and decide how many buttons would be open on the shirt and roll up sleeves. The shoot in Santa Fe, that's how I became friends with Georgia O'Keeffe, the artist. We used two of her houses. We photographed jeans. We photographed all the different products that we made. I decided as it was happening, this has to be told as a story. And so that was the first time I did a portfolio, anywhere from twelve to fifteen pages or something like that. Before that, it was a single page in a magazine or a spread, two pages, to tell your story. I had more to say.

In *Vanity Fair*, you did a large outsert.

I don't know how many pages. I thought it was twenty-seven. But it was a statement. It was exciting. It was provocative. And it created a lot of talk and sales.

And it was Carré Otis and Marcus Schenkenberg, right?

I saw Marcus Schenkenberg the other night, actually. He was like the killer body of all time in that campaign. And he still looks pretty good.

Now we're into the fall in the early 1990s, in '93, when the first tents in Bryant Park went up. You were a critical part of that success at the beginning. Years later, the Calvin Klein company didn't show there and people thought you weren't involved. But I know how important your initial support to organize American designers and do that together was.

I think your involvement and the whole idea of the tents brought attention. It brought the press from all over the world to New York to see what American fashion was about. Whether we were showing in the tent or all over New York almost didn't matter, because suddenly

there was this real focus on what was happening here. American film and music had always been at the forefront and an inspiration for everyone around the world. Fashion, too. Because so many of us—I'm thinking about Donna Karan, Carolina Herrera—are really inspired by the way modern women live and work. That's an American thing. I think we've had great influence. And truthfully, there are American designers designing all over Europe now, too.

Absolutely. Okay, we're going to skip a few things here because there's a lot more to talk about. Can you tell us about the importance of opening your flagship store on Madison Avenue and how you got John Pawson?

Ian Schrager, a buddy of mine who owned Studio 54 and then went into the hotel business, left me a booklet of John Pawson's work. I visited John in London. That's another passion of mine, working with architects. I'm sort of a frustrated architect myself. I went to his home. People would be terrified that someone could actually live in such a pure, minimalist environment with two little children who seemed happy as clams. I knew instantly that John should do the store. And we've had a wonderful relationship ever since.

You've had a very strong relationship with architecture your whole life, and continue to now, with your new house that you're building.

Well, I worked with John on my apartment in New York, which took four years to build.

Is it true that there was a scale model built of that?

I built a full-scale model of the house that I'm building in Southampton.

Where do you build a full-scale model?

On the property. I tore down the house that was there. It was a monster. And an embarrassment to the town. We donated everything, all of the cement and the glass and the stone and everything, so it all got to be reused, which was a really good thing. And then I built a full-scale model of what I thought I was going to build, so that I could walk in the space. Very difficult to know proportion and height on paper, to get it right. So we built a model.

It's extraordinary. Okay, in licensing, you also broke a lot of ground and had many licensees that you managed and controlled.

Fragrance and jeans were our biggest licensing partners. And fragrance was really interesting. Originally, Barry and I owned it ourselves and lost so much money, so I sold it and took royalties on sales, which is what a normal licensing arrangement is. But I always created all the product, oversaw distribution, did all the marketing, and left the licensing partner to manufacture the product. We were in business with Unilever. Unilever is like the size of a country—they do so much, eighty billion or something. And they were the most supportive licensing partner I had—probably because we made a lot of money for them—during any controversy. Lots of people would get nervous, or companies would get nervous, especially public companies. But Unilever was fantastic.

Let's move up to end of 2002. You and Barry decided to sell the business for seven hundred million dollars. Why did you decide to sell it?

Barry was very involved with the New York Racing Association and he had lots of other interests. We were a global company, but to open up lots of retail stores and to do the things that I thought we needed to do, we'd have to go public or sell to a public company. I thought, it's time for a change. I was at an age where I felt young enough. And our timing was very good. I mean, financially it was very good.

So you never regretted that decision.

No. No.

Shortly thereafter, though, you had a very public meltdown at Madison Square Garden. Do you want to talk about that?

I've had a couple. That one happened to be in the Garden. I'll never forget Kelly saying to me the next day, "Did you have to do it at a game where it was like, before the playoffs?" Everyone was watching TV. I struggled with addiction and lots of people do. And that was a really shameful, horrible moment. But you know I want to say something about that. It had nothing to do with work. Addiction is something that is not caused by stress on a job, even though lots of people in the fashion business have suffered from the same problem. It's not about the work. It has to do more with your childhood, how you grew up, lots of other things.

And is it still an issue for you?

You're always aware that this is something that you do not want to do. You don't want to go back there, whether it's drugs, sex, food.

Are you still involved in any creative capacity with the company?

When I sold the company, I consulted for three years. Actually, I did a lot more during that period of time than I thought I would do. They kindly asked me if I would stay on and continue after my three-year commitment. I think, for me, it was best to just let go and move on and enjoy a new time in my life.

Do you like what the company's doing now?

I don't follow what the company does. I don't really follow much of what anyone does.

So do you read *Women's Wear Daily* in the morning?

I look at *Women's Wear Daily*. We were doing about two billion at retail. They're doing about six billion. I still have a financial interest, a very serious one, in the company, so—

[TO AUDIENCE] So he's not going to say anything negative about it.

—I'm not complaining.

Since you don't cover or see the collections, do you have a sense who some of the next stars in fashion are?

No, I don't. The stars that I know are the ones who are established—Vera Wang and Carolina are good friends of mine, Donna Karan, a very close friend. We've traveled through Africa. We have a great time together.

[TO AUDIENCE] Don't you all want to be a fly on the wall on that trip?

We had so much fun. We just laughed like crazy, and it was great. And I took a lot of pictures. Instead of standing behind photographers, directing, I was now holding the camera myself. And I'm interested in that and we talked about the house. I could build that house in Southampton for the rest of my life, because architecture is so interesting. When you give it a certain amount of space, how you use the space is, for me, fascinating.

Absolutely. Is there any advice, though, that you would give to new designers?

Well, I think you need to have a vision. I think a designer, any designer, needs to say something that is different than what is being said out there. And then you have to be convincing. Even if you're not confident, act as if you are confident. That's the only way you can convince people to believe in what you believe in. And that's not easy. I think repetition is reputation. You think of Ralph Lauren and think of his great success—you know what he does. Donna Karan, same thing.

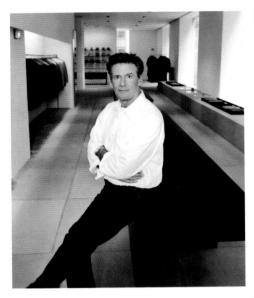

Left to right: Calvin Klein in his new flagship store on Madison Avenue, New York, September 6, 1995; Calvin Klein Collection, Spring/Summer 2003

Are you surprised they're both still in their companies and haven't made the switch?

Well, Donna sold her company a long time ago.

She's still there, though.

She's still there, right. She and I have talked about that a lot. We're both happy. But I think it helps if you have a vision and then that vision comes through with the clothing, the home furnishings, cosmetics, beauty, communication through advertising. You have to see it. You have to know and stand for something. You have to keep changing, but you still need to know that you're being true to yourself. People will know this is Calvin Klein or this is Ralph Lauren.

Do you think there still could be another Calvin Klein company, like what you've created?

I always think positively. And people, when I started way back then, they said, "Oh you're crazy. This is a terrible time to start a business. And if you're lucky, you can have a two-million-dollar business." The one thing about fashion is that the stores, the press, they're always ready for something new. Staying there, being established, lasting for a long time when you think of brands like Hermès and Gucci and some of the great names out there, that's tough. But the opportunities always exist for someone new, young, and talented.

Is it hard now that you're not Calvin Klein the business anymore, but you are still Calvin Klein the person, to see your name still on billboards, ads, commercials, everywhere, all over the world?

Sometimes when I see visuals and I see creative, I think, if I were doing it, I would do it differently. But I'm not doing it, I'm not in control, so I don't really have a problem. When I can't control it, why get upset about it?

What is a day in the life of Calvin Klein like now? And what does the Calvin Klein studio work on? Archives, books, the house?

All of it. I don't know if people know how much work goes into every detail. I mean, it's not an accident when something is well done. It requires such devotion and such talent, and so I can't begin to tell you what I've been through doing my apartment, my house. It's fun to do things for myself, because I always did it for the company. I always did all my work for people out there. Not that I had a bad life, but I am now enjoying living in

environments that I'm creating, or with people that I greatly respect, and spending time speaking to groups, universities, and—

Giving back a little.

Things are good.

Have you joined the tech revolution? Do you read your magazines and newspapers on an iPad?

I look at newspapers on the computer, and I also get the papers delivered, so I see both. I don't use the iPad all that much, although—

I know you love your iPhone.

I do everything on the iPhone.

Did you ever meet Steve Jobs?

No, I never met him, and we lost one of the really great visionaries. And I must say, my personal aesthetic—I mean, I'm a total addict when it comes to Apple.

I can imagine. Amazing collaborations if you and he were to work together.

That would've been really something.

Okay, we talked about the house, the new technology, your trips with Donna. What do customs agents say when you get back from a trip and they look at the passport and it says "Calvin Klein"?

Well, I generally don't go through customs. They come on the plane and—

Oh, there you go. [LAUGHTER] All right. Got away with that one. So what is still on your bucket list?

What's the bucket list?

Things you haven't done yet, that you still want to do.

I fell in love with a young man who's a total athlete, and we went paragliding off Aspen Mountain. That was a trip, let me tell you.

You know, when Donna did that, she always came back with a broken leg, so you survived that.

Yeah, I survived. Just barely.

Okay, we're at the end of this. If you were to summarize the three highlights of your career, what would the Calvin Klein legacy be?

I can't summarize. People used to ask me, what was your favorite dress in a collection? There are no favorites. It's the culmination of all the work that's really important. It's not one collection. It's not about one anything. I think it's about all of the years of constantly doing the best you can do. And for me, that's really the definition of success. People sometimes think, it's how much money you make or whatever they think about success. For me, it's always been just doing the best I can do, and then hoping people appreciate it.

And what are you the most proud of?

In the end, family and friends are what completes life. I devoted a great deal of my life to my work, which I'm very happy that I did. But I was there, I was a father. Marci and I, we now have the greatest relationship. I'm so proud of her success in her career and that it has nothing to do with fashion, which is also so interesting, and her success as a parent. She chose her own path. Everyone tells us we're very much alike.

Well, I think that's a very good note to end on. Thank you. That was great.

Thank you. [APPLAUSE]

DONNA KARAN

Donna Karan. Donna is us. Donna is every woman, and that is the key to her success. She designs for herself and for us. She feels for us, she cares for us, she gains weight like us, and she loses it. She is devoted to her family. She is a mother, a mother-in-law, and a grandmother. She has loved and lost and had her share of tragedies that have impacted her life and influenced her career. She is insecure like most of us. She is curious. She's a leader and an organizer, a businesswoman, a philanthropist, an artist, a mentor, and I'm proud to say, a friend. You have no idea how close we came to doing this entire interview on Skype. So let's meet this extraordinary woman who really did fly back from Haiti to be with us.

FERN MALLIS: Donna, you have had an amazing life and career. You were born in Forest Hills, Queens, on October 2, 1948. How old do you feel?

DONNA KARAN: Did you ask Calvin how old he was, too?

Yes, everybody knew Calvin's age.

There's a cute guy out there. How's that going to work for me? Just kidding.

How old do you feel?

Twelve, thirteen, fourteen. In my twenties, thirties. My daughter's older than I am. I have more energy.

You're a Libra. Does that mean anything to you?

Completely imbalanced. As a Libra, I try to find the balance in everything. It's neither one nor the other, but a very balanced sign. But I have a lot of Virgo in me.

A Libra characteristic is waiting until the last minute to decide things. Is that true?

Me? Never. If you asked me what the collection looks like before it goes out on the runway, I couldn't tell you.

You grew up in Woodmere, Long Island. And you went to Hewlett High School, where the girls wore Pappagallos.

They all wore Pappagallos, but I couldn't afford them. I had only a pair of Roman sandals that laced up my legs.

If you could afford them, would you have wanted to have Pappagallos?

Probably not. I was a hippie. Still am.

Why did your family move from Queens to Long Island?

Good question. They never told me. We moved when I was three.

What did your parents do?

My mother was in fashion. My father was in fashion. My mother was a model, a showroom model. And my father made custom-made suits for gangsters, and he worked near Macy's. He unfortunately passed away when I was three. But I remember watching the Thanksgiving Day parade from there.

Best seats.

It was the most important moment of my life; I watched the parade and then I got scared by the Indians and I went under the table.

Was that one of the best memories you have of your father?

Probably the only one.

You grew up in the Five Towns, and your family, as you say, was in the fashion business. Were you a clotheshorse?

I lived on the other side of the tracks in the Five Towns.

So you weren't quite a clotheshorse or a JAP [Jewish American Princess]?

I worked in a clothing store.

Doing what?

I was a salesgirl. The store was called Sherry's. I drew an amazing sketch in the dressing room, and all the mothers loved me to dress their kids. I was about thirteen or fourteen. I lied about my age [to get the job]. And I was a really good salesgirl. I told anybody in the fashion industry that I wanted to be an illustrator, not a designer.

You still are the best salesgirl.

If you want to be a designer, you have to—you must—work in retail. There's not even a discussion about it.

That's very good advice. When did you go to Parsons?

I didn't want to go to Parsons. I wanted to work at *Women's Wear Daily* as an illustrator and [in my interview] John Fairchild told me that I better take up design because I wasn't a good enough illustrator.

So we have *Women's Wear Daily* to thank for you becoming a designer.

I figured I'd go to FIT for illustration and Parsons for design, so I wasn't sure who would take me. I know Calvin went to FIT and I went to Parsons. But I didn't graduate, you know that.

I know that. So, how many years did you go to Parsons?

Two. I had to go to summer school because I failed draping.

Failed draping?

I showed them.

So that means there's hope for some people out there, right?

I failed draping. I failed typing in high school. That's why I'm not very good on a computer.

When you went to Parsons did you commute from Long Island?

Long Island Rail Road, back and forth, back and forth.

Why didn't you finish your degree?

Anne Klein hired me for a summer job.

Was she recruiting at the school?

Actually, my mother worked for Chuck Howard and Chuck said, "I want you to meet Anne Klein." And I walked in with my bag and she said, "Take a walk." I asked, "What do I have to walk for?" She said, "You're here to be a model. Your hips are too big." It really pissed me off. I said, "No, I want to be a designer." So she said, "Let me see your portfolio." And she hired me and then I said I could only stay for the summer because I had to go back to school. And then she said to me, "Why would you want to go to school? You're going to learn more here." So I learned how to make coffee and sharpen pencils, and it was really an extraordinary experience.

Were you sorry that you didn't go back to school?

Just a few years ago, Sheila Johnson gave me a graduate degree at Parsons.

So your summer job continued—

I went to work for Anne for nine months, and then she fired me.

Clockwise from top: Donna Karan as a baby; Donna with her daughter, Gabby; Donna's parents Gabby and Helen Faske; Donna and her mother

Left to right: Donna Karan with Louis Dell'Olio at Anne Klein; Donna Karan fitting a model

What was Anne like?

Anne taught me the best lesson in the world. A designer is a designer even if she's designing toothbrushes and hospital gowns. And her body and my body were different. She had a bigger belly and I had a bigger butt. So it was dependent on which part of our bodies we were looking to design on.

So together you can make a great ad for something, right?

No, we had to be one or the other. We had her patterns and my patterns and they were very different, because she was really small and I was really tall.

Is there somebody in the industry now that you would compare her to?

There is no other Anne Klein. Anne was the first person who really brought designers together. It was a collective. It wasn't only about Anne Klein. Anne Klein was humble. She was the first person who did sportswear, shirts, jackets—

Okay, explain what that meant. Because that was the revolution of Anne Klein.

Well, because everybody was doing dresses. You know, kind of like Seventh Avenue dresses. But Seventh Avenue was really nothing because it was all about Europe, in terms of fashion. But Anne really put the stamp on sportswear, you know—navy blazer, plaid skirts, shirts. But she was an artist, too. I designed Anne Klein longer than Anne Klein, so it's kind of weird.

After you were fired, you went to work for Patti Cappelli?

I went to work for Patti Cappelli the next day. Someone just said, "You should meet Patti." And it was different. At Anne Klein, there were many, many designers. And I was the designer to the designer to the designer. I was a kid, you know—water, coffee, sharpening pencils. They put me in the patternmaking room. And then I worked for Patti, and it was just Patti and me. But it was on Broadway—Broadway versus Seventh Avenue. I learned about jeans and Bloomingdale's and Kal Ruttenstein. I was not only a designer, I was also a salesperson. I sort of did everything.

It's a small business.

That was when the budgets for designers were good. They used to let us go for inspirational trips. We went to Saint-Tropez and I saw all these colored jeans—purple, yellow, orange. We thought [they were] the greatest thing since chopped liver, and when we came back, we were knocking off the concept. I went to the Bristol Hotel in Paris, and I was a girl from Five Towns, going into Paris, and I was supposed to be married. I was engaged to be married. That's a whole other story. I mean that would take seven hours—

You wanted a family.

My mother was a working woman and Anne was a working woman and all I wanted to do was to get married and have children. I didn't want to stay on Seventh Avenue.

I read somewhere that Patti [Cappelli] encouraged you to marry Mark Karan.

I was engaged to Mark. And then all of a sudden, at my engagement party, Stephan [Weiss] walked in the room. And I thought, oh my God, who is he? Ten years older, ponytailed artist, the whole nine yards, and I said, "Now what do I do?"

He was at your engagement party?

I met Stephan at my engagement party.

Oh, I didn't know that.

We had a little problem.

Houston, there's a problem.

Exactly. But Stephan had children, he was an artist, he was ten years older than me— stuff like that. So then I went off to Paris and I broke off the wedding. I said this is ridiculous, I don't know what I'm doing right now. Here's a guy I love, my best friend. He was my first boyfriend, since I was sixteen, and he was going to take care of me. He was a fantastic guy. Or [there's] this other guy, who's an artist, hot, bohemian kind of guy.

But not available.

Well, sort of not available. So I went home and I married Mark three days later.

He was a retailer. What kind of store did he have?

We opened our first men's store, called Piccadilly's in Cedarhurst. Oh God, this is really weird. If anyone wants to know why I'm a woo-woo, this is why. My father died when I was three. Mark was opening a men's clothing store, and an order didn't come in, so the store was empty. So we went to Brooklyn to pick up all these clothes. And my father-in-law at the time opened up the clothes and he asked, "What was your father's name?" I said, "Gabby Faske." He picked up a hanger. It was my father's, with all the suits from Brooklyn that he found on Orchard Street or something.

Oh my goodness.

My father was a blessing to the store.

Did you keep that hanger?

I still have the hanger. It's in my office.

Is there anything hanging on it?

My sister actually took it from me because she knew I'd lose it. When I turned one of those wonderful golden years, she gave it back to me.

Did you consider staying in business with Mark in Piccadilly's?

No, I was working in Sherry's in Cedarhurst. So we opened a store called Gabby's. And we then had a little clothing store in Cedarhurst, women's fashion.

Somewhere along the line you got pregnant and you also went back to Anne Klein. So tell us how that transition happened. Not how you got pregnant, but how you went back to Anne Klein.

Fern, I might tell that. This was probably the most important thing in my life that ever happened. I was pregnant with Gabby, and I was in Europe, doing the fabric shows. That's when Anne and I went to Versailles, and I thought I was going to have the baby right then and there. I was eight-and-a-half months pregnant. And Anne had cancer. But in those days, nobody discussed that word.

Was it breast cancer?

Yeah. At that moment I said "I'm going to go home and be a mommy now." And Chip Rubenstein, her husband, said "I have to tell you something. Anne has cancer." And I thought, I'm having a baby. My boss has cancer. What do I do? So I said we'd better hire somebody. I had a friend, Louis Dell'Olio, whom I went to Parsons with, and I called Louis and said, "Get your ass over here—I am in deep trouble. I'm having a baby, my boss is sick, and we have a collection due." So I am in the hospital, ten days after my due date, and I went into labor and Gabby was born. I got a phone call, and they asked me, "When are you coming back to work?" I said, "Would you like to know whether I had a boy or a girl? By the way, I had a girl, if you care." They said, "Well, that's very nice, but we have a collection due." So with that, the company took everything out to my brand-new house. I figured bagels, lox, the whole nine yards. And everybody would see my baby and that's what it would be all about. And the entire company comes to my house that morning—I'll never forget this as long as I live. For all of you women out there who know what it is to have a ten-pound baby girl, because you're nine days late, you aren't exactly feeling so good. I had my mannequins there. I'm doing the clothes. Anne's in the hospital. I am freaking out. And a call comes in. And I go, "What's the matter?" Anne dies. And I went to the city for her funeral. There I was, living birth and death, in the exact same week.

So Anne was the second significant loss in your life after your dad.

So Anne died and I had to go back to work. And that was not my plan.

This was all in 1974. The happiest thing that happens to you is having a baby, and then the saddest thing—your mentor dies.

I wasn't planning on being a designer. I guess you've got to realize, there's somebody up there who's guiding your life. If you think you are, you're not, by the way. I thought I'd let everybody know, we have nothing to do with this.

What was it like working with Louis?

Louis didn't want to come. Because he had to do his collection, I was all by myself. And when we were in Versailles together, Anne and I met Kate Thompson and Liza Minnelli and I asked Kate to come in and help me put the show together. So I said, "Louis, when are you going to come here? I've got to go take care of my daughter." So finally Louis came about two collections later. And we teamed up to do Anne Klein.

How many years did you and Louis work together?

About nine years. And then I started Anne Klein II.

Did you ever miss working that close with a designer?

To me, I only work with teams. It's never, ever only about me. It's always about the we. I mean, it's my people, I do fit everything. I'm a little bit obsessed about the fit and the body.

What was the impetus in 1983 for starting Anne Klein II?

I needed a pair of jeans, and I needed my T-shirts, my sweats, and all of my casual clothes that I wasn't doing at Anne Klein. And at Anne Klein, I found that my resort collection and my summer collection were the collections that I loved. They were less expensive. So it was a doorway to something between the collection and Anne Klein II.

Well, Anne Klein II was essentially one of the first bridge collections in the industry; you started an entire category on Seventh Avenue. So that was in 1983, which was another important year for you because you married Stephan Weiss, whom you had

met seventeen years earlier.

Where'd you get this all? I'm very impressed. Can I have that for my biography?

I'll give this to you after. So where did you reconnect with Stephan then, after all that time, and you got married seventeen years later?

I had met him in a major snowstorm, and ten years later there was a major snowstorm in New York City. Everything was paralyzed. And I said to his brother—I was on the Long Island Rail Road at the time—"How's Stephan? Have you seen him? Have him give me a call." And that was it. Stephan called me that day. And that was the end of it.

Well it was the beginning of it, not the end of it.

We don't have to go into details, do we?

So he was an artist?

He was a sculptor. He was an artist. He was an amazing guy. He had two children. And he had his studio and living space on Second Avenue. And he did theater sets for Broadway shows.

A year after that, Tomio Taki and Frank Mori, who ran Anne Klein, basically fired you so that they could start another company. What was that like?

Well, I went in and I said I have this great new idea. I said I see this small company making clothes for me and my friends, because I was getting very frustrated. I said I just want to do these Seven Easy Pieces. You didn't discuss my yoga world.

We'll get there.

That's why I started the bodysuit, because of yoga. I've been into yoga since I was eighteen, and wanted my bodysuit, my legging, my scarf. I just wanted a wardrobe for me and my friends. That's it. They said to me, "Donna, there's nothing you can do that's small." "That is ridiculous," I said. "I've done Anne Klein II, I've been at Anne Klein. I'm ready to do just the clothes for me and my friends. If you keep me here, I'll keep it small." And he said, "You're fired." Louis stayed at Anne Klein, and I moved on to create Donna Karan. And that was the end of it. I did it in my apartment—that was my design room. It was just a young designer and me. I was sitting there, looking at a shoebox that read, "Maud Frizon Paris, London." And I said, "What about 'Donna Karan New York'?"

So you opened up Donna Karan, and your mission was to define clothing for you and your friends? Describe what the Seven Easy Pieces were.

Bodysuit, skirt, pants, tailored jacket or coat, cashmere sweater, something leather, and an evening piece. I still dress that way.

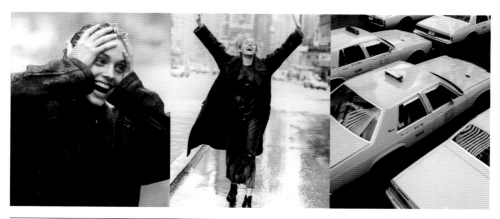

And what was Stephan's role in the company?

Well, it was just me and Stephan—he felt so bad I was all by myself. I had nobody. They had just fired me.

But didn't they also put up money to set up the business?

They gave me the production person, the person who used to go out and buy fabrics with me, [Julius] Stern. He was fantastic. He was like my father. And everybody knew I was a fabric junkie. I love fabric, I love color, I love everything to touch and feel. I'm kind of sensual that way. And so he came in as the president of Donna Karan. It was really a tiny little business.

And that business started around the time your mother died, so it seems like this recurring theme. There's always a yin and yang… sad and happy at the same time.

I had a show and my mother was in the hospital with cancer. She was up at Mount Sinai. She passed away, the day of the show.

How was DKNY born? And why?

I needed a pair of jeans. Everybody makes jeans, but I wanted a collection that was not about clothing. It had been my dream to do a collection that wasn't just about fashion. I'll never forget this. So Jane Chung, who worked with me at Anne Klein, quit Anne Klein, thank God. That's why I could get her to be with me. Jane said to me, "Donna, I want to do this kind of less expensive jean." I said, "Jane, I really want to do a lifestyle brand. I want to include food, flowers, children's clothes, everything." Because Gabby would come into my closet with all her friends and steal all my clothes. And I said this is ridiculous. My daughter went to school with her boots and my beaded evening clothes and all her other friends came into my closet and were wearing them, too. And she and I said, "Well, I've got to do a collection for my daughter." Everybody was wearing my clothes—I felt like I had no identity any longer. So I started doing DKNY, and I did men's, women's, children's, dog clothes, everything. And my bosses—my partners, excuse me—walked in and I said, "Well, I have this new little collection. It's DKNY." I showed everything with sneakers. It was a jumpsuit, it was jeans, it was a blue jacket, it was a T-shirt with a great logo. It was a great logo: NY, DKNY, NYC.

So how important is the "NY" to the "DK"?

It was the most important thing.

What does New York mean to you?

Because Donna Karan—who's Donna Karan? It's just a name. New York meant the world to me.

How did the men's collection start? Was it for Stephan?

No. This guy walked into my place and told me he wants to do men's clothes for me. And I asked, "Why? My husband wears Armani." My husband never wore a jacket in his life until he came into the fashion industry. He was in jeans and T-shirts. So this guy walks in from Brooklyn—oh God, please Donna, don't forget his name.

Martin Greenfield.

Martin Greenfield. Fabulous. And he has this place in Brooklyn. And I said, "If you could make a suit for my husband that I would be proud for him to walk out in, then we'll discuss this." So he makes a custom-made suit for my husband. And I wanted a forty-two extra long. And he made the suit. And I said, "Listen, and I want it to stretch." He said, "Stretch?" I said, "Yes, you know how women wear black clothes? You know black day-to-night?" If Donna Karan was going to do it, I wanted black suits and I wanted Seven Easy Pieces for men. At first they wanted me to do it for DKNY. And my husband said, "Donna, if you don't start at the top, you can never go to the bottom." So I did a collection, and I called my partners at the time and told them I'm opening menswear. They said, "What?" I said, "Try on this suit—what do you think?" And he said, "It's nice, I really like it." I said, "Well, look at all these suits here. How do you like them? We're showing them down the runway tomorrow."

Surprise.

I said, "We guess we're in the menswear business."

They were the sexiest men's clothes ever—

—well now, you know President Clinton wore—

—so it was poetic in that first year of your men's collection you won the CFDA award for Menswear Designer of the Year and it was presented to you—I remember so clearly—by Giorgio Armani.

Oh my God, really? I didn't remember that.

You don't remember that? [APPLAUSE]

I'm telling you, Fern, that sheet is fabulous. I might write a book now. I might be able to get a book out. This is great. Thank you.

I'll be your collaborator on the book.

I think you might have to.

I remember that clearly because it was one of my very early years at the CFDA and producing the annual awards gala. It was a well-deserved and very special win.

Thank you.

That kind of leads to Hollywood and Washington, D.C., which are a major part of your life and work. But first, how did you meet Barbra Streisand?

Actually, I wanted to sing like Barbra Streisand. I think everybody in this audience would want to sing like Barbra. I wanted to be Barbra and dance like Martha Graham. That was who I wanted to be.

Those are good role models.

But I couldn't do anything so I had to be a designer. That really annoyed me. My girlfriend called me up, and she said, "I have somebody who you're going to meet, and you're going to freak. It's Barbra Streisand." I said, "You've got to be kidding me." She said, "No, she's at my husband's furniture place right now and she needs raisin-colored clothes to go with this fur coat that she bought at Bergdorf Goodman." I said, "Oh my God, she bought one of my coats." So I emptied out my entire closet, brought it into the showroom. Barbra's

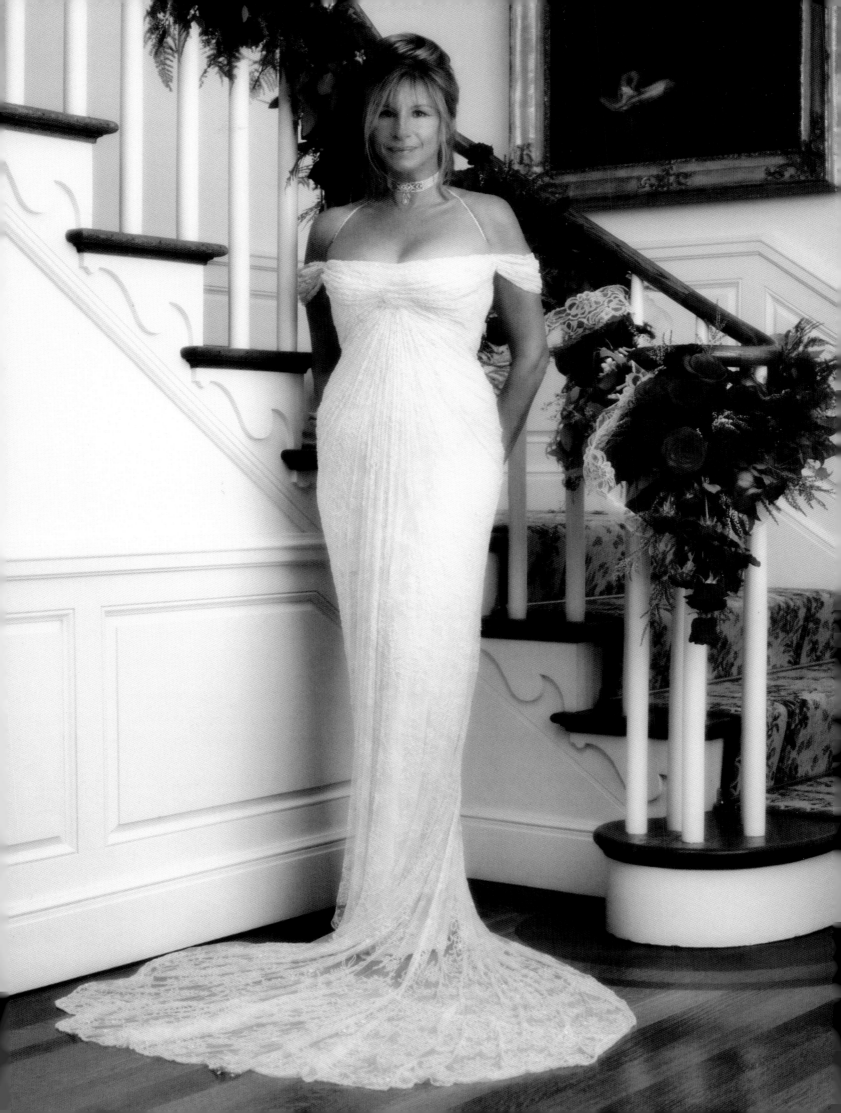

sitting in a chair, I walked to the back into Frank Mori's office, and I thought, I need to sit down and take a pill. Because I had my hair like Barbra, I wanted to sing like Barbra, I wanted to be Barbra. Barbra, of course, only wants her clothes. So she went into the design room and said, "I want that, that and that and that." I did these chenille sweaters that were amazing—[they were] on the cover of *Vogue*. I hope there's no legal in the house, but this is the truth of what happened: I was at Studio 54 or somewhere, smoking a cigarette. And all of a sudden my sweater went up in flames. And I thought, oh my God, now what do I do? This is the hottest item going right now, these long chenille sweaters, and they're flammable. So I said to Barbra, "There is no way I am getting you these sweaters." She said, "You do not say no to Barbra." We went back and forth and I said, "Barbra, you can't have these sweaters, I'm sorry. I love you, but there's no way. I can see it now: Barbra Streisand burns up in Donna Karan. But when Barbra wants something, Barbra really wants something. And later she called me up and she said, "Give me the yarn supplier, I'll make them myself." I said, "No, Barbra, you're not getting them. That's the end of it." So that's how my life with Barbra began.

Could you ever have imagined growing up, as a nice Jewish girl from Long Island, that you and the nice Jewish girl from Erasmus High School in Brooklyn would become BFFs?

Best friends forever. What about the wedding dress I did for her? That was a good story.

Tell us about that.

Barbra does everything. She is a great designer. So she told me she's getting married and said she needs a dress. And, of course, she sketched it. So I made two dresses for her wedding. There was Barbra's dress and my dress. And I'll never forget this moment as long as I live. I said, "Barbra, okay, you can wear this dress or that dress." She put on my dress and she liked it. She got married in my dress, thank God.

How did you first meet and get to dress Bill Clinton?

I met President Clinton through Barbra. He is a very tall man. My husband is much shorter than he, and my husband wears a forty-two long. He called me and said, "Donna, I need a suit for the inauguration." Now this is four days before the inauguration. I asked, "What size are you?" He said, "Fifty-four long." I said, "No, you are fifty-four extra long." He said, "No, I'm fifty-four long." So I called Martin Greenfield and said, "You've got to make these tuxedos for me." And he made me a fifty-four long and a fifty-four extra long. And Barbra and I were at the Arkansas ball, and it was getting a little cramped and everybody was taking everybody's pictures and we're standing in the VIP room, and all of a sudden they say the president's coming. They put us up on stage with the president and Hillary. And he said, "I want you to meet my family." So it's Barbra, me, Chelsea—who's like this tall— his mother—an amazing woman—my husband Stephan and some friends of mine. The first words out of my mouth are, "What size are you wearing, fifty-four long or extra long?" "Long," he says. I couldn't believe it. He actually was right.

And then you got Hillary into your cold shoulder dress at the inauguration.

Women's Wear Daily said that dress was the worst thing I ever designed. I figured, you go to work, you have a wonderful turtleneck dress on. Then you go out, take off the jacket, and your shoulders are cut out. And the only place you never gain weight is your shoulder.

Which is a great line.

It is a guarantee—you will never, ever gain weight on your shoulder. Every other place, I can't talk about. But the shoulder, you'll never gain weight. So I did this dress with these cutout shoulders. Liza Minnelli goes into my closet, pulls out the cold shoulder dress and wears it. And gets great press. How did Hillary get that dress? I have no idea. She bought it retail.

She has to buy it retail. You're not allowed to give them clothes.

Hillary Clinton in the cold shoulder dress. That started a lot of cold shoulder dresses. And you know how fragrance started. My husband said, "Donna, you can do all the clothes you want, but unless we make fragrance, we're not going to be in business." So he actually made the fragrances. I said, "I want it to smell like my husband's neck." I gave him a 'Casa Blanca' lily and a piece of suede. "If you can put a 'Casa Blanca' lily with a piece of suede and my husband's neck, I'll talk to you about fragrance." And I worked every single day, and my husband was mixing all the oils, and I swear to God, this is what my life was like. And we went into the fragrance business, and Stephan designed the bottles. My husband was such a Virgo. He gave me three bottles to choose from. So Stephan started the beauty business really, himself. We designed our own special hair shampoo. I was very particular about how the shampoo would feel, because that's what I really cared about—the body products, all the moisturizers, and all of that. We had all these businesses. We had the beauty business. We made candles. Big candles, oils, everything that I loved. It was beauty through a whole other lens.

Then you sold it to Estée Lauder?

Mmhmm.

A few years later, you opened your first stores, both DKNY and Donna Karan, in London. Why London and not New York?

Christina Ong, whom I worked with on international business and is a dear friend, found this amazing store space on Bond Street for Donna Karan in London and she showed it to me. I said, "This is not a Donna Karan store." It's DKNY and it had to have an escalator, because it was a real "energy" kind of store. And then I found a place where I would do Donna Karan. I will never forget that moment because I worked with Peter Marino. I'm in the store and it was architectural and it was fantastic. And I called Christina, and I said there was too much white in the store. "Could you paint a little bit more black?" So I basically had a black store. And it was really one of the first. But it was very sculptural and artistic. So now that I did these stores in London, I wanted to do a store on Madison Avenue. DKNY was first. I wanted DKNY to be a part of the street scene. I wanted the café on the first floor. I figured if people would come in and buy juices and coffee, maybe they'd go buy clothes. I wanted the collection to be a sanctuary kind of thing. Donna Karan was actually the first Urban Zen store.

Around that time Stephan was diagnosed with lung cancer. And in 1997, you stepped down as CEO and were named chairwoman and chief designer.

We went public first. That was the most exciting period of my life. If anybody wants to go public, have fun.

When you were removed as CEO, was that a humbling experience or a liberating one? That's when you brought in executive John Idol as CEO to run the business. You started doing a lot of collections that were very Zen and very Eastern because you were exploring that universe, because Stephan was sick.

Page 63: Barbra Streisand wearing a Donna Karan dress at her wedding, 1998. This page: Andres Segura and Adriana Lima photographed in Haiti for the Donna Karan Spring/Summer 2014 campaign by Russell James

The company went public. That was really a hard time to go public. I wanted to control the company. I wanted triple A stock, because I was a baby company and I wanted to make sure that the company would grow. This story really hasn't been told—but I own the name Donna Karan. I owned the name and the public company licensed the name. When Stephan was sick, he was concerned and he said to me, "Donna, I can't leave you as a public company." And I said, "I agree with you." It was not the most fun—I mean, the most exciting day is when you ring the bell at the New York Stock Exchange, and the worst day is when you ring the bell.

Good news, bad news.

And LVMH and Gucci both came by and wanted the company, but I owned the name, so they bought me—

Right, so this is 2000, 2001. Bittersweet years. You're negotiating to sell the business to LVMH, the luxury conglomerate, and also navigating the final years of Stephan's life. It's again that yin and yang. You sold the company to LVMH, for a record-breaking price, around $640 million. Will you share your lawyer's name? Or was it Stephan who structured it? Everybody thought that was a brilliant deal.

My husband. Here was this ponytailed artist husband, [about whom], everybody thought, what does he know about business? And he said, "Until this deal is done, I will not cut my ponytail off."

So his appearance was disarming to people.

It was. When we met with LVMH, I had a very clear vision. I said to them, "When I started Donna Karan I wanted a manufacturer and when I started DKNY I wanted a retailer." Now I said, "I really feel that we're going to have to put philanthropy and commerce together." I had a complete vision for Urban Zen and what it was going to be. It was mind, body, and spirit and fashion and hotels and condominiums and lifestyle. I really wanted to look at the world of mind, body, and spirit.

So you set up Urban Zen as a new company, to integrate all the elements from your life.

I would go to Canyon Ranch and all these spas, but there was nothing in the cities that were catering to these people. I would travel from place to place, taking my juices with me,

working 24/7, traveling all over the world, exhausted. At night I need acupuncture, I need massage, and this was at one o'clock in the morning, and there was no place that I could get what I can get in New York. It was really about honoring cultures of the world, because I had been to Bali, Africa, India. In my ad campaigns you would see I was always inspired by travel. And we went back to Tibet or went to India, and we would shoot our campaigns in Morocco and travel all over the world. My inspiration has always been the world.

You brought the world to many people. Tell us about working with the Dalai Lama.

A friend, Sonja Nuttall, said to me, "Donna, how would you like to have the Dalai Lama at Stephan's studio?" Because I had already turned Urban Zen into a space and a place where I wanted to bring people who wanted to create change in the world, very much like the 92nd Street Y. I really felt philanthropy and commerce should join together, because the world is in such chaos right now. During the AIDS epidemic, we did 7th on Sale to bring the consumer awareness about AIDS. I could no longer go into a dressing room and talk to women and not realize they or their husbands or their children had cancer. I was dressing their inside.

Are there plans for an Urban Zen permanent center, where you can go and get acupuncture and go and get massages at night and is open 24/7?

Well, that's what I wanted, of course. It's great—I'd like my doctors to be in one place. I mean, I do have a vision and a future.

So that's still on your list to get done.

Absolutely. The whole thing came as a dream, as a fantasy. I saw a building, and in the building was cotton, cashmere, candles, and CDs, a café—all "C" words. And in the café was nutritious food. I eat very healthy, and certainly I learned all this through all my friends, and my husband living with cancer. And Lynn Kohlman, who also passed away from brain and breast cancer. And in this place—you went upstairs and it was a meditation room. It was a yoga room. And it was a conference center, where all of us who wanted to create the change in the world would get together, and bring in integrated healthcare—mind, body, and spirit into the healthcare industry, into the educational industry. Because in our children's education, we can teach reading, writing, and arithmetic until we're blue in the face, but unless that child is in a grounded place... I really believe if you would give schoolchildren meditation in every single school, then they would be able to hear and be able to learn. Yoga is being. The world of yoga is sitting and just being present.

[TO AUDIENCE] How many people here do yoga?

I would love to do a meditation with all of you.

Not now.

Okay. So, as a philanthropist, I have my own foundation. I want to give money to people who are changing the world. My husband said to me, right before he passed away, "Donna, make sure you take care of the nurses." What he meant was take care of the caregiver, because in the medical system today, we are a disease. Where do you take care of the whole person? Every day Stephan had a yoga person come in and help him breathe because he had lung cancer. He worked with an Iyengar teacher. But he also had acupuncture and nutritional food—that holistic experience. A woman who works with me worked for my husband. She'd go to Sloan Kettering—where my husband was for seven years—and work with essential oils. And everybody would go [SNIFF, SNIFF], "What is

that? I want that." So the oils would go through the hospital and I realized very, very clearly at that point, what was missing in the hospital system was that nobody was caring for the patient, the loved one—everybody was caring for a disease. So I called my people in my foundation and asked, "Who's out there doing this?" And the only organization that was doing it was Bravewell [Collaborative], but they were training doctors in holistic experience with medicine. I don't believe in either/or. I do not not believe in Western medicine, but it's Western and Eastern, together and combined. That has governed everything that I do today.

Well, Urban Zen is a very significant part of your life now. I encourage you all to check that website and learn about the programs. Not to compete with the Y, but they're very different and very interesting speakers and programs.

No, the Y is a perfect example: like-minded people who want to come together to be educated, who want to make a difference in this world. Around a little table one night, I started the Urban Zen Integrative Therapy Program. We started a five-hundred-hour training program, and we train yoga teachers, nurses, and allied health professionals in in-bed yoga, Reiki, aromatherapy, palliative care, and nutrition and bring it into the hospital. If I would tell you how much money is saved by an integrative therapist, how much less medication you take… It's the same with education. If you bring these tools into the educational system, the student is going to be able to receive the information on a much higher level. This is not about me, Donna Karan. I align with the brightest, most important people who are doing this out there in the medical and educational fields.

Okay. Let's move on because I know there're still some things that you care a lot about that we want to get to. I want to acknowledge your commitment to philanthropy and charity, working at CFDA's 7th on Sale, your initiative to create some of the most extraordinary AIDS benefits and raise millions of dollars. You were one of the first chairpersons of Fashion Targets Breast Cancer and Kids 4 Kids for the Elizabeth Glaser Pediatric AIDS Foundation. Super Saturday, in the Hamptons, was started by you for the Ovarian Cancer Research Fund in memory of Liz Tilberis, the late editor of *Harper's Bazaar*. Donna is really the one who made that happen. And how much money has that raised now, after all these years?

The last year, we raised, what was it?

PATTI COHEN [TO AUDIENCE]: Over four million dollars.

In just one day in Bridgehampton.

It started in Liz Tilberis's backyard. I called Liz up and I said, "Listen, we've done 7th on Sale [for AIDS], but nobody knows about ovarian cancer. Why don't we all empty our closets—and bring all our stuff to your backyard? The art, photography, clothes—bring together philanthropy and commerce and really raise awareness."

The entire industry clears out its closets and sells its stuff. And then at the Clinton Global Initiative meetings, which I've had the privilege of going to for several years, Donna is the only designer in the room with a thousand people who are all trying to change the world. And I applaud you for that.

Thank you, Fern. He's my inspiration. The man is a genius.

A few more questions because then we want to talk a little bit about Haiti, [which is] near and dear to your heart. Could you sum up your legacy as a designer in one sentence?

Not to dress people on the outside but to dress them on the inside.

Left to right: Donna Karan with children at St. Damien Hospital, Port-au-Prince, Haiti; Donna with Philippe Dodard and one of his paintings. Page 71: Donna making accessories in Haiti using tobacco leaves

Perfect. Is it possible to describe a day in Donna's life?

I am not a morning person. I have to have my yoga, my green juice. Give me a green juice in the morning if you want to get me started.

Is it wheatgrass or just a mix of green vegetables?

Green vegetables. I'm a juicer. I start with my green juice. I start with yoga or Pilates. I really like Pilates. It helps me fit into my pants. And I'm a little cranky in the morning. As I'm getting older, I'm a little bit tired, so I usually consider until ten o'clock my time. And then when I start my day, it goes until two o'clock in the morning.

Yup. Were you ever approached by Target or H&M to do special collections?

I'm sure. I don't know if I can say that in front of Mark [Weber, my CEO].

So is that something we can expect to happen in the future?

I don't know, you have to ask Mark. My boss is over there.

Do you feel a sense of responsibility, being the most famous women's designer?

I don't think I am.

Who do you think is?

Miuccia Prada? I mean, it's different, we're different people. You know, what I'm very, very proud of is that I really don't consider myself a fashion designer. It's one of the things that I do. If you ask Barbra if she is a singer, she does not see herself as a singer.

She's a singer, she's a director.

She's everything. You know, she's an actress, she's a singer, she's a philanthropist. She's very involved in politics.

Who is the next Donna Karan?

My daughter, Gabby.

What advice do you give aspiring designers?

I would tell them one thing: "You either are or you're not." I mean, I wish I could take time to relax. People say to me, "Oh Donna, you could just go and travel." I can't do that. I wish I would. My daughter keeps telling me, "Mommy, go away. Do something." I'm a designer. I mean, it's who I am. You know, I'll have time afterward, when I go meet Stephan. My clock is ticking. I've got a lot of work to do out there. It's freaking me out a little bit.

I'm getting older and I'm worried about this world. I mean, I can't sit here and sit back and go la, la, la-la, la-la, la-la, la. We're responsible citizens today. And I don't want anybody to point the finger at the government. It's not the government's problem; it's our problem. Everybody, point your finger, and don't blame them, blame yourself. You all, every one of us is responsible. If there's a problem in the world, we're all responsible for it. [APPLAUSE]

So where do you go to get nourished so you can fight the fight?

I have a wonderful, wonderful, amazing place in Parrot Cay. And Bali has been my inspiration. To me, Bali is really the model for the developing world. I can't say enough about Bali. Bali really says it all because it preserves its culture. It is magnificent. I mean, there are very few places you can go like that right now. If you go to Madison Avenue, Faubourg Saint-Honoré, you go to London, they're all alike. Where do you go for the preservation of magnificence and culture? Bali is just one of those places that has elevated itself because of its artists.

Is there a model there for what you're doing in Haiti?

That's exactly the whole point. Bali is the model for me. But when the earthquake in Haiti happened, two years ago—it was two years ago today so I'd really like everybody to just reflect upon that.

It's true, Donna called Monday morning from Haiti and said, "Thursday night's the big anniversary, and President Clinton, the president of Haiti, everybody's there. Can we Skype this interview?" I was sweating, of course. We're happy she came back. But this is an important time. [APPLAUSE]

It was a very tough decision. Unfortunately, I was in a hospital two years ago, when my son-in-law's father had a major heart attack, so I didn't know about the earthquake in Haiti. And I got a call to do something for Haiti. I said, "Listen, I will not do anything, unless I feel it, understand it, know it. I will not give money to anything unless I know exactly where that dollar is going." So I said, "Okay, I know people need housing. So we'll sell tents." I started the campaign A Tent Today, A Home Tomorrow. We'll deliver the tents into Haiti, to Paul Farmer to Wyclef Jean. André Balazs, Andre Harrell, Mary J. Blige, and I got together. I went down to Haiti and asked, "What's the most creative area?" They said Jacmel, Croix-des-Bouquets. I said, "I love the name. We'll make a fragrance out of Croix-des-Bouquets. What do they grow there?" Vetiver. "Great, we'll make a fragrance out of vetiver." I'll give it to every single designer, because it's not about me, it's about the we. And everybody designs their own bottles and we'll have a fragrance. We'll make a lot of money for Haiti. It hasn't happened yet, guys, so—

Is it in the works?

I hope so. Oh, you bet that fragrance is coming. I realized that every single person in Haiti is an artist. And I said, "Oh my God, it's [like] Bali." Really, the big place the earthquake happened was Léogâne. Léogâne is where the stoneworkers are—in every community there is a different group of people. So in Léogâne it's stone, so we started a Million Hearts for Haiti campaign with their stone hearts. And we have to sell a million hearts, so everybody who wants a heart, just raise your hand. You can have a heart for Haiti. And it helps the people of Léogâne. So, after Léogâne, I went to Port-au-Prince. Haiti is about carnival and papier-mâché masks and papier-mâché leopards, lions, tigers, and bears. So I take a piece of paper, and I say, "What can I make that every designer would want?" They can put

Clockwise from top left: Erin Wasson featured in the Donna Karan Twentieth Anniversary campaign, 2004; Fall 2000 runway looks; Demi Moore featured in the Donna Karan Fall 1996 campaign

their logo on it and then we can sell millions and millions, like a T-shirt. So I made a paper bag, a papier-mâché bag.

Where will these be sold?

Right now they are at Urban Zen. They're online. They're at ABC Carpet. All the money goes to Haiti. Then I go to this other place, and it's the Hornisans. You would not believe the conditions these people work in. Look at the website and you'll see the video. It is unacceptable. So I work with the Hornisans, and a Donna Karan–designed horn necklace went down the runway. And these are horn bracelets. You know, you see horn as always that shiny, shiny shellac kind of thing. So I made a group of horn jewelry, and—

And these are all available at Urban Zen, as well?

Yes and they will be at Donna Karan, too. So along with the paper bags, the horn, the stone, I do raku, tobacco leaves. Okay, how many of you smoked cigarettes? Great, perfect. So my husband dies of lung cancer, and we all know that cigarettes cause lung cancer… So I figured, okay, we'll do a campaign: how to use tobacco without smoking it. There're these tobacco-leaf vases that we do that are absolutely magnificent. President Clinton basically asked me, "Would you up the level of the designs in Haiti?" And I said that that's the thing I love to do more than anything. So I work with the artisans there. I work with the designers there. And it's not about me. Kenneth Cole went down there, I hope to bring Tory Burch. I'm bringing all the designers down there. Factories are being built there. My friend is building an amazing factory, completely LEED certified, all in natural fibers with windmills and everything, and that's very, very exciting.

And it's only a couple of hours away.

Well, three and a half hours away. Instead of going to Bali and Africa and India, in three and a half hours you can be in Haiti. I now have the Urban Zen Integrative Therapy Program in the hospitals in Haiti. They could be in any hospital—we have them all around—but they love Haiti. So I have been going down there quite a bit. I go about once every three weeks to a month. I believe in philanthropy and commerce.

How do you help these people?

What's very exciting is how a print dress, which walked down the runway at the Donna Karan collection, was designed. The print was from [Haitian] artist Philippe Dodard. Now Philippe is a major artist, and when I went to Croix-des-Bouquets, I saw metalwork and went to the hotel where we stay and asked, "Who did that ironwork? It's brilliant." And of course, the man is standing right behind me and his name is Philippe Dodard, a gray-haired artist, just not what I need in my life right now—of course, he reminds me of my husband. So I go and I buy all his artwork. And I bring it back to the Donna Karan company, and I come in with my baskets of stuff, and my designers love the things, so we design a collection about Haiti. And we shot the campaign in Haiti.

And it brings money to the community when you do that work there.

I went down with the president of the Parsons School of Design. We hired eighty-five people from Jacmel to do this campaign, which is very exciting. The people of Haiti, the president of Haiti, President Clinton, everybody is ecstatic over this.

I think we get a sense that Donna is not only designing for the outside, but for the inside. She's helping to make this a better world for everybody. And on that note, I'd like to thank you for being here. [APPLAUSE]

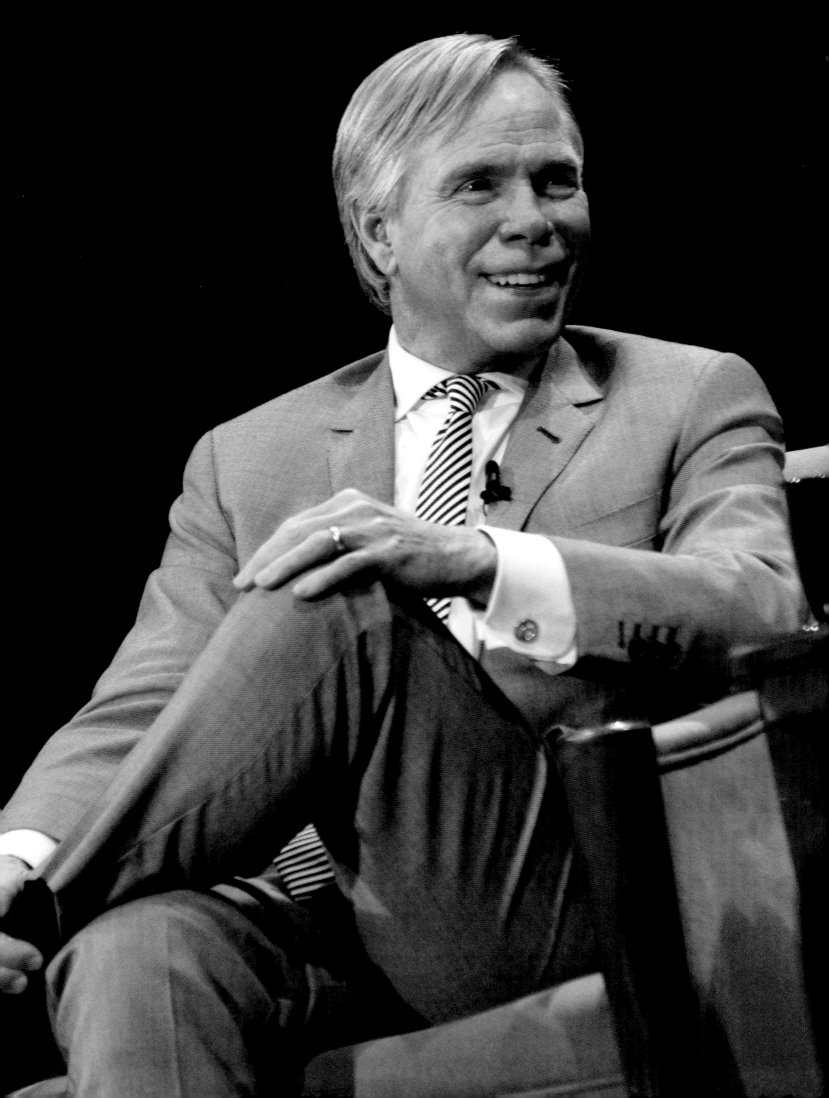

TOMMY HILFIGER

Good evening. You're here to hear the amazing story of Tommy Hilfiger, and how from upstate New York, he became a fashion icon. Or is it a fashion idol? Tommy has created one of the world's best-known brands. Terry Lundgren, the chairman and CEO of Macy's, said, "Tommy started with nothing." He did it all on his own. He's a hustler. He's scrappy. I say he's fashion's Peter Pan. He's cute, he's smart, and [he's] smarter than most people give him credit for. If you know my mantra, "Be Nice," Tommy is beyond nice. I need to find a new word for him. I spoke to people who have worked for Tommy and journalists who have interviewed him through the years. They all love Tommy and immediately mention his kindness, openness, and generosity, and say they would do anything for him, and vice versa. I will always have a special place in my heart for Tommy, as he had the very last show in Bryant Park, where from the runway after taking his bow he lovingly thanked me and Stan Herman for having created Fashion Week in those iconic tents. But enough of my nostalgia, let's tour the world of Tommy Hilfiger.

FERN MALLIS: You were born on March 24, 1951. That makes you the youngest looking sixty year old.

TOMMY HILFIGER: That's a great compliment, thank you. But I'm not so sure about that.

You're an Aries.

I am an Aries.

Well, I love an Aries. Is there anything in astrology that rings true for you as an Aries?

Well, from what I've read, I think Aries are determined and probably because of the ram, they push forward. And I've always been determined, so maybe there's something similar there.

Aries are also leaders, but we don't always finish everything we start.

That could be. I'm trying to finish.

You finished a lot of things in your career. You described yourself as having been a scrawny, dyslexic kid. Did being dyslexic impact your learning?

When I was in school, I didn't know what dyslexia was. I thought I was just not very smart. I think my teachers and my parents thought the same. I always had to find another way to read through a book or finish my homework. I could never do it the conventional way. I was convinced in high school that I was not very smart. But I had dreams. I wanted to be a football player, but the football players on the team were about six foot six and 250 pounds, and I was maybe five foot four or five foot five and 90 pounds as a freshman or a sophomore. So the coach advised me not to play. That was very good advice.

I think that was a good decision. What was life like growing up in Elmira, New York? How far is it from the city?

It's 250 miles from the city, about five hours driving. I had eight brothers and sisters. I'm the oldest boy. My father was a jeweler—a watchmaker—in a local store. My mother was a nurse. I started working when I was nine years old, shoveling snow, raking leaves. I always had a job. And when I was eighteen, I had saved $150.

You had a big family and family is a big theme in your work. Was your family like the upstate New York Kennedy clan?

Well, I lived in a neighborhood where there were families with twelve and thirteen children… Irish Catholics.

So there wasn't much to do at night—these people were having a lot of children.

There was a local bowling alley, but not a lot to do.

Tell us about your siblings.

My brothers are and were musicians, so I felt I was not treated fairly by God when my brother picked up a guitar and started playing it and I couldn't play it to save my life. My sisters are schoolteachers, nurses. They're spread out all over the country.

But you're all still very close.

We're all very close.

Is it true you're related to the Scottish poet Robert Burns?

I have an aunt who is fanatical about tracing it, and she is absolutely certain we're related somehow. It could never be discussed in my house because Robert Burns was a womanizer and a boozer. So we were never told we were related until maybe we were in our teens or early twenties.

Where did you go to school?

I went to high school and I started my business with my best buddies when I was a senior. When I told my parents I didn't want to go to college, they couldn't even believe I was saying it. So I enrolled in college, and I left after the first semester, because we had our business and it was really starting to take hold.

The business was buying jeans?

Buying jeans and hippie clothes, cool clothes at the time, and selling them in our stores.

You went to New York and bought them?

That's right.

Where did you buy them?

On the streets. We found vendors. My friend Larry Stemerman had been to New York many times and he led the way through the Village and he knew all of these cool shops and boutiques. We used to buy excess merchandise from a lot of the cool stores, pack the clothes into our Volkswagen, and drive it upstate.

You couldn't have taken too many in a Volkswagen.

We would just pack it and take many trips. Then we got smart and bought a van.

How much did you pay for the jeans?

Like five dollars a pair.

How much did you resell them for?

We sold them for twelve, fifteen dollars. We stonewashed them, we cut them, we decorated them. We embellished them.

So you and your buddies were buying crafts in the local Michael's?

I guess you could say that.

Then how did people find them?

Our first store was in a basement in Elmira. We painted it black and called it People's Place. We burned incense, played cool music, and all of our school friends came shopping. No other store in the area had what we had.

How much did it cost to open the store?

The rent was very high. It was fifty dollars a month. And our inventory was about a total of

Clockwise from top: Tommy Hilfiger in front of his first store, People's Place in Elmira, New York; young Tommy hitchhiking; Tommy Hilfiger's childhood home in Elmira, New York

two hundred dollars. So we really started with nothing.

And then you expanded to seven stores.

We opened stores on college campuses in New York State, on the Cornell campus in Ithaca, Cortland, Corning.

Did you negotiate with the colleges for retail space?

No, we went to landlords in the area.

What kind of marketing did you do?

We did flyers. We went to the dormitories. We did fashion shows on the street. We did all sorts of things.

Did any of your siblings work with you?

At that time some of my siblings worked with me.

I read that you and your pals made a lot of money and couldn't spend it fast enough. That you were wild and had a Porsche, a Mercedes, a Jaguar, and a Jeep.

I think that's accurate. Everything changed when we went bankrupt.

Is that why you went bankrupt? Too much money spent on cars?

Studio 54 had opened in New York, and we decided we should go there rather than watch the business. We basically let the business slide through our fingers. That was my master's degree. My friend, my partner, and I looked at each other one day and said, "This is really happening." We went Chapter 11. So we had to reboot and start over. That was a tremendous learning experience. What it taught me was that you have to mind the business. So when people ask me if I'm a designer or a businessman, I say both.

You were quoted as saying about that time, "I vowed never to fall into sloppy work habits again. Money, after a certain point, is not what drives me." And you admitted if you're a failure, it's your impetus to succeed.

I was afraid to fail. I still live by that.

Was your family okay that you were a retailer? Or a designer?

When I told my family and friends I wanted to be a designer, they said no way. You have to go to design school. You have to learn to cut patterns. You have to have money. You have to have connections. I said no. I know I can do this. So I started designing clothes for my

This page: Model wearing an outfit from the Tommy Hilfiger Spring 1988 ready-to-wear collection, New York, November 4, 1987. Following spread: The infamous Times Square billboard launching Tommy Hilfiger, designed by George Lois, 1985

stores, and the public really accepted what I was designing. So I began freelancing for companies in New York, and taught myself the business. I always knew I didn't want to do any of the technical work. I didn't want to cut patterns or sit at a sewing machine. I wanted to come up with the idea, and then have other people execute for me.

After People's Place, you moved to New York and started freelancing. And you were married to Susie at the time and started a family.

In 1985.

Was it true you worked at Jordache Jeans and were fired?

After a month. They had one jean that was really their core business. When I designed a collection of clothes, they said we don't need a collection, and, by the way, we don't need you. So I was really out on the streets. I worked for a couple of different jeans companies. I started my own company called Twentieth Century Survival. It didn't survive. I started another company called Click Point. We didn't have the financing. I worked at a company in California called Tattoo. That didn't work out because of financing. And I kept moving and kept going and thinking at some point I would be able to start my own brand. I was very fortunate to have met Mohan Murjani.

We'll get to Murjani in a second. But I read you befriended Perry Ellis. How do you befriend Perry Ellis?

My Click Point business was on 1441 Broadway and Perry's business was on 1441 Broadway. One Sunday, we needed a spool of thread, and we went knocking on doors.

This is like getting sugar at the neighbor's house.

Perry and his team were working. So he loaned us thread, and somehow we became friends. He offered me a job. At the same time, I met the people from Calvin [Klein]. And they offered me a job.

You turned Calvin down, too.

I was traveling to Hong Kong to manufacture, and I met some of the Murjani family in Hong Kong. They said, "You have to meet Mohan." When I went back to New York I did. That same weekend I met Murjani, and he offered to back me.

What did you show him that made him say, "I'm investing in you. I'm going to be your business partner"?

I had just won a design award with Abraham & Straus called the Design Spirit Award, with Willi Smith, and Alan Gilman, the president of Murjani, had read that in the paper. He contacted me and asked me to meet Mohan. When I met Mohan, we immediately became friends. And he said, "I'd like to back you because I want to back a new American designer." He owned Gloria Vanderbilt at the time.

He was the head of Gloria Vanderbilt jeans and he was an Indian textile magnate.

He's still a very close friend of mine. So he said, "I'd like to back you." And I said, "Fantastic." I called Perry. I called Bob Suslow, who was the president of Calvin [Klein] at the time, told him I wasn't going to take the jobs, but I was going to go into competition with them. They laughed.

How much money did Mohan put up for you at that time?

About five million dollars over a period of four or five years. Then he ran into financial problems after about five years.

But not before he put up the famous billboard in Times Square.

THE 4 GREAT AMERICAN DESIGNERS
FOR MEN ARE:

R_ _ _ _ _ _ L _ _ _ _ _
P_ _ _ _ E _ _ _ _
C_ _ _ _ _ K _ _ _
T_ _ _ _ _ H _ _ _ _ _ _ _

THIS IS THE
LOGO OF THE
LEAST KNOWN OF
THE FOUR

2182 Columbus Avenue
at 73rd Street
New York, New York 10023
(212) 877-1270

SAMSUNG
ELECTRONICS

I have to give George Lois the credit for that.

Did George Lois also design your flag logo?

No, another company did the flag, but George did the billboard.

The billboard read, "The 4 Great American Designers for Men," and below it was like Hangman, with spaces to fill in whose name "R L" is. The P, E, then C, blank, blank, blank, K. And then T, H. And then underneath it was Tommy's iconic flag, the red, white, and blue logo. And it said, "In most households, the first three names are household words. Get ready to add another. His first name, hint, is Tommy. The second name is not so easy. But in a few short months, everybody in America will know there's a new look in town and a new name at the top. Tommy's clothes are easygoing without being too casual, classic without being predictable. He calls them classics with a twist. The other three designers call him competition." This was a very bold and brazen campaign. How did the industry react?

Very negatively. That was the only time in my career I thought of quitting. After the billboard went up, and the ads started running, the press surrounded me and basically said, "Who the hell do you think you are?" The whole industry said, "Who does he think he is?"

A lot of humble pie.

Well, I said, "It was a joke, sort of."

Sort of.

And they didn't want to hear that. So I felt that there was only one way out of this mess, and that was to prove myself, to roll up my sleeves and work very hard to make great clothes. I had to deliver on that declaration. It took a little time and then Murjani was running out of money, because the Gloria Vanderbilt business was going in reverse. Then I had to go out and find new financing. So that was a turning point.

In two years, with Murjani heading your business, you grossed $10 million—a lot of money, but not by industry standards.

That was a lot of money. For the first two years we thought it was a lot of money.

Absolutely. How did you manage to buy out Murjani and join forces with another extraordinary man in the industry, Silas Chou?

When Murjani told me he didn't have the money to finance my business any longer, I talked to Goldman Sachs, Morgan Stanley, all the investment banks. Basically they said, "We don't back people in the fashion business. We think it's very risky and we don't really have any interest." So after many months of trying to find financing, I had to get back to Hong Kong to try convincing my suppliers to front me the merchandise that I'd promised the retailers. I met Silas Chou at the South Ocean knitting factories. And I told him my problem. Then Silas came on as a partner, and he had another partner by the name of Lawrence Stroll, who owned Polo Europe at the time. So we joined forces in 1988 and bought the company back from Murjani. Joel Horowitz had been president of Murjani but came with the new partnership as CEO.

So two very important moments in your life happened in Hong Kong. Silas Chou and Lawrence Stroll also made a few dollars taking Michael Kors public. They have been legendary in the industry.

They've been great partners.

You were bringing in $25 million after three years. Then in 1992 you became the first

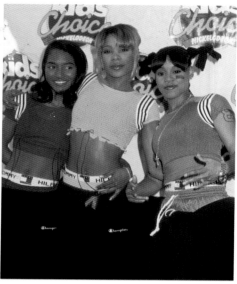

Left to right: Aaliyah wearing Tommy Hilfiger; TLC at the Nickelodeon Kids' Choice Awards in Los Angeles, 1995

designer listed on the New York Stock Exchange. Why go public?

It was always my dream to build a global lifestyle brand. I wanted not only my own shops, but shops in department stores, advertising, marketing. And in order to do that, we needed big financing. We decided the only way to raise that kind of money was to go public. Initially, we reinvested all the money into opening stores, shops in department stores, more advertising, more marketing, more staff. The motto was to hire the best people, industry all-stars, to do the production and the merchandising and help us get to the next step.

Did you enjoy reporting to shareholders?

For a while it was okay because the business was exploding, and the sales and the growth were phenomenal. A lot of shareholders sold after the business leveled off after we hit a billion dollars in 1998. And when the business leveled, the shareholders became nervous, and it became a different story.

You became known as the American designer who saw what was happening on the streets. You became a big influence in fashion, thanks to your love affair with music— dressing a new generation of rock-and-roll musicians and rappers. Your clothes were in their videos, even in their lyrics. When you dressed Snoop Dogg for *Saturday Night Live* in 1992, he wore a big oversized top with the letters "TOMMY." It was like a billboard. How did watching that feel?

It was very exciting because at that time, the styles were not only changing, but we were creating a brand new trend with big logos, looser clothes, very bright colors. We took the preppy look and twisted it. We were setting new trends with young people. At the same time we were setting a new standard in the workplace because a lot of American corporations decided to allow their employees to dress casually on Fridays. So we sold khakis and button-downs and casual sportswear. We really caught the wave of the casualization of the workplace.

At what point in your business would you say that the hip-hop clients, who were making you rich and famous, realized they could become rich and famous by putting their own names on the clothes?

I'm not sure. In the '90s, lots of things were happening. We went into womenswear, expanded

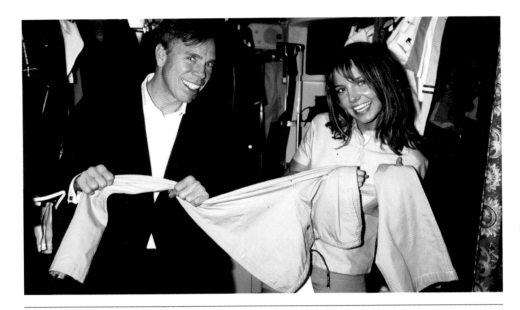

Tommy Hilfiger and Britney Spears during the shooting of a Tommy Jeans advertisement. Pages 88-89: Tommy Hilfiger on the runway, Fall/Winter 2014 at Park Ave Armory, New York

in Europe, started licensing, did the fragrance launches and childrenswear.

But there was a sense that you had abandoned that preppy, classic customer and the DNA of the company was unclear. You were dressing the Fugees, Bruce Springsteen, Usher, Lenny Kravitz, Mariah Carey, Britney Spears, David Bowie, Michael Jackson, and your hero, Mick Jagger, now your neighbor, in Mustique.

We dressed a lot of musicians, skateboarders, surfers, and kids on the street. We were the first to use celebrities in our advertising. We used the sons and daughters of celebrities. Then we were sponsoring concerts by Lenny Kravitz, the Rolling Stones, Britney Spears. The rappers came and left and moved on to develop their own brands and wear Gucci and whatever else. And we continued to wrap the brand around pop culture. I had a saying that I still use: F.A.M.E. F is for fashion, A is for art, M is for music, and E is for entertainment.

I love that.

I was always using F.A.M.E. as a marketing vehicle, always looking at Hollywood for inspiration or music or art as inspiration, Andy Warhol for his colors, and the Kennedys, Audrey Hepburn, Steve McQueen, James Dean—always looking at iconic Americans for inspiration. But music was the core, because of my love for music and because I believed that if we were dressing the right musicians, then their fans would also come. And I think that did happen, and it's still happening.

Speaking of fame—I won't list all the awards that you've won—Mick Jagger cheered you on when you won the CFDA award for menswear in 1995. And Spike Lee directed your video tribute, which was pretty amazing.

I set out twenty-five years ago designing clothes for everybody. I didn't go into couture or very expensive luxury, which I love, because I wanted to build a business based upon dressing a very broad audience. I wanted it to be affordable, accessible, inspirational, aspirational, and I wanted the clothes to last and for people to wear them.

In 1999, your company was grossing more than a half a billion dollars, and was the highest-valued clothing stock on the NYSE. Did your life change?

I was busier than I'd ever been because we were traveling all over the world manufacturing, opening stores, expanding in Europe, expanding design teams. It was about always making

it better. From the fashion shows to the buckles on the shoes to the pocketing in a trouser, it's about doing what we did yesterday better tomorrow.

That's the way you have to do it. And then in 2004, the company had 5,400 employees and revenues in excess of $1.8 billion, and Beyoncé was the face of your True Star fragrance. What was that like?

I met Beyoncé when she was sixteen. My brother Andy, who was marketing our jeanswear with musicians, set up a fashion show at Macy's. He said there's this group called Destiny's Child, they're teenage girls, they sing very well, and we can get them to do the music for the show. So we booked them. When I saw Beyoncé, I said, "Andy, she is going to be a star." Her voice was incredible. She had a great look and total confidence. A couple years later she became The Beyoncé. And we used her as the face of our True Star fragrance. She was wonderful to work with. She was incredible.

Did you feel at that time that you were getting the respect for the business that you wanted for the amount of business you were generating?

Well, interestingly enough, I think in this business, if you're affordable, you're looked upon as not being as chic or as sophisticated or as cool as some of the smaller, higher-end luxury brands. So I don't think I was getting the same respect as other brands were. But it didn't matter because I was doing what I wanted to do. I really wanted to become a global lifestyle brand. We were opening stores in Tokyo, in Seoul, and all over the world.

You were also producing Tommy Sport, athletics, golf, swim, sailing, jeans, red label, bodywear, underwear, robes, sleepwear, eyewear, sunwear, watches, handbags, socks, small leather goods, home and bedding products, bathroom accessories, and luggage. How many different products does your name appear on?

It's in the thousands.

Is there something you still want to put your name on?

I'd like to do a hotel. I believe dreams come true.

How important is the fragrance category?

We have six fragrances with Estée Lauder and that partnership goes back many years. We were Estée Lauder's first license, and Leonard Lauder and I became close friends as a result of our partnership. He really believed in what we were doing. We launched Tommy in the early 1990s and then Tommy Girl right afterwards. We became the number one selling fragrance for many years. Now it's a different business. You continually have to come up with new fragrances. The fragrance business led the way in many markets, and then we would come in with clothing, apparel, and everything else.

There are close to twelve hundred Tommy Hilfiger stores in your global arsenal. Outside the U.S., which country is your biggest business?

Germany is very big. Spain is very big. China is growing fastest. India is growing second fastest. But we have pockets. We're very big in Turkey. We're very big in Scandinavia. Our business in South and Central America is very strong. We continue to grow outside of the U.S. at a very rapid rate.

Does the American flag still sell around the world?

I don't know if the American flag sells, but our red, white, and blue flag sells. The American relaxed, casual, spirited look resonates worldwide, especially the preppy American classic look. It's almost a uniform in many countries. People wear preppy clothes, whether it's a

polo shirt or chino trousers, or madras or striped rugby shirts. It may not be very cutting edge, but we leave that to the collection we do on the runway.

The American flag is very much, in addition to your iconic flag, a big part of your DNA. I was wondering if you were maybe a tiny bit jealous when Ralph Lauren wrote a check for $10 million to restore the giant "Star-Spangled Banner" American flag at the Smithsonian?

I was very happy he did that. Better him than me.

You wouldn't have wanted to do that?

I would rather give $13 million to breast cancer and MS research.

Which you did. But while I'm on the subject, how does the Polo Ralph Lauren branding design aesthetic and business impact or influence you and the Tommy brand?

Wherever there's a Mercedes, there's a BMW. Where there's a Coke, there's a Pepsi. He's my biggest competition worldwide. He's done an incredible job. And I think that he sets a standard in the world of design.

Well said. In 2004 you acquired the trademarks of Karl Lagerfeld for an undisclosed amount of money. How did that come about? You seem like unlikely allies.

I was doing a photo shoot for *Bazaar* in Paris, and he was the photographer. After the shoot, we had coffee. The next day he invited me to his home for lunch.

Was it an amazing home?

It was incredible. Over lunch I told him we were thinking of acquiring other brands. And he said, why don't you buy my brand? I said okay. And we consummated a deal in less than thirty days. So we bought the Karl Lagerfeld brand.

Do you still own that mark and brand?

I am a partner in it.

Are you guys pals?

We're friendly. It's a respectful relationship. I think he wishes we had done with Karl Lagerfeld what we did with Tommy Hilfiger. I think he was unhappy we didn't invest as much in his brand as he thinks we should have. However, now it's getting traction and taking hold.

So it still has potential?

Yeah, because in China, he is a rock star. In Japan, he is, as he says, a rock star without the guitar. And his name and his brand are strong.

Can we talk about your brief stint on reality TV in 2005? You were the star of *The Cut*, the forerunner to Donald Trump's *The Apprentice*, though you have much better hair. What happened? Why didn't it work? Were you not mean enough?

We had seven million viewers, and CBS was expecting thirteen million. It was frustrating for me because it was supposed to be a reality show, yet we had producers and scriptwriters telling us what to say and do. And that wasn't what I signed up for. So I wouldn't have signed on to another season anyway. I felt it was a waste of my time.

But that was a show about getting new designers and encouraging new talent and giving them jobs. I read that you once had lunch at Le Cirque with Andy Warhol, and Andy introduced you to Stephen Sprouse, who was looking for funding. And you passed.

Yeah.

Regrets on that?

He understood the artistic viewpoint but not the business of fashion. I think it would have been very dangerous to be only one-sided, so to speak.

But that's why they came to you for funding, to help the business side.

At that point, I didn't have funding for another designer. I was focused on building my own brand. I introduced him to Murjani, and Murjani passed.

In 2006 you sold your company to Apax, a private equity firm in Amsterdam, for 1.6 billion dollars. Almost two years later, you got married to the beautiful Dee and a new baby, Sebastian, was born in 2009. How is it being a dad to a baby and four grown children?

It's fantastic. With Dee's two boys and my five—my four and the one we share—we have seven children. So it's life all over again, because as I said, when I was growing up, I had eight brothers and sisters.

It's like the campaign, the Hilfigers.

That's right. We're used to organized chaos.

You moved into an amazing landmark building, an entire floor in the Plaza Hotel?

It's not quite an entire floor.

You commissioned Hilary Knight, the illustrator of *Eloise*, to create a mural in your apartment. That's pretty special. Does Sebastian channel Eloise?

I think he likes Eloise, but he thinks Eloise is his girlfriend.

So cute. Then in 2010, the business was sold to Phillips-Van Heusen, the company that owns Calvin Klein, for $3 billion. Is this the final transaction?

I think PVH is happy with the purchase. I think they'll hold on to it.

That's great. Now in the U.S., your collection is exclusive to Macy's. What's the difference between that and what's at your flagship store?

The flagship store on Fifth Avenue sells all the European product and the collection product, which is more expensive, more sophisticated. The Macy's product is more broad-based. It's Macy's largest branded business. We have men's, women's, children's, and all products in all of their stores. We decided to do that rather than to sell to many department stores because we wanted to have the partnership and the focus. That proved to be a very good move on our part. I have to credit Fred Gehring, the current CEO of Tommy Hilfiger, for doing that and Terry Lundgren for really making it phenomenal.

You just came back from Paris where for the second year in a row you have financially supported the CFDA/Vogue Fashion Fund Americans in Paris showcase. Can you describe this initiative?

I was having lunch with a woman by the name of Anna Wintour—

We all know who she is, right?

And Anna said, "Tommy I'd like to ask if you would you do me a favor." I asked, "What is it?" And she said, "Would you ever consider sponsoring young designers in Paris?" Because these young designers need to go to the international marketplace. But they're young American designers in the CFDA. And they really cannot afford to go to Paris and show their collections. They can't even afford a flight. So she asked if I would sponsor them. And I did, and it was successful for them. So we did it another season, and we plan to do it yet another season. And my former partner Silas Chou is now doing the initiative in China.

And you have a party at the ambassador's house.

We had a party at the U.S. ambassador's home in Paris. The previous season we had

a party at Diane von Furstenberg's home in Paris. The young designers loved it. They're cultivating their businesses.

What advice do you give these young designers? Which is also one of the questions that came from the audience.

The advice always has to do with the business part of the business. These young designers have amazing ideas, but they don't know what to do with the business. They don't know how to strategize and plan for the future. When they do make a little money, do they spend it on advertising? Do they build their staff? Do they open a store? Do they expand their showrooms? There are different flavors and different ideas for each designer. I actually enjoyed giving them advice because through my experience of many failures, I, perhaps, helped some of them.

Do you give the same advice to your daughter, Ally, and her new label?

I do. My main advice to her was that she should stay the course with one category of merchandise. So she started her business with just dresses.

Is your family part of the inspiration for your fabulous new campaign, The Hilfigers? Which is also a question that someone in the audience had. Because you have a great range of people. It's a great-looking campaign. Is it all done in house? Who does it all?

Trey Laird at Laird and Partners. The idea was to create a family. And because we have a large family, and it's somewhat dysfunctional.

As all families are.

The Royal Tenenbaums. A dysfunctional but fun and quirky and spirited family.

In 1995 you set up the Tommy Hilfiger Corporate Foundation to manage your philanthropic initiatives, which are substantial and very generous. The Race to Erase MS has been a major cause. Did you start this because you have a sister who has MS?

Yes. We've been part of raising funds for MS for over sixteen years. They tell me they're coming closer to a cure. That excites me and keeps me going.

You're also a big supporter of The Fresh Air Fund, the Anti-Defamation League, and the Juvenile Diabetes Research Foundation. How do you choose which causes and organizations to support? Because God knows there are so many.

Nothing is more difficult because all of the causes are good causes, and you have to pick and choose. So we have a committee, and we vote. That's the only way to do it. In years past, it was about The Fresh Air Fund, where we built a summer camp. It was and has been about breast cancer, because I was very close to Evelyn Lauder, who did an amazing job creating the Breast Cancer Research Foundation. All along, I always wanted to make a difference. I think that if they find a cure for MS or if we can save a life for someone who had breast cancer, then maybe I'm making a difference.

Your foundation also contributed $5 million to the Martin Luther King Memorial, which was unveiled last fall in Washington, DC. You also teamed up with Quincy Jones and Russell Simmons, among others, to produce the Dream Concert that honored Martin Luther King in 2007. Why is he your hero?

He was a genius in his own right. He wanted to spread equality throughout the world, starting in the United States. When the *New York Times* announced that they were thinking of building a memorial, Joel Horowitz called me from the road, and said, "Let's do something." His parents had marched with Dr. King and were big believers in equality and changing the world. It was near and dear to Joel and we thought that if we did something, we should do

something substantial. So we did. [APPLAUSE]

Absolutely. Can you tell us about the Millennium Promise project that you also are involved with?

The Millennium Promise was started by [Columbia University professor] Jeffrey Sachs. Many of the world leaders promised at the millennium to eradicate extreme poverty in the world. We thought it was important as a global brand to be involved in a global initiative because all of our previous charity work had been done in the U.S. Being a global brand with more employees now outside of the U.S. than in the U.S., we were thinking of doing something that would involve our employees worldwide. The Millennium Promise allowed us to adopt a village in Uganda. When we went to the village initially, they didn't have a hospital. They didn't have a school. They didn't have running water or electricity. Now they have running water. Now we have a hospital, an infirmary. We have two schools. We're making a difference.

Incredible. Are you going to move to other cities?

We need to perfect this. We're teaching them how to grow corn and we have teams of our own employees going back and forth. They're volunteering. Some of them read books to children in the schools. Some of them donate medicine. Some of them bring clothes.

Do you send a lot of your clothes over there?

Yes.

So a lot of these kids are running around in Tommy Hilfiger.

If someone doesn't steal it and try to sell it in another village.

Well, that's how you started selling other people's jeans.

We did steal them at five dollars a pair.

Okay—this is a question from the audience: is there something that stands out as the biggest mistake you've made?

I've made a lot of mistakes. In the very early days, I should've paid attention to the business. The bankruptcy is something I'll always regret. It was a real failure on my part. But I was young enough to dust off and then continue.

I'd say you recovered pretty well.

I did. I don't regret much because I think that all of the obstacles and some of the pitfalls and mistakes were great learning experiences. I vow never to make the same mistake twice, even though I'm sure I do sometimes.

What are you the most proud of?

My family; my children, my wife, Dee.

Here's another: who are some of the designers who influenced you?

I look at the Old Guard, like Saint Laurent or Dior. The way they did their collections was quite remarkable. I look at them as inspiration. But I also look at Giorgio Armani or Ralph Lauren or Karl Lagerfeld, and I think they're geniuses. And as my hair gets whiter, I keep thinking, look, if I'm standing next to Karl, Giorgio, or Ralph, I'll be in the right crowd. They're much older, by the way.

They're much older.

So I have a long way to go.

I think on that note, ladies and gentlemen, I want to thank you, Tommy, for being forthcoming and so honest.

Thank you, Fern. Thank you very much. [APPLAUSE]

TOM FORD

Good evening. Welcome to the hottest place in town tonight. I have been the most popular person lately because friends and acquaintances far and wide have emailed or called, begging for tickets to this evening, which sold out four months ago. Tonight I am thrilled and excited that we get to hear from a designer who has accomplished so much [that] I only hope we can cover it all. He's the real deal. He understands fashion and style—and how to create an identity and a brand. He is fashion and style. He's in the center of the media, fashion, and the Hollywood universe. He brought glamour and sexy back to fashion. He's nice, and you know how much that means to me. He's romantic and the ultimate seducer. And believe it or not, he is actually shy. He says he doesn't like being photographed or going out to big fashion parties and events. Hmm. He's a man whom both women and men have the hots for, but he also claims, "No one ever flirts with me and no one comes on to me." Hard to believe that, right? So let's find out what turns on Thomas Carlyle Ford. Ladies and gentlemen, Tom Ford.

TOM FORD: Thank you. Wow. There are a lot of you.

FERN MALLIS: How lucky are we tonight? I wish we had the microphones on in the green room, because we've just been having the best time backstage.

Yes, but I wouldn't have said any of that out here. Remember, I'm nice.

That's right. He's going to be very nice tonight. Tom, I always start at the beginning, usually when you were born. But before we go there—as you heard, tonight has been sold out for four months. Why?

I don't know, but I'm thrilled about it.

You don't have a clue? What do they want to know about you?

No, you know, it's funny. You could probably ask this of most people who are well known or famous. You never think of yourself that way. When a young kid comes in and interviews in my office and I realize they're shaking, I think, "why are you shaking?" So, no, I don't think of myself that way. I'm always happy, pleased, and surprised when someone tells me something like that. Because in our world it just means, okay, it's still working.

Absolutely. Before we get back to Texas—

Are we going back to Texas?

We're going to go to Texas.

Okay.

Can you tell us what you thought of the Costume Institute Gala and the work of Miuccia Prada and Elsa Schiaparelli in the exhibition?

I'm a huge fan of Miuccia's. I thought it was very smart. In fact, I emailed Miuccia that it was very smart, because Miuccia is smart and she thinks about what she does. There are different kinds of fashion designers. Some fashion designers feel, some fashion designers think, some fashion designers are artists, some fashion designers are businessmen. Miuccia thinks. She's very thoughtful. And looking at what was done with Elsa Schiaparelli's work and with Miuccia's work, there were moments when you couldn't tell whose was whose, because outfits were put together with half of one and half of the other. If you're

going to be a fashion designer and you're going to be relevant, you have to be part of your time. But you also have to have a good sense of history and pick up the spirit of those who came before you, and then make it your own. And I think that's what Miuccia did. The dialogue really showed what she had gathered and taken from Elsa Schiaparelli, but also how she'd made it her own. So I thought it was really smart. I think it's the first time that actually an exhibition had been done in that way.

Well, he's also, in explaining that, trying to clarify his quote in the *New York Times*.

Oh yeah, I said Coco Chanel once said that creativity is the art of concealing your source. Now, the way I've always taken that to mean is that we all suck up inspiration from everywhere. And the way to conceal your source is to make it your own. You could take a direct line to me back to Halston. But you could take Halston and Madeleine Vionnet right back. Open a Madeleine Vionnet book and you'll see a lot of things that Halston took. I was a kid in New York when Halston was designing, and I took so much from Halston. It doesn't mean I copied something literally, but I took the spirit of that, and it's very present in my work. So each generation, we move on but we hopefully put the stamp of our time and the stamp of who we are on it.

Absolutely. I also thought it was very nice to read that Jeff Bezos asked Anna what to wear and she said a Tom Ford tuxedo.

I love that.

It was pretty good.

He paid retail, too. At least I think he did.

He can afford to.

I think so.

Okay, so now back to you. You were born in Austin, Texas, on August 27, 1961. Makes you a Virgo.

And Fern was born on March 26, 1948. And she is on the cusp of Pisces and Aries.

Oh God, who's interviewing whom?

When I do an interview, I Google my interviewer right before I come on.

Now you're in trouble.

And then you have to disarm them.

He's seducing me right now.

If you disarm them, then it gets looser.

Okay, so you believe in astrology. And the Virgo traits are being precise, a perfectionist, everything in order, almost uptight, sharp memory, keen attention to details.

Oh my God, yes. Anal retentive. I don't like that term, but, yeah, it's often used with Virgos.

Loyal and loving.

We're loyal.

Somebody told me that the world can't run without Virgos.

I don't know about that. You know, I think the world might be a really scary place if it were only run by Virgos.

Oh, that's for sure.

We've taken perfectionism to really the point of an illness. Often people ask [me], "What's your greatest flaw?" and it's perfectionism. You know, a perfectionist is more prone to depression than other signs because perfection is not achievable. By the way, in fashion

Left to right: Tom Ford's parents, Shirley Burton and Tom Ford Senior at their wedding; Tom and his sister Jennifer, 1969

there are a lot of Virgos. Stella McCartney, Karl Lagerfeld, Carine Roitfeld—there are lots of us. I think to really obsess about a millimeter on a shoe heel, it helps to be a Virgo.

Let's see how that all started—

Am I talking too much? Am I jumping over your questions?

Well, we're never going to get through this.

Should I shut up? Okay, I'll shut up.

Describe growing up in Texas in the suburbs of Houston. What did your house look like and what did your parents do?

House looked very typical: American, ranch, flat, wide. It's very hot in Texas. My parents met at the University of Texas. My dad was in law school. My mom was twenty. They got married. She didn't work when we were young, and she went back to college and got a degree in political science. I had a wonderful childhood.

So your parents are still alive?

They're both alive. They both live in Santa Fe, New Mexico. They are no longer married. They live two blocks away from each other and a block away from me, each with their partners.

So you spent your weekends in different houses, like joint custody.

A little bit, yeah.

You have great self-confidence, and that usually comes from one's parents.

Not true.

No? This is all a fake.

It's not all fake. But I think a lot of people who strive to constantly jump through hoops to achieve, to work, to do, to perform if you're an actor—it comes from somewhere deep inside, of wanting that approval. And so the self-confidence is there, but it's also an armor and a mask that you put on to get through whatever it is that drives you.

Siblings?

Yes, one sister, Jennifer. Teaches English, high school, lives in Los Angeles, three children, two husbands.

As a child growing up in Texas and later in Santa Fe, did you ever have the cowboy thing, like a Ralph Lauren moment?

Oh, I grew up that way. And I still have the cowboy thing. It's funny, because my family's been in Texas since the 1840s or something. I put on a cowboy hat, you can see the genetics. Most people look stupid in a cowboy hat. I put on a cowboy hat, and it's like it just grew there, out of my head. It's very bizarre. I actually look surprisingly good in jeans and

a plaid shirt on a horse [wearing] a cowboy hat.

Isn't that surprising, that he would look good in a cowboy hat and jeans? Okay. It's in the genes. All right, your grandmother. She was apparently a huge influence in your life. Taught you the fantasy side of life [and] was very stylish, like Liz Taylor.

Well, she was many times married.

Is that the Liz Taylor part?

She thought of herself as Liz Taylor. She had six husbands. And she was buried with husband number three. She liked him the best. Husband number three's name was Harold. Actually this is not a joke, but her last husband she married when she was seventy-seven, and she just called him Harold. And he didn't seem to mind. She was one of these Texas women that, you know, big hair, big makeup, big Cadillac Eldorado, and always gifts and presents. When I was a little kid she was in between husbands, and so she was very present and very flamboyant and kind of a cartoon character, almost. She was a real breath of fresh air in our house. When she came it was exciting. She jingled and she smelled good and she gave us gifts and she was extravagant.

What would you say you learned from her?

She used to say one thing. I don't know whether she stole this from Auntie Mame, the character, but she said, "You have one decision to make in life: you can either be happy or you can not be happy." And she was like that about everything. Everything that happened to her, she would try to find a way to make it fun.

What was her name?

Her name was Mildred Ruth Shelton Floyd Ford [Ebo] Graham—I'm missing a couple. Well, I'm giving you all six husbands. We called her Ducky because she didn't want to be called "Grandmother."

I read, when you were five years old, you wanted to be fifty.

I did.

Why was that an age you related to? You knew what you would look like, what you were going to be doing, except for apparently gray hair at your temples.

It's under the Just For Men number three.

What about being fifty appealed to you when you were five years old?

I wanted to be an adult. I was never comfortable being a child. I wanted to hang out with the adults. I wanted to listen to what they were saying. I wanted to go to cocktail parties and mix cocktails. I ended up mixing a few too many in my time and don't mix cocktails anymore. You know, I just didn't feel like a kid. Richard Buckley, whom I've lived with for over twenty-five years, I think he's always kind of sixteen, seventeen. He was born in 1948. We all come into the world at a certain spiritual age. It's just I've never felt more comfortable in my life than right now.

When you were five, you envisioned fifty. Now that you're fifty, is it what you expected it to be?

Well, things are always a little different than what you expect. But, yes, in general, I am the most comfortable and happy I've ever been, and I feel very satisfied. It doesn't mean I want to die tomorrow or anything, but I feel very much myself.

So you don't feel like you ever missed out on being a kid.

I mean, I was a kid. Maybe I was a strange kid, but I was a kid.

You were a kid who apparently carried briefcases and wore suits.

I really did.

And was bullied for that and beaten.

Well, yes. I wouldn't say I was beaten. The big thing was to put rocks in the end of a sock and swing it around and whack me. Or slit my bicycle tires. I didn't want to carry a book bag. I thought it looked messy. I had a nice little overcoat and I had a briefcase. And it was a real man's briefcase. When you're seven years old, a real man's briefcase is like going to school with luggage.

So this was the first case of bullying for having too much style.

Well, you know, any kid that's different. And maybe it depends on what school you go to, maybe it depends on today's world. Now might be different. But individuality at the school that I was going to in Texas wasn't something that was—

So embraced.

If you were different you were teased. You were tortured.

Have you come out now to help in anti-bullying campaigns?

I'm working with Brett Ratner. We're judging some anti-bullying films. It's very important. Individuality is key. We should all be able to be who we are. And we should live in a world where we are free to be who we are.

So when you were carrying this fifty-year-old-man's briefcase—

And my parents let me. They totally encouraged it.

Did you think or know at that time that you were gay?

No.

So that wasn't a [concept]—

Am I gay? Fern, am I?

Richard, I wish you were here tonight.

Well, first of all, I hate that word. Plus, of course I'm gay. But I don't like these labels.

Okay.

I look so forward to the day when we say, "You're married. Are you married to a man or are you married to a woman?" "Well, I'm married to a man." Or, "I'm married to a woman." Or, "Are you dating a man?" "Well, I'm dating a woman." It's not how I define myself. Yes, I'm gay. And I'm absolutely completely open about it. But I'm also a pain in the ass.

Okay, so we'll call him that. Instead of a gay man, he's a pain in the ass.

A pain in the ass. Oh, I hope you weren't trying to make a pun there, Fern. It was pretty good. I think Joan Rivers has met her match here on *Fashion Police*.

I want to hear the story about your shoes when you were seven.

I don't know whether I'll tell this exactly as you have it written, but this is the way I remember it. We were in the back of our car, which was a Mercury Cougar, which I thought was very cool. [The shoes] were patent leather, but they had sort of a little crinkle to them. And I had put them on, as you often do when you love something—you put it on right in the store and wear it out. I remember looking at them, and I was so disappointed because I realized the bump of the toe was just—there was something wrong with it. It's a true story. It sounds ridiculous, but yeah.

And he didn't think he was [WHISPERING] maybe gay? Okay, so you're eleven.

Now, Fern. There are lots of architects and designers who are not gay.

Yes, who cares about the bumps of their shoes?

Who cares about the bumps of their shoes? Ask Mr. Ralph Lauren.

Okay, we're moving right along. When you were eleven years old, you moved to Santa Fe. Why did your family move there?

Well, my grandmother married her third husband, who was born and raised in New Mexico. She moved to Santa Fe, so from the time I was five, we started spending our summers in Santa Fe. Then, he—husband number three—developed cancer. He had a real estate company, and my father moved out to take over his company, and we wanted to be with my grandmother while her husband died. And we had loved Santa Fe always, anyway. I think my parents had been looking for an excuse to move there. Santa Fe, coming from Texas, was very exotic. Charles Manson was living there. He lived there right before he moved to Los Angeles. Many of the streets were dirt. Canyon Road, which is little art galleries now, was dirt. There were hippie Colombians and people painting them. It was right in the middle of the 1960s and '70s, and it was very exotic coming from Texas. It was very appealing to me.

And you have a fabulous house there now. How often do you go there?

I'm going there tomorrow to move some trees around. And I have a ranch about an hour and a half outside of Santa Fe, and we have cattle and horses and cowboys and I wear a hat and a plaid shirt and jeans and I get on my horse and yup.

Sounds fabulous.

It is, it is. I'm very lucky.

You went to school in Santa Fe?

I went to a little school in Santa Fe with nineteen people.

After that?

I went to NYU. It was 1979. I lived in the Weinstein dormitory.

You went there to study art history. But you dropped out after a year. Why?

Well, I was going to Studio 54 a lot and paying people to write my papers.

When you went to NYU and dropped out, you started acting in commercials. Were there any special ones you remember or especially enjoyed doing?

There are, and I've never told anyone what they were. I had twelve national commercials running at the same time. I was at J. Michael Bloom, my commercial agent at the time. I acted under a different name, so you will not find it. It will not be on YouTube. You won't be able to pull anything up. Because there was a Tom Ford in SAG when I joined.

So you won't tell us what that name was?

No. You think I really want to see those things again?

But after the commercials, you didn't want to go into acting and movies, television?

No, I was really lazy. I didn't really want to be an actor. I wanted to be a movie star. I didn't realize you had to really work. I was also very insecure. When I was seventeen, eighteen, I played fourteen, fifteen, so at my age it was like, wax your chest, you're growing some hair. And put some [pancake] on your beard. And so already by nineteen, I was starting to stress because you had a moment in time where you worked a lot as a young teenager, and then there was not a lot of work until you could be a young father. And I was stressing because I was moving out of that lucrative teenage moment. I was doing a Prell Shampoo commercial, and this guy was brushing my hair and he said—and I would do it with a lisp, but

I don't want to make stereotypes—"You're going to lose your hair." And I just panicked. From then on, I'd go home and look at it, and [it was] starting to recede. I'd go do a commercial and the hairdresser would do my hair, and the director would call me out and I'd go do it [again] myself. I'd come out, and they'd say [WHISPERING], "What's wrong with his hair?" I became too weird. I couldn't do it. I was very insecure. I would make a better actor today.

And so I guess you never used Prell Shampoo after that. Then you went back to school again, to Parsons. For interior or architectural design?

It was called environmental design at that time, which was a combination of interior design and architectural design. A lot of my friends went on to graduate architecture school.

Did you want to be an architect?

I did. I was living in L.A., and I started first at Otis-Parsons and then transferred back to Parsons in New York. Then I went to Parsons in Paris. But I'm jumping ahead.

You are jumping ahead. But yes, so it's true that in your final year, you switched to the fashion department.

I tried. And I was told you can't switch because you'll have to go back and start over. There was foundation year at Parsons, and it was quite structured. So I took all my electives in fashion, as many as I could—in illustration mostly.

What degree did you graduate with?

I graduated with a bachelor of fine arts in environmental design.

What year was that?

1986.

So you had the year in Paris, where you interned at Chloé.

1984 and 1985. I had a summer internship at Chloé, in the press office with a woman who just died this year, a wonderful woman named Françoise. And she was terrific.

What did you do in that job?

Oh God, I packed up shoes, I zipped things up, I sent them back to *Vogue*, I unpacked them, I organized the fashion closet—the Chloé sample closet. You know, the same things everyone does when they first start in fashion.

Was that your first trip to Europe?

Page 99: Tom Ford in Santa Fe, New Mexico. This page: Tom Ford in his twenties

It was not my first trip to Europe. It was my first time living in Europe.

Did you learn French during that trip?

I lived in Paris off and on for twenty years. My French is a disaster.

Still?

Yeah, my Italian isn't so bad, but my French is not great.

You graduated from Parsons. What was the dream job you wanted then? Was it in architecture, design, or fashion?

While I was at Parsons in Paris, I took a school trip to Moscow. This was 1984. I was really struggling because I was having feelings that architecture was so serious. I had Zaha Hadid as a critic once—

Wow.

And I just didn't seem to be able to do anything serious enough for my professors. I realized that I was always trying to work in my models. You cut and build, and I was always trying to figure out who was going to stand where and how they were going to stand. While I was in Moscow, I got really sick and couldn't go out [one] night, and everyone else went out and I was stuck in my room. It was like two in the morning, and I was thinking. I had been obsessing for weeks: what am I going to do? I don't know about architecture. I don't know what I want to do. And I literally sat up in bed, and it was fashion. I've always been obsessed with fashion. This is what I want to do: fashion. It was just *bing*. Which is how things happen to me—I think about them for a long time.

Aha moments.

I think for a long time. And then it just clicks. And the answer comes. That's when I decided I wanted to go into fashion.

And then you sketched and went around with your portfolio.

I was a good illustrator, and if Cathy Hardwick is here, maybe she'll [say that].

The first job was Cathy.

Well, I graduated from Parsons with a degree in environmental design. I wanted a job in fashion. I did not have a degree in fashion, but I could sketch. So I drew up a fashion portfolio, and I wanted a job with this woman, who's wonderful and lovely and sitting somewhere around here, Cathy Hardwick. I went to 575 Seventh Avenue—back then we didn't have cell phones—with a bunch of quarters and I just called and called and called and called and called, every ten minutes. Finally they saw me. Showed her this portfolio. Of course, you would assume if someone's showing you a fashion portfolio that [they] studied fashion. I didn't. I got the job. She said later it was because I had pretty hands, not because she liked my drawings. The first day on the job, she said, "Draw some circle skirts." And I'm like, shit. So I went to Bloomingdale's, flipped open the circle skirts, saw where all the seams were, ran back up to the office, sketched some circle skirts, and put them on her desk. So I learned on the job.

In the interview, she asked you who your favorite designers were and you identified that she was wearing Armani and Chanel.

Absolutely. I'm not stupid.

That's good. Good interviewing tips, for anybody looking for a job.

I have people come in and they say my favorite designer is Nicolas Ghesquière. I mean, he's mine too, but you don't say that when you're coming for a job with me. [APPLAUSE]

And Nicolas is one of my favorite designers.

You were Cathy's assistant for two years. And you learned more than circle skirts. What did you learn from her?

Well, Cathy introduced me to Richard Buckley, love of my life.

Yes. She was also Cupid.

Cathy has an amazing eye. I learned so much just visually from Cathy. An incredibly hard worker, very practical, very pragmatic, able to dream and create things. She was incredibly inspiring.

Tell us the charming story of meeting Richard, whom you've been with for over twenty-five years: the elevator, *Women's Wear Daily*, and that whole story.

I went with Cathy to a David Cameron fashion show—not the P.M. of Britain, but David Cameron the fashion designer, whom a lot of you might not know. He was the hot thing. And he had been Cathy's assistant before I was. So we went to this David Cameron fashion show, and I remember this silver-salt-and-pepper-haired guy. I remember turning and looking at him just staring at me with these piercing, watery blue eyes. It scared me. I've later realized it scared me because when I looked into his eyes, I absolutely saw and knew my entire future. He was the one. But I didn't realize at that moment why it scared me. I just couldn't look at him. At the end of the show, I bolted. I had to get out of there. I couldn't talk to him. And then, about ten days later, Cathy asked me to pick some clothes up from *Women's Wear Daily*. Richard, at the time, was fashion editor, and he just moved back from Paris. I'd moved from Paris the year before. Later, of course, we found out we had lots of mutual friends, and our lives had crossed so many times. But I went to pick up these clothes, and Richard was standing on the roof. I'm telling this from Richard's vantage point now. He was working with someone and they said, "Have you met anyone?" And he said no. "Have you seen anyone that you like?" And he said, "There was this guy, and I saw him at a fashion show." And at that moment the elevator door opened and there I was. And Richard said [WHISPERING], "That's the one." Now, I didn't know this, of course, because I hadn't been up on the roof listening to them. I know it now. I said, "I'm here to pick up clothes for Cathy Hardwick." Richard jumped onto the elevator, and he was just practically tap dancing. The elevator went down and he was flirting and batting his eyes and acting like a complete goofball. But I just remember looking at him and listening to him, and by the time that elevator hit the floor, I just knew this was the one. We had three dates. We were living together four weeks later. On New Year's Eve he gave me the key to his apartment. And we've been together ever since.

Extraordinary. [APPLAUSE]

So, thank you, Cathy.

So, at the beginning, Richard was the more well-known one.

Oh my God, I was twenty-five, Richard was thirty-eight or thirty-nine. And, of course, having lived in Paris and worked for *Women's Wear* and worked for John Duka at *New York Magazine* before—he knew everybody. He was very connected, and I was a young, twenty-five-year-old assistant, and very much in love and very much impressed. Richard's still very beautiful, but he was startling.

To this day, is Richard the man that keeps you grounded and focused?

Oh, he keeps me so grounded. So grounded he's mean. No, he's got me so grounded I'm

Tom Ford and his husband,
Richard Buckley

Gucci campaign,
Fall/Winter 2000,
by Alexei Hay

down in the hole, that's how grounded.

Okay, 1988 you went to work for Perry Ellis. Marc Jacobs was there. Did you work for Marc?

Marc hired me. He had just gone to Perry Ellis and he hired me to design Perry Ellis America, which was the jeans collection. And a few weeks after that, Perry Ellis and Perry Ellis America ended up splitting, and Perry Ellis's estate took over the part Marc did. And I became part of—I don't remember the bigger company—Salant Corporation? I became design director of that little division. I only worked for Marc for a few weeks.

You left two years later, saying something like America is tacky. And went to Europe.

Now, I don't remember saying that. Who told you that?

I read that in several [places].

Oh, so it must be true.

And you said that Americans didn't have passports and they don't travel.

That's not why I remember leaving. You know I was very, very ambitious. I took Richard on our very first date to Albuquerque Eats because, of course, I was from New Mexico, where else do you go when you can only afford five dollars for dinner? I remember telling him I want to be the design director of a big company that's global, because thinking in a national way doesn't make sense. And I need to move to Europe. I admire Ralph Lauren—he's the creator of this entire world, and this is what I want. And Richard tells me now he thought I was a fool and it was ridiculous and it was never going to happen. So that's why I left. That's why Richard and I left. But there were other reasons that we left. At that time, all of our friends were dying from AIDS. When Richard and I met, my best friend was dying, Richard's best friend was dying.

Do you think that also helped keep you both together, the fear?

It kept us both together. It also kept us both apart, the fear. Richard had cancer right before we moved to Europe. It was very serious and he was not given a great chance to live. We had been together about three years. And he was at Sloan Kettering, amazing hospital. Absolutely cured, twenty-three years later, totally fine and wonderful. But a lot of things had happened to us, and we just thought, we need to get out of here. We had both lived there before. We both had wonderful lives in Europe. So we decided to move to Europe.

Okay, so we're up to 1990, and Dawn Mello, who's right over there.

Oh, Dawn. And Richard Lambertson, too, by the way.

Dawn was the former president of Bergdorf Goodman, and at this time she was Gucci's creative director. And she was challenged with reinventing a very treasured and honorable brand, which actually had become tacky.

Fern likes that word.

Is Dawn best known now for bringing back the classics of Gucci? The bamboo-handled bag and things like that? Or for hiring you?

Dawn's best known to me to be a wonderful person and a great, great friend, and someone I learned so much from. The first time I saw Dawn, I was with Cathy, and we were at the Principe Hotel in Milan. It was the year Calvin did these little red skirts and black legs were in, so it was opaque black stockings, black shoes, little red skirt, little red jacket. I just remember this blonde woman went through the lobby, and everyone sort of moved and the corridors went phoo, phoo, phoo, and Dawn got in and they went phoo, phoo, phoo. And I remember saying to Cathy, "Who was that?" She said [WHISPERING], "It was Dawn Mello." And I was like [WHISPERING], "Wow." Bergdorf Goodman, at that period of time, was stunning. Not that it isn't a beautiful store today, it is.

But a woman also running it as president was special.

Stunning. I came to meet Dawn through Richard Lambertson because I had been obsessed with Geoffrey Beene, and I wanted to work for Geoffrey and Richard was at Geoffrey. He had interviewed me so many times, and I don't think Mr. Beene liked my sketches. When Richard joined Dawn, he brought me in.

Richard was design director.

He said, "Come in," and I met Dawn. And they hired me.

Richard left two years later, and you became design director.

I did. And I had a wonderful two years. Dawn and I having dinner every night together at Harry's Bar and drinking a good bit—

Yeah, it's a tough life.

—and talking and bonding and sharing stories that, don't worry, I won't repeat.

Okay, then you became creative director. You added fragrances, corporate image, advertising, store design, and eleven product categories at Gucci.

Yeah, well, design director before. I didn't become creative director until Dawn left.

You were doing shoes and men's.

I was doing all those products that Richard had been doing before. But Dawn, I have to say, taught me one of the great, great lessons that I tell everyone who comes to work with me or asks me. She said only hire people you want to have dinner with. And that's been the most valuable thing anyone ever taught me.

Early on, you had Christopher Bailey, now at Burberry, on your team.

I had Francisco Costa, Christopher Bailey—

So you had dinner with Christopher Bailey?

Yes.

And you hired him.

Yes.

Okay. I'm going to smack you.

Clockwise from top left: Kate Moss in Gucci's Spring/Summer 2001 ad campaign, by Inez van Lamsweerde & Vinoodh Matadin; Eva Herzigova wearing Gucci in *Harper's Bazaar* editorial, October 1997, by Terry Richardson; Gucci Spring/Summer 2002 ad campaign, by Terry Richardson

Go ahead.

Okay, so you would consider yourself a very collaborative designer.

When I like their idea, I'm collaborative. I do think that part of a job as a designer, as any creative person, as a film director, is to hire great people. Then you have to support them and make them feel comfortable, so that they can contribute and give you their best. You have to have a vision, but then you have to inspire them—that's the most important thing— and you have to slowly help lead them toward your vision. But in the end, it is not a democracy. You have to say, well, that's a great thing, but I don't want to do that.

I heard that you do ask the opinions of everybody around you.

Of course I want to know everyone's opinion.

And you're very democratic, but you make it clear it's really a dictatorship. You always know exactly what you want.

I want to hear everyone's opinion. I want to digest all of it. And then I make the decision. I'm very decisive and I'm very quick. I usually don't waver on it. Once it's decided, I don't really want to hear about it again. Move on.

When you were at Gucci Group, some other people you also brought into the company, Stella McCartney and Alexander McQueen.

Yes. I took my job very seriously and I was a good corporate soldier. When François Pinault invested 3.3 billion dollars in our company, I was the only creative leader designer in this company. Our task was to take this 3.3 billion dollars and invest it and build a group. I felt it was very important that I was not the only creative designer. So I thought, okay, who do I admire? Who do I think's great? Who do I think has potential? And who doesn't conflict? Stella does something very different than [McQueen] did. Nicolas did something else that was very, very different. I assembled a group of brands that I thought we should buy, and I took them to the board and said we should look at this, we should invest here. And so that was my job.

At Gucci your hallmark was bringing glamour and sex back into the clothes. And by 1996, their sales increased ninety percent. And you did what I thought was also quite spectacular, the very coolest Gucci dog bowls, and the big beach balls that were in every pool in Fire Island and Beverly Hills—big, black Gucci beach balls.

Black Christmas trees.

Black everything.

It was a black moment.

And you had a problem with Maurizio Gucci, who owned fifty percent of the business at one point. Because he wanted everything round and brown and you wanted it square and black.

I think Maurizio had a great intention. He wanted very much to bring back the glamour that as a child he remembered this brand had. Which was why he went after Dawn and Richard. He was not a great businessman. He had enormous energy, though, and I think a very positive desire. He just didn't know how to implement it. And yes, he was quite partial to what he remembered, which was brown, country, equestrian—even though Gucci really was never an equestrian company. But it wasn't that we had a battle.

Just a slightly different aesthetic.

Dawn at that time was the one who interacted more with Maurizio. In fact, I think he tried to

fire me. So maybe we did have our differences of opinion.

Gucci went public in 1995 at twenty-two dollars a share. A year later, there was another offering at forty-eight dollars, and a third offering in 1999 at seventy-five dollars a share. This success led to the famous long battle with LVMH trying to take control. How did you and your partner then, Domenico De Sole, handle this?

We were like the cast of *Friends*. You couldn't separate us. And people tried to separate us. We stuck together. We would spend a good part of every morning talking about what had happened the night before. Who had bought what? How much? What was happening? What did our attorney suggest? Should we meet with Mr. Arnault? Should we not meet with Mr. Arnault? And then we would try to design. Or I would try to design and Domenico would go and run the business. It was very, very stressful, and it was tough. But the company stuck together and it worked out.

In 1990, when you joined the company, it was almost bankrupt. In 1999, it was valued at 4.3 billion dollars.

And when we sold it to François Pinault in 2003 or 2004, and you'd have to dig this up, it was more like twelve or thirteen billion.

How did you, at that time when the company became that successful, celebrate your success? Did you feel you'd made it? You were making serious money.

You never make it, especially in an industry where you have to constantly churn out things. You're never finished. And you're only as good as your last collection. In the last year, I've had a comeback, I've been finished, I've come back again. You cannot rest. How did I celebrate?

Did you buy artwork? Another house? A plane?

Oh, yes, you know I was—I didn't buy a plane because what's that thing: if it flies or you rent it, don't buy it? I won't fill in the Fs for you there. Anyway, okay, I'll shut up. No, I didn't buy a plane. I bought a house and then I bought another house and then I bought another house and then I was able to buy great art. Then I bought all the things that I wanted when I was a kid, so I was drawn to the 1960s. I was initially drawn to Franz Kline and Alexander Calder and Warhol, of course. And I was very lucky because Warhol hadn't taken off like it has now. I bought a lot of material things, which ultimately did not make me happy, Fern. But I think sometimes you have to be lucky enough to be given all those things to realize that.

Absolutely. I read somewhere you really don't wear a coat, which, according to Fran Lebowitz, is a sure sign of success because it means you have a car and driver.

It's true. I think Caroline Roehm was the first person to say that she didn't wear a coat. I remember reading that.

January 2000, the Gucci Group acquired Yves Saint Laurent and YSL Beauty. You became creative director. Plus you worked at Gucci, overseeing all of the image branding, the product categories.

I was creative director of Gucci Group. And then I was also creative director and designer of Gucci, and then I became creative director and designer of Yves Saint Laurent as well. So I had three jobs.

Did you ever have any reservation about doing that for two companies with such distinctive, high profiles?

Of course I did. I didn't have a choice. Yves Saint Laurent was bought, because at that

Ford at a 2002 fitting,
GQ, November 2004

moment in time, Gucci was so successful and people seem to think when you're really successful that you're the answer to all their prayers. Yves Saint Laurent was bought for me to design. Unfortunately, in the process, a very talented designer, Alber Elbaz, left, and we're now friends because I think he realizes I didn't fire him. And so it was kind of a given.

But you hired Stefano Pilati and Hedi Slimane.

I didn't hire Hedi. Hedi was there and I was an incredible fan of Hedi's, and I still am. And I can't wait to see what happens with Hedi and Raf. It's going to be very interesting in Paris. But Hedi left while I was there.

I saw Stefano when he was interviewed in New York, and he said that he was quite nervous at the beginning working for you, but you had so much confidence that it carried over for him. He was very gracious and said he learned a lot from you.

Stefano's very sweet. And you know, we were a very, very good team.

So tell us about heading up a house with one of the strongest fashion identities ever, while the designer was still alive. What was your relationship like with Yves?

Well, Yves was very friendly at first. We knew each other, and he very much wanted me to design the collection. We had dinner a few times, and I knew Pierre [Bergé] as well. The first collection I did was Cruise, and we had Yves and Pierre up and showed them the collection. As things started to go well, and as the shows started to get good reviews and better reviews and better reviews, and our sales started going up and up, Yves was no longer my friend. I actually have some wonderful handwritten letters in very beautiful handwriting, in ink: "In thirteen minutes, you have destroyed what I have worked forty years to create." I didn't say that while Yves was alive, although he was pretty pointed about me in the press. It was tough.

Did you make peace with Pierre Bergé?

I haven't seen or talked to Pierre since then. But I have to say, one of the reasons I wanted to design Saint Laurent was that I, like most people, was an incredible fan. And all I really wanted to do was to try to keep it what it once was. And so I was a little devastated when Yves felt that way. But then you move on, and our sales were great and our reviews were great and more and more people were wearing the clothes.

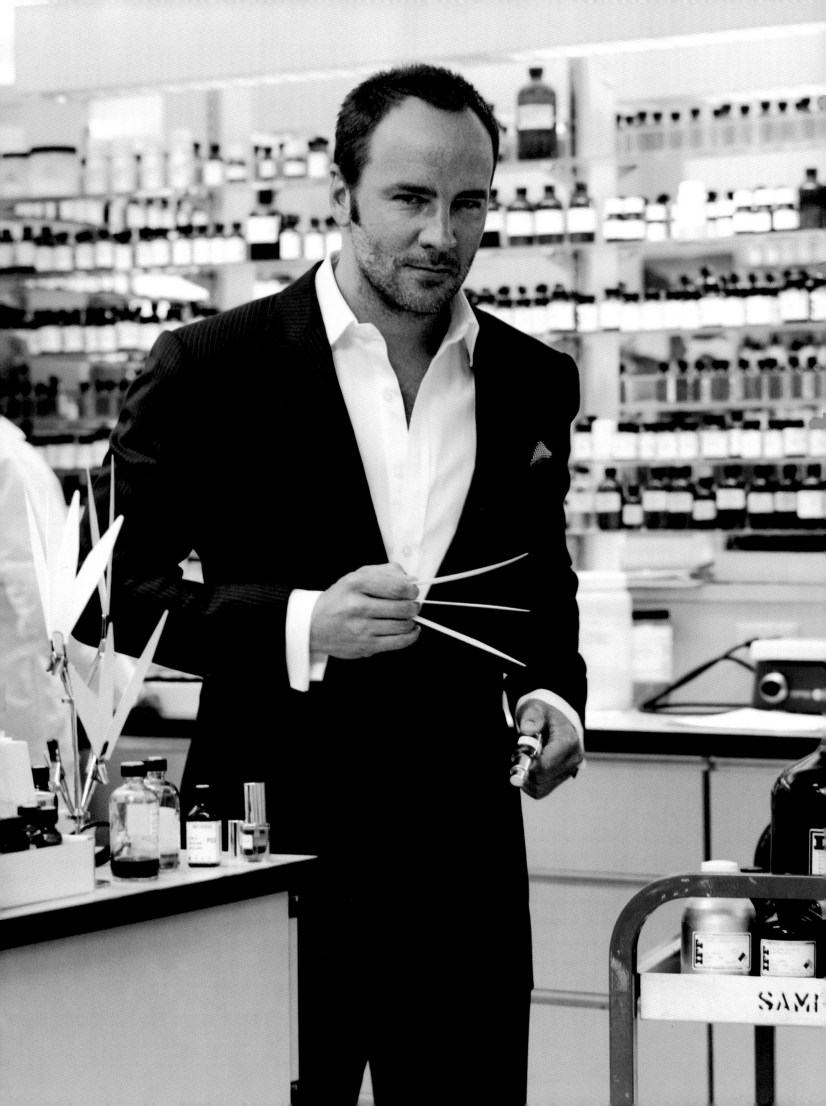

It's kind of the best way to go. But then what went wrong in 2004? The artistic direction control, between you and Pinault?

No. It was that we were no longer a public company. We were being completely bought out by PPR, and as such we were not going to be able to run the company with the autonomy that we had. I had been very used to having complete autonomy. Domenico did on the business side, I did on the creative side. When you're used to that, you run a company like it is your own—I don't mean that you misuse it, I mean that you put that much into it and that much passion. It wasn't going to be that way anymore, so we left.

So you left from being on the top of the world. I came to Milan just to see your final show. Then you fly off after an amazing emotional Gucci show in Milan, in the middle of the night, on a private plane, to where and what?

To L.A. for the Oscars. And I flew right back to Paris where I had my last Yves Saint Laurent show, ten days later.

Was this the beginning of the midlife crisis?

No, it had been coming before. In a lot of ways, I think I willed my departure from Gucci. I really knew in 2002 that I couldn't keep going. By 2002, I couldn't keep designing both these collections. I had everything I'd ever wanted in my life. I had a wonderful person at home whom I loved. I had every material thing you could want. But yet I was not happy. I was increasingly unhappy.

And you started to drink.

Well, I had been drinking always, since I was a kid. But yes, I started to drink more.

Too much.

And I was no longer drinking to relax and to be social. I was drinking to escape—that's a very different kind of drinking. I knew I had to quit. I also knew that what we had created was finished. That sort of rapid swing from trend to trend every season that I'd been doing, the globalization that we really helped create in the world, where all of a sudden everyone was buying the same thing all over the world… it was draining. And producing sixteen collections a year, which is what I was doing.

I can't even imagine that.

As well as going to business meetings, because I was vice chairman of the board. We had numbers and companies to buy and things to do. It was too much, and I just couldn't take it anymore. I knew it had to end, and I kind of probably willed it to all fall apart. For me. Obviously, it didn't fall apart. It's a great company and it runs beautifully.

A year later you announced the creation of the Tom Ford brand.

I thought I was going to retire. I really thought I would never go back to fashion. I hadn't played golf in years. I bought some new golf clubs. Can you imagine me on a golf course? Well, as a kid I was pretty good, but in Texas, everybody lives on a golf course.

What did you wear playing golf?

Well, that was hard because golf shoes had changed. You couldn't wear metal cleats anymore, and so I had them custom-made. I also insisted on playing with wood clubs, which nobody did anymore either, because I had the most gorgeous wood clubs. But I realized quite quickly that I needed a big ping. I did play golf a little. But I was bored out of my mind, and my retirement did not last very long.

Thank goodness. You started this business in a major recession.

Well, it wasn't a major recession when we started. Lehman Brothers had not quite melted down. We were fortunate that we started in a recession. This sounds weird, but we were making a product that was about quality. Like some other brands, like Hermès, we did not dip as much as everyone else. We were new, and our brand recognition was increasing every day. Most people's sales were dropping, but our traffic in sales was going up because more people knew about us as we had just been newly created. So we suffered a lot less than other people.

You started with a sunglasses license and then with Estée Lauder for the Tom Ford Beauty brand.

I first did Tom Ford for Estée Lauder, because it takes a long time to develop your own brand, at least an eighteen-month lead time. So that was what I did first, but we created Tom Ford Beauty, and when I signed a deal with Estée Lauder, that was the intention.

How many fragrances are there?

God, how many fragrances do we have? Twenty-something.

Which is your favorite? Which do you wear?

I'm wearing Tobacco Vanille. Actually, tonight I'm wearing Tom Ford Noir, which is our new men's fragrance.

I'm wearing Neroli.

But I'm very partial to Tobacco—Neroli Portofino, that's our number one. Yes, the naked people splashing each other. I took that picture.

I love that the names are, in fact, the ingredients in the fragrances.

Well, quality: that's what our brand is about. The most commercial things for us are the highest quality, and often that means the highest price. Believe it or not, those become the most commercial things for us.

The Private Blend—the highest end of the line—are the most successful.

They're very, very, very successful, because it's great quality, the ingredients. Which sounds like a big commercial. Let's jump back to some dirt, Fern.

Okay, well, now we're getting to movies. You announced the opening of Fade to Black, your film production company, in 2005. Was this a lifelong dream of yours, to make a movie?

It wasn't a lifelong dream. But I would say by the mid-1990s—I've always loved film and been obsessed by film, and as you know, flirted with wanting to be a movie star—I realized, God, I really want to make movies. That had been my intention when I left Gucci, to play golf and make movies.

And why did the Christopher Isherwood book mean so much to you that that became your first project?

I have a lot of friends in Los Angeles, and I had a house there since the mid-1990s, so I felt very comfortable there. When I made it known that I wanted to make films, I received so many screenplays. I have a great agent, Bryan Lourd at CAA. I talked to everyone, I read everything. Nothing was striking me. I was really struggling. A lot of things, as I said earlier, just bang me on the head. I was driving to my office, and I thought, George. I always think about this character George. I'd read a book in my twenties when I lived in West Hollywood, and I fell in love with the character George, from the point of view of the younger guy. I met Christopher Isherwood, and I became obsessed with him and I read all of his works. And I

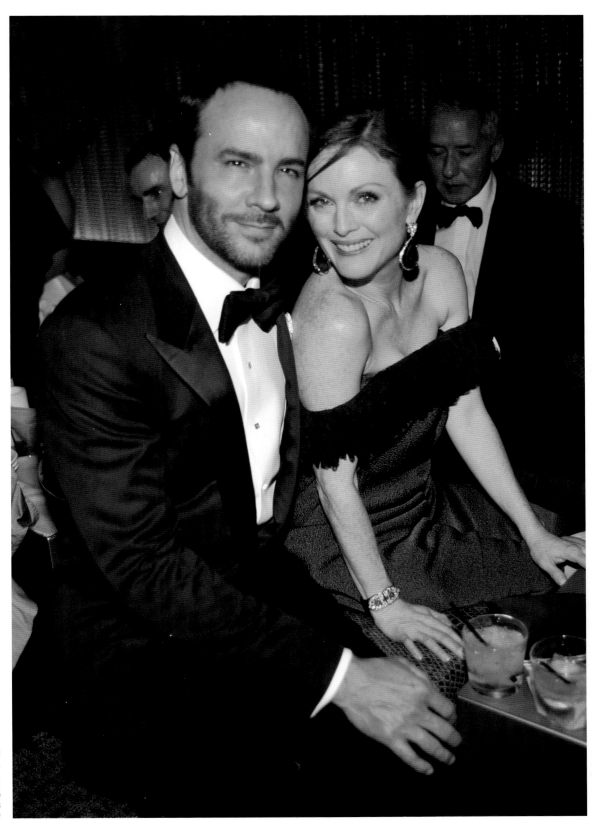

Page 110: Tom Ford at the International Flavors & Fragrances perfumery lab, photographed by Jonathan Becker. This page, clockwise from top right: Tom Ford with actress Julianne Moore at a Golden Globes after-party in Los Angeles; Tom Ford filming *A Single Man*

realized, this is the book. And it was really, bang. I went back to my office, got on the phone, called Chris's boyfriend, Don Bachardy, who is a wonderful man in his seventies. Went out to see him and convinced him to let me have the rights to the book.

Fantastic. And was it difficult getting Colin Firth?

It was not difficult getting Colin Firth when you have a great agent like CAA who can get you to everyone. I actually had met Colin at a party a couple of years before. He was my first choice for the role, but he was booked up. And all of a sudden, his schedule freed up. I emailed him. I said, "Colin, I've got something I want you to read." He read it, emailed me back, said, "I loved it, [but] I have a problem with the nudity." I said, "Don't worry, we'll cover you up, you don't have to be completely nude." I jumped on a plane to London. I took him out to dinner. We had a few cocktails. We did a handshake deal. I went right back to Santa Fe the next day, and then we were in preproduction three or four months later. Julianne Moore had signed on first—that gave the project legitimacy. In the book, the character is very, very different, and I wrote that part with her in mind, hoping that I could get her to do the movie. She read it and loved it. So I was able to go to Colin and say I have Julianne, and I have this and that, and he said yes.

How good did it feel when he got an Academy Award nomination?

Oh, it felt wonderful. I mean, that was my goal: to have an actor get an Academy Award nomination. And he did.

And how does this compare to creating a collection of clothes and showing it, putting a movie together?

Very, very different. I love both of them. The film industry is slow. And I would lose my mind, because you can really only make a movie, even if you're really successful, every couple of years if you're a director. I love being able to do things that are quick and fast, so fashion suits me. I'm a commercial fashion designer. I've always designed jackets with two sleeves. People have two arms. It doesn't mean I don't admire jackets with three sleeves or that can turn into tables or the layers and layers come off them like little dolls in Russia. But I'm a practical commercial fashion designer. I love it. It's creative. For me it's an artistic endeavor, but it is not art for me. Now, for Alexander McQueen, it was art. He had to express himself,

and that was his art. I wasn't trying to create a big box office hit. I was trying to make something personal that I loved, that I didn't compromise on, and it was a very different type of expression.

Is there another movie in your future?

There are three projects that I'm working on now, but, you know, having just started women's ready-to-wear—

No scoop tonight? Come on.

Well, I could tell you about them but you won't see them for a while. I have to face the fact that I'm doing women's ready-to-wear for the next couple of years before I can even think about making a movie.

[TO AUDIENCE] How many of you saw his movie? *A Single Man*? **[APPLAUSE]**
Thank you.

I think that's everyone. So you couldn't stay away from fashion, as you said, and the quickness. You opened your New York flagship in menswear collection in 2007. Why men's firsts and not women's?

I was in denial that I was really going back into fashion. And I thought, oh, I'll just do lipsticks and fragrance.

Lipsticks and men's clothes.

No, but I started at Estée Lauder, with Tom Ford Beauty. And then I thought, okay, I'll do eyewear. I love eyewear. And then I couldn't find clothes to wear. Good things, I think, come often organically. At Gucci, I made everything I wanted. If I needed a new pair of shoes, I drew it, I made it. I needed a jacket, I made it. I didn't shop. All of a sudden I was shopping. I couldn't find anything I wanted. And I realized, there's a niche in the men's market. And so it was very organic. If I need this, other men need this, and other men want to shop this way. At that time I really thought, I'm not going back into womenswear, no way, no, no, no. And then I started looking at women and thinking, God, that's a lot more fun. You get to have sort of sparkly things, and you get to make them really tall. And then, here I am.

Do you have to be a CEO or chairman of a board to afford your men's clothes?

Well, you could have very rich parents and be a very handsome twenty-five-year-old with a trust fund. You could be a twenty-five-year-old boyfriend of a very beautiful, rich woman. You could buy some fragrance.

So there's no H&M collection coming up or Target?

No, and I keep reading that and I find that amusing.

It was an April Fools' joke, [wasn't it]?

It was. I keep reading about it. I've never had a conversation with H&M.

Would you like to?

No, I'm really happy doing what I do. I designed a jeans collection for Perry Ellis, where I spent a lot of my time in Hong Kong. Our sample room was in Hong Kong. It was, "This fabric is [$1.68], and we have to go with a fabric that's [$1.62] a yard." I'm not kidding. What excites me now is the very best: the best stitching, the best fabric, the best quality. And unfortunately or fortunately, that does tend to cost money.

But wouldn't you love to give people an opportunity who can't ever get there to be able to wear something of Tom Ford? Or is it just lipstick and nail polish?

It's lipstick and nail polish and sunglasses. But you don't have to wear designer clothes to

have style. Well, I guess my answer to that isn't no, because that would sound terrible. It's just that what excites me now is designing the very, very best, and for people who appreciate it, because not everyone appreciates it. Not everyone cares that their buttonhole's open. And for those people, that's fine, they don't have a jacket with buttonholes. It drives me crazy if they don't open. And you know, I want to design for people who get excited about the same things that I do.

So you launched your women's collection in New York, and you completely bucked the fashion show system. Tell us about that, and why.

I did that for a few reasons. I knew there would be a lot of expectation if I were to say I'm coming back and I'm doing a women's collection and I'm having a show. I'm very practical. I didn't want to set people up. That's like hyping a movie—you open and everyone's heard so much about it they're sick of it. I wanted it to be a complete surprise. And honestly, we did it so quickly. I finished promoting my film at the Oscars, which was in March. I hired a design studio team in the month of April. We put everything together. The collection was finished by the end of July. We had to find manufacturers. We had to get it made. Then I showed it at the beginning of September. I honestly was not sure we could pull this off, so I wanted to keep it secret in case at the last minute it didn't work. It wasn't just clothes—it was shoes, it was bags, it was jewelry, it was everything. I thought, I'm going back into fashion, I've got to have something new to say. Otherwise, why go back? What excited me, at that time, and what excites me still to this day, is everything is globalized now. And what's also happening is a resurgence of individuality because everyone can have everything. I don't think there's ever been a moment in time where every fashion lives together at the same time. It's perplexing. If you're a fashion designer or a customer, you open a magazine, there's a stiletto, there's a platform, there's the 1950s, there's floral—it's all living together at the same time. I was inspired by all the women that I knew who were quite, quite different. I wanted to design a collection that really emphasized character and personality rather than a sort of unified stamp. And that's what I did.

Did you design those clothes specifically for those women?

I thought, who are the thirty most inspirational women in my life, who are friends? People are always saying where do you get your inspiration from? My friends, people who work with me, people who I think have great style, people whom I've always admired. Marisa Berenson I didn't know very well, but she's been on my inspiration board season after season after season for years. I met her at a party and said, "Would you do this?" Then I thought about their characters, and I looked at everything and designed something specific for each one that I thought represented who they were. Not one person asked to see what they were wearing. They showed up two days before the show, I fit them, and they did the show.

And they went home with the clothes?

They didn't, because that was our sample collection that had to go out and be photographed. We were a start-up company.

They weren't all sample sizes if they were all different women.

Oh, we altered them. Those women have carte blanche for a long time. They did a great favor for me, and so yes, I make them clothes and I dress and help people whenever I can.

And the photos, everything was embargoed. [Terry Richardson] took pictures and

you were waiting until the clothes hit the stores to be out.

When I look at fashion six or seven months before you can buy it, I'm a little bored with it by the time I see it. Our customer doesn't necessarily want to wear the same jacket that she's seen in all the magazines—who rocked it best, forty-nine percent vote this, fifty-two percent [vote that]. What I do now is small presentations in London in my showroom. I have groups of twenty people at a time. I have thirty top models, full hair, full makeup. They do not change, that way I can really customize, personalize, make them look great. I do a show at nine, nine thirty, ten, ten thirty, eleven, eleven thirty, twelve, twelve thirty. And I talk. I say, "Look at the lining—come over here, look how it's sewn, look how it's stitched, look at this detail." All the editors tell me they love it.

Did you not have the pictures released, even from the London show?

No. I [even] photographed it myself. So after we do all this, I stay up until three o'clock at night getting all those girls in, and I shoot it all. Then I edit and retouch a little bit, and it's the look book the next day for the PR office to work from. And then we release it, ultimately, online. But we hold it back a while.

But you don't have to wake up in the morning and read the *Women's Wear* review of it.

No, although at first, I didn't invite dailies and newspapers. Now I do. And so, yes, you do read it. But it's a different kind of review, because it isn't a show.

Did you think when you did that, more designers would follow and start that movement? Because some people would like to do that.

Not necessarily. It's a very hard thing to do. I totally understand what Marc does and Karl does, because the scale is massive. Thousands of people need to see those shows. And so I totally understand it.

Donna's forever trying to not [have the shows].

I know, Donna actually sent me a note or told me in real life, I don't remember, but she said, "Oh God, yes, you did that."

You expanded, just last year, the beauty brand, with the full-on color cosmetics. I understand that you know every single product on the market, you come very prepared for your meetings, and you've tried everything.

I do. I do.

What products beside yours did you love or inspired you?

I'm not going to promote other brands sitting here. Creativity is the art of concealing your source.

Okay, concealing your sources. I was told that your designer cosmetic launch was the most successful in the last twenty years. Do you wear any makeup?

Well, I'm on camera, so yeah, there's a little powder on my forehead. Do I wear makeup? I don't come out fully made up every day. But if I have a little pimple or something, I'm going to cover it up, of course.

I know aging is a concern of yours, that you talk about.

It is not. Am I aging?

No, you? You're Peter Pan.

Oh God. You're freaking me out. I'm gay, I'm aging. This is brutal. This is like a roast, Fern. Have I gained weight? [LAUGHING]

Is there a cosmetic procedure where you would draw the line?

You really have to have a good eye. You have to have a doctor who will say, "No, that's wrong for you, you shouldn't do that." But if you don't like something about yourself and you can fix it or change it in a safe way, and you're prepared for the consequences, because it might not look the way you want, you might wreck your face, or—I don't know. I can't answer that. Would I draw the line for myself? Yeah, I would draw the line. You know, men can't have a facelift very well because they have to cut here and then your sideburn is in your ear. I quite like my beard. In another life, I would love to be a cosmetic surgeon—it's architectural. You're trying to figure out where the seams go, how you can hide them. Can you do it out of one piece, like Halston? Or Madeleine Vionnet?

All right, we're talking about beauty rituals and regimes. Can we talk about your baths?

People seem to tease me about my baths.

I actually took one tonight before I came, in honor of you.

I'm glad you took a bath. Although you are wearing my fragrance, so you don't need a bath.

He does take four to five baths a day, which I think is kind of interesting.

Well, if I'm sending emails and I get all wound up and stressed and I don't know what to do with myself for twenty minutes, I fill up the tub with hot water and lie there and think, mmm. I get out, dry myself off. So it's meditative for me. It's relaxing.

But there are some rituals. Some are with just warm water. Some are with bath products. Is that not true?

No, I just soak in a hot tub. Soap in the morning and wash my hair. Then I don't do that for the rest of the day, I just lie in a hot tub.

And is it true that you walk around the house mostly naked?

Yes.

Nice.

Don't you walk around your house naked sometimes?

Sometimes. And what's a typical night like at home? Do you have a chef at home? Do you cook? What's your favorite meal?

Richard is an amazing cook, and Richard cooks many nights. Yes, we do also have someone who cooks for us sometimes. But we also go out probably four nights a week. In our industry and the life we live, you're often out.

I heard you're addicted to *Glee*. Is that true?

I love *Glee*. I'm addicted to a lot of things.

Is there any particular music you love?

Oh my God, I have such a mix of music. Azealia Banks right now is amazing. Lianne La Havas is also a great young new talent. I grew up in the 1960s and '70s. Put the Bee Gees on and there's no way you can be sad. At least I can't. Immediately I'm staying alive, and I've got that hair that I don't have anymore. Or Stevie Nicks. Or it could be Michael Jackson and Diana Ross singing—and I'm back in 1980 in Studio 54.

Are you tech savvy? Do you use the Internet? Are you a Tweeter, a texter?

I do. I live on the Internet. I do not carry a cell phone. But I am on my computer eight hours a day.

But does somebody walk next to you carrying a cell phone?

With my coat, yes. No.

In the car with the driver.

I feel like if something really happens, somebody's going to get to me. Otherwise, I just can't stand that constantly. I want to be looking and living and engaged. I don't want to walk past something amazing because [I'm on the phone]. I can't stand to talk to people on cell phones. I say, "Are you on a cell phone? Let's talk later when you're at a hard line."

Good for you. What do you read every day? Newspapers, blogs?

Oh God. Okay, we're promoting people. I read the *Daily [Beast] Cheat Sheet*, which I love in the morning. And then anything that's on it, because it pulls things from everywhere. I immediately go and read those articles. I don't have time to read every newspaper. I live in London, and it takes me exactly the time from my house to my office to get through the *Herald-Tribune*. It gives me a great international, which I miss when I'm in America. I have to say—I live part-time here and I am very much an American, but I do miss the international take on the news. Rather than live at five, five new ways to reduce cellulite.

Why don't you like living in New York?

It's funny. I'm starting to not like living in any city, and it's probably the fact that I grew up being able to see for two hundred miles. A lot of people are freaked out when they're in the middle of nowhere. I am so comfortable and so at home. I loved New York when I was young. I used to hate to go to the country for the weekends because I felt like I was missing something. But at this stage in my life, I find it's over. You probably have noticed, I close my eyes a lot when I talk, because I get overstimulated. I have to close my eyes to focus and think. And there's so much stimulation in New York. Even when I am trying to sleep I feel this vibration. So it doesn't mean that I don't like New York, it's that I can't function or think here. And also, I had to leave New York to figure out who I was as a designer. I grew up in a very kind of preppy environment. I could read where people went to school by what shoe they had. And like all of us, we learn to read the cues of our culture, so I couldn't really think, what kind of shoe do I really like, because I had been so ingrained with all these things. I had to leave my own culture to understand who I was and what I believed in as a designer.

How do you relax? Do you?

Rarely. I relax skiing, riding, playing tennis. I have figured out why. Because when you're playing tennis, you can't do anything except focus on that little ball. Your mind goes blank. When you're on a horse, you're constantly aware. You can't be thinking of something else—that's when you get thrown. Skiing, same thing. You can't think. That's how I clear my head.

That's a good one. Do you follow any other designer's work?

Every other designer's work.

But who do you admire? Any of the new young ones?

Well, yes, Joseph Altuzarra I met last night. He sent me the sweetest email this morning.

So you met him last night and gave him your email.

I didn't, but he got it. It was there this morning. It's so wonderful watching someone's career really take off, and especially such a nice person. And I admired him before I met him last night. But of course I look at everything.

Is there any kind of words of wisdom you would give to new young designers here in the audience?

It might be the same thing that people used to tell me when I wanted to be an actor—because I really did want to be an actor. I was being silly about wanting to be a movie star.

If there's anything else in the world you could be happy doing, do that. I'm serious. This is the hardest industry. Having worked briefly in the film industry, and hopefully [I will] have more time in the film industry, I'm telling you, that industry is easy compared to what we do. Creating on command and on a schedule and calendar, stores needing new merchandise every six weeks so that people can shop—if you love it, great. You will have a wonderful life. If you doubt it, it's a tough, tough industry. But it can be a wonderful industry. And there are wonderful people in fashion. I don't think people realize how hard people work in fashion.

No, I think that's absolutely true.

You couldn't do it if you didn't have passion.

I read that you tell people who love people that they should tell them all the time how much they love them.

Absolutely.

How many times a day do you tell Richard that?

Every time I see him. Really, if I'm sitting there and he's reading the newspaper and I happen to just look at him, I say, "Aww, I love you, sweetheart." You have to. [APPLAUSE]

Will you and Richard get married?*

I would absolutely get married to Richard. You know, we're California residents. You can't do that right now. And, by the way, the federal government does not recognize same-sex marriage. So I'm telling you, if we were married after twenty-five years and I died tomorrow, Richard wouldn't be able to inherit everything without paying taxes. If I die tomorrow, Richard would have to sell things, change his life, because half of it goes right to the federal government. So we do not have the same benefits that heterosexual couples have. And I would marry Richard in an instant.

Do you want children?

I have always wanted children. I think I better get busy soon, though.**

That would be marvelous to see you parenting. We covered most of these questions that were asked by the audience, but here's one here that asks, "What is your favorite fashion moment?" And I will say that Gwyneth at the [2012] Oscars was extraordinary. That dress was the best.

Thank you. [APPLAUSE] I have to say that was one of my favorite fashion moments, and it's happened recently in my career. Thank God, they're still happening. But I loved that dress. I loved the simplicity of it, and I loved it for that moment in time because there is so much stuff on those red carpets, and I love that Gwyneth was brave enough to do that. She stood so perfectly in that dress, and I was very, very proud. I loved that dress.

It was beautiful. Is there anything on the bucket list?

Just to have maybe forty more years of all this?

Well, that works. Is there something next for Tom Ford that we can all look forward to?

Well, I just hope more—and I do hope another movie soon. I have three that are in the works, and as soon as I have time to shoot one, you'll see one.

Well, we have taken way more time than we were allotted here, but I hope you enjoyed this as much as I did.

Thank you. Thank you. Thank you. [APPLAUSE]

* In April 2014, Tom Ford and Richard Buckley announced their marriage.

** Alexander John Buckley Ford was born on September 23, 2012.

MICHAEL KORS

I am all wrapped up in Michael Kors this evening. If Michael wasn't a designer, he could probably have his own stand-up routine. So get comfortable because I think we're going to be here for a while. He is one of the most honest, decent, hardworking, and talented designers in our industry. But more importantly, he is the funniest. I'm sure you all know his company recently went public on the New York Stock Exchange, and we will obviously talk a little bit about that and how he is now a very rich person. You know how some people begrudge others and are jealous of friends who make it big? Well, there is not one person I've spoken to who hasn't said, "Isn't it great?" He deserves it. He's worked his butt off, and I couldn't be happier for him. He is adored by all his colleagues and the many layers of people in our industry. I always say we like to work with people who are nice. And he is nice. He is loved by his customers—the famous celebrities and the civilians. Those are the ones who buy his clothes and his accessories and pay full retail. And he is universally loved by his TV audience, who feel like they know him, having shared ten years of Project Runway with him. He has made the American dream a global dream and a dream come true. We will find out how a cute Swedish-Jewish boy named Karl Anderson Jr. became Michael Kors. Ladies and gentlemen, my friend Michael Kors.

FERN MALLIS: So Michael, we always start at the very beginning. August 9, 1959. You were born in Merrick, Long Island. You're a Leo. What does that mean to you?

MICHAEL KORS: Well, I think if you're a Leo, you're definitely not shy. You're definitely opinionated. And I'm a summer baby. I am a beach boy at heart. As I got older, I realized I had Chanel and I had Saint Laurent. These were good Leo designers to have in your sign. I think Leos like to have a good time. I think they're energetic. I think they're upbeat.

My Leo research says you're very independent, love being the center of attention on stage, love the applause. Leos are also the king and queen of the zodiac. They're leaders by birth; they're not elected. They have a big overview, are good at delegating people, won't take orders from others—but luckily other people don't mind taking orders from them—and you will not settle for second best. Other Leos, as you mentioned, in design are Coco Chanel, Anne Klein, Yves Saint Laurent, Anna Sui. And other Leos are Jackie Kennedy, Diana Vreeland, and Obama and Clinton.

And Andy Warhol.

So you agree with all of that.

Sometimes people think it's all hocus pocus, but I have to say, I do think there's also something about the style that is different from different signs. You know, everyone says, "Oh, Tauruses, they're earthy." Well, you know what? They kind of are. And Leos, let's be honest. You think about Jennifer Lopez—she's definitely not the shrinking violet. I think there's definitely a confidence.

I think that's true. Tell us about your mom, Joan, who I think is the best fashion mom in the business, and your dad, Karl Anderson.

My mom had me when she was twenty. So she was a young mom. She lived in Brooklyn

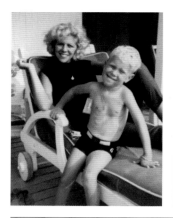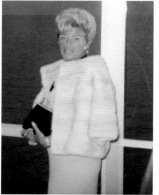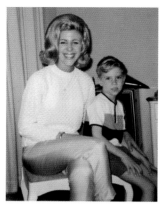

This page, left to right: Michael as a young boy with his mother, Joan; Michael's grandmother Bea Hamburger; Michael with his mother. Opposite: Michael in a General Mills commercial. Page 126: Michael at his mother's wedding to Bill Kors, 1964

and then grew up on Long Island, moved when she was a teenager, and met my dad. It was the fifties, and he was this blond, crew-cutted wrestler. She was a nice Jewish girl, and I think he probably seemed a little dangerous. I think my grandparents were having a nervous breakdown. And the next thing you know, they eloped. My dad was going to college on a wrestling scholarship. And here I arrived as Karl Anderson Jr., the least likely name for a nice Jewish boy. We were living in Michigan—Kalamazoo, glamorous. I was a baby, so I have no memories of Kalamazoo.

What did the environment you grew up in at that early age look like? Did that inform your design aesthetic in any way?

I think what's interesting, you know, my mom got divorced from Karl Anderson when I was really small. I was two. And so I don't remember any of it. But then we came back to New York, and suddenly we were with my very indulgent, very fashion-obsessed, very style-obsessed Jewish grandparents.

We're going to get to Bea in a second.

So from Kalamazoo to the Five Towns. It was a big switch.

Did you stay in touch with your biological father after they were divorced? Did you [ever see him again]?

No, I didn't. My mom started dating my stepfather very shortly thereafter. Bill Kors. He was really the dad I knew and grew up with.

So when she married him five years later, obviously your name changed to Kors. You didn't like Karl Kors?

MK: Well, it's a little bit of a crazy thing. Listen, we all know in fashion there's only one Karl. So—

FM: But you were five years old.

I somehow had a premonition that maybe I would leave it to him. You know, in fashion, people love to call everyone by their first name. It's like Calvin, Donna—there's only one. My grandparents were still dealing with the shock of their grandson being Karl Anderson Jr. when my mother's name is Hamburger—that was a stretch. And my grandmother was Beatrice Hamburger.

Bea Hamburger.

And my grandfather was [Austin] Hamburger, so he was "A. Hamburger." My grandparents always said that I was a very happy baby. I was always just this very upbeat kid. So my grandfather used to call me Chuckles.

That's what I was going to ask you, how you got the name Chuckie.

Well, "Chuckles," I think, sounded like I was a clown. So "Chuckles" turned into "Chuck," which turned into "Chuckie." So I had this made-up name that was a nickname, Chuckie Anderson. By the time my mom got remarried, I wanted a really adult name. And my mom said, "Your stepfather is going to adopt you, and you're going to be Kors. And you don't want to be Chuckles Kors." So my mom wanted to name me. She loved the movie *Exodus* [and] at first she wanted to name me Dov. And I said I'm not going to be Dov. I said, "I like Michael. I don't want to be Mike. I don't want to be Mikey. I want to be Michael." Then I gave in and I had David as the middle name. And hence Michael David Kors was born.

You kept Chuck Anderson as your modeling name?

Yes. I got discovered at a birthday party and there happened to be a television producer there.

He liked your curly hair?

He said, "I think you'd be great on television." And the next thing you knew, we were doing Lucky Charms and all this crazy stuff. I was in first grade, about six, and my mother realized I didn't want to go to school. I just wanted to work. I thought it was great.

Do you still have a SAG card?

I still have my SAG card, yes.

Under the Chuck Anderson name?

Chuckie Anderson. She retired me, though, at six. I was done.

That sounds like a good name for a collection: Chuck Anderson.

Or maybe a steakhouse.

What did Bill Kors do? And did you like him?

Oh, he was a great guy. He owned four different gas stations. My mother pulled her car into one of his gas stations, and that's how they met.

Wrestler father to gas stations to this?

Husband number two—my grandparents at first [were] a little nervous. Not a nice Jewish boy, once again. My mother liked blond guys.

There are some Jewish blond guys.

She had a thing for Scandinavia. I think that was her thing.

Okay, so when your mom married Bill, that was your first foray into being a designer. Tell us about her wedding dress and what you did to it when you were five years old.

My grandmother was so excited that there was going to be the big wedding finally, and my stepfather converted to Judaism—

Well, that was nice of him.

—so it was going to be a major wedding instead of an elopement. And so my mother went with my grandmother and picked out a wedding dress. Everything was going smoothingly smooth. She brought me to her first fitting for the dress. I was her partner in crime for everything. I was used to being around adults. My mom tried the dress on, and it was covered with a zillion bows. It had bows everywhere. And my grandmother said, "That's magnificent. Oh, it's the most beautiful dress." And I sat in the corner like, not so great. My mother said, "What's wrong? What do you think?" I said, "I think it's really busy." It just looked like too much. So my grandmother said, "Oh, he's five, don't listen. It's perfect. It's Priscilla of Boston, how can you go wrong?" And the next thing, the tailor came in and my mom said trim off a few of the bows. So they took them off the bodice at first, and my mom kind of said, "Mm, I think he's got something there. I think he's right. Take them all off." And the bows came off. And my grandmother was like, whoa, there was a power shift here. And the truth is, my mom ended up getting divorced from Bill Kors but, quite frankly, I think the dress is pretty timeless.

So was your mom a little bit like Mama Rose with all your commercials and things?

Actually, my mom was modeling at the same time that I was modeling, and it's kind of crazy. We would come into Manhattan together and my mother—I was five or six—put me in a taxi, and said, "Here's the address." I would go on my go-see, meet my agent.

She'd be arrested today.

I know, today she'd be on the front page of the Post: "Child Abuser." But my mom was off on her go-see, I was on my go-see, and we were just having fun with it.

Can you remember that at five, six years old? Going around in taxis by yourself?

I actually remember a go-see. My mom put me in the taxi, I got to the go-see and walked into the room, and there was this army of six-year-old blond, blue-eyed boys. My mom, [who] got there because she was coming from something else, basically said, "This is a cattle call. He doesn't do cattle calls."

So you went to acting classes for a little while?

As a teenager, yes. Herbert Berghof's studio on Bank Street in the Village. A little shocking when you get there and realize, you can't sing, you definitely can't dance. No, gay men are not all good dancers. And as much as I'm comfortable talking and being in the public eye, I realized, I don't belong being an actor.

When you were at acting school, when you got there as a teenager, is that when you knew you were gay? Did you know that when you were five?

My mom started asking me when I was like seven.

What did she ask you?

She said, "Now, you know you can tell me anything." [LAUGHTER] I'm seven. I'm sitting in my room sketching endlessly, all day long. I knew by the time I was ten or eleven that certainly I was different. But I grew up in a family where difference was applauded.

Talk about Bea Hamburger. She was a stylish person, lived large. Was she a high school principal? I read that somewhere.

My grandmother was this strange dichotomy. She grew up in a time when women really weren't going to college. She went to NYU. I think she wanted to be a lawyer, but her parents said, "No, you're not going to law school." So she went into education. And she ended up being a high school principal.

What school was she at?

She was at Farmingdale High School on Long Island. But her proudest thing was to say, "I never repeat an outfit." She was fashion obsessed. She had a brother who was in the fashion business. My grandfather was in the textile business. She would stop on her way home from work, run into Loehmann's Back Room, and scan the racks. "Oh my God, that's the remnants of a Bill Blass label!" Psh. Right on her back. So I grew up listening to people shop and talk about clothes. It was just normal.

She said a blouse could change your life.

Yes.

She also favored everything printed, patterned, embellished. Taught you to never underestimate the value of a dramatic entrance, which is not your design aesthetic.

It's a strange thing. My mom is very understated, very sporty, loves clean lines. She's really, for the most part, about solid color and neutrals. My grandmother was an explosion of print, color, jewelry—loved all of it. I think my aesthetic is this blend of the two. I love glamour. I love indulgence. But at the same time, I love simplicity and I think that yin and yang is something that started early for me.

And Grandma brought you gifts from Mexico, Morocco, Greece. Did she give you the travel bug?

Oh, my grandparents were constantly traveling, and you waited for them to get off the plane—oh my God, you're coming back from Morocco. What are you going to bring me? We'd always have their little poodle, [Sammy], with us, with his blue bow and blue nail polish. My grandfather thought he was a child. I think my love of travel and of exotic places and finding things when I travel came from my grandparents. Other people's grandparents were going to Boca for the weekend. My grandparents were off to Morocco.

So you opened your first store in your basement, when you were eleven years old. Did it have a name?

Yes, it was called the Iron Butterfly Boutique.

What did you sell and to whom?

Well—I don't know if this word, except in Martha Stewart's vernacular, exists anymore—I was very crafty. I made fabulous candles. I made whipstitched leather bags. I made hammered copper bracelets. I had a girl up the street who knew how to crochet, and we made snoods. Remember snoods? Ugly. So we had all this stuff, and I think my mother thought I was insane, but she's like, okay. So I set the whole thing up in the basement of our house in the suburbs. And I invited all the kids from the neighborhood to come over. And I sold everything in a week.

So you were the first pop-up store.

Oh yeah, it was definitely the first pop-up store. Under the radar.

So you liked being a retailer?

Oh, the rush. The rush. I mean, first off, I think I have been such a shopper my whole life. The rustle of the tissue, the bag, the whole experience, it's just like oooooh, you know? By the time I was twelve, I saved every shopping bag. That Bergdorf bag was just, whoa. So to see it on the other side at that age, you got to see that it worked two ways.

So did you restock and keep it going?

No, it was limited edition. I made enough candles and I was done.

You were the early H&M collection. Okay, let's jump a few years to your Bar Mitzvah.

Oh, God.

Tell us what you wore, the color scheme, and how you designed that party.

Every decade has its good points and its bad points. The 1970s, the good point? Halston. The bad point? Mustard and chocolate as an entire color theme, down to the invitations, the yarmulkes, the matches, the tablecloths. It was a pretty insane moment. My father's family had never been to a Bar Mitzvah. They didn't know what it was. I got Bar Mitzvahed in June. My mom said, "What kind of party do you want?" I said, "I want it to be a summer kind of casual party." I actually wanted a lobster bake, which didn't go over too well. And so my mother's family came in evening gowns. My father's family came in madras shorts. And my parents' friends—it was the height of the hippie era, so we had men in kaftans and women with 'fros. It was pretty outrageous.

And your mom divorced Bill shortly after. It didn't have anything to do with it, right?

I think the party was the signal that this wasn't working.

Did you stay close with his family?

I did. His sister lived in the Village. She was in the advertising business. As I watch *Mad Men*, it was her era. Audrey Hepburn was her idol. She was very attractive and very stylish. And in fact, [she] even did the streak in her hair. I'm still very close to her.

That's nice.

She brought me into what life in Manhattan was going to be. She took me to see Bette Midler when I was eleven. I was blown away.

She was a little Auntie Mame for you.

Yeah, she was a hippie-chick Auntie Mame. So my dad's family, they were the counterbalance to the ladies playing canasta in Atlantic Beach.

Okay. So you always had an entrepreneurial streak. Tell us about the business you set up at sleep-away camp and your French laundry.

Oh, God. Camp, for an only child who's perhaps been a bit indulged, can be shocking. You had to deal with no air conditioning, the food, all of that. We all know that. I hated how my clothes came back from the laundry. And I realized that a lot of other people hated how their clothes came back from the laundry. So we decided that we would have the Madame Paulette of Camp Birchwood. We would hand wash people's clothes for Madame Paulette–like prices. We drip-dried everything. We had no irons, so we took the wood that you had for the bunks, for the shelves, and we sandwiched the clothes, and wrapped everything beautifully. And people appreciate beautiful service. What can I tell you? [APPLAUSE]

You then went on to sell sketches to the UFO Jeans company for two hundred dollars a design. How did you get that gig? And what did you do with your first earnings?

I remember, growing up on Long Island, there were so many people around me who were in the fashion business, people's dads in the business. You know, *Women's Wear Daily* was at the newsstand in Merrick. I had a friend whose father owned UFO Jeans. And she said, "You should talk to my dad." So I did some sketches, and I went to their office and showed the sketches. And he said, "Well, these three are fantastic. Can we buy these sketches?" And I was like, oh my God. This is so easy. So he bought the sketches. I, of course, immediately took the money and put it right on my back. My mother was like, but where's the money? I think it might have gone to the beginnings of a Cartier Tank watch, which, of course, every sixteen-year-old needs. My mother kept asking, "Don't you want to save your money?" And I said, "No, I'd rather have the watch."

What were some of your other early jobs? I read you were night manager at a tennis club in Long Island, and you took over the pro shop at seventeen. What did that entail?

I'm a terrible tennis player—Anna [Wintour], I'll never, never, ever be playing tennis with you—but I always looked great and loved watching tennis. So I got this job at this tennis club in my hometown. I was the night manager. And, of course, we had a lot of women who played tennis regularly, and I was always sitting and sketching. They would say, "What are you working on? Oh, that's cute. Oh, I like that." The guy who ran the pro shop said to me, "We're not selling anything. What's wrong with the clothes?" I said, "They're ugly. You've got great-looking women who are stylish, and they don't want to wear these clothes." So he said, "Well, what do you suggest?" And I said, "Let me buy the women's clothes." Seventeen years old, I went to Head and a few different companies, and I sauced the place up. Of course, I knew all the women, so the next thing you knew, they were all wearing their brand-new clothes, and it was a good experience.

Okay, this was also the disco era. And you were going out every night to Studio 54. Tell us about some of your outfits.

I, to say the least, have a uniform now. But when I was young, I was truly like an insane fashion freak. I wore it all. I went to Studio 54 the first time instead of going to my senior prom. Studio 54 had just opened.

That was your prom.

That was my prom night. I wrapped a girlfriend of mine in hot pink gauze, a strapless pareo, a harem pant, flower behind the ear. I was wearing a piece of raw silk jersey wrapped into a diaper pant, with a panama hat, a burlap jacket. And I took three luggage straps, wrapped them around my waist and my thighs, which were considerably smaller then, and we got to the door at Studio 54.

They let you in?

They were like, these kids are fabulous. They didn't realize that we had to get in the car and drive back to Long Island when we left. As soon as I walked in—it's this strange thing in life when you know you're in this incredibly special moment and space, and you've got to hold on to it. And even though I was seventeen, I knew it was that.

Well, that's for sure. And now you're still kind of connected to the Studio experience with your architect, Scott Bromley.

I am indeed.

You weren't going to school then. Were you working?

Oh no, I was at FIT.

In 1977. You studied design, but not for very long.

First off, of course, I had been sketching since I was really small and—we talked about being a Leo—I had such firm ideas about what I liked. So I'd be fighting with the teachers. They'd be like, no, you have to have a dart in the jacket and the lapel must be cut. And I'm like, I don't like a dart. I think it's old. While I was in school, of course I was going out a lot. And quite honestly I thought Bianca Jagger's birthday party was a pretty great lesson. You got to see how people dressed and what was going on and just the whole excitement of it. And that's when I first started working part time selling clothes on 57th Street.

Who were some of your classmates when you were at school? Anybody now that you're still friends with?

You didn't talk about this with Leos: we're very loyal. My immediate circle of people that I met in school, some of them are here tonight. Our creative director of menswear, I went to college with, Tim DiSalvo. And we've been friends for over thirty years now. My friend Lauren Buccellati. We were this merry band of stylish kids having a great time in New York.

So you don't regret not staying in school longer? Would you recommend that young aspiring designers stay in school and get real training? Because you can't sew, right?

Oh my God, you don't want to see it. Well, I don't think that there's a rule in fashion of how you chart your course. I would never tell anyone, "Oh, drop out and work for me." My grandparents were not happy. I called my mom and said, "I think I want to work. I'm ready to work." In fact, I had a teacher—how strange is this?—who said to me, "You need to get out there in the world and work. You're ready to roll." And I said to her, "Really?" And she said, "Yeah, you're ready."

You had already been a retailer, a buyer, a designer, so you might as well.

Why not?

Okay, so your next big, pivotal job was at Lothar's on West 57th Street, between Fifth and Sixth Avenues.

Tie-dyed jeans. Oh my, for two hundred dollars. That was a lot.

You called it the "Gap for the Guinnesses".

It was. It definitely was.

The customers were Jackie O, Nureyev, Diana Ross, Greta Garbo. What did you do when they walked in?

I mean, think about this. I'm working part time in this store on 57th Street while I'm going to school. And I'm pulling Jackie O's boots off. It was the first time I realized that people who were affluent could be thrifty. I think she had some old hose on underneath. Nureyev would be in the dressing room and leave the curtain open purposely. It was an incredible education. Obviously, celebrity was exciting, but I also got to see, really, how do the affluent dress? How do people really get dressed?

It's good experience. What was your exact job: window dresser, designer, salesperson?

The first job was sales. Of course, timing is everything in life. All of a sudden, whenever you have this singular trend, it can die. And the tie-dyed jeans at two hundred bucks, everyone owned them, and everyone was sick of them. So I left school and initially I thought, okay, I'll work in the store just in sales, and then I'll go to work for another designer. Because that's what I thought you do.

And that's when you interviewed with Donna, when she was at Anne Klein?

John Anthony, who was an incredible designer in the 1970s, was a family friend. He made all of these remarkable evening clothes. He said to me, "You're a sportswear designer. You need to go to work for a sportswear house. I'm going to call Donna Karan and Louis Dell'Olio over at Anne Klein." So I feverishly put together a book. My theme was a little crazy. It was the 1970s. It was called "Christopher Street Women." Oh, too crazy. Everything was leather for a summer collection. I went in to see Donna and Louis and showed them the book. Donna asked me, "Where did you go to school?" I said, "Well, I went to FIT, but I dropped out, and I'm selling clothes on 57th Street." She said, "You're really talented. Do you want to go back to school?" And I said, "No, I want to work. I'm ready." She asked, "You're ready so quickly?" And I said, "Yeah, I'm ready to roll." She asked me if I was sure I didn't

want to go to school. And I looked at her and said, "You dropped out." And she was like, okay, touché. And I think at the time she asked, "Would you like to work here in licensing?" I said, "No, I want to work on the collection." So it wasn't meant to be.

It wasn't meant to be. So you were still at Lothar's, and at that time Vera Wang was an editor at *Vogue*. She came in and covered the lines there, and you became friends. Did she discover you at Lothar's? Or was it Dawn Mello, the fashion director of Bergdorf Goodman, who saw you in the window in 1981? What were you doing in the window that stopped her?

Well, we went from these tie-dyed jeans and very casual sportswear pieces to suddenly doing a full soup-to-nuts collection. Not only was I designing it, I was selling it. I was dressing the mannequins, and I was actually in the window with T-bar pins in my mouth, [when] she walked in and said, "Excuse me, these clothes look different than the tie-dyed Lothar's clothes. What are these clothes and who designs them?" And I said, "I do." And she said, "But you're the window guy." I said, "Well, I'm kind of the chief cook and bottle washer here." And she said to me, "If you ever start your own business, call me. I think what you do is really great." And of course, I rushed home and said, "Okay, maybe I should start my own business." Vera was working at *Vogue*, and she had such great style and such energy, and she started trying on clothes. She was putting all this stuff together, and I was like, oh my God, this is so exciting. And then she bought all these clothes and said to me, "Do you want to go with me to the Met for the Costume Institute? And I was like, what? I think I was twenty.

Well, that was a nice perk.

Vera wore a Michael Kors for Lothar's charmeuse slip with a leather down vest, a mohair sweater tied around her waist. I think we were definitely doing creative black tie. And in we went. It was the year of the Saint Laurent exhibit, and I got to meet him. I almost levitated. The party used to be in December; it started snowing while we were in the Temple of Dendur. Suddenly the room got very quiet. We found out that John Lennon was killed.

The night that John Lennon was killed. I remember that. John Duka told me that night at the party.

It was, you know, just a roller coaster of Saint Laurent and then John Lennon. Vera was a champion and certainly a great muse and looked wonderful in the clothes.

But it was Dawn Mello that you finally had the meeting with, which set you on a new career to design your collection.

Definitely.

We acknowledged Dawn when she was here with Tom Ford, because she also hired him for his first job at Gucci. So, two in a row.

I think she, to say the least, has a very good eye.

Absolutely. Okay, so you went to this meeting at Bergdorf Goodman with Dawn. And you needed to have a collection to show her. So, what did you do?

I had no idea that you had to open on a certain date and I didn't know the style number. It was just one, two. And only two sizes, everything came either P or S, pretty limited. I put together this collection, and we made the samples in my apartment on 23rd Street in Chelsea.

So "we" was who?

I and the women who had worked with me at Lothar's. I borrowed some money from my family, just to buy fabric. I decided it would be cheaper to rent sewing machines than to buy

them. So I rolled the rental sewing machines myself up Eighth Avenue, across 23rd Street, took them into my building, and one of my neighbors said to me, "I keep hearing sewing. What is that?" And I said to her, "I'm making curtains." And what's interesting, when I first spoke to Dawn Mello and everyone at Bergdorf's, I didn't even really know what a trunk show was. But I knew that I kept reading that people like Bill Blass and Oscar de la Renta did trunk shows. So I asked, "Can I have a trunk show?" And she said, "Sure." She was thrilled. And the reality is, I knew a lot of New York women from being at Lothar's, so I called all of them and said, "I'm not at Lothar's anymore, but we're over at Bergdorf's." All of my clients came, and at twenty-one years of age, I sold most of what we had there that day. And everyone at Bergdorf's was blown away.

So now you had to produce it.

Yeah, now I had to make the clothes. And I have to say, when I think about when I started versus today, there wasn't that glare of the spotlight in the same way then, so you could learn your craft and slowly grow. I waited three years to have a fashion show. It was all about making the clothes not only fit beautifully, but the quality had to be great, and you had to ship them on time. I had a pragmatic side to me.

So, you did have a show. Did you use those beautiful models from your very first show?

I did. I have to say, I was very lucky, when I think about it now. Even before I had a show, we had Iman doing our *Women's Wear Daily* photo shoot. And I've always thought, and I still think, the best thing that I do is frame a person. It's the woman or the man who brings it to life. So when you take a woman like Iman, it's like, whoa. From day one, we had great girls. I remember the first show that I did. It was in a gallery downtown. I didn't like the art that was on the wall, so I tried to tell the gallery owner that they had to take down the art. And they said, "No, we're an art gallery." And I asked, "Can I have white walls?" And I think they had green walls. So we took all the art down, and we painted the whole place white, not realizing that people were going to be asphyxiated sitting at the show. And my *Women's Wear Daily* review said something like, "… in a gallery reeking of fresh paint."

In 1990, you hired a very young designer fresh out of Parsons, Derek Lam. How long did he work for you, the first time, and the second time, and the third time?

Well, that's a very Michael Kors thing. Actually, Derek's not the only person who's worked for me numerous times. Derek worked for me on the collection. He first came as an intern. And then we hired him in collection design. I think he was with me, probably, through '95, so about five years the first go-round. Then he was working in Hong Kong. Then I started doing a second line called KORS. I called Derek and said, "If you're ever sick of living in Hong Kong and want to come back to New York, come on back." So he came back, worked on KORS, and then he left again, and then he ended up freelancing for us. So, three times.

That same year you also hired another intern named Lance LePere. That was a good hire. What did he show you that made you hire him?

Well. [LAUGHTER] He's my husband.

We're going to get to that.

So, anyway, what did he show me? Fern, what a loaded question. Oh my God. I'm going to get sued. You know what? I saw incredible talent, incredible eye for detail, imagination, taste, kindness, and at a very young age, a very sophisticated eye, which I think is the coolest thing in the world. As you get older, you want to keep your curiosity, keep a young

eye, but when you're young, can you have a sophisticated eye? And Lance was all of that.

Then in April 1991, you had a runway show in an empty raw space in the building where your showroom was, on West 24th Street. Tell us what happened when the loud music went on, because that particular show changed my life.

Well, we used to do shows in New York in random, assorted lofts and spaces. And we were in this raw space downtown, which I thought was kind of edgy, and the music started. It was very hot that day, with pounding, pounding, pounding music. Naomi Campbell was out there, strutting her stuff, and all of a sudden, I heard an explosion. It sounded like gunfire. I was like, what on earth is that? Naomi came off the runway and said to me, "The ceiling just caved in." I said, "What?" She said, "The plaster just came down and hit a few people." We hit Suzy Menkes from the *International Herald Tribune* and Carrie Donovan, who was working at the *New York Times* at the time. Two remarkable ladies of the fashion press. I walked out. We turned the music off. I said, "Is everyone well? Are you all okay?" We swept it up. I said, "If anyone wants to leave, I totally understand. We're actually going to do the rest of the show with no music." And we finished off the show. And I think we all realized that it was time for New York to get professional show spaces. Voilà… Fern! [APPLAUSE]

That was a memorable year. You then launched a menswear collection in 1992 at Grand Central Terminal. Was that about making clothes for yourself?

Well, considering that, I probably did. I think one of the worst things I've ever done in my design career [was making] bodysuits for men. I thought—now every guy in the room can relate to this—when you tuck your dress shirt into your underwear, you want to look all smooth and polished. So I thought, why not take your front briefs, attach it to your shirt, okay? It'll stay tucked in. I thought it was very smart. Of course, snaps and the male anatomy are not a good thing. I had these ideas that I thought were really clever ideas, I learned, though, that as a men's designer, it can't be just about me. You know, I might love a camel-hair coat, but not every guy loves a camel-hair coat. And, of course, if I wouldn't have made those bodysuits, I wouldn't have learned anything. There's this rule I have when we design men's clothes: I wouldn't and I couldn't wear it all, but I have to want to wear it all. That's really how I always gauge it.

Not long after that, there was a recession in New York and you declared Chapter 11 bankruptcy in 1993. Can you talk about that? When Tommy [Hilfiger] was here, he said that was one of the most pivotal moments in his career. What did you learn from that?

Everything was gangbusters in the early 1990s. We were expanding, doing all these new things. And then the next thing I know, the company whom we licensed KORS to went bankrupt. I never stopped showing. We never stopped shipping. I realized at that point, more than ever, what people appreciated was my being true to myself and doing what I do well. At first, you feel like you're on ground that's moving. I thought, oh, maybe I have to change my direction. Maybe I have to make more incredible evening clothes. Then I realized no.

Stay true.

Stay true to yourself.

Good for you. After that, you went on to Onward Kashiyama to design the ICB line. They helped you also launch KORS Michael Kors in '96. You added the Pologeorgis fur license. You were named one of the most influential designers of the decade in *Vogue's* "Fashion's New Establishment" issue. And in 1997 you were named the

Page 131: Michael Kors debuts his first collection at Bergdorf Goodman, 1981. This page, Michael Kors Spring/Summer 2015 runway, New York City

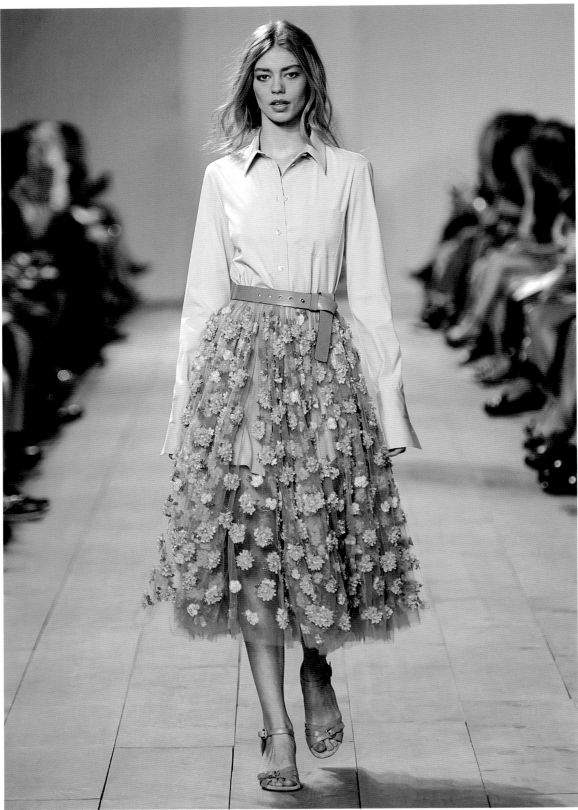

designer for Céline, an LVMH company. How did that feel? Your debut show was in March 1998. It was a heady time for Americans in Paris.

Well, let's be honest. I always wanted to do what I do and be a designer. But the last thing you ever thought growing up in Merrick, Long Island, was that you were not only going to have a fashion show in New York, but that you were going to have a second fashion show in Paris. And you were going to be showing in the Louvre. And you were going to be showing to a bunch of very grand women all dressed and polished. And here I was in jeans and sneakers and very casual. It was an interesting time because Marc [Jacobs] got to Louis Vuitton at the same time Narciso [Rodriguez] got to Loewe. I think a lot of people in Paris thought, oh, it's the invasion of the Americans. But what I realized as soon as I got there was that the world was changing.

Right.

And, in fact, the world was global. And it didn't matter where you lived, life was fast. Sportswear and clothes that you could actually live in and function in made sense. So it was certainly a culture shock. Prior to that, my idea of a foreign account was what's selling in London? Or what's working in Toronto? Suddenly, I had to think about Singapore and Tokyo and what's happening around the world.

Okay, so it was difficult navigating several shows, designs, companies, and collections, in completely different parts of the universe, in New York and Paris.

Insane.

You were popping melatonins like Tic Tacs, I read.

I was. The Concorde made it doable. But still, I mean, fried. Off the plane right to a meeting. Always pretty crazy.

After two years, you were promoted from designer at Céline to creative director, and LVMH bought a thirty-three percent stake in the Michael Kors business. Did that affect and change your business?

Certainly a company like LVMH, where you have a company that's such a global [behemoth], suddenly I think people said, wait a minute, you know what? Michael Kors is not just an American designer, Michael Kors is a global designer. For the first time, I got to see the power of accessories, and how you might be having a bad day, you know, your hair doesn't look great or you had too much to drink last night—well, a handbag works no matter what. That's the reality. And I really got to see that. I think if I would've stayed in New York, I wouldn't have seen that.

Right. That year, in '99, you won CFDA's Womenswear Designer of the Year award. You also were making the clothing for Rene Russo for the remake of _The Thomas Crown Affair_. What was that like?

Well, I am a believer in the right thing at the right time. Rene was someone I had known for a long time. And she's such a great beauty, and really stylish. When I was growing up, my favorite movie was _The Thomas Crown Affair_. Who didn't want to be Steve McQueen? I mean, I was seven. And Faye Dunaway, oh my God, the hat, the plaid, the skirt, the whole thing. Rene called me and said, "Michael, you're not going to believe this, but I'm starring in the remake of _The Thomas Crown Affair_. I had a feeling you liked the [original] movie. My character is successful, sexy, adult, glamorous, powerful. She's got to wear Michael Kors." It was a wonderful thing to see how the clothes affected the character. We watch it once

every year or so just to see. And I think you look at it now, it's been more than twelve years?

It holds up.

Holds up, for sure.

Okay, back to the dual life at LVMH. You were there six years, but you have said in an interview that you spent approximately three hours total with Bernard Arnault, including the two shows that he attended. Did you feel neglected? You never even had a meal with him?

I now know for myself, when you're doing a zillion things, you have to be a consummate juggler. And at the time, I think Céline was one of the smaller of his brands. I think he was very happy with the growth that was happening from the brand. So I think it was like, the kid who does well in school, well, he's doing well in school, we don't need to spend that much time with him. I certainly was aware that we were not doing a couture show; it was a sportswear house. We weren't Dior. Honestly, I was so busy, I didn't have time to think about it.

Okay, good. Has Mr. Arnault congratulated you on your success?

For my thirtieth anniversary, we had a fabulous party in Paris. Yves Carcelle, who has been at LVMH for so long, came to our dinner and said to me, "Michael, I feel like a proud papa, I'm so happy for you."

That's great. I have to tell you, going to the shows at the Louvre when I was at CFDA to talk about show dates, I had a meeting with Didier Grumbach when you were at Céline. He actually could not have been more dismissive of what all the Americans were doing there. He said there's no design. They're just making clothes. And I said, "But the Céline store is empty in Paris. The stuff is selling out so fast, they can't keep it in stock. So whatever he's making, it's apparently what people want to buy and wear." He just didn't want to hear it.

Changing world.

One of my favorite collections you did was called "Palm Bitch."

I started spending time in Palm Beach in the 1990s. And started seeing this shift at the time—the granddaughters were changing the whole attitude of Palm Beach. There was this riffing on all the traditions of Palm Beach, but with a wink. And I thought, this modern age is all about a girl who totally appreciates the tradition and all of that, but she wants to be sexy, she wants to have fun, she wants to be a "Palm Bitch." We opened the show with an orchestral version of Abba, "Money, Money, Money," which I thought was kind of perfect. And we sent the models out in very sporty clothes but dripping in jewels, with towels wrapped on their heads. And it was fun, glamorous, sporty. It was a very Michael Kors moment.

Michael Kors shows always have the best music, without question, and always the most beautiful and happy models. Running Fashion Week for twenty years, people always asked me, what's the hottest show to get into? It was Michael Kors.

Well, thank you.

In 2000, you hired Lazaro Hernandez, now of Proenza Schouler, as an intern. Thanks to Anna Wintour.

Yes, indeed. Designers say it all the time, but it's true. Unless you want to make one dress and spend eleven years doing it, like Charles James, if you really want to do such great work, you need an amazing team. So to see all the new talent that comes up, I mean, that's what keeps fashion fresh and alive.

Peter Som also worked for you.

Peter Som was an intern for me. I think we've been a good training ground.

You opened your first store on Madison Avenue. You also launched your first fragrance, named Michael, appropriately, with Estée Lauder. What was doing a fragrance like? Did you have smells in your head that you wanted to get out there?

I did. Once again, very opinionated. I was a teenager who doused himself. I wore Halston Z-14. I was a boy wearing Opium, which is unfortunate.

Better than smoking it.

I mean, hey. All I wanted to do was go to that Opium launch party on the junk.

That was a good party.

I have a very good memory of scent. It's great working on fragrances. Clothes are different. It's how does it work on your body. It's not as much about this transporting thing. I kept saying, "I want it to be enveloping but light." And they kept saying, "That's a contradiction." I said, "That's the whole idea." And we ended up winning Fragrance of the Year on our launch year, at the FiFi Awards.

In 2003, Sportswear Holdings, the company owned by Silas Chou and Lawrence Stroll, spent about a hundred million dollars to purchase an eighty-five percent stake in your business. They bought all the LVMH shares, Onward Kashiyama shares, and your partner John Orchulli's shares. So who was your boss then?

Everything you do in fashion is partnership. Fashion is not a part-time job. You need a team. This is not a nine-to-five job. So I've never felt that anyone is my boss.

John Idol came in at that time.

John Idol became one of our partners and CEO. It's like a great tennis game; you've got to have the volley back and forth, and you've got to have the support. You've got to have the direction, the ideas, and you have to be able to execute it, so you need the right team.

You have a very strong relationship with celebrities everywhere who love and wear your clothes to everything. Any special thing you want to tell us about celebrities you love dressing? Or any great stories?

I have seen women through the years, at vulnerable moments, go for Michael Kors. Jennifer Lopez, literally two days after she broke up with Ben Affleck, hits the red carpet: Michael Kors. Jennifer Garner has her first child, she's presenting at the Academy Awards ten days later: Michael Kors. And I think there's that confidence boost. You know, Debra Messing told me that the first time she got nominated for *Will & Grace*, she wore a dress of ours. She said, "I loved how I looked." Confidence, that's what it's about.

Okay. Let's try to go fast because we're only at 2004. You and your team made a strategic decision that year. Instead of spending millions of dollars on advertising your new MICHAEL Michael Kors collection, you became a judge on a new breed of a reality TV show called *Project Runway*. That apparently worked. Tell us how this changed your life and the impact it has had on your business.

When I first was approached, I knew Heidi [Klum] and one of the producers, Desiree Gruber. They called and pitched, and I was like, ugh, reality television. I kept thinking *Survivor*—they're going to have a bunch of designers eating fabric. Fashion has traditionally been really hard to get right on film and on television. They asked me, "Are you aware of a show called *Project Greenlight*?" I said that yes, I love that show. They said, "That show's all

about the process of getting a movie made; this is going to be about the designer's process." I said, "Okay, we'll try it for a year." I initially thought the only people who would watch it would be fashion-obsessed women, gay men, and men who were obsessed with Heidi Klum. The next thing I knew, I had investment bankers say, "Oh, I watched last week's episode with my wife and kids." And I'm like, what? Then I realized it was the first time that people got to see not only the hard work that goes into fashion, but also that fashion is full of interesting people. And because it's fashion, there's always something new. I used to pride myself, Fern—I was like, I've got customers of all ages, women in their twenties, thirties, forties, and on up. Well, suddenly, with *Project Runway*, I have twelve-year-old customers, which is mind-boggling. We make the Bat Mitzvah shoe. It's called the Berkley T-Strap, zips up the front, and it's like the training wheels of high heels. And in a million years, we never thought that we would be seeing Michael Kors customers who were twelve and thirteen.

So you have three generations shopping your stores now.

We're at four, I think, in some instances. Yeah.

You opened a complete lifestyle boutique in SoHo. You lived downtown for some thirty-plus years. What is it about downtown? What do you love about it?

I am such a city boy. But, let's be honest, I grew up in the suburbs, so I grew up with the best of both worlds. And I feel like, when I leave midtown, and I get down to the Village, scale changes. It slows up, it's great people watching. I love living near NYU. It's like I could sit and pull up a chair and watch kids arriving at school—they're fabulous. They remind me of myself. And I think it's kind of an exhale for me.

The beginning of 2009, Michelle Obama wore a Michael Kors black sleeveless sheath for her official White House portrait. That puts you in the history books. Did you know this was happening?

I had no idea. Other than fashion, one of the things that I love most is theater. We were in London at the theater, and had turned off our phones and Blackberries. We went out at intermission, and I had about eleven hundred emails. It was Michelle Obama wearing black stretch matte jersey in her official portrait. I had no idea what she was planning on wearing it for. When I was growing up, after Jackie Kennedy, the reality is the First Lady was always in a little suit, all buttoned up. This was unbelievably fabulous. We have a First Lady now who's wearing a jersey dress with an athletic armhole. Wow, the rules have changed.

The year 2011 also became a very big one for you, which we're getting up to now. You and Lance got married in Southampton. Describe what that was like. What did you both wear? And what did your mother wear?

Well, here's what's interesting about it. Even though I've known most of my life that I'm gay, it's certainly amazing to be able to share your life with someone as amazing as Lance. But I never had a fantasy of a wedding. I never thought that it was actually going to be a reality. It just seemed, I don't know, pie in the sky. So there was no fantasy of wearing matching suits and doves flying. We looked at each other and asked, "What do we love?" We love the beach. We love being barefoot. We love a sunny day. And we love privacy. So off we went, I in black T-shirt, white shorts, and barefoot, mayor of Southampton, and Lance in his blue chambray shirt and chinos, and we had a double wedding with my friend Tim and his husband, John. The sun came out. It was glorious. My mother and every woman I knew were infuriated. Because I said "no, we're not having a wedding." My mom got married

a third time. The first time, eloped; second time, huge wedding; third time at City Hall in Los Angeles. I wasn't there for wedding three. So she said to me, "I get it, you want to keep it low-key." And we're probably the only people who got married on the beach, jumped in the Jeep, went to Easthampton, had pizza at Sam's, and saw *The Help*. [APPLAUSE]

A memorable wedding day. But the year ended on a very high note. On December 15, you rang the bell on the New York Stock Exchange. And your stock, under the ticker Kors, began trading. You broke U.S. records by launching the country's biggest ever public offering in fashion—very impressive—valuing your label at three and a half billion dollars. Bankers taking orders had to stop selling the stock, which was over-subscribed by up to ten times. Describe that day.

It beat my Bar Mitzvah! My mom came from L.A. and, while I was just about to ring the bell, I looked down and saw my mother and she's like, straighten your tie.

Always a mother.

Moms are moms. I'm incredibly fortunate to love what I do. I knew early on that I love this. And each step of the way, all these astounding things have happened, because I'm empathetic, I care about people, I love what I do. I certainly never planned on Paris. I certainly never planned on ringing that bell. You just keep your eye on the ball, and you do what you do, and you do it well. [APPLAUSE]

And in March of this year, with the secondary offering of shares, you were put on the *Forbes* Billionaires watch list. What has changed in your life with that? Did you buy art, a new car, a plane, a house, gifts for people?

I have to say, Lance and I live a very low-key life. I will always. It wouldn't matter if I had ten zillion dollars in the bank or ten dollars in the bank, I care about people, I care about nature. Sure, comfort's fabulous. It's not like the next day I ran out and said okay, solid gold Cadillac. That's really not how I operate, that's not how I think. And quite frankly, we're so busy every day that it's about doing what we do and doing it well. We're very happy to go home and have a club sandwich and sit with our cats and watch *Mad Men*. That works for us.

Are you setting up a charitable foundation?

Yes. We have the Kors LePere Trust Foundation. New York's been pretty fabulous to me, and we're very happy to be able to give back to New York.

Great. So now you have two hundred and thirty-one stores, including concessions, open globally in seventy-four countries. You're sold in five hundred and forty-nine stores around the world. Your collections are sold in eighteen hundred department and specialty

Left to right: Michelle Obama wearing Michael Kors in her official portrait, 2009; Heidi Klum, Michael Kors, Jennifer Hudson, and Nina Garcia on the *Project Runway* season 10 finale, October 18, 2012

stores in the U.S. You are the leader to just under three thousand employees. How do you stay healthy? You love being by the water. Water Island, St. Bart's, Parrot Key in the Turks, where I had a wonderful dinner with you, Round Hill in Jamaica. Tell us the story of staying in the ocean for an hour because you saw Ralph on the beach.

Well, I was down in Round Hill. I think it was Thanksgiving. And the weather was horrific. It rained every day. And I was like, God, I want the sun, I want the sun, I want the sun. And I think probably the last day that I was there, the sun came out and I think I was oiled up and on the beach by seven a.m. I was having my sun bake, and I go into the water. I'm in the water, and I'm swimming, and I hear, "Michael! Michael!" And I look up and I see Ralph and Ricky Lauren, looking spectacular and bronzed, in little black bathing suits. I'm in my board shorts to the knee, pale, probably red, and I literally stayed in the water and waved back, like saying, "Hey! Hey!" I stayed in for an hour. I pruned.

What's downtime like for you? Is there any?

I couldn't be a nine-to-five kind of guy. So either I'm really burning all cylinders, or I've learned that you have to be like an athlete. You have to know about endurance. So you have to say okay, now it's time for me to click it off, stop. So being somewhere near nature, it can be Water Island, it can be down in the Turks, it can be Bali, it can be Africa, Capri. Give me water and nature—it regenerates me. And then our downtime in New York? Truly, nothing. The DVR stacks up, all of your shows that you love, you haven't had time to watch. And I am very happy—Lance and I are very thrilled—to be able to sit there on a night off and just say, we're chilling out, and we're catching up—*Magic City*, love—catching up on all the shows, and seeing friends. Cooking? New York, never, ever, ever. At the beach.

At the beach, yes.

Well, a lobster, tomato, and mozzarella. Does that count? But I do love being barefoot and casual and entertaining at the beach—that's fun.

What advice would you give a new young designer? And would you ever invest in a new emerging designer?

I think the most important thing is to spend time in a store to see how people shop, to understand the whole mechanism of why people shop and what they buy. And also to really

think, what can you add to the fashion picture? You have to be able to add something. You know, the pie is the pie, and you have to figure out what can you do differently. And hopefully you have an idea that has longevity, because, you know, it's easy to be a flash in the pan. Invest in another designer? No plans on it right now. But, you know, you never say never.

What are some younger designers out there now you're impressed with? I know from being at the CFDA with you and admissions meetings, you were the one designer at the table who always knew exactly what every new young designer was doing. You had your ear to the ground. You totally understood that from your friendships with all the editors and just seeing what's happening.

Listen, I think the most important thing, when you look at designers, whatever point they're at in business, is do they know their customer? Who are they designing for? I look at Proenza Schouler and what Jack and Lazaro do, and they know their girl. Alexander Wang, he knows who he's designing for. You need the talent, but you also have to have that handle. So I look at both of them and I think it's interesting to see them grow and mature.

I also heard your name bandied about as possibly the next president of the CFDA. Would that ever happen?

I have so much spare time. You know, listen, between television and everything else I do right now, my juggling is—

What would you say is your legacy? What's tonight's takeaway?

I truly believe that my legacy will be that you can have it all. I think you can be glamorous, I think you can be sexy. But at the same time, you can be comfortable, you can feel good in your own skin. I think that I balance the indulgent in people's wardrobes with the pragmatic. I think that will always be what I'm about, that balance. Hopefully, whatever I do, when people put it on, they feel great. I mean, that's what it's all about.

How many people in the audience own something of Michael Kors's? Wow, that's a lot of hands in the air!

Oh my God, it's my crowd.

That is beautiful, Michael, thank you. This was extraordinary.

Thank you. [APPLAUSE]

DIANE VON FURSTENBERG

What can I say about Diane von Furstenberg? DVF. She's one of two designers in the world known by her three initials. She's a princess. More importantly, she's a mother, a grandmother, a wife, a president, a CEO, a designer, a philanthropist, a mentor, an activist, a leader, a friend, and an inspiration and role model to women everywhere. And she speaks all the good languages we all wish we spoke. As president of the CFDA, an organization that's near and dear to my heart, she is the voice and heartbeat and the Jewish mother of the American fashion industry. Her life story is pretty well known, but tonight we will go over it from the beginning as I always do. We'll learn how she created a multi-million-dollar business and hear about how much fun she's had getting there. Ladies and gentlemen, Diane von Furstenberg.

FERN MALLIS: If you could believe, this is my first DVF wrap dress. [APPLAUSE] It's never too late to start.

DIANE VON FURSTENBERG: Never too late.

Diane, do you like being called Diane or Dee-ahn?

You know, my real name is [pronounced] Dee-ahn but I do answer to Di-ann, and I call myself Di-ann very often too. So it's whatever you want.

You were born Diane Simone Michelle Halfin on December 31, 1946, in Brussels, and you are a Capricorn.

No, I'm not sixty-six, I'm sixty-five. I have three more months.

We're very sensitive about that here. What's it like to always have fireworks go off for your birthday?

Well, you know, I have not had any other. What I like about my birthday is that when the year is over, it's over. So what I do, and what I've always done, wherever I am, whether I am skiing or wherever, I take a little time and I go for a walk or I isolate myself. Then I take a piece of paper and I make three columns, and I write the things that I would like to achieve. Usually it's family, work, and me. And then I fold it and I put it in my diary. And usually when I get to about June I look it up—

You look back at it?

I look back at it, and I actually have done most of it.

That's a very good New Year's thing to do.

The hardest thing to do is actually identify what you want.

Well, we're going to talk about you identifying lots of things you wanted to get done. As a Capricorn, its cardinal [element] earth gives you a potent combination of patience, practicality, and ambition.

That sounds [accurate].

I've read that you're persistent, confident, strong willed, self-sufficient, loyal to your family and inner circle of friends. Capricorns are practical, prudent, ambitious, humorous, reserved. And on the dark side, pessimistic, fatalistic, miserly, and grudging.

I'm not pessimistic, not miserly, but I am everything else.

Your [father was] Leon Halfin. Was he Russian or Romanian?

Well, the place where he was born, which is now called [Moldova], then was called Bessarabia. [It] was Russian and then Romanian, then Russian and then Romanian. So it kept on changing as they invaded the borders.

And he was an electronics distributer. And your mother, Lili Nahmias, was born in Greece. How did they both wind up living in Belgium?

Well, my mother went to Belgium when she was quite young, actually. She was maybe five, six years old, and the family moved to Belgium to live. My father came to Belgium when he was about eighteen to go to school. And he never actually went back.

Your mother was a Holocaust survivor. She came out of the camps at twenty-one years old, in 1945, and weighed forty-nine pounds. Did she talk about this horrendous experience to you as a child?

I always heard about the camps, but she protected me. She, like many people after the war, protected their children from what they had lived through. I kind of knew it, but it wasn't really something that we addressed. And then later, when she'd talk about it, at least to me, she would only talk about the good things: the camaraderie, how she knew that she would survive, and this and that. And what she did teach me is that fear was not an option, and that no matter what you do, you should never be a victim. Much later, I really got interested in it. And now I am absolutely, totally interested in it. And I have found out incredible things.

I did read that she said that you never really know what's good for you, and sometimes what looks the worst can turn into the best.

As a matter of fact, when I am in line at an airport, and it's a long line and I'm exhausted and I'm just about to get really mean, I think of my mother and I immediately calm down. [My mother] was arrested in Belgium and then they were all put on cattle trains, and the trains were sealed. And so it took about three or four days, I assume, to go to Poland. It was pretty bad. I mean, you can imagine, people being sick, going to the bathroom, and all of that. And she had always been such a protected child. She couldn't believe what she was going through. She became friends with an older woman, [who was] maybe thirty-five or forty and spoke a little German, so my mother thought, I am never going to leave that woman, no matter what happens. And so they arrive, and it's the whole kind of thing: take their clothes, wash, shave their hair. There's the big line, and then there's a man, a soldier, who says you go right, you go left, you go right, you go left. Behind the soldier is a little elevated podium. And there is a man in white, of a higher rank. He doesn't move, he just watches. The woman who was with my mother, it was her turn, and the soldier said, "Go right." So my mother does not wait to know what is being told to her, and she follows and she goes right. And the soldier lets her go. The other man, in white, in the back, gets up, goes to her, takes her by the arm, and whips her and throws her on the other side. And my mother looks at him with such hate and says, "Why? Why do you care?" She had never hated anybody so much. Well, the truth is that this man saved her life. Because the other line was going to the gas chamber. So the lesson to take is that sometimes you think that something is the absolute worst thing that could ever happen to you, and maybe it isn't.

It's a very good lesson. Your mom got married only two years later, at twenty-three. It's the same age you got married.

No, I got married at twenty-two. My mother got married when she came back. She was very skinny and was in very bad shape. My father was in Switzerland. Her mother was there.

She fed her, a little bit every ten minutes. By the time my father arrived, she had gained her weight back, although she was always skinny. They married a few months later.

And against all odds and medical prognoses, she got pregnant. So you were a miracle birth. Did that set up all sorts of expectations for you?

Well, my birth was a miracle, so I had already won the day I was born.

I also read that she bought something quite fabulous when she got a reparation check from the German government.

She bought a sable coat because she had been so cold.

A clear indication of your life to come. You have a brother, Philippe, six years younger. Are you close? Where does he live and what does he do?

My brother—my baby brother I call him, and then people look at him and he has white hair—my baby brother lives in Belgium, has two very smart girls, and his wife has the DVF shops in Belgium. We're very close.

I read that you didn't particularly enjoy being a child, always wanted to be grownup, and didn't play with dolls or toys. When Tom Ford was here, he said, when he was a kid, he always wanted to be fifty. Was there an age you looked forward to?

I always wanted to be a grownup, too. I was a happy child, but I didn't like the condition of a child. I still feel sorry for children. They're being told what to do. So I have the absolute opposite of the Peter Pan syndrome.

What type of house or apartment did you live in?

We lived near the Bois, near the forest in a beautiful apartment. I walked to the tram, and then I took it to school.

What language did you speak at home?

French.

And what became of your father's business?

My brother still has it.

So this is a family business.

It was, and it turned out to be semiconductors, so in a sort of way my father was a pioneer.

Your parents sent you traveling a great deal and to several boarding schools, Switzerland at thirteen. I read there was an ulterior motive for your mother sending you to Switzerland.

Where did you read that?

I read a lot of things, that you had a boyfriend in Switzerland.

I think that you're reading the book I'm writing. I went to boarding school, indeed. And I

Left to right: Diane and her parents, Leon and Lily Halfin, 1948; Diane and her mother

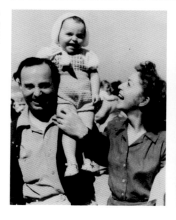

Clockwise from top left: Diane and husband Prince Egon von Furstenberg, Ischia, Italy, 1972; Diane with her children, Alex and Tatiana; Diane at age twenty in Geneva. Page 153: Diane and her first favorite dress, the wrap dress, photographed by her friend Roger Prigent (deceased)

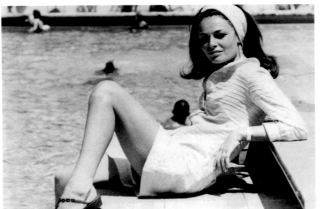

loved boarding school, actually. And I now have thirteen- and twelve-year-old grand-daughters, and they both are desperate to go to boarding school. So of course I push them, I say, "You're right." They both want to start their own life.

Switzerland at thirteen, England at fifteen. And then I read that Keats became an inspiration and focus in your life, at that early age.

"A thing of beauty is a joy for ever." That's John Keats. It's a great poem. In England I learned many things. First of all, I really discovered the beauty of nature, because my school was out in the wilderness. I loved nature. I loved nature in England. It's just so beautiful. I discovered love. I had my first boyfriend. And what else did I discover? Books.

I read that you have written hundreds of love letters and saved the ones that you got.

Yes, I wish I had the ones I wrote. But actually—

Nobody's put those up on eBay yet?

No, no, it's not true. About two years ago, a boyfriend that I had in Italy, he died, and his wife found this big box. She wrote to me to tell me that he had died, and she found this box. Was I interested in getting it? I said, "Of course!" And I got this huge box. I mean, I hadn't been with him so long, but I must have written every single day. So I have them. They're in Italian, and I started to read them, but they get a little repetitive.

Do you still write letters?

Well, now I write emails, but I love words. I love the use of words. I think it's very, very important to watch words. I can never understand when people say, "I'd die for this." I think, you can't say that. I do think that words are very, very powerful. And that's also a little bit why I like to Tweet. It's fun. You can have an inspiration in the morning, and you just put it there—

Send it out to the world.

—and it goes into the universe. I kind of like that.

Then you went to the University of Madrid, during the anti-Franco times. Did that impact your consciousness?

Well, I went to Spain, and it was very dark in Madrid, and Franco was there. But it was just at the beginning. There were lots of riots, so the university was closed a lot. So I learned Spanish going to the movies.

And then you went with your family, your parents, on a skiing trip to Gstaad, where you were first introduced to what was known as the jet set. How did that influence you? And how would you describe what that jet set was?

I didn't know that world. I went to a party with a friend of mine, and everybody seemed to know each other, and everybody was so beautiful. It was a revelation. I didn't know how everybody knew each other. Now I know.

Now you know. And a year later, you met someone special at Griffin's Club in Geneva. Tell us about that.

That was Egon. He was an Austro-Italian prince. He was very cute. I was eighteen, and he was eighteen. And he became the father of my children, and my husband. His mother is an Agnelli.

I read that you were charmed by him because he was helpless when he couldn't get his car out of the snow in the Alps at the family's chalet.

What attracts me in men, usually, is shyness and helplessness. I don't like a confident, joking lawyer. That's not my type.

Your first job was as an assistant to a photographer's agent in Paris, Albert Koski. You got your first taste of the fashion world with imagery, models, magazines, photo shoots. Tell us about that job.

Well, I mean, my job was to answer the phone, and usually to say that he wasn't there. And it was either two girls whom he had slept with the night before or photographers whom he owed money to. He represented wonderful, very talented photographers like Bob Richardson and Harri Peccinotti, Art Kane, Jean Louis Schleff. I mean really, really good photographers. And it was indeed my first connection with the fashion world, the world of photographers. David Bailey—he represented him. And at the time David Bailey was married to Catherine Deneuve, so that was super glamorous. And then it was 1968. And in May, there was a revolution in Paris.

Is he still alive? Are you friends?

He is still alive, and he is a very, very, very good friend of mine. And he has been, for the last thirty years, living with a very good friend of mine, so I see them a lot.

At that time you were partying at Régine's, New Jimmy's, and that was while the Sorbonne and the streets were occupied. Marisa Berenson became one of your best friends.

She did.

And her grandmother, Elsa Schiaparelli—her home, I read, influenced your tastes a great deal. What was that like?

She lived in a little hôtel particulier, rue de Berri, and it was a little extravagant, but in a very kind of negligee way. I never met her. She was upstairs always, and Marisa lived downstairs. I mean, I knew that she had this very famous grandmother who was a tyrant.

Then came a time in Capri, where you met Valentino and George Hamilton and the Italian playboys. What was that like, those times?

You know, it was Capri, and I was a young woman. I was Marisa's escort because she was modeling for some fashion event. Valentino and George Hamilton were there. He was very, very tan, already at that time. And his girlfriend was Alana, and they were dressed the same way, both all in black with a black shirt, black pants, and bell-bottoms. And a big, low-on-the-hip belt—and chains.

Gold chains.

Everybody had gold chains. Everybody, men, women—everybody had gold chains.

Egon, at that time, had moved to America and was with the training program at Chase Manhattan Bank. When did you hook up again? In New York or was it in St. Moritz on your birthday?

We met in St. Moritz and we kind of hooked up again. And then my mother gave me for my birthday an airplane ticket to go to New York and visit him. So I did this, I went to New York, and it was so interesting. My first impression of New York was that it wasn't [modern]. I imagined New York being all modern, and it wasn't at all. I remember that. And then, in New York, I saw a completely different type of fashion than what was in Europe. It was the beginning of Halston, Stephen Burrows, Giorgio Sant'Angelo. That opened a whole world for me. Then I went back, and I was doing an internship for an Italian manufacturer.

Angelo Ferretti?

Yes, Angelo Ferretti. He had three mills. One was a printing plant, and I learned everything about printing: discharge, colors, pigment. That was very interesting. Then he had another

factory that he had just bought, and it was full of hosiery machines. And, of course, it was just at the beginning of panty hose, so hoses weren't that interesting, so he bought these machines for practically nothing. They were tubular machines that would knit nylon and turn them into hose. I don't know exactly what he did, but instead of using very, very thin nylon threads, he used cotton and whatever, and it was the beginning of jersey. He was making these incredible jerseys, and in the other factory he was printing. So printing the jersey, that's step number one and step number two. And while I was there, he bought a third factory near Florence, where they were making nightdresses. I was with him all the time, and I think he had a little crush on me. And then Egon came back, we met in Rome, we got engaged, and we had a big party. But there was no date or anything for a wedding or anything like that. And then he went off on a trip with a friend of his, and I went back to the factory. Angelo Ferretti had a Maserati, which he drove like an Italian: very, very fast. We were going from factory to factory in the Maserati. And I was so nauseous. I thought it was the Maserati, but I was pregnant.

That was spring of 1969; is that year correct?

That's correct. And so I found myself pregnant. I said, "Oh no." You see, I didn't know what I wanted to do then, but I always knew the kind of woman I wanted to be and that I wanted to be independent. Then all of a sudden I find myself pregnant with a man who was like the best catch in Europe. And I think, oh my God, everybody's going to think I did it on purpose. At first I was really, really unhappy. I wasn't sure what to do. And my mother said, "Well, listen, you have to tell him, because you're engaged." So I told Egon, and he said, "Let's get married, all right?"

So he didn't really propose, you just had a conversation about it?

No, it was a telegram. I never really had a proposal, not from my second husband either.

We'll get to that. You wore a wedding dress when you got married, designed by Marc Bohan for Christian Dior. Can you describe it? Do you still have it?

No. I gave it to an artist to turn it into a sculpture, and he lost it. Anyway, so how was the dress? Well, since I was pregnant, I felt it wasn't really appropriate to marry in completely white. And I had just seen a movie called *Tom Jones*, where there was this big, wonderful party in the countryside. So I went to Marc Bohan, who was the creative director for Christian Dior, and he and Philippe Guibourgé saw me. I said I would like a dress that feels like a countryside wedding, and I don't want it to be [all white]. So it was white, but it was like an open cutout—almost like lace. And inside it had colorful petticoats and a belt made out of lots of colors of ribbons, and I had a hat with flowers and other things. And I had horrible shoes, which made me look like a duck.

Getting married while three months pregnant to such a prestigious family… was that a scandal at the time?

Well, it wasn't really a scandal. But on the German side, they weren't particularly happy to have a little Jewish blood coming around, but it was fine. They loved me.

And what's the story about a fortune-teller who had predicted all of this for you?

When I was in Paris, I went to see a fortune-teller, and she said that I was going to get married, have a baby, move somewhere far [away], and my face was going to be all over billboards. I came out of there crying. I said, "She's crazy."

So did you ever try to get back in touch with her afterwards?

No, no. I took care of the rest.

You took care of it. And then part of your honeymoon was in a house in Sardinia's Costa Smeralda, which Egon's mother bought for you as a wedding gift. Now, that's a great wedding present.

It was a very small house.

Still pretty fabulous, I'm sorry. Wow. So you moved from that wedding present, and two months later, in 1969, you sailed for New York aboard the Italian liner Raffaello. Alone. You were twenty-two years old.

We were staying in a furnished rented apartment on Park Avenue. My son was born there, and then we moved somewhere else. And then Tatiana was born. It's very recently, actually, that my son said, "I never realized that you were such an asset." And I asked, "What do you mean?" He said, "Well, when I meet some girl on the plane and so on, I talk to them, it's okay. But if I tell them you are my mother, that's it."

You had a famous appointment with the legendary editor in chief of *Vogue*, Diana Vreeland. Tell us about it.

Well, I was pregnant and then I was immediately pregnant again. When I knew that I was pregnant and I was moving to America, I went to Ferretti and I said, "Listen, I'm getting married. I am pregnant. I'm moving to America. But I really, really want to do something, and I want to be independent. Do you think I can make some samples to sell in America?" And he said okay. So at night when the factory closed, I would stay with the patternmaker and take whatever I found on the floor. And I made my first dresses. The reason I came [to New York] on the boat is because I wanted to [travel] slowly. Egon was already there. I wanted to think about my future. Of course, I was pregnant and I was nauseous the whole time. I did go and see Diana Vreeland, with my suitcase, and they put me in this office. It was so glamorous with lots of colors and scented candles and jewelry everywhere. They gave me a rack, and I put my few little dresses on the rack. And then, all of a sudden comes this woman with a long cigarette holder and red polish and black, black hair. She pulled my chin up, and she said, "Chin up, up, up." And I [thought], "It's not starting well." Then she looked at my clothes and she said, "Great, wonderful!" [Then] push—I was pushed away, [out the door]. And her assistant, Kezia Keeble, looked at me and said, "You know she liked it, so I think she'll help you." And I asked, "Well, what do I do now?" She said, "Well, you should take a—"

A suite at the hotel.

She said, "Soon it's market week, so you should take a room in the Gotham Hotel. You will have traffic because that's where the California people show." And then she said I should list myself in the fashion calendar and take a small ad in *Women's Wear*. I did call the hotel and the fashion calendar, and a few days later, I asked a friend of mine to take a picture. I sat on a white cube, and I had my little dress on. But there was this huge cube that was too big for the picture. So I said I have to write something on the cube. And without thinking, I promise you, without thinking, I found myself writing, "Feel like a woman, wear a dress!" And I signed my name. That picture is still being used today. That first dress was the first print that I did, with the little links. I reissued [it] a few years ago, thirty-three years later or something like that. And the First Lady, Michelle Obama, wore it for her Christmas card.

You had a lot of what became famous friends giving you advice and helping you:

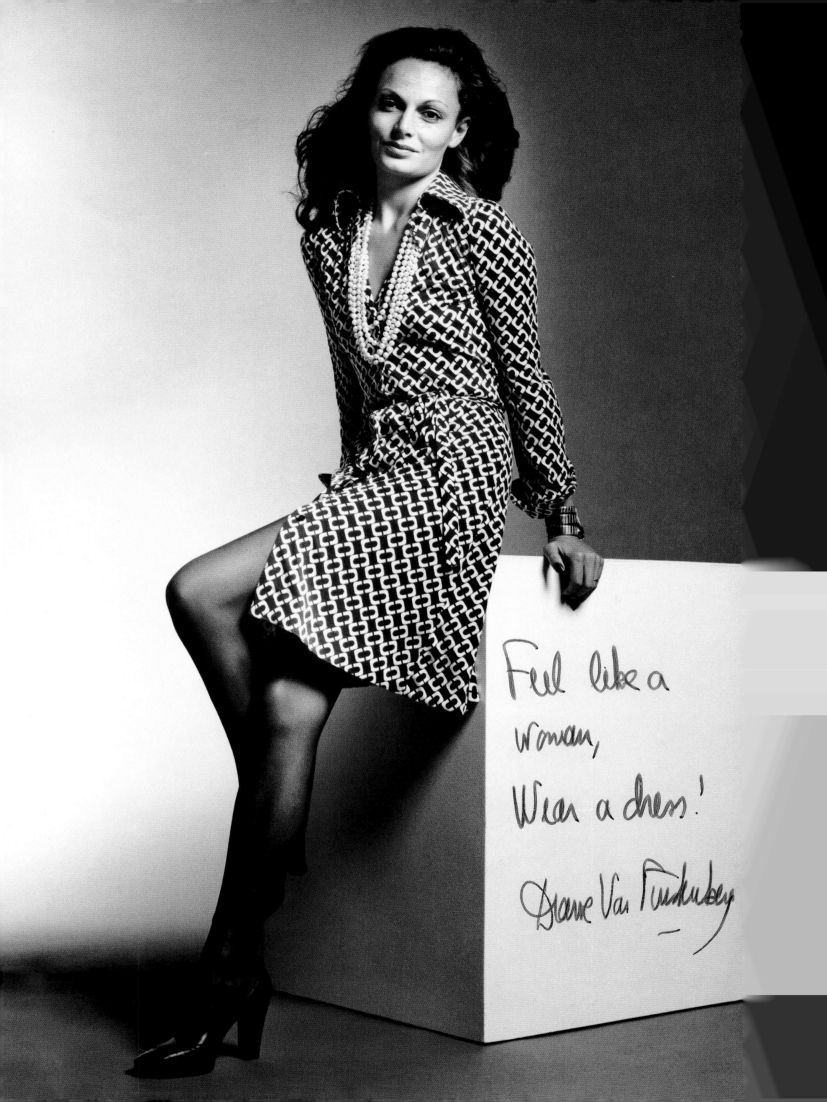

Feel like a
woman,
Wear a dress!

Diane Von Furstenberg

Kenny Jay Lane, Bill Blass, Elsa Peretti, Giorgio Sant'Angelo, Marino Schiano, Paloma Picasso, Halston, Joe Eula, Fran Lebowitz, Joel Schumacher, Loulou de la Falaise. That was a pretty good posse to be running around with.

Yes, but we were all completely clueless. I mean, other than Bill Blass and Kenny Lane, who were a little older, so they knew already. But the others, all of us, we were clueless. So we didn't know that we would become glamorous.

Well, you certainly did. And you were also, I had read, socializing with Salvador Dalí and his wife, Gala, and the Duke and Duchess of Windsor.

Well, I saw them each once.

Did you spend two days with Fidel Castro?

Yes, but that's much, much later. I didn't have an affair with him. I mean, that was really amazing. I couldn't believe I was going to meet him and talk to him and all of that. And I had this incredible, idealistic image of him. And he's quite good-looking. But after two days, I must say that I was pretty disappointed.

Oh. Okay, so back to making print dresses and tops and bottoms that were being stored in your dining room, with no office, no staff. You bought office supplies at Woolworth's. I mean, this is how businesses start. You don't become a million-dollar business right away. And you were apparently negotiating your orders with Ferretti, begging him to continue to make these things for you.

Ugh, yes, because my orders were twenty-three pieces, seventeen, forty-seven. And he would scream. He'd say, "I have a factory, I can't do all these orders." And I would beg and I would cry, "Please, stay by me." And so I would get the order. And then, of course, what I ordered in red came in blue, and when I ordered sizes they came in wrong. But everywhere I shipped [an order], it would go. And therefore I knew there was a little traction.

And then your daughter, Tatiana, was born.

Yeah, one year later.

And in order to finance this growing business, is this true that you pawned and later re-bought a diamond ring that Egon gave you?

I did pawn a diamond ring for about three weeks—

Three weeks?

—and it's super expensive to pawn. I did, I did. Because I needed the cash flow. I remember very well, it was a pawnshop across from the library, on 42nd Street. I'm sure it still exists. You see, for the first two years, I did everything out of my dining room, and then I thought, okay, I think there's traction here, so I thought the easiest thing would be to be a division of a Seventh Avenue firm. So I went to see three. Then I went to see Johnny Pomerantz. He was just starting to work for his dad. And he said, "You don't need us. You should just do it by yourself. Just get a showroom and a salesman." I said, "But I don't know any salesmen." So he introduced me to a man who then became my partner.

Dick Conrad.

That's right. He said, "Okay, I will work for you." I said, "I can't pay you very much." He said, "Give me three hundred dollars a week and twenty-five percent of the company, and I will do it." Twenty-five percent of nothing is nothing. I said sure.

End of 1972, your wholesale revenues were a million two, and a year later it multiplied sevenfold. It's pretty impressive. Was Egon supportive at this time?

It happened pretty fast, because I started the company [in] 1972 and with no knowledge, nothing at all. In '74, I created the wrap dress. And in '76, I'm on the cover of *Newsweek*, *Wall Street Journal*, *Interview*. I make twenty-five thousand dresses a week. And I was twenty-eight. [APPLAUSE]

During that circuitous path, you also bought yourself a house in Connecticut called Cloudwalk. What does that place mean to you?

The children and that house have been my salvation. I mean, that's what kept me sane. I bought that house for my twenty-seventh birthday. For two hundred and ten thousand dollars. I put fifty thousand dollars down, and the rest was a mortgage. And because I bought it for my birthday—which, as you know, is New Year's Eve—it would say that I would finish paying my mortgage on New Year's Eve of 1999. The year 2000 seemed like, oh my God. We'll be walking on—I don't know.

Outer space. In 1975, Hollywood agent Sue Mengers brought a young man named Barry Diller to a party you were having. He was the thirty-three-year-old chairman of Paramount Pictures. Describe that time and what your relationship with Barry was back then.

I was separated from my husband. I met Barry and I thought, you know I was European, so Hollywood, I love to meet movie stars and things. I thought, oh, it'd be so nice to be his friend. And he called me the next day and we had dinner, and then he asked me to come to L.A. And we fell in love. We fell passionately, madly in love. And we lived together for five years.

And on your twenty-ninth birthday, he gave you a Band-Aid box with twenty-nine loose diamonds in it.

I thought they were rhinestones. Because at the time, you used to put rhinestones on your jean jacket.

Do you still have them? What did you do with them?

Yes, I went to David Webb and he made me a necklace.

Okay, now we're up to fourteen million dollars in wholesale business, and sold five million dresses at this time. You then began licensing eyewear, scarves, luggage, sleepwear, everything, worth about forty million in sales.

If we start talking about boyfriends, then we're here until tomorrow morning.

Should we skip over Studio 54 days? You were there. It was the center of the universe.

But it lasted such a short time.

Don't a lot of good things last just a short time?

That's true. It was fun.

Okay, you left the garment business, and you left Seventh Avenue for 745 Fifth Avenue, in a ten-thousand-square-foot space and purple carpet, to become the next Estée Lauder.

I was selling so many dresses that at some point the markets got [saturated]. I got scared, so I licensed my dress business to Carl Rosen, who is Andrew Rosen's father and who at the time also had Calvin Klein Jeans. And then, because I had started with the fragrance, I decided okay, I'm going to now become the next Estée Lauder. And I started this business and I became very, very successful in five years. And then I sold it to Beecham.

For twenty-two million dollars.

Then I sold everything. I moved to Paris. My children were teenagers, so when your children are teenagers, you love them but you don't like them and they don't like you either. And

they went to boarding school and I went to Paris. I thought I was finished with the fashion business. I had another fantasy to have a literary salon. I was living with a writer, Alain Elkann, so I started a small publishing company, and I lived there for five years until it became a little boring. I came back and I realized that I had lost something that I had created. At the time you didn't even call that a brand, you just called it a business. And I realized that my business was so much part of my identity. And I had lost it. I tried to connect with all these people who had my licenses, and it had deteriorated—it had no spirit, it was junk. It was awful. And it was pretty bad those years. I couldn't express myself and as a result of not being able to express myself, I got cancer on my tongue. So I started very small, on 12th Street. I bought a little carriage house and I started there again, because I had noticed that young girls were buying vintage, or the wrap dress in vintage, and paying a lot of money [for] it. So I started again with that same wrap dress.

And then you had Catherine Malandrino as your head designer also, for a little bit. And speaking of that, you always gave great credit to your designers.

Yes, because I think it was important.

And is it true that ninety-seven percent of your employees are women?

Yes, and I used to be very proud of it and say that in my company the men drive or clean. But now I realize that [having] a few men is actually kind of good.

Yes, you need a few. In 1999—okay, we're moving forward—you created the Diller – von Furstenberg Family Foundation. And then you were voted on the board of CFDA. And then in 2001 you gave Barry a birthday present that no one else could. What was that?

We had left each other after five years and I did my thing and he did his thing, and we always knew somehow that we would eventually get married at some point. And so it was his birthday and I didn't know what to give him, and I said, "Okay, if you want, I'll marry you." And we married in a week at city hall. My brother came from Belgium. My children came.

[TO AUDIENCE] And he is romantic, because his gift to her was twenty-six wedding bands, one for each of the years they weren't married.

It's true. And whenever a friend of mine is sad, I give her one. Because what am I going to do with twenty-six wedding bands?

So, how many do you have left?

I have still a lot.

You sold the house on 12th Street, became an anchor in the Meatpacking District, and redefined living above the store.

Yes. You see, when I moved to that neighborhood, people said, "Why are you working there? Nobody's going to want to work there." It smelled bad. We had all the butchers; there were condoms all over the street. But that neighborhood completely changed. And when you move into a neighborhood, the first thing you do is you meet your neighbors. So the first neighbor I met was Florent Morellet, who had this wonderful little restaurant. From Florent, I met these two wonderful guys who had the dream of creating a park from this elevated railroad that was going to be destroyed. And so we did our first fundraising at the studio. And we had zero chance to make it happen. Every developer in the neighborhood absolutely didn't want it to happen, because they thought it would take away from real estate. And of course, now they're very proud to have a view on the High Line.

That's extraordinary.

We have this incredible, elevated ribbon of greenery suspended on the equivalent of the fourth floor.

You and Barry deserve a great deal of credit for that, for really leading the charge in the fundraising and something like a ten-million-dollar contribution as well. But you've really, in spirit also, just made it happen. In 2004, you were presented with CFDA's Lifetime Achievement Award. That same year, Egon died.

He died in Rome from liver cancer.

A host of awards followed: The Fashion Walk of Fame on Seventh Avenue, Pratt awards, all sorts of things. And then you were named the president of the CFDA. Tell us why you wanted to do that job.

Well, first of all, when times were tough and I came back and I felt like an outsider, that's when Stan Herman asked me to join the board. I felt very warm about them wanting me to join the board because I felt like I had a contribution to make. So when the time came to find a new president, I said that I would be on the committee. I had a few ideas and went to these people and none of them wanted to do it. And so I said, "You know what, I'm going to do it for two years, and then everybody's going to want to do it after that." Well, this is six years later. I'm still there.

It's remarkable to see the growth of the CFDA and what it's become. When Stan and I started, it was an office a little bit bigger than the area we're sitting in, with a phone and an answering machine.

I know, I remember.

And now it's quite an organization.

I know. And it's amazing because people really remember the initials—which [is a] good sign—all over the world. And I must say that I help there because I get a lot of exposure all over the world.

Absolutely.

I didn't know what I wanted to do, but I knew the woman I wanted to be, and I became that woman. And I became that woman through fashion, therefore through other women. And so, now that I'm much older and I look back, it's very nice to see that every facet of my life is all about empowering women. I do it with my business, by giving them confidence with the clothes, with the accessories and whatnot. I do it through mentoring, and I do it through philanthropy. And my major cause in philanthropy is women. I am on the board of Vital Voices [Global Partnership], which is a wonderful organization that Hillary Clinton founded and that empowers women leaders all around the world. Three years ago, I created the DVF Award. It's part of the Women in the World conference at the UN. We have honored these amazing women, and we give them money and exposure. It's very humbling to see all these women that go through such horror, and yet they survive. And not only do they survive, but they become leaders and help others.

And you pledged fifty percent of your wealth to the Bill Gates and Warren Buffett initiative. How does that work?

Well, you just pledge and then you pay.

You were just named on *Forbes*'s World's 100 Most Powerful Women list.

I know. I don't know how I got there.

You were number thirty-three, Anna [Wintour] was fifty-one, Miuccia Prada sixty-

seven, and Gisele [Bundchen] eighty-three. Pretty impressive.

Well, I had three eras in my business. The first moment, the goal was to become financially independent. I was very lucky and I lived an American dream. And that was beautiful with the ups and downs and whatnot. When I went back to work, fourteen years ago, it was comeback kid. And at the time, my motivation was to show myself and the world that it hadn't been an accident the first time around. And I did that. When young designers ask me what's the advice I should give them, I tell them, "Try to find your own vocabulary." If you have a vocabulary, it's really important.

You are very active on social media. How many Twitter followers do you have?

Okay, in America, I have four hundred and twenty-five thousand. And in China, I have six hundred and nine thousand. And I am completely addicted. I wake up in the morning and I check how many more Chinese are following me. And just to tell you how quickly it goes, on Sunday it was only six hundred thousand. And tonight, it was six hundred and nine thousand.

What's still left for you to do and accomplish?

In my business now, I really focus on accessories. But I'm clear. That's the worst thing, when you're not clear. If you follow me on Twitter, you know I always talk about clarity, because I always think if I write about it, it will happen, so clarity is very important.

Is there anything that you would have done differently, given the chance for redoing your life?

You know, I think that you only regret the things you don't do. And I think I've done a lot. Even things that are not good, you process them and then they become part of something else, and then something good comes out of it.

To whom or what do you really believe you owe your success?

My mother. My mother gave me my strength. My mother gave me character. She taught me that the most important relationship is the relationship you have with yourself. And my father gave me love. And that made me confident with men.

Diane, thank you. This has been incredible.

Thank you. [APPLAUSE]

POLLY MELLEN

Polly Mellen. When I mention her name to anyone in fashion, and I mean really in the fashion business, their eyes light up and they immediately say, "We miss Polly." What do they miss? I believe it's her energy, enthusiasm, and her unabashed love and passion for all things creative. What a joy it was to watch her at a fashion show. I never had the good fortune of watching her at a photo shoot, where she made her mark and became a fashion icon. But at a fashion show, she always had the best posture in the industry, as it's very easy to slump in the front row. When something excited her, she let you know it. She'd clap loud and exuberantly and even stand up in the middle of a show. Needless to say, she's probably a very bad poker player. When I conceived this series here at the Y, I always wanted to bring you not only designers but also fashion's iconic players and their stories, as without people like Polly Mellen, you wouldn't know much about the designers. Polly won the CFDA's Lifetime Achievement Award in 1993. When my good friend Jeffrey Banks was interviewing Polly for his book on Perry Ellis [Perry Ellis: An American Original], he said to me, "You have to do Polly." When I called her at home, she asked, "Do you really think anyone cares about me or what I have to say?" Let's welcome the woman [about whom] Richard Avedon said, "From Vreeland's rib came Polly Mellen, and from that day on, Eden never looked better." Ladies and gentlemen, Polly Mellen.

FERN MALLIS: Polly, you were born on June 18, 1924, in West Hartford, Connecticut.
POLLY MELLEN: Correct

That makes you how old now?
Eighty-eight.

That's pretty fabulous. You're a Gemini. Do you agree with the star signs?
Yes.

Geminis love to talk—not just idle chatter. Their driving force is their mind. Intellectually inclined, probing people in places, bright, quick-witted, life of the party. Boredom is toxic. They're prompt in speech and quick in whim. And a lightness of spirit and youthful exuberance [helps them] to appear forever young, with a skip in their step. I think that describes you. I read that you had a very stylish family. Describe what that means.
Well, my father and mother were a little bit different. Clothes meant something to them, but they weren't superficial. My father was a very big-time insurance man, very successful. And my mother, at two hundred and fifty pounds, loved to wear bright colors and bright prints. It was a part of our life, a small part, but something that meant something to their four daughters and one son. My sister Patty, who was thirteen months older than I was, always wore blue. I wore pink. And we dressed alike.

Did that bother you?
Not until I was in my early teens, and then, as the youngest of the four girls, I wanted to be myself and express myself.

Tell me about the Chanel pajamas that your mother apparently had copied in the West Indies, in Antigua.

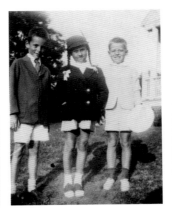

This page, left to right: Polly Mellen's parents, Walter and Leslie Allen; Polly at three years old; Polly in school at seven years old. Opposite, left to right: Polly in a rowboat, Hay Harbor, Fishers Island, New York; Polly on her family's dock, Hay Harbor, at eight years old

She had one pair of Chanel pajamas. They were wonderful-looking pajamas with a cup cutout monogram. When she went to Antigua, she took her pajamas to a dressmaker in town, in St. John's, and had them copied for three dollars.

Your parents had a house in Antigua?

Yes.

Did you spend a lot of time there?

Yes. My father, along with four other men, started a club in Antigua called the Mill Reef Club, and we went as often as we could and we loved it. And they're both buried there in St. John's cemetery.

Is that where your dad wore his white terry-cloth blazer?

No, no, no.

No? Where was that?

That was where we went in the summer, which is an island called Fishers Island. That's interesting you bring that up, because he had a white terry-cloth, double-breasted, very chic blazer, with his monogram in bright blue.

You said that your sisters were very bright and capable. How so?

They were. They were very good at school and exactly what you just said, Fern. But I was not.

So did they make you feel inferior?

Yes, a little bit. I've always had—you may not agree with me—I've always had an inferiority complex, and still do. I'm never completely sure I've done the right thing. When I was a working girl, I had a passion for what I was doing, so I just went ahead and that passion took over, so a certain kind of holding back was not a strong suit for me.

Your sisters and your brother, what did they all go on to do and to accomplish in their lives?

My sister [Patty] was a housewife. Leslie, also a housewife. And Nancy married. She was in fashion, a buyer at Lord & Taylor, and went on to being managing editor of *Glamour*.

When you were growing up, you also were influenced a lot by dolls. You dressed dolls?

Yes.

I read you were a big fan of Carole Lombard, Greta Garbo, Marlene Dietrich, and the guys Gary Cooper and Fred Astaire, and you wouldn't let anybody come see your William Holden movie with you—

Never.

—because you wanted to see it by yourself?

I remember once watching *Picnic*, and I had such a crush on William Holden. And somebody tapped me on the shoulder behind me and said, "Polly, you were here when we came in." I said, "I know. I'm going to see it again. Shh. Go away." There's a story that goes along with William Holden. When I was on my honeymoon with Louis Bell, we were in Portofino, and we went to the Splendido and then down to a place where there was a wonderful swimming pool that went on into the ocean. And there were two rafts out in the ocean. I quickly went into the ocean and got onto one of the rafts. And I noticed a fellow on the other raft who said, "Why don't you come over here, onto my raft?" And it was William Holden. It's true. And I quickly—

Almost drowned?

—if you can believe this, I dove into the water and swam home to where my husband was sitting. I don't know if I regretted that or not.

I think that would go on the regret list that you didn't swim over.

He was gorgeous, I mean brown, white trunks, oh heavens.

That's a great story. You went to the famous Miss Porter's School in Farmington, Connecticut, in the early 1940s. You were a year behind Gloria Vanderbilt and just ahead of Jacqueline Bouvier. Can you describe those days?

Oh, it was wonderful. I didn't go to Farmington right away. I went to the Ethel Walker School for two years—two dreadful, difficult, awful years. And I was a terrible student. I left the Ethel Walker School because they told my father and mother that they felt my body had developed ahead of my brain. I always wanted to go to Farmington anyway because all my sisters went there, so why couldn't I go there, too? Why did I have to go to the Ethel Walker School and wear a uniform? I was the youngest girl in the school. It was miserable. I'm a terrible student. But a good tennis player. And a good horseback rider.

After Miss Porter's School, you chose not to go to college. Was that a family decision or just yours?

No, I couldn't get into college.

You were a nurse's aide at an army hospital during World War II. That had to have been difficult, caring for patients there—but probably good experience for dealing with the fashion industry.

Oh, an incredible experience. After [being a] nurse's aide, if you had fifteen hundred hours, you went to an army hospital. I was sent to a hospital with my sister [Patty] and other friends, to Ashford General Hospital, which is in White Sulfur Springs in West Virginia. I was

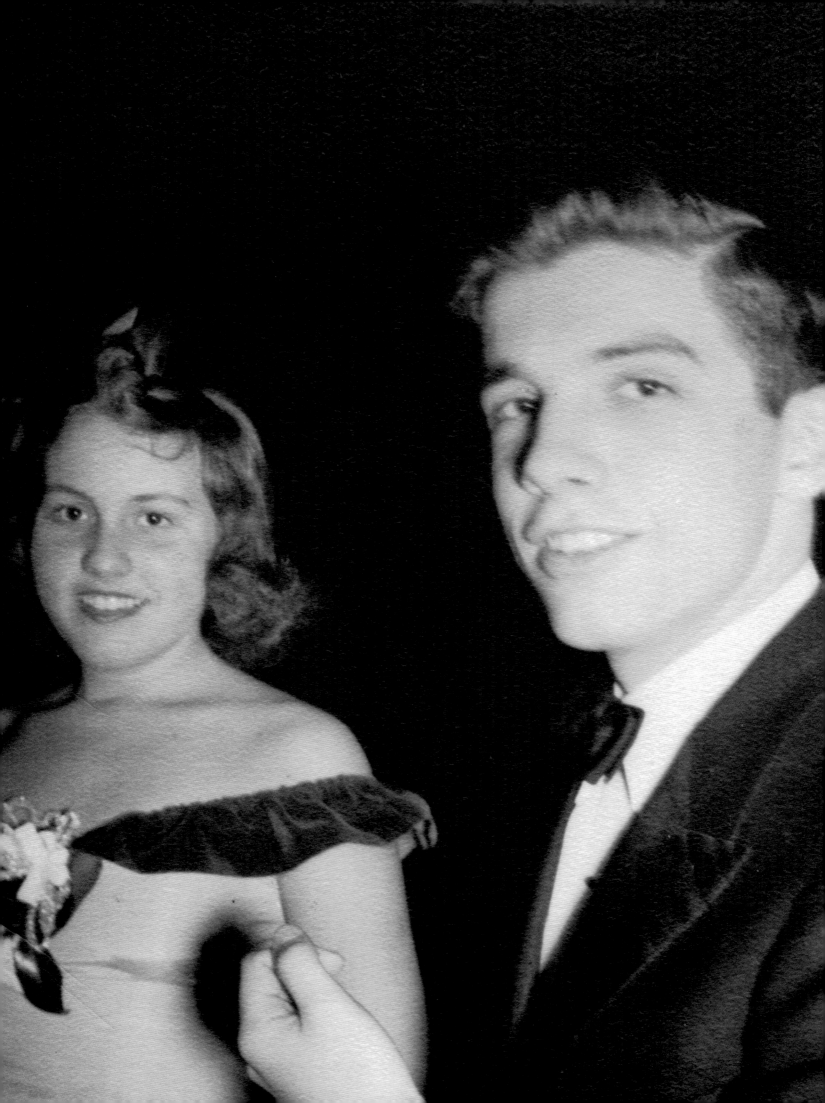

put on the detail of meeting the airplanes that the wounded came from. It was an incredible experience, something that you'll remember and something that brings on a certain seriousness in you. And there was some humor in it, because I can remember walking with the medics who were carrying the stretcher of one of the wounded soldiers, who would look up and say, "My God, I've gone to heaven." And that made me feel very good. You know what I mean?

You were the angel. In 1949 you moved to New York. Did you have roommates? Do you remember where your first apartment was?

Yes, we went to [Miss] Hixson's at 1155 Park Avenue.

Not bad.

And then we moved on to [Miss] Outerbridge Horsey's brownstone, which took the elite young women. I was working at Lord & Taylor.

Your sister helped you get that job? That's where she worked. And you were in the college shop. That's when stores had "college shops."

And that's the closest I ever got to college, the college shop at Lord & Taylor. I started out in the sweater department, which is obvious. And then moved on to being head of the college shop, and then my career continued.

Is that when you thought you could have a career in fashion?

Yes. Yes, yes, yes, yes.

And then you were moved quickly to the display department, working on windows. What did they notice about you that made them move you to that area?

That I don't know. I think just my deep feelings about fashion and about fantasy. If you remember, the Lord & Taylor windows at that time, the Christmas windows, were extra-ordinary. We made them in the basement. They came up by elevator. I think that they knew that I was a little restless, just being in the college shop and selling clothes. I wanted to do something a little more creative. Henry Callahan, who was the head of the windows display, hired me.

And right at that time, you learned two truths about yourself, that you like being behind the scenes, and that you needed to create a dream.

Yes. That's right. And that continued, Fern.

Absolutely it did. You went from Lord & Taylor to your next job at *Mademoiselle*, which was my alma mater and first job. What did you do there, and for how long?

Well, believe it or not, I was the hat editor. And I didn't even own a hat. I did own a little French beret, so every time I went into the hat market, I had to put on my French beret.

And while you were there, Sally Kirkland—who was your sister's friend—wasn't she at *Vogue* at the time?

Yes.

She wanted to introduce you to the fashion editor at *Harper's Bazaar*, who was Diana Vreeland. What was your reaction to that opportunity?

Fright. Sally wanted to me to take the job of an editor that was leaving, named Constance Woodworth, who was this glamorous, fantastic woman. And I said, "Please don't do that to me, Sally. I can't do that. I'm sick. Please don't make me do that." She said, "You are going to meet Diana Vreeland. And Polly, now, really, this is ridiculous. It could be a great opportunity for you." So she talked me into it. Oh, I'll never forget it. We sat in Henry Halper's drugstore

on 56th Street and Madison Avenue. Sally said, "I have a little brandy here. Do you want it?" I said, "No, no, no, that's all right. Are you coming up with me?" She replied, "No, you're going up by yourself." And I did. And it was a wonderful, wonderful interview. Great fun.

Do you remember what you were wearing?

Oh, what I was wearing? I do know I was wearing little white gloves.

What was Mrs. Vreeland wearing?

I can't remember what she was wearing at that time. But at another time when I went to see her with my two children—a boy and a girl, bless their hearts, I love them so much—we walked in, and Mrs. Vreeland had on a gray flannel skirt and a turtleneck sweater in gray, and medallions hanging on gold chains, and I remember her saying, "Polly, I've seen you. Now I want to be with your children. You go do something." The door closed and the two children were in there, and I thought, they're never going to forgive me. Ever. And when I was called to come back into the office where Mrs. Vreeland was, Baker had on her earrings. And Leslie had on a couple of the chains. And they were laughing and having a ball. The only trouble was that Mrs. Vreeland, every Christmas, would send me two beautiful little dresses for my two children because she forgot that Baker was a boy.

So after that first meeting with her, you were hired at *Harper's Bazaar*. You went from a hat editor to the lingerie and foundations editor. Then you were asked to go on a shoot. You were at *Harper's Bazaar* for two years while Carmel Snow was the editor in chief.

Yes.

And I read she gave you some of the best advice of your career: Go see every designer, everywhere, big or small. You never know where the next talent is coming from. Open your eyes, have a little humility, and let go of ego.

That's right.

It's excellent advice. You absolutely took that for the rest of your career.

Yes, I did. It taught me a certain kind of humility. You had to see everything because you don't want to miss out on a talent. And I kept that always in my heart. I think today it's wonderful what young people are doing, and there's much more action and help with younger people than there was in the days when I [worked].

Absolutely. So your first shoot now at the magazine is with Dick Avedon, who initially didn't want to work with you because, he said, you were too noisy.

That's right.

What did that mean?

When I was moved, I expressed myself, and I guess it was a bit much for Dick. He said, "I can't work with her, she's just too noisy, Diana. Get me somebody else." She said, "I want you to work with her, and I will talk to her." And she did, and I did a shoot with Audrey Hepburn. She wore a Ceil Chapman yellow voile dress. It was wonderful. I sat behind Dick, way behind, and I did not speak. When the shoot was over, Dick looked at me and said he was very pleased. He came into the dressing room and told me, "You never said a word." I said, "I know that you think I'm too noisy, so I want to work with you again and I needed to use that self-control." He said, "You must never do that again, ever. Because the feedback that you can give me when I'm working, I feel it, and sense it, and you must not hold back. If you know what you're doing, and you like what you're doing, let it go." And I did.

And a new fashion team was born. But then, in 1952, you left it all for love and married

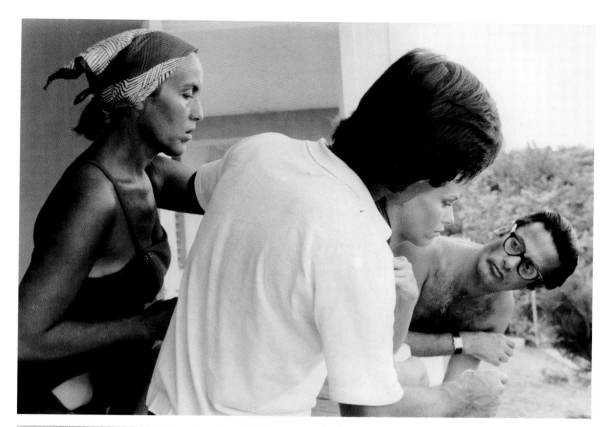

Page 164: Polly Mellen and Tom Critchfield. This page: Polly Mellen working and traveling with Richard Avedon

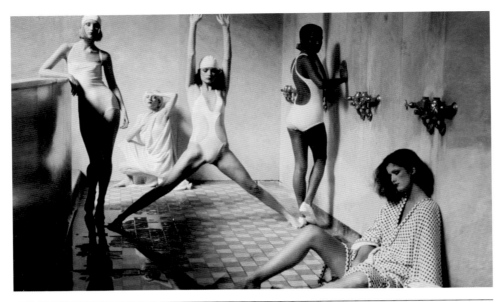

This page: Bathhouse,
by Deborah Turbeville,
Vogue, 1975. Pages 172–73:
Nastassja Kinski, actress,
Los Angeles, June 14, 1981.
Photograph by Richard Avedon

your first husband, Louis Bell. What was his business?

He was the coat and suit buyer at Strawbridge & Clothier.

You had two children and lived on the Philadelphia Main Line for ten years. How did you adjust from that fast lane of fashion to that life?

Well, easily. First of all, we had a wonderful life. My marriage was difficult, but I had my two children. I didn't want to go back to work, because I wanted to raise my children and be with them during the formative years. And then we realized that the marriage was not working, and we were divorced after eight years.

So, then ten years later, in '62, you moved to a gardener's cottage in Tuxedo Park and actually thought about going back into hospital work. But you didn't.

I wanted to do something that I thought was maybe more meaningful, more meaty, more to do with humanity. Women were being noisy then. The Pill, Vietnam, Warhol, Betty Friedan.

And then you met—and I love this name also—Henry Wigglesworth Mellen. Where did you meet him? And what did he do?

Henry worked at Steinway Pianos. Henry has perfect pitch, so he helped with the sales of Steinway pianos and pitching them. And worked with wonderful, talented people, one being Dave Brubeck.

I read you have four children, so were two of those Henry's children then?

Yes, and the girls are three months apart and the boys are—Palmer was born December 11, and Baker was born the following April. So it was like having two sets of twins.

Busy house. And then Mrs. Vreeland called you back, after she moved over to be editor in chief of *Vogue*. In 1966 you joined her there. She asked if your passport was in order, because your first big assignment was to go to Japan with Dick.

For five weeks.

The most expensive shoot in history.

That's true.

Do you want to talk about that?

Fifteen trunks. Well, it was a fur caravan, so naturally it was pretty expensive, but it was an extraordinary experience, and I came back more Japanese than the Japanese. I mean, it

completely affected my life. Their habits, the change, everything you ate, every taste sensation, every smell. It was just an extraordinary experience. We went to a Zen Buddhist monastery, and I wanted to go to first prayers, but that was five o'clock in the morning, so I went to second prayers, which was seven o'clock in the morning. And it was something that affected me and that I have taken on. It gave me a certain feeling, a spiritual feeling, a sense of discipline. All of those things that I feel one needs to make it on one's journey through life.

Incredible. How many people were on that shoot, your entourage?

One model, Veruschka, and a sumo wrestler, whom we got in Japan.

I read you got the tallest sumo wrestler in Japan.

He was seven foot one. Dick had three assistants: one came from Tokyo, and the other two went with us, and the very great and famous Ara Gallant, who did the hair.

Okay, so let's talk about some of your groundbreaking shoots, because you often went to the erotic, it seemed. Was that for reaction, or was it just a reflection of what was happening in the world, or what the clothes dictated? Let's talk about Lisa Taylor in 1975 with Helmut Newton in Saint-Tropez.

That was a shoot that was called "The Story of Ohhh." I talked with Helmut about it. We had two [female] models and one male model. And we wanted to do what I felt was going on in the world with young women, which is their growing up and their sexual feelings and their feelings also of holding back—push when you mean pull. The more I talked, [the more] Helmut would egg me on and make me explain a little more. And then Lisa really got into it and understood it. And so did [Peter Keating], and it developed into the shoot it became. I'm very proud of that shoot. I think it looks great, even today.

Working with Helmut Newton was not very Miss Porter, huh?

Now, Fern, as you get a little older… At a certain time in my life, I was having a very serious love affair, and I think that teaches you a lot of things. It's an arousal of yourself and knowing yourself. I thought that was very modern. I wanted to bring it into my sittings, if it was right, if it worked into the sitting that made sense. If it didn't seem like it made sense, then I wouldn't go in that direction. But, in this case, with this particular sitting—

It certainly did make sense.

Yeah, it made great sense, I thought.

And then what about the groundbreaking, controversial Deborah Turbeville photos of swimsuits in a derelict bathhouse?

They were vacant baths downtown. Debbie and I went to look at the baths, and we talked to Grace [Mirabella] and Alex [Liberman] and said we thought that would be a wonderful setting for the bathing suits, as opposed to just going to a pool or even going to the West Indies or something like that. I mean, it's not that going to the West Indies wouldn't be great, too, but Debbie was very turned on, and so was I because the baths reminded me of old pictures I'd seen of Roman baths, and it had a great interest to us both. And Debbie took five or six models, and placed them very specifically into the scenario and the situation. I think the pictures are amazing. When we were doing the pictures, I never thought they looked reminiscent of possible German atrocities or anything like that. I didn't think they were difficult to look at. It didn't occur to me. I mean each model is on her own. It's a tableau, it's true, but each model is detached from the other model. And I love the pictures. When they came in, it was a shock. I think Grace—

This is Grace Mirabella, who was the editor of the magazine.

Yes, wonderful editor. She wasn't sure of them. And I could tell that, because they called me in to see the pictures. And Alex said, "Polly, I think you should leave the art department—

This is Alex Liberman.

—and go for a walk." So I did. And I realized that they were a bit much. I mean, I could see that they always spoke a lot when the shoots came in, and you went to the art department and saw the pictures. But they were completely quiet and said nothing. And so I knew I was in trouble. And when I got back from my walk, Alex called me up to his office, and he said, "I don't want you to worry. The pictures are extraordinary. They may not run as fashion pictures. They will run as a feature in a more artistic way, maybe. Do not worry, and thank you for them."

Oh, wonderful.

Yup. Well, with his eye and being an artist himself, he understood something more was there. And that was one of his greatest gifts. And he was somebody who, when you felt he believed in you—which I did—that gave you enormous confidence, but it also was a growing-up experience.

Is there anybody in the industry that plays that role now, like Alex did then?

I have great respect for Fabien Baron. I think he plays a very important role. [And] I think some photographers are so gifted. So to answer your question, is there any art director who is of that caliber? I'm not sure. But I don't compare, Fern.

Fair enough.

I think you move on. We're in a different time, and the digital age, the enormous technical things that go on, it's a different situation. And I think it's very interesting. I read everything, I look at everything.

You then became the fashion director of *Vogue* and one of the true believers and supporters of new talent at that time. Are there some designers you want to mention who you feel like you discovered?

Well, I think that Nicolas Ghesquière is a genius. I think he's a fantastic designer. The explosion of talent that has happened with Michael Kors. I think where he is today is just wonderful, as a great American designer.

I agree.

And when we talk about American designers, we have to talk about one of the best, Marc Jacobs. And then the other genius, Ralph Lauren. I mean, it's unbelievable, his empire. It's something else.

You also had a "Who's Who?" of assistants who learned the ropes from you—some who said you were not so easy to work for—from Vera Wang to Elizabeth Saltzman and Joe Zee. He said that he learned to run and not walk because of you. Going down a corridor, being asked for something, he wasn't quick enough. And he said that to this day he runs.

Oh dear.

You were always the first one in the office and the last one to leave, even when you were creative director of *Allure*.

I remember Arthur Elgort said to me, "Polly, whenever you interview anybody, drop something. And if you pick it up quicker than they do, they're not for you. Move on."

That's a good one.

Well, it's kind of terrible, I think.

Can we talk for a couple seconds about your famous shoot with Dick and Nastassja Kinski? That's probably one of your most favorite ones.

We were working in a studio of a Los Angeles photographer whose work was on the walls. And when I went in there—Dick was testing lighting—I saw all of his pictures on the walls. And I thought, oh my God. Nastassja Kinski arrived, and we did a fashion shoot. We photographed her, did some pictures that were interesting. Not great. And then I went upstairs to the dressing room where she was, because I wasn't really satisfied with what we were getting. And I asked her, "Do you have any favorite things that you love? Any pets? Anything?" She said, "Yes, I love snakes." I asked, "What kind of snake?" And she said, "I love cobras or pythons."

Big ones?

I asked, "Would you like to do a picture with a snake?" And she said, "That really interests me." Well, I ran downstairs, I got Dick, up he came, and we told him the story. He said, "Everybody go have lunch," and we called a trainer who brought the snake, the famous snake. And she held it and I could tell that she was really fascinated by it and turned on to it. She asked, "Polly, would you like to hold the snake?" I said I'd love to. And I did. And I think I said some things that were a little suggestive because holding a snake is so very seductive. And Dick asked her, "Will you hold the snake and will you lie down and will you be nude?" And she said, "Oh, sure." And she did. I put the bracelet on. I shouldn't have done that. The snake wound up her body. Now, you understand the snake is defanged, otherwise we would be off limits. It wound up her body very, very slowly. Dick was taking pictures as the snake moved up her body. Nobody was telling the snake what to do. The handler was behind me, and I was just watching on my knees behind Dick. I could hardly believe what I was seeing. When the snake got to her ear, he kissed her and put out his tongue. And the shoot was over.

It's pretty magical.

I was crying. I mean, it was just so moving. And Dick, all of us, were thrilled. Dick was so pleased. When the pictures came in, Dick called me and said, "Polly, you must come right now. You have to see the snake picture." And the rest of it is history.

Did they sell a lot of bracelets?

I don't know about those bracelets. But why'd I put that bracelet on?

In 1991, you joined *Allure* magazine, which was a brand-new magazine for Condé Nast. Anything you want to say about your time there?

I had a wonderful time there. I had a great editor, Linda Wells. She's a wonderful person, extremely intelligent, and knew exactly what she wanted for her magazine. A pleasure to work with. With Linda, you knew what she wanted. There was no gray area. It was a different kind of experience. There were some problems because we had to use different photographers than *Vogue*. We had to use different models than *Vogue*, and that was challenging. I think that's good, because it pushes you to discover other talent. And there were even moments when there were clothes that I wanted to use and *Vogue* wanted to use them too. I was told, "I'm sorry, we can't give you those clothes—those clothes have been held for *Vogue*." Well, that didn't bother me. Move on. Pick something else. And that's good

Photograph by Richard Avedon

Photograph by Richard Avedon

for you. It stretches you—your eye. And it's more challenging. I loved my years at *Allure*.

Then in 1999, on the eve of a new century, you left *Allure*, saying you didn't want to be controlled any longer. A year or two later, in 2001, you retired with your beloved Henry to a converted apple barn in South Kent, Connecticut, in Litchfield County. And you're surrounded by a four-hundred-acre nature conservancy.

Yes.

That sounds pretty amazing.

After I retired, I did some freelance work. And then [came] [9/11]. I worked at *Allure* with a wonderful woman named Ricky Vider Rivers. Her husband was having breakfast at the World Trade Center that day. He wasn't even working there. And he was one of the people lost. I called her up and said, "I don't know what to say to you. I just want you to know I'm here for you." And she said, "Polly, you've done it. You've done it all. You go home to Henry. He's there." And that really brought me up quickly. I'm not very good, Fern, at doing little bits of this and little bits of that. It was much better to get rid of the apartment, make the break, and be with Henry, my children, and my grandchildren. Another journey in your life.*

It is a wonderful chapter to have.

Yes, terrific.

So your house is filled with photography, I understand. Great portraits of you.

Do I have portraits of myself?

Hanging in your house.

Yes, I have my Avedon portrait. And I have a Helmut Newton portrait. Arthur Elgort, my dear friend. And I have a few others, which I love.

Lots of family pictures. What do your children do? Did any of them go into fashion, creative, visual jobs?

My daughter, Leslie, is enormously creative. But she's in the real estate business. Baker Bell is a potter and a painter and she's extremely creative and my dear, dear friend.

So your days now, you are certainly not idle. You do Pilates, work out, you walk, you swim, and you garden, which is a very fulfilling exercise.

And golf. And ski.

Ski at eighty-eight? Is Henry the cook at the house?

Yes.

Does he cook organic, healthy foods?

Very healthy.

Do you still eat grapefruit and cottage cheese with black pepper for lunch every day?

No, I don't.

So that's from somebody who worked with you.

Who are you?

There's no name on it.

Oh, is that you, Paul?

AUDIENCE: No, no, not Paul. Douglas Keeve.

So, are there any regrets?

No. I was the spoiled brat of the fashion world, and I knew it. I know it. And I loved it. I ran

*Henry Wigglesworth Mellen passed away January 7, 2014.

to work and I have no regrets.

Good. What's still on your bucket list?

Oh, Christmas.

That's an easy one. What you were telling me earlier, that you still want to go to India and places like that?

Oh, I would love to go to India and Russia. Who's going to take me then?

I'll take you to India.

Okay.

What do you make of the fashion scene today? The magazines, do you see them all? Are there any that you like a lot?

Yes. I think they're very interesting. Different magazines take a different twist. And they're all very different. *Vogue Italia* is completely different. The head of the magazine, the editor in chief—like our most famous one, Anna Wintour—she believes in her magazine and wants the magazine to be the way she wants it. And it's the most successful fashion magazine in the world. She's a great talent. Her capacity is remarkable. The editor in chief has the right to make the magazine what she wants it to be. And that's what you see.

What about Carine [Roitfeld]'s new magazine? Did you ever want to have your own?

Yes, of course I did. But I think I was considered a bit too wild. And not enough business sense, which I don't agree with. I would have loved to have my own magazine.

But it's not enough to be on a regret column, though.

Yeah. That's a regret.

What about the photographers? Can you talk about anybody who's doing new, fabulous work today that stands out for you?

I think Steven Meisel is a great talent. I think there are lots of photographers out there that are good, really good.

What about the models? Who was the most difficult or the best to work with?

The most difficult model I ever worked with, I won't mention.

Oh, come on.

And the most difficult celebrity I ever worked with was Raquel Welch. And Faye Dunaway wasn't easy. And Barbra Streisand wasn't easy. Sorry.

You want to tell us which model?

No, I don't.

Is she still working?

Yes.

Okay, and the designers. I know you've kept all your authentic Jil Sanders and Helmut Langs, and you still wear Marc Jacobs and Prada and your Vera Wang pants.

My Vera Wang pants.

Are there any young designers working today that you admire? Any of the new up-and-comers?

Yes, I think Zac Posen is interesting. I think the guy who took Nicolas's place—

Alexander Wang.

Wang. Very interesting.

What advice do you have for up-and-coming stylists, editors, designers? Anything you want to share for the young talent here?

Page 174: Polly Mellen, fashion editor, New York, August 21, 1975. Photograph by Richard Avedon. This page, clockwise from top right: Polly Mellen on the beach, 1981; Polly Mellen with models, 1990; Polly Mellen by Bruce Weber. Page 179: Polly Mellen by Steven Klein

I think you have to do your homework. I think you have to research. You have to look at photography in the past. You have to study artists. I think there're so many interesting, really interesting artists. And you have to keep your eyes open on the street. I love the street. I love what goes on in the street. You have to be aware and search and be interested. It's not easy. The program *Project Runway* is fantastic. I love watching it because my grand-daughter will not let me not watch it. It brings a spirit and a belief and something that young people feel they can strive toward, by watching these young people who have no money, and they've worked so hard. And the ones that lose, it's heartbreaking.

Have you not been a judge on that show?

No.

God, we should try and make that happen for you.

Let's do that.

All right, we'll work on it. Do you miss being—well, up in Connecticut, miss that street energy and pulse?

Yes. I miss that. I miss the theater. And I miss the ballet. I'm an avid moviegoer. I could go to a movie every other day. I mean, the last movie I saw that I thought was really amazing was Ben Affleck's movie.

AUDIENCE: *Argo*.

It's a fantastic movie. And so is *Lincoln*.

What's your take on social media, bloggers, Twitter, all that? Would you take to that if you were still working?

Yes, I think I would.

But you're not on the computer much now.

I have a computer, but my nephew is in the audience, and he knows that I don't know very much about the computer, but he's going to help me. I can do emails. But I'm not very good at anything else. And neither is Henry.

But she does answer the phone when you call her. What look, whether current or not, are you in love with right now?

I love a lot of it. I'll probably think of a million things after I leave. But I can't think right now. Almost every designer, I can find something that really interests me, that I wish I had. I love Prada and wear a lot of it, because I'm comfortable in it. Jil Sander.

Do your daughters take your clothes from the closet?

No, they don't wear any of my clothes because they dress their own way.

Do you have granddaughters who are coveting [them]?

I have a granddaughter coming up. We'll see. She's just turned thirteen.

She'll be very lucky if she gets to go into your closet.

It's there if she wants it.

And in times of doubt, how did you find the bravery to follow your own voice?

In times of doubt, I don't have trouble trying to find my voice. I'm not sure I even believe in doubt. Because if you're learning and if you're curious, something else takes hold, and doubt can be erased. I think doubt is a negative feeling. And I'm not a negative person. I think there's no need to be negative. It's much better to feel rosy, to look forward to tomorrow, and that's what I do with great pleasure.

I think on that note, Polly, thank you. [APPLAUSE]

MARC JACOBS

Good evening and happy New Year. I can think of no more exciting way to start the year than with Marc Jacobs. I have to admit, even I am a bit nervous about tonight's conversation. Marc is clearly the most important American designer to be recognized globally. He has a unique and independent vision and has consistently delivered influential groundbreaking collections and blockbuster shows. He is the designer who made the front page of the New York Times year-end summary Style section for the unusual outfit he wore to the Met Costume Institute. He has been called a genius and a junkie—although he's now addicted to the gym and a rigorous health regime— brilliant and trite, an original and a copycat, a chief arbiter of hip, a survivor, and a success. He has always stayed true to himself and to his protector, friend, and business partner, the person he says cares more about him than anyone else. Robert Duffy is equally responsible for having created the Marc Jacobs brand. Together, they've survived more highs and lows than most and have repeatedly reinvented their business. Together, they shook up the fashion world when they took on the most revered, respected, trusted luxury brand in the world, Louis Vuitton. Between Marc Jacobs and Louis Vuitton stores, Marc's influence and designs are available in 698 stores world-wide. The Marc Jacobs shows in New York are without question the most anticipated and largest extravaganzas of Fashion Week. When I was running Fashion Week, we'd always start the schedule by blocking out Marc's timeslot. His show defines the week and sends the loudest message, has the most celebrities, artists, musicians, and is the one that even I can't seem to get a ticket to. And it's now the only show that actually starts exactly on time. Marc has not only transformed the fashion industry, but he has transformed himself. Well, I can go on and on, but I know you'd rather hear all about this from the man himself. Ladies and gentlemen, Marc Jacobs.

MARC JACOBS: Thank you. I was crying. Thank you for the beautiful introduction.

FERN MALLIS: Well, thank you for being here. I am really thrilled that you're here. It really means a lot to me. And to everybody here, apparently.

Yeah, thank you all. [APPLAUSE]

Marc says nothing's off limits, so let's get through this volume of questions.

You were born in New York City on April 9, 1963. And you have the same birthday as—

Marylou Luther and Martin Margiela.

That's good fashion creds. And your birth name was Marc Silver.

No, Marc Jacobs. That's a mistake on Wikipedia. Don't believe everything you read on the Internet. Silver was a stepfather, my mother's third husband. My father is Stephen Jacobs.

You know, I got into that trouble with Tom Ford. Are you already thinking about your fiftieth birthday? How will you acknowledge that milestone?

I think I'll go to Rio. I like it there. I think I'll just be in a bathing suit on the beach somewhere, drinking coconut water.

You're an Aries, as am I. Do you believe in astrology?

I do not believe in it. I don't really follow it. I kind of believe everything is possible.

Some of the things about Aries that are important that I think are relevant for you are that Aries is the headstrong ram. It's the leader and the pioneer of the zodiac. And red is the favorite color. Aries are strong, restless, quick-witted, impulsive, ambitious, and catch the first fire of spring. You also have a distinct point of view, enjoy mental debate and friendly combat. That's what we're going to do here, friendly combat.

Okay. Yeah, I'm an Aries, then.

Aries is the eternal boy, and has a youthful quality—which your clothes definitely do— and is always ten steps ahead of the curve. You don't like messy details or when things drag on too long, and you work best in a partnership. At worst, you can be rebellious and like to be seen as a bad boy.

True.

Enough astrology. Let's talk about your family. Both your parents were talent agents at William Morris. Is that true?

Kind of. My father was a talent agent at the William Morris Agency. My mother was working as a receptionist when she met him there. And her uncle was the vice president and then later became the president.

And your dad represented Joan Rivers?

That's true. She said in some article, "If I knew that that brat of Steve Jacobs was going to grow up to be Marc Jacobs, I'd have been a lot nicer to you when you were a kid." What I remember was when I was six years old, the year before my father died, Joan Rivers had lent her house in Fire Island Pines to my parents, and I got very, very ill. I came down with some kind of fever and that was one memory I had before my dad died.

[Did] you work at William Morris?

I worked in the mailroom when I was fifteen. I hated it. I'm not real good about delivering, picking up things, getting the right things to the right people on time. No, I did a good job there.

I'll bet you did. Your dad passed away when you were seven and he was thirty-two? How did he die?

He died of cancer from undiagnosed ulcerative colitis.

Which you have, too.

Yup.

Do you remember a lot about him?

I have only good memories of him. I run into a lot of people—entertainers and artists and other incredibly talented and successful people—who remember my dad. And they all have really great things to say about him. There were people in the entertainment industry that were very fond of him, [like] Gregory Hines. I remember Calvin [Klein] introducing me at some event to David Geffen, and Geffen said, "Oh, I know Marc Jacobs. I was his father's secretary." And I have just the best memories of my father. Unfortunately he wasn't around long enough.

And you have two siblings, a brother and a sister?

I do.

Older or younger?

They're both younger.

Can you tell us anything about them?

Not really. I lost touch with them years ago. I mean we had issues and problems—it's

Left to right: Marc Jacobs with a model from his Perry Ellis collection; Parsons School of Design party, New York, 1984

probably not a very interesting story. Maybe it's not the nicest thing in the world, but we just didn't get along and didn't manage to ever repair our differences and stuff, so I've not really had any contact with my brother and sister in years.

And your mother, as you said, was remarried. She remarried three times, moved the three of you to Teaneck; Huntington, Long Island; then the Bronx and back to New Jersey?

Huntington, then Teaneck, then we were living at Fort Tryon.

Why so many moves?

Her father, who worked at MGM, was a commercial artist, actually a graphic artist. He had a brain tumor, and so she moved us into his place to take care of him. I didn't have the most delightful childhood.

Well, you're having one now.

Yeah, I'm enjoying my childhood now at forty-nine. Some people say I'm having a midlife crisis. And I'm like, what? I'm only fifteen.

So you don't have any regrets about not having your biological family in your life or sharing anything with them?

I have no regrets about anything.

Where did you go to school?

I went to the High School of Art and Design. My father had gone to Horace Mann, and my grandmother really wanted me to go there. She wasn't convinced that the High School of Art and Design was going to give me a proper, well-rounded education.

But you knew at that age that you were interested in art and design?

Yeah, I went on the interview at Horace Mann. But I introduced my grandmother to some of the liberal arts teachers at the High School of Art and Design. She was convinced and she let me go to school there. And then I went to Parsons School of Design.

You moved in with your paternal grandmother?

I did.

When you were seventeen? Is that right?

No, younger than that.

And she lived in the Majestic on Central Park West?

That's correct.

That's kind of fabulous.

Twelfth floor, 12L.

Can you describe her?

She was very, very beautiful in my eyes. She had white, white hair and very beautiful light blue eyes. My father was blond with blue eyes, which is strange.

Blond with blue eyes? Really?

Yeah. My sister and brother are dark haired with eyes like mine, and my mom had black hair and green eyes.

The dominant gene.

My grandmother loved to dress up. She was very well dressed. She was somebody who had me organize her shoes: the spring shoes went to the top of the closet, the fall shoes at the bottom of the closet. She changed her handbags with different outfits. Every department store was specifically for a particular item. You got stockings here, perfume there, cosmetics there. This was the time of Lord & Taylor, Bonwit Teller—

B. Altman.

Bergdorf Goodman, B. Altman, all of those places. And each one of them had a very specific purpose for her.

And she taught you to knit and embroider and do needlepoint.

Needlepoint came in handy when I tried to stop smoking. I made a couple of cushions—one for my partner, Robert Duffy, who got my first needlepoint cushion. It was called "Pansy the Cow."

When I spoke with Tom Ford and Michael Kors, both said that their grandmothers were the most important influences in their life, more than their mothers.

My grandmother was amazing. She completely believed in me. And she was very encouraging. She would go to the supermarket or the butcher or wherever and she'd say my grandson is going to be the next Calvin Klein. And I would turn eight shades of red and want to die, but smile. I knew that made her happy. It was very sad that when I had the show at Perry Ellis, she wasn't there. I knew how proud she would have been.

Well, she knows.

She was there.

In 1976, when you were thirteen, you applied for a job at Charivari on the Upper West Side. Did they hire you?

They hired me as a stock boy after a lot of begging.

But not until you were fifteen?

Yes that's right. Fifteen. [I was] folding shirts, bringing things up and down. Taking the clothes [once they had been pinned by the tailor] downstairs to have alterations done, filling out alterations tickets, putting tissue paper behind the register. I met Perry Ellis there.

So when fashion people came in, you knew who they were?

I was already a huge fan of Perry. He stood out in the Seventh Avenue design scene. He represented this spirit that felt more European to me than American, although it was completely American. [The clothes] had the kind of whimsy and humor and spirit and exaggeration of proportion that you would see more in a European designer. They didn't seem like career clothes. They were really fantasies. They changed from season to season

and Jed [Krascella] and Patricia [Pastor], who worked there, were just incredible. And Isaac [Mizrahi] worked there.

So when Perry came into the store, what did you do? Did you run up to him and say, "Hello, can I meet you?"

Yup. I'm not shy. I met Calvin at Fiorucci when I was fifteen. He probably doesn't remember. But when I ran up to Perry I said, "I'm really serious about being a fashion designer. You're my favorite American designer. Could you give me any suggestions?" And he introduced me to Jed and Patricia and said, "They both went to Parsons, and if you're serious, then that's where I'd suggest you go to get a good education." And that's what I did.

When you were sixteen and still at the High School of Art and Design, you were sent to see Stan Herman, known in those days as Mr. Mort. Stan told me when he saw your portfolio of sketches, he was freaked out—they were brilliant. He said you worked for him for several months while you were at Charivari, that you had a library of fashion in your head, and were opinionated about everything, especially the lack of talent his other assistants had.

No, he had this amazing, amazing assistant named Laura, whom I loved so much. Stan was amazing and open about his sexual relationship with his lover of many years. I knew a bit about his fashion. I knew that he was doing Federal Express uniforms, other uniforms, loungewear—and it was in this beautiful loft on 40th Street. It felt almost more like a made-for-TV movie about the fashion industry, because you're in this loft in a gorgeous building overlooking Bryant Park, and you'd actually have a place to sit with all these colored markers, and you'd get to draw. And it just felt like what you dreamed of—or what I dreamed of.

So that was a nice apprenticeship.

And he is such a good man.

Stan? You hear that? [APPLAUSE] He's right there.

Hi, Stan. I didn't know you were here. I wasn't saying that for your benefit.

I read that while you were in high school, you took your books to Studio 54 at night so you could go straight to school in the morning.

On Thursday nights, so that I could make my Friday classes.

What was the Studio 54 experience like for you?

Oh, it taught me a lot of things. How much of that would you like me to share?

Pick one.

It taught me how to behave in rather decadent fashion. And it gave me a sort of unhealthy curiosity about substances and anonymous sex and stuff like that. I wasn't the only one, by the way, who learned this lesson. Several of your other speakers were there too.

Many of them, actually.

I won't name names.

That same year, while still in high school, you took a summer course offered by Parsons to go to Paris to study costume design. How did you pull that off?

It was one of these programs where anybody could sign up. There were a lot of nurses, housewives. I had to take a loan. I had this thing in my mind that I had to go to Paris before a certain age. It was [about] the history of costume and you ended up sitting in these museums and they'd show you paintings and explained what was important or relevant. And I thought, I'm in Paris, I don't want to do this. So I went a little AWOL and stayed much

longer than the four weeks of the course. But [at] the end, we got to meet designers. I didn't meet Saint Laurent but we did go to the Saint Laurent atelier, and I got to hear Sonia Rykiel, who was a great speaker. I remember writing her a letter and begging her for a job. Sending her tons of knitwear sketches.

So it would be a stupid question to ask what you loved about Paris.

There's nothing I don't love about Paris. I'm envious of anybody who goes to Paris for the first time.

And you cried like a baby on the flight home because you knew you were meant to live in Paris.

I really cried on the plane. I was so happy in Paris. And I still am. I spend just under six months a year there. And there's not one morning that I go to work or one night that I come home that I don't pass the Place de la Concorde or see the Eiffel Tower, sparkling with electric lights, and I think, oh my God, it's so beautiful.

It's a dream come true.

It's beautiful. It's special. And I probably see it very differently than what it really is, because I don't vote.

And I guess you're not going to have to pay taxes there either, right?

Well, let's not talk about that because I did.

When you came back, you did finally go to Parsons, and, as you said, you credit Perry Ellis with suggesting that. Did you get a scholarship?

I got a partial scholarship the first year, I think. Maybe the first and second year.

Can you describe your years at Parsons? Were there any designers working today, colleagues, who were students with you?

We were a class of forty-two. There was a little troupe of us: me, Susan Martin, Chris Iles, and Tracy Reese. The four of us were inseparable. And we were kind of overachievers. Like, just like bring it on, no matter how much work. Just give it to us and we would do five times what was required just because we really enjoyed it. So we hung together, and we were inseparable. The year before us, there was Isaac Mizrahi, and we would go into this little lounge and see the upperclassmen, the seniors, Isaac and Bill Frawley and Peter Speliopoulos. And we were all still into dressing up. Every day was like a fashion parade. That, of course, dissipated in our final year—when we were just too tired to get dressed.

When you graduated in 1984, you were the Design Student of the Year. You won the Chester Weinberg and Perry Ellis Gold Thimble awards. For your senior class show, you presented three Op Art, oversized knitted sweaters, with dots and smiley faces.

The smiley-face thing was the first collection we showed in New York, but the sweaters I had graphed out, and they were inspired by Op Art. Perry Ellis was my critic for that project. I remember I presented sketches, and maybe this is that Aries thing, but he said, "You'll have to choose one." I said, "No, it has to be three." And he said, "You're not going to be able to finish one outfit in time, let alone three. Don't you think this is a little overambitious?"

But you did it anyway?

With a little help from my grandmother.

Those sweaters caught the attention of a young executive at the show named Robert Duffy, who was working for Reuben Thomas. So then what happened?

Well, he—Reuben Thomas—and his son were very fond of Robert, who had been working

Page 187: Marc Jacobs celebrating with models on the runway after presenting the Fall/Winter 1985 collection he designed for Ruben Thomas Inc.'s Sketchbook label. This page: Marc Jacobs and his business partner, Robert Duffy

there. What was the name of the dress line? Jonathan Hitchcock—quite fancy, dynasty-like dresses. They had decided that, besides the dress business, he wanted to start this thing called the junior business. And Robert had convinced them, instead of hiring a known designer, which they had wanted to do, to give this kid from school a chance. I couldn't believe that I was getting the opportunity. It was in a little space on 38th Street, between Eighth and Ninth Avenues. I had to call people and find a patternmaker, a cutter, and two seamstresses. I didn't know where to buy fabric, where to do anything, But luckily I've never been really afraid to ask for help. And that's what I did. And I made a lot of mistakes. I think it's courageous to ask for help. [Or] brave.

Then in 1984 your very first company, Jacobs Duffy Designs, was formed while you were designing a line [for Reuben] called Sketchbook.

We had made a deal with each other to form this partnership. We really hit it off from the very beginning. And he believed in me and still does. And I believe in him and always have. And we just said that, no matter what happens, no matter where this goes, let's stick together.

Robert has "1984" tattooed on his wrist to remember that first company. Do you have a "1984" tattoo?

No. And I'm terrible with dates.

But you're not terrible with tattoos. How many do you have?

Thirty-three.

And you have a personal tattoo artist.

He's not a personal tattoo artist. He's a good friend. Scott Campbell. He's a great artist and a sweetheart.

Any favorite tattoos?

Yeah, it's a couch, a Jean-Michel Frank couch. Ask me why a couch. Because everybody does, and there's no reason. That's exactly the reason.

And you have "perfect" on your right wrist.

That comes from "I'm a perfect being in a perfect world where everything that happens benefits me completely." I learned that in rehab. I thought it was a very good way of letting go and saying like, things may not go the way I want them to, I may not be happy with things, but everything is the way it's supposed to be. It's an acceptance thing.

Do you look at that tattoo a lot?

I'm right-handed and I see it, but you know, as much as I'd like to be, I'm not the Dalai Lama. I'm not the most enlightened, spiritual being.

You have the couch, you have M&M characters and SpongeBob SquarePants. What's with all the cartoons?

Kids on the beach like them. They're colorful and I think I see life in a kind of cartoony way. And I like colorful tattoos. I never saw tattoos as a dark thing—or ritualistic. When I started to get in shape, I just thought it was funny, and then what was funny got sillier.

Back to Jacobs Duffy Designs. Barbara Weiser, the daughter of Charivari owner Selma Weiser, ordered sweaters from you. But there was a new label called Marc Jacobs for Marc and Barbara. And she sent you on your first trip to Japan.

Yes. She went on a buying trip to Japan, and then we went to Hong Kong, where we met with a man—if my memory serves, and this would be shocking if it's right—named Abe Blum, who hooked up these knitters in the Far East to make the sweaters. And Barbara

committed to buying three hundred sweaters, and then sold them to her friends like Joan Weinstein from Ultimo in Chicago, Knit Wit in Philadelphia, etcetera. It was my first trip to Japan, my first trip to Hong Kong. But the biggest part of it, the most thrilling, was that she had taken me and was putting faith into making these sweaters. Then Bill Cunningham, from the *New York Times*, took pictures—

That you said helped kick off your career.

It definitely did. The same season there was a very popular Gaultier sweater with all this floral—it looked like a tapestry. [In Cunningham's photographs] there were four women wearing this Gaultier tapestry sweater and four other women wearing my sweater. That's when people started saying, "Who's this kid?"

A year later, Sketchbook went out of business. And in January 1986 you formed your second company, Marc Jacobs Inc., with Canadian manufacturer Jack Atkins. Then what happened? You and Robert both got fired from Atkins?

Yeah, That's right. I think he had problems. Robert and I ended up stranded in Toronto. It wasn't a nice ending.

Then in April of that year you did your first collection under your own name backed by Onward Kashiyama. That was the year your grandmother passed away. Was that really traumatic?

I think it was probably the most painful… I've lost a lot of people in my life. I've lost a lot of dogs in my life. Dogs seem to affect me much more than people. I don't know if I became very insensitive because my dad died at such an early age. My psychiatrist, Dr. Richardson, he might be able to tell you. But no, I accept people dying. With my grandmother, it wasn't that I didn't accept it. It just felt like a really great loss.

Then Robert really became your guardian.

Robert is the longest relationship I've had with any human being. We're not lovers, nor have we ever been. We've never even kissed each other on the lips—not on purpose anyway.

Then you were named a rising star by *Vogue* and in January of 1988, you received your first CFDA award at twenty-five, the youngest person to receive the Perry Ellis Award for New Fashion Talent. And Perry had died two years earlier. How did that feel, getting an award in Perry Ellis's name?

It was very hard—he was very special to me, not because I really had the first-hand experience with him but because he represented something so special to me. He was a hero. And watching this hero go, that was such a traumatic thing—

It was also one of the early AIDS deaths.

Exactly. He represented a lot—that time in New York was just very scary and very sad.

You were also interviewed that year for the TV show *48 Hours*, and before your show you were busy vomiting in the bathroom while Robert was building the runway. You've referenced that because it reminds you of how far you've come.

Oh yeah. Robert was banging away at these little platforms on the floor. And I get so stressed. I wasn't eating well at that time, and I drank too much coffee and Coca-Cola and ate too much McDonald's and pizza, and I'd get physically ill and vomit. It wasn't an eating disorder. I'd just get sick with nervous anxiety.

By the end of that year, it seemed like another circle was closed, and yet again, a new beginning. You and Robert joined Perry Ellis, you as vice president of design and

Robert as president of the women's line. With [the] aura of Perry, did you feel a sense of responsibility and awe, taking that job?

Oh my God, yeah. I was twenty-five years old. And it was huge—I mean, walking into this showroom that was a bank. I remember the first day I showed up, on a motorcycle, and someone told me deliveries are around the back. And I was like, no, I'm the designer here. Actually, I hired Tracy Reese to do Perry Ellis Portfolio. And I asked Tom Ford to do [America].

What was Tom like at that time?

He's amazing. He's incredibly talented. I thought if he did the jean line he'd bring sophistication to something that was considered casual. His references were Warhol and art, and I thought that would elevate the jean line.

September 1992, you designed the famous grunge collection, which you often acknowledge as your most memorable and liberating collection. Why?

The stars were all aligned. I was very inspired by a group of girls who were the antithesis of what was considered perfect and beautiful and glamorous: Kate Moss, Kristen McMenamy. And photographers like Juergen Teller, Corinne Day, Craig McDean, David Sims, and music like Nirvana and Pearl Jam, and Sonic Youth, and I felt like all these forces were saying the same thing: that there was this angst, this feeling that something's got to change. It wasn't punk and it wasn't hippie—it just felt like a very different movement. There was something very real and very honest, and it was saying I'm perfectly imperfect and I can wear a flannel shirt and no makeup and Birkenstocks and look just as amazing as you do. So I guess there was that fuck-off thing and—oh, sorry. There were a lot of the supermodels in that show. Kevyn Aucoin did the makeup. And Kevyn was like, you want no makeup? And I was like, yeah, no makeup. It seemed so ironic and perverse. And Oribe was like, you don't want me to do their hair? And I was like, not really.

What a good gig for them. That collection probably got more press than anything ever. It was ahead of its time. Why do you think it didn't sell?

Well, I don't think it was only that—there were a lot of circumstances going on at Perry Ellis, and this gets into Manhattan Industries and licensing and the financing of the collection. I can't even remember all the details. It wasn't like a licensee was paying for it. So it was a big

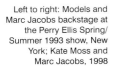

Left to right: Models and Marc Jacobs backstage at the Perry Ellis Spring/ Summer 1993 show, New York; Kate Moss and Marc Jacobs, 1998

expense. It wasn't going anywhere. It wasn't selling. Fashion was in a different place then.

You won the CFDA award for that collection, and then you both got fired. Were you shocked or surprised?

Yeah, it was probably the best thing that ever happened. Robert and I were aware of what was going on there. We weren't stupid. When Perry Ellis could collect money from its licensed products, why should it spend money on something that wasn't going to make money?

They closed the designer business after that.

So it didn't seem irrational, and it didn't seem like it was because of the grunge collection. But it happened to be timely.

In 1993, you and Robert started a fourth venture, a licensing and design company, Marc Jacobs International Company, LP. You guys kept your lawyer busy.

He's like ninety-eight years old. Thank God, he's still around. Eugene Kline.

Everybody keeping all these sources, this is a good list for the industry. In April 1994, on your birthday, you staged your small collection. Naomi, Linda, everybody walked for free. And then you had Iceberg, Renown, Gilmar—

I have Anna Wintour to thank. She was a big supporter of mine. She had just gone to *Vogue* when I started at Perry Ellis, and in fact, she opened the editorial with a double-page of Tatjana Patitz in a little short sequined dress of ours. So it represented, for her and me both, a start of something. When we had finished at Perry Ellis, Anna had introduced me to Gianni Versace and Karl Lagerfeld. Gianni was very instrumental in introducing me, as was Franca Sozzani through Gianni, to Italian companies to do consulting work, and I got a job consulting for Gilmar Iceberg.

To all those young designers out there, I hope you see that this is not an easy career path.

Piece of cake—any of you could do it with your eyes closed. It's just simple. Right, Stan?

And then in January 1997, you were appointed artistic director of Louis Vuitton, with responsibility for designing their luxury goods and creating their first clothing line for men and women. LVMH took a major stake in your label. Today, it's ninety-six percent, correct? How long did those negotiations take?

You'd have to ask Robert. Lawyers or accountants start talking and I [tune out]. But if you want to show me fifty thousand swatches of duchesse satin, I'm an attentive audience. I'm not real good at staying within a budget.

Not many designers are. You said in an interview, you thought that what Tom Ford was doing then for Gucci inspired Mr. Arnault to call [you].

I think it was hard to ignore that success. Mr. Arnault is a very smart man. No one would argue that. He is the wealthiest man in France, and it's got to be for a reason. But I think he saw what was going on at Prada, what was going on at Gucci. He had already hired John Galliano to do Givenchy. And then Alexander McQueen, then John went to Dior. I think [Arnault] saw that Vuitton had the ability to get out of just making luggage. I think he also saw that it was becoming this thing that your mother or your mother's mother carried. Although it was extremely lucrative and very successful and probably the biggest money-maker in the LVMH group, he felt the time had come for something younger and newer.

Describe the French reaction when you were announced for that job.

The French don't really like anything. I'm being sarcastic. Not really. But I think a lot of people within the company were very threatened. First of all, it was Mr. Arnault's decision and he's

the big boss. Yves Carcelle, the president of Vuitton, and Robert Duffy had their differences. The head of communication, Jean-Marc Loubier, wasn't a big fan because he didn't want me to be the designer, and it was somehow stepping on his creative toes. And then there was all this intrigue, kind of Shakespearean—well, it wouldn't be Shakespearean because that's not French—

Was this a dream of yours, to design for a French house?

As I said, I cried leaving Paris and I wanted to live there so badly, so to get the opportunity to work for a big luxury brand and be able to spend time and actually have a life in Paris was a dream come true.

So this new relationship with Louis Vuitton made you a very rich man. Did your life change right away?

I don't think I'm very rich. I think I'm very lucky. And I'm certainly comfortable. But I've never been really uncomfortable. I've always worked.

When you got the job at Vuitton, whom did you call first?

It was Kal Ruttenstein or Candy Pratts. There was probably a string of people that we told.

Did you have to hire a new team or work with everybody there?

There was nobody there. There was no fashion, there was not a soul. Even though it's part of this big company that has Kenzo and Dior and Givenchy, it doesn't work that way. We got a little studio on the rue du Bac, which was an apartment building. People were bringing their dogs. It was a mess. And the neighbors were furious because the lights were on after eight o'clock and they didn't want us to work on weekends but we had to. It was Peter Copping, Jane Whitfield, and Victoria Grantham, me, and Camille Miceli—

Are they all still with you?

No, everyone's gone. Jane Whitfield was at Balenciaga working with [Nicolas Ghesquière]. Peter Copping does Nina Ricci. I don't know what Victoria's doing now. And Camille Miceli is also at Dior.

Do you consider Paris home?

No, I consider New York my home.

Do you speak French?

I do. I never learned to speak properly, and I'm a little timid. Around the time of the shows, I speak with everyone in French and sometimes I make some really terrible mistakes.

Can you tell us a little bit about your very first show for Vuitton? How you set the tone? You did only one bag for that show?

Clockwise from top left: Marc Jacobs holding the Stephen Sprouse-Louis Vuitton collaboration bag, by Terry Richardson, *Harper's Bazaar*, January 2009; a general view of atmosphere at the Louis Vuitton and Yayoi Kusama collaboration unveiling at Louis Vuitton on July 10, 2012 in New York City; a model walks the catwalk at the Louis Vuitton 2008 Spring/Summer fashion show in Paris

Yeah, one bag and it was white. It was embossed and lamb. It was the most impractical thing. I thought it was going to be very clever, and we went back to the original sort of trunk, which everybody knows Vuitton for, [with its] iconic monogram. [The collection was inspired by] the first Vuitton trunk, [which] was a pale gray, and it had only the name "Louis Vuitton" written inside the trunk, the iconic monogram. So that's what I looked at. It was a very minimal collection, where the only logos were inside the clothes. The hems of the cashmere sweaters were as deep as the sweater. Everything was doubled. It was all about hidden luxury, because of this pale gray trunk. But that wasn't really what people were hoping for. They wanted the monogram.

And lots of it.

I understood. It's luxurious, but what makes it so universally popular is that people recognize it. When I was a kid I wanted an Izod Lacoste shirt because I wanted the alligator. And I wanted Keds sneakers, and Ray-Ban sunglasses. So I understand. Vuitton represents quality and craftsmanship, so you belong to that clique.

You also saw a Louis Vuitton trunk painted black and it got you thinking about Marcel Duchamp's painting, the L.H.O.O.Q.

Which means "she has a hot ass." It's the Mona Lisa with a mustache.

And you realized that the LV monogram was the core of that business.

That's when I asked Stephen Sprouse to do the graffiti. It was the idea of defacing something iconic, which is what Duchamp did with Mona Lisa.

The Sprouse work brought a whole new energy and confidence—

There were all these calls back and forth, and they weren't going to produce it and they were going to do it and they weren't going to do it. They told me I was absolutely not allowed to print on top of a monogram. It was a big no. Finally they did, and there were so many copies, the counterfeits were all over the place. Victoria Beckham was on the cover of one of the English newspapers with a counterfeit [graffiti] bag. That's how I met her, because we sent her a real bag, when we saw she had the counterfeit one. That's when Vuitton realized that there are people counterfeiting all this stuff and getting it out there quickly.

That led to other artist collaborations—with [Takashi] Murakami, Richard Prince, [Yayoi] Kusama. Do artists contact you and ask to work with you?

Some do. But it's a very instinctive thing, and I've tried to explain to Mr. Arnault that it needs to feel right. If it becomes a formula—if you just do with anybody—it'll lose its special quality. When I was in Tokyo I met Yayoi, whose work I completely admire. And Richard Prince is one of my favorite American artists.

The Murakami designs sold $300 million worth of bags.

It was crazy. But again, it was something we were "not allowed to do." It went from a three-color print to thirty-two colors.

Do you think in some way you're making art affordable to people who can't buy a Richard Prince painting?

Contemporary art actually influences the whole landscape of the world, even when we're not aware of it. I remember when we worked with Murakami, I had a Motorola cell phone with these colorful circles that looked inspired by Murakami. A lot of people may not be as enthusiastic about going to see contemporary art as maybe I am, or art collectors or art enthusiasts, but I think it does infiltrate advertising, clothing, everything.

Did working with these artists fuel your collecting and passion for art?

The collecting started before. It's because I got over this intimidation about going into a gallery or a museum because I didn't have an art history background—so who was I to look at a painting? And again, it was one of these lightning moments of revelation, where I thought, you know, my opinion, whether I like this or not, is all that matters.

Right, if you like it, that's good enough.

It's fine, and if you don't judge, the doors are wide open. You can actually see and experience things. I thought I couldn't—I didn't have the right. That's just silly. But it took me a long time to learn that.

But what a well-learned lesson. So now when you look out in your Paris apartment, you see not only the Eiffel Tower but also works of art by [Georges] Braque and [David] Hockney and Warhol, [Francis] Picabia, Ed Ruscha, Richard Prince.

It's really nice. And they are only temporarily mine. Steve Martin—you know the comedian?—he's a great art collector. He did an exhibition [with] a quote from someone who said, "Temporarily lent by owner." Things, as they are, are only temporary. And I'm just glad that I have beautiful things to look at for now.

Is there an artist you're coveting at the moment?

I love the work of John Currin and Rachel Feinstein, his wife. I love Elizabeth Peyton, Cindy Sherman. Ed Ruscha is my very favorite artist. There isn't anybody new whom I can tell you about.

In 1996 your first Marc Jacobs store opened in SoHo on Mercer Street. How many years did it take before you took over Bleecker Street?

Robert was living in the West Village, and he just felt he wanted so badly to open stores there, and it was a destination.

He got it. Bleecker Street is now on the bus tours of New York.

Sarah Jessica Parker has something to do with that. People are there for the *Sex and the City* tour—or Magnolia Bakery.

It all helps. But the rents there now rival Madison and Fifth Avenue, and I think you're responsible for that.

Robert's responsible for that.

So he's the real estate guru?

Totally. I mean except for the Palais Royal, where there were no designer shops except for Didier Ludot, which was vintage clothes. It was my dream, dream, dream, dream to have a boutique at Palais Royal. Mr. Arnault and all the LVMH executives said nobody's going to shop at the Palais Royal. [But] the rent apparently was very affordable, so he said, "Look, it's not that big of an investment. If it really means that much to you, you can do it. I'm telling you, even my daughter Delphine wouldn't go to a shop there." And now you've got Rick Owens, Stella McCartney, Pierre Hardy, all these people.

You then win more CFDA awards, one for women's, two years later for accessories. And at that time, your business was going through the roof and your business couldn't be higher, but so were you.

Big secret, Fern.

I know, exactly. So in March or April of '99, there was an intervention by Robert Duffy—described as an act of love—with an assist from Anna Wintour and Naomi

Left to right: Advertisement for Bang cologne by Marc Jacobs; Marc Jacobs with dog (Neville), 2013, NYC

Campbell. Was it a call made to Mr. Arnault, or did Robert fly there?

Robert and I went to Mr. Arnault and explained what was going on. I didn't feel good about it, but I knew that I needed help. And I knew Robert was going to insist on it. When Robert would leave me there in Paris, he was like, these people don't really care about you. They don't love you. They don't care about your health. They want you to work and perform, and as long as you do that, in some sense they'll take that. So Robert insisted that we meet with Mr. Arnault, and we told him the truth, that I had a problem with substances and alcohol and needed to go away for a month. And that's what I did. I mean, I did it more than once. It was a couple of times, but it made sense, you know? I needed help and I finally admitted it. That's the first part.

That's the most important part, being out of denial. Do you remember your famous meltdown on the airplane?

I was on an airplane. That's about all I remember. I've had a couple of meltdowns on airplanes. I'm much better now. I don't miss flights really, normally. Sometimes I change them or cancel them or postpone them, but no, I'm better with planes now. And I don't have anger issues. I don't throw cell phones—I only hurt myself. I don't really hurt other people.

In 2001, you began adding fragrances, the first was called Marc Jacobs, and then it was Gardenia, then Daisy.

Daisy is my dog, named after Daisy Buchanan from *The Great Gatsby*, who's my favorite character. There's Daisy and Eau Daisy and Daisy Eau. And then there's Lola and Oh, Lola! and Lola Eau and Lolita. And then there's the Marc Jacobs and all the splashes, which change every three or four months. And we just did Dot.

And then there's Bang.

Bang—that's the men's fragrance, which is not as successful as the women's. But Daisy is the big success.

In the next five years, you won three more CFDA awards, and in 2006 you opened your first Marc Jacobs European flagship. How is Marc Jacobs perceived in Europe? Is it as popular there as in the U.S. and Asia?

I don't know. It's hard for me to say. I doubt it. I think we're probably more known here and

This page: Marc Jacobs in costumes attending his annual Christmas holiday parties. Page 203: Marc in Paris, 2008. Pages 204–5: Marc in his New York studio

in Asia than in Europe, except maybe in Paris. But it's hard for me to see because the Marc by Marc store is super popular there, and there's always tons of kids drinking coffee and smoking cigarettes outside and hanging out in the shop, a vibe that's almost like from another time, which you don't see in Paris in a retail store, except for maybe Colette.

Was Marc by Marc Jacobs your idea or Robert's?

It was our idea. Both Robert and I love things that are as honest as a cotton T-shirt for twelve bucks—as we love a cashmere sweater [and] a duchesse satin dress or a beaded dress. As long as things have the integrity of design and honesty, you go at them with the same passion. And it's great to reach more people. You can't do that with fur and sequins and beads and stuff.

You appeared on *Oprah*. You did ballet costumes for Amoveo, with Philip Glass music from *Einstein on the Beach*, at the Paris Opera House. Would you do more of that?

No. I got trashed for those costumes. In fact, they just redid the costumes. Benjamin Millepied was the choreographer. It was an evening of young choreographers. And I was very flattered that Benjamin had asked me. And he, of course, is a great dancer. And I loved the music. Philip Glass is my favorite composer, so I spent a year listening to *Einstein on the Beach*. And I designed forty-four different costumes. There were forty-four dancers, two principal dancers for the pas de deux and the forty-two core. It was a lot of work. Dancers are really difficult [to design for] because they have to move. So they have to raise their arms, and I wanted to use metal thread and they were like, it's abrasive. Oh, I would not like to do it again.

But you do enjoy costumes. You have legendary costume parties.

We did. I wish we still had them. They were fun. But that's Robert—Robert would throw these great Christmas parties.

You've come dressed as a giant pigeon, a stuffed camel-toe, a polar bear—what else?

A bottle of ketchup.

And you've had to be transported to these parties in a flatbed truck.

Yup. Each year the thing was how much more complicated could I make it, to the point where the last one, the camel-toe one, had to be built and assembled in the Rainbow Room because they couldn't get it through the revolving door. And it was actually great, because there was a stool inside and I sat there, and everybody just wanted to have pictures taken with me all night. I didn't get to dance.

I don't think big camel-toes dance a lot. Then in the midst of more success—in 2007, the day after your Vuitton show, you suffered a relapse and voluntarily checked back into rehab. How long did you stay?

They're usually twenty-eight days.

Have you been sober since then?

I wouldn't say I'm one hundred percent sober. I'm not perfect. I've had a glass of—

Look at the wrist.

Perfection is an ideal, and yeah, I've had a glass of wine and maybe a couple of whiskeys, maybe I've smoked a joint, but I'm mostly sober.

You are addicted, apparently, to smoking.

Cigarettes are my big vice. I do smoke a lot. I don't recommend it. Every doctor will tell you it's a really stupid thing to do.

Have you ever tried to kick that?

Many times. I've gone three months, seven months, but no longer.

I read, at one point before your transformation, you had twenty-one percent body fat. You were always sick and in and out of the hospital, spent hours in the bathroom with ulcerative colitis, and you were told you needed to have your colon removed. Was that an "aha" moment that focused you on your health?

That's when I stopped believing in medicine. And I started believing in nutrition and taking care of myself. A friend, Kim Gordon from Sonic Youth, said, "Why don't you see a nutritionist?" And what's the nutritionist's name? Are we sharing that with everybody? Dr. Lindsey Duncan, and he said to me, "Okay, I'm going to give you a change of life, starting with your diet." I drank green kale, wheat grass, raw egg whites inside green vegetable juices. I had only boiled chicken. No olive oil, no white flour, no dairy from a cow, though I could have goat cheese or goat yogurt. No caffeine. And for the first year no sugar of any sort. And I was one hundred percent compliant. He told me I had to take a nap every day or meditate. I had to laugh every day. I had to sweat every day, which meant go to the gym, do yoga, do something physical, get out of the chair, get out of the fitting room, get out of the office.

Why laugh every day?

The thing is just not to take everything so seriously.

Did you make a conscious effort to be funny?

I laughed at myself when I saw myself at the gym.

Are you still doing the juices and the green drinks?

Yeah. But I'm allowed to cheat. I cheat on Sundays and get away with it. You know, what he worries about he said was not having a piece of carrot cake or having my espresso in the morning. The problem is that if you see that nothing's going wrong then you start doing more of it. So if the coffee's not bothering you, then you just think you can drink caffeine all day. And if the sugar isn't bothering you or the white flour. [The point is] I don't want to get back to where I was.

How hard was it to make that change and drop all those things?

It was incredibly hard. I cried for like the first year. Because I was sitting alone, eating my lunch and dinner. I'd have a bowl of buckwheat noodles and [miso] broth, and I had almond milk and white rice, all the blandest—

Were you able to go out and be social?

No.

And you had a chef preparing all that for you?

Yeah. It was all organic. It was a lot of juices—really horrible-tasting, bitter, nasty juices because I couldn't even have sugar from fruit.

Wow. That's got to be rough.

But, it was worth it. I have my colon. [APPLAUSE]

You said that going to the gym was like the song in _Chorus Line_—everyone looks great at the ballet—but [in this case] everyone looks great at the gym.

At David Barton they sure look great. Nice way to spend the morning, believe me. There are a lot of really nice-looking people there. David Barton? That's another one for you.

How often do you go?

I go five or six days a week, two hours a day, in the morning, usually at nine. Tomorrow's my late day. I go at ten. Then I go to work.

And how late do you stay at work?

Right now, I'm still able to leave at six or seven. But as the days go by, it'll be progressively later. And there's no day off anymore.

So what is a typical meal like now?

For breakfast I usually eat fifty grams of oatmeal, and I take all these juices. Usually for lunch, I have some carbs, whether it's bread or rice or potatoes. I either have a grilled hamburger on spelt bun or a tuna salad with olive oil–based mayonnaise or a grilled chicken paillard. And at night I usually have a steak or chicken and green beans, green vegetables, spinach, juices.

That's pretty manageable, right? Is there anything you crave?

Pasta and pizza, all the time.

What was it like to finally start liking how you looked and felt?

That was really fun. I'm really insecure with the way I look. But not like before. I do take good care of myself. Actually, when I took a shower to come here tonight, I took a picture of myself in the mirror to send to my boyfriend. And I obviously wouldn't have done that if I didn't feel pretty good about the way my body looks.

And you get regular haircuts, manicures, pedicures, facials?

Well, the manicures and pedicures I've been a little lax on. But I do like to have a facial. And I use nonabrasive products, so hopefully I'll have my skin for a lot longer. And I haven't been in the sun since last June.

Will you add those kinds of products to your line?

Well, we're doing cosmetics, but they're not skincare products.

Marc Jacobs brand?

Yeah, with Sephora.

Does this new confidence influence your collections?

I think so. For a long time I didn't care about my appearance, and I was down and having all this discomfort. Even though work was the work I love to do, it was difficult. Although I was physically present, I don't know that I was really giving—or could give—my all. When I started taking care of myself, I became better to myself and better to others. And although there [are] still days, moments, hours, weeks that are super stressful, there's also laughter and excitement. I like to buy clothes. I like to buy suits.

Skirts and kilts and—

Lace dresses, all sorts of things. Fur boas from Prada.

Do you consider yourself a heartthrob?

No, Tom Ford's the heartthrob.

Oh, I think you've become one. Your social life played out on *Page Six*. Does that make you crazy?

I love attention. I always find it very funny when people say they don't like attention. Because a baby who doesn't get attention when he's born—if the baby didn't cry, wouldn't get attention from its mother, it wouldn't survive. Maybe my desire for attention is a little too out of control, but I'm very honest. I love attention. I wouldn't go out at the end of a show or put on a show if I didn't want to entertain the audience and want the audience to like what we did. Of course, we're doing it for us but we're also doing it to please others; that attention, that praise, that applause, is the reward we're looking for. Or I'm looking for.

In 2009, you had an engagement to Lorenzo Martone that was all over the media. Had

you actually planned to get married?

Well, he asked me to marry him. Then he broke up with me. I still wear the ring. Everybody thinks I'm the bad guy, like I got rid of Lorenzo. But he just changed his mind. But we're best friends.

You've dressed Miss Piggy. You won the prestigious French honor the Chevalier des Arts and Lettres. You made *Time*'s 100 Most Influential People list. You appeared with Anna [Wintour] on *Late Night with Jimmy Fallon*. And then you were also given the Geoffrey Beene Lifetime Achievement Award from the CFDA—your ninth or tenth, maybe—more than anyone else has ever received. Are you over the award thing?

I don't believe in awards. It's always hard—I don't mean to sound—well, I'll just say what I think. I think it's an opportunity to get on stage and thank publicly all the people I work with. That is the reward, or the award is the doing. The journey is really the important thing. It's the process of putting it together, and although the show marks the end of that process for us, it's every bit of it that's important, not just the trophy. And it's not just a check, because that's not what we all signed up for. The passion is in all aspects of the process.

Let's talk about the inspiration for some of your shows, and the extraordinary sets, designed by Stefan Beckman and Rachel Feinstein. Clearly, at Vuitton there is funding to support your vision with everything from carousels, trains, elevators—and I don't know how you're going to top the six escalators with models in stripes on every stair. How do you envision a show when you're designing a collection, and collaborate to make that happen?

I'm not a very linear thinker. So it's quite difficult even for me to follow my train of thought. But after the romance, everything is a kind of reaction to the season before. And so fall, both at Marc Jacobs and Vuitton, were very romantic. One was this [Dickensian], weird journey in Rachel's magic wonderland. The other one was a train trip that was kind of Vincent Minnelli, Barbra Streisand, *Funny Girl*. We wanted to do something very nonromantic. So we were looking at the work of a great French artist named Daniel Buren. There was a precision and a sort of mathematic—I found it very comforting and very soothing that there was nothing soft or romantic. And it was very conceptual. I'd also gone to see Philip Glass's *Einstein on the Beach*, which I never got to see the first time. And I sat through the four and a half hours without moving, just watching and being in heaven. But it was Daniel's work and we wanted to do something that was non-monogram, so we chose the Damier pattern, which was a grid. And it was inspired by the work Les Deux Plateaux, which was [at] the Palais Royal. So in a very conceptual sort of art performance thing, we just made columns that were three lengths—short, middle, and long—for Vuitton, and they were all in checks. And Daniel Buren did these escalators that went up and down on a checkerboard glass floor, and it was really magical and beautiful.

The visuals were extraordinary.

Usually I can't tell and I ask somebody backstage, like Katie Grand and Julie de Libran, "Was that good?" But when we were watching the video of this last show at Vuitton, we're like, whoa, we've never seen anything like that. I really loved it.

You also have a great relationship with Juergen Teller, probably one of the longest and most influential designer-photographer relationships in the industry. What's your most memorable campaign or ad with him?

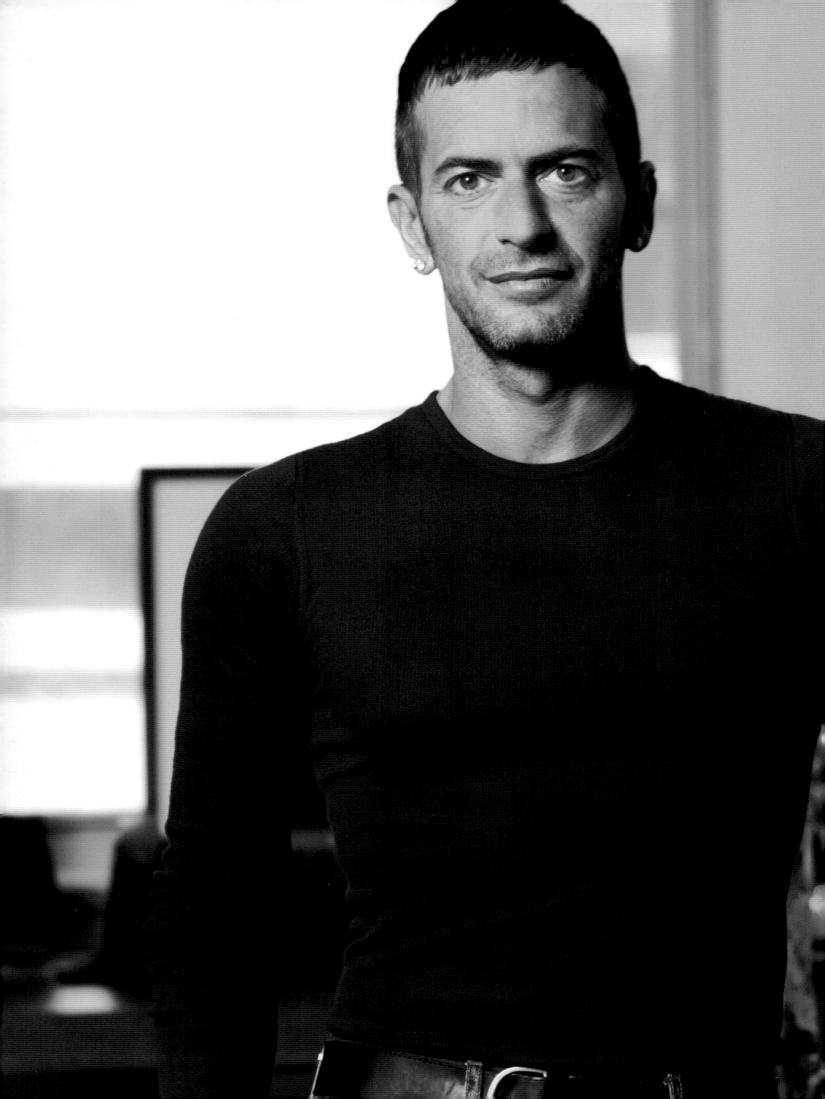

Probably the first one, when my friend Kim Gordon from Sonic Youth was wearing a dress of mine onstage. Joe McKenna—a stylist who was doing a magazine called *Joe's*—asked us for an advertisement. We didn't have money to do an ad, but we wanted to be supportive of Joe. So I asked Juergen to take a picture of Kim in my dress. And he did, and he gave us the picture and permission to use it. That started the way we worked and how it became a family tree; everybody in the ads is connected in some way. Lately, we've been working with a lot of models. The Victoria Beckham one was really funny. Sometimes it's Juergen's idea and sometimes it was mine. Whether it was Sofia [Coppola] or Victoria or Kate Moss, we've had this really nice dialogue.

Which designers working today do you admire and respect the most?

I respect Rei Kawakubo, who creates the clothes for Comme des Garçons. My very favorite designer is Miuccia Prada. I feel very close to the spirit [of] what they create. It's very sophisticated. There's also something subversive and it's not conventional. It's not about a pretty dress on a pretty girl. It's valid commercially and clever and intelligent and attractive.

I'll never forget the moment when I was backstage at the CFDA Awards when Miuccia Prada was getting the first international award and Bill Blass was the next award up; when she came out, he looked at her and looked at me and said, "That's the ugliest dress and shoes I've ever seen in my life." He just was mortified.

I have a good Bill Blass story. Bill Blass loved to smoke cigarettes and he and all the receptionists sounded like they smoked cigarettes and drank whiskey. Anyway, I was invited to a lunch at Veronica Hearst's house, and Bill Blass was there. And I was so nervous. And I [asked him], "Do you think I can smoke here?" He said, "Go ahead, smoke. You won't be invited back if they don't want you back. But it won't be the smoking that'll be the reason."

Were you invited back?

Um, no.

Was there a chance that you were going to go to Dior after [John] Galliano?

It was a very big discussion, and it went on for quite a while. And it was very flattering and also a little tortuous for me. I think it would be a very difficult place to work. I was flattered, and I was very honored that Mr. Arnault considered me for the position, but I really wanted to stay with my team and I held my ground. It was actually Dr. Richardson, my psychiatrist, who asked, "How would this improve the quality of your life?" And I said, "It won't." Luckily the decision didn't have to be made because Mr. Arnault also realized that I was right for where Robert and I were, at Vuitton. And while we've achieved a lot and accomplished a lot, there's a lot more we can do. So while it was very flattering, it was really months of psychodrama.

Are you a Tweeter?

No. Marc Jacobs [the company] does, but I, Marc, don't.

So people call you to [reach] you.

I like to text. I have an iPhone.

And you're on email?

No, emailing is not so good for me either. If people text me, I answer.

Have any of your design assistants come to you wanting to open their own label, and would you ever fund them?

Yeah, Richard Chai was working with us and he started his own business. Anything's possible I suppose, but I think we have enough problems funding ourselves sometimes.

We're almost at the end of this. We have a good question from the audience: Where do you think you fit in the fashion universe?

Square peg in a round hole? I don't know if I fit at all.

I think you fit in and have an important place in the fashion universe. Are you still insecure and think that you aren't talented enough and don't deserve everything you've achieved?

Well, you know, I look over my shoulder and I always think somebody else does it better. That is still an issue. It's not 24/7, and it's a lot better than it used to be. You can start to use these spiritual sort of axioms, but when I'm in the moment and doing my thing, I'm safe and I'm good and everything's fine, all is perfect. But when I look over my shoulder and say, "Oh God, they're so much better," or that one did this better than we did, then you get lost. It's like living in the past or living in the future—those aren't real. The moment is now, and that's where safety and comfort and all that good stuff is. So if I'm not comparing myself to somebody else, I don't need to be better than anybody and I don't need to be worse than anybody. I don't need somebody to be less than me in order for me to feel better about myself. I need to stick on my own path and stay in the moment, as best as I can.

Okay. What's on your bucket list?

What's that?

Things you still want to do in your life that you haven't done.

More.

More of all of it?

Have more sex. Eat more food. Go to the gym more often. Do more collections. Have a manicure. Buy more art. See more art.

All right. That all works. Another audience question: what advice do you give to someone who wants to be a designer?

I don't give advice, but I can share my experience. What's worked for me is not quitting, being passionate about what I do, and not giving up. And when I don't believe in myself, turning to others who believe in me.

Why don't we close here: Do you care about the critics anymore and what they say?

Yeah. I'm a human being. I get hurt, too. I don't mean this in a bitchy way, but there are very few journalists whom I respect because I don't think a lot of them know what they're looking at, so I don't sometimes feel the criticism is valid. I'm fine with constructive criticism, but I'm not so good with stupidity. And again it's one thing to say I like or I don't like something, but to misread something or to mislabel something or to be out of sorts because it was raining or it was too late and you were hungry—that just all feels not valid in terms of constructive criticism. There are certain critics that I do really respect, and when they don't like something it hurts because I feel they're right. But it hurts in a good way.

Well, then, let's not end on a critic's moment.

Okay.

What moment did you know that you had made it?

I don't think I've made it yet.

I knew you were going to say that. Well, I think you've made it. This audience thinks you've made it. [APPLAUSE]

Thank you, and you, too. And you guys, too. [APPLAUSE]

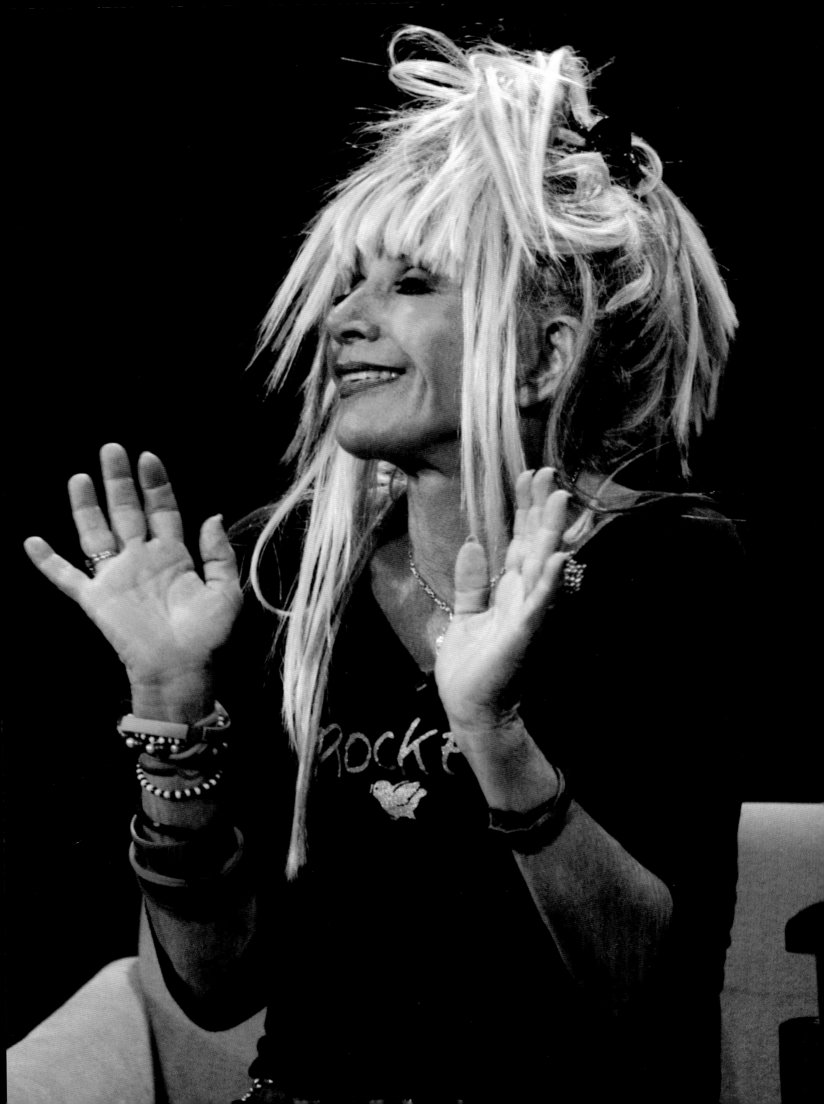

BETSEY JOHNSON

Tonight will be a roller-coaster conversation with my friend Betsey Johnson. What can I say about Betsey? She has had more lives than an alley cat and [has] more energy than the Energizer Bunny. And she has fun, which is something we all could use a little more of. My nieces, and tons of other young girls, were devastated when she closed her stores and bought whatever they could: the hangers, the fixtures, the props. Her fashion shows are always a blast, because Betsey never panders to the media or the press, and she is consistently inconsistent. Being backstage at a Betsey Johnson show is like being in Times Square on New Year's Eve. There are balloons and confetti and colors galore, stacks of cupcakes, champagne, candies—basically it's a sugar high. And I predict that when Betsey no longer does a cartwheel at the end of her show, we'll know she's hanging up her scissors. It's impossible not to have a good time when you're in Betsey's presence. So, ladies and gentlemen, let's welcome the lady whom I was quoted in the New York Times as calling "the youngest old designer in the world or the oldest young designer in the world," Betsey Johnson.

BETSEY JOHNSON: This lady—along with Marylou Luther—are two ladies in my life who have made me feel loved and at home and respected me.

FERN MALLIS: Thank you, Betsey. Sit down, and thank you so much for doing a cartwheel onto the stage and for joining me tonight.

I'm so honored.

You were born on August 10, 1942, in Wethersfield, Connecticut. You are a Leo, actually, a double Leo with the Taurus rising. Do you follow the zodiac?

Yes. I hung out with Linda Goodman when she was going to Pratt so I got into it. What's the name of her book?

Linda Goodman's Sun Signs. **Leo is the showboat of the zodiac, the party giver. Your sun and moon in Mercury are all in Leo.**

But the thing is, the sun is the top and the moon comes along with the bucket, so that's why I'm very shy, basically—very insecure. Designing is a challenge to prove that I make sense on the planet.

The lion is also the Leo sign, and look at Betsey. Look at her hair. She is a lion.

Cost five thousand dollars a shot to look this cheap and trashy. Twenty grand a year.

Okay. Leos also look for Klieg lights and applause. They are proud and willful, magnetic, generous, outgoing, want appreciation from people. Leos' work reflects what's really inside of them. There's youthfulness in their enthusiasm. You grew up in Terryville, Connecticut. And your family was very WASPy Protestant. That's kind of hard to imagine.

Very sweet, loving, the perfect 1950s family.

Your father was a mechanical engineer and your mother a guidance counselor.

There's nothing like having your mom be the guidance counselor in your high school.

So you have siblings, right? Tell us about your relationship with them.

My sister and brother are my two dearest, closest friends, especially my sister. She's two years older and she looks thirty-nine. I used to be so jealous of her fingernails. I would go in

her bed at night and I would try and bite her nails off. Sally was a cheerleader. Sally was the prom queen. She was so much to live up to.

What did your siblings do for a living when they grew up?

Sally always ran helpful things for kids: swimming lessons, gymnastics. My brother runs a great hospital.

You made your first garment at four years old. How did you do that?

I still have that apron. The print is so great. It has little Scottie dogs on it. I think babysitters weren't around those days, or nannies. So if Mom was going to sew us dresses she'd give us kids some fabric so we could learn it, too.

You loved dance as a child, and at age four you also started to study dance: ballet, tap, jazz, and acrobatic.

That was my passion. I had the best dancing teacher, [Anne Pinn]. She was a Broadway showgirl in *One Touch of Venus* and *Pal Joey*. She taught in black leotards with a white starched, tiny tutu skirt. She taught for sixty-five years. She just retired. She gave me escape, fantasy, makeup.

Was your mother always driving you to a dance class, or did you dance at Betsey's Dancing School, which you owned and operated when you were a kid?

One of my best girlfriends was the dancing school teacher in Terryville. Any dancing school teacher in Terryville is going to make it because kids like to dance. And Patty asked me to be her assistant the year before she went off to college, when I was in eighth grade. I did my own dancing school. My best girlfriend, Marian, would sit at the piano, hear something, and play it. She could play tap and dance and jazz. We went into this dancing school business together, every Friday, Saturday, Sunday and for prom. It was great.

What was it about dance that appealed to you?

The escape. And Anne Pinn was such a brilliant costume designer. She let me design clothes, and I dressed as a butterscotch candy or a Neapolitan ice cream or Pinocchio or a whale or a flame. We didn't look for costumes in catalogues.

So you made all these things.

My poor mother, who did not like to sew, had to make these highly intricate costumes. And one time, Mom left a pin in my little two-piece cowboy costume. I had this pin sticking me. But it happens.

It happened once. She never did it again.

Yes, this is my favorite memory of growing up.

You were also an extraordinary illustrator. Did you design the programs and sets for your dance recitals and do all of that?

Yeah. I didn't even think about it, but I wanted to go to New York to be a Broadway dancer. I really loved my art teacher and I loved art, too.

You were a cheerleader in high school. Did you love the pom-poms?

I was confused—I just wanted to cheerlead. Now I look at cheerleading as another dance recital, another fashion show, another performance. I never understood any of the games, football or basketball. It gave me a chance to be an acrobat, and I liked the costumes.

What were the school colors?

Orange and black. Terryville was fit-and-flare black corduroy, little mandarin collar with orange underneath. We'd come out on the field with our little pizza-orange skirts. Not sexy

Clockwise from top: Betsey Johnson as a baby with her mother, Lena Johnson, her brother, Robert, and sister, Sally; Betsey's mother and her children; Betsey in her dance costume

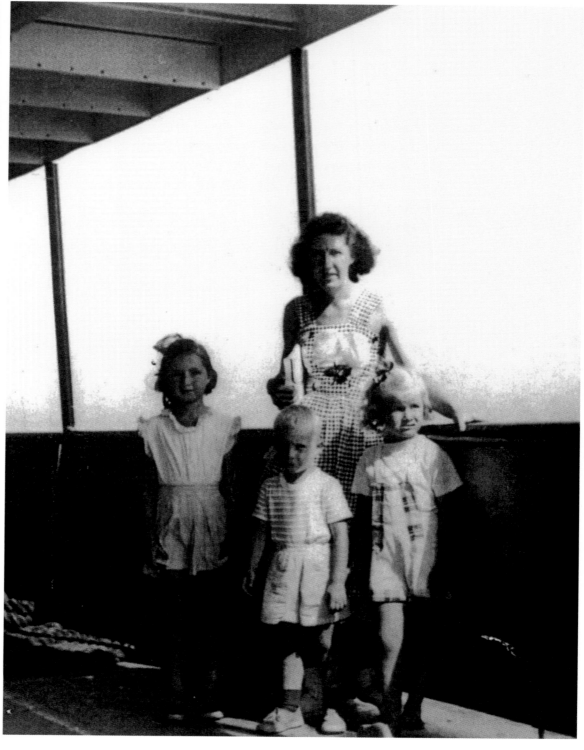

cheerleading, it was cutesy. And I always went out with a basketball player or the quarterback.

Cheerleaders were usually the most popular girls. Were you?

I was popular. I never thought I was good-looking. I was always thirty pounds too heavy. My popularity wasn't built on looks as much as being a good kid.

You graduated high school in 1960, and decided to pursue art and design at Pratt, but then you left after one year. Why?

I thought, if I went to Pratt, I could keep doing my dancing and continue the art. Pratt was a bitch. It was a killer year. I think I gained a hundred pounds. And I didn't sleep. We were in constant panic. I only realized what I learned twenty, thirty years later. Phenomenal school. It was heavy-duty then, under the Myrtle Avenue L. They didn't like my cheerleading for the basketball team.

That's not a very Pratt thing.

I was top student. I was As and beyond. But I had to leave and cheerlead.

When you left Pratt you went to Syracuse. How did you pick Syracuse?

I was going to check out RISD and Syracuse and Chicago, and Syracuse was the first place I went to see. It was a little cornball school back then, the Quad was real grass. Very campusy. I saw that football field. I really chose Syracuse because of the cheerleading.

I think that probably surprises people when they hear that you, Madame, were Phi Beta Kappa and magna cum laude when you graduated, in 1964. [APPLAUSE]

No. [LAUGHING] But oh, I used to have to study so hard. I was brain-dead in college, but I worked at it. I told you, don't ask me any smart, intellectual questions, Fern.

You'll know everything I'm asking you. When you graduated Syracuse, you were selected as a *Mademoiselle* guest editor in 1964.

I entered the contest because I wanted to get my toe into New York. If you won, you would go on a trip on an airplane, and you would get to work for your editor on the August/September college magazine issue. And they'd put you up in the all-girls Barbizon Hotel.

If that happened today, it would be a reality TV show.

Oh, it was beyond. Who else were guest editors? Ali MacGraw.

Designer Bonnie August, Sylvia Plath, and me.

Oh my God, that's right. My editor, D.J. White, was about twelve months pregnant. So I was thrown in the fabric department, because I loved fabric at Syracuse, though I got my lowest grade because I used to scrape into the screen with my fingernails.

At *Mademoiselle* the guest editors got to interview special people. In my year we interviewed Stan Herman, whose label was Mr. Mort at the time. Whom did you interview?

I chose Carol Channing, who was starring in *Hello, Dolly!* I feel ancient when I talk about this. But I loved Carol Channing. I was so happy and shocked to hear what a nervous wreck she was before every [performance]. I relate to that.

***Mademoiselle* would send their guest editors on a trip. Your group went to London. Was that your first trip to Europe?**

Yes, it was my first trip. We went to England, and I had no idea at the time that I wanted to be a designer.

That was the heyday of Carnaby Street. The Beatles, bell-bottoms.

And Mary Quant. And Biba. I met Margaret Thatcher, and Penelope Tree was a little kiddo, or probably my age. When we finished our promotional work for the magazine, from eight o'clock in the morning until eight o'clock at night, we would go to clubs and dance around on the mattresses and pop these little pink pills. We didn't sleep for a week.

You didn't want to miss anything. It was an amazing time.

I came back and I wanted to be an American Mary Quant. I never connected with couture, but I connected with that primitive, basic, almost flat-pattern, primal, kindergarten kind of clothing.

And you basically became that. When you came back from London, you got a full-time job at *Mademoiselle*, when Edie Raymond Locke was the fashion editor.

I ended up being the serve-the-coffee gal in the editorial art department. The great thing was I didn't get stuck in the clothing area or the travel area or [any particular] area. I had to go around with the photostats every day to Mary Cantwell or Leo Lerman or Debbie Turbeville or Edie Locke and get their sign-off. I loved the women at *Mademoiselle*.

That era was extraordinary. My first job, after being a guest editor, was at *Mademoiselle* for six years.

Wow. I didn't know that.

Edie recommended you to Paul Young, who was at a store called Paraphernalia on 67th and Madison and was looking for a designer. You had done a high-armhole, tight-fitted T-shirt. What was Paraphernalia like in those days?

It was the time of Emmanuelle Khanh, Paco Rabanne, Saint Laurent, Courrèges. The only American designer seriously making a mark was Rudi Gernreich. I got picked up when they discovered they missed the jean thing. The only stuff I have in the Met is because of Jane Holzer. She used to buy my jasper jersey, flippy T-shirt dress. They were all transparent, except for the three layers over the bust. It was the best design work of my life.

Paraphernalia was a part of the Puritan Fashions business and owned by Carl Rosen, the father of Andrew Rosen, whom we all know from Theory.

Carl and I were buddies and Andrew was a little kid. I did the Youthquake line with Mary Quant. For Paraphernalia I went to the factories and made my patterns. I sewed my [dupes] in the backroom between the racks. I loved Carl. He was very classy. Marisa Berenson was Miss Paraphernalia. We had our own rock group. We would fly to L.A. and open the store next to the Brown Derby. Then we would go to the Hecht Company in Washington. And we

would have our Paraphernalia department.

What you were doing in those days sounds like a *Project Runway* episode, with shower curtains, Yankee pinstripe uniforms, interior linings of automobiles.

The fabrics were modern. The colors were neon. The main materials I liked using were metallics, and silver was the big thing.

What was the thirty-five-dollar dress Julie Christie wore, which led to a lot of success for you?

She was my favorite. Most beautiful movie star ever. Julie was coming to New York for her first big photo shoot, along with Geraldine Chaplin. I gave the stylist who was pulling clothes for her my favorite things, the London-inspired navy-blue little dot knit with a collar. And then I had this very Courrèges windowpane suit, very architectural. Out of all these clothes that they had to choose from, Julie picked my dress, so it was called the Julie Christie dress. And Geraldine picked the windowpane suit. And that was the first time I made *Women's Wear Daily*.

A lot of firsts. You also dressed Penelope Tree, Raquel Welch, Twiggy, and First Lady Jackie Kennedy.

I was making these satin-backed crepe bush shirts, and Jackie went in and bought twelve, thirteen, fourteen [and wore one on the] cover of *Life*, tromping around in Cambodia. There was no schmoozing. I was living in a five-story walk-up under the Brooklyn Bridge.

Just sit still for a minute.

That's my hardest thing to do.

How did you become friends with Andy Warhol?

I think maybe Andy said six words to me out of all the years [I knew him]. "You look great. Hi, Betsey." It was very sweet.

Did you go to Max's Kansas City?

I saw Mickey Ruskin build it. I was eating the hamburgers before he opened, because I lived around the corner on 19th. Every time I left a boyfriend, I ended up at the Chelsea Hotel and Max's. It was a place where [Bob Dylan] would walk through and you'd be super cool and try not to stare at him. I met Andy and Edie Sedgwick because they wanted silver clothes. I was doing stretched silver bell-bottom jeans and T-shirt tops. That was the first time I got in *Vogue*. We were all hanging out—it was artists. It was like the old Cedar Bar in the 1950s where [Barnett] Newman and [Jackson] Pollock were. It was a collaborative place for the nutcases who were poor and passionate. Andy was our God. Debbie Harry was a waitress. Julian Schnabel was a busboy. We were all there because of our passions. I went into making clothes and putting them in the ladies' room in the Condé Nast building. I think I was taking home sixty-two bucks a week—and so that's why I started my little illustration thing. *Mademoiselle* gave me a shop here, a mail-order gig.

You married John Cale of the Velvet Underground. What was that like?

The Velvets liked my clothing and they asked me to do their clothes. Lou Reed said I cut a really good crotch. I'll never forget that. He wanted gray suede, so I did the jean jacket and the pants. I feel when you're dressing people you have to become them, they don't become you. The Velvets liked my velvet stuff, so there was a connection. I fell in love with John because he wanted a black outfit with lots of Victorian Welsh lace and he wanted his hands to be on fire. I thought, there's the guy for me.

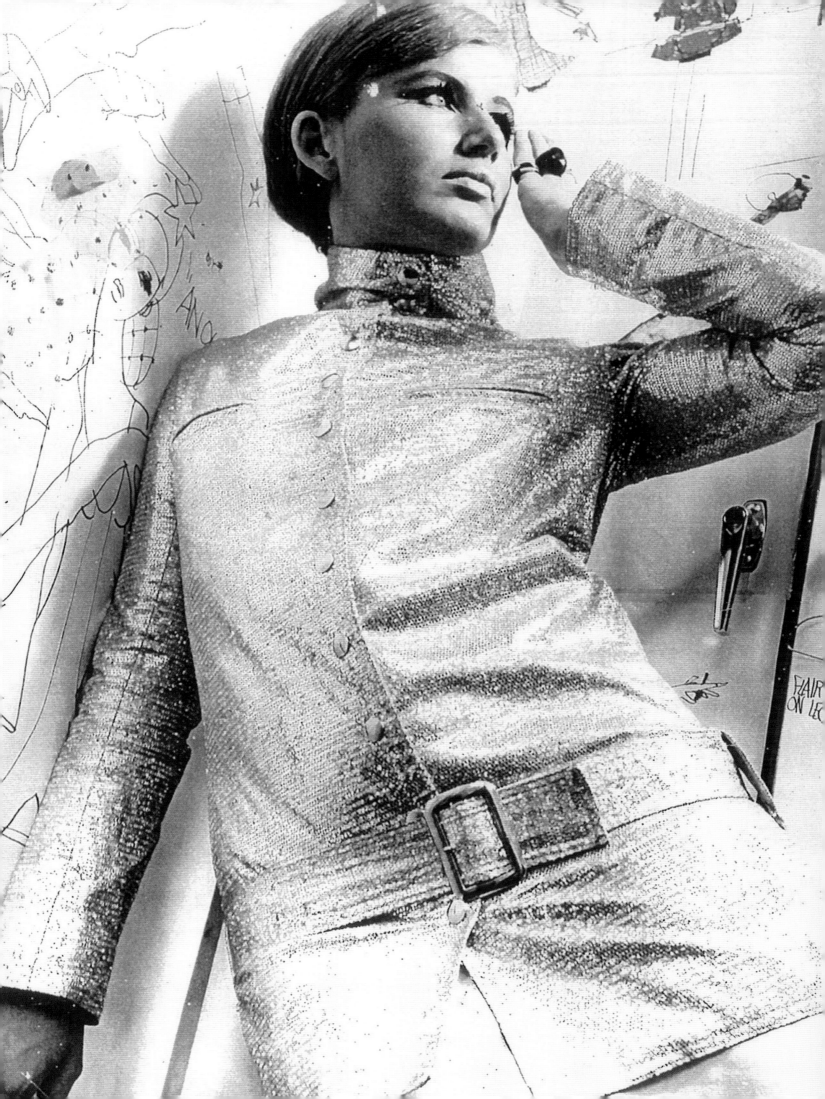

You freelanced after you left Paraphernalia at Butterick and some other places. Then you took creative control of Alley Cat and had your name on that label.

After saying, "Leave me alone," for two seasons. If I don't cut the mustard, I'll go very happily. But while I'm here, I have to design the showroom, I have to do the ads, I have to do the clothes. I always had to beg and swear to prove [myself] to them. I went from Paraphenalia mini to Alley Cat 1970s maxi. But at least I was free, as long as I sold, which takes design students a long time to learn. I learned it my first week. My clothes were a week late after the Madison Avenue opening, and they asked me to be a salesgirl. After one day, I went to Paul, crying, and said, "I can't do this." I don't communicate with people about what they like to wear. I would rather die than be in the position of having to sell my clothes. They said, "Betsey, hang in there. Your collection will come." Sure enough the clothes came the next week and they [sold].

So at twenty-nine, you won a Coty Award, when you were at Alley Cat.

Yes. With Halston.

You were the youngest.

And that's where I met Rudi. I was doing a lot of artwork in my jacquard sweaters, and very environmental, ecologic, the birds and the trees. They're in *Annie Hall*. For a younger, "Youthquakey" audience, I think I was the American Mary Quant. But to the real industry, a lot of people thought I was kind of a bad choice.

Nobody ever agrees on anything in the industry, don't worry about that. In 1970, you opened a very hip boutique on 53rd Street: Betsey Bunky Nini.

Bunky and Nini and I were at Paraphernalia. Bunky was production. Nini was in charge of imports. We imported a lot of [Mr. Freedom].

Are you still friends with them?

Bunky's in California, and Nini and I used to run into one another on the airplane all the time. I'd hang out with Nini and Bunky to this day if they were here.

And the store still exists, on Lexington and 70th.

I was shocked. I never had a contract so it just went on and on with my name. But they didn't buy my clothes. But Nini's boyfriend was playing basketball with the Alley Cat salesman, who was trying to find a designer. I didn't like doing custom boutique stuff, but all three of us were at Paraphernalia, and we thought they really fucked it up because nobody really understood the genius of Paul Young, and they didn't give him a business head behind his creative head. Joel Schumacher started at Paraphernalia.

Alley Cat went out of business in the mid-1970s, because the youthful, young customer started to need work clothes.

I broke my contract. It cost me money to quit. I had a five-year contract, [but] I couldn't stand it anymore after four years. And I had my career. I had the 1960s boo-doom. I had the 1970s do-do. After that, the working woman's wardrobe came along. While at Paraphernalia I freelanced for extra money for Capezio and Nina and I. Miller and lingerie. But at Alley Cat you legally couldn't design any other products. I was asked to do a television commercial for Bayer aspirin. Ten thousand dollars [SNAPPING], and I said no, because [I wasn't allowed to] endorse a product. That's tacky. And then I thought, but you know, I have grown up on Bayer aspirin. This is a sideline, I never told you. I've taken Bayer aspirin my whole life, so be a whore, get off your ass, and make some money. I did the commercial. I did it

in one hundred takes. Ozzie Nelson took like two hundred fifty. My parents made me put that money away until one night at Max's I ran into a Wall Street guy and I invested it in a lady gynecology machine. Eight Thanksgivings later, Aunt [Elsie] says, "Boy, you know that stock Dynatech's going through the roof." My ten thousand dollars turned into sixty thousand. And the bank that watched me make money for Alley Cat matched my sixty. Now my daddy came in, then Chantal, my best girlfriend who became my partner.

You also had a new boyfriend. And you gave birth to your pride and joy.

I knew I wanted to have a kid. And I had been married and he had been married and it didn't work out, so we decided [to] have a kid. And that's when it really didn't work out. He was such a true artist. He didn't want to bring ten cents home. And I needed a hundred dollars a week. I needed to be a family.

You were quoted as saying you never would have found time to sneak in a kid if it hadn't been for the rise of the working woman's wardrobe.

And I had the time to do Betsey Johnson's Kids and freelance.

You freelanced for I. Miller, Nina Footwear, Capezio, GANT. And then you and Chantal, with the money that you made in the market, started your new business.

I went to an astrologer, Frank Andrews, because I was ready to shoot myself. Frank said, "You're brilliant, but if you don't pay for it yourself, you can't ask to be creative. You want to do what you want, pay for it." When Lulu was two and a half, I thought, now is the time. I can't take this full-time mommy shit. I would take Lulu with me all the time. She went everywhere, Hong Kong and India. But then I went to CBGB and I saw the B-52s. One guy is wearing the inner tube. They're singing "Rock Lobster" and he has on a neon-green wing-tipped—anyway, I got inspired by CBGB and girls wanting to wear my Paraphernalia clothes. I felt it [was] my time.

And then you opened a store in SoHo. Was that your first store?

Our first season was perfect. Elio Fiorucci was my big supporter store. And then we overcut the second season. We had so much shit left. And it went from black-and-red and black-and-white [stripes] to hot-pink-and-black stripes and neon-turquoise-and-black stripes. So Annie Flanders, from *Details* [and] *Soho News*, says there is this cheap store on [Thompson] Street for rent. So we took it. And all of a sudden, my girls came out of the sidewalk cracks. They found me again, after the ten years and the freelancing. Chantal and I believed in our company. We would die for it. And we did for thirty-five years.

Somebody told me that you lived somewhere near the corner of Church and Walker in an apartment that was bubblegum pink and that there were lots of windows, so when the lights were on, everybody in the neighborhood knew when you were home. It lit up your whole neighborhood.

Years later, you know who said that inspired him? David LaChapelle.

Do we want to talk about Jeffrey Oliviere, your second husband?

No, didn't I tell you he committed suicide? He died. I met, married, and divorced him in three months. I have very bad taste in men. Except for Cale.

Then you started growing your business. In the 1990s you were in department stores everywhere. You were opening up stores. Give us a quick synopsis of building that business.

Because it was our money, and Chantal still has the red-and-white checkerboard wooden

box, we took the money in personally, we paid the bills personally, we tracked it. We really wanted to do our thing. Chantal believed in me. She was studying at a college in New Jersey. But she was working with Cathy Hardwick. I met Chantal when she sold my children's wear line, Betsey Johnson's Kids. And we really became great friends. Hard work, watching the money, a lot of luck. I knew that I definitely would not make it in New York unless I brought something new to a slot that hadn't been filled. I learned from my first job what my work was. I could never explain what it was, but it was the T-shirt dress with the placket and the buttons and the little printed side. It was very primitive, childlike. It was my best work ever.

You were quoted as saying, "I've never had a new or brilliant idea. I just like to make things. The truth is fashion doesn't really change all that much. I'm still doing the same things now that I was doing back then."

Right. I've seen it come and go like three times around. It goes rock-and-roll romantic to petticoats prairie house then punk, which is the new rock and roll, and then it goes to the environmental kind of 1990s. It's a cycle. I always believed, like my dancing costumes and like me, that there are a lot of people packed in one person. I used to do lots of costumes. I'd do the French maid, I'd do the petticoat Marilyn Monroe, Jane Russell. And I just loved everything kind of showgirly. I grew up in the 1950s. I remember baking my white sneakers in the oven because they had to be white and crispy. And the petticoats, my prom pictures.

"Crispy sneakers." That's the first time I've heard that expression.

Oh, they had to be baked with white shoe polish and my petticoats. It was so sexy. My favorite outfit was a Dolman mohair yellow mock turtleneck sweater. And a skintight vegetable-soup tweed wool skirt, and the little pointy toe pumps with the kitten heels. We looked like dorky little country girls. Now I think, whoa, I lived in the time of great clothing that I love. I love the 1950s. Then I did the 1960s, and then the 1970s. That was all new and trendy. And the 1980s were new and trendy. After that, I don't think there's really been anything.

In 1999, you were honored with a CFDA award for Timeless Talent.

I think that had a lot to do with you, Fern.

Well, a little bit. I at least named the award.

I was a wreck. Saint Laurent got his Beyond the Beyond award. I loved meeting him and he actually knew who I was. I had the Lunachicks on stage. And I did a retrospective. I did my three cartwheels. Lulu and John introduced me.

It was a special moment.

I bet you guys were like, what is she going to do? But you, Fern, supported me.

A year or two later—you came to my office at CFDA. There was a major interruption in your life. One of your breast implants either exploded or deflated. And that bizarre occurrence led to a breast cancer diagnosis that saved your life.

[TO AUDIENCE] And Fern was the only person I told outside of Lulu. It was so funny because months before I [knew I] had [breast cancer], you asked me to do the General Motors breast cancer car. My car was a Little Kim, pink with neon fur inside with diamonds all over the place. There weren't a lot of women coming out. Liz Tilberis had just died [of ovarian cancer] and there was no one, no women—

Acknowledging their breast cancer.

I went to see Fern because I thought, if I'm doing the GM car—at the opening of the

Fashion Week in September, where I had the Playboy Bunny implants on the runway—it was so perfect. Maybe Fern could let me tell my story once and for all to the press and get it over with because I haven't told anyone in like six months. So I go to see Fern—we're crying, then we're laughing. That just changed my life that you gave me the opportunity to talk, to get the coverage. It was so great to come out about it. I didn't tell anyone because I really thought that nobody would sell me fabric and everyone was going to think I was going to kick, and they just wouldn't deal with my business at all. It was an awful feeling. It was like having AIDS or some contagious, awful disease. And I caught it, because I hadn't changed the implants for ten years. It was very old-fashioned—there was a second scar tissue building up next to the implant tissue. I didn't have a mastectomy. I've always been this flat. A lot of people look at me and think, oh, that's why. But I liked being a dancer and being flat. So yeah, I noticed a teeny kinda thing. So I went du du du du du du du dum. And found out I had it the day that I had to throw my company Christmas party. So I decided in the taxi ride from the doctor to the Christmas party that I wasn't going to tell anyone but Lulu, because I couldn't handle it. It was good not telling anyone. Until the day before, until about ten minutes before I went over to the tents, to announce it with you.

[TO AUDIENCE] We did a press conference with General Motors and that's when Betsey revealed that she was doing a car to raise money for breast cancer awareness and revealed her condition. [APPLAUSE] You've been fine ever since, right?

Yeah. Unfortunately, I belong to a big club. Thank God, the last seven or eight women I know, family included, caught it early, and that's the trick. And I really loved [using] my stores to support breast cancer [awareness].

So then you built a business, which has inspired a lot of younger designers like Heatherette's Richie Rich, Jeremy Scott, the Blonds, and now Nasty Gal. In the mid-2000s, you had four hundred employees, $150 million in annual sales. You were licensing products including footwear, handbags, sunglasses, fragrances, timepieces, watches, outerwear, belts, accessories, leg wear, socks, underwear, hats, scarves. Anything else?

Lingerie, swimwear. [The] Carole Hochman lingerie company called—her agent is my ex-

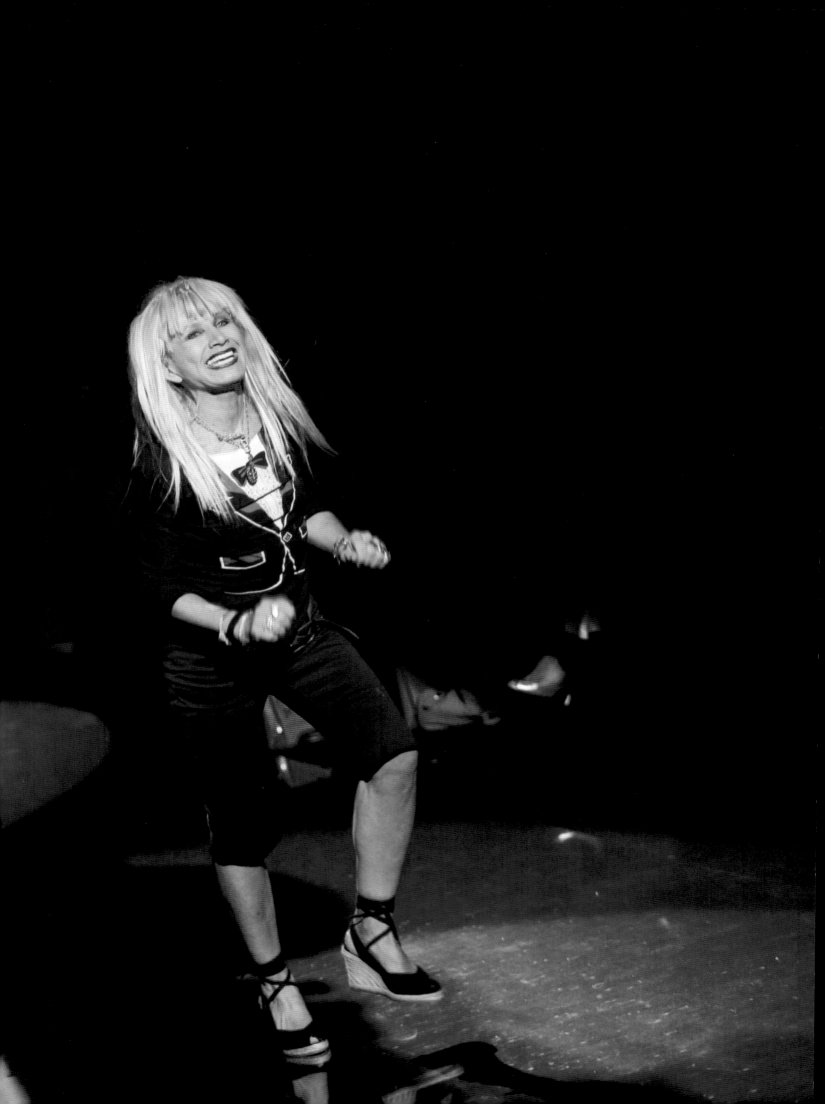

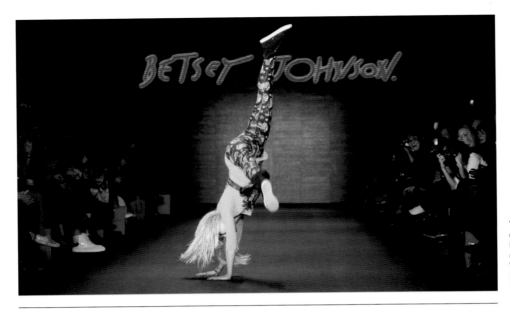

This page: Betsey Johnson on the runway after her Fall/Winter 2011 collection during New York Fashion Week. Page 224: Betsey Johnson scream by Adam Weiss

roommate from Syracuse. Carole believed in me, and the lingerie sold. It was the first time that anybody thought I was bigger than a little cult. Then the bag people jumped in, then the shoe people. By the time we sold [the company], I had built all the licensing gigs, but they really wanted to be Betsey, so I would work about one or two years with all of them, so that they would get it right.

Your products then became available in more than two thousand specialty stores and department stores. You never went into home decor, though, did you?

I tried. I love home. I'm better at home. Dressing furniture, dressing a room, it's the same as dressing a girl or a guy.

What happened in 2007? You took in a partner—a private equity firm. And then the company defaulted on the $48 million loan?

[We] worked our ass off so much; we put all our money back into retail stores. We never accumulated. And we sold for way less than we should have.

That brings us to 2010, and Steven Madden comes to the rescue of your company, takes over the loan and ownership of Betsey Johnson.

First it was Castanea [Partners who] bought us. These equity people buy you—you owe the money and the interest on the loan. We had to pay, I think, $6 million in interest on a $56 million loan.

Yup, there's no free loan out there.

Chantal understood. She oversaw the business, sales, and production.

She did the books, and you did the looks.

That's perfect. I'll use that. We built our business like a family business. Then all of a sudden, the apples coming into the basket were not the have-a-nice-day people. Chantal saw it coming. Steve saved us. I always loved Steve.

How did you know Steve?

Thom Browne was making shoes for a retail store, but they couldn't have heels, so they were flat. That was cool. I don't know how I heard but he knew me when I was at Nina. He likes the industry. He likes the stories. He's just like Paco Rabanne. He's great and he's a whiz kid. I call him Stevie Wonder.

When he came in and took over, you marked the bankruptcy with sparkling wine and cupcakes and a trip to Puerto Rico, which was formerly the price of a party dress for you.

I insisted on closing the doors, making the announcement instead of making it depressing, because it was a shock to all of us. I served my classic champagne and cupcakes and videoed it with a little thirty-dollar camera. It was a very close family, except for like four major people, the COs and CFOs. It was only my fans that I ran into on the street and real supporters who got me through that horrifying time going home every night, past my Madison Avenue store, where I saw my furniture being sold. It was only from the fans and the people that I realized what I had built for thirty-five years—it worked because it was so pure. It had its commercial sides too—otherwise I wouldn't be on this stage with Fern. I realized it couldn't last, [but] it was a long time, thirty-five years. It outlasted any marriage I ever had. When Steve took over, he said I could quit. I could have retired.

Which Chantal did.

She's so happy. But I said "You know, I've got to keep working." I love my work. I love what I've built. [APPLAUSE] I didn't realize, I always knew my girlfriends were my fans, and I always just wanted to be the same kind of girlfriend. And when she bought my clothes I felt, that's my girlfriend. I just want to thank my fans—because it was those girls who made me realize, through their sadness of the store closing, through their coming over to me on the street and talking about it. I wouldn't get into it. It just made me realize, wow.

You made a difference.

It was the first time I realized I really achieved something special.

Absolutely.

And I think if I had kept going—[APPLAUSE] I would never have realized that. Well, it takes people to have you sit up here. I mean, I am only cool because my fans liked me.

Now there's a new Betsey Johnson brand. And you're the creative director?

I'm the creative director of all my brands under Steve Madden.

The clothing will be available in places like Macy's and Nordstrom?

The dress line's finally kicking in. The other licensees were always there. I must say, though, the clothes will never be the same as when Chantal and I had our retail stores. [But] I appreciate the licensing. You've got to do volume. It's a very, very different world now. I feel I could make the Betsey version of *Valentino: The Last Emperor*.

I read the clothing will be priced from $99 to $249.

When I was twenty-three, I swore I'd never make anything more expensive than the cost of a roundtrip ticket to Puerto Rico—ninety-nine dollars with hotel—because I never felt a dress was that important. I started out with throwaway clothes. And I still love cheap clothes—inexpensive, affordable, accessible clothes—more than anything.

So tell us about the real loves of your life, Lulu's children, Layla and Ella. Are your grandchildren fashionistas?

I used to see little vintage dresses when Lulu was pregnant. I thought, I just pray I live to see my granddaughter. It had to be a girl. I would want to stay alive to see the kids in the dress. They hated vintage clothing. They just buy costumes online.

Do they rifle through your closets?

They do. They love the closets.

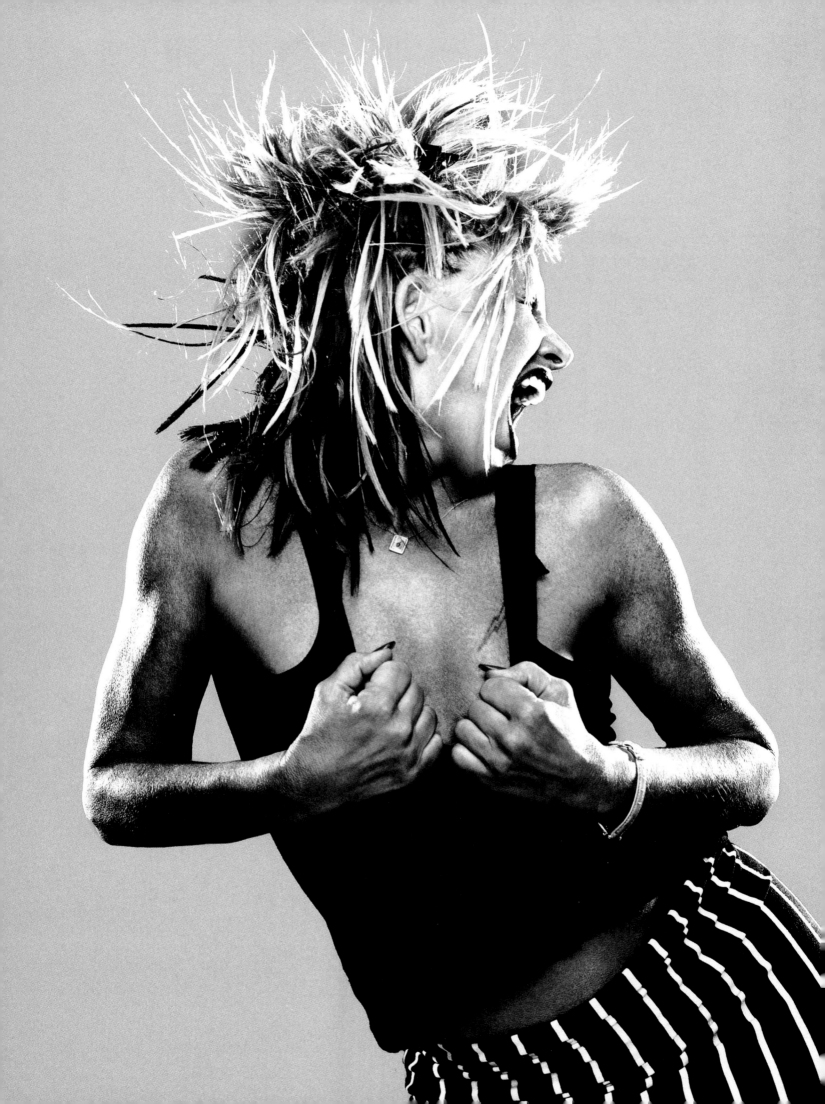

Can they do cartwheels?

Ella can. Ella is going to be me, the crazy cheerleader side. And Layla is going to be the artist out-there girl. I can't believe that I'd ever see my own kid, my grandkids, that we would all live in the same building. I'm on the tenth floor; they're on the fifth. I wake up and as much as I try not to open their door, I end up downstairs with Lulu and the kids. Every morning. I'm the happiest, most proud of my success—of being a grandmother who lives in the same building with her grandkids.

Are there any designers working now whom you're impressed by?

Well I've always liked the oldies—McQueen, Gaultier, and Westwood—for years. It's hard for me to watch a lot of fashion now. I still have the feel, but no, I don't follow. And I'm so bad at the CFDA Awards, because I've got to vote. And I mean, I just don't like to shop unless I go to Lanvin and I can buy another ceramic figurine of the little fashion lady, or go to Zanotti and buy a $1,200 pair of shoes that I really need and never wear. These are my sneakers. I love my sneakers.

Those are great sneakers. Is there any advice you would give to aspiring designers?

Kick ass. Just keep on kicking. You [need] luck, and you have to be talented. But it's more, just keep on kicking.

Any thoughts on today's technology, Tweeting, Tumbling, Facebook, texting, email?

What's that?

I guess the answer is no.

I have an iPhone. I don't want to know any more about it than to text or not to text. A long time ago an astrologer told me that I am antimagnetic to anything you plug in. I jinx the machines and I can't work them and my hands are too crazy to stick to those damn numbers. I don't like that form of communication. I know it does brilliant things, though. I've seen what it does, but not for me.

That's okay, you don't have to. But I would to see what your hair would look like if you touched something electrical. Is there anything still on your bucket list?

Is that when I have to jump out of a plane?

No, it could be anything.

To meet a great guy and finally maybe fall in love.

Aw. So you would get married a fourth time?

I tried. I don't think the marriage thing would happen, but I would love to. I love being in love. If I can't be in love, I'd just find some beautiful piece of eye candy. And somehow the eye candy's getting younger and younger. But I go for communication—good, sincere, happy, sad communication. I don't think it has anything to do with age.

Here's an audience question: when you studied fabric design at Syracuse, a Mr. Waterman was your professor. And someone in the audience says that she has a ton of your clothing that was made in the 1980s, if you're looking for it.

I would love to see some of my old stuff. I always collected stuff that inspired me. Now when I go vintage [shopping], my own stuff inspires me. I like my own stuff better than anyone's. But I don't have it, so I'd so appreciate hearing from anyone who would loan me my clothes to see [them] again.

Okay, well, on that note. Thank you, Betsey… now you can pass the roses out.

Thanks, everybody. Awesome. Thank you. [APPLAUSE]

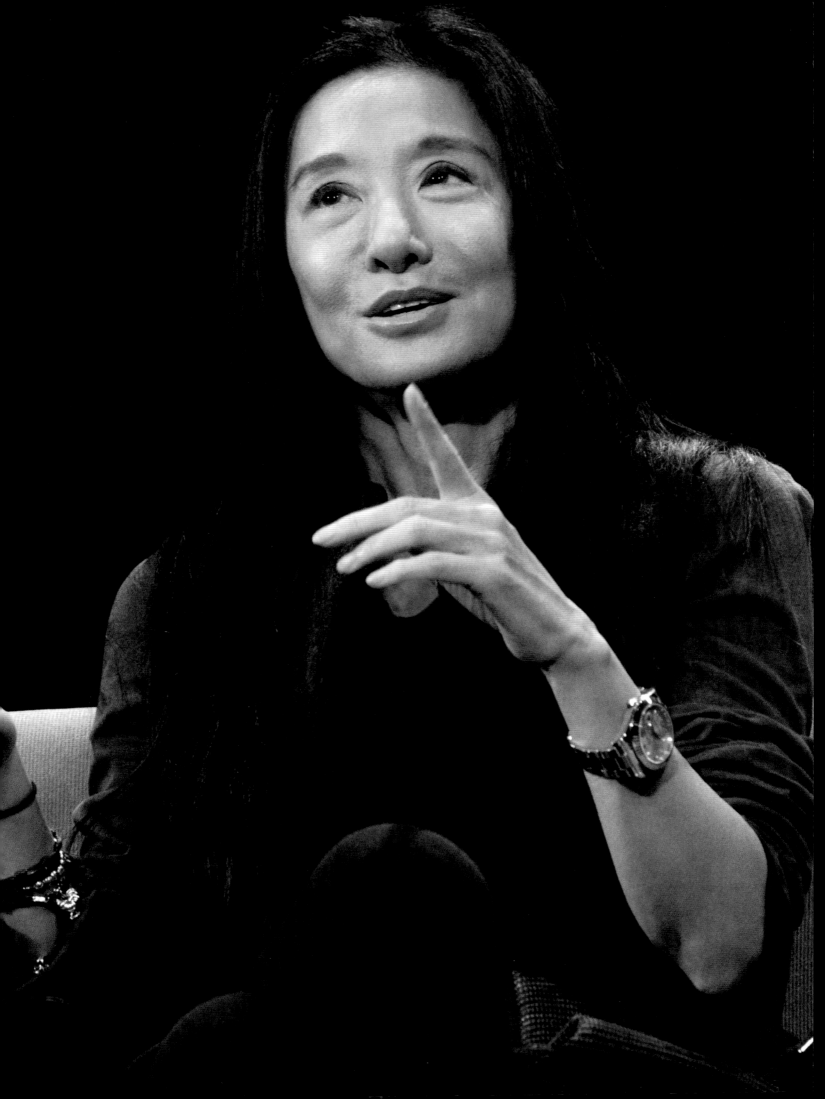

VERA WANG

Vera Wang. Her name makes young girls start panting and visualizing their life living happily ever after. The minute a girl has a good date, her friends will ask, "Was he a Vera Wang?" She's become a cultural noun. Vera is an inspiration and enormously successful businesswoman. She has followed her gut instincts. Many of the most successful businesses started when people were trying to find something that they couldn't find, so they made it. That's how Vera Wang became a designer and started her bridal business and reinvented the entire bridal market. Vera is also an exceptional athlete, an ice skater who fell short of making the Olympic team as a teenager but now revisits the ice by dressing our skating stars. She became a great golfer so she could spend more time with her husband, then [she] suggested to Ralph Lauren that he design a line of golf clothes. And I don't think there is a designer who has dressed more stars for their weddings and red-carpet appearances. She is one of the funniest and most self-deprecating people you will ever meet. So, ladies and gentlemen, let's welcome my first guest, who has a plane at Teterboro waiting to take her to L.A. for Academy Awards Oscar fittings: the one and only Vera Wang.

VERA WANG: I'm thrilled to be here. I've always idolized the Y and all the great performers and artists and intellectuals who have appeared here. Tonight's a great honor.

FERN MALLIS: My pleasure. We always start at the very, very beginning. You were born on June 27, 1949. How old do you feel?

Somewhere between thirty and ninety. It depends on the day.

Today?

Eighty-five.

You are a Cancer. Do you believe in astrology?

I'm beginning to believe in it a little bit. Yeah, I never really took it that seriously, but I'm beginning to see that perhaps there are some types that really do follow certain patterns.

Cancer is about the crab living in the ocean, where tides rise and fall twice every day, and because of this, Cancers have developed a hard outer shell for protection but are typically very sensitive. That shell is like carrying their home with them. They pack everything when they travel, as home and comfort are very important—we're still nodding, so we're okay. Cancers are fiercely loyal if you're let into the inner circle, and they're connected to tradition. And America is actually a Cancer country and it's tied to tradition, apple pie, and mom. And nothing is more traditional than weddings. So there is a connection for you.

True.

Also, I learned from my astrologer, after I gave him the date of your birth, that you have just come out of the most intensive period of transformation in your life. The two biggest planets of change [are] Pluto, which signifies deep change [and] often manifests itself in divorce [and] partnership changes, and Uranus, which represents the new and is restless and revolutionary [and] means greater freedom, and that there is a whole new creative energy ready to rip through your life. Interesting, no?

Very. I sound so much more intriguing that way.

Your dad, Cheng Ching "C.C." Wang, was the son of a Chinese general.

Yes. My grandfather was a military general under Chiang Kai-shek, and for those who remember World War II and the Communist revolution, he was supporting the group that did not win, as the Communists took over China. He went on to live with his children in Formosa, [now] Taiwan. Anyone who's old enough would know that there were two competing Chinas. He gave his whole life to the cause of Chiang Kai-shek. So they never really went back to mainland China.

Where did your father meet your mom, Florence Wu?

My mother always maintained that she pursued him. So I would think that probably it had to do with school because they both studied in China.

She was the daughter of a Chinese warlord. What was a warlord?

A gangster. They had armies; they had guns. She lived a very extraordinary life, also very tumultuous. These were very turbulent times. There were feudal states in China at that time, all vying for power, and when the Communists [wanted] to take over, they had to choose between them. My mother was extremely educated for a Chinese woman of that era; [she] chose to go to college. Eventually, after she married my father, [she] chose to follow him to America.

And she was quite glamorous, a wearer of Madame Grès in feudal China who also shopped couture.

Totally, and later at Yves Saint Laurent and Dior and Balenciaga, and all of those during-the-war and postwar designers in Paris.

So you got a fashion education without knowing it.

I was annoyed. Mostly I had to follow her around.

Did you get to keep a lot of her clothes?

I still have a lot of Cardin and other clothes that she owned. But she was also very, very tall and lean. I could never wear them with the same kind of style.

Where did they first live when they came to New York?

They lived in Peter Cooper Village on the Lower East Side. My mother became a translator at the United Nations, and at the time there was a [housing] project developed for many of the people that worked at the United Nations. I was born while they were living there and I had a really lovely upbringing. It was like being in the country but being in the city.

Your father was a pharmaceutical executive?

My father started a trading company with his classmates from MIT. He went back to Asia and he named the company U.S. Summit, [combining] "United States" and [the acronym] "MIT." The four of them all spoke English. In those days there weren't even hotels in China. Fern, it was like the Wild West. They would go over there on not even a Pan Am Clipper flight. And they started to use all their connections to be able to create businesses, including distribution for all these new big pharmaceutical companies like Hoffmann-La Roche, Merck, Wyeth, that still exist today. My father helped build all those markets after World War II.

Did you speak Mandarin at home or English?

Mandarin, always. We spoke English as well. My Mandarin was so good my parents were worried I'd never speak English. But now my Mandarin is not so great. I have to brush it up for [business in] China.

You have a younger brother, Kenneth. Are you close?

Very close. He was always the brain. I was always the creative one. When he took the SATs he walked out an hour before me and got eight hundreds. I saw him put his pencil down and leave. He ended up going to MIT, as did my father, and then Harvard Business School. Now he actually runs the family business.

Impressive. But you went to [the] Chapin [School]. Where did you go before that?

I went to Friends Seminary, downtown. And I didn't graduate from Chapin. I quit five days before my senior year. I had been training in figure skating since I was six, and I was really desperate to make the U.S. Olympic team.

Are you still friends with people from Chapin?

Totally. We are a very close class. My friend Emily Rafferty runs the Metropolitan Museum of Art. They always say the two dumbest girls in the class—

Not so dumb. And you went to Balanchine's School of American Ballet?

That's right, to help me with skating, to gain core strength and arm movements and stretching a kind of line that at that time skaters didn't really have.

How did you get involved with skating? Who gave you your first pair of skates?

My father gave them to me when we lived downtown. As luck would have it, there was this Chinese guy who knew how to figure skate. He actually could do figure eights—it was kind of surreal, actually. We skated at the 72nd Street boat pond. I fell in love with it. From then on I just wanted to skate. My mother, being a good professional mother, made sure I got lessons and worked my way up the skating hierarchy. I got the best trainers, the best music people, and the best costumes.

Do you remember your outfits?

Most of them. Sadly, there was no stretch in those days, no Lycra.

At twelve, you won your first regional competition. Were you very competitive?

Actually, I think I won at ten. I was very competitive, not with other people, but with myself. You can't control how other people perceive you. You have to control how you manage, not only your own expectations but your own performance. That's always meant a great deal to me.

You tried out for the 1968 Olympic team that was going to Grenoble, France. How close did you come to making it?

Not close enough. There were a lot of skaters, and you had to qualify in so many levels just to make it to the Nationals. I was skating in pairs as well as singles. And I had a very bad accident in Philadelphia at the National Championships in pairs. I was very badly injured. I skated, and I shouldn't have. My partner tripped, I went flying thirty feet in the air and landed and compressed the whole left side of my body. It was a very serious injury. To this day I have scar tissue.

So that laid you up for a while.

It did. And then [my partner] wanted to continue with his singles skating. He was [ranked] about fourth in the United States. So we broke the pair up.

Do you skate now?

I try to once in a while. My skates are very old, like me. They're not in very good condition. My blades are in even worse condition. But I do like to skate. I love the feeling of freedom. Skating is a very unique sport, particularly for a young woman, I think. And I tried to introduce both of my daughters to it—not to compete. There's the element of knowing your

own body. There's the element of speed. There's the element of music and costume. The most wonderful thing is the wind, the wind in your face as you skate.

You make it sound very poetic. And then you went to Sarah Lawrence?

Yeah, a very, very checkered college career, too. Just like high school.

Did you graduate?

I graduated [in 1971]. It was the happiest day of my dad's life. I didn't get on the [Olympic] team and I didn't get the Chapin diploma, so that was two strikes.

While at Sarah Lawrence, you studied in Paris. What was that like?

I couldn't skate anymore. I felt this incredible void and emptiness, because I think very few people find their dream so early in life. I found mine at six. So when I was forced to quit at nineteen because I could no longer make the team and I didn't think I could sustain more injury, I decided to move to Paris to be with my boyfriend at the time. He was a ten-time French champion and [recipient of the] Legion of Honour and held the flag for two Olympics. A lot of his friends were in fashion, and that's how I grew to love fashion and, of course, to perfect my French.

So you speak fluent French as well?

Yes.

And a good college pal of yours was the model Penelope Tree.

She was a very good friend. A real fashion icon. My God, she was from such a high-society American family. Her parents were very famous diplomats, Marietta and Ronald Tree. She was quirky. I remember our first year in college [when] I asked, "What are you doing for Christmas?" And she said, "I'm going to London." She was dating David Bailey, the famous fashion photographer. And I said, "Wow. I'm just seeing my friends from prep school who are coming home." I was in awe. But that was her life.

Well, it certainly became your life, as well. One of your first jobs was at the Yves Saint Laurent boutique in New York [on Madison Avenue]. What were you doing there?

My parents wouldn't give me any more spending money, so I got a job as a salesgirl and I did the windows. I also went to Columbia summer school, [studying] art history and French and Italian.

Do you speak Italian now, too?

Not great, but I speak a little bit.

Sì. So how did you meet *Vogue* editor Frances Patiky Stein?

When I was a salesgirl at Yves Saint Laurent, I was helping her buy clothing and she said, "You are really gifted—when you get out of college, call me and I'll give you a job at *Vogue*." I knew what *Vogue* was, but I didn't understand what a fashion editor did. I think some people still don't understand what they do. My mother said, "Don't be ridiculous. She's not going to give you a job at *Vogue*." And I got out of college and I called her up. I said, "You may not remember me," but she did, and I got the job. Isn't that crazy?

Your mother should have had more faith in you.

Right, I had to learn to type because I had to do ninety words a minute. I graduated from Sarah Lawrence, attended Columbia, but I still didn't type fast enough. So I went to Betty Owen Secretarial School.

I remember Condé Nast had a typing test when you applied for a job. So in 1972 you are twenty-three and you are at *Vogue*. You became an assistant to Polly Mellen. Tell

230

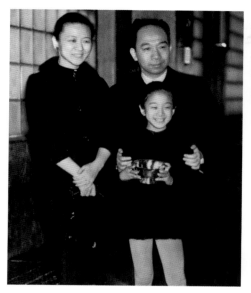

This page, left to right: Young Vera with her parents, C.C. Wang and Florence Wu; Vera with her two children, Cecilia and Josephine, in Rome. Following page: Vera Wang ice-skating in Central Park in one of her own designs

us what she told you on your first day when you came dressed in a white crepe de chine YSL dress, high-heel pumps, and long red nails.

Well, I had been living in Paris, and I thought that's what a *Vogue* editor-wanna-be in training should look like. She looked at me and said, in Polly fashion, "My dear, what are you doing?" I said, "Well, I thought I looked sort of good for this job." And she said to me, "Go home and change right now and get rid of that red nail polish," which I have ever since. She said, "You're going to be working really hard," and she wasn't kidding. I spent the next sixteen years at *Vogue*.

Polly said you were inspiring, that you had great energy and never complained. Has that changed?

That's fairly true. I'm a little angrier now at sixty-three, a hair angrier. But I didn't complain. I was a hard worker. I haven't had that many real jobs, and one of them would've been *Vogue*. And so I felt very privileged to have the opportunity to work for such an amazing magazine and with incredible talent. I worked with Mr. Penn and Mr. Avedon and some of the real greats.

Do you have any great Polly stories?

I've got plenty of Polly stories. One time I forgot a hat on a shoot, and it was raining. And she kicked me out of the van. And I ran to the next van, the *Glamour* magazine van. And knocked on the door and I said to Patrick Demarchelier, "I need some money to get back to the office [to get a hat for the shoot]." And he gave me money. He told that story to everybody for the next twenty years. I went back and got the hat and finished the shoot and I kept my job. But it was touch and go.

Grace Mirabella was editor when you started, and then Anna [Wintour] took over. In the foreword to your weddings book, Anna writes that you were one of the only people who spoke to her when she started, that your devotion to fashion was unparalleled. She thought you spent your nights sleeping in the fashion closet.

It became my life, [as it did for] our generation. Anna, Grace Coddington, and a lot of the other editors [and] certainly Polly, because she's young at heart. Polly's twenty in her mind and she always will be to me. It was a very rare group of women because, as you may have

seen in *The September Issue* or *The Editor's Eye*, the new *Vogue* film for HBO, [these films] delve into the level of dedication, the level of taste, the level of energy, the level of passion of the women at *Vogue*. And you know when you look at the clock and it's 9:00, and you look again and it's 9:02 and look again it is 10:00 at night? I don't know where my youth or my days or my nights went.

Or your fifteen years.

But I was really very happy there.

So while you were at *Vogue* you also had time to enjoy Studio 54?

I managed a little clubbing.

Most of our guests on this stage did.

Couldn't get a husband, but I could get to a nightclub.

While you were at *Vogue*, you befriended and discovered a talented designer working at Lothar's on 57th Street.

That's right, Michael Kors.

Michael told us that story when he was here. Apparently, you met him once at the store and took a lot of clothing out and didn't have any money with you, and nobody knew if you were going to come back and pay for it.

And I did come back and paid for it. I wore it with him to the first Met Ball that he ever went to, the night John Lennon was killed. That was the famous Met Ball in the winter.

[Speaking of Lennon], in the 1980s, you both went to a Dolly Parton concert, [you] wearing a Fendi fur coat and Paloma Picasso gold Ping-Pong ball earrings, and the crowds were shouting, "Yoko! Yoko!"

[Michael] loves to tell that story, too. Yoko used to like fur. I know Yoko. She's obviously a very eccentric and brilliant woman.

There was also a story about an infamous shoot with your late friend, the photographer Chris von Wangenheim and Christie Brinkley and a Doberman pinscher and a Geoffrey Beene dress.

Well, it was a Doberman pinscher and the trainer kept shoving steak into his mouth. I started to get worried. What if he didn't have a piece of steak in his mouth every minute, would he bite [the model's] leg? And he bit the dress and had a frenzy attack and was tearing the dress up. This was a very expensive dress. Geoffrey Beene was a very good friend of mine. The next day I knew I was in really deep trouble. But that was a very famous series of pictures. It was car crashes and Dobermans that were very, very vicious. And it was a beautiful maiden, like *Beauty and the Beast*. That darkness was very much part of the shoot, and that was very much what Chris intended. I mean, that was one of those crazy shoots, but we got great pictures.

And Geoffrey forgave you. He offered you a job two years later.

He offered me a job, yeah. I don't know if he forgave me. He knew how [fascinated] I was with design. He was such a master and I wanted to learn from a master.

But instead you took a position for more money as design director for accessories at Ralph Lauren.

That's right. I went to work for my mentor, Mr. Lauren.

And how long did you stay with Ralph?

I think two and a half years. From the time I said I was leaving to the time I actually left, there

was another year in there. I was having a hard time. When I left *Vogue*, I realized I didn't have much of a personal life. And it meant something to me and I really wanted eventually to [be a] parent. And I wasn't meeting anybody between the last car on Madison Avenue and the thirteenth floor. So I told Grace that I really wanted to have a break and try something new, and I left *Vogue*. And then at Ralph I said, "The one thing I don't want to do is to travel all the time like I did with *Vogue*, when I'm in a plane every single week doing a shoot." And he said, "Don't worry, you won't have to travel." Well, I did have to travel.

What was it like working for him?

Anything you wanted, any fabric or yarn or technique or jewelry or leather—anything we needed as designers, particularly as a design director with a team, just magically appeared. It was like designer heaven. If Ralph believed in you, he really believed in you. And he really supported and believed in me. It was very hard to leave him. It was very painful.

And Ralph told you to go get yourself a husband and a family?

He did, on a plane ride to London. He said, "I don't want you to become a fashion widow." I said, "I have to be married before I'm a widow, so you probably mean 'nun.'"

Then you met businessman Arthur Becker and started dating him.

Yes, I did. I did. I had met him, actually, at *Vogue*. He saw me at a tennis match. He was twenty-nine and I was thirty and he was making movies at the time in California. And we were fixed up by his friend's wife who worked at *Harper's Bazaar* and knew me from the magazine world. They introduced us. And we dated. And then we became friends, and then we didn't date, and then he was dating a model friend of mine, and I was dating an art dealer. And then we came back together, and it was really like *When Harry Met Sally*, the two of us. But he didn't like fashion.

Well, he learned to, though.

He liked wearing fashion, not working in fashion. He worked at Bear Stearns.

Describe the Hawaiian vacation when you got engaged.

When he proposed to me, I was crying because he said there'll be no ring for three years. And I said—

Is that what made you cry?

Yeah, kind of. I said, "So does that mean there's not going to be a wedding either?" But he was good to his word. We really did get married within three years.

So now you're planning your wedding to Arthur at the Pierre Hotel and you're searching for the perfect wedding dress.

I was already thirty-nine.

Were you trying to get it in before forty?

I managed by about five days. Nobody believed I would ever get married, not Calvin Klein, none of my friends. They thought I was just going to work myself to death.

But you knew you would. Or you didn't think so either?

I can only be motivated by really loving someone and a connection. Whether it's people that work for me or people that I live with—meaning my family, or my husband—or my very best friends. We have to be able to grow together, and that's the key to me. And also not be judgmental. I think those are as important in my office—

Let's get back to searching for your wedding dress. You finally designed a dress for ten thousand dollars because you couldn't find one.

Yeah, I had a dress made.

Did you have one dress? I thought you had several.

I had seven. I got a little overexcited. It's Chinese tradition: you wear a Western dress and you wear a red dress, preferably a qipao, which is a Chinese dress, and you wear a pink one. One's good luck and one's happiness. And then you change into something else that you want to dance in or whatever.

Did you change seven times during your wedding?

No, I didn't change seven times. But we started off wanting just to have thirty people, and then Arthur's side of the family was a hundred and fifty. Then my father said, "Well, I'm not paying for the hundred and fifty people." And then there was that argument. So the dress that I picked to go downtown to a nice restaurant for thirty wasn't the dress I could wear with his family, my family. So it turned out to be a whole different process.

Describe the main dress.

The main dress was very classical for that era. It was lace with long sleeves and, for good fortune, some little gold beads, [and] very tiny, tiny beading and some beautiful handmade flowers and a very dropped waist, which was unusual then. And a very full skirt because my husband really wanted me to look like a bride and not like a fashion freak. He said, "Please don't come in one of your fashion outfits. Please come as a bride." So I came as a bride. I wonder if he remembers that now, that I really did come as a bride.

And David LaChapelle took your wedding photos.

Yes, David took all my wedding photos. Boy, what a departure for him. Beautiful, absolutely beautiful [pictures]. We were in the *Times* social section, two so-not-social people. But there we were.

So, now your gut tells you, after searching for this wedding dress—

It wasn't my gut. It was my father. I didn't feel equipped. I didn't know anything about the wedding business, except my own dresses. And he said there seems like a very good opportunity here to start a business.

So he fronted you some money?

No inventory, working in only five fabrics, custom ordered so you never have too much in stock, and you can keep the business small and manageable and the overhead low. And now that I've told you all the good points, I'm going to tell you all the bad points. You rarely get a repeat customer because if they divorce in your dress, they never want to see you again. Although I did have one [woman] who did come back for a second round. And the second is that you have to fit pretty much every girl in a bustier, so you become a corset-maker, in essence. And you can be a [size] two and have a very, very ample bosom, and you can be a [size] fourteen and not have an ample bosom. So it's extremely challenging to produce on any sort of mass [scale]. The third problem is the kinds of weddings girls are having. There was one wedding in Hawaii and the bride weighed about eighty pounds and the veil was very large and a gust of wind came and she almost blew away. It was like Sally Field in *The Flying Nun*.

Was Arthur always involved in the business?

Actually my husband was really annoyed by the business, and not that involved at all, except to be a very good partner in attending fashion events with me. He was at Bear Stearns and then he went on to do some other things and started a digital Internet business.

He was very, very busy and traveled a great deal.

Then in 1990 you opened in the Carlyle. At the beginning, you carried Guy Laroche, Arnold Scaasi, Carolina Herrera, Christian Dior, Donna Karan.

I shopped the world for interesting dresses from friends of mine who were designers. And I loved that because I could put such amazingly different concepts of wedding into the store. And then little by little, I started putting in a dress of mine and then two and then three. It was a very, very cautious, conservative business plan.

You also began some bespoke custom clothes, such as the great satin ball gown for Sharon Stone for the Oscars in 1993.

One of my favorites of all time. That was a major moment. Mr. Armani had been dressing Annette Bening and Jodie Foster in these suits [and] pants at the Oscars. And, of course, Barbra Streisand wore Scaasi and wore see-through pajamas and all that stuff, and very creative, inventive things. I felt it was time to do something really glamorous. And Sharon was the right girl at the right time, a beautiful blonde with golden skin in a beige champagne dress and nothing else. It really put my name on the Hollywood horizon in one fell swoop.

Around that same time, you and Arthur adopted two daughters, Cecilia and Josephine. They're very beautiful girls. What are they doing?

I don't want to speak for them, but I think perhaps both of them have not yet found their grail like I did.

So they're not skaters or designers.

What's really great is that so much more is available to kids today. When I was young, I never would have thought of something like entertainment law or being a lawyer for a recording firm or for Sony or working for a hedge fund in Shanghai. Those are not options that even existed. I think it's a very exciting time to be young.

In 1994 your friend, skater and commentator Dick Button, introduced you to Olympic skater Nancy Kerrigan. Describe what you designed for her appearance in Lillehammer.

One [dress] was white, for the short program, with black velvet and illusion sleeves. And then [for] the main Olympic program, we did a very beautiful dress based on Marilyn Monroe's "Happy Birthday, Mr. President" dress to John F. Kennedy. And it was all nude—

This page, left to right: Alicia Keys wearing Vera Wang at her wedding; Chelsea Clinton wearing Vera Wang at her wedding. Page 239: Model wears a look from Vera Wang bridal for Spring 2014. Page 242: Vera Wang by Patrick Demarchelier, *Vogue*, 2005

not literally nude, I wouldn't do that to an Olympian—but nude color. She wore this really beautiful dress in Lycra with illusion sleeves, and all of the Swarovski was heat-set onto this dress so that it was weightless. It looked like it was all heavy stones but it was so light and she could skate beautifully, and unfortunately she did not win. She also had a thing called a "knee clubbing."

Yes, she had a very famous little incident with a knee clubbing. So while you didn't make it to the Olympics, your clothes certainly did.

Absolutely. Not me, the clothes.

And speaking of Marilyn Monroe's "Mr. President" dress… You've attended quite a few State dinners at the White House.

Yes, I've attended a few.

You and your husband are friends with the Clintons… and golf with Bill?

Golf. Not me, my husband.

Tell us the story about one of your visits to the White House when you wore two different color shoes.

Did Oscar de la Renta tell you that or did Michael? Who told you that story?

I have my sources.

Well, I was in a real rush to get to the White House for lunch and all the designers were going. I had a black [shoe] and dark brown shoe—they [looked] exactly the same. I put on one of each. When I got there, everyone noticed. Oscar was laughing his head off, [and] Michael would say, "Vera, this could only happen to you." I said, "I was in a rush," and he said, "You always are." I never went to the White House with unmatched shoes again.

In 2000 you had your first fragrance deal with Unilever. And in 2001, William Morris published *Vera Wang on Weddings*, an extraordinarily beautiful book. Anybody planning a wedding needs to buy this book.

I wrote every word myself, so it took four years.

By now you've designed dresses for Holly Hunter, Goldie Hawn, Meg Ryan, Whoopi Goldberg, Helen Hunt, Kate Capshaw, Charlize Theron, and Sharon Stone. And wedding dresses for Mariah Carey, Karenna Gore, the Barbie doll, and more recently Chelsea Clinton, Alicia Keys, and Hillary Duff. And, of course, Kim Kardashian's short-lived second wedding.

God, Fern, I'm going to kill you.

Describe the challenge and pressure of designing a wedding dress for these high-profile ladies for the most important day of their life.

When I design ready-to-wear, I'm trying to channel myself. Women designers, of whom I admire so many, have a very special relationship with design and clothing and other women. It's a very personal journey. You can't help but bring yourself into it. So if you're feeling for a certain silhouette or you're feeling for a certain dress length or you're feeling for black or you're feeling for color, that will affect your work as a woman designer. And it will affect how you feel about other women. So it's really what you do in this particular case, as a designer; you're really channeling your own creativity and trying to bring it to women. When you dress a woman for a red-carpet event, like the Oscars, and you dress a woman for a wedding, it's about them. For me, it's a hundred percent about the client.

And her mother?

For weddings, but not the red carpet. For the Oscars I've always collaborated with the star. Charlize Theron wore a dress of mine and she'd just done this very, very period film called *The Legend of Bagger Vance*, very 1920s, 1930s. And she wanted to stay in that mood for the Oscars. Holly Hunter won for *The Piano*, and she'd been wearing crinolines and heavy steel petticoats for seven months with Jane Campion. She wanted to look really modern. So it really depends on the star and the evening, whether she's a nominee or not, or whether she's a presenter or if she's performing. It's a different process for each woman.

Would you share with us your favorite celebrity wedding?

Oh, I can't. I have to be a diplomat. But also, each one's so different. Alicia Keys got married in Saint-Tropez five hours before Chelsea Clinton in Rhinebeck. On that day, to have had two such different weddings, one for the president's daughter, and one for a woman who's such an incredible artist, it was amazing. One was pomp and circumstance and respectful of the president of the United States. And the other one was about a woman who's an artist, and her whole life is about her music and performing. She wanted to be barefoot and was pregnant. They were just two such different weddings, and in one day, five hours apart, it was kind of crazy.

It was a nice doubleheader. How did you celebrate?

I was happy for both. I was calling Alicia and I was with Chelsea.

Let's get back to your business. In 2002, you're adding lines of china and crystal for Wedgwood, and more fragrances, followed by a string of licensees for eyewear, fine jewelry, stationery, silver, giftware, barware, flatware, luggage, mattresses, and hotel suites in Hawaii and uniforms for the Philadelphia Eagles cheerleaders. How involved are you in all of these license deals and designs?

Very involved. I think what is a tad frustrating, having all these lines, is that you really do have to come up to speed, not only from a business sense, but technically. That learning curve is something I embrace because I love to learn. But at the same time, when you're licking an envelope in stationery, and you want to make sure that the flap is the right shape and that the right fonts work on that paper, there's such a specificity that it is quite challenging.

So you enjoy all the different aspects of the business?

I do, because I've learned a lot. But also you have to make sure that you perform from a business point of view. And the more licensing you take on—we just opened about fifteen stores globally this year for bridal—the more responsibility it is. So I never take expansion as necessarily a positive thing. I'm always very, very cautious and very worried about it.

In 2005 you won the CFDA award for womenswear. How did that feel?

I felt like a movie star, like I had won the Oscar. It was a dream I never even dared to have, but it was unforgettable. It was a bit embarrassing. I just grabbed a dress out of the closet because I never thought I'd win. And then I ended up sitting there, and—I don't know if I should tell this story, but I'll tell it.

Go for it.

So I sat there and my daughters did not come because I didn't want them to cry if I didn't win, and so Anna Wintour said, "Get your daughters here." And I said, "What do you mean? What if I don't win? They're going to cry like when Michelle Kwan didn't win the Olympics." And then she said, "Well, I don't sit with losers."

Anna didn't know who the winners were, did she?

No, but I think she had a very good feeling it was my moment. She was trying to give me a lift and give me something I desperately needed after working for thirty years in the business. That was my moment. She actually sent for my children to come, which was the best thing she ever did. It was so nice to have them there, and I did win and I didn't have a speech. I sounded like a fool. But I still got the statue.

And then you started doing another licensee for FTD floral bouquets. You made a deal with Kohl's for Simply Vera by Vera Wang. The collection includes sportswear, accessories, intimates, linens, towels.

Small leather goods, hosiery.

Is that a challenge, doing it at that price point?

I have an incredible support team. As a woman designing for other women, I bring my attitude of liking things to be a little bit easier and more comfortable and layered and cooler and easier. A lot of women outside of New York drive everywhere and they need clothes they can get in and out of their cars with, and they have to be washable. It's just really a great privilege to dress women across America.

It's also nice that times have changed, from when Halston designed for—

J.C. Penney.

That destroyed his career. Designers are now able to do it all.

I think that people are ready to embrace every designer's singularity, and to be able to get that and not break the bank is just fabulous.

Let's go to another very difficult day in your life. In 2006, on the morning of your spring 2007 show at the tents, you took a very painful, tearful walk on the runway after your show.

I usually don't walk the runway, ever.

You walked the whole runway and there were many people in the audience who were crying with you and for you, at least those who knew that your father had just died that morning in Southampton. How did you do that walk?

He had been very sick and for the first time was too sick to come to my show. I got home early that night. Usually I used to be at the office until about two to four, even six in the morning. I said, "Oh my God, I'm getting home at ten thirty. I'm going to take a nice hot bath, and I'm going to look human tomorrow." [Then] I got a call saying, "Your father's dying, you have to come and we're going to try to keep him alive until you get here." Unfortunately, they told him that, which I'd hoped they would've spared him that, because I didn't really think he needed to know. And we had just let the car go and all the garages were closed on the Upper East Side, [so] we couldn't get our cars out. And we finally got into a car and drove out to Southampton. He held on. He held on for about another three hours. And my brother went to his house just to take a shower, and he came back and my dad had passed. I was there with him and my husband was there with him. And, you know, like in the films, it's so surreal if you're not in medicine. The heart is beating and then it's just dying and then it's just flatlines. My mother had died two years before that, and I was so filled with despair that I didn't want to leave her, so when they took her away to the morgue, I wanted to jump on the gurney with her. I said, "She can't be alone." And they said, "You cannot come down there, it's illegal." And you can't just show up at the morgue with your mother. With my father, they made me leave the hospital. They said [for me to] go back to New York, and the doctor asked, "What do you have to do today?" And I said, "Oh,

I have a fashion show." And he said, "Go do your fashion show." That's what [my dad] would have wanted.

And the show was dedicated to him.

We quickly wrote something and we put it on every seat, and then I said just this one time, I'm going to walk the runway for him.

It was a special, special moment.

Thank you.

Do you think that he was proud of what you accomplished?

I've been told he said it to other people, but I didn't have an easy success story. It was a very long path.

In 2010, [for] the Vancouver Olympics, you designed clothes for Evan Lysacek. That was rumored in the press to be a romance. Do you want to clear that up?

Oh, come on. I'm his mentor. His true mentor, for, I hope, his life even after sports.

That year you opened boutiques in L.A. and London, after opening one in Qatar.

We opened Tokyo [and] Korea a year and a half later.

Then you [made a big deal with] David's Bridal. Wedding dresses for six hundred to fourteen hundred dollars. That's really making it available for people.

I'm really proud. My team is totally dedicated. I sit with them on design meetings and it never ceases to amaze me how much detail and quality and design we can create.

And Leighton Meester from *Gossip Girl* became the face of Vera Wang Fragrance.

She's also a good friend. I also mentor Leighton.

You also started a new partnership with Zales for a bridal jewelry collection called Vera Wang LOVE Collection. Are there any categories left you still want to conquer? Home? Furniture? Food? Vera Wang Wine? Champagne?

I do love doughnuts. I think I could do a mean doughnut. And because I was such an athlete, I would love to do athletic clothing. And not just yoga. I think that women and men today, on weekends, in the Hamptons, in Florida, or L.A., there's a natural desire to be comfortable and to be in clothing [in which] maybe they've played a round of golf or played some tennis or just walked. That kind of clothing is joyous to walk around in. And if you can bring a sense of fashion to it…

Do it. Do it. Do it.

I'd wear it. I'm almost there, in my leggings.

You recently bought a gorgeous $10 million house in Beverly Hills. How much time do you spend in L.A.?

Most of my trips are around four to five days, and I probably go about five or six times a year. Not enough.

There was a beautiful spread of the house in *Harper's Bazaar*. The closets in those photographs took my breath away.

They're not as big as they look.

And the swimsuit-clad pictures of you were pretty fabulous.

Oh God, Fern.

Is it true that in your New York apartment that you have a room dedicated solely to your T-shirt collection, which numbers around a thousand and are organized by designer?

No, they're organized by color. Black, gray, and navy. A little white every now and then.

New York is the fancy house. That's where I live and work and create. It was my parent's home. I think my daughters still consider it home, [though] they were not really raised in that apartment. I'll be very Chinese. It's our ancestral home.

And then you began penetrating the Asian market with freestanding stores in Hong Kong, Shanghai, Beijing, planned for 2014. You opened bridal boutiques in the Ginza district in Tokyo and in London, Moscow, Sydney, and Seoul.

It's been a very busy year.

Last year you acknowledged in the press that you and Arthur Becker separated. Is he not involved in the business at all now?

He actually is. He was never not involved in my business.

I read that Vera Wang was a billion-dollar business.

Oh Fern, God. Is this the Dun & Bradstreet checkup? Where's the Securities and Exchange Commission here? Where's the SEC when I need them? I think we do over a billion dollars' worth of product. But that doesn't mean I'm worth a billion dollars. Let's clarify that right away.

Okay. How do you keep on top of all of this? Do you do yoga? How do you relax? Do you relax?

No, I don't do yoga. I used to love tennis when I was younger. I really love golf, but golf is not great in the Northeast nine months of the year. I don't get to travel that much, really because most of my traveling to California is based on award shows. It's about the Golden Globes, it's about SAG, it's about [landing] actresses, it's about making sure that everything goes off flawlessly. And that doesn't leave me a lot of other time, because there are twelve months a year for Kohl's that we deliver product, and ready-to-wear, as you know, is four deliveries a year. That's every twelve weeks we have a new collection to do. And then I have all my licensing. So that would be kind of hard to run from any other city in the world except where it's happening [in New York]. I mean, you really have to be in your office and available, 24/7.

So what's next for Vera? A new collection of second-wedding dresses?

I don't think anyone will come to me for that.

Is going public of interest—the Michael Kors route?

No, I don't think so right now. I think our really big push is into Asia.

Somebody asked from the audience if you will do a maternity line?

If anyone would buy it, I'd be glad to do it.

I can't believe every bride you dressed wouldn't buy your baby clothes.

I've always loved baby clothes. My children can attest to that. They hated them, but I got to dress them the way I wanted to and then I couldn't dress them anymore. No, I think the big push for us will be all of Asia. I don't mean to sound like Genghis Khan here— I'm not on a horse and I don't have a whip and my sword—but I mean, China and Japan and Korea.

The future for the whole industry is there. And being Chinese and speaking Mandarin also gives you a great advantage.

Yeah. I actually have won the Chinese fashion award, the second one ever given, and I won. I think Alber Elbaz won the first.

***Vogue* has ten fabulous pages of ads from you with only Asian models. Do you feel a responsibility to use Asians in your ads and campaigns?**

I always have, but it wasn't that easy to find them until the last decade. The person who really first did it wasn't me. It was Miuccia Prada, whom I absolutely, totally respect.

Who else do you admire and respect in fashion?

I respect absolutely everyone who has the courage to put themselves out there and to ask such huge sacrifices from their families, not only their parents but from their loved ones or partners or husbands and wives. It takes incredible courage to put yourself up for criticism and ridicule. And, it's not an even playing field, obviously. Everyone doesn't have the budgets of Chanel. But among the people that I probably most respect would be a Japanese designer named Junya Watanabe and Rei Kawakubo from Comme des Garçons. I love Jil Sander. I think she is still a great talent.

And you wear a lot of Rick Owens also, don't you?

Yes. And then, of course, I love Marni and Consuelo Castiglioni. And I respect my friend Donna Karan, really one of the first modern American woman designers. There's so many, and I love male designers as well. Besides Rick Owens, I wear a lot of Givenchy from Riccardo Tisci and Alexander Wang.

What are you wearing tonight?

Tonight I'm wearing me. I don't know who the leggings are by. I think the leggings are Danskin. And the shorts are Balenciaga. I like to mix it all up. That comes from having been an editor.

You are one of the few designers who wears a lot of fabulous clothes and doesn't always feel compelled to wear your own clothes.

I get really bored by the time I've done it. As a woman designer for other women, I try on everything I make. Like this jacket was tried on twenty times before we actually made it. And by the time you've lived with it and you've sketched it and cut it and fit it and shown it and then reproduced it and shipped it, you don't want to look at it anymore. No, that's not true. I love it. It's kinda nice after you've eaten a diet of hot dogs or hamburgers to have a slice of pizza every once in a while. So it's kind of just fun to mix it all up and I love all my designer friends. And I respect what they do. And some of them are really, really good friends. Like Michael.

Will you ever do _Dancing with the Stars_? I know there was a time when you almost, it was rumored, were going to do it.

There was a rumor, but then there was a little problem. I'd have to give up my day job to do it. Again, it's the time restriction of doing fashion. I can't be in L.A. between September and Thanksgiving. I can barely manage being here [in New York], let alone not being here. So that sort of put the end to my Ginger Rogers career. I would love it if I were retired, maybe. I don't know. Right now we're just so busy and I'm going to have to be in Asia a great deal in the next three years.

An audience question: what is your favorite place in the world?

I have a few. One is my own bed in New York.

Is it a Vera Wang mattress?

Yeah. That's one of my favorite places because I can be comfortable, relaxed and eating in bed. I love a slice of pizza in bed.

But you also have somebody who's been cooking for you for thirty years.

Yes, she has. She's family.

Do the girls speak Mandarin?

They both do. They don't speak French. I love Paris, but I feel more excited by London. Actually, the next place I've actually been looking for a place is London. It's just gotten so expensive recently with everybody leaving France. But London is definitely on the wish list for me. I'm following Tom Ford, actually. I followed him to L.A., now I'm going to follow him to London. I'm stalking Tom Ford.

Does that mean you'll do your show in London, too, like he did?

I don't know about that. A lot of people are showing in London. But I would love a place in London. I know my kids would love it.

That's great. Do you have a mantra that keeps you balanced and focused personally and professionally?

Absolutely none. If someone has a good one, I'm really open. I think what I try to do every day is not to get hysterical. I just take a deep breath and prioritize. And everybody's going to have to wait. We're going to get through one thing before we go to—[like] point A before we get to point B, instead of A, Z, F, G, and not knowing where we are. But I don't do anything really well because I gave up on perfectionism long ago.

Oh, you do everything well.

No, when you become a mom, the house doesn't really look that great, the plant's dead, the dogs have shed all over the house. I just gave up. I can't live like my friend Calvin. He lives in perfection.

Minimal perfection.

I live in chaos. I live in chaos, with dogs screaming—

You seem to thrive with that, though.

I don't know anything else. When you raise kids and they're home, they're coming in and out, and one likes to bake and another one likes to cook. And then everybody fights in the kitchen because our Chinese housekeeper doesn't want anybody in the kitchen. And it's not what one would probably say a designer's glamorous life should be, but—

That's life. On a final note, any special advice that you would give for up-and-coming designers who are here tonight?

Absolutely. I've done FIT and Parsons and I would [say] work for somebody that you really admire. My dad wouldn't pay for me to go to design school after college, but he always said to me, "Go get a job and get someone to pay you to train you." And he was right, because I would've never learned what I did if I didn't go to *Vogue*. And what you really learn are things that are invaluable, and you're not even sure you're learning anything. I said, "All I do is messenger slips?" So if you're lucky enough to get a job with a designer or a house or a company that you really respect, even if they don't pay you the most money, just think the privilege you have of learning from them. And later on, if you want to go off on your own, and you really feel you've earned the right or you have the proper financing or the proper backing or the proper support or you resonate with other clients, that's a different story. But to begin with, I would say if it's at all possible, work for a design company so that you can learn. And just think, you're getting paid in your learning.

I think we've all learned a lot from Vera tonight. And we want to make sure she gets on her plane. So, thank you, Vera. [APPLAUSE]

Thank you, Fern. Thank you. Thank you.

OSCAR DE LA RENTA

Good evening. Oscar de la Renta has been described as the "Sultan of Suave," the "Couture Conquistador," and the "Guru of Glamour." The very mention of his name conjures up a glamorous, unforgettable night or a romantic, magical wedding, whether you are a CEO going to a board meeting, a sexy celebrity walking the red carpet, or a philanthropist going to a gala benefit. Oscar's life parallels all of these special occasions. He has been at the center of it all, the Metropolitan Museum of Art, the Philharmonic, New Yorkers for Children, the CFDA, and a host of other charities that are near and dear to his heart. He has won more awards and accolades, presented to him by movie stars, presidents, and prime ministers, than we have time to talk about. At this stage in his life, he is fashion's elder statesman. And boy, what an extraordinary life it has been. He has made it absolutely clear he is not stopping and not going anywhere. He has said, "To rest is to rust." Oscar was presented with yet another award, the CFDA's Founder's Award, for his unique contribution to fashion, presented by none other than Hillary Clinton, and she looked better than I've ever seen her look in her Oscar pantsuit. Hillary is just one of the many first ladies he has dressed, on both sides of the political aisle. Known for speaking his mind, he told Women's Wear Daily that he'd rather get the Designer of the Year Award for what he's doing now [than for] what he's done in the past. We will hear Oscar talk about where he came from, what informed him, his upbringing and foundation, his philosophy of love and life and music and dance. He is, after all, Latin and will charm us like no other. We'll hear how he managed to build a business that no one else has been able to do, from dressing a certain caliber of women to their daughters and now their granddaughters. Not an easy task in fashion. And what do they all have in common? They all look fabulous and appropriate. All three generations love Oscar. So ladies and gentlemen, let's give a very warm welcome to Oscar de la Renta.

OSCAR DE LA RENTA: Thank you. Thank you. Thank you. Great audience. I have never gotten this kind of applause ever before.

FERN MALLIS: Very nice. Well, you deserve it, and they're all here to take it all in. Oscar, we start at the very beginning.

Don't ask any tough questions.

You were born Óscar Arístides Ortiz Renta Fiallo on July 22, 1932. That makes you how old?

I'm eighty years old.

[TO AUDIENCE] Looks pretty fabulous.

I always think that age is in your mind. Sometimes in your body as well.

Well, that's my next question. How old do you feel?

It depends on the day. When I'm lying down or when I am sitting, I think I can do everything. And then suddenly, when I start moving around, my body doesn't respond in the same manner.

Yeah, the knees go.

That's right. But my passion, my spirit, my joy for life—those remain intact.

You were born in Santo Domingo in the Dominican Republic. Your astrological sign is Cancer. Do you believe in horoscopes?

If it's good, yes. If it's not good, no.

Well, the crab is a water sign, which signifies your highly emotional nature. And it also makes you highly caring, generous, and intuitive. You are loving, susceptible, sympathetic, sensual, faithful, instinctive, charitable, over-reactive, and moody. Do you agree?

Moody, I'm not. You can scratch that off. All the others—

All the others work. So your mother, María Antonia Fiallo, came from a long line of Dominicans. And your father, Óscar Sr., was from Puerto Rico. How and where did they meet?

My mother, they were a family of eight. My grandmother had eight children, four boys, four girls. My father came to the Dominican Republic to work on the [sugar plantation] as an engineer. And then he met my mother. To tell you the truth, I don't know really exactly how because I have a deeply controlling grandmother. In fact, I have three of my aunts who never married, not because they were not pretty, just because—

Because your grandmother wouldn't let them?

—there was never a man good enough for those girls.

Your dad also worked in the insurance business, I read.

That's later on.

Right. You had six siblings.

I am the only boy, and there are six sisters.

And where do you fit in? Are they all older? Are you the youngest?

There's one that is younger. Otherwise, five are older than me.

And so you were very doted on, being the boy.

Not really. I have sort of a great relationship with some of my sisters. Not great relations with all of them, especially with the one who is five years older than I am, which is the one who is next to me. Still today, we don't get along really very well.

What was your house like when you were growing up?

We lived in Santo Domingo, the oldest city in the hemisphere. My mother's side of the family had been on the island for over two hundred years. There were masses and masses of Fiallos. We lived in the old part of the city, what we call today the Zona Colonial. I lived surrounded by family. At the time I was born, the Dominican Republic was already under the dictatorship of Rafael Leónidas Trujillo. He came into power in 1930. I was born in 1932. Probably most of the members of my family were against the dictatorship of Leónidas Trujillo, except for one uncle of mine, to whom I was really very close. Many years ago, rumors were in *Women's Wear Daily*; sometimes they said that my name was not de la Renta, that my name was Renta. I never responded to it because I knew what my name was. My great-grandfather was the founder and the constitutional mayor of the city of Ponce and was reelected seven times. So you can look at Juan José Ortiz de la Renta, and you will know about my father's side of the family. Though my mother's side of the family was the side of the family that I was the closest to.

Your mother and father's families were very prominent, [and you] grew up surrounded by politicians, poets, scholars, businessmen—all a blueprint of what your life would

Left to right: Oscar de la Renta's grandfather's home in southern Puerto Rico; Oscar's father, Óscar Sr., and mother, María Antonia

eventually become. Tell us about that grandmother and how she was very formidable.

My grandmother actually came from the land of Coriso. She was [of] Dutch origin and came to the Dominican Republic. She was, in fact, my grandfather's second wife. With the first wife, my grandfather had seven children. And then at age thirty-five, I suppose exhausted after fifteen children, he died, and so my grandmother really, in fact, had fifteen children to take care [of]. She had a good time.

You're always surrounded by a lot of family. What were the values they taught you?

We were a very tightly knit family. We sat at meals every single day, for lunch and for dinner. Obviously, the younger ones who had to go to bed were not allowed to sit at the dinner table, but later on, once you reached a certain age, we sat at every meal. One of the reasons I really love food and like to eat almost everything is because no one was allowed to leave the table. If you said, "I don't like that," my mother would say, "Who asked you?"

Good answer. Was your mom a good cook, or did you have lots of cooks in the house?

I never saw my mother in the kitchen. Actually, we had somebody who cooked and someone who worked with us for many, many, many years. I've seen that in the Dominican Republic mostly. It was a time you could afford to have a cook.

Do you cook?

I used to. I love food, so I like to get involved. You know, my wife, of course, never eats, so if I don't get involved in what I'm going to eat on a daily basis, I would not eat at all.

I read there was a time when you and your siblings each had a section of the gardens at your home. And you grew corn and spinach and sold it back to your mom.

We were not allowed to go and play in the street. We had a big yard in the back of our house, and we had one a little plot allotted to each one of us. And of course, my sisters, they all wanted to grow flowers. I wanted to grow something that I could sell.

So you were an early entrepreneur.

I learned very quickly that things like spinach and corn grew very fast. And there was only one client, which was my mother.

Were your mom and your sisters glamorous? Did they love clothes?

I don't remember at all how my sisters were dressed. I do remember, though, that my

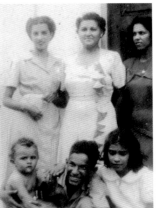

This page, clockwise from top left: Oscar as a teenager in Santo Domingo; Óscar de la Renta Sr.; Oscar with his sisters Avelina and Alicia and neighborhood friends. Page 255: Baroness Aino Bodisco (right), looking on as Beatrice Lodge (center) is being fitted by Oscar de la Renta, 1956

mother—some of her friends called her Madame Georgette, because she was always wearing georgette dresses. One of my uncles lived in Havana, a much more cosmopolitan city than Santo Domingo at that time. My mother would go to visit her brother and spend some time in Cuba. I [would always] ask, "Why do you go all the time to Havana, when you could go to New York and Paris?" And she said, "The gaiety of the Cubans, the gaiety of the people." But the one thing that I remember about those trips was that all my clothes came from a store in Havana, a sort of Bergdorf Goodman called El Encanto, which was a very famous store in Havana. I was always the tallest in my class. When every other boy was already wearing long pants, I was still wearing short pants.

And you had skinny legs.

I pleaded with my mother, "Please, please, buy me a man's suit." But to no avail.

Your home was surrounded by beautiful fragrant flowers, which came into play later in all your fragrances. Tell us about the perfume you tried to make when you were seven years old, this time to sell to your sisters.

I was always curious about how perfume comes out of a flower. When I was little, I thought that if I would get up very early in the morning and collect all the dewdrops, I could sell it as perfume. Of course, it did not smell. But as a souvenir of that memory, my very first bottle of perfume had a dewdrop on it.

Do you have a favorite flower or plant today?

I like mostly flowers that have a scent. I lived in a country where there were a lot of flowers that had very strong scents, things like ylang-ylang and tuberose and jasmine. There is one flower, actually, we Dominicans call "gentleman by day." It's not really a beautiful flower, but when it blooms, the whole place just smells…

Is there one flower that takes you back to your childhood?

Ylang-ylang, because […] very close to where I lived […] was a big square with one ylang-ylang tree. And when that tree was in bloom, you could smell it for blocks.

You were schooled in the Dominican Republic, and I read you also went to art school there because you were a doodler. What did you doodle?

I doodled. My father had different kinds of aspirations for me than I had for myself. [As I was] the only boy in the family, he, of course, thought that eventually I would work in the family business. I didn't see myself really selling insurance. I had a very, very strict mother. But at the same time, she always said to me, "I will always back you as long as you do what you want to do in a serious way," which I did. If I ever told my father then that I was going to become a fashion designer, probably he would have dropped dead on the spot. But I was never really interested in fashion because I was never exposed to it. I thought that I could become an architect. I love to draw. I went to the first year of university, and at the same time, I enrolled very early on in the art school in the Dominican Republic. It was a very, very important time, because we had extraordinary teachers. A lot of great Spanish painters had left Spain because of the civil war and immigrated to the Americas, so all these students who came out of that period, many of them have become really wonderful painters.

Did you have other interests—in sports or anything like that?

I was never very much into sports. I used to play volleyball because there was one girl whom I liked a lot and she was playing volleyball too.

It's always a good reason. Tell us the story about seeing your uncle's fancy car on the

street near your home.

My uncle was Federico. He was at the head of the Dominican armed forces, a general in the Dominican army. He was the only member of our family who was very devoted to Trujillo. One of my sisters was already married. I was seven years old, and I was so unbelievably proud that I had a nephew. I was allowed to walk to my sister's house, who lived about three or four blocks from where we lived, all by myself, to visit my sister and my nephew. My uncle had several cars. There was the official car, which had three stars for his title. But then he used other cars when he did other kinds of things. And I spotted one of those cars, several times, close to a house that I used to pass by. So I would peek into the house. And one day, an unbelievably beautiful lady came out to the balcony and asked me what I was looking for. I said, "I have seen my uncle's car park around here, and in fact, I have seen him enter in your door."

Busted.

First of all, she was very tall, very blonde, big blue eyes, which was quite rare in the Dominican Republic. She offered me a cup of tea from a samovar. And she gave me some cookies. And most importantly, she gave me twenty-five cents.

She won you over.

Then she said to me, "If you want, we could be friends, but it would have to be a secret. Your uncle is my friend, but this is a secret. Would you be able to keep that secret?" So quite often, two or three times a week, I would go to visit my sister and stop by the Russian lady's. And I would have my tea, I would have my cookies, and I would have my twenty-five cents. She opened my eyes, because later on, my uncle built a beautiful house for her on the outskirts of the city, and the house had the name of the town she came from: Calcas. At that time, [the possibility of] divorce was nonexistent. My uncle was married. He had three children. One day, I went into an almond tree, and I was bitten by nine wasps on my ear. And apparently I had a very high fever and I didn't want any food. I said, "No, no, no, no, no, I want some cookies and tea from the Russian lady." So my mother asked me, "What is this business about this Russian lady?" I said, "She's a very, very nice lady. And she offered [me] some tea and some cookies." So, of course, my mother knew about the existence of this lady, and my mother then wrote a note to the lady and said I was having a fever and would she like to come and visit me. And then my mother met this lady, and [then] my grandmother, as well, said, "Well, I would like to meet the lady, too." She never liked the first wife, the only wife of her son. So suddenly I became sort of like the go-between, the big hero in the family, the discoverer of this extraordinary lady. And it was really an unbelievable love affair. Every Wednesday, my grandmother and I would go and have lunch with the Russian lady and with my uncle. I felt so big because there was this huge car that would pull up to the school and pick me up, half an hour before my classes ended. And it was so mysterious and exciting.

At eighteen, you left the Dominican Republic to go to Madrid to study art at the academy of San Fernando, and your family supported that because it was what you wanted to do.

My mother was very supportive of it, and I always say that a lot of what I am I owe to my mother, because my mother actually died very young.

She died that year you went to Spain.

She had multiple sclerosis. At the time, we knew very little about the disease. I don't think that I fully understood how sick my mother was. By then, I had already graduated from our school in the Dominican Republic, I was eighteen years old, and I wanted to move on. My first choice was to go to Paris. But to go to Paris was unthinkable. It was like going to Sodom and Gomorrah. One of my very close friends from our school had gone to Spain the year before, and it was decided that perhaps I would be allowed to go to Spain. What is extraordinary is that my mother really twisted my father's arm to let me go to Spain, probably knowing that she would never see me again. But she knew that if something would happen to her, he would have never allowed me to go. That is the kind of sacrifice that only a mother can do.

What was life like in Spain at that time for a nineteen-year-old, tall, dark, handsome, talented young man?

When people ask me about Madrid—this is 1951—I say, a woman could walk naked on the street at three o'clock at night and nothing would happen to her. I felt at times very lonely, but at the same time I had this great curiosity and freedom of being on my own. I was so hungry to learn about life, and my years in Spain and all my early years in Madrid were really wonderful.

And you started to work, getting jobs, sketching for the newspapers and magazines.

My father started to put pressure on me, after my mother died, that I should come back to the Dominican Republic. And then a very good friend of mine who was going to our school with me was doing fashion illustration for the newspapers and magazines to support himself. And I said, "Well, I can do that, too." Not that I was making any big money with my sketches, but I pretended to my father that I was. My two older sisters, who were already married, were the ones quietly helping me. And I am very grateful for that. I started doing these sketches for magazines. [In] the fashion industry in Spain at that point, there were some very great names.

I bet there were.

The house of Balenciaga in Madrid was not called Balenciaga. They would always tell us that no one is a prophet in his own country. He started off in his first house in 1937. [He] was thirty-six when he went bankrupt in Spain. Then he went to Paris and became very famous. [He] was never able to use the name Balenciaga in Spain.

Let's backtrack. You're drawing and you're making some money. But at that same time, with no design work or studio, you designed a dress for Ambassador John Davis Lodge's wife, Francesca.

Now you ask me what I was doing at Balenciaga; I was picking pins from the floor.

Picking pins from the floor, you made a dress for the ambassador's wife and for her daughter Beatrice's coming-out party.

I had to design a dress, and Francesca Lodge had seen the dress and asked me if I would design a dress for the coming-out party of her daughter.

Which made the cover of *Life* magazine.

Well, the dress did not make the cover. There was a photograph of me fitting the dress inside the magazine. She was the cover, just a headshot.

And you did, as you say, get to work for Cristóbal Balenciaga. What was that meeting like, when you first met him?

Balenciaga by then, of course, was a very, very famous designer in Paris. I met him through a friend. But Balenciaga, all through his life, remained very Spanish. In fact, after his big success in Paris, he opened not one but two fashion houses. One in Madrid and one in Barcelona. And I was working in the house in Madrid. He would come after he had done his collections for the house in Paris and design another collection, which was almost exactly the same collection that he had done in Paris, but using the Spanish fabric for his Spanish customers. This is the first time that I met Emanuel Ungaro. Emanuel was one of the tailors working for Cristóbal Balenciaga.

The world keeps getting smaller and smaller. So what was the most important thing you learned there? You didn't have a lot of interaction with Mr. Balenciaga.

Not really. I never, ever went to a fashion school.

That was fashion school.

I had the great luck of observing and seeing a master at work. You know, going into the sample rooms and seeing how clothes were cut, where they were made, I fell in love with it. Not that I quit my art school altogether. I kept painting and being part of group shows at different galleries in Madrid. But it's only when I came to the United States for the first time that I decided one of my biggest problems was that I had a very small talent. Sometimes you are able to do a lot of different things. And I realized that if I was going to excel in something, I should do only one thing. So when I came to the United States, I focused my career just in fashion.

So, you're in Spain, it's 1951, it's a vibrant, free place with a nightlife of flamenco, ballet, artists, bullfights, peasants, gypsy guitar players, who all became your friends as easily as the aristocracy of the city. And then you met someone, a friend who became a señorito, an upper-class dandy who got you your suits made.

I was not very much into dressing at that time, because I thought I was being a painter, I'm going to art school. Almost everyone who was in our school—

Dressed like they were in art school.

Exactly. But then I evolved and met some other group of friends and a lot of my friends who had gone to school in England said, "If you have to be a part of our group, you have to really change your way of dressing." And they took me to a tailor, who still today makes my clothes.

That's loyalty.

Well, of course, now it is the son. In fact, the grandson now runs the house. I started to learn that life [in] Spain [is a] really a wonderful life.

Tell us about meeting Ava Gardner.

Ava. I remember that one of the very first times I went to a bullfight, I was sitting on the sunny side, which is the very inexpensive side. The shady side is where all the expensive seats are. I was way, way, way up there, the least expensive ticket that you can buy for the bullfighting. All the matadors came out and paraded. It was extraordinary pageantry. There were three bullfighters, and one of them put his cape in front of a lady way far away from me. So I ask, "Who is this lady?" And they told me, "It's Ava Gardner." I said, "Oh my goodness, Ava Gardner." So I guessed from which door she was going to leave. In a corrida there are six bulls: three bullfighters, two bulls each. So I left on the fifth bull, and I waited to see if I could see Ava Gardner at a close distance. And I was waiting by the door,

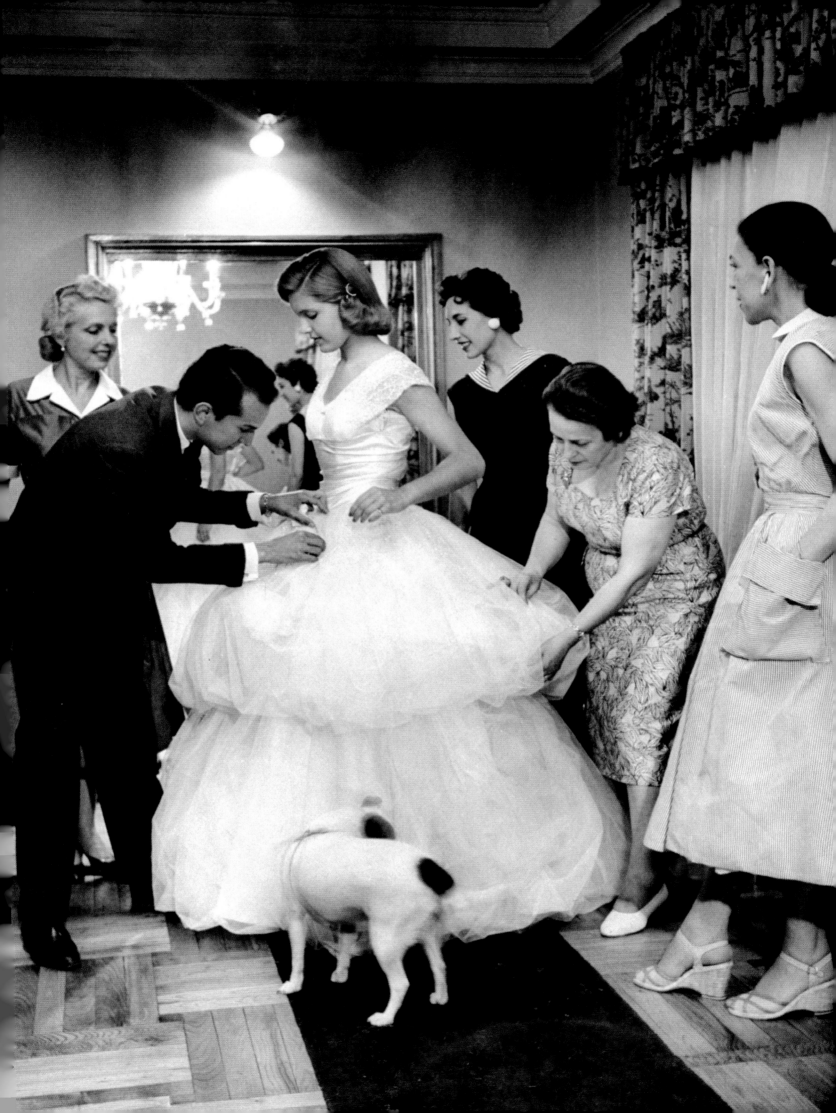

and she, of course, decided to leave a little bit early to avoid the crowds. Suddenly, I found myself face-to-face with Ava Gardner. And I said, "My name is Oscar de la Renta and I come from Santo Domingo." And she said, "Oh, how sweet." And she just kept walking.

Well, that was a good way to start, introduc[ing] yourself right away. Three years later, 1959, you were vacationing in Paris, and you went to the house of Christian Dior.

I wasn't really vacationing. I was—

Working.

While I think that New York today is really, with no doubt, the capital of fashion in the world, Paris at that particular time was really the center of fashion. I went to talk to Mr. Balenciaga, and I asked him if I could come to work in his studio in Paris. And probably he was totally right in saying, "I think that you should stay for one more year, and then I will take you to the studio in Paris." But by then, I was too anxious, too restless to move on. So, unknown to him, I bought myself a train ticket to go to Paris for a week, and I've got to say, don't ever start at the bottom. Start at the top and go down.

That's good advice.

I had wonderful sketches because I could draw very well, and obviously my sketches were very Balenciaga inspired. I arrived in Paris and went to the house of Christian Dior. This was the time when Yves Saint Laurent had just left Dior. They were in the process of hiring Marc Bohan, but it had not yet been announced, and I was interviewed by a lady called Madame Marguerite. She looked at my sketches and said, "I like your sketches, and I would like for you to work for us." My goodness, I was so excited. I am in Paris less than twenty-four hours and I am being offered a job. So I ask how much they will pay me. I am not going to mention the amount—very little. But I was so excited that I was going to get a job. Walking out from Dior, I met this friend of mine from Madrid who was, by then, living in Paris. And he asked, "What are you doing here?" I said, "I'm still painting but I am interested in fashion and I just came from the house of Dior and they have offered me a job." I showed him my sketches. And he said, "There is a very good friend of mine who is the head of the house of Lanvin, Antonio Castillo. And, in fact, he's looking for an assistant. Would you like to see him?" And I said, "Yes, of course, I have a job at Dior [but] I would love to see him." Half an hour later, I was in front of Mr. Castillo. Mr. Castillo looked at my sketches. I don't lie. I never tell lies because I've seen that you have to cover a little lie with a bigger lie. But at that time, I did lie. He asked me one question: did I know how to drape? And I never draped anything. I told him, "I came because this friend insists that I come and see you. But in fact, I have already accepted another job." And he asked me, "How much are they paying you?"

So that was another little lie.

I doubled. And he offered me a job. Now you're going to ask me, why did you decide to go to Castillo and not Dior? First of all, my French at that time was almost [nil]. At Castillo, I was going to be his assistant, and I could speak Spanish.

And he was paying you lots more money.

And he was paying a lot more money. So I went to Castillo at Lanvin, and I stayed there for three years.

And you learned a lot there, besides dancing every night at Régine's.

I was a fantastic twist dancer, you know?

I know you were. You're a fantastic everything dancer. Mr. Castillo often invited you to

his very social dinners, where you also met Gloria Guinness for the first time.

I met a lot of people. Castillo had a very active social life, and whenever he needed an extra man, I was it. There was another assistant at Castillo. He was short and fat, so they always asked me.

So, it's interesting that you actually had experience with all three of the hottest houses in the business. Would you care to comment now on Raf Simons for Dior, Alber Elbaz at Lanvin, and Alexander Wang at Balenciaga?

I think that all three of them are great, great designers. I think that Alber is doing an extraordinary job at Lanvin, and as you know, he started his career here in New York, working for Geoffrey Beene. He's a very, very talented man. Raf Simons I have never met really. Alexander Wang, I think, is extremely talented and it's quite extraordinary that the roles have reversed. That we went to France to learn the trade, and that now France comes to America looking for talent.

Then you visited New York in 1962, with three letters of introduction to open doors.

I had more than three letters, but three important letters. Jacqueline de Ribes gave me a letter for Diana Vreeland. Edmonde Charles-Roux, the editor in chief for *Vogue* magazine, gave me a letter for Alexander Liberman. James Brady gave me a letter for John Fairchild.

It's nice to have friends who help open doors for you.

Obviously, to have the friends is important, but I always tell fashion students, you don't need the introduction, you need a good portfolio to show your work. Because perhaps the introduction will open the door, but if you don't have the work—

No, you need the work. On that same trip, you had a friend, Count Lanfranco Rasponi, who did PR and was doing a ball for his client, and he sat you next to her at a dinner. And she was Elizabeth Arden.

He sat me next to Elizabeth Arden because he knew that I was coming to New York with the idea of exploring New York. A lot of assistant designers like me, working in Paris, have come to New York, and they will go back and say how much money they were making. It was a very interesting time, when I first came to New York in 1963, because when you look at the name on the labels [there] was the name of the manufacturer—and not the name of the designer. But there was Originala, Ben Zuckerman, on and on and on and on.

Maurice Retner.

And the designer was a little guy working in the back. And I have to give credit to John Fairchild, that he is the first one who came from Paris and said, "You know, I'm not interested in the factory. I want to know who the guy is who made that dress."

Who's making it?

And so I happened to come to New York at a time [when] a lot of very interesting things were happening in the city.

Then you were offered a job, apparently, at Dior in New York.

There was, at that time, a Christian Dior-New York ready-to-wear, which no longer exists. What is very funny is that Mary McFadden then was doing public relations, working for Dior as a PR person, and she got me an interview for Dior. The designer who was working at the time was going back to Paris. They were looking for someone for the job. On that specific night, Lanfranco Rasponi sat me next to Elizabeth Arden. Antonio Castillo had worked for five years for Elizabeth Arden before he went back to Paris. Antonio Castillo, early in his

career, worked for Chanel. And then he worked, I think, for Patou, then came to the United States and worked for Arden for five years. So I knew a lot about Elizabeth Arden.

That's a great history there.

I was sitting next to Elizabeth Arden at this dinner. She was already a lady of a certain age. I remember one time she told me, I have lied so much about my age that I don't remember exactly how old I am. [So] I was sitting next to her, and I started the conversation to my left and right, and she asked me, "What are you doing in New York?" I said, "Well, I am going to my country and I came to visit New York." So she asked the question that I was waiting for. She asked me, "Who do you work for in Paris?" I said, "I am the assistant for Antonio Castillo at Lanvin." And she said, "Oh, he used to work for me." Very quickly she said, "Why don't you bring me your sketches? I would like to see your work." I said, "Ms. Arden, I came here just for a week's vacation. I am going to my country to spend Christmas. I'm very flattered you would like to see my work [but] I really did not come prepared. I don't really have anything to show you. I do have some sketches that I am bringing for my sisters, but it's really not my best work."

You played that perfectly.

I had been working on my book for a whole month. I wasn't very sure if she was being real. I said, "Ms. Arden, I am so flattered that really you'd like to see me." On the place card I wrote my name and the hotel. And at ten thirty in the morning, the phone rang. It's Arden's secretary. [He] said, "Ms. Arden asked me if you could come and see her and bring your sketches."

And you said, "Let me check my schedule."

No, I didn't say that. I said, "I'm embarrassed to show her these sketches because it's really not my very best work, but I will be very happy to come." So I did go to see Ms. Arden, and she looked at my sketches very, very, very quickly. What I read in her mind was, "This is Antonio Castillo's number one—I'm going to get even with him, I'm going to take him away from him." And I, of course, grabbed the opportunity. But in fact, I had been in New York less than a week and [I had] the offers for two jobs. There's one thing that is very important. I felt that the future of fashion was changing. I felt that ready-to-wear was becoming the great future of fashion. In France, the old couture houses, they all have a little ready-to-wear line. But except for at Lanvin, the assistants made the ready-to-wear collection. And took the ready-to-wear collection to Mr. Castillo—he never was involved in it. And I suppose that in other houses it happened exactly the same way. I felt that in New York, there were things happening that were important. So, I now go to visit with Mrs. Vreeland, and—

And she gave you some very good advice.

She received me in that red room. And she said, "Young man, tell me what you are here for. What is it you want to do?" And I said, "I would be interested in coming to work in New York. I feel that the future of fashion is ready-to-wear and I see that there are great opportunities here." I then talked to her about the two offers of jobs that I had received, and she said, "Well, I think that you should go to Elizabeth Arden." I said, "But at Elizabeth Arden, I will be doing exactly what I was doing in Paris, because Arden was going to be, again, a custom-made collection." I thought that she misunderstood me with my accent, which I still keep. She said, "No, if you go to Dior, you will be working behind a very big name, and it will be very difficult to make a name for yourself. While not only Castillo but [Charlie] James had worked at Elizabeth Arden and started his career there." So Diana Vreeland convinced me

that I should go take the job at Arden.

She said you'll make your reputation faster, because [Arden] is not a designer. So she will promote.

I stayed at Arden for about two and a half, three years. In 1965, I tried to convince her that she should go into the ready-to-wear business, and at first she agreed. When I came to Seventh Avenue there was a man called Benjamin Shaw, who at the time owned three fashion houses: Geoffrey Beene, Donald Brooks, and Jane Derby. Ms. Derby was retiring, and the Derby label was going to be called Elizabeth Arden. I said, "You're selling your beauty products to these stores; why not to sell ready-to-wear with your name?" And then she changed her mind. So I came back to Benjamin Shaw, and I said, "Ms. Arden has changed her mind, and she doesn't want to do the ready-to-wear." And he told me, "Well, we are not interested in Elizabeth Arden, we are interested in you." And so, in 1965—

You joined forces with Ben Shaw. And you were designing for Jane Derby. Then she died very quickly.

Yes, but I had become a little smarter then. I said, "Well, my name has to be on the label. My name has to be bigger and above the Jane Derby label." And if you find old, old vintage clothes, [the labels] say, "Oscar de la Renta for Jane Derby." Ms. Derby died, and then within six months the label was changed just to "Oscar de la Renta" in 1965. In '67, I won my first Coty Award. I won it again in 1968. [APPLAUSE]

During that time you were also having a relationship with an editor from French *Vogue*, Françoise de Langlade.

I had known Françoise from Paris, but we didn't really start seeing each other. I came to New York and she came to New York, and I was coming out of a hotel where I was having lunch. She was getting in and she said, "What are you doing here? And you are doing very well." I said, "Yes, I love my job." And then I said perhaps we could have lunch. And she said, "Well, I'm very busy, but perhaps we can have a drink." I didn't call for a drink. Later on I went with friends to Paris and at every dinner I was sitting next to Françoise because we were both in fashion. And the rest is history.

Well, it's good history. So, two years later, on Halloween, at lunchtime, you and Françoise—

I never knew it was Halloween.

It was Halloween, October 31; you and Françoise went to city hall on lunch hour and got married.

You know, I have very bad luck.

I'm not sure about that.

None of my wives ever wanted to marry me. I only have two, of course. But Françoise back then was editor in chief of French *Vogue*, and she had a fantastic life in Paris. And then at one point I said, "I've seen that these sorts of relationships, of crossing the Atlantic back and forth have to change, somewhere, somehow." But it was difficult for her to leave her life in Paris.

Well, she gave up that life in Paris, came here and married you, and had a very glamorous life here in New York as well.

I was married for [eighteen] years.

And she was twelve years your senior. Was that an issue at that time?

Clockwise from top: Oscar de la Renta with Jane Derby at his first show for Jane Derby in the fall of 1965; Oscar de la Renta being interviewed at his office in New York, 1963; Oscar and Françoise at a friend's wedding in Washington D.C., 1973; Oscar with Françoise the day after their wedding in their New York apartment

She was twenty years younger than I was. Her spirit was.

In 1971, you bought your dream country house in Kent, Connecticut. At that time, it was a hundred and ten thousand dollars. Why is that place so special to you?

I knew the area because Alex and Tatiana Liberman lived very nearby. Alex was the [editorial director] for Condé Nast, and we used to go quite often and spend weekends with them. They had bought their house, forty-five acres for forty-five thousand dollars. And so I told Françoise, perhaps we could find ourselves a house for forty-five thousand dollars with forty-five acres with a view. Françoise—much wiser than I was—said, "I don't think we should buy a house in the country. We cannot afford it." And so I went looking at houses. And every house, by then, for forty-five thousand dollars was right on the road with a quarter of an acre of land. I said, "No, no, no, no, that's not what I want." This lady then told me, "There is a house for sale, a little bit more expensive than you are looking for, but it has one of the best views in Connecticut, but I cannot take you there." And I said, "What do you mean, you cannot take me there?" [She] said, "We might find corpses in the bedrooms." I immediately got very curious about the corpses in the bedrooms.

You're used to corpses in the bedrooms?

I'm used to corpses in the bedrooms. She took me to see this house. Of course, no corpses anywhere. But even before I arrived, I had this pang in my heart and I said this is the place where I want to be.

Places like that do talk to you. Okay, we're going to try and get through some of this quickly because there's so much. In 1973, you became president of the CFDA. And one of the really incredible things you did at that time was to create the CFDA Awards and take it away from Coty.

I felt that at that time, American designers were expanding their business and going into other areas. I felt that there was a conflict of interest, and that if there were going to be awards, we should be in control of it. Bill Blass and Ralph Lauren and Perry Ellis—we all met and discussed the idea of creating our own awards.

Wise decision.

One mistake that I still regret was giving an award to a foreign designer. Because—not that I want to be mean—Italian or French designers don't honor American designers. So why do we have to honor [them]?

Because we're bigger than them.

I don't know about that.

But they don't give it every year to a foreigner—only when it's appropriate.

Well, I think it's debatable.

Okay. Let's tell a little bit of 1973, when you, Halston, Anne Klein, Bill Blass, and Stephen Burrows were invited to show in Paris, at a special benefit for Versailles, and what became known as the "Fashion Showdown." The Americans completely upstaged Yves Saint Laurent, Dior, Ungaro, Givenchy, and Cardin. What was the role you and Françoise played in pulling that evening off?

The idea of the show came from Eleanor Lambert. Five French designers will invite five American designers.

They invited Americans?

Well, it was going to be a charity event, and they thought that they were going to make

mince pie out of us. And in fact, they almost did. Every designer was going to be the guest of one of the French designers. I was going to be the guest of Yves Saint Laurent. But the fact is that, eventually, our show was bound to be a disaster. My wife went to Paris with Joe Eula, the great illustrator. We were doing the show in this unbelievable beautiful small theater at Versailles. We have no money for sets. We each have to put in ten thousand dollars, which was, at the time, a lot of money for all of us. And all the measurements that Joe Eula took—we arrived in Paris with Joe Eula's sets, and they hung twenty feet above the ground. We could not use them.

It was all in centimeters instead of inches.

Exactly, centimeters instead of inches. We were having meeting after meeting on how the show was going to happen. Finally, on the very last day of the very last meeting, Halston would not talk about models. We wanted to take twenty, thirty models, and so, if you were in the first designer's show, you could not be the second one because there wasn't time for change. I took a cab with Bill Blass to Joe Eula's studio and I told Bill, "I don't want Halston to get away with whatever. If we propose that the show is done alphabetically, I am last." So what I proposed is that we draw from a hat.

Fair enough.

Kay Thompson was going to be doing the choreography. Liza Minnelli was going to be in Halston's segment. But he wasn't telling people exactly what he was doing. His clothes were really wonderful, very good-looking clothes. But he was being very secretive. I called Raquel Welch, who was doing a film in Spain. I said, "Raquel, would you do me a huge favor? We are doing this show in Paris, and Liza Minnelli is going on the segment of Halston. Will you come and show one of my dresses?" So when I announced at the meeting that Raquel was going to be wearing my dress, Liza Minnelli said, "If Raquel Welch is on that show, I will not sing. Because," she said, "she is going to walk out, and I am going to be singing my heart out." So then the idea came that Liza will be the link among all the designers. Now Kay Thompson starts saying that Anne Klein should be first because it's sportswear. Stephen Burrows is second because he's the youngest designer. Bill Blass third, he's American clothes. Oscar is four. And Halston, of course, because [evening clothes] should be last. I said, "Bill, don't let this happen." And Bill said, "Oh, that sounds wonderful." I could have killed him. So I didn't say a word. And going down from the meeting, Anne Klein and her husband said, "Oscar, you disappointed me today." I asked, "What do you mean?" [She] said, "You let Halston get away with it." So I was supposed to call the following day and give the order of the presentation for the programs. And I said, "This is the order: Anne Klein, Stephen Burrows, Bill Blass, Halston, and Oscar de la Renta." Let me tell you about the show. The show was fantastic.

Absolutely.

We were so unbelievably unprepared. The French segment of the show, they were first. They have everything that you can think of.

It was like operatic [sets].

Yves Saint Laurent had a white Cadillac convertible. Josephine Baker was doing another one. They had every single big star. We only had Liza Minnelli. They had never in Paris seen black models. And they had never seen girls moving to music.

Then Stephen really personified the black models.

Marc Bohan, Philippe Guibourgé, Oscar de la Renta, Halston, Joe Eula, and Bill Blass arriving at Andre Oliver's farewell lunch at Maxim's, Paris, 1973

We started our show [and] by the end of our segment, everybody was standing, giving us the biggest applause that you can think of. But it was sheer luck, because we were not prepared to do what we were doing.

It was also sheer talent, because the Americans really did show clothes that everybody was impressed by. And the minimalism of the sets just shocked them. It was so fresh.

The only set we could use was a little Eiffel Tower that was hanging in the back.

It was a very momentous moment in fashion.

Unfortunately, there's so little in the way of a record, but it was a great, great moment.

We can talk about creating your first fragrance in 1977. But let's go to 1982 when you founded La Casa del Niño in the Dominican Republic. Because this is important to you. But give us the CliffsNotes version of it.

I have always been very close to my roots. I built a house in the Dominican Republic back in 1969. One lady came to me and asked me if I could help her start a little school. We rented one room in a house, and I bought some tables and some pencils, and we started collecting children. But the children from the street, they were not interested. The idea was for us to teach them how to read and write, but they have a job to do. They have to go on the street to help their single mothers. Then I said, "Well, perhaps we should give them a meal. That perhaps is the only square meal of the day for a child." And from eight, ten children, all of a sudden we have eighty, and from one room we have a whole house. Today, La Casa del Niño has over fifteen hundred children.

That's extraordinary. And then in 1983, amidst all of this success of yours, Françoise died of bone cancer. And then in 1984, dealing with that grief, you adopted Moises, whom you said came to your rescue and, I guess, vice versa.

I think that Moises was the youngest orphan at the orphanage. I [have known] him since he was twenty-four hours old. And I think that we sort of knew each other. I never thought I would remarry. I think that emotionally we needed each other.

So how old is he now?

Moises is twenty-eight years old now.

And he is designing T-shirts and jeans. Are you a backer of his business?

No, not really. I help him whichever way I can, but I think that he has to try to do it on his own. But Moises has far many more advantages than I had when I started.

Happily, at the end of 1989, you then did remarry. Annette is a formidable, well-respected philanthropist in New York City, and you make a wonderful couple in New York.

I am the luckiest man in the world. I have two extraordinary wives. [APPLAUSE]

Can I ask you a question about that wedding? Was that also a city hall lunch date?

Annette and I were sort of seeing each other. She had divorced, but she didn't want to get remarried. And so on a vacation to the Dominican Republic, I sort of took her passport away and I organized the wedding without her knowing about it. My wife's birthday is the twenty-fourth of December, and that day, I got up to make a toast at dinner, and I said, "I want you all to know that Annette and I are getting married tomorrow." She did not know anything about it.

Then you went to Paris again, as the first American couture designer for Balmain. Why did you feel the need to do that when you had your own line?

I had a longing for my past life in Paris and in Madrid, and I was offered the opportunity of going to Paris and doing an haute couture collection. Of course, by the time—this is 1992—the couture business had tremendously changed. I signed a contract for three years. I stayed a total of ten years. But I realized that my business in New York was suffering from the fact that I wasn't devoting full time to the business. So I [gave up] Balmain. By the time I left Balmain, we were selling a lot of clothes. It was so very different at the time when I was working at Lanvin in Paris. There were eight hundred people working in the house, seven or eight sample rooms. By now, couture is very, very small. It's a business that serves other businesses.

That is absolutely true. In 2004, your business became a family operation, with your son-in-law Alex Bolen taking on the CEO role.

Yes, he's the best.

Your stepdaughter Eliza took over running the $250 million-dollar licensing business.

Well, let's not talk about money.

We won't talk about numbers. But you love having the family around you.

For a long time, I had all this worry about will happen to the brand when I am no longer here, though I am planning to be here for a very, very long time. But, you know, having my family involved in the business, now I know that there is continuity to the brand. I am very lucky that Eliza and Alex are very much involved in the business.

This page, left to right: Oscar with his wife Annette, *Vogue*, 2003; Oscar with his stepdaughter, Eliza Bolen. Opposite: Oscar de la Renta with models at the end of his Spring 1997 ready-to-wear runway show

Since there is somewhat of a succession plan with the family in place, is there any truth to the rumor the business is for sale?

No, the business is not for sale. If somebody comes with a huge, big offer—

So it's always maybe for sale.

Everything is for sale. But this is not something that we're contemplating right now. The business is growing. The business is healthy. A lot of companies are going public. I won't say that this is the way we want to go. We are very happy.

Is there any role in the future of that company for John Galliano? I know everybody here is wanting to hear your take on that. Tell us how you worked together for three weeks and what his contribution was to your collection.

John came to me because he wanted to reenter. We are not going to talk about John's problems, because his problems are not my problems. But he is a wonderful guy, unbelievably talented. I have known John for over twenty years. And I was asked if I would have John within my studio to reemerge himself into a world that he knew really well. We had a wonderful time together. He's such a nice, nice, great guy, you know? And I strongly feel that, regardless of what he did, everyone in life does deserve a second chance. And I am happy that I was able to give John the second chance.

Did you see a difference in your collection with his influence in there?

Yes, I think that there are a lot of things that John, with his eye, tweaked around, and I tweaked around. I have to acknowledge that I have a wonderful, extraordinary studio. I have very, very talented people working with me. I am not a loner—I love to be surrounded by people, I like to be contradicted. At the end, I have the last word. But I like to be challenged on a daily basis. And another thing, Fern, is that people ask me, "At your age, when are you going to retire?" "The day," I say, "I've learned it all." To me, every single day, there is a learning process. When you think of the woman I was dressing when I first arrived in this country, and the woman that I am dressing today, it is a completely different woman. So it is that woman who teaches me what I should be doing.

Well said. In 2006, on the *Vogue* timeline and bio, it lists that you were diagnosed with cancer. Do you want to tell everybody how you are?

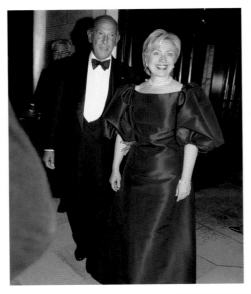

Yes. I had cancer. I am right now totally clean. [APPLAUSE] You know, we always think that we are going to live forever. There are two realities about life. One day we're born and then we die. The dying aspect of it, we will never accept. The one thing about having this kind of warning is how much you appreciate every single day that you are alive. I always say that life is a little bit like a garden. There is a time in life when you plant, and there is a time in the garden when you have to weed. And you have to weed so that the beautiful flower will really grow without weeds around. I'm having a fantastic time, and I love every single day.

That's fantastic. [APPLAUSE]

I want to say one more thing.

Please.

I don't think that I will ever, ever—and I don't want to embarrass her—I never would have been able to go through what I went through without my family, without my wife. [APPLAUSE]

I would love for you to share with the audience and talk just a little bit about all the first ladies that you've dressed. And I know you have a strong opinion about Michelle Obama.

No, I don't have any strong opinions about Michelle Obama at all. I think Michelle Obama is a really, very good-looking lady.

But she hasn't worn Oscar yet.

That's her own right. Would I like to dress Michelle Obama? I like to dress everybody. She's not an elected official. She happens to be the wife of the president. This is the only country where the First Lady does play a very important public role. I see the fact of lost opportunities. For example, I was upset that when the Chinese prime minister came on an official visit, she was wearing a dress from a foreign designer. What a lost opportunity to promote an American industry. And I'm sure she didn't do it on purpose, just she was not well advised of how she should do it. But I think that she's a good-looking lady who could give tremendous help to the industry.

Is there a First Lady whom you enjoyed dressing the most?

Well, the first [one] whom I ever dressed was Mrs. Ford. But I have to say that the last two First Ladies before Mrs. Obama I have a wonderful relationship with. With Secretary Clinton,

I hope that she will be our next president. She's an extraordinary lady. And I am so unbelievably proud to say that she is my friend. Laura Bush is a wonderful lady who does unbelievable, extraordinary work. But what is important is not the First Ladies. What I want to dress is every single woman in the street. That's the woman whom I'm interested in. You know, there is no loyalty anymore among the consumers. That makes our work so much more exciting. Because never, ever, in the history of time, has there been a woman as in control of her destiny as a woman today. And so it makes our work much more difficult, but so much more exciting.

So to dress every woman in American, are you going to do a collection for Target or Kohl's or H&M?

No. Offers have come, but I'm not about gimmicks. I am about dressing a woman who can afford to wear my clothes.

Okay, I'm going to ask you one last question for all the young designers who are in the audience. What advice would you give a young designer today to be successful?

I remember the time when I already was working in ready-to-wear, when I was already selling my clothes to the department stores. Department stores would remove the label of the designer and put in the label of the store. I remember back in the late 1960s perhaps, when I got a call from Adam Gimbel. He wanted to talk with me. I was terrified. What did Mr. Gimbel, who was then running Saks Fifth Avenue, want to talk to me about? And then I walked into his office. I met Bill Blass and I met [Donald Brooks] and Geoffrey Beene, and there were four or five of us, and we were wondering what we were there for. And we were there because they announced that no longer would they remove our name from the label, that the stores would carry the name of the designer. And that was a big beginning for all of us.

So what advice would you give a young designer today? What's the most important thing that they should know or do?

Work hard. Believe in yourself. It's not the publicity that is going to sell your clothes, it's the woman who buys your clothes who's going to make it happen.

How has music influenced your designs?

I love music.

I mean, music is a big inspiration for a lot of designers.

I don't play the merengue when I am designing clothes.

If you can live by one rule for the rest of your life, what would it be?

Love is number one. And always try to do your very best.

Is there any person you would still love to dress whom you never got the chance to?

I want to dress every single woman in the street.

Oscar, I think that you've broken the record. We've gone longer with you than anybody. You have been delightful and enchanting and informative. Thank you so much.

Fern, it's wonderful to be with you. Thank you. [APPLAUSE]

Oscar de la Renta passed away on October 20, 2014 after a long battle with cancer, just as this book was going to press. This is the last in-depth interview he gave and I'm so grateful that we had this special evening together. His words here now take on new meaning. His legacy will endure, and he will be sorely missed.

SIMON DOONAN

Good evening. I am happy to be having this conversation with my friend Simon Doonan, the creative ambassador at Barneys and the author of The Asylum. In addition to learning about Simon's life and background, we'll find out why he is so knowledgeable about asylums and crazy people—to him, it's just another name for the fashion industry. We New Yorkers know Simon for his irreverent Barneys windows and his amusing books, including Gay Men Don't Get Fat, Wacky Chicks, Beautiful People, Confessions of a Window Dresser, and his New York Observer columns. Let's learn more about what makes Simon Doonan so charming, funny, irreverent, relevant, and entertaining.

SIMON DOONAN: Bonsoir.

FERN MALLIS: We start at the beginning to find out how you became who you are. You were born in Reading, England, on October 30, 1952. That makes you—

Soixante. Once I got past sixty, I went into French. It makes it easier to contend with.

It sounds chicer, too.

I'd highly recommend it.

And a Scorpio. How do you say "Scorpio" in French?

I'm not sure.

Do you believe in astrology?

No, I don't. My grandfather was an astrologer. He lived in this working-class part of Cardiff, and he did these horoscopes by mail to the [former British] colonies. His rationale was if you just talked a lot of nonsense, nobody could recriminate with you [from] Nepal or Bangladesh. And then one day he got up and shot himself. My dad saw his involvement in astrology as some kind of terrible portent. He was very anti-astrology, as a result, which you could understand.

I understand. But I'm going to tell you about Scorpio and how I think it relates to you. As a Scorpio, you present a calm and calculated outward nonchalance and possess an inner fire. You strive for success, and you work tirelessly to meet your goals.

That sounds a lot more like Anna Wintour. She's a Scorpio, too.

Those born on October 30 are supposed to be lively, excellent communicators, more outgoing and approachable than most zodiacal scorpions. You have an inquiring mind and diverse interests. And you mix seriousness, sociability, and a lighthearted sense of humor. Is that still Anna?

I think it's me and Anna merging.

Scorpios are also stubborn and extremely emotional.

I'm stubborn.

Reading was a small town during postwar England, most famous for two things. Oscar Wilde was imprisoned there, and Marianne Faithfull went to the same convent school that you did. Tell us about that.

Actually, hers was an all-girls school. But I went to the one next door. My parents had both run away from home before the war, and after the war they weren't quite sure what to do because they couldn't really go home. So we ended up living in Reading in this horrible

rooming house. The landlady was called Pat Burchett—it's B-U-R-C-H-E-T-T—which is impossible to say without sounding like "Pat Birdshit." She was this eccentric woman and her best friend was Marianne's mother. When Marianne had a hit record and was dating Mick Jagger, that was big news in our neighborhood. Marianne's mother and Pat Burchett actually opened a gnarly little cafeteria in the town center called the Carillon Cafe, which was subsequently closed by the health authorities. Just a little tidbit about Marianne.

Sounds like they were making those pies from Sweeney Todd or something.

I think it was more to do with vermin running through the scones.

You described Reading as a slaggy, violent kind of town.

Reading was one of those satellite towns, very industrial, mostly working-class, and tough. My mom had left school at thirteen, and my dad left school at fifteen. But my dad had this idea that he was going to go to university, and the only place that would even think about accepting him was in Reading. So they moved to this squalid garret at the top of Pat Burchett's house. You couldn't get into university without learning Latin, so he sat there trying to learn Latin, looking after me and my sister, while my mom went to work.

That was very ambitious, trying to learn Latin.

It didn't work, and he didn't get into university. He ended up taking a job. The BBC had this office where they collated news from all around the world. He got a job as a "Russian monitor." But it was broadcast in English, so he had this weird job where he would just type away. He used to sit there with headphones on, typing up messages from Radio Moscow in the 1950s and '60s. So he knew all about the Cold War.

This is Terry and Betty, your parents. Your mom worked in a cork factory, and your dad, was he an alcoholic?

That was my grandfather and my uncle. And my dad a little bit. Betty's family was all Northern Irish. So drink reared its ugly head. We would go to stay with my granddad in the summer—he lived in this little bungalow in Belfast—and it would take weeks to get the empty bottles out of the house.

Your parents met in a soup kitchen?

Yes. So Betty and Terry, who ran away from home at the end of the war, were filing their nails and trying to figure out what to do and they were eating at a soup kitchen. I asked my dad years later, because my mom had been married before to some other guy and she was about ten years older than my dad, "What was it that attracted you to Mom in the soup kitchen?" And he said, "She was the only person wearing tomato-red suede platform shoes and she had great legs." They got married two months later. Obviously my mom was up the duff, which is a working-class expression for [being] pregnant. They went to a registry office and then they went to the pub next door and got really smashed and lost the certificate, so they never knew when they got married and they never had an anniversary. They were very young, unconventional, self-invented people. My sister, Shelagh, and I were talking last night about how neither of us have much of a sense of occasion about conventional things. It's very liberating. Think of the agony.

Well, you save a lot of money on Hallmark cards. Tell us about growing up in Reading when your parents tried to find a place where they could work and where you and your sister could be, and they thought that the orphanage was proper daycare.

Oh God, it's already grim enough. This story is about to get grimmer. So, Terry's trying to

learn Latin. It doesn't work out. He finally has to get a job. So what are they going to do with me and my sister? They can't leave us with Pat Burchett, because she's opened a café and is much too busy. So there was an orphanage on a hill, this awful, grim, state-run orphanage, and they would drop us off every day. Cunningly, they used to refer to it as "the nursery." It was really horrifying, like beyond *Oliver Twist*. Lots of children were very traumatized and acting out. It was really grim.

Amazing that you survived being funny and clever and not in an asylum.

Especially because in our family we have a lot of alcoholics, a lot of schizophrenics. Like, a lot. My sister and I grew up fearing it was only a matter of time before we would go nuts, too. When we moved out of Pat Burchett's house, we moved next door because my grandmother had come out of the mental asylum. She had had a lobotomy and she had a little bit of cash, so she put down money on this house and we all moved in there with my blind aunt Phyllis and my uncle Ken, who had just come out of the nuthouse as well. It is a miracle I'm even halfway normal.

So you have a sense of an asylum. It's not just a word for a book title. And we're all laughing, but mental illness was rife in your family.

Absolutely. I think [after] growing up with so many eccentric people, I re-created that, somehow or other. And it wasn't hard to do that in the fashion world, to surround myself with unpredictable personalities.

You and your sister said if you didn't find an outlet for your nuttiness and gayness, you thought you might have gone crazy.

Yeah, because my sister's gay, too. We're both gay. But Dusty Springfield and her brother were both gay. So there were precedents.

When did you know you were gay? Was that a surprise or a big deal for your family and for your sister?

My sister and I had different gay journeys. I was always running around the backyard, dancing around in the style of the Russian ballet. I was fashion obsessed from an early age. All the markers and signifiers were there. All I could think about was Rock Hudson and the Everly Brothers, and I wanted to sleep with both of them. I was just gay.

Left to right: Simon's mother, Betty Doonan; Simon and his sister, Shelagh, with Santa

We didn't know Rock Hudson was gay then.

No, but I didn't care. He was handsome and that was enough. So for me, it was always there. But my sister, it took her longer. She came out much later on.

You were obviously supportive of her.

Totally. My question was, "Why did you wait so long?"

Okay, so before you escaped Reading, you worked in the local cork factory. What did you do there?

When I was eleven—this is going to get even grimmer now. Oh God. [TO AUDIENCE] You came here for fluffy fashion talk. When we were eleven, we had to take this examination called the 11-plus. Everyone had to take it, and if you passed, you went to the grammar school and had a fluffy, middle-class, gorgeous life. If you failed, you went to the secondary modern [vocational] school. And I failed. I failed at the age of eleven. I remember saying good-bye to all my friends who were going off to the grammar school; it was horrible. I remember getting to the secondary modern school and the first thing I saw was this classroom filled with girls who looked like Amy Winehouse at typewriters, learning to type. And I thought, well, at least you can learn something useful, right? So the boys, we had to do woodwork, metalwork, that kind of thing. I was there until I was sixteen. My mother had worked in the cork factory and she said, "I can get you a job." Cork would come in from Burma and India, and they would grind it up and make it into sheets and then cut it into things that go in the tops of bottles. My job was to take the sheets off the stamping machine and stuff them in stacks and throw them in this big, hideous, chicken-wire yard out the back. I thought, this isn't going to work out.

Was this very [Lucy]?

More like David Lynch meets *Lucy*. I thought, I'm going to get my A Levels and go to college, which I managed to do.

You also worked demolishing toilets.

That was after college. My mom said, "You have to get a job." So she sent me and my sister to the Manpower agency, and the first job I had was demolishing public toilets. This was a very seminal moment for me, because I thought, I'm not j'adoring this job. It was really hard and smelly and awful. We were demolishing these Edwardian, beautiful gothic toilets that looked like St. Pancras Station, that kind of Victorian architecture. Now it would have had a preservation order slapped on it. Jamie Oliver would have stuck a restaurant in there. But then we were demolishing it. I got fired after about three weeks, and I went to the local department store John Lewis. I sold clocks and watches. It was like *Are You Being Served?* That was the beginning of my fashion journey.

You had a friend, Biddie, and you two thought it was time to get to the swinging '60s scene erupting in London.

By then it was the soggy '70s, about 1970, '71. I had this childhood friend who was really insane and very flamboyant, also gay. David Bowie had just hit big, and my friend Biddie had transformed himself into the local Bowie, to a T. He worked in soft furnishings [at John Lewis], and I worked in clocks and watches. People would come in and say, "David Bowie's [here]." As if Bowie was going to be slicing up chintz in a suburban department store. And then Biddie and I said, "We've got to get out of this place before we get beaten to a pulp by the local skinheads." So we got on a train and went to London. It was a half-hour

journey, so it wasn't like [the overnight train]. It was more like John Travolta looking from Bay Ridge at Manhattan. So near and yet so far. We thought we were going to be living in this glamour pad with a circular bed with satin sheets, and we were in this squalid bedsitter next to this old [hooker]. But it was good. Took us down a peg or two.

Then you started working for a dress shop on Bond Street.

Yes, I worked at a dress shop where they were selling French sportswear, which was a new thing—prêt-à-porter, Daniel Hechter, Christian Aujard, those names from the seventies. I was selling and dealing with very demanding, temperamental, Mayfair women, a mixture of local tarts and socialites.

So it was good training.

Very good training. Then I thought, I want to get into display because I got friendly with the guy who was doing the windows. I got myself an entry-level job in display at Aquascutum—which everyone called Aqua-scrotum—a venerable raincoat emporium. The queen always wore Aquascutum raincoats. That's a Latin word. I did windows there, and there was a guy called [Michael Southgate], who was the big window designer. He was very flamboyant and completely mad and a great mentor.

What was Biddie doing? Are you two still friends?

Biddie became a cabaret sensation. He was performing at a place called the Blitz. He had a singing partner called Eve Ferret. That was actually her name. The names people have in England, it's insane. He eventually became a pantomime dame.

What's that?

In every English town they have a pantomime every Christmas, and it's full of the iconography of musicals and folklore and fairy tales. It's hard to explain. But he played Widow Twankey [from *Aladdin*] and he was very tall, so they called him the Lanky Twankey. You're probably dying to get to some fashion, right?

We're going there. Then you met Tommy Nutter.

When I was working in Aquascutum, the display was conventional. It was a very conservative raincoat shop. I always wanted extra cash, so I started doing freelance jobs. A lot of stores don't have the money to have a full-time display person, so you can always get freelance work. So I would go into a shop that I liked and say, "Oh, is anyone doing the windows? I'll do it for five quid once a month, or whatever." I had some great freelance jobs. There was this shop on Portobello Road called the Last Picture [Frock], run by Shirley Russell, who was married to [director] Ken Russell. Shirley was responsible for the look of all Ken's movies. *Women in Love*—remember how beautiful the clothes were? She would put the costuming together and then sell or rent everything afterward in the shop. I did that window. That was my big introduction to the history of fashion, because she would have Schiaparellis and beautiful Vionnets that she was selling for ten quid—shocking, the prices. I also had a freelance job on Savile Row [for] Tommy Nutter. He was the first trendy tailor on Savile Row, really the first crossover, who went from dressing the aristocracy—

To dressing Mick Jagger.

He did Mick Jagger's wedding suit when he married Bianca. And she's wearing white Saint Laurent, the big hat. So that was really fun because they wanted really insane windows. They wanted provocative windows.

Like the taxidermy rats with diamond chokers? Tell us about that.

Clockwise from top: Maxfield's LA;
Simon in a window; Simon shot
in the early 1980s in West Hollywood
by Albert Sanchez for *Interview*
magazine; Simon preparing a
window; Simon in Sprouse shorts

They wanted to do tuxedos at holiday time and I thought, tuxedos, Rat Pack. There was this taxidermy warehouse in North London. They had a standing Labrador, a squishy Labrador, a been-run-over-by-a-car Labrador. But they also had a shelf of rats that were animated brilliantly into these little poses. So I rented about ten of them and put them in the window and made little wing collars and put them adjacent to these tuxedos that Tommy Nutter had prepared. This guy came in and said, "I love that window. Come work for me in L.A." I went home and I said to Biddie—at the time, he was dyeing his hair and had a face pack on and cucumbers on his eyes, getting ready to do his act—"This bloke offered me a job in L.A." He said, "Where's that?" I said, "I don't know." Back then, A, we were stupid. And B, it was a smaller universe.

And this bloke was Tommy Perse and the store was Maxfield.

So six weeks later, I packed me a little suitcase and went to L.A., just because I thought, oh, maybe I should go. He seems to want me to go. I was very obedient.

That's still one of my favorite stores in this country.

He is a great retailer. He's a brilliant, creative guy. There aren't many owner-operated stores left that have a real personality of the owner.

Tell us about the difficulty getting your green card.

Well, everybody said to me, "Oh, it's really hard to get a green card." [Sandra Rose] was a friend of mine at the time, and she came to America a lot, and she said, "Oh, it's really hard to get a green card." But Betty Doonan clicked in and I thought, I can get my green card. But the only hard part was back then, they didn't give them to you if you were gay. So the lawyer in L.A. said to me, "They are going to ask you, 'Are you gay?' You have to say no." So in my interview, the guy said, "We believe that you are a homosexual." And I had to pretend to be irate: "I like girls and how dare you?" It was outrageous discrimination. But at the time I just thought, butch it up. Because I just wanted my green card.

You were at Maxfield for eight years. Did you love living in L.A.?

Oh my God, I loved it. London in the 1970s was very depressed and there weren't a lot of opportunities, and L.A. was sunny, [and] you could get a big car with fins very cheaply. And I lived on next to nothing. The other day, I found my W-2 [and] it was something like five thousand dollars. It was a great time to be in L.A. There were twelve million fewer cars on the road. You could park anywhere. You could get a cheesy little apartment off Hollywood Boulevard for a hundred bucks a month.

Did you meet lots of celebrities doing those windows at Maxfield?

I did. It was a revelation to me. I thought, this is what people do. They become successful, make some money, and then go shopping. Literally, they would hang out there for hours.

At Maxfield they buy like nobody's business.

Back then it was people like Natalie Wood, Cher, Shirley MacLaine, Linda Ronstadt, Fleetwood Mac, Jackson Browne, and Joni Mitchell. And I lived right opposite Bette Davis. On Havenhurst, just south of Sunset, there's this big Spanish building. George Gobel and Sylvia Kristel lived there. Jamie Lee Curtis and Bette Davis lived there.

Did you meet and talk to Bette Davis?

No, I was much too scared. She was there all the time, on her balcony, coming in and out of the front door, very chic, always in black, like a little black dress with a brooch and a little hat. She dressed a bit like Diane Keaton, that kind of man-drag situation. Her crates of

scotch would come to our building sometimes by mistake.

Well, that would be a good excuse to meet her, to deliver her the crate of scotch.

You've got to have something really good to say if you ambush Bette Davis. What are you going to say? "Loved you in?"

That always works.

Or maybe take the scotch back, like, "This is for you."

Could you ever live in L.A. again?

I could. It's changed unbelievably. When I lived in L.A., it wasn't groovy. People were still wearing platform shoes and bell-bottoms—and not in an ironic way—when I moved there. It only became groovy in the early 1980s. Tom Ford made L.A. groovy. Before that, it was like the pool-party scene in *Annie Hall*. Remember where he's there and everyone's really dingy and out of it and they're wearing [patio] gowns? It's sort of like that. No, it was fun. But hokey, you got this—it was hokey, in a charming way. There were still trains going down Santa Monica [Boulevard].

In 1985, you came back to New York and Diana Vreeland hired you to work on her upcoming exhibition at the Costume Institute. How did you manage that?

In the early 1980s, a lot of my friends died of AIDS. One day a friend, Sarah Richardson, and I were commiserating, and she said we should go to New York and work for Diana Vreeland. She had volunteered on some of Vreeland's exhibits. I thought, I can't possibly volunteer; because I'm so experienced, I'd have to have a paying job. Somehow I talked my way into one, as display designer on the exhibit called *Costumes of Royal India*, which was the occasion upon which Diana Vreeland said "Pink is the navy blue of India."

"Pink is the navy blue of India." I didn't realize it was associated with that exhibit.

I'm probably making that up. But she definitely said it.

Well, that works.

She might have said it thirty years before.

Tell us about the peacock hat that you asked Bill Cunningham to design for that exhibit. The great *New York Times* photographer was a hat designer for years.

Bill did hats and taxidermy. And Mrs. Vreeland thought that a show [without] something that Bill made would be essentially cursed. When I was setting up vignettes, I was told that Bill was making a stuffed peacock to go in this particular vignette, with these maharajas and beautiful costumes encrusted with diamonds. I worked around the space thinking, where is he with this bloody peacock? And right before the show opened, Bill cycled into the parking lot with this thing in a garbage bag on the front of his bicycle. And he carried it in and plunked it in the space, and I thought, I'm going to leave him to position his peacock. Well, first of all, he unwrapped it and showed it to me, and I was aghast. Do you know the Yiddish word "meeskite" [ugly]? This peacock was like if Marty Feldman was a peacock. It was so hideous looking. I said, "What's the story?" He said, "Well, young fella, I was cycling through Central Park and I saw a dead seagull, and I thought, that's going to be perfect." So he boiled it up at home and stuffed it and jabbed some real peacock feathers in the back. But I thought, I'll let him play around with it and position it and do the lighting. And I came back and it looked fabulous. And there's a lesson there for all of us, you know? When in doubt, great lighting, right? Or just backlighting.

Did Bill ever make more hats for you?

He continued to do stuff for the Met shows as long Mrs. Vreeland was involved. But that was only another couple of shows. After that, she passed away.

Right. The China and Africa exhibits.

And the Dance exhibit.

How does exhibition design differ from window dressing?

Back then it was quite similar. The vignettes were kind of hokey. When you go to the Met now and see exhibits like the McQueen exhibit, it's gone to a whole other level. I don't know if the installations are more labor-intensive, but they're certainly more expensive. And they use interactive components. Back then it was more like hokey dioramas. I would get a mannequin and if it wasn't tall enough, I'd cut it in half and put some newspapers in there.

While you were working at the Costume Institute in that event, you bought your own ticket to the dessert party. We young ones in the fashion industry couldn't afford to go to that party. But you met somebody there who changed your life.

It was great. The dinner was very socialitey. Pat Buckley and all the Nouvelle Society broads were there. And then everybody else bought a hundred-dollar dessert ticket, which Anna Wintour very wisely got rid of because actually the Met Ball is so successful and does so well. But all the riff raff, we would buy a hundred-dollar dessert ticket. People say, "Well, didn't they give you a ticket because you worked on the show?" No, because everyone bought one. And I remember going to that, and it gave you access to this freak-out.

It was great for people interested in fashion who would never otherwise get to go.

It was great. Quite democratic. Almost. I went with Susanne Bartsch and my friend John Badum, who introduced me to Gene Pressman. He said, "You should meet Gene because Barneys is reinventing itself." And Gene said to me, "I know you, you do those sick, twisted windows for Tommy Perse." I said, "Guilty as charged." He said, "Come work for me." It was one of those things where this great opportunity came along and I just grabbed it.

Well, you don't have a master plan, but things happen and evolve when you're doing great work. Somehow people find you and connect.

I never had a grand plan. I always just threw myself into stuff. If I hadn't met Gene, I was going to go back to L.A. and carry on working for Tommy, but I got diverted into Barneys.

At Seventh Avenue and 17th Street.

Downtown, with a whole block of Manhattan to play with and do insane things in the windows. Really fun.

Describe the magic of Barneys at that time, and the exclusivity and the labels that they introduced to many of us in America.

Barneys had been a discount menswear store and was transitioning into also being a very hotsy-totsy women's designer store. The list of people that they introduced is a long one, everyone from Zegna to Romeo Gigli to Giorgio Armani and the Japanese designers. Dries Van Noten's first collection was at Barneys, twenty years ago.

I think they also brought in Sonia Rykiel and Missoni.

Because we were "Downtown," we were outliers, and the Pressmans approached it without all these sort of "Uptown," preconceived ideas.

How did you feel about Barneys moving to Madison Avenue?

Barneys moved to Madison Avenue in 1994, and [it was a] big revelation for me because, like a lot of people in Manhattan, I didn't go outside my neighborhood, so I thought, we're

going uptown, we're going to have to be sensible. Then I remember when we were setting up the store, I thought, my God, all the real freaks live uptown. You would see these extraordinary dandies and ladies walking down Madison Avenue wearing vintage Courrèges as if it was still 1965. Really interesting, overdressed, exhibitionistic people. And we were all in the window like, oh my God, wow. We thought it was all happening downtown.

So that [was a] revelation.

Yeah, that's one of the paradoxes of uptown.

Eventually you started doing much more than windows for Barneys.

I was in charge of windows, then eventually Gene put me in charge of advertising, then publicity and also store design. I became an executive vice president and I really enjoyed it. I was very organized and very diligent. I was amazed that I could do that and deal with budgets and hiring people and being sensible. Then, at the end of the 1990s, when I [published] Confessions of a Window Dresser, I renegotiated my arrangement with Barneys and became creative director, so I was involved only in advertising and windows.

Let's talk about your holiday windows. Any favorites?

When he hired me in the 1980s, Gene Pressman said, "I want everyone to talk about our windows." And I really, seriously thought about what it would take. Then when the Reagans were leaving the White House, I did a caricature of Nancy Reagan staring wistfully out of the window, clutching a plane ticket with her horoscope scarf on and all her china. And people went nuts, and it got picked up everywhere. And I thought, okay, next year I'm doing celebrities, because at that point, celebrity wasn't such a thing in our culture. So the next year, I thought of all the celebrities who had had a really rough year in the tabloids, everyone from Margaret Thatcher to Tammy Faye Baker to Madonna, and with the help of artist Martha King, [made] life-sized, full-sized caricatures and created vignettes around them. I love my Margaret Thatcher window, because I'm probably the only person to put Margaret Thatcher in an S&M outfit. She was the Iron Lady in a dungeon, and she was ironing and she was listening to Iron Maiden. I love a pun.

Did anybody ever complain that they were parodied in the windows?

The only one we had to change was a collaboration the following year with *Vanity Fair*. They had a big article about Susan Gutfreund, the socialite who hauled her Christmas tree outside of her apartment building, and there were all kinds of stories about her ostentatious lifestyle. And we did her without getting her permission and had to take that one out.

So with all the others you always got their permission?

Technically, if you're using someone's image for commercial purposes you have to get permission. Madonna always gave us permission. In fact, she loaned us her gold Gaultier pointy bra outfit from the Blond Ambition tour. And it arrived in a box and we were all having a heart attack because it was Madonna's outfit and there were long blond hairs from that ponytail. Remember the ponytail? They were like ancient relics. Well, not ancient, but—

It's too bad that was pre-eBay, or you could have sold her hair online.

Yeah, even if it was wig hair.

You were also obsessed with the royals and Queen Elizabeth, who ascended the throne the same year you were born.

Yes, I was born the year of the coronation. We all got this horrible little commemorative spoon that I had for many years. I don't know where it is now.

Your last window for Barneys, after twenty-seven years, was all about food.

Yes. With the holiday windows, I always wanted to think of something that was going on in the culture and riff on it. The year people were talking about Andy Warhol, we did a War-holiday. Get it? I never took much interest in the foodie revolution, but I was aware of it. The Food Network was opening another channel. [People like] Bobby Flay became rock stars. So I thought, we'll have a foodie holiday. We had caricatures of all the key players: a food fight with Guy Fieri, Paula Deen in a Snuggie with butter in her pockets. And Ina Garten and Martha Stewart, of course.

Okay, so when did you add "author" to your resume? How did that come about? Did you ever consider yourself a writer?

Well, since failing the 11-plus, I always thought of myself as profoundly stupid, and so yes. Well, you would, wouldn't you? Nicholas Callaway from Callaway Publishing called me up and said, "You need to do a book of all your windows." By this time, I had rooms full of slides. So I went through all these slides, edited them, and he said to me, "I'll go through them, [and] you write an introduction." I wrote this introduction and he called me immediately and said, "You're a hilarious writer." So the book became more text driven. When it came out, Madonna and New Line Cinema bought the rights to it.

And it became a movie?

No. Maybe one day. But you know how that goes, that's Hollywood.

Well, we can go to the movie thing, but first I want you to share your theory about gay food and straight food.

People are under this misapprehension about food. They think there are four food groups.

There's only two: gay food and straight food. For example, sushi is obviously gay food, because it's very delicate and labor-intensive [and] aesthetically pleasing. Mexican food is obviously straight food. Burritos. Hello? That was my theory. I said the key to being healthy is to have a good mixture of gay and straight food. And I was amazed at the number of people who took that at face value.

That's a good mixture in life. Okay, tell us about auditioning for *The Devil Wears Prada*.

When the book came out, I had a very hard time reading it. No disrespect to the authoress, but to me, what's so great about fashion is that it's an asylum, a welcoming place for all these eccentrics—gypsies, freaks, creative, idiosyncratic people. Her version of fashion was driven, overachieving bimbos in high heels who want to claw their way to the top. So I was disdainful about the book. Then two years later, my phone rang, and this casting director said, "We're making a movie of *The Devil Wears Prada* starring Meryl Streep, and we want you to audition for the role of Nigel." Suddenly, miraculously, all my disdain for the book evaporated. I went in and had repeated auditions. Then I met with the director. I was learning these big chunks of text. I was thinking, I'm not going to be able to ride the limited-stops bus anymore when I'm famous. Then I ran into Phillip Bloch and he said, "I'm auditioning for the role of Nigel." I looked at him like, "Bitch, you better not take my part. I'll cut you if you steal my part." Then the next day I ran into Robert Verdi, and he said he was also auditioning for the role. I realized, we've all been had. We've been part of some cunningly orchestrated piece of free research for the benefit of some straight, overpaid, more experienced actor. Cut to two days later they hired Stanley Tucci. Isn't that awful?

Awful. They probably did learn a lot of the behavior characteristics from the three of you auditioning.

I should have smelled a rat when the director said to me, "Tell me what Anna Wintour is like." I said, "She's incredible. She's nothing like the character in the book. She's straight-forward. She's highly intelligent. She's a great mother. She's very well liked by her employees." Suddenly I saw him glazing over. Not what he wanted to hear.

Did you like the movie?

Well, again, that's not my idea of fashion. When I think about the Jean-Paul Gaultiers, all

Simon with his husband, Jonathan Adler

the great, nutty, interesting, diverse people, the Stan Hermans, all your pals, the incredible people who are part of the fashion world, they're a great group. I mean, one of the great misconceptions about fashion [people] is—

That they're all crazy.

They are all crazy, but they're not all bitchy. It's a very collegial atmosphere. The music industry, the finance world—those are tough. But in the fashion world, people look out for each other. My book is really a love letter to the fashion world. There's nothing nasty in there about anybody.

On a personal front, how did you meet your husband, Jonathan Adler?

I met Jonathan Adler almost twenty years ago. We were set up on a blind date. He was very charming and funny and fourteen years younger.

Cougar.

He was a twenty-eight-year-old clay-spattered potter. By then I was an EVP, so I was wearing a suit. And I thought, he'll think that I'm this corporate drear, he probably won't be that into me. But I was very into him and thought he was really cute and funny. Then I went off on some trip with Gene Pressman. When I got back, the friend [who set us up] called and asked, "Well, what did you think?" I said he was great. And he said, "Well, he really likes you." And I thought, oh my God.

And his product was already in Barneys before you were together.

Yes, I'd like to make that clear. People think that Jonny shagged his way into Barneys, but it's not true. I remember looking at the ads, with his beautiful striped pots, thinking they looked like glass, I had to look at those. And I'm approving the ads. Glenn O'Brien was writing the great copy. Mrs. Pressman discovered him.

How proud are you of how his business has grown?

I am staggered, because when I met Jonathan, he was in a shed studio with three other people. And they were pooling their money to buy toilet paper, literally.

Now he's designing toilet paper.

We call it the fantasy factory, where he designs everything now. He's making stuff in brass, needlepoint, all these fabrications. It's unbelievable. But it's a twenty-year process to get to that, if you're lucky. He worked very hard. I remember he'd get an order for forty decanters and three hundred coffee mugs and make them himself. That's like Donna Karan having to sew every dress.

And you got married in September 2008. Was getting married something you ever dreamed possible?

I'm not from that generation of gay that thought about marriage, kids. We were too busy working on our look. But when it came along, I thought, why not? We went to city hall in San Francisco and [Jonny's] mom and sister came, and all the lesbians in line thought they were a lesbian couple, which was cute. It was a very—another Yiddish word—it was a very hamish little wedding.

And you still have your dog, Liberace?

He's fifteen. He's celebrating privately at home.

And Jonathan's the decorator in your various homes?

I don't believe in democracy in the home. Either one person has to do it or the other. Otherwise it ends up like that horrible show that used to be on HGTV where that man would

moderate between a husband and wife. He wants a den, she wants a new gift-wrapping room, and that guy would try and merge their expectations. That was so gruesome. [Jonny], he has a vision. Vision, you can't screw with it. No one helps Azzedine Alaïa figure out those frocks. He's the visionary.

Describe what you mean by "upward-mobility syndrome."

You're looking at it. People in England fetishize being working-class. Prince Harry and Prince William, the way they speak is not the way our aristocrats used to speak. They talk in a more lower-middle-class accent. Biddie and I were at school with the teacher screaming at us to stop dropping our vowels, l's, h's, and t's. You had to claw your way out of the cork factory, so you could get some nice Thom Browne jacket.

Do you do most of your writing on Shelter Island?

[I do] lots of writing on Shelter Island, but lots of writing at home because of my new role at Barneys, creative-ambassador-at-large—which is a veiled reference to my lack of height. Dennis Freedman is the new creative director, doing a lovely job, especially the windows. I love my new role. It's more event focused, customer focused. I'm going to L.A. to do an event at the Barneys store in the Grove.

Do you go into the office at Barneys every day?

I go a couple of times a week, check in with the girls, especially the PR department. I love to go in there. I also love to walk around the buying floor. You and I were talking about this earlier. At a fashion show now, there's like two thousand people, none of whom are playing a critical role except for the buyers. The buyers from Barneys are really interesting people. They have to make these creative selections. They love product. They know how stuff's made. They're the great unsung heroes of fashion. I don't know why designers put a buyer in the third row and some blogger in the front row who's still in diapers, practically.

Speaking of the shows, tell us your take on Fashion Week.

Well, Fashion Week—it's this mad Mardi Gras, whirligig, Coney Island sideshow. People have lost sight of the fact that it is a tradeshow—clothes that will be available, if a buyer buys them, four, five months, six months from now. It's hard to see what the goals are. I guess it gets people excited about the general idea of fashion and maybe they go shopping. I hope to Christ they do.

It's become content and a big photo op.

You have to surrender to the madness, but you have to figure out what it means and try and steer it in the right direction.

Talk about Thom Browne's show, when you walked into the white padded space with headless bodies hanging from the rafters and lights flashing.

Thom Browne is an extraordinary guy. I have a whole chapter about him in my book. He is very unusual because American [fashion] is typically sportswear, practical Western wear, Ralph Lauren, Calvin, wearability. Cut to Thom Browne—his shows are so extraordinary and so insane and so avant-garde. This one, the theme was an asylum and the girls looked really out of their minds. Their lipstick was all smudged and they had these deranged coiffures. It was Miss Havisham meets Daphne Guinness.

Meets Nurse Ratched.

Yeah. And intensely complex outfits.

Latex leggings and [blouses].

Simon and Jonathan in Capri

Amazing, slashed latex with ruffled lace coming through it—labor intensive. So, God bless Thom, because it's good to have that in American fashion. It was certainly entertaining. What did you think?

I think it was brilliant in many ways. But it was very much an asylum. It started fifty minutes late and everybody thought they were going to go crazy. The "nurses" came out and gave people little cups with white M&Ms that looked like meds.

Did you have one of those pills?

I loved those pills—they were M&Ms.

One of the nurses came up to me and gave [me] one and I thought, I must be really paranoid or something, because I was like, I'll start tripping if I take one or something horrible will happen. But you ate one.

We ate a bunch in our section. We were waiting so long for the show to start. Look it up on Style.com. It was extraordinary.

Yeah, the fact that happened at American Fashion Week is completely bizarre and fun.

It was definitely *One Flew Over the Cuckoo's Nest* in there. Were there other highlights for you at Fashion Week?

Proenza Schouler has gone to a whole other level of sophistication. Barneys bought their first collection when they were right out of college. I think that arc has created a problem. A lot of kids think now that's the model for how to succeed, where it's really not. The model for how to succeed is to schlep for somebody else for fifteen years and then decide if you want to open your own company. Because they're kind of exceptional boys and—they're unicorns.

Didn't they pass Anna Wintour a note on a plane to get their break?

And I think Anna told Julie Gilhart about it. Anna's so amazing at hooking people up and making stuff happen.

Are you very involved in social media?

I'm a bit Granny Clampett when it comes to that. In my defense, I write my *Slate* column. I've written two books in three years. I have to concentrate. But I've recently gotten into Instagram, which is easier than Twitter. My big problem was, because I'm such a carnie and I've done windows for so long, I always need to know whom I'm communicating to. When I was doing Barneys windows, I knew the customer, what made them laugh, what they read, what TV shows they watched, their sensibility. When I was writing for the *New York Observer*, I know who reads the *Observer*: it's fifty thousand smartasses in L.A. or in

New York. But Twitter is like, whom are you talking to? So I felt very paralyzed with it.

So who's your audience on Instagram?

Good question. I got around it by taking a picture and then writing a goofy caption, so I was at least reacting to the image.

So if people here want to follow you on Instagram?

Simon underscore Doonan. [Simon_Doonan.] There's only about forty posts.

Any advice for young talents or folks who want to go into the business?

I'm so old that my story is not very useful to people. Young kids, they'll say to me, "How did you get started?" Can I tell them about the cork factory and the toilets? It's not relevant anymore. They look at me like I'm insane. And my trajectory is so huge, from grim postwar poverty to where I am now. So I just say to them, "Work hard, have fun." The one thing I do proselytize about is retail. Retail's great. You're busy all day, it's fun, you meet the general public. What's more fun than seeing the real stuff come in from Givenchy and Alaïa and Dries Van Noten and then watching regular women try it on? Then you find out who's a genius or not. I remember we did a Lanvin show in L.A. and Alber was a bit perturbed because I told him, "We have to use local girls." That's a phrase that can strike fear into the heart of the average designer. So these local L.A. models drove up with flip-flops and Coca-Cola stains on their teeth. But Alber didn't bat an eyelid. He dressed each girl himself. He was involved in their hair and makeup. Each girl walked in looking like an L.A. girl in hot pants, and he turned them into existentialists, Sorbonne students, circa 1968. That's what fashion's supposed to do.

That's the power of fashion, that transformation.

It's supposed to make you more interesting and make you more glamorous and make you more substantive.

Okay, we've been doing these interviews for two years. These are the best group of questions I've seen. I will ask you one question that was Tweeted to me: Will you do an audio version of *Asylum*? [With] your voice, you should be perfect for that.

I would love to. Penguin hasn't asked but I'm folksy, I'm available. I think that only happens if you get to Jackie Collins–type level.

Who should play you and Jonathan in a movie of your life?

All I can think of are weird people. Who's short? You can't tell on film, can you? I don't know, [Jonny], who do you think?

JONATHAN ADLER: Linda Hunt.

Linda Hunt could play me? Wait till I get you home. Okay, Linda Hunt could play me and [Jonny] could be played by—

JONATHAN ADLER: Billy Crystal.

Billy Crystal. Bam.

A psychiatrist in the audience wants to know about the fashion industry's attitude toward mental illness.

That's a good question. I thought a lot of people would get tripped up by the title of my book and ask me about mental illness. The first chapter of my book is all about my relationship with this person who works in a mental hospital. She and I would have endless conversations comparing her world and my world. I would say things like, "Everyone's wearing fishnets or orange is the new black." And she said, "You have to realize, my

hospital is full of people who see patterns where there are none." When she said that, I thought, hello, [this is] the fashion world—people seeing patterns where there are none. And it gave me the whole idea for the book. Our big contentious conversation was about *Grey Gardens*. I was on a photo shoot and we were using *Grey Gardens* as the inspiration for the styling, because, remember, Little Edie is very creative and inventive with her styling.

She didn't think that was funny.

She said to me, "She's tying sweaters around her head to try and muffle the voices in her head." This friend of mine is a really amazing person, and she has given her life to these patients in this public mental health facility—she gave me the idea for the book.

Does she keep you in check?

Yes. She reminds me when I get a bit carried away, which I need. I'm a therapy achiever. You know, I've had the same shrink for twenty-five years. Anyone in this room top that? Same shrink.

Still going?

Yeah. I think, would my poor grandmother have had a lobotomy if she'd had to see a shrink? So it's sad.

Do you think Barneys lost its luster and uniqueness when it moved to Madison Avenue?

No. Barneys is very well differentiated from all the other stores, [in terms of] taste, luxury, humor, the tradition of doing unexpected things, having new, exclusive product. So no, it's so fun to be there now because retail needs to be dynamic. We needed a shake-up at Barneys. It was great having Mark Lee, our CEO, and his team reorient everything. I was the creative director for a really long time. Retail can get dusty.

What was the first article of clothing that you adored or aspired to own? And how old were you?

I think it was futurism. I remember when the futuristic thing happened in Cardin, Courrèges. I remember seeing this picture of an Asian model in a white helmet with the front cut out and the spaceship. That whole idea [was] we're all going to live on the moon, and everything's going to be made of Formica.

We were all going to be in Mylar clothing. What is currently inside your Goyard purse?

My purse has two travel-sized tubes of toothpaste that I bought for my upcoming book tour because you can't take the big ones on the plane, some Purell, a Goyard agenda, my phone with a Jonathan Adler [case], and a picture of [Jonny] and Liberace, our dog. Nothing sinister. Oh, and a revolver and some half-eaten cake. Just kidding. That's not funny.

Who is the most interesting designer you have worked with?

I'm fortunate to have been at Barneys, because [I've gotten to work with] really, really interesting ones. Martin Margiela, fashion's great enigma, the Greta Garbo of fashion. Azzedine Alaïa, such a brilliant craftsman. Romeo Gigli, who reinvented the way we look at color, with all those incredible colors. Christian Lacroix. I'm very fortunate because I got the golden age of designer fashion, when people were doing very new things. Now they don't do so much new things [as] they just make great, beautiful stuff. Ha, I got overcome there, going down memory lane.

Okay, well, I think, on that note we want to send you all out to the lobby so you can buy this book, *The Asylum*. Thank you, Simon.

Thank you. Thanks for coming. [APPLAUSE]

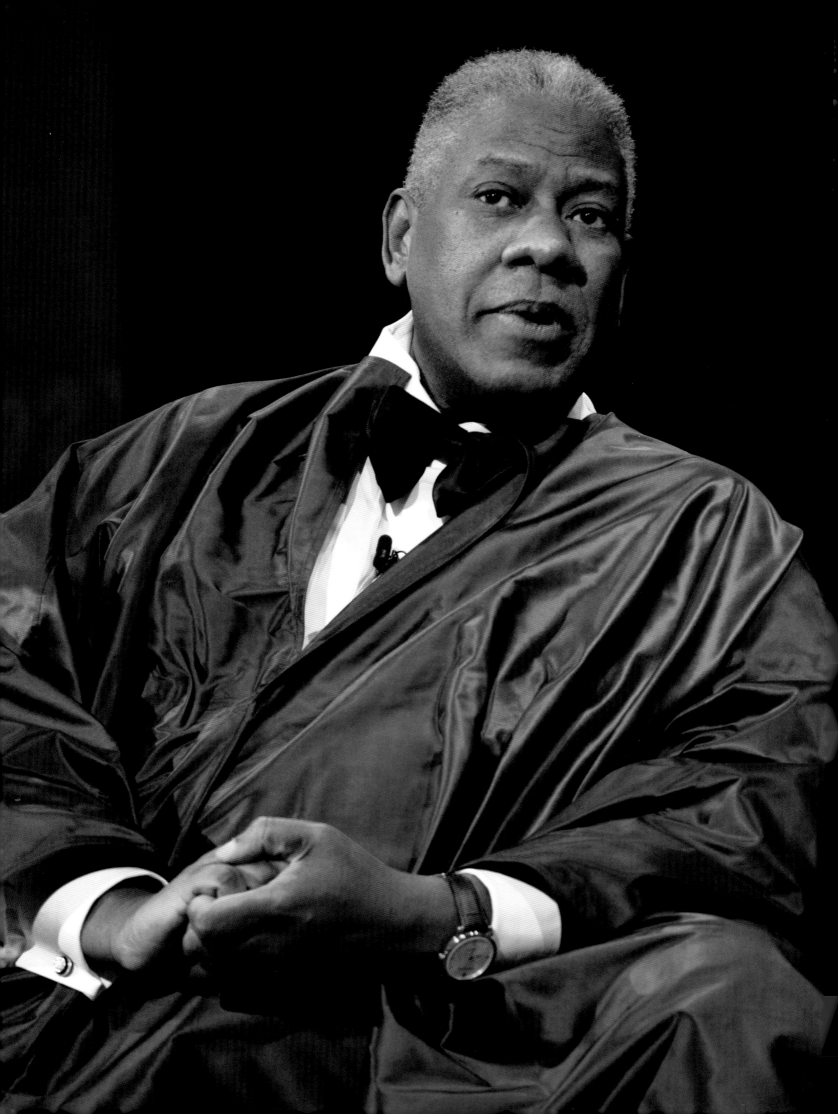

ANDRÉ LEON TALLEY

Tonight we've snared a really good one. The fashion industry is a quirky, unusual world, filled with great talents, huge egos, and massive insecurities. It's a fragile ecosystem, but it also creates personalities and cults that are sometimes larger than life. There are also a handful of players, call them crazy and obsessed, mentors or muses, gurus or guardians. There's a fantasy and mystery to these people that contrasts starkly with the harsh and demanding realities of the commerce of fashion. I am thrilled that tonight you will meet one of these very special, unique individuals. Tom Ford says about André, "He is one of the last great fashion editors, who has an incredible sense of fashion history. He can see through everything you do to the original reference and predict what was on your inspiration board." Marc Jacobs says he's "not sure there are even a dozen individuals like Talley left—that he has seen and absorbed the fashion history firsthand and he is made up of so many real, incredible moments." He has worked alongside some of the most important and enduring fashion legends of all time, and he learned about fashion and style from two women: his grandmother Bennie, who raised him with love, grace, and humility, and Diana Vreeland, who took him under her exotic wing. His presence at events is like holding court, whether on a shoot or an interview or nurturing a designer behind the scenes or sitting prominently in the middle of the chaos at the biannual Manolo Blahnik sample sale, advising frenetic ladies what looks good on their precious feet. So get comfortable, and we'll let André tell us how he came to be the fashion icon he is today. Ladies and gentlemen, let's give a warm welcome to the one and only André Leon Talley.

ANDRÉ LEON TALLEY: Thank you, Fern. That was fabulous. Thank you.

FERN MALLIS: All right, first off, whose caftan is this?

Ralph Rucci.

And the bow tie?

Tom Ford.

And the brand-new shoes?

Manolo Blahnik.

[TO AUDIENCE] Now you got the picture, right? All right, now we're going to go back and start at the beginning, as I always do. You were born on October 16, 1948.

That is correct.

You have a birthday coming up.

Yes, sixty-five.

That's a big one. Any plans yet for how you're going to celebrate?

Should I tell you, really?

Sure. You're among friends.

Okay. Oprah Winfrey will have a crew at my house, filming me for a segment on where I've gone, where I've been, and where I am now, or something like that. So that's what I'm doing on my birthday.

How old do you feel?

Some days I feel a hundred and five. Most days, if it's a good day, I feel twenty-five, mentally. Physically, sometimes not. I think that I'm very lucky. I've had a fabulous career.

Absolutely. Okay, you're a Libra. Your sign is about balancing the scales in life and work. Do you follow astrology?

No.

Well, I'll tell you what I know about Librans. They're among the most civilized of the twelve zodiac characters. They have elegance, charm, and good taste. Sounds right.

Sounds pretty good.

They are lovers of beauty, harmony, and the pleasures that these bring. However, their love of pleasure may lead them to extravagance and [to] be careless about money.

What I love most about my birthday is the two people [who] were born on the same day as I was: Marie Antoinette—extravagance, trouble with finances, lover of beauty—and Christopher Columbus. And so I identified with those people. I certainly do not hope to have my head chopped off in the town square, but I do certainly identify with the beauty that Marie Antoinette so treasured in her lifestyle, in the court of eighteenth-century France. It's been a big inspiration to me.

So there's some truth to that.

There's total truth to that. I have terrible problems with my finances. I consider myself a very creative person. I know nothing about finances. And when I find out that people have tried to help me with my finances, I get very upset, because I have no idea of money. I know how to spend it, certainly.

Well, yes, most creative people do.

Back in the day, you could go to Hermès in Paris and have a charge account. That does not happen now. You would have to be someone working probably at *Vogue* magazine. When I got my first huge, oversized Hermès custom-made box Kelly carryon, I was with Anna Wintour in Hermès. They brought out my bag and she said, "What are you buying this for?" I said, "Well it's so fabulous, it's so beautiful. It's a down payment on a house, the price of this bag, but they'll let me pay for it on layaway." So for years I was getting stuff at Hermès on layaway. I could just go in when I could and have these extraordinary things, shoes and bags and this and that and the other.

Do you still owe them money?

No, I got it paid off. They would've come after me.

Well, the last thing I'm going to say about Librans is they dislike being a slave to fashion.

Oh, really? Well, I don't consider myself a slave to fashion. No, I consider myself a custodian, a curatorial person of fashion. [APPLAUSE]

Let's go to Durham, North Carolina. Your mother, Alma Ruth Davis, and your dad, William Carroll Talley. How did they meet?

I don't know. I think they met just at a party or something. I never really asked them about their love life. I didn't think it was appropriate.

Not appropriate?

Why would I ask my father and mother how they met?

You never heard them talking about it?

Oh no, no, no, no, because see, I grew up in my grandmother's house. When I was born, they took me to dinner at my grandmother's and I never left, except to go to summers in

This page, clockwise from top right: André's grandmother Bennie Frances Davis; André's aunt Dorothy Bee Davis, China and Benton seated in the front, standing from left are Bennie Frances, Pattie, Ennie, Minnie, John, Louvenia, Myra and Mozella; André's aunt Dorothy Bee Davis. Page 296: André Leon Talley by Roxanne Lowit, 1982

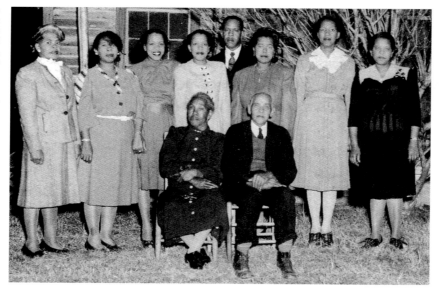

D.C. where my parents lived.

Why did you not stay with your parents?

Because they were young and struggling to have a career, and my grandmother was alone and living with her mother, my great-grandmother, whose name was China. So she decided to take me in. She helped raise me because it was helping her daughter.

In all the things I've read, there wasn't a lot about a relationship with your mother.

No.

You stayed close with your father through the years.

I stayed close to my father. My mother, we are close now. My father's deceased.

Your mom's still alive?

Yes, she is. She lives in Durham in assisted living. My grandmother is the person responsible for the person you see here today.

Your dad, what did he do when you were growing up?

He was a taxi driver. He used his taxi as an open university. I remember being in my father's taxi in the front seat, and he would give money to the children in the backseat.

Well, that's a nice taxi driver.

Yes. And he used the taxi to learn about all kinds of different people from all different walks of life.

So he was inquisitive?

Yes. And he did everything for me that he could possibly do. He gave me my first set of *World Book Encyclopedias*, which I still have [and] which probably cost a lot of money. And he would go with me to get summer jobs in D.C. I once was a park ranger at Fort Washington.

Oh, I didn't find that in any of the research.

I loved the outfit, I did.

It's all about the uniform. Okay, let's go back to Bennie Frances Davis. She worked cleaning dorm rooms at Duke University.

She did for forty years.

When you grew up in the house, you said your great-grandmother China was there. Were there other relatives living in the house, too?

No, just the three of us. I grew up in a home that was full of love, full of total attention on me, of course. And I didn't know it at the time. I grew up in a very strict environment. Neither my great-grandmother nor my grandmother ever saw the inside of a college campus or a university—

Describe a typical day in Bennie's house. I read she chopped wood in the morning, boiled the laundry, cooked an amazing meal—all before she went to work.

She was a pioneer woman. She would get up at five o'clock and stoke the fires. When I was really little, the kitchen stove was a wood-burning stove. You could boil water inside of it. It was very, very strange to have this stove removed from the house when we got an electric stove. She made breakfast. On the weekends, she did everything. She cooked, she made homemade biscuits on Sunday morning. She got us ready for church. She washed all the clothes in the house. Sometimes my great-grandmother did that. And we did not have a washing machine. The clothes were washed in a zinc tub. In the summertime, they would have a cauldron, a big pot outside under the peach trees. They would make a hot fire, and the white sheets would be boiled in this water. They had a stick from the tree and they

would stir, and the linen came out impeccably white and beautiful. It was hung on the lines. There's nothing like the smell of white sheets that have been dried in open air.

That's true. Did you help in any of these chores?

No, I just looked. I was totally spoiled. I have seen my grandmother and my great-grandmother both decapitate a chicken to cook.

And you didn't become a vegetarian.

No, no, no. I also saw my grandmother skin a squirrel that had been hunted by my uncle. For us in the South, squirrel and possum meat was considered a luxury from the woods. Now, did I eat it? Of course not.

Okay.

But I watched my grandmother skin the squirrel and put it in boiling water to make it antiseptic. And she cooked it.

What were some of the key values you learned from your grandmother?

Well, one of the things was maintenance and discipline and just rules and rigor. We did not have a lot of money, and I did not come from any sort of wealth. One of the great things was that everybody was busy scrubbing and maintaining. They wanted to keep the dirt out of the house, keep the floors clean. So I learned early on. One of my tasks on the weekends was to scrub and wash all the floors.

So you did help a little bit.

Well, that's all. I did not cook. I regret that I was never allowed to go near the stove to cook. But I was certainly told to scrub the floors and wax the floors, so you could see your face in the reflection. In the summer I used to scrub the front porch and I loved it. That was one of my favorite things to do. It looked like a reflection pool once I had washed it down with suds and rinsed it four or five times with water. That was a great thing to do.

It's very gratifying.

Yes, I remember First Lady Michelle Obama saying that she taught her daughters to make up their beds. It was a great thing to be told I had to make up my bed. And I had to make up a neat bed—I couldn't just throw it together. It had to be perfect.

Good hospital corners.

Yes. And my grandmother ironed everything. She ironed the sheets. She even ironed towels. She ironed everything in the house. So I had to make a perfect bed.

It's interesting that your grandmother was this important influence in your life, because for many of the designers I've spoken to here on this stage, their grandmother was the major force in their lives. Tom Ford, Michael Kors, and Marc Jacobs—for all of them, grandmother was the primary source.

Grandmother was very, very important to me.

Describe her sense of style. Where did she shop?

Well, when I was little, I used to sit and watch my grandmother comb her hair. She had beautiful hair. It was white, with a blue tint. I thought that God had given her special hair that was blue, because nobody in my family had blue hair. So when I grew up and realized that she had the hair tinted at the hairdresser with a blue rinse, I was quite surprised. I started reading about people in style, such as the great [Elsie de Wolfe], who had blue-tinted hair. My grandmother had a black suit, copied from something in Paris, that she bought probably downtown with the money she saved, and the suit is still in the closet in her bedroom. She

wore it for forty years. She wore it when you needed a black suit for a funeral. She wore it when you needed a black suit in church. She wore it on the plane when I took [her] first plane ride with her and brought her to New York.

And she always wore it with gloves.

Gloves are so important. My grandmother had a drawer full of gloves. She had a drawer just for her handkerchiefs. Now, she didn't have the most expensive gloves, but she had gloves for every occasion, every season. And these were the luxuries in her wardrobe. She saved her money and she would buy the best pair of shoes she could in Durham, in Naturalizer. She had navy blue. She had bone. She had black. And when I started making money I used to go to Washington, D.C., and buy all these extravagant things at Garfinckel's. I would buy her Kislav gloves. Do you remember Kislav's?

Beautiful.

Beautiful gloves. And I would buy her handbags. They had handbags that Jackie Kennedy was carrying in the photographs, with the chains copied from the Chanel bag. So I was constantly buying her crocodile shoes, anything, anytime I had money.

Crocodile shoes?

Yes, at Garfinckel's. And she would just put on anything I bought her. She loved that I would give her these presents.

How many pairs of Manolos did she have from you?

She had about six to eight. They were low-heeled, because she was very old and she didn't want to walk in high heels. She had the most extraordinary sense about hats. Her sense for buying hats was amazing. Once she went to buy a hat for Easter in this store called [Jobel's] on the main street in Durham, which was the place to go to buy hats. And she walked in to [Jobel's] and certainly could afford the hat, and the lady said to her [before she tried it on], "Would you please put tissue paper in the hat?" Because of course this was a store owned by a white retailer, and she thought that perhaps the African American woman with blue hair should not have her hair next to the hat. And my grandmother threw the hat down and said, "Pshaw," and walked out of the store and never went back. When she told everyone in church not to go to Jobel's, they lost some money.

Good for her. Was there other discrimination like that that you experienced in the South growing up?

Yes. Not so much, because my grandmother protected me from it, so things didn't touch me until one day I went to a Jimi Hendrix concert in Atlanta. I was in college, and I thought it was chic to go to Jimi Hendrix and get dressed up in the bohemian style like a gypsy. So that's the only reason I went. I really wasn't into his music.

It was an opportunity for a new outfit.

I went with friends in a car from Durham. We got stranded and we got lost. It was a three-day festival. I slept there on the grass and kept my clothes on. And then I had to get back home. I had to hitch a ride back to Durham on the highway. And I'll never forget that a state trooper kicked me and I had to keep walking.

Just like that. Just kicked you.

Just like that, just kicked me out in Georgia. And I just had to be brave enough to continue on home. I hitched a ride with strangers—and they were white—and I got safely home to Durham.

Let's go a little earlier back. You wrote that you were a true fashion convert by the age of twelve. Did it have anything to do with the yellow paisley Christian Dior pajamas your grandmother bought you for your birthday?

Yes. Those pajamas were a New York licensee of Christian Dior.

But you did know what that meant at the time?

I didn't know what that meant at that time. All I knew was the label said Christian Dior, they were yellow paisley, and I kept them for years. I treasured them so, because it was the first true luxurious thing that my grandmother bought me.

So you were somewhat aware of labels and brands at twelve years old.

Somewhat.

You went to Hillside High School. Were you a good student?

I was a perfect student. In high school, I gravitated more toward my teachers and just a few very close friends. There were always girls who had a great deal of style. They came from a background much more financially luxurious than I did. So there was [Ann Bibby], the homecoming queen, and her whole pack. And I used to hang out with them. At the prom—I went to the prom alone, of course—Ann Bibby's mother had made her a fabulous evening dress from a Givenchy pattern that they bought downtown. She had the most beautiful silk evening dress with these extraordinary white kidskin gloves. And I was sitting in the corner in this gymnasium, where the prom was held, just minding my business, and she came over. She had a powder puff in her handbag, and she said, "Would you please come and powder my back?"

Sounds like an honorable thing to do.

Not only was it the honorable thing to do, I did it in the center of the dance floor, so that everyone could see.

Take that, everybody.

Yeah. It was the highest moment of my senior year.

You love books. You got your first job as a student librarian. And you even, I believe, at twelve, read John Fairchild's _The Fashionable Savages_.

That is correct.

How, at twelve, do you pick that book out?

You just gravitate toward it in the card catalogue. I loved the book because I learned about Coco Chanel. I learned about Balenciaga and Givenchy and the late Isabel Eberstadt. Mr. Fairchild called her "a locomotive." She used to dress in Madame Grès in Paris, so I had all of this in me at a very young age.

Pretty impressive at twelve. You said you were also reading _Vogue_ in your teens. How did that magazine come into your life?

I'm very naïve, and I used to, after church every Sunday, walk to Duke University and buy _Vogue_ when it was coming out twice a month. Little did I know, I could have subscribed to it. But I loved the idea of walking to the Duke campus after church. My grandmother would be in the kitchen preparing supper. Before I would walk to get the magazine, I would look at Julia Child and her cooking show on the PBS channel, because she said, "Bon appétit"; she was speaking French, so I related to that instantly. Then I would leave the house and walk across the railroad tracks by myself and buy _Vogue_, and with my little allowance, I would buy the _New York Times_ and any magazine that had anything to do with fashion. I

remember an incident that happened, another sort of horrible incident. This one Sunday, I was walking across to the Duke campus, and people threw rocks at me out of a car.

You were bullied.

Yes. I was bullied. And this was students from the Duke campus, some guys. But the rocks didn't hit me, and I kept walking.

Did your grandmother read *Vogue* when you brought it into the house?

My grandmother never read *Vogue*. My grandmother read the Bible and the newspaper. She loved to write letters to her sisters in New York. We used to come to New York sometimes and go to Saks Fifth Avenue. And she would buy very expensive hats. The most she ever paid for a hat was thirty-five dollars, and for her that was a big decision. Thirty-five dollars for a hat then was like an enormous amount of money to spend.

In 1966, you graduated high school and went to NCCU—North Carolina Central University. It was the nation's first state-supported college for black students.

That's correct, yes.

How and why did you decide to study French?

I had the most amazing French teacher in high school. Cynthia P. Smith was my French teacher in level one, two, three, and four. By level three you were only in the lab five days a week, listening to French in earphones. And that's how you learned to speak, with the dialogue. She was very much like Maggie Smith in *The Prime of Miss Jean Brodie*. She went to Europe once a year in August, by herself, and she came back and she had two dresses: one red and one houndstooth, with white pique collars and cuffs. And she would wear them on special days when she was going to show her slides, the way Jean Brodie did. She was my favorite teacher. The year my grandmother passed away, Hillside High School honored me, and I made sure that she was on stage.

When you have a teacher that makes an impact, it's quite extraordinary. And then while you were at NCCU, you learned about Brown, where you applied for your master's degree in French Literature.

I had a scholarship. A full scholarship. Full.

A full scholarship? Based on your grades?

On my grades, and also my love of France. By the way, one of my favorite teachers in college was Mrs. Jackson, who was the mother of the first black mayor of Atlanta. And she was extraordinary, too. I really gravitated toward French teachers. I used to wear to school things like capes that I found in a thrift shop and tassels as necklaces, the way Scarlett would pull down the tassels and make a dress.

So you stood out a little bit, [at] Brown.

Oh, totally, totally, totally.

Providence, Rhode Island, was far from Durham. And then you decided to take art history courses at RISD, Brown's sister school.

Yes, I did. And I loved it because it became a place for me that I felt right at home. The RISD campus was full of fabulous, wealthy people. Probably their parents sent them to get them out of the house. I remember there was a friend of mine named Paul from Grosse Pointe and Reed Evins.

Reed Evins, whose father owned the [Evins Shoe Company].

And Reed pulled up to Providence, Rhode Island, with a huge truck full of furniture.

Chippendale chairs, mahogany dining room tables, china, silver, linens, everything.

This was not for his dorm room?

This was for his apartment. And Madeline Parrish, who was from Virginia [and] who later became a *Vogue* editor, also had an apartment where she had all the most fabulous Knoll International furniture. And she had all the best YSL Rive Gauche. She had a little Mercedes two-seater. It was the world that I wanted to know. They were all shopping at Rive Gauche and Sonia Rykiel. So I started writing a column at the RISD school newspaper.

About?

"After Dark." The social life of the high elite at RISD. Madeline Parrish used to give parties on weekends that were so soigné. "Soigné" is a word that I love. She had on her Yves Saint Laurent smoking dressing pajamas and her fabulous Delman high-heel shoes from Bergdorf. She served the most fabulous food. The late Richard Merkin, one of the great professors at RISD, would come over, and we would all put on our best clothes to go to Madeline Parrish's house for her Saturday night parties.

[One] of your other early friends at RISD, I read, [was] Robert Turner, who was quite flamboyant. He eventually became a fashion editor at *Vogue*.

At *Vogue* before I was. Robert Turner was not only flamboyant, but he was very restrained in his flamboyance.

And then he became a decorator?

He became a decorator. He still lives in New York.

And another friend of yours there was [Jane Kleinman], whose father was president of Kayser-Roth Hosiery.

Yes. I sort of piggybacked and came to New York with Robert Turner in his BMW, and I would sleep some nights on his floor and other nights on Reed Evins's floor. Reed's floor was carpeted. Robert's was not, so I had to get an old vintage horse blanket to put on the floor when I slept there.

I read Robert took you to the Coty Awards one time in New York.

That's where I met Carrie Donovan. I had written a letter to her.

And what was the letter about?

I wanted to know about Pat Cleveland and how she was discovered. And she wrote me back in green ink. I still have the letter somewhere. She wrote back graciously and said, "It's I who discovered Pat Cleveland on the subway one morning when going to work." So that was thrilling for me that she answered the letter.

But I thought that Joel Schumacher discovered her.

Carrie and Joel probably discovered her together.

They were probably on the subway together. Okay, so when Robert took you to this party with Carrie, it was at Halston's house?

No, Joe Eula's house. Joe Eula was having an after party, and there was everyone. Elsa Peretti, Mrs. Vreeland, Carrie Donovan, Pat Cleveland—all the people who were associated with Halston. Stephen Burrows. And it was a fabulous party.

Lots of cocaine?

The cocaine was not flowing at that moment, when I was at the first party. I would say that once I got to know Halston, the coffee tables were mountainously filled with cocaine.

So in the midst of that, you got your master's degree in 1972.

Left to right: André Leon Talley working with Diana Vreeland on a Marlene Dietrich costume from a Metropolitan Museum of Art Costume Institute exhibit, November 1974; Halston and André Leon Talley attending a presentation, 1977

Yes.

And your senior thesis was on—I love this—the pivotal role of fabulous, exotic, North African women in the works of poet Charles Baudelaire and painter Eugéne Delacroix. What was it that intrigued you about those works?

I loved using Delacroix for his *Sans Dangier*, his famous painting. And I just love Baudelaire and his correspondences. So that's what impacted me.

And you got a good grade?

Well, I wrote my thesis and got my master's degree. I was working on my doctorate and that's when I decided to come to New York to go to the Coty Awards. Then I saw Carrie Donovan and met all these people and I just never looked back. Ms. [Kleinman's] father wrote a letter of introduction to the Metropolitan Museum's Costume Institute.

That was in 1974. You moved to New York to work at the Costume Institute at the Met, with your hero Diana Vreeland.

The official administrative person read the letter, so that's how I got my foot in the door, as an intern, a volunteer. My first assignment was not given to me by Mrs. Vreeland. You did not approach her and just say hi. You had to worship at the altar of Madame Vreeland. As anyone here will tell you, Vreeland was, and still is, the empress. And the language of Mrs. Vreeland was so fabulous. The language [she used] to impart upon you what fashion is, in terms of history, was the most amazing thing to me. It was just the best lesson in style. When I started working on *Romantic and Glamorous Hollywood Design* as a volunteer, my first assignment was given to me by the associates of Stella Blum, which was to take a costume from—what's the name of the movie?

The Prodigal.

Yeah, and it was *The Prodigal. The Prodigal*, with Lana Turner, when she kills herself in a vat of fire. I had never seen this thing, and they said, "Put this together. Mrs. Vreeland will come into the museum after lunch and she will review this." So I had this metal Paco Rabanne–ish costume and some pliers. I didn't know what I was doing. I somehow managed to assemble this to put it on a mannequin. When Mrs. Vreeland came to work, she was announced. They would come out of their offices, downstairs in the basement of the

Costume Institute, and they said, "Mrs. Vreeland will be arriving any minute. Therefore you have to stand."

Everybody get in place.

I hid behind a column, just to see the arrival, the feet, the toes. She does not walk on her heels. The makeup, [Kabuki]. The pink jacket from Saint Laurent. The polished Gucci bag. The flats from Mila Schön. This dramatic theatrical moment. And it happened. She passed by this suit that I had just put together with pliers. Five minutes later, someone came out of Mrs. Vreeland's office and said, "Mrs. Vreeland will see you now." I thought, "Uh oh, what have I done?" I go into her office, red, lacquered—she's sitting at her desk. She says, "Sit down." And she speaks in such clarity of tones, and it's just the biggest moment of my life. She has a yellow legal pad, and I can see it on the other side, she writes [in big letters]: "André, the helper." Then she puts her pen down and stands up and says, "You will stay by my side for the rest of this exhibit." And I did.

Just based on how you put that dress together?

Yes, yes.

How fabulous.

We became great friends and I learned so much from her.

Absolutely. Who else was working at the Met at that time? We know Simon Doonan was, but he said he got paid.

Oh, well I was happy to be a volunteer and sleeping on Robert's floor or Reed's floor. This was my first Christmas that I was not at home, because even at Brown I would go home for Christmas. So on Christmas Eve, [Reed] went to his mother's apartment in the U.N. Plaza, and Robert had already gone to Baton Rouge. My grandmother called me from Durham. Now, I have eaten Hershey's chocolate syrup out of a can out of Robert's cupboard for Christmas Eve dinner, because that is all I had. And I had no money. Reed had bought me lunch at a hamburger joint, and then he went to his mother's house, so I had chocolate syrup with a silver spoon. And then my grandmother rings, and she says, "I'm sending your father right now tonight to come and bring you home." I said, "I can't go home. Mrs. Vreeland told me not to go home."

André Leon Talley with Studio 54 co-owner Steve Rubell and Andy Warhol, 1981. Page 304: André Leon Talley leaving the Ritz Hotel in custom CEO by Damon Dash sweatshirt and trousers, Pro-Keds sneakers, and Vuitton gear, *Vogue*, 2007

And why did she tell you not to go home?

She said because if I ever went back to Durham, I would never come back, it would never happen for me.

Weren't you already hooked?

I thought if I go home, I'll just turn into a schoolteacher. And that's not a bad thing. But I thought, I'll never come back to New York, because I was so close to my grandmother and my roots. It's Christmas Eve, I'm very lonely and depressed with the chocolate syrup, probably high on sugar. And my grandmother calls and she says, "I am sending your father right now." I said, "But Mrs. Vreeland is going to help me get a job in the New Year." This is 1974 into 1975. By the way, Mrs. Vreeland did get me the job at Interview with Andy Warhol. She told Fred Hughes, "He has to be at the Factory, okay?" In the meantime, my grandmother says, "I want you home." I said, "What's wrong?" She said, "I know what you're doing. You're sleeping with a white woman." Which indeed was not the case.

Why was that an issue for her?

It was an issue for the Deep South. It was 1975. My grandmother was very old school.

But she still held that [hope] that you'd be sleeping with a woman?

She never discussed this, but she certainly didn't want me sleeping with—if I was going to choose to sleep with any woman—a white woman. By the way, I've slept with a white woman. Don't wait to get to that question. Yes, I've slept with a white woman.

[TO AUDIENCE] You all got that? [APPLAUSE]

I knew that was coming. I beat you to the pass.

Well, somewhere in there I was going to try and weave it in. But that's okay. I'm glad you hit that one on the head. Okay, so Interview magazine, we know how that happened. Did you work closely with Andy?

No, I worked in the magazine side. The magazine was separated from the Factory where they did the art. Bob [Colacello] was my boss. We had a separate staff, but we could go into the Factory when we were invited. For instance, if Mrs. Herrera came to lunch, I would be invited. I did the first interview with Carolina Herrera. (Interview was one of her favorite interviews.) But in the meantime, I was in the Interview office, acting as a receptionist, answering the phone.

I read you were the happy and festive receptionist.

A festive receptionist, dressed in Rive Gauche. And Mrs. Vreeland would come with Consuelo's sister, Gloria Schiff. Consuela Crespi had a sister, a twin, Gloria. One day there was this big conversation I will never forget, between Mrs. Vreeland and Gloria. And it went on like this. "Gloria, are you insane? Marisa Berenson discovered at a debut ball? What are you talking about? I discovered her." So these kinds of things were very, very colorful to me. But my real duties were to go to the post office. I took messages for Fran Lebowitz. I took messages for everyone who was a writer at Interview. I got to do my own interviews. I also got to go out every night with Andy. If there were premieres, if there were Broadway openings, you could go with Andy and the whole entourage. This was a great thing because I was then living in the YMCA on 23rd Street with the human cockroaches and the real cockroaches.

And furniture from Halston.

And furniture from Halston. Halston sent down antique furniture, and I decorated my room. And he also sent down his Ultrasuede jackets, because then I was thin like Halston, and I

could wear all his clothes. And then my clothes became furnished by Karl Lagerfeld.

You were the happy, festive receptionist. This was like the equivalent of being in L.A. in the mailroom at William Morris, where people started. But you only did that for a month before you became a fashion editor.

That's correct.

That's a pretty good move.

I think I had something to give. I think they recognized that.

I believe that's true. So that was a very fun time in your life. Did you know how important all those people were at that time?

Listen, I knew who Andy Warhol was before he even came to New York.

But all the other players who you were surrounded by.

Oh yes, I worshipped everybody that came through that factory. I worshipped all of them— Michael Jackson, Caroline of Monaco to get her portraits done. I made great friends, like my fabulous late friend São Schlumberger, who was so close to the Factory you cannot imagine. When they went to Paris, Madame Schlumberger basically introduced the entire factory, Ed and Bob and Andy, to the higher haute mode, the beau mode of Paris. When I went to Paris for the first time, I went to work for *Women's Wear Daily* with Mr. Fairchild, I arrived with thirteen unmatched suitcases of luggage. By the time I had left I had—

Thirteen cases?

Thirteen unmatched pieces of luggage. By the time I left Paris, I had thirty-four matched sets of Louis Vuitton. And I paid for all of them. My best friends, of course, were Paloma Picasso, Loulou de la Falaise. I had privy interest in Yves Saint Laurent and Betty Catroux, so this was a great time for me. And São Schlumberger would have the most incredible Saturday afternoon luncheons. The first lunch she ever gave, sort of in my honor [de facto], there was the Baroness [Marie-Hélène de Rothschild]. In those days, people did not invite people from *Women's Wear Daily* into their home for lunch or dinner. So it was very, very special. I'm going to jump ahead. So when John Galliano did not have any more money to have a fashion show, and he was going under, Anna Wintour said, "André, do whatever you have to do. Get him back." I took John to lunch with Madam Schlumberger, and I said, "We have something to ask you." She said, "There's no such thing as a free lunch. What is it?" I said, "We need your house for the fashion show." She said, "Fine. I'll just get a touch-up, I'll have a little eye lift and it'll be fine."

And that's where that collection was launched, wasn't it?

Yes, yes, yes, yes.

And at this time you were the Paris bureau chief, right?

No, that was when I was at *Vogue*. That's 1994. When I was the Paris bureau chief was when Madame Schlumberger had a luncheon for me.

So those were absolute dream jobs come true, right?

Such things are dream jobs, yes. They were dream jobs.

At *Women's Wear Daily*, did you work closely with John Fairchild?

Absolutely, my goodness.

And what did you learn?

I learned the beauty of what clothes must be to a woman from Mrs. Vreeland. She taught me that luxury is inside of the dress as well as outside. And from Mr. Fairchild I learned the

discipline of deadlines and reporting and how to view a collection and analyze it mentally [very quickly]. I was accessories editor. I made twenty-two thousand dollars a year. And then I moved to Paris and that money became a little bit more. But in Paris in those days you didn't have to pay taxes if you worked for an American company. That's why I went to Vuitton. Every paycheck I went and bought another suitcase.

Do you still have those bags?

Oh yes, I have them. Absolutely, I have them. Lacquered. I used to lacquer them and shellac them. Mrs. Vreeland used to shellac hers. She didn't, but somebody did. I shellacked my own. On the weekends my main job was to cover the accessories market. So my desk was here with a typewriter. We didn't have computers. And [Mr. Fairchild's] desk was right behind me. And you could hear everything he said, every conversation. When I had to do something special he would stand up over me with his arms folded and basically dictate verbally what he thought I should say, especially when I was covering big social events. I moved up fast at *Women's Wear*. I knew that I had really made the grade when one Christmas, everyone was going away. He says, "André, we're going to leave you in charge, and you're going to do the ['In and Out' issue] of *W* by yourself. When we come back, present it and we'll print it." That was a big moment.

Tell us about the early report you did on Saint Laurent's Porgy and Bess collection.

January 1978, I had been sent to Paris to be the fashion editor. I later became the bureau chief. And my first big triumph was that Mr. Saint Laurent had done this extraordinary collection based on him listening to the Porgy and Bess opera in his Volkswagen radio on his way to work. I interviewed him. I said, "You've gotten the South so correctly, because these clothes reminded me of the clothes that my family used to wear to church." They weren't Saint Laurent couture but they had the same style, the same ability to put color together in a jaunty hat, the way the hat [was put] on the head. And just the idea of the clothes was the nuance of the chic South, where people who had very little money had great style. You could live in a log cabin and have fabulous style. And so, there I was, typing away on a telex machine, because we had telex machines and it was very hard to type when it goes bump, bump, bump, bump, bump.

Very noisy.

And it was a deadline. I had seen this collection where Mounia, one of Mr. Saint Laurent's favorite models, from Martinique, I think, had come out in this fabulous pink suit with the trousers raised way above the ankles, so they were sort of mid-calf. But it was a fabulous, dressy suit. It was an amazing moment. And Mr. Fairchild had orchestrated the cover for *W*. He called it the Broadway collection, and then I had to write about it. And I thump, thump, thump, thumped this review, and Mr. Fairchild sent extraordinary praise about it. But the best thing was Mrs. Vreeland wrote me a note about this later in the season, saying, "You describe Saint Laurent's collection as if you've worn the clothes yourself."

And did Saint Laurent appreciate the reviews you did?

Yes, he did. Saint Laurent and I were very close.

Great. And when you were at *WWD*, you also did a very special interview, an early one, with Truman Capote, and you became friends.

Yes, I met Truman Capote through the Factory and his late, great friend C.Z. Guest, who was a very important part of my life and is still a great influence. She was one of the ladies of

great style, and she took me to meet Truman in her apartment on Park Avenue. Through the interview I became great friends with Truman, and he was one of my great heroes. I used to see him at Studio 54. C.Z. Guest was extraordinary. She was true American style.

When did you become friends with Karl Lagerfeld? During your time at the Paris bureau?

No, 1975. I was still at *Interview*. Andy had said you're going with me to the Plaza Hotel, and you're going to meet Karl Lagerfeld and you're going to interview him for our Paris issue. This was a Sunday afternoon when people still went to tea at the Plaza. So we went up to Mr. Lagerfeld's suite, and it was an entourage of people: Andy, me, Antonio Lopez, Juan [Ramos]. Antonio was sketching as I did the interview. I was prepared. I had read everything there was to read about him. There was not going to be a moment missed. So we've done the interview, Andy is there, Antonio is sketching, and it's the first time I have seen Karl Lagerfeld in the flesh. He had a beard. He was fabulously dressed in crepe de chine, four-ply, six-ply, seven-ply.

Multi-ply.

Multi-ply crepe de chine, muffler seven feet long, crepe de chine shirts. And at one point, we're all sitting in the salon, and in his German [accent], Karl says, "Come with me in my bedroom." And I thought, uh oh. But it's five o'clock in the afternoon. I think, what is going to happen in this bedroom? I can handle it. He went into one of his big trunks, and he kept throwing things at me, saying, "Take this, you need it, this is what you should wear." And it was all shirts that he had designed for himself. So I had a whole wardrobe of Hilditch & Key, four-ply crepe de chine shirts with matching mufflers. When I got my first job at *Women's Wear Daily* in August, I used to wear these four-ply crepe de chine shirts with Fruit of the Loom T-shirts underneath. Mr. Fairchild was very intrigued by my uniforms.

That's quite a uniform.

Yes, and I was proud of them. I kept them for years, until they wore out.

Tell us about the very generous and beautiful gesture that Karl did when Mrs. Vreeland and your grandmother passed away.

Mrs. Vreeland and my grandmother passed away the same year. And so it was a very depressing year for me. That year, Karl lost his best friend, Jacques de Bascher, his lover,

Truman Capote and C.Z. Guest by Bob Colacello, late 1970s

Clockwise from top: Oscar de la Renta and André Leon Talley during Talley's book signing in New York, 2005; singer and actress Diana Ross dancing with André Leon Talley, Studio 54, New Year's Eve, 1979; Karl Lagerfeld and André Leon Talley at the Élysée Palace, *Vogue*, 2010

so he sent me a Concorde ticket on Christmas Eve. I left New York after church with my Vuitton luggage, and I arrived in Paris at ten o'clock at night. His chauffer met me, and I was whisked away to the country house, where I stayed two weeks in January. I had my own suite, and we would meet for lunch and dinner. He gave me a Fabergé pen with my initials in diamonds, [in] a little paper box at Christmas Eve. And it was just the most wonderful time.

Nice to have friends like that.

It is lovely to have friends like Karl Lagerfeld. When I turned fifty, he gave me fifty thousand dollars.

I didn't read that anywhere!

And I never slept with him. [LAUGHTER]

So do you think you might get sixty-five thousand dollars for your next birthday?

Hopefully.

That would be nice. Okay, then you came back to New York and you were hanging out with Oscar, Halston, Diane, Bianca.

They were already my close friends. Diane was a very close friend of mine before.

And was Studio 54 where you went at night?

When I came back, Studio 54 had closed. I was at the opening of 54 and the closing.

As were almost every designer I interviewed on this stage.

It was the place. I miss it.

Well, don't we all. Simultaneously, you continued to develop your very deep and close friendship with Mrs. Vreeland.

Absolutely.

Can you talk about those later years and the bond that was created? You read books to her at night?

Well, Mrs. Vreeland was an extraordinary human being. And the best thing about her was she was so enthusiastic about anyone whom she thought had a modicum of talent. She just embraced you in a way that no one else has ever embraced me. I learned so much from her. I knew she loved to hear the spoken voice, because her late husband used to read as entertainment after dinner. So I think one day she said, "Come up, André, and read to me. I love to hear people speaking out loud and reading." And I said, "Of course." It would always be on the weekend. She would make an entrance. We had dinner, the two of us. We'd have little tiny thimbles of straight vodka. And then I would go at it. I would read things like a whole book by Hannah Pakula called [The Last Romantic: A Biography of] Queen Marie of Roumania, which was one of her favorite books. I had to read that twice. It would take me two or three nights to read a book. I read Baron Guy de Rothshild's book. She loved memoirs. She said, "Just read anything to me, just bring a magazine." Once there was an article in Musician about Prince, and I was reading this article to her out loud, and she said nothing. And then she said, "Get him on the blow." And I said, "I beg your pardon?" "Get him on the blow." "Blow" is telephone. She said, "Get him over here for dinner."

And you did.

No, I did not.

You never got him?

No. But she was the kind of person that you would do anything for. When she and Diana Ross went to dinner, Diana went to this fabulous store on Fifth Avenue called A La Vieille

Russie and sent her a Fabergé egg. Mrs. Vreeland used it for her Q-tips in her bathroom. She never shared anything she considered private, but once she showed me a note Mrs. Kennedy had sent her. It was a book, and the note said, "Perhaps your exotic friend Mr. Talley could read to you." She thought that was wonderful and showed it to me. And it was.

Do you have that book?

No, it's Mrs. Vreeland's book, not mine.

But did Alex or the family give that book to you?

No, no. I would go up on Christmas Eve and read and have dinner with her alone. And then on Christmas morning at seven o'clock, I'd go to La Guardia and take a plane home to be in time for breakfast at my grandmother's house.

You got both women for the holidays.

I got both of them in, yes. They spoke on the phone once. They did. And they were just so happy to speak about me.

In your book, you make some beautiful comparisons of the two of them.

Oh, they are wonderful. I've learned so much from both of them. They were similar, except one had the means to support and maintain her extravagance and my grandmother's extravagance was love and nurturing. And she nurtured not only me, but all her sisters looked up to her, her one brother looked up to her. Her nieces, her nephews, everyone in the church looked up to her. She was like this dowager without money.

I read when she passed away and was buried, you designed an obelisk as tall as you, so that she would think that you were looking over her.

Yes, yes, absolutely. Absolutely.

Which is wonderful. Back to your CV. You were hired in 1982, by Eunice Johnson, as fashion editor of *Ebony*.

Yes.

Why did you leave after only one year?

I adored Mrs. Johnson and Mr. Johnson. Mrs. Johnson really loved me, and she took me on the Concorde with her when she would go to the couture. We would go buy Saint Laurent clothes for her fashion show. But one day, someone from *Ebony* called up and said, "You know what? You're writing for white people." And I thought I was writing for everybody. So I thought we should part ways.

Would this be a good time to segue into diversity in the fashion industry? Because I know that's a cause that's very important to you.

Absolutely. There's been much focus on it this season, because the Diversity Coalition has taken upon itself to rightfully show that each industry should be accountable. The fashion industry has ignored the fact that most designers think one black model in the show is appropriate, when actually there may be five, six Asian models. We were starving to see our presence on the runway, as there are black women who go to shop at fabulous stores like Hermès. Oprah Winfrey went to some store in Switzerland and they thought she couldn't afford a forty-five-thousand-dollar handbag. So it's to clean up the perception that we, as a people, as a culture, do not have style and do not want style. I've seen black women with Céline bags, black women with Hermès bags, black women with Chanel bags. It's important that we see people who look like us in the shows.

And black women in the White House with great style.

Thank you. Thank you. Thank you, thank you. [APPLAUSE]

Okay, so back to 1988. You were hired by *Vogue* as fashion news editor, oversaw *Vogue*'s "View" section. And that was the same year that Anna came to the magazine.

That's correct.

And you were named creative director. When did you first meet Anna and what was your first impression?

Well, here we go. Anna Wintour was already extraordinarily famous. It was 1983 when I went to *Vogue*. I still was not interviewing, but Andy and I were close friends, and we used to go out often for dinner, sometimes just Andy, me, and one other person. The only thing I had to worry about was Andy had to keep his hand out of my crotch. I remember once we were in a movie house, and the lights went down, and there's Andy, Azzedine Alaïa, and me. And I suddenly felt something, and I looked and it was Andy's hand. I slapped him and Azzedine Alaïa never stopped laughing. But it was not something really vulgar—it was just like Andy's innocent pat.

Love pat.

Lovely idea. "Love pat." Anyway, Andy and I had gone to this party, and there stood Anna Wintour. She was at *New York* magazine, creative director. And Andy said, "Just go over there and talk to her, André. She will love you." I said, "Andy, I can't talk to Anna Wintour, she's too powerful." He said, "Oh, André, she will love you." So Grace Mirabella brought me to *Vogue*, and I went into *Vogue* to meet Grace. Anna Wintour was then creative director. I took the subway back to my apartment at 1 Astor Place. I had gotten to turn the key in my door, and there is a man knocking at my door with a hand-written note from Anna Wintour. "Dear André, I am so thrilled you are coming to work at *Vogue*." Not a hand-written note from Grace Mirabella, but from Anna Wintour.

That's how you learned, changing of the guard?

Also I learned that she obviously noticed me and that I could work with her. Yves Saint Laurent loved feathers and we were doing stories on feathers and the African influence of people wearing feathers for ornamental dress. I went into Ms. Mirabella's office to explain that I wanted to show this African man in headdress and feathers, to explain the Yves Saint Laurent correlation. And Grace Mirabella said, "What have I done to deserve this Downtown influence?" Meaning the Factory, Andy Warhol. Anna Wintour was there, and she was quiet, and she wrote me a note and said, "André, just stay here and work with things. Just stay with me." And so I did. And look where I am. And, by the way, when Mrs. Wintour got married to Dr. Shaffer, I got an invitation to the wedding, held in her house. It was a weekday. I assumed that all the people at *Vogue* were going to be there. I assumed Polly Mellen was going to be there, Mr. and Mrs. Newhouse, Grace Mirabella. The only two people at that wedding were Laurie Schechter, her assistant, and me. Her wedding was over at four thirty, and I went back to the office and they all were, "Tell us what it was like."

And you held court there.

I did not hold court. I kept it all to myself. I knew where my bread was buttered—it was with Anna Wintour. Before the wedding was over, as she's getting ready to go on her honeymoon, she's coming down the steps. And she's got on this fabulous blue-and-white Chanel. Her whole trousseau was done by Chanel. Chanel crepe de chine pleated skirt and shirt. There were no bridesmaids at her wedding. You know the tradition is you throw the bouquet. So

she's coming down the steps and I'm standing there in my double-breasted four-piece suit from Saint Laurent, and with her determination that she has, she's walking down the stairs in those Manolo stilettos, and she takes the bouquet and she thrusts it in my chest. I assumed that she thought I was going to get married. But she was basically just giving it to me to get rid of it.

Did you keep that?

I did not keep it. I threw it away.

You could have dried and pressed it.

I didn't know at that time how to dry and press flowers.

Imagine what those would have gone for on eBay.

Oh, wow. I guess so.

So what would you say you learned the most from Anna? Was she as influential in your life as Diana?

Absolutely. It's the best school for learning how to look at fashion and edit a magazine. I couldn't do *Numéro Russia* without having worked with Anna Wintour. First and most important thing I've learned from her is to be quick, make a decision, and don't change. Make the decision, stick with it. Do not have meetings that go on for an hour. You can go to a meeting with Anna Wintour and it's nine minutes. The first time I had lunch with her, when we got to *HG* (*House & Garden*), we went to lunch somewhere in midtown, and it was one o'clock. And I'm about to just dig into the lunch and have a fabulous time, and at 1:09, she says "Finished lunch, let's go."

What did she eat in nine minutes?

She ate a steak, a piece of steak. Raw steak. I didn't finish my lunch. I've learned a lot from her. I've learned discipline. I've also learned to have a visual sense of the layout, to pick clothes so that the woman will see on the page something she might want to tear out and go to the store to buy.

Let's get you to Savannah. How did you get connected with SCAD, the Savannah College of Art and Design?

Well, you know, from the time I went to Georgia to the Jimi Hendrix concert, I never wanted to go to the South again. And so, there was this fabulous person interning at Manolo Blahnik. And he's the son of Nancy Gonzalez, the handbag designer. He was a graduate of the school and had written a letter to *Vogue*, an invitation to go to Savannah College of Art and Design. I thought, why do I want to go to Savannah, Georgia? But then, when it mentioned the person who had made this possible, I remembered him being an intern at Manolo Blahnik, so that made me connect to the human being who thought that I should be at that school.

It's a remarkable school.

It's an extraordinary school. And it's founded by Paula Wallace. She wanted an art school in the South with twenty-six students, and now she has eleven thousand five hundred.

And owns most of Savannah.

Oh, yes. And she's very kind to me. I'm on the board of trustees. I have my own gallery named after me.

In 2000, they set up the André Leon Talley Lifetime Achievement Award.

Yes.

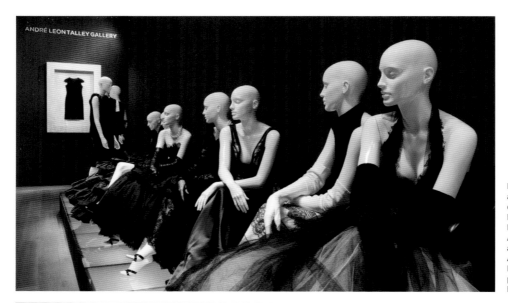

Page 313: Anna Wintour and André Leon Talley during Mercedes-Benz Fashion Week Spring 2003, New York. This page: The André Leon Talley Gallery at Savannah College of Art and Design, Georgia. Page 320: André Leon Talley photographed by Jonathan Becker, 2013

And you've brought many fabulous people down there to be honored.

I brought Tom Ford, Miuccia Prada, Vera Wang, Manolo Blahnik, Oscar de la Renta.

I go down to SCAD a lot, as well.

Yes, you do. And they love you at SCAD as well. That's why I got to do the little black dress in my exhibit, because it was started at SCAD, and this summer it went to the Mona Bismarck [Center for Art & Culture] in Paris. It was a huge hit. And the book is in its second printing. But the best thing was to have an exhibit in Paris. I thought they would hate me, but people have told me how much they loved it. So that was a good thing, because I expected to go to Paris and just be torn down by the French. And the person who loved it most was Suzy Menkes, who gave an extraordinary article in the *Herald Tribune*.

Well, I think everybody loves you.

Oh, not everybody.

All right, can we go to 2004 when there was an intervention? By Anna and Oscar.

Anna, Oscar, and the Reverend Calvin O. Butts III—he didn't really know what he was going to the meeting for. I was taken downstairs by Patrick O'Connell, the public relations communications director. I thought I was going to be fired. I said, "Why are we going down to the executive board lunchroom?" I walk into this room and there they sat, Mr. and Mrs. de la Renta, Anna Wintour, Shelby Bryan, Reverend Calvin O. Butts III. And they started with the intervention about running to lose weight. I was so thunderstruck and in denial that I just kept cool, I kept my composure, and I said, "Let me go away and think about this." Eventually I went to Duke. And I lost a lot of weight. I would go lose the weight and then come back home and put the weight right back on at Thanksgiving and Christmas, because you associate food with love. I grew up with chocolate cake and pound cake. I was medicating myself with food. I went to Duke several times. But now, this summer, I realized that sugar is poison and sugar will kill you. So I have stopped eating anything cooked with sugar and I have stopped having pasta, bread, root vegetables. I go to Dr. Charles Passler, and I realize that a lot of people go to him in fashion. Pat McGrath and I were having a moment backstage in Paris at the Valentino show when I saw Pat trying to eat a macaroon, and I said, "Put it down. And put it down now."

So have you lost weight?

Oh darling, yes, I've. Well, I've lost eleven pounds in three weeks. And I don't worry about it. It's learning how to maintain your weight at home. And now I can pass by the chocolate madeleine and the chocolate cake at Balducci's. I have bought chocolate cakes and taken them to parties over the summer and sat there and watched people eat them in front of me and not eaten a crumb. So that's a big achievement for me.

I read that your friend Princess Gloria von Thurn und Taxis took you to a doctor in Germany screaming that she was afraid that you were going to die.

She didn't say "afraid." She said, "You're going to die tomorrow." I felt so bad because my legs had swollen [up] and [it] hadn't gone down for four days. I was a guest in her house and I thought, I have to do something. So I said Gloria, "You've got to take me to a doctor." The doctor was a lady, which helped, and she spoke perfect English. I'm sitting there half-naked and I have two German women standing over me screaming, "You're going to die tomorrow!" I think this is so absurd, I start laughing. Then Gloria said, "I'm going to have to find a place for you in the crypt"—the burial vaults of her house. I started dieting at her house, and I continued when I came home.

So what's your birthday cake going to be?

Um, probably a check from Karl Lagerfeld. [APPLAUSE]

Much better than a chocolate cake.

Much better.

Are you friends with Mrs. Obama?

Let me just clear the record here. She has never called me and asked, "What should I wear," ever. That's not who she is. But we bonded way back, before she became first lady, when Oprah had her Legends Ball. Oprah had this extraordinary party in her home in Santa Barbara, and I wasn't supposed to be invited on the first night. It was supposed to be girls' night out. But I did push my way in. I got there and had a tour. It was five o'clock and I was supposed to go back to the hotel. And Oprah said, "No, you're staying for dinner." And I said [WHISPERING], "Oh, thank you so much." And there was—

Everybody.

Everybody was there. Alicia Keys, Tina Turner, they were all there. And Oprah put me next to Michelle Obama at the table. And she turned and she started talking to me. This was when [her husband] was still senator. And I said, "Oh, you were so wonderful. I saw you on TV with your husband at the convention." That's when he made his famous speech. She said, "And I know who you are." I said, "You really know who I am?" She said, "Of course I know who you are." I was so impressed. So when Anna Wintour gave me the assignment to do the first cover story on the First Lady, I was so proud of that. And I'm proud of the notes that I got both from her and President Obama. But the best thing that happened with me and Oprah is that I was put on the train from Philadelphia to Washington on the Saturday before the Inaugural. Abraham Lincoln had done that train ride. I was by myself. I was supposed to be in the press car, with the CNN people. I was sitting there and had already paid two thousand dollars to be driven to Philadelphia to make this train. And then the driver went on to D.C. with all the Vuitton luggage, because I wasn't going to get on the train with seven pieces of Vuitton luggage. Diane von Furstenberg and I were going to the Inaugural together, and I had said, "Diane, you must take every fur coat and every diamond

bracelet, because you never know where we're going to end up." I'm taking everything I've got. Every fur, every muff, every diamond. Because this is a big moment. So the driver went on with my luggage to D.C. to put in the hotel. I got on the train. I ran into Mrs. Obama's best friend, Yvonne, from Chicago, who said, "Come with me," and we went into the family car of the train, which was amazing. And when President Obama came [in], and Michelle, they were just like, "Oh, hi, nice to see you." They didn't say, "Get him out of here."

You were family.

Yeah. I love the way she dresses. I love what she's done. I love the mix, I love that she wears that Alaïa belt. I love that she mixes high and low, she goes to black and white. I adore that she loves and wears Tracy Reese.

Okay, do you want to talk about any of your TV gigs? *America's Next Top Model* or being in *The September Issue* or *The Last Emperor*.

I love *The September Issue* because when it started, R.J. Cutler came to *Vogue*, and Anna said, "We have to do this." Well, Grace Coddington [and I] were not having any of it. We were in Paris and couture in January. R.J. was trying to film her, and she gave it to him. She was not having him around. Then they became best friends and he made her famous and she wrote this book.

She became a star.

She became a star. And with me, I wasn't as standoffish as Grace was. So I had invited him to lunch at L'Avenue. I got to know him, and he really looked up to me. He said, "I want to film you doing something." I thought, okay, we'll play tennis in Los Angeles and I'll just get dressed up in Vuitton. Now the Vuitton I have in that scene was Vuitton borrowed from the Los Angeles store. I didn't have that water box. That water box was a jewel case or something. I had this fabulous Piaget watch that I borrowed from a friend of mine. And I just sat there, pretending that I played tennis in Louis Vuitton.

Isn't that the way everybody plays tennis?

I had played tennis in Louis Vuitton in Paris. So there are pictures to prove it. Marc Jacobs couldn't believe it. I was playing tennis because Anna was insisting I had to play tennis. You do what Anna Wintour says. So, I get a call from R.J. He says, "I'm going to send you a rush of the film and I want you to tell me what you think." I saw it before Anna did. And I said, "You've taken out the funniest thing in the whole film. People will see me trying to play tennis and they will laugh and they will love it. You have to put that back in." And he did. And people laugh and love it.

Do you think the fashion industry is too obsessed with celebrities?

No, I think the fashion industry needs celebrities to continue to channel their fabulous gowns and clothes. Now, you could have said to me last year, or even maybe two months ago, "Kim Kardashian," and I would have said, "Oh please, no."

You had lunch with her in Paris?

She came up to me backstage at a show and she was such a nice person. Then suddenly she's with Kanye West. One year she's not invited to the Met [Ball], and the next year she's invited, full-on pregnant, in a Givenchy dress with gloves to match the print, and then suddenly, you realize that this is a nice human being. When I saw her at L'Avenue, we weren't together, she was already at the restaurant. I knew she was there because Givenchy was having a show. And she is the nicest person when you meet her. She is a sweetheart.

You're editor-at-large for *Numéro Russia*. What does "editor-at-large" mean?

It means the same thing it means at any magazine. You could put your foot in any page, you can give a point of view from the front to the back of the magazine as well as the feature section on fashion. You are to bring to the magazine points of view about culture, art, and style. It does not have to be just a dress, it can be Kim Kardashian.

How often do you go to Russia?

Twice a year. I love the romance of Russia. Once I got the job, I did not love the romance of going to Russia. It's very hard to go to Russia in the winter, especially Moscow. But if you go to St. Petersburg in the beautiful weather, it's the most fabulous thing you can do. The history of Russia is very extravagant, very opulent, very brutal, very cruel and savage. But I still love Russia. I love Russian literature. Tolstoy is one of the greatest writers of the world. And Chekhov. And I love that Catherine the Great had five thousand dresses.

And are you concerned about the strict antigay sentiment and legislation in Russia?

Terribly, terribly. I am concerned about being in Russia with Putin. I'm terribly concerned about the savagery of the Russian culture. And there are skinheads and Nazis—you feel that in the streets of Moscow. Putin, I think, is terrible. I would never take a walk alone in streets in Moscow. I would never go out of the hotel without people who've come from the magazine to escort me to the office.

Can you use that platform of the magazine in any way to say anything?

Yes, I think I am going to be saying a lot in the future issues. I have an upcoming article on Peter Marino. I have an upcoming article on Tom Ford, where he talks about the love for his son and the love for Richard. That's going to be, I think, something very important to put in the magazine.

However you can do it, I think that's your responsibility.

Thank you. [APPLAUSE]

Tell us about White Plains, where you live. Why White Plains? That just doesn't seem where we'd expect you.

First, in 1999, I decided to move to Westchester County. I had been a guest at Stephen Sills's house in Bedford. And it was a cold, cold, cold winter weekend. John [Gallagher] and I had been invited the weekend. John had his suite, I had mine. It was time to go back to *Vogue* on Monday morning, for a 9:30 meeting, and James Huniford drove me to the train. And when I got on the train, it took less than fifteen minutes to be right down there on Lexington Avenue, where *Vogue* used to be. And so I thought, well, other people can do this, I can do it, too. I wanted to move to Westchester because I wanted to be in a place that reminds me of where I grew up. I want there to be trees. I want there to be squirrels. I want there to be red birds. I needed a backyard. I needed to have a place where I did not go into an apartment building. I moved to White Plains because I found a house that reminded me very much of the way my uncles and aunts used to plant flowers. I call it a yard, not a garden.

Do you garden?

I garden through direction. I put, point, point, point, pull, push, point, point. And the money goes out the window, you know, planting, pruning. Oscar came one day, unannounced, because he was on his way to the county house. And one of the things I learned is you must prune trees. I thought trees took care of themselves.

So Oscar came and gave you some advice about your trees?

I learned from Oscar that you must prune your trees, which I now do. I don't garden, I just point and try to keep the bills in order.

That works. And how many closets do you have in this house?

[Four] bedrooms are empty because one's for guests and the other three are closets.

Oh, three bedrooms are closets?

Yes, yes, yes. I have shelves and plastic bins. I know where every piece is.

Do you take the train up there? Or you drive?

No, I have a car service. I think I've evolved at least into a car service.

Yes. Do you entertain a lot at the house?

I do not entertain at all. If you come to my house and sit in the wrong position on my Truman Capote sofa, you will be told to get up and go to the porch.

Is that what your grandmother taught you?

Well, yes, we did not go in our living room. Black folks in the South only use their living rooms for entertaining on Sundays. We did not sit in our living room. That was off-limits except for holidays and Sundays. That was where the best furniture was. You did not just go plop yourself down on the sofa in the living room. I don't sit in my own living room.

So where do you hang out in the house?

In my bedroom. And the room where the TV is. Some people have come and had to sit on the floor because they fell in the chair the wrong way.

All right, I don't think we're taking a fieldtrip to White Plains.

No, you won't.

Okay, let's talk fashion for a few minutes. Is there a show you'd never miss?

Well, I would never miss shows of my friends. I love the Americans. I love Michael Kors. I love Carolina Herrera. I've always loved her sense of glamour and style. She represents style at its best. She exudes an important thing, which is the word "soigné." She's always soigné. I love Alexander Wang. I was not even going to Alexander Wang shows, and then he got to Balenciaga and this spring he had an extraordinary show. Anna Wintour and I arrived at the same time, so it was interesting to go backstage before the show and see how laser focused he was. I really responded to the clothes. Miuccia Prada, Tom Ford—you can't go wrong. Chanel, Karl Lagerfeld, one of the greatest shows ever, where he made fake art and created a gallery, the mixture of art and fashion. It was extraordinary.

Were you at Marc Jacobs's last show at Vuitton?

Yes. It was a fabulous, beautiful, all-black tribute to his entire career at Vuitton. It was like a hyper-baroque funeral Mass. Not that there was sadness; it was just like what people would have done at the court of Versailles in all black.

And what about any of the other young ones, here? The next guard? I read somewhere you had commented on Bibhu Mohapatra at one point.

Yes, Bibhu Mohapatra I met recently. I love what he does. I think he has great promise, a great sense of sophistication. And it's not always about an evening dress. I like people who don't make evening dresses, as well. I think if you can put together a look of fabulous khaki trousers and a white shirt, which is a very standard American uniform, you are doing a very good thing. I was just looking at Alber Elbaz. He had the most amazing white shirt and long skirt with a slit up the side. That's what an American woman of style, like C.Z. Guest, would have been drawn to if she were here.

What's your greatest extravagance?

Porthault sheets. After Hermès, Porthault sheets. I stopped Hermès, I paid the bill. Now I go to Porthault and buy sheets that I never use. I hoard them. But I go to the annual sales. It comes from my childhood. Sheets were the luxury. I run into Porthault and I bought a pair of sheets a year ago. And then the sheets were on sale, and I said, "Well, can't you give me my money back?" And they said, "No we can't." I have these sheets that I bought in 1989, the year my grandmother died, and they're red. They're just like sheets Mrs. Vreeland had. So I bought the sheets for three thousand dollars. Three thousand dollars for sheets? Am I crazy? Yes, I am. So I have the sheets and I don't use them, except at Christmas, for years and years and years. And then suddenly I thought, I'm going to be sixty-five. I need to use these sheets.

You better start using them.

So I started using these sheets on a regular basis. And they sort of wore out at the end.

Is there anything on your bucket list?

What's a bucket list?

What you still want to do that you haven't done yet.

And it's in the bucket?

Well, that's the expression. Anything you want to do—skydive or waterskiing. Something crazy.

I've always been drawn to the art of horseback riding. Maybe that is a fantasy, because I'm afraid I'll fall and break my neck. I used to get dressed up to go follow the hunt in England, but I would be in the car, beautifully dressed.

But that's great clothing.

I just want to keep sharing my vision of style and making people feel wonderful and special. That's all I can ask for in life. And I don't want to do anything except continue to just grow and learn. I mean, you cannot be anyone without reading and having curiosity and enthusiasm for human beings.

Well, you've certainly proved that tonight. [APPLAUSE] There are many questions here, so let's go through a couple of them very quickly. If you could wear one color, or one designer for a year, what would it be, and why?

Tom Ford. Because if you are not sexy, you are going to feel sexy in them.

How do you recognize a young talented editor, one you feel will thrive in the industry?

That's a difficult, good question. I would recognize a good, young editor if they had a fabulous upbringing. If they approached their work with manners, with courtesy and politeness, if they did not act as if they knew everything there was to know already. Young people today act as if they already have arrived, when they haven't. They think they know everything, and they know nothing. So first, they need to know how to speak to people who perhaps have had a little bit more experience. When I was working with the great Diana Vreeland, I didn't open my mouth until I was spoken to. I did not go in saying, "Oh do this, do that." I cannot stand the way young people think today. They think they have nothing to learn. I also think that manners can get you so far in life. The way you speak to someone, the approach to how you comport yourself in front of people, women in front of men, people who are in a station in their life that's bigger than whatever you are, it's important to respect that.

What is the biggest misconception about Anna?

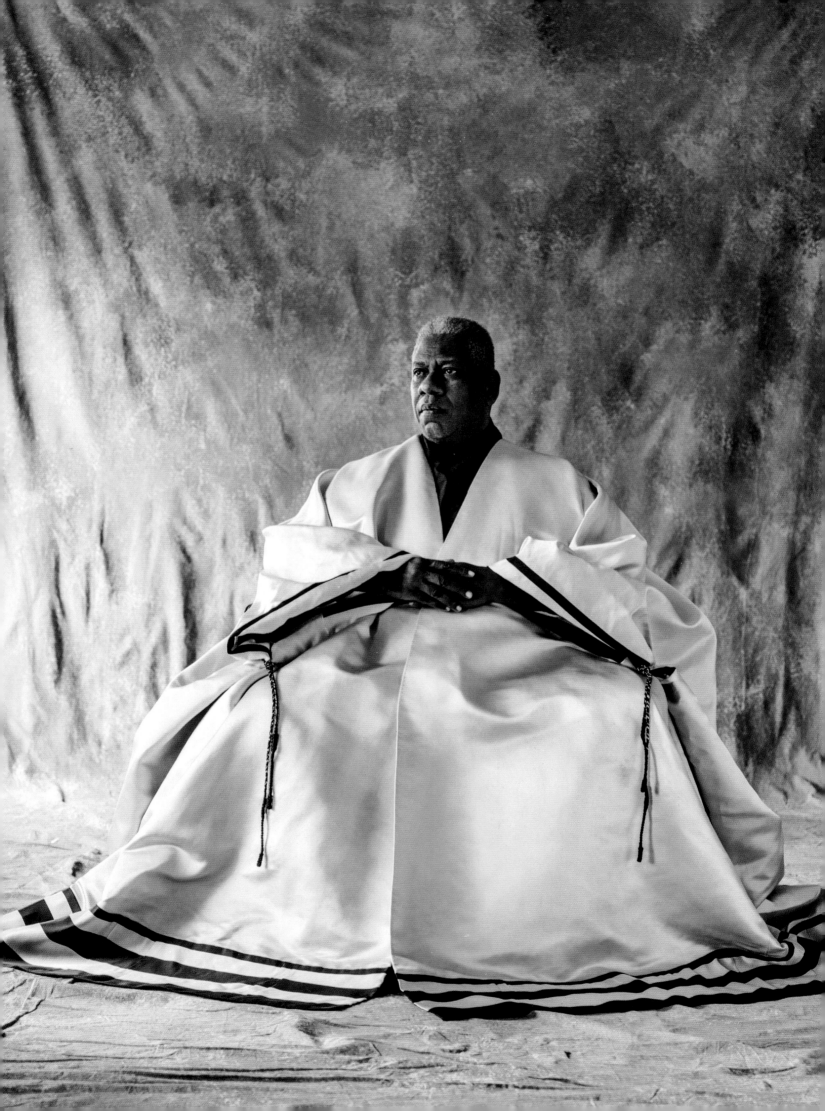

That she is a cold person. She is not a cold person, she is a guarded person. But she's very warm in her relationships to people whom she's known for a long time. And I do think she's very shy. Pathologically shy.

There are quite a few avenues for young designers but far fewer for fashion photographers. As an editor, what advice do you have for photographers?

I would say, intern with a photographer. Just go in and work with a photographer. If you are in the presence of a photographer and you've got any sort of intelligence, you'll learn something. The way I learned with Mrs. Vreeland—just intern with experts.

Do you have a favorite *Vogue* cover?

Yes, the one of Michelle Obama, the first one.

Great. What idea has inspired you in life? An idea, a quote, a notion?

Well, that's a very good question. I had an extraordinary uncle. He was my uncle who was married to my grandmother's sister. And Uncle George made the best ice cream on the back porch. There was such myth about Uncle George because he would go hunting at five o'clock in the morning and come back with what was called luxury food: possum, coon meat, squirrel. Possum was a delicacy that I never ate, but for his generation, this was a great thing to have possum meat. Uncle George was perhaps the most important deacon in our church. One day they were honoring him. I must have been nine or ten. And he got up and made this speech, and he said, "No matter how high I go in life, I will always look up to Thee". And that has stayed with me, no matter how far I go in life. I always look up to God and say that "on Christ, the solid rock, I stand, all other ground is sinking sand," which is a favorite, favorite hymn of mine. And I remember that I used to sit with my father in church in D.C. and they would sing this song. He loved that song. So those are the things that have inspired me from my family. Also my grandmother and Mrs. Vreeland. I was just reading today a memo from Mrs. Vreeland to Consuela Crespi, who was the editor of *Vogue* in Rome, during her reign. How she talks about a pair of boots, it's literature.

When did you decide to wear caftans? How many do you have?

Oh, I have hundreds. I decided to wear caftans when I realized that North African men can look fabulous. You know, if you go to North Africa in Marrakech, men are dressed in things like this. I've been ordering a lot of caftans from Ralph Rucci. Once Marc Jacobs went to the Met in a lace dress, and I decided, if Marc Jacobs can wear a lace dress, I can wear caftans or anything I want any time of the day.

Let's make this the last question. What advice would you give a young black man confronting racism in the fashion industry?

I would say that he has to take a stand, make it known, go to the press in a very intelligent way. There's a young man, a very fabulous creative editor of *W*, Edward Enninful, who last season was not placed on the front row at a fashion show in Paris, and he somehow let it be known through the powers of the media. And this was a very strong move and it was done in an intelligent way. Because he said, "Why shouldn't I be treated like all the other important editors?" So you have to make people aware that they may not be racist, but they're doing racist acts.

Thank you all for coming and thank you, André.

Thank you for having me. I'm so thrilled to have been here with you. Thank you so much.
[APPLAUSE]

BRUCE WEBER

I've shared this stage with some of America's most iconic designers and personalities. When you think about those designers—what it is about the ones who leave a lasting impression—it's primarily because of the photographs and the ads and the commercials. It's the image that remains, not necessarily the clothes—or in some cases the lack of clothes. God forbid there's a fire in your house, what do you grab? After the kids and pets, it's the pictures, not the clothes. Creating a lasting image and identity in fashion is as much the work of Bruce Weber as it is of Calvin Klein, Ralph Lauren, and Abercrombie & Fitch. Tonight's guest has said, "I like to start out each day from the beginning. I am always learning things." And so are we, just from absorbing his images and watching his films. Bruce has said photography is a way for a shy person to find himself. Well, Bruce Weber has found himself, traveling all over the world, working with every major supermodel or discovering the newest ones, working with every great editor, stylist, art director, designer, and publication. He has photographed everyone from Nelson Mandela, Archbishop Desmond Tutu, and Georgia O'Keeffe to his friends, Elizabeth Taylor, Michael Jackson, C.Z. Guest, and even Kim Kardashian. An art critic has said the photography of men is sharply divided into two periods: before Bruce Weber and after. And his long-time friend and collaborator Vogue editor Grace Coddington has written that Bruce Weber's pictures and his life are one. His photographs are all about relationships, and the people he works with become his extended family. His clients and friends list is too prolific to recite. He's had numerous exhibitions, including a show at the Victoria and Albert Museum in London, many top galleries, and the Whitney [Biennial]. He has published fifteen books, and now has his own publishing company, Little Bear Press. He's directed six full-length feature documentaries, one with an Academy Award nomination, and made more than one hundred short films. He has six gorgeous dogs, who, like lucky grandparents, just left to spend the winter in Miami. Bruce is a photographer who just likes taking pictures, not being noticed or seen or heard. We are very lucky tonight for the rare chance to hear from him about his extraordinary life and career.

FERN MALLIS: Okay, I'm going to start off first with the bandanas. When did you start wearing a bandana on your head and why?

BRUCE WEBER: A lot of people wonder about that, but they're afraid to ask. So I'm glad you did. I was with Grace Coddington on our first trip together in Australia, in the outback. And it was just so hot. So I started putting the bandana in water and just putting it on my head. And I got used to it and liked it. And then as I got older and my hair started going, I thought, oh, I'll just use this bandana. I have a hard time in Paris sometimes, because certain restaurants are quite stuck-up and they'll say, "You can't have that bandana on." And I say, "It's part of my religion."

So do you have a drawer full of them?

People give them to me all the time. I have so many I don't know what to do with them.

So [your wife], Nan, is the only person who really sees your head?

No, no. I go swimming.

You were born on March 29, 1946, in Greensburg, Pennsylvania. How old do you feel?

Like about eighteen going on nineteen.

Perfect age. And your astrological sign is Aries, like me. Do you believe in horoscopes?

Completely.

Aries are eager, dynamic, competitive, quick, and easy to get along with.

I don't know about that. Don't ask any of the people in the audience I've worked with.

Aries makes an incredible number of connections in a lifetime. They are independent and ambitious. Leaders of the zodiac—it's the first sign. They start everything, but they don't necessarily finish. Do you agree with any of that?

I'd say a lot of that's really true. As a young person, I just really wanted it. This is kind of embarrassing to say. It's not like I wanted to be successful, or I wanted to have a lot of money. I wanted to express myself. I wanted to be proud of myself. I was quite young and my mom was really sick with cancer, and I went and spent time with her, away from all my friends, when I first got to New York and NYU film school. And when she passed away I was so proud that I was there for her, like I was for my dad when he was sick. That's something nobody can take away from me. And so, when I do photographs and people say they don't like them, maybe I cry or flip out and take a long walk, but it doesn't damage me.

It doesn't? Good. We're going to go back to that childhood now. In Greensburg, Pennsylvania. What was your house like when you were growing up?

It was really beautiful. We lived on the edge of a farm with so many animals there. My mom and my dad were really good-looking—

Very handsome. Alvin and Ruth.

She loved clothes.

How did they meet?

That's a wild story. She was engaged to somebody else. And she met my dad and she went crazy and loved him. When I was at the Whitney [Biennial], I had a letter on the wall that my dad wrote to my grandparents—her mom and dad—that was so sexual and so physical about the way my mother looked when she was taking a bath and how she would get dressed, and I was like, should I put this up? I just love the freedom of it and the romance of it. My parents were very physical with each other and with [other] people, and I always loved that about them.

Your mother had several boyfriends while she was married, and your father also seemed to have a few affairs along the way.

I've been talking about it in my Mitchum film, how my mom would pick me up after school, take me to a bar, and I'd sit there and all these guys would help me with my homework while my mom was talking to her boyfriend. I got sophisticated pretty quickly.

I'll say. And your sister, Barbara? Older or younger? Close?

Four years older. We were really tight. We'd come home from school sometimes—when I wasn't at the bar—and we would listen to show tunes and we knew all the songs of Rodgers and Hammerstein. My sister was in the music business. She worked with David Bowie and Iggy Pop.

I read she took you to your first rock concert and left you there. That's not the kind of thing a big sister does.

Left to right: Bruce Weber, c. 1950s; Bruce Weber, c. 1950s

Yeah, it was crazy. In a way I think she wanted to push me into that swimming pool and see if I could survive. And I did.

Your maternal grandparents lived next door. Every designer I've spoken to on this stage has had a very significant relationship with his or her grandmother. Were you close to yours?

So close. Every Sunday back home, the whole family—this very dysfunctional, wacky family—would get together. My sister was at Catholic school, we were Jewish.

Oh, wait. Go back. You were a Jewish family, and your sister went to Catholic school?

You know how a lot of Jewish families like my parents would invite the rabbi over on Christmas Eve, and I'd go, "Mom and Dad, the Christmas tree's right there." Anyway, she was at Catholic school and I was left at home and the [maid] would make me grilled cheese sandwiches and then she would fall asleep. And then I was up all night listening to Alison Steele on the radio, "The Nightbird," and, that's how I got into music and everything.

I read that your grandparents had a Sunday peace treaty, when nobody would fight on Sundays, and that's when they'd take pictures.

We'd take pictures, we'd make films, we'd go to painting class to learn how to watercolor. And it was pretty magical.

Did you grow up associating taking pictures with that happy day of the week?

Completely. A real bit of peace.

Who had the camera in the family? Who took the pictures?

My dad and my grandmother and my uncle.

Did you know then that it was something you wanted to do?

I saw how my dad was having so much fun. I just want to say, it's not so serious taking pictures. It's fun. And I hope that my pictures explore that a little bit. I sometimes see older photographers and they can't carry their equipment anymore. It makes me really sad. But one thing you have to realize, Ansel Adams didn't climb all those mountains alone; he had people there to help him.

Early on, your dad and your uncle gave you a very important lesson on the facts of life. Can you tell us what they taught you?

Well, I made a film about it. Sometimes I wish I hadn't because I showed this film, *Backyard Movie*, at the New York Film Festival with my friend Gus Van Sant's film *My Own Private Idaho*. And in it, my dad and my uncle were talking to me about sex and trying to teach me about sex, and I had a guy flying in the air on a trampoline, nude, with my dog, and I looked down at the end of [the film] and there were all my relatives in the audience. And they were looking at me like, "Who are you? We don't know you." And yet, they liked that the people applauded. And they liked the film. And for once they really accepted me.

Was that the first time you've really felt that from them?

Definitely. I was like this weird, skinny kid.

You looked like a pretty handsome kid in pictures.

Oh, thanks, [Fern]. I appreciate that, thanks. It's a part of my life.

Look at that kid up there.

Oh God.

Don't make that face… You picked that picture.

I know I did. But I think I picked it because I—this will come as a surprise to people—but I really like the geekiness in people. And I find that really attractive. That's why I picked it.

Growing up, your dogs were Charlie the schnauzer and [Malvo] the poodle.

Right.

So those were your first dogs. Did you take care of them?

Yeah. They slept with me. My parents were great with animals. And my grandmother was so close to our dogs. And she was a wonderful painter. She played the piano. One moment, it was completely a wonderful, easy life. And the next minute my parents were fighting, my sister was having wild parties, almost burning down the house. And I was always getting in trouble for what she did.

Sounds like most families. You attended boarding school, the Hun School of Princeton. Were you a good student?

Not particularly. But I was so happy to be able to go to a safe place, where I could really sleep through the night. And something happened to me when I first walked into my room. I had a roommate. His name was [Andy Yarrow], and I ended up loving this kid. His family started Radio Free Europe. He was a real New York City kid, really suave in character. But he walked in carrying a life-size cutout of Elizabeth Taylor from *Suddenly, Last Summer* in a white see-through bathing suit. And one night she would sleep with him, and one night she would sleep with me. [LAUGHTER]

So what were your interests in school? Reading, sports, film?

I was interested in reading books. I had an incredibly handsome English teacher from Princeton. He drove a beat-up old sports car. And he got us to read James Baldwin and other literature like that. And we'd hide those books in *The Scarlet Letter* and things like that we were supposed to read. Mr. Irving was really amazing. He really turned us on to other kinds of literature that maybe we shouldn't have been reading at that time. But it was wild. It really opened my life.

When you graduated in 1964, you moved to Ohio to go to Denison [University] and study theater. Why theater, if you were so shy?

When you're young, you think you can do anything, and I thought maybe I should try to be an actor because I'm no good at anything else. And then I realized that I wanted to take

pictures, in the middle of all that. And I had a wonderful teacher there, Dr. Wright. I was always really depressed. I was in a jock house where everybody played lacrosse, and I felt nobody understood me. But I did have the most handsome guy in school as my roommate. And he built his own motorcycle. We would drive out on the weekends to the country and I'd take my little Argus Instamatic and I'd take pictures of him. And I'd go to the drug store, get them developed, and I'd go, wow, this is what photography is like. It's pretty special.

That gave you the urge to move to New York, halfway through school?

Yeah, to go to NYU film school.

Did you graduate?

No, I had that itch to go to Paris. And I went to Paris.

Before Paris, where did you live in New York?

The first time I lived in New York—I sound like a spoiled brat—I lived on East 75th Street in a tiny little house. That's where I met Maury Hopson. He used to come over and cut my hair—I had hair then—and I'd say, "Maury, can't you make me look like Warren Beatty in *Splendor in the Grass*?" And he would just hug me and continue cutting my hair.

But if anybody could, Maury could.

Exactly.

You started to work as a model when you needed money. Was it the Stewart Agency?

That's correct. You know more about me than I do.

You said that Roddy McDowall was your friend at school and he took some of the first photos and headshots of you.

Yeah, I met Roddy through a mutual friend, Stephen Sondheim. I was always interested in older people.

With your mutual friend Stephen Sondheim. How can you just drop that?

Well, I don't mean to just sound like that. I met him through friends of my parents. And I just adored Steve. He used to invite me to all the shows when they opened. And one time, something weird happened. It was an opening night. I believe it was *Follies*—no, maybe *Company*. I went to his house for a party. I wanted to give Steve a gift. So I wrote a little story about Steve and all his friends who were jealous of him and how they were always trying to mess him up. He said that night at dinner to all these Broadway people, "I got the best gift today and I want to read it to you." And he read the story. It was pretty wild.

You said you were really shy, and the camera was like a handshake or a hug. But if you were shy taking pictures, how did you have the courage to be a model?

I figured that I was going to start my own school. I thought that it would be really nice to meet all these photographers that I really admired. So I'd be there helping them, like holding the reflector or holding their cameras while they were changing a lens. And so I got to know all these photographers—Melvin Sokolsky, Saul Leiter, Dick Avedon—though I never did that so much with Dick. I just loved being around that whole thing.

As a model you worked with Art Kane doing Arrow shirt ads?

Yeah.

You said you were a terrible model. You were always late.

I was worse than Naomi Campbell. I was always late. We didn't have cell phones then. But my head wasn't into modeling. I wanted to be on the other side [of the camera].

Do you tolerate models who are late for your shoots?

Oh sure. Yeah.

You were photographed by legendary photographers Richard Avedon, [Francesco] Scavullo, Art Kane, Jerry Schatzberg, and Saul Leiter. What did you learn from them?

I learned that even when they had to do a picture they didn't believe in, they were going to make something beautiful. And I also learned that they really wanted to have a good time. The ambience of their studio was like a painter's studio or sculptor's studio or a writer's room. You really felt the presence of them. Not because they had pictures of themselves on the wall, but their personalities were so big.

What prompted you in 1966 to show your work? And what was the work that you showed to Avedon? And what did he say?

I showed him some photographs I had taken up in Maine over the summer. At the same time, I met Diane Arbus. I had just gotten back from Florida and I was really poor. I didn't have a job. I had stopped going to school. But I had an old camel-hair overcoat from boarding school. And I was tan because I had visited my family in Florida. So I saw Diane sitting at this little restaurant in the Village, and I said to her, "Excuse me, Ms. Arbus, I really love your photographs." And she said, "Do you want to take photographs like me?" I said, "No." She said, "Good, sit down. But are you very rich?" And I go, "Why would you say that?" She said, "Well, you're tan, you have this beautiful coat on." I said, "I barely have enough money for the coffee and doughnut that I had." And we became good friends and she would call me at three, four in the morning and she'd be throwing away her negatives and very emotional. The last time I saw her, we were up near where Halston used to be, on Madison, and she couldn't cross the street. I went across the street and said, "Diane, come here. I'll help you. I'll walk with you for a while." And we walked. And she turned to me and said, "You know, I did these pictures of Mae West because I always loved her for *Show* magazine. And she called me the other day and she said a baby would look terrible in that light. I just can't keep going on." I really love Diane's pictures and I find they're extraordinarily romantic. She became so involved with so many of the people that she met—the Jewish Giant, the little kid in the park with the grenades—they became so close to her.

Both she and Richard Avedon told you to work with Lisette Model, a Hungarian photographer, at the New School. What did she teach you?

It was a hard class to get into. And she had done some extraordinary photographs with [Alexey] Brodovitch when he was at *Bazaar*. She had photographed a very heavy woman out in Coney Island, like a bathing beauty out on the beach. And I thought the pictures were extraordinary. Before she came to America she did some amazing photographs of all the Nazis in Switzerland. You see the coldness and the deadness in their eyes. Her husband was a painter and had ribbons all over his clothes, and she was just this totally amazing lady. After class, we would go to Howard Johnson's in the Village. I'd sit at the counter with her and we'd just talk about photography. I was so in love with her, and with all the drag queens and all the druggies. It was really great.

Did you have the fried clam strips at Howard Johnson's?

No, because I don't eat fish. [LAUGHING]

A few years later, you went to Scavullo and met Nan Bush, who would become your wife. She was his agent. Tell us about that meeting.

I don't think Nan liked me too much at first. She probably thought I was just another model

showing his book. She went through my book really fast. But we got to be close when she worked with a friend of mine, a photographer, Bill Connors.

He shot a lot for *Glamour*.

Yeah. And did these beautiful pictures with Cheryl Tiegs, incredible spreads of girls in California. Bill was going off to Paris to work for French *Vogue*, and Nan and I got real close; we decided to go to Martha's Vineyard for the summer and we lived in a barn and we had one dog. We'd lie in bed and you could see cows really close to us, and it was pretty great.

So that was the beginning of a long-term love affair with Nan?

Yeah. The amazing thing about Nan was that not only did she believe in me as a person, she believed in my photographs and what I wanted to say. I wasn't used to having so much confidence from people. One day she was sick, and so instead of Nan taking my portfolio, I took it. We used to take these big portfolio cases. Most young photographers now would never do that. They have it on an iPad or something. I carried it into this art director's room. I had some really nice pictures of Patti Hansen and Lisa Taylor, topless [and] swimming in the ocean with the waves crashing, and they said, "Oh, that's a really great studio shot." And now I knew what Nan was up against, having to take somebody's work to people who couldn't really see. Photographers are always dealing with that.

In 1973 you had an interlude in Paris. Was that your first trip to Paris?

No, no. I'd been there with a trip with some kids from school. I was there for almost a year. It was a really hard time. I was trying to work. I was really poor. It was near Christmas and there was a little bit of snow on the ground, and I went to the post office to call my family to ask if I could get like two hundred dollars. And they hung up on me. And I thought, I'm never going to ask anybody for anything again. And I didn't.

Did you take lots of pictures when you were there?

Yes, I did.

Did you learn French?

A little bit. You had to or you wouldn't be able to get dinner.

So then you returned to New York and landed your first group show at the Floating Foundation of Photography. Do you remember your work in that show?

I had a wonderful time photographing all the kids who were the losers of the Mr. America and Miss Teenage America contests. They were all bodybuilders and I took pictures of them with their families. There was all this pride. It was really fun.

Then you landed your first solo show at the Razor Gallery. That was the year that Nan became your agent.

Right, that's right. How'd you find all this stuff out? I didn't even know it.

Okay, and with her involvement, you began getting editorial jobs with *Glamour* and *GQ*. Was that the beginning of your friendship with *GQ*'s Donald Sterzin? You described him, I read, as the "bodyguard of good taste." I love that description.

Donald was like a brother to me. He almost lived with Nan and me. And he was a really great picture editor as well as a great art director. I learned a lot from him. A lot of people in this audience knew him and loved him. He and Sandy Carlson, we all worked with Ralph [Lauren], and it was such a family kind of situation.

And then you did your breakthrough photo with a water polo player from Pepperdine University named Jeff Aquilon.

Page 328: Bruce Weber, c. 1960s, by Larry Rivers. This page: Nan Bush in Thailand, 1996, by Bruce Weber. Pages 334–35: Waikiki, Hawaii, 1982

Well, that was thanks to Annie Flanders at *Details*. I said, "Annie, I met this guy out in California and he had a Band-Aid on his nose. He was really good-looking." She said, "Let's try to fly him in." She said, "I don't have any money, but let me see if I can borrow some." And Annie borrowed some money, and Kezia Keeble, Paul Cavaco, and I got to the studio, where we were doing a campaign for Valentino. And a lot of the guys we had on the job had these really tough-looking faces. And Giancarlo [Giammetti] walked into the studio and Valentino, and they said, "Who are these people? This is terrible." And—Kezia was so good at selling a photograph and a job—she said, "It's the prison look."

She made it a trend.

She [said], "Everybody's doing it. It's going to be the newest thing." That's when we first photographed Jeff and Calvin saw the pictures we used them.

Describe that picture. He was apparently leaning back with his hands in his boxer shorts and caused quite an uproar.

Well, truthfully, he was so sleepy he didn't know what he was doing, and we only had two hours to do all the pictures.

That led to you being hired by *Vogue*, the same year, to shoot the American designer collections of Polo by Ralph Lauren, Calvin Klein, and Brooks Brothers for *Vogue*'s men's section. Were you concerned that you were going to get pigeonholed doing men's work?

No. I was really happy just to be working. I was lucky. I'm a Jewish kid, but I had the luck of the Irish, because I always had great friends who were great in pictures. Because models wouldn't come downtown when I first started, down in Little Italy. So I just had great friends, and I used them in my pictures. That's where I met Buzzy Kerbox, a wonderful surfer I photographed for Ralph, and so many people.

Tell us about the *L'Uomo Vogue* shoot with the portfolio of soldiers, sailors, and Marines in Honolulu drinking and misbehaving.

[LAUGHING] I was in Hawaii. I used to go there all the time. When I was a young kid I wanted to move there. I went to Waikiki [and] I met all these different guys in the Coast Guard, the Marines, the Navy, the Air Force. I didn't know that they all didn't get along. And

there was a street called Hotel Street then, where all the tattoo parlors and the whorehouses [were], and I loved photographing on that street. Barbara Dente was the editor. We were working for L'Uomo Vogue, and we got there and they were almost in fistfights. But they ended up being really great, and we even got them back to our room and they were all in boxer underwear, sitting around watching TV.

Then came the famous Calvin Klein underwear shoot in Santorini [with] Tom Hintnaus, an Olympic pole-vaulter from Brazil, which became a huge billboard in Times Square, one of the ten pictures that changed America according to American Photographer magazine. How did that picture come about?

We were in Santorini, photographing on top of this roof: me, Calvin, Tom, my assistant Dick Nystrom, and the hairdresser, Howard Fugler. And Calvin said, "Who's that little girl?" I said, "Calvin, I can't ask her to leave, her parents own this building." She had braids and glasses, and she'd say, "I think [the model] looks good standing over there." All of a sudden she was like the art director. She had a lot of good ideas. And I thought, I better start listening to this girl. I didn't really take that picture, that girl took that picture, that little kid. I really hope to run into her again someday. She's probably all grown-up, it's [such] a long time ago. But I thought that was pretty great.

Describe a typical casting call for a shoot. Do you call agents or friends and say, "Send me all the good-looking guys with the great bodies"?

I don't know if having a good body is so important.

Looks like it's important.

It would be really nice for somebody to say, "I'd like to take my shirt off, but I'm not in really great shape." And then we'd usually book them anyway, because we like them. And they have a lot of some kind of soul about them. I don't want all that perfection in my pictures. And the older I get, I want less and less.

But why do we all in this audience think that there's a photo shoot where all these people come in and you ask them all to get undressed?

I don't. I think they really want to. [LAUGHTER] One time we were working for Calvin and we got to the shoot and the clothes hadn't arrived, and we had no clothes to photograph. We were out in Santa Barbara at this really beautiful estate, and all the guys and girls went swimming, they were on a trampoline, they were playing tennis. My sister was doing the production. And she said, "Bruce, these kids have got to put some clothes on for lunch." After those two days, I couldn't photograph a nude person for about a month. [LAUGHTER] I was really over it.

About a month?

Yeah, about a month. [LAUGHTER] You said you want to know what casting is like. You just never know when you're going to meet somebody. What I always loved about working for Ralph and some other people is that on our way to the shooting, we would see somebody, like in a field or down the road and say, "Hey, what are you doing? Come with us." And that person would turn out to be really amazing. That's the way we really like to cast. It's not always with an agency. Sometimes somebody will come on our assignment and they'll meet a girl on it and they'll fall in love with her, and she'll just blossom. That's a great thing I learned from Julie Britt. She always thought of taking the person that nobody likes and really making her the star of the shoot. I like that challenge, that conquest.

We were talking backstage about Tom Moore, who was the husband of *Mademoiselle*'s fashion editor Nonnie Moore. He wound up in many of your shoots.

Oh yeah, all the time with Ralph.

We're just up to Ralph Lauren, who's here with us tonight, which we're thrilled about. Tell us about how you began working with him.

He hadn't seen my portfolio. I didn't meet him in a boardroom. I met him at his house in East Hampton. I was doing a family photograph. Ralph dressed everybody. Ricky and the kids did the hair. We talked about cars and all the kinds of things we liked. That day turned into a thirty-five-year relationship. I'm really proud of it because I'm proud of the people who work there and I'm proud of Ralph and his generosity in helping so many people. Ralph was really one of the first designers in the fashion business who got behind charities like AIDS.

And I was privileged to work with him raising millions of dollars for breast cancer when I was at CFDA.

It's funny talking about him and knowing he's here. He knows me pretty well. We've had so many good times. And I just want to say one thing: one of the best things to do with him is to go antique clothing shopping. Nan and I will be looking at something, and Ralph will just go and get the most perfect jacket. And we'd be so jealous, then Buffy [Birrittella] would find one better. It used to drive me crazy.

When you were working at Ralph, you worked with children a lot. You were quoted as saying you'd photograph them at ten years old, then in their twenties, and then when they were thirty-year-olds, and that they have become family to you. And you were working with Sandy Carlson a lot, who was creative director there. Tell us some of your more memorable campaigns working with Ralph Lauren.

When he was doing the safari campaign, instead of going to Africa, we went to the big island of Hawaii and we were on Kona. It was really incredible, but we brought all the wild animals over.

You brought all the animals over from where?

From Africa.

From Africa to Hawaii?

Africa and Los Angeles, yeah.

That was not an inexpensive shoot.

No. But it was worth it because we had zebras and lions and lion cubs and all kinds of animals. It was amazing on that trip because Chris Lawrence, this guy who used to do production, persuaded the government to let us bring the animals over.

Oh my.

And it was really unbelievable.

How many people put that campaign together?

I'd say maybe thirty, thirty-five. That's small now.

That's small now?

Yeah. Yeah.

We're in the wrong business. I'm still processing that in my brain, bringing all the animals to Hawaii. Okay, in 1987, you filmed the documentary *Broken Noses* and did a book about boxer Andy Minsker. Were you a boxing fan?

I really never boxed myself, and I was kind of a wimp and I liked the idea of that boxing world. I like to go into worlds I'm not really too comfortable with. And I adored Andy. He was

part [Chet] Baker, part Jack Palance, and he always said really funny things.

At a screening [of that film] you invited only your immediate family and close friends, and you said that that was a major mistake.

Don't ever invite your friends and your family to your film when it's not finished. It's a nightmare. Jeff Price, my cameraman, was in tears. All our relatives were talking about how terrible the film was and what was wrong with it. We should've asked a lot of enemies [to come]. We'd have been better off.

The following year you released the documentary about jazz trumpet player Chet Baker, *Let's Get Lost*, which was nominated for an Oscar. How did that feel?

I was working for Gianni Versace that day when I found out, and Nan called me and said, "You're not going to believe this." And I had to sit down because I was happy, but really sad because Chet wasn't alive then to share it with us.

How soon after making the movie did he pass away?

Probably about three months.

Wow. Then after that you directed some of the legendary black-and-white campaigns for Calvin Klein's Eternity with Christy Turlington, doing Versace with Linda Evangelista. Any special stories about those women and those campaigns?

When we'd work for Gianni, Donatella is incredibly generous. During the whole shooting, they would talk about the party we were going to have. Once we had a Hawaiian luau. They flew in all the food from Hawaii. They had a punk rock band from New York come down when we were in Florida. They gave the best parties. Gianni was a really complex person, but extraordinarily talented. I really miss him. And he loved to argue—like a lot of Italian people, right? They're very dramatic. The last time I saw him, he just wanted to argue with me. And I said, "Man, I am not going to argue with this guy. I am just not in the mood." And I didn't. And he opened the window of his office and he said, "Look at the tree out there. Look how beautiful." And it was a tree that flowered with the most beautiful pink flowers. And we hugged, kissed, and I left, and that was the last time I ever saw him alive.

Then you started working a great deal with Grace Coddington. Can you share some stories of working with her, like in Australia or in Bellport, [when] you did the homage to legendary photographer Edward Weston?

Grace and I had a lot of fun doing trips, and we still talk about doing a sitting. Just the other night we were talking—she loves redheads, and I do, too—and we said, "Let's do a redhead sitting again." Once we did a dog wedding for *Vogue*, and Grace and I were so enthusiastic about it that we forgot to think about whether the groom was a guy and the bride was a girl. [It turned out] they were the opposite. To this day, Anna [Wintour] doesn't know that. She'll probably make us take the pictures again.

Might have been a same-sex marriage, for all you know.

That would've been really fantastic.

How did you pull off a dog wedding shoot?

Only Grace could. All the people, the owners, were like that Visconti film: "Oh no, our dog doesn't want to wear that hat. Our dog doesn't want to do this and that." And Grace got all the designers to make things like really wonderful hats. I had an extraordinary dog then, called Blue, and I just loved him. He had so much soul. And I thought, what character am I going to make him at this wedding? I said, "I know, he's going to be the wedding

This page, clockwise from top right: Bruce Hulse and Talisa Soto, "Under Weston Eyes," *British Vogue*, Bellport, New York, 1982; Andy Minsker with the Mt. Scott Boxing Club filming *Broken Noses*, Portland, Oregon, 1986; Andy Minsker filming *Let's Get Lost*, Cannes, 1987; Christy Turlington in Calvin Klein Eternity campaign, Santa Barbara, California, 1991. Following spread: Chet Baker filming *Let's Get Lost*, Santa Monica, California, 1986

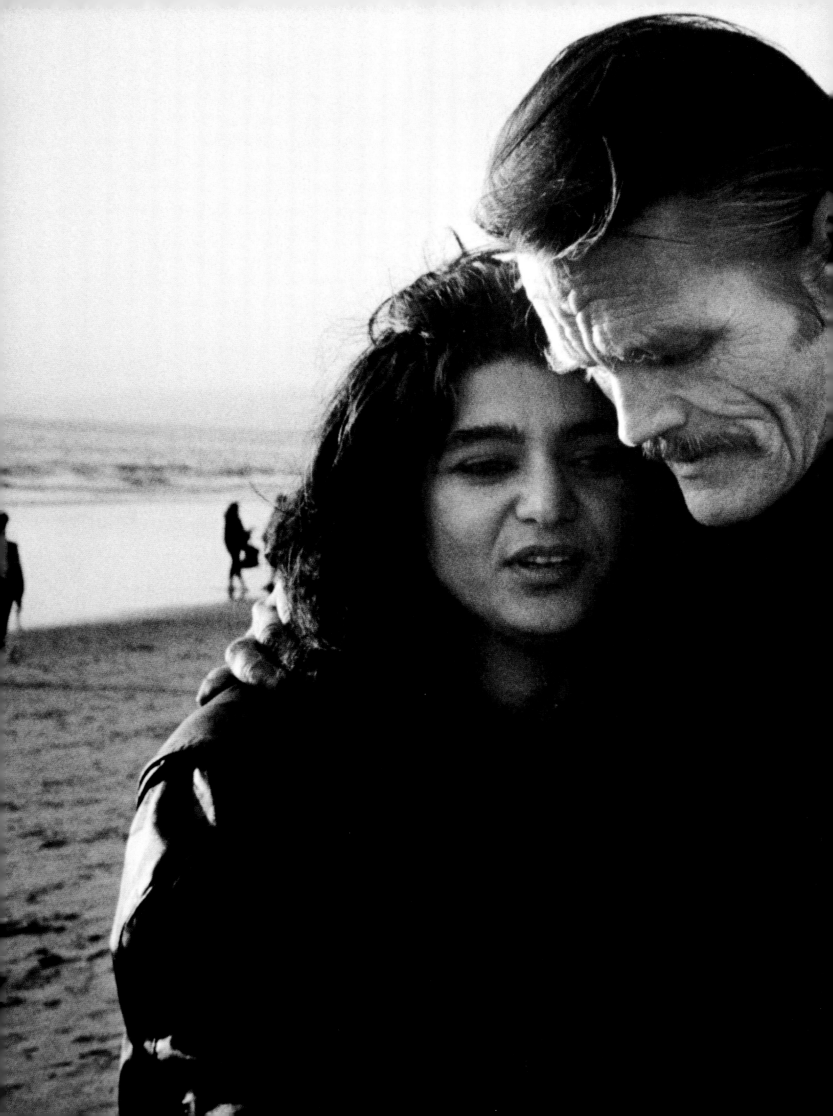

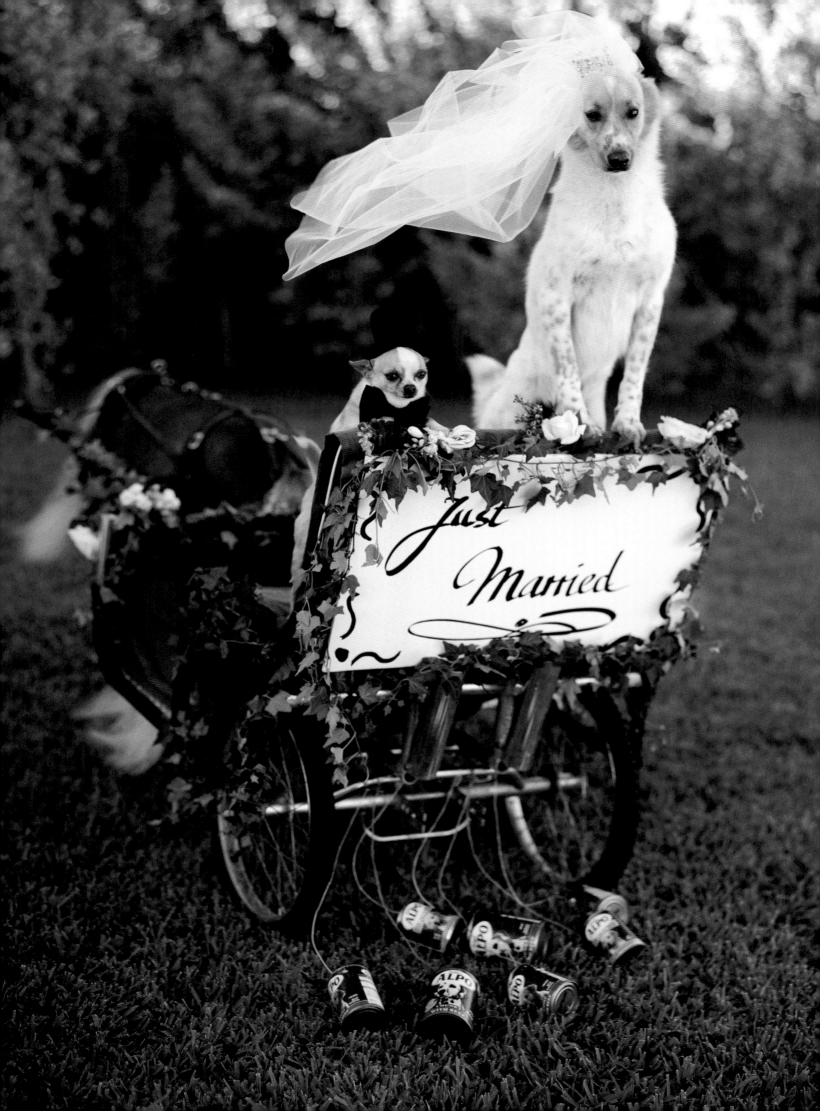

photographer." So he had the camera around his neck and a little hat that read, "Press."

What a sweet story. So tell us about Bear Pond, the place and the book.

It's really great. I had two goldens at that time, and I wanted to make a record of this moment in their life. Nan and I really wanted to make this book for the AIDS Resource Center in New York City. These guys don't have clothes on. The people in the Adirondacks were kind of horrified. I'm really proud of it, I'm really proud of those guys—all friends of mine, people I knew. We had the exhibition at the Robert Miller Gallery, and most of those guys brought their mothers to the exhibition. A lot of their mothers came over to me and said, "Thank you for taking that picture of my son. I always want to remember him like that."

And you also raised a lot of money. Let's talk about Elizabeth Taylor, who became an important friend. How did that happen? I also want to talk about the White Diamonds campaign. Because I read a delightful story in the *Los Angeles Times* by an old pal of mine and a good friend of yours, the producer Howard Rosenman, and the unexpected birthday present you gave him doing that shoot.

It was his birthday, and I called him and said, "What are you doing?" He goes, "Well, I might be going to a birthday party." And I said, "Well, why don't you come to the studio?" He thought there's going to be all these good-looking guys there. I said, "No, Howard. You're going to be in a car and you're going to be Elizabeth Taylor's date." Part of the commercial we were doing for White Diamonds was that she was arriving at a big premiere. It was like something out of *Saturday Night Live*. The driver was an out-of-work actor who was a friend of my sister's. He didn't know how to operate the Rolls-Royce. And Howard kept looking at her. Finally she said to him, "Are you looking at my necklace?" And he said, "No, I'm looking at your breasts." She was so flirtatious and very seductive with guys.

And husbands.

Definitely. When I grew up I was so crazy about her that I used to call the Desert Inn in Las Vegas, where Eddie Fisher was singing, just to talk to her. And so finally I reached her publicist, Mike Hanley, and I said, "My name is Bruce Weber. I'm having my Bar Mitzvah, and I just want to tell her that I really love her." And he laughed and he said, "I can't get her on the phone. She's in the lounge right now listening to Eddie sing and she's with Sammy Davis Jr. and Yul Brynner." I always wanted to tell Elizabeth this, and I never did. But she was the kind of person who never liked to deal with her fame too much. One time for Christmas she rescued a hundred dogs for me, and one night I was sitting on her bed talking to her. I couldn't believe it. I had to slap myself. And her grandson, Quinn, who's a filmmaker—Liza Todd's son, wonderful kid—he was there with us. And [Richard] Burton was playing Hamlet, but she would come out at night and the whole street was all blocked off with thousands of people, just to see her. And Elizabeth was so smart; she wore long white gloves, so when she waved, her hand completely bounced right out of the crowd, and you knew it was Elizabeth Taylor. And she would always say, "Well, you know, I'm used to a big crowd." I think the last years of her life were very, very lonely. I think a lot of people really gave up on her. They gave up on waiting for her. She was fun. She had a good time. And she was flirty. And that's the kind of thing I really miss a lot now with people. When you go and you photograph actors, they're so not flirty at all.

Let's talk about the other Liz with whom you had a great relationship, Liz Tilberis, the editor of *British Vogue* and then *Harper's Bazaar*, before she died of ovarian cancer.

I went to Nebraska [with her] on a trip. I'm really proud of my pictures from that trip. Liz was just about to adopt her first child, Robbie, and she put all that love and that excitement into dressing all the kids in this town of Red Cloud. We both read all these Willa Cather books. Liz had a great street sense, too. One day we were with Grace, and I remember Liz said to me, "Look how gorgeous Grace looks, don't you just hate her?" They were like two wonderful sisters. I have a great picture of Liz. It's a personal picture in a suite at the Ritz. She was drinking champagne in front of her little bar, the tiny little refrigerator. And she was in her bathrobe. She looked like a schoolgirl from England who was on a great trip.

Let's talk about your love of dogs. You have six dogs now. What are their names?

Dream, Tao, Kodiak—after Kodiak Island where they have all the bears in Alaska. River, after River Phoenix, and Hud. And I have a rescue dog called Billie Holiday.

How many dog sitters and handlers do you have to manage them?

Man, I have a lot of people. I don't like to leave them alone too much. They get a lot of acupuncture. They go swimming in the ocean all the time during the winter. Then they go swimming in a pool, then they run around the house and we have to clean up all the couches and everything else. It's a mess, but I like it.

So they have free rein in the house? They all sleep on the beds with you and everything?

Yeah. Finally, as Nan and I are getting older, we only let three dogs sleep with us now instead of all six.

What about cats?

We had a cat called Tyson. He was really the alpha dog of my group, and he was so tough and he wasn't afraid of any of the dogs. They were on their best behavior with him. I love cats and I wish I could have a lot of cats.

You can have anything you want.

I can't really, because in Florida I live very close to the road, and my cats—I let them go outside and their circle gets bigger and bigger.

Tell us about the great story shooting the Kate Moss photograph in Vietnam, looking for an old man with a beard.

As you [might] gather from some of these stories, I'm a bit obsessive. We had this beautiful

John Galliano dress [that] we carried in a crate with us all over Vietnam. And it was the last picture. I said, "Oh, I really want to find one of those older Vietnamese men who had, like, before the war they had those beautiful long beards." And we didn't find one, so we had to go ahead with it. We were in a rice field. And the sun was going down. All the women, Nan, Terry Lawrence—everybody—was unpacking the dress and helping Kate get into it. The train was as long as this stage. And [up] walked this gentleman with a beard, in pajamas the exact same material as the dress, and stood with Kate.

Just walked out of nowhere?

Walked out of nowhere. And it turned out that he was returning home through the fields after kissing his grandchildren goodnight… and that's the incredible thing about being a photographer. So many of these things happen. And I feel like I've been so fortunate and really lucky that they have.

Is Kate one of your favorite models?

I love being with Kate. You can walk down any street and say, "Go stand with that person or talk to them." And she immediately has a relationship with them.

Okay, now we're up to Abercrombie & Fitch. Tell us about the meetings. How did you all brainstorm a campaign to rebrand this company from an old fishing sport company to the hottest brand in the world? Did you all decide that there's this kind of clothing, but we're going to show it all with half the clothes?

I knew you were going to ask me something like this. I learned a good lesson once working with Ralph. I was on a shoot for him and we went to a beautiful white farm out by the sea. And to me this was the kind of farm that Ralph always dreamed of living in and having. And all the people from Ralph Lauren with the clothes came up to me and said, "Bruce, we have ten people waiting to be photographed. You can't just be photographing this farm." And I said, "But this is something that Ralph always wanted to have, and it's right for him." And we brought the pictures back and it was those pictures of the farm that Ralph ran in every single magazine, double pages, single pages. So sometimes you've got to forget about the clothes or even the people. Why does everything have to be so literal? I felt like with Abercrombie & Fitch I first had the great support [and] the camaraderie of Sam Shahid. It

Page 340: The Bride and Groom from "Puppy Love," *Vogue*, 1998. Page 342: Linda Spierings at Karl Lagerfeld's château, Brittany, France, 1984; Elizabeth Taylor featured in the White Diamonds campaign, Los Angeles, 1991. This page: Kate Moss in "Good Morning Vietnam," *Vogue*, Vietnam, 1996

was Sam who really thought about putting pictures on the shopping bags, in the store.

It was a collaborative effort.

It always is. And the incredible thing is—and Sam and I talk about this all the time, and I tell the people at Abercrombie—listen, I'm really happy you have ten million stores, if that's what you want. But what's really great and lasting about Abercrombie is that we take a lot of kids [and] it's their first time in front of a camera, they take acting classes, they have dance classes, we run it like the old sets at MGM. And yet they have a camaraderie and a bond with each other, and they leave there having friends for probably the rest of their lives. And I try to show that in the pictures. It's not so important whether kids have clothes on or not. I think it's important that they have that future.

And that's the Abercrombie future that you hope kids will go in the store and feel that way, about the store.

Sometimes you work for people, and they don't feel the same way you do. But I was so spoiled. I [worked] with people I could call up. I could call Ralph up and say, "Ralph, I met this girl. She's perfect for our pictures." And he would listen and want to see her. I would call Buffy and say, "Buffy, I saw the most handsome guy. You're going to flip out [at] the way he dresses." I would call Calvin and say, "Calvin, I met this guy who was on a diving board at the University of Miami. You've got to meet him." I'd put him on the phone and next week they'd meet, and we were all of a sudden photographing him. There was this incredible connection. It wasn't this corporate attitude. It was like a family business then.

Do you feel that's changed now?

I think it doesn't exist anymore. And everybody you work with says, "Why can't we do that again?" Well, we can, and anybody can, but it was a whole group of people who were very tight and very close and very truthful with each other.

How did you handle the religious right's reaction to Abercrombie, which shut down the catalogue and the book? Did you just brush it off and keep going?

People always say to me, "Oh, that picture's so wild." I don't know, maybe I've had such a crazy life, but I've kept my eyes open. And I've seen a lot of things, [but] I'd rather see something beautiful about a person's feelings or sexual feelings than all this violence. So I didn't have a problem with it.

That I agree with. How did you convince the American Ballet Theatre's principal dancer, an Italian, Roberto Bolle, who's very shy, to dance and prance around nude for your book *An Athlete in Tights*?

That's a good question, Fern, because he is very shy. When I first met him and photographed him, I said, "Why don't you just travel with us for a while?" So he traveled with us and we'd be in Berlin, in Rome working, and he'd be there.

It sounds like a caravan.

Exactly. And so he came along with us for about six, seven months. And so we were down in Miami, and I said, "Look, Roberto, you've got to do some nudes. All the great dancers have." I said, "Look, you're not going to look like this when you're ninety-five years old. You need to do a record of it."

And he loved it.

I couldn't get his clothes back on! It was really kind of funny. He was running up this hill nude and all of a sudden, these construction workers came along, because we were at a construc-

This page: Robert Bolle, from the book *Cartier, I Love You*, in Golden Beach, Florida, 2009. Page 347: Sean Penn at the Little Bear Ranch in McLeod, Montana, *Interview*, 1995

tion site. We're yelling, "Roberto, put your clothes on." He said. "No, I'm finally free."

You and many of your colleagues trained under a generation of great iconic photographers. Have any of your assistants gone on to fame and fortune?

I'm really proud of all my assistants. I don't judge them by how much they work. I judge them for what kind of people they are and how they treat photography in their own life. For instance, I have an assistant, Andrew, who worked with me a long time. When I met him he was dating Helena Christensen; they had this great affair. They broke up [and] he was really depressed. We went on the road and we photographed Newfoundland dogs for a long, long time. And I couldn't have done that book and my film *Gentle Giants* if it wasn't for Andrew and his need for affection from the animals. And now he works every single day, but I am so proud of him because I love his pictures. But mostly I love who he is. [Shane Sigler] was a kid I met at a wrestling camp out in Iowa, and then he went to UVA. He was a great athlete, but he started working with me. He was a terrible assistant at first, and then I gave him a second chance and he was great. He was with me for five or six years, and now he's an extraordinary cinematographer and works in a lot of movies. So, many of my assistants are doing really well. Nan and I don't have any kids. These are like our kids. Sometimes you look at them and think, "Was I too nice to them? Was I too good to them?" I didn't give them enough tough love. [It's] a little bit like the army, where you're tough on them, but you're there and you're loving and you know they have the support and they always have a home with us when things get bad.

Who is in the next crop of photographers that we should look out for?

I would probably say my nephew Jasper, because he showed me a picture and it was so beautiful. And he's like ten years old. [LAUGHTER]

Okay, we'll look out for his work soon. But really, I had this conversation recently with some designers and people in the industry and they said, "You know, there doesn't seem to be that pool of the next [generation of] photographic talent."

A lot of art directors and magazine editors say that to me. I was lucky because I had the support of really good people who loved what they did. I think it's more the support of the magazine, the editors, and the way young editors are trained—they're not forced to read

anything. They just go to fashion shows and look at them and don't even think about putting fashion or photography into their life. I know so many young photographers, and they're really good, but like all of us, we need somebody to our left and right—

To train and see them.

Exactly, and see things.

And you were saying how important the stylists that you work with are. Tell us why.

Yeah, I had that relationship with Kezia Keeble and Paul Cavaco. Paul worked with me for so many years. Paul really loved it when somebody was very vulnerable. And he just had a knack of mixing clothes, and I felt that way so much with Grace and Phyllis Posnick. One time we were in my studio and we were photographing Sean Penn. And then there's Sean, hung over and crazy, and she was able to dress him with a lot of ease. It's good when people have crushes on people.

Crushes drive a lot of motivation.

Exactly. And a lot of people forget that that's part of the photographic process. There's this young photographer we just worked with for a book that we do every year—a journal, *All-American*. It's a young guy from Nebraska, Sean Thomas. And he did this beautiful story for us about senior prom there. Really amazing pictures. So when they came back, Nan and Nathan and Matt and Skylar and I looked at them and we said, "Well, who's this couple in these pictures?" And they told us and he said, "We'll just go back and photograph them some more." And it reminded me a lot of Bea Feitler. I worked with Bea and Ms. Bea was so amazing, and I have to tell you this because I think it's really important. I went up to *Rolling Stone* to see her one day, and she said, "Bruce, what do you think about this book I'm doing on Elvis Presley?" It was a beautiful cover shot of him in a red shirt, like a velour shirt. It was really so cool. I said, "Oh God, where are you going to put the type?" Which is such a normal, square thing to ask. And she said, "Why put type on a book about Elvis Presley?" And it really taught me a lesson.

Who are some of the people who have been the most instrumental in your career? Who inspired you and continues to inspire you?

I have to say Nan. We've been together almost forty years. Nan and I are so different, and yet so much alike. She always makes me look at things in a more level-headed way, because my head is always in the clouds so much. She inspires me to get up in the morning and work really hard. I grew up in a farm town, and I used to see the farmers come back from work and I loved that feeling that they would come back and their hands were dirty. But they felt good about themselves.

And their woman was there for them.

Exactly. You have to understand, when I first met Nan, she did everything. She was not only an agent, she talked to everybody on the phone, she took the portfolios out. I might come home for dinner with twenty people, and she'd cook for everybody. She was really amazing. I'd [also] say [I'm inspired by] a lot of the stylists I get to work with today. Joe McKenna and I are always getting in trouble. I like a stylist to get me in trouble a little bit. When I worked with Carine Roitfeld, she gave me this really great job at French *Vogue*. She said, "I want you to come to Paris and I want you to photograph Paris and its people." And I thought so much about those early days when I was there and I was so poor and starving.

It's a dream job.

Definitely. So I photographed all these angry men and women. And then I went to the Rodin Museum, which is really unbelievable. And all the flowers were out, and there were all these amazing African kids there looking at a statue of *The Thinker*, and I said, "Oh, Paris really makes you think."

Is there anyone that you still want to photograph?

Every day I meet people I still want to photograph. Photographing celebrities isn't so important to me. I don't really like it. I think they don't have that hunger to do good pictures. And I feel bad that so many photographers are forced to photograph them. I really miss seeing great girls who were great models in clothes in magazines. I really miss that.

What was it like shooting Kim Kardashian?

I wasn't sure I was going to be the right guy for that job. And then I met Kim. I felt that her mother was really interesting. That's who I really wanted to photograph. But I met up with Kim, and she came to the set, and I always judge a person I'm photographing by how they are with my assistants and with my crew. And she looked at each of them and introduced herself and was so personable with each of them. I really had the best time. She was wonderful, and I loved photographing her.

Has anyone ever turned you down?

Oh sure. I wouldn't be a photographer living and working today.

But you're not going to tell us who.

Let me think now for a second. I once had a terrible shooting, but I guess I can't talk about it. You talk about these things and all of a sudden they're in the press and then you're thinking, wait, that was like thirty years ago. What am I even saying that for?

Have you ever gone somewhere without your camera and regretted it?

Nan was telling me that she ran into a photographer we all know, and he was saying that he went on vacation and didn't take his camera. And Nan said, "Oh, Bruce is always taking his cameras with him on vacation." I don't want to sit on a beach all day. I want to be out taking pictures on my holiday. That's a vacation for me. And she understands it, but she was teasing me.

When are you going to mount a full-on retrospective of your work?

 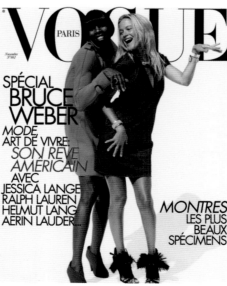

This page, left to right: Kim Kardashian, *DuJour*, 2013; Andre J. and Carolyn Murphy, *French Vogue*, 2007. Page 350: Robert Mitchum and friends filming *Nice Girls Don't Stay for Breakfast*, Los Angeles, 1992

I'm still young and I'm still just growing up. I've got a long way to go before I do something like that. I'm more interested in being out in the world and taking pictures. When I'm not here anymore, if people still like my pictures then they can hang somewhere. I get kind of embarrassed going and seeing my work.

You can just hide in the corner and watch everybody enjoy it.

I feel that way too, when I've done a book and I go to a bookstore, and I think, oh man, I can't go back to that bookstore. My book is out.

Whose photography work do you collect?

I have an amazing collection of photographs, a lot of Edward Weston. I just got into collecting Brett Weston. I have some beautiful Imogen Cunninghams, Paul Strand. I have some great Cecil Beatons. But also pictures I got at flea markets. One of my favorites is of pyramids. Oh, it's so beautiful—the frame's coming off. I like a lot of mountain-climbing photographs. In my library in Montauk, I have some really beautiful photographs by Bradford Washburn. I met him when he was head of the science museum. He was ninety. And I did a little story on him and his wife. They spent their honeymoon in an igloo. And he would go on the airplanes, and he photographed every mountain in the world, but he loved it when the storms and the clouds were coming and they'd be in this little plane. And he would sometimes have to take over for the pilot. And he worked with a really huge five-by-seven or eight-by-ten camera. He was a hero to me. I was with him and his wife, and we were up in Boston, and I don't know what overcame me, it was fall, right about this time of year. The leaves were still on the trees. And I said to Bradford and Barbara, "Let's go outside for a second." And we were walking and I said, "I want you to kiss each other." And they leaned over and they kissed each other on the mouth, and I can't even believe I asked them to do that, but they did it with such a feeling. And every time I think about that, I look at this photograph I have of Bradford and Barbara, and they are on top of this mountaintop together, and I see the happiness that they have with each other.

Sweet. This is probably a question you've been asked a lot, but do you enjoy making movies more than stills?

I like both. I think of them both as going to school. When I make a film I loosen up a lot, you can't control it the same way you control a photograph. So I start all my films out by taking pictures, and I take photographs throughout the film. I'm working on this film on Robert Mitchum right now, and I'm always taking pictures of the people we're interviewing. We were with Clint Eastwood and Al Ruddy in L.A. a couple months ago, and I was taking pictures of them. It was fun. It just loosens me up a lot. So when I go back to just taking photographs [after making a film], I notice that my photographs are freer and there's more looseness about them.

Do you think you still need to do a lot of editorial work, or could you spend more time focusing on films?

I'd like to do both. I'd be really unhappy not doing both. I don't really talk about this very much—but about eight months ago, I had an illness and I almost couldn't take pictures anymore. And I thought, well, what if I can't do that anymore? And I had Nan's support. And I thought, well, I could teach, which would be great. I could maybe go back to school because I really wish I could write better. Luckily, it's not the case anymore, and I'm okay and I can still take pictures. It was really traumatic for me. But I just prayed every day that I would be able to do it.

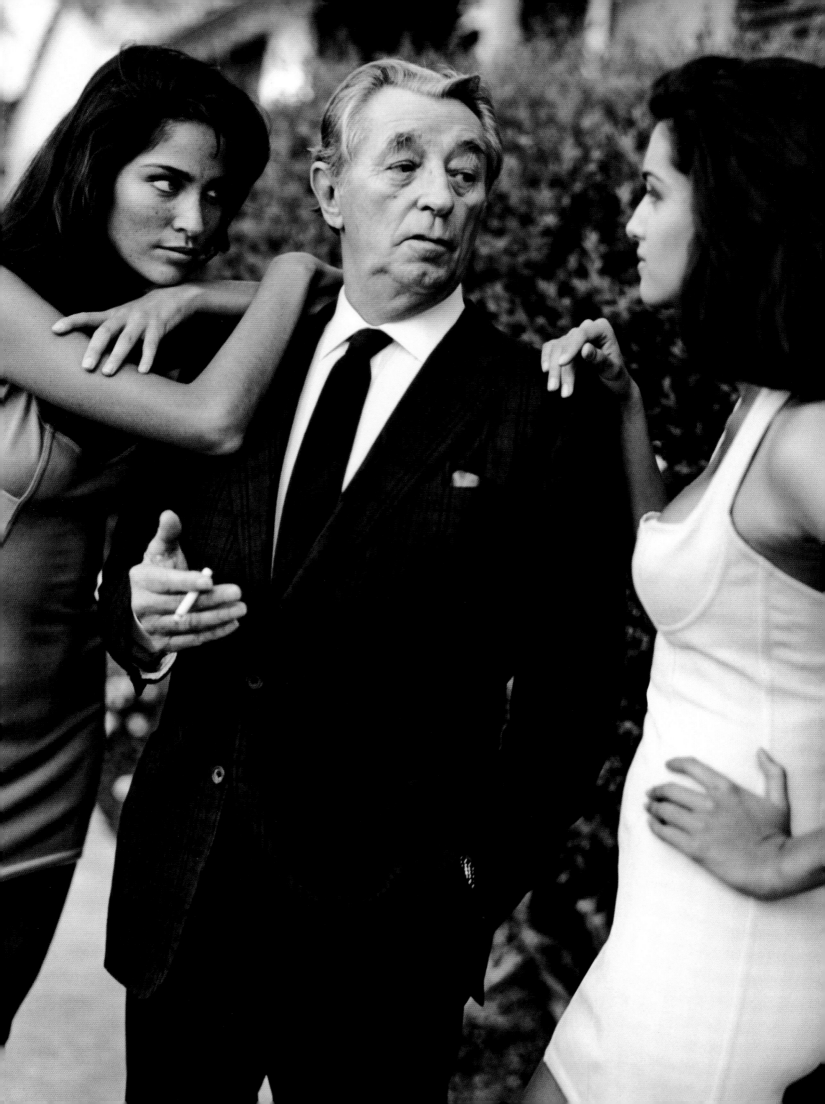

So will you still teach, though, and try to write more?

I don't know if I'm such a good teacher. I'm so crazy and I'd be teaching the students about sex and all kinds of really weird things.

What do you think of the generation now where everyone is taking a picture every second with their phones and posting them, and how many trillions of photos are going to be lost in cyberspace that nobody ever sees?

I think it's okay for people to be taking pictures with their phones.

Do you ever take pictures with your phone?

David Bailey [and I] just did an assignment up in Harlem for Nokia with the new Nokia phone. I adore David, he's a really great guy, and I'm a big pal of his. We had a great time up in Harlem, which I think's really exceptional. And we made a film that I'm pretty proud of. I think it's okay to be taking pictures with anything you want, but this whole posting and all this Instagram—I don't know. I want to tell photographers—or people who just like taking pictures—don't put those pictures out there, save them for yourself. Make a print.

You could be somebody who could teach a generation how to preserve these pictures, how to print these pictures how to really see them and not just share them [online] without even looking at them.

A lot of these photographs now can be printed on really nice paper, so at least you can touch them. I just love it that you can touch a print and feel it.

I know. I miss going to the Kodak store and getting the pictures back after you shot a roll of film. I miss that anticipation.

Isn't that the most amazing thing? [For me] that equaled going to a record store, which also doesn't exist anymore. Just the people you can meet at a record store and listening to all these albums and the art. It was like a museum.

Can't meet anybody in stores anymore because everybody's head is down in their phone, texting and typing. Nobody looks at anybody.

I know, and also, you go to a restaurant and you can't talk. Jessica Lange said something really interesting to me. She happens to be a really good photographer. And she said, "I don't understand all this digital stuff." And I said, "Well, I do. It's good that it's out there and people are doing it." She said, "I don't like it. It's not so intimate. It takes the intimacy out of taking pictures." I think that's a little true.

What advice do you have for aspiring photographers?

Don't get caught up in what you think you should be doing. Just take pictures that you have a strong connection to and read a lot of books, because it's the books that will inspire you for ideas. And don't look at other magazines and other photographers' work as a way to get your work out in the world—find your own path. [APPLAUSE]

Is there something that you fear the most?

Well, I was in L.A. with Wendy Stark and we went to see the [Homeboy] Bakery. We met Father [Greg] Joseph, who has helped a lot of men and women who have just gotten out of prison, and given them a whole new lease on life and helped them to get jobs. And he has a sign on his desk, which says, "I hope everyday that I do something that I'm really frightened of." So I try to do that. There're a lot of things I'm frightened of. And especially, which will come as a surprise, going up to people and saying, "Hey, I want to take your picture." But sometimes I get the courage to do it.

What would you like your legacy to be?

I knew you were going to ask me that question. I don't know what I want my legacy to be. I just want to live to the last moment. When I was a young kid, I really was so close to my family. When they all passed away, and my sister passed away, this one editor of a magazine said the strangest thing to me. He said, "You know, you're all alone." And I thought to myself, it's funny how in life we inherit a second and a third family—with friends.

It sounds like you have an extraordinarily large family.

Yeah, I do. [As for] my legacy as a photographer, I have a great book collection. I want students to be able to read it and look at it. I want to be able to have a place where there are photographs, [where] people can show their work, not just mine. I want the liberation of that. I had to do the HBO special *Masterclass*—that was really hard for me. And at the end of it, a curator at the museum wanted them to know what it was like for one night. We made a poster and everything. And she said at the end, she was very critical of them. And I said, "Look, I think it's more important that they're a human being first and an artist second." I think if I had to say anything, I would say that.

Want to talk about the little red book you've been holding all night?

I'm always writing stuff. I have some notes here from a little film I made on Elizabeth Taylor, right before her estate auction. I was talking to this girl today, and she told me about a movie called *Lipstick & Dynamite*, and it's about all these women wrestlers from the 1930s, and they have the most incredibly exotic names. One's called the Fabulous Moolah, then there's Killem [Gillem] and the Great Mae Young and Diamond Lil and Peggy the Punisher. And she was telling me that this woman, Fabulous Moolah, dated Hank Williams Sr., and they used to go to little honky-tonk bars around the country, and she would wrestle for an hour and he would play music. I just loved the romance of it.

Is this a movie that you're going to make?

No, it's already a movie from a long time ago. But I thought, well, who am I going to call up to say I want to make these pictures of a girl wrestler and a country-western singer? Then I thought, hey, Grace, are you here? Are you interested in that? Phyllis, are you into that? Camilla, [Nickerson] are you into that? Joe? I called Joe McKenna, yeah. That's the way things happen. Not because, oh, let's see what's happening on the runway. It comes from the character of the people.

So in about six months we're going to see a spread somewhere like this.

I'm really into the idea of women wrestlers wearing clothes.

Here are some good questions from the audience. Who should play you in the movie of your life?

[LAUGHING] Oh, wow. At what age?

You can pick a young one and a now one.

Can I pick somebody who's not alive?

Why not?

Richard Harris.

That would've been great. Who else?

Well, it would be nice if it was Brad Pitt, like twenty years ago.

All right. We'll do the story of young Bruce Weber. What have you found to be the differences between working with editors and working with designers?

Left to right: Rhett Butler filming *Gentle Giants* at the Newfoundland Specialty Show, Michigan, 1994; Bruce Weber with True and Polar Bear in Upper St. Regis Lake, New York, 2005, by Michael John Murphy

I think all the really great designers are like great editors. I think that they approach photography like they do when they're thinking about making something out of nothing. We all do that; that's what we do.

I don't think this came from Maury Hopson, but how important is hair in your images?

It sounds like a question Maury would ask me. [It's] very important because it dictates a little bit of what the photograph is saying. On most actors' contracts, the biggest question is what their hair is going to be like for movies. And all the directors tell me that they're always stuck on that. And sometimes it doesn't work out and they can't get that actor or actress because of what their hairstyle is going to be.

Favorite song, model, city, designer; period in fashion, media, design. Pick one or two.

I'll pick a song. I love Julie London, I love her singing. I got to meet her once. I went to the Americana Hotel to hear her play and she was really drunk, and I was with my roommate and all these people. We met this guy and I thought he was busting us because we were seventeen and we were drinking scotch. He asked, "What are you kids here for?" And we said, "Oh, we love Julie London." And he said, "I'm her husband, Bobby Troup. Come on up after the show and come to the room. We're going to have a party." We go on up on the elevator and knock on the door. Julie London opens the door and she's in a red teddy.

That's all?

Yeah, that's all, with that red hair. I have that image just branded in my head. And we went in and we hung out with her in the kitchen. All the guys were wearing sunglasses and wearing black and playing poker. It was so exotic. I loved it.

Is there a place you like to photograph the most? And why?

I would say wherever I am with Nan and our dogs.

Okay, let's end with a dog question. When are you planning on buying your first Newfie puppy?

I can't get a Newfie because, even though I have a huge support system, Newfies really bond with their owners instantly. It's like being with an elephant. You can't leave an elephant. So I sadly realized that when I was making my Newfie book and my film, that whole thing had been propaganda so that Nan would accept me getting a Newfie. But I know that I can't because I'm not always around. Goldens are like a lot of blonds—they love everybody. They're happy when they see Nan and me, but they're mostly happy that somebody's there to hug them and kiss them.

Well, on that note, ladies and gentlemen, thank you. Bruce, thank you. [APPLAUSE].

KENNETH COLE

Tonight, I will have the joy of speaking with a designer who has been a good friend for a long time, a great talent, a smart businessman, a brilliant marketer, and an extraordinary humanitarian. Kenneth Cole cares more about what you stand for than what you stand in. He and his company are celebrating thirty years in the business. And to paraphrase one of his ads, "getting by in this business is no small feet." He will share with us how he started his business, his iconic ad campaigns, his role at amfAR, where he has served on the board since 1987 and since 2005 as chairman. He's been at the forefront of the AIDS crisis for twenty-six years, and is the executive producer of the HBO documentary The Battle of AmfAR. He is a straight man who stepped up, in great shoes. He is a board member emeritus of the CFDA and was presented with the CFDA Special Award for Humanitarian Excellence in 1996, among many other honors in the course of his career. He's a founding board member of HELP USA. He is married to the philanthropist and activist Maria Cuomo Cole, daughter of our former governor, Mario Cuomo and the fabulous Matilda Cuomo. And he's the brother-in-law of our current governor, Andrew Cuomo, and father to three beautiful daughters, Emily, Amanda, and Katie. And he golfs with Bill Clinton. Let's get to the sole—S-O-L-E—of Kenneth Cole.

KENNETH COLE: What a treat.

FERN MALLIS: I'm wearing Kenneth Cole now.

[So] both the people on stage are dressed by the same cool designer.

You were born on March 23, 1954. That makes you how old?

I can't deny that, can I?

Nope, it's on the web.

I started the business thirty years ago when I was six. You do the math.

Come on, this is all about honesty. You're an Aries, like me. Aries is headstrong, the leader of the zodiac, strong, restless, quick-witted, impulsive, and ambitious. You have a distinct point of view and enjoy debate and friendly combat. That sounds about right.

I'll take it.

Your father was Charlie Cole, and your mother Gladys Cole Levine. How and where did they meet?

They met in upstate New York in the Catskills. That's where people met in those days.

Did you grow up in Brooklyn or Long Island?

I was born in Brooklyn, but I spent my younger years on Long Island, in Great Neck.

And where in Brooklyn were you when you were born?

Can I call my lawyer? [LAUGHTER]

Your dad was in the shoe business. Tell us about that.

My father had a shoe factory. Actually, he had several. But ultimately, he had one in this very rough part of [Brooklyn] called Williamsburg.

Don't you wish you had that factory now?

Yeah, it's an amazing place. So I did that for a few years and then I started my own business in 1982.

You're racing through those years. You have two brothers, Neil and Evan, and a sister, Abbie. Most of us in the fashion industry know Neil's business Iconix.

I had the privilege of working with them at different points. Evan and I worked together for a little while and Abbie's doing other creative things now. We started a business called Candie's in the late '70s. We were accused of crippling half a generation of Americans.

The shoes were known for wooden soles and high leathers, right?

Among other things, yes.

Were you and your brothers competitive?

Only when we were awake.

How old were you when you worked at Shea Stadium?

My first job was selling peanuts at Shea Stadium. It was during the World Series. It was a big deal. I got to do two things that I loved: make money and watch baseball.

Did you learn anything from selling peanuts?

I learned that there's a direct correlation between how hard you work and how much you make. I sold a lot of peanuts, and today I work for peanuts.

Everything comes full circle. You went to Emory University in Atlanta and studied law.

I actually never went to law school. I enrolled a couple times and I came to realize that law is essentially a compilation of initiatives. And in business, you basically write your own [initiative] every day. And the further it is from anything that has been written before, the more likely it will be successful. [So] I was on my way to law school when I worked in [my father's] factory, in the sample room and learned how to make a shoe. I was totally obsessed with how you can create something unlike anything else with basic raw materials by hand. I loved it. We started Candie's a couple years after that. And then I decided, if I didn't go out and do my own thing I might never.

So in 1982 you decided to do that. Tell us how you set up the business.

I had a little bit of money, and I knew that most start-up companies fail in the first year. Sixty to seventy percent don't make it through their first twelve months because people invariably underestimate the amount of money they need and/or the time they need to realize a return on that initial investment. I needed to register for a trade show. I needed to go [to Italy] and make shoes. And I needed to make stationery and business cards and introduce myself to people. Rather than make up a name, I used my own name. You can almost always get your own name registered and it made my mother happy. I went to Italy knowing I had a better chance at getting credit from an Italian shoe factory that needed business than from an American bank that didn't. And I came back and I had to sell it. In those days you had two choices if you were in the shoe business. You could take a room at the Hilton Hotel and be one of many companies, not very compelling, not very distinctive. Your other alternative was to take a big fancy showroom within a two-block radius of the Hilton. I didn't have the time or the money [for either]. So on a whim, I called a friend of mine in the trucking business. I said to him, "If I can figure out how to park one of your forty-foot trailers across the street from the Hilton Hotel, will you lend it to me?" He said, "This is New York. You can't park a bicycle for five minutes, let alone a truck for three days. If you can figure it out, I'll help you decorate it." So I called the mayor's office, Mayor Koch at the time. Excuse me, Mr. Mayor, how does one get permission to park a forty-foot trailer on the corner. And the answer [was], "Sorry, son. We give permission only if you are a utility

Clockwise from top left: Candie's El Greco advertisement; Kenneth and his brother Neil, Atlanta, Georgia, 1976; Kenneth Cole, 1983; Kenneth with his father, Charlie Cole on a business trip, 1980

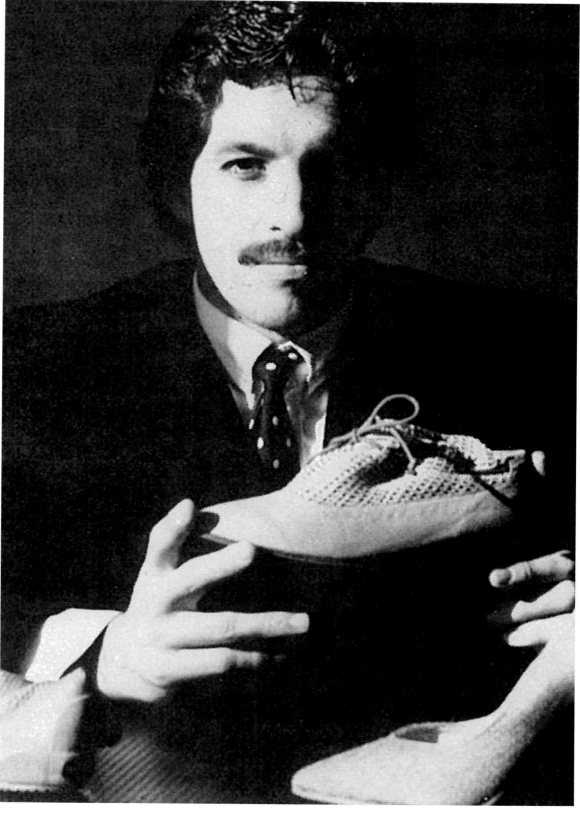

This page, top to bottom:
Dr. Mathilde Krim, Kenneth Cole,
Natasha Richardson, and Harry
Belafonte coming together on World
AIDS Day in 2005 to unveil Kenneth
Cole's We All Have AIDS campaign;
AIDS ribbon in a Kenneth Cole ad,
December 1993

—Kenneth Cole

NEW YORK LOS ANGELES SAN FRANCISCO AMSTERDAM

company or a production company shooting a full-length motion picture." That afternoon I went across the street to a stationery store, changed my letterhead from Kenneth Cole Inc. to Kenneth Cole Productions Inc., and filed for a permit the following morning for permission to shoot a full-length motion picture called *The Birth of a Shoe Company*. I opened for business on December 2. I had two New York policemen as my doormen, compliments of Mayor Koch. I had a director. Sometimes there was film in his camera, sometimes there wasn't. And I saw every important buyer in New York and we sold forty thousand pairs of shoes in two and a half days. And the company is still Kenneth Cole Productions. We were public for twenty years and traded on the New York Stock Exchange [under] the symbol KCP. That story reminds us that the best solution is rarely the most expensive; it's almost always the most creative.

Absolutely. That's a good lesson. When you started your business, your friend Sam Edelman, later of Sam & Libby, worked for you.

Sam was with me in the trailer. Sam would work with me every day in the apartment as we tried to figure out how we were going to chart our path.

And are you still pals and competitive shoe guys?

We're still pals. I'm actually his son Jesse's godfather.

In 1985, you did your first major ads promoting AIDS awareness. Tell us about that.

In 1985, no one spoke about AIDS. The stigma was so pervasive. Ronald Reagan was president and didn't mention the word AIDS publicly until 1987, until forty thousand people had already died. But there was this desire to want to be part of something bigger. There was this [social] consciousness that we hadn't seen since the 1960s. Remember, it was [the era of] "We Are the World," Live Aid, Hands Across America, [and Farm Aid], but nobody was talking about this ominous black cloud called AIDS. If they did, they were presumed to be at risk, which meant they were Haitian, or IV drug users, or gay. And I was a single male designer, so I knew everybody would assume that I was Haitian. Maybe I was comfortable doing it because I wasn't in one of those at-risk groups. I found some extraordinary iconic individuals in our industry, and Annie Leibovitz agreed to photograph the campaign. It changed me profoundly as an individual. It changed the brand. It changed the corporation. But it wasn't what I built alone. It was a shared commitment and dedication to speak to not just what people looked like on the outside, but who they were on the inside, to find relevance and significance that was greater than what we did every day and the collection that we created every season.

Do you ever worry about how your views on politics and public policy might affect sales? Have they ever affected sales?

I don't know if they've affected sales. I've gone places and done things and said things that most wise businesspeople wouldn't. I have always felt the need to speak about what's on people's minds and connect with them in as relevant a way as possible. I often addressed issues that I knew were very sensitive. I was very careful and I sat on the fence originally [on] most of these issues. The first ad was a picture of an automatic weapon and a pair of shoes. And it read, "Regardless of the right to bear arms, we in no way condone the right to bare feet." If you really read the words, we weren't really saying anything specifically. But we got a lot of irate letters at the time. This was long before emails. And I think it was even before faxes. People wrote long letters and they'd say that the Second Amendment gives

me the right to bear arms, go back to making your damn shoes and you have no right to be part of this discussion. And I'd answer back: maybe you're right, but the First Amendment gives us the right to tell you how we feel about it, and isn't this a great country we live in?

So people answered those letters.

People answered. We also did a campaign that [was] a little more specific: "We think women should have a choice when it comes to being pregnant. Barefoot is another story." We don't talk about termination. But people presumed that we were and we'd get all these long, irate letters. I remember one woman wrote this three-page handwritten letter. And at the end she says, I have bought my last pair of Cole Haan shoes. [LAUGHTER]

In 1986 you married Maria. How did you meet? Were you always politically minded, or did marrying into the Cuomo family accelerate that?

Maria and I met in '86 and got married in '87. We had a like-mindedness, which was a big part of our coming together and has been a big part of our life since. But I have always been an extraordinary fan of her father and her mother. Business-wise, people have said, all of your political messaging, is it right? Is it appropriate? I struggled with that because the messages were not political messages. The messages were, for the most part, social messages, human messages. I didn't comment on political things, except a couple of times when I couldn't help myself.

The Bush-Cheney street signs got you in some trouble.

That was a mistake. For the most part, I was very thoughtful, very careful. Fortunately, social media didn't come around until later on.

In 1988, *People* magazine named you the Sexiest Businessman of the Year. How did that feel? Get any flak for that?

My brother-in-law, Andrew, the governor, just was named sexiest something [by *People*]. He talks about it, but I didn't really speak about it. I didn't really feel that was on brand, so that wasn't a billboard that I carried or a flag that I waved—but my daughter subtly reminded the governor at dinner, at Thanksgiving, that her father received the same award thirteen years before he did.

Good one. So, in 1984 you went public. Do you want to talk about the trend of fashion IPOs? Later, you made a point of trying to get your business back.

I went public because that's what I believed you were supposed to do. You access resources that aren't necessarily yours, you leverage that which is yours, and you create something bigger than you could ordinarily. It was a very exciting moment in my career, the day I went public, but by far more exciting and more invigorating was the day we went private. I'd tell you about it, but it's private. I am very quick to tell people there is not a single reason you want to be public today. As a public company we became a little opportunistic and did things we felt we needed to do as a public company. We grew revenue and expanded the distribution. But at the end of the day, I don't think we enhanced the brand and the business. And I knew to change it, so I set out down this road [of buying back the company].

Is your men's or women's business bigger?

The men's business is a little bigger, but women's is getting better. We're trying to stay focused and elevate the quality of design, the quality of production, the quality of distribution.

What is the percentage of shoes and accessories to ready-to-wear?

Our shoe business might be forty or fifty percent. We started as a women's shoe company,

WE ALL WALK IN DIFFERENT SHOES.

THEO KOGAN.
SINGER, ACTOR,
ENTREPRENEUR
AND FEMINIST.

KENNETHCOLE
.COM
25 YEARS OF
NON-UNIFORM
THINKING

"Regardless of the right to bear arms,
we in no way condone the right to bare feet."
—Kenneth Cole

New York Kenneth Cole for Men and Women. Our footwear and handbags are also San Francisco
353 Columbus Ave. available at Fine Department and Specialty stores. 2078 Union St.

Clockwise from top right: Spring 2008 campaign for Kenneth Cole shot featuring Theo Kogan, by Terry Richardson; 1988 advertising campaign commenting on the sex scandals of televangelists Jimmy Swaggart and Jim Bakker; Spring 2008 campaign for Kenneth Cole featuring Channing Moss, by Terry Richardson; 1989 advertisement after the Cleveland school massacre that led to California's ban on assault weapons

WE ALL WALK IN DIFFERENT SHOES.

CHANNING MOSS.
U.S. ARMY SOLDIER
INJURED IN THE LINE OF DUTY
IN AFGHANISTAN.

KENNETHCOLE.COM
25 YEARS OF
NON-UNIFORM
THINKING.

Reverend Jimmy Swaggart Tammy and Reverend Jim Bakker

"These days, it seems we're
the only ones you can trust
with your soles."
—Kenneth Cole

New York Kenneth Cole shoes are also available San Francisco
353 Columbus Ave. at selected Department and Specialty stores. 2078 Union St.

making cool shoes for cool people. Then we made shoes for her companion. In business, you essentially put yourself in the proverbial shoes of the person that you want to do business with, and that's how you think. You try to think like them and anticipate where they're going and how they're going to get there. One day I wanted to go into the clothing business in the worst way, and I did, because I was a public company, as a licensee. Now our goal is making and elevating it and we're executing better as a private company.

The collections have been really terrific in the last couple of seasons. Do you ever wear anything besides Kenneth Cole?

Not admittedly.

Do you own any other people's shoes?

Not admittedly.

If we were torturing you, who would you say?

[WHISPERING] Cole Haan.

At last count you have 95 Kenneth Cole stores and outlets, 5,700 stores carrying your lines, and licensees for everything from swimwear to fragrance, all dual gender. What's your next big expansion? And are you global in a big way?

The fashion world has changed in such a profound way. We stopped doing runway shows seven years ago because I believed at the time not only was it not productive but it was wearing at all of our creative, financial, and human resources. The Internet had redefined access to fashion. All of a sudden, these fashion television networks all around the world [were] getting free content, and would run all these fashion shows. Our show was being introduced to people in places that never had access to the product. And even if they did, it was the wrong season because we were showing spring when they were looking to acquire fall. So we stopped doing fashion shows, and then all of a sudden a year ago, I woke up one day and said, wait a second. It's all changed. As bad as it was then is as good as it is now because people consume fashion differently. First of all, almost everybody has [his or her] own brand. And they curate their brand every day on their Facebook page, on their Pinterest page, on [their] Instagram feed, on their Twitter feed. My job as a designer is not to try to get you to want to define yourself by my brand, but to allow me to be part of

This page: Kenneth Cole with his wife Maria Cuomo Cole and daughters Emily, Amanda, and Catie Cole. Page 364: Kenneth Cole and his associates visiting Cité Soleil in Haiti

your brand. [Fashion is] global now. If you are viable anywhere, you are viable everywhere. I just got back from a trip to India and to Bangkok, where we just opened new flagship stores. Our new store in Mumbai has almost the same merchandise as our store on Fifth Avenue. There is a bigger audience for it here in New York than there is in Mumbai, but the audience is for the same product. And the deliveries are a little bit different, the size-scales are different, but at the end of the day, fashion is happening everywhere in real time. Fashion today may be the only universal language. A year ago, we went back to the runways. I heard this introduction [for which] they advised you that it was illegal to put your cell phones on and to take pictures. But right before our show, we had a video and it said, "Out of the interest of the fellow members of the audience, we ask you to please take out your communication devices and turn them on." Then we said that this show will be live simulcast and curated on every social [network] platform. Before the models left the runway, every third or fourth look would be posted on Twitter and they all went up on Facebook. The models were taking pictures of the people taking pictures of them, so everybody became involved and fashion has become a social experience.

Speaking of social media, you're constantly on your phone.

Today you need to be able to network independently of the traditional process because [social media can be] extraordinarily efficient and targeted and productive. As a business-person, you recognize the need to build a following. So you find an audience for your product. And you find a meaningful and compelling way to communicate your message. Traditional media is very inefficient, but it still has its place. I'm a little obsessed with social media. I'm trying to keep it in context, because ironically, social media today is probably the most antisocial thing that we do every day.

You haven't done an ad about that, have you?

No, no, it's coming. But I haven't.

How big is your e-commerce business?

We're private. It's so nice not to have to answer these questions [with specific numbers]. It's getting bigger. E-commerce is a platform that has multiple masters that you need to serve. You need to serve the brand's agenda and the business agenda. It's a global platform, so you need to find a way to speak to people everywhere.

Whose reviews matter the most to you?

My daughters' and my wife's.

Tell us about your daughters. Are any of them joining the business?

I think they're wiser than that. One of my daughters, Amanda, graduated from college and has been helping with our social enterprise [HELP USA]. We've done a lot of AIDS work; our organization participates in seventeen AIDS walks around the country. We started a shoe drive twenty years ago because we had a dilemma. We needed to sell our winter shoes—in February. We had a store on Columbus Avenue at the time and one on Union Square in San Francisco. You couldn't go on sale because we also sold to the department stores and if you did you... essentially [bit] the hand that fed you. I needed a way to generate business, so it became apparent that there was this constituency group that nobody was addressing: homeless individuals. Businesspeople didn't speak to them because they didn't consume. Politicians didn't speak to them because they didn't vote. The rich were getting richer. The poor base was getting bigger. We were going through the

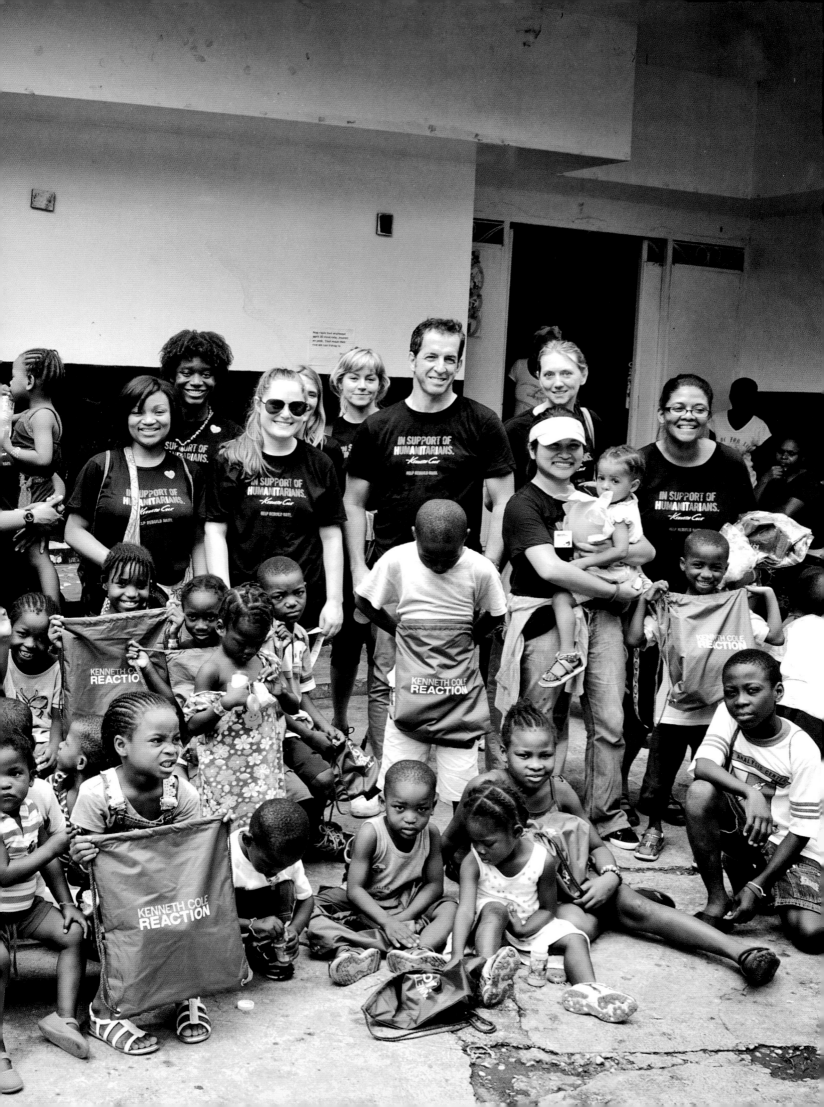

Bush-Reagan years and the social safety net was dissipating. So we did a campaign with a picture of a homeless person that said unfortunately too many people would love to be in [our] shoes. We said bring in a [used] pair that you don't wear [anymore] for someone who will, and we'll give you a discount on a new pair. Many years later we [had] collected over two million pairs of shoes. And it became a very defining part of what we're doing. And the earthquake in Haiti had just happened. We typically would distribute those shoes through HELP USA, which Maria runs. But it was clear that we needed to find a way to connect with these individuals in Haiti who had been so devastated [by] the earthquake. We collected $150,000. I took sixteen of my associates and we went down to Port-au-Prince. We eventually aligned ourselves with St. Mary's in Cité Soleil, just outside of Port-au-Prince, with a population of a million and a half people, and built a healthcare center in conjunction with Father Rick and St. Mary's.

Which do you find more fulfilling, philanthropy or the design and creative business process? And why?

I love what I do for a living. I love making great clothes. People make a very important decision every morning: how they're going to introduce themselves to the world. It's a very powerful choice because people often don't get to know any more about you than how you present yourself. So, to the degree I can be a part of that, it's a gift. It's a privilege. I believe after thirty years, I've earned the right to be considered, but every day I have to earn the right to be chosen. It's what makes the business so great. We all have to work everyday, we take nothing for granted. And I love that we can do it. And I also love that it's a platform to do something even greater, and hopefully make an impact in peoples' lives.

Who works on all the brilliant slogans and puns? What are some of your favorites?

My brain works that way. I have found that today ADD is something we all live with. It's not a medical, clinical condition. It's socially imposed. It starts with social media and with all the stimulation in our lives. You look at kids and unless they're speaking to five people at the same time, they're bored. So the goal is, how do you say as much as you can in as few words as possible? It's a big part of Twitter's success. My job as a designer is not to tell people how they're supposed to dress, but to find out what they want and give it to them but not how they expect it. It's a wonderful challenge, because what's fashionable to some-body today invariably won't be tomorrow, and what's fashionable to me may not be to you. I meet young people all the time. I always tell them that fashion is a great platform—don't let it define you. It's a wonderful tool that will enable you and be an amazing mechanism to affect your journey, but it's not the destination.

Are there any up-and-coming designers you see who you think might take the mantle from you and speak out on social issues?

I'm not the only one who talks about things. I talk about what I think matters and I try to do it respectfully and appropriately. I try not to offend people. Sometimes we've overstepped the line a little bit, but never intentionally. But I'm not the only one that does it. And people do it in different ways. And the fashion industry has supported it, it's encouraged it, and it's been a wonderful enabler.

I think [in the fashion industry] you singularly hold the banner of putting your money where your mouth is, making it a message of the company. You're to be applauded for that.

Thank you. [APPLAUSE]

ISAAC MIZRAHI

I am thrilled to share the stage with one of fashion's most famous, multitasking, and multifaceted designers, my friend, Isaac Mizrahi. He is fashion's Renaissance Man. He sings, he draws, he writes, he directs, he performs, he acts, he does cabaret and more, all in addition to being a fashion icon and designing his ever-growing brands. He has designed countless costumes for Mark Morris's dance company and for three Broadway revivals—The Women, which won him a Drama Desk Award; Barefoot in the Park; The Threepenny Opera—and the Met Opera's Orfeo ed Euridice. He's written comic books and co-written the PBS historical documentary The Kingdom of David: The Saga of the Israelites. He narrated, designed, and directed Peter & the Wolf at the Guggenheim Museum, following in the footsteps of Carol Channing, Boris Karloff, Alec Guinness, Elaine Stritch, and David Bowie. And he did the sets and costumes for Stephen Sondheim's A Little Night Music for the Opera Theatre of St. Louis. We also can't forget the infamous Unzipped, which I'm convinced started the trend for fashion documentaries and set the bar to which they all aspire. He has dressed many stars, including Nicole Kidman, Selma Blair, Julia Roberts, Sarah Jessica Parker, Debra Messing, Natalie Portman, Meryl Streep, Liza Minnelli, and even First Lady Michelle Obama, for the president's State of the Union Address in 2010. On TV, Isaac has played himself on episodes of Spin City, Sex and the City, Ugly Betty, The Big Scene, The Apprentice, Jeopardy, and hosted The Fashion Show on Bravo with Kelly Rowland and me. He also hosted Project Runway All Stars and appeared in three Woody Allen movies. He loves designing for the masses and the couture, and was the first designer to combine those in a fashion show. As he said, "I don't know what's more chic than a sable-lined raincoat worn with twenty-five-dollar penny loafers." He has over fifty licensees for women's and men's clothes and accessories and can be seen on QVC every week. Like many of the fashion icons who have appeared on this stage, he's had his ups and his downs, been in and out of business and the spotlight, gained and lost weight. And he has more Belgian loafers than anyone and in every color imaginable. Isaac's next big project is directing and designing the sets and costumes for the opera The Magic Flute. Ladies and gentlemen, let's welcome the man Time magazine called the Oscar Wilde of Seventh Avenue, Isaac Mizrahi.

ISAAC MIZRAHI: Hi, Fern. Hello, everybody.

FERN MALLIS: I always start at the very beginning. You were born in Brooklyn on October 14, 1961. That makes you how old?

Figure it out. I'm not going to say it. I'm not going to say it. You're going to have to figure that out for yourself. You can do math, right?

And you're a Libra. Do you believe in astrology?

I do. I don't know why, because I don't really believe in God. And I don't believe in reincarnation, but I like the idea of being able to chart things based on—

The planets and the stars.

That's right. I love Jews. I love all religions. I want to make it clear before we go on.

Well, [the 92Y] is a good house for loving Jews. Libras are known to be diplomatic, graceful, peaceful, idealistic, and hospitable, as well as superficial, vain, indecisive, and unreliable. Does any of this apply to you?

I concur with everything except unreliable. I have some kind of crazy gene that makes me very reliable.

Libras are also about partnerships in groups, are happiest when others are around, and are also lazy. But that can't be true of you, with all the things you do.

No, that's true. I think my life is overcompensation for being the laziest boy in the world.

Libras also like posh surroundings and nice decor, and are nice to everyone they meet and—this part I think is true—can be silly, funny, and sweet. But they're not the kind of people you'd want to mess with.

That's all very true.

Last, but not least, Libras are very creative. A good way for Libras to become wealthy is through artistic endeavors. They can be painters, interior decorators, actors, screenwriters or composers, or in your case, all of the above. All right, back to Brooklyn. Were you born in the Midwood section?

Yes. I love being from Brooklyn, but I don't want to go back.

Even how hot it is now?

Especially now. Seriously, I went to dinner there the other night and it was just so crazy.

It was just too cool?

It was just the levels to which people torture food now in Brooklyn. The level to which they salt chocolate in Brooklyn now is perverted, I think.

Tell us about your parents. Your father, Zeke, and your mother, Sarah, were both conservative, observant Syrian Jews.

They were weirdly kind of liberal. And they weren't that observant. They were more American than anything else. I don't know how, but my sisters got very, very religious. They went sort of the other way. They make up for my nonbelief in God.

Where did your parents meet?

They were both the same age, which is funny. They met when they were thirty, late for that era, and married right away. My mom says he married her because all of her shoes matched her handbags. She had me when she was thirty-six, which was a risk at that point.

You have two siblings.

I have two sisters.

What did your dad do?

My father was a manufacturer of children's wear. He had factories in Philadelphia, in [the] Dominican Republic, and eventually in China. I used to go with him to factories. I was very heavy and I had to have all of my clothes custom-made at his factories.

So that was your introduction to the fashion business.

I went to high school on 46th Street. So after school I used to wait in his office at 34th Street to drive home with him. I would go to Macy's and Saks every day. At the time, Saks had the most fantastic Rive Gauche boutique on the first floor. This was in the 1970s. I used to go there and go mad.

How old were you at that time?

When do you start high school? Thirteen or something, right? One thing I remember was

Clockwise from top: Isaac as a child with his sisters, 1969; Isaac with his mother, Sarah, 1968; Isaac, 1968

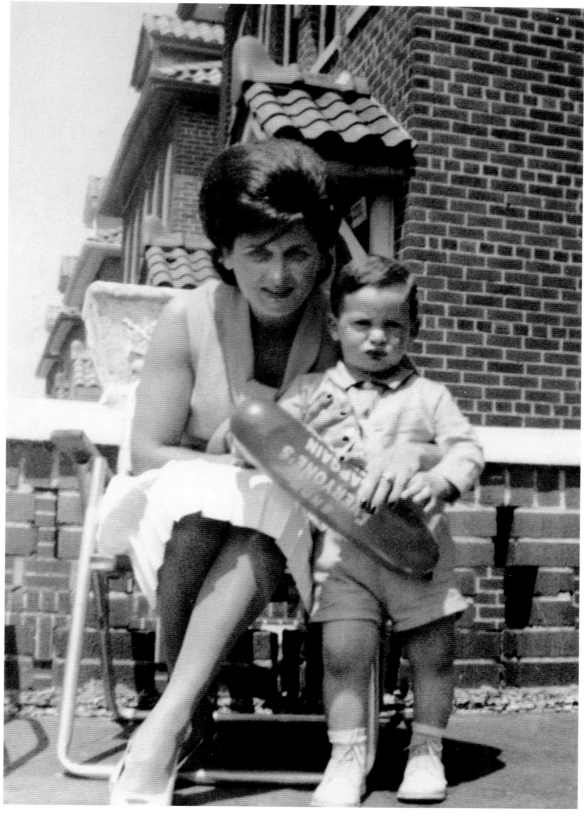

my father introduced me to this incredible person who was a mentor to me. Her name was Ellie Fishman. She was like a little angel smiling down. She writes me notes all the time.

She's here tonight.

Look at you. Ellie Fishman, you are so beautiful. She looked at my sketches and she criticized them, and she said, "You should go to Parsons." And I did. I started taking evening classes while I was in high school.

You're jumping ahead, Isaac.

I'm sorry. You know Carol Channing does this fantastic one-woman show, and three hours later she still hasn't started talking about *Hello, Dolly!*

Back to Brooklyn.

Brevity is the soul of lingerie.

Describe your house growing up. What did your room look like?

Well, I have a very funny story about that, actually.

I bet you do.

In my formative years, it was really clean. The whole first floor was carpeted in this beautiful Spanish-olive-green carpeting. It was a thin pile of a woolen thing. It was very beautiful and rich; it looked like moss. Then when I moved into my apartment when I was thirty or so, I got this rug and my sisters were like, "What's that?" It was the exact carpet. Not just the same color but the same carpet. It's crazy. So I just replaced that from my childhood.

What did you have in your room?

Brown-and-white campaign furniture [with] gold brass corners. It was the 1970s and I had this wonderful hand-painted striped wallpaper, a really terrible combination that my mother liked. It was a terrible blue—a sickly blue—and brown. It was just awful. I did have a cork wall with pictures of Judy Garland all over it.

Your mom took you shopping with her to the original Loehmann's in Brooklyn—

That's right, that's right.

And to Bergdorf's and Saks. She was a fashion plate.

Like any good, middle-class Jewish lady, she liked a bargain, she liked a sale. She also respected the retail thing, too.

So shopping with her at Loehmann's growing up, did you learn to appreciate getting things at a good price?

No, I was more aware of the kind of gigantic size of panties and girdles. You know, Spanx are revolutionary. Did you see that article in the *New York Times* about women's pubic areas and how they are choosing to keep them fuller?

Where did your mom go, wearing all her [Norells]?

I don't remember. I just remember her appearing before they would go out. It was a funny, glamorous thing, growing up in the 1960s and '70s. I remember New Year's Eve. They would take us first to dinner at six o'clock at Patricia Murphy's, with the upside-down Christmas trees and the ladies with those long tongs and popovers. Then they would bring us home and [my mom] would get all dressed up and my dad would get dressed up, and then they would go out for New Year's Eve.

Did she keep all those dresses?

Some of them. Some of them my sisters have and they've been cut and altered. It's really a shame. There was one hat that she had that was so good. It was Dior and it was all flowers.

I asked her, "What happened to that hat?" She said, "Oh, I cut it up and gave the flowers to the grandchildren." I was like, "What? You cut this hat up?"

She should've checked with you. So at ten or eleven you got your first sewing machine.

There were these giant machines down in the basement.

Old Singers.

The whole room vibrates when you turn it on. There were those iron horses, a sewing machine or two and a Merrow machine. I wasn't allowed to use those. I learned to sew by hand from this crazy aunt of mine. Then I was making puppets by hand and eventually I decided to start trying to make clothes. So I babysat for a summer when I was twelve. And I saved up money and I went to the Singer center with my dad to buy a new machine.

A more user-friendly one.

Yeah. It was one of the things with a case that fits over with clamps. It was white plastic. And [my dad] was like, "No, you're not getting that machine," because he saw another machine that was actually so much better.

It's good you brought him with you.

It wasn't an iron-horse thing. It was a home Singer sewing machine from the '30s or the '20s. One of those beautiful, elegant little things that had a backstitch. I loved this machine.

And you made puppet clothes and clothes for your family?

I made puppet clothes and then I started making clothes. I remember my dad had a factory in China and he said, "Why don't you do a sketch and we'll get it made?" So I did these sketches and I made my mom a wonderful black jacquard silk quilted coat with pants, black with a red tunic. But that wasn't the first thing [I made]. It was a [skirt made of] double-faced Shetland wool. As opposed to some slimy sort of thing that feels good. Who needs fabrics to feel good? Give me wool, right?

Something nice and abrasive.

Nice and rough and scratchy. It's so chic. And I made a straight skirt for her in this double-faced wool. I didn't know what darts were—I just figured it out before I knew anything about construction. But it was a pretty nice skirt. I forget how it closed. I managed to put a zipper in it. And she wore it with a sweater and jewelry.

Did your mom say, "This is my son, Isaac. He's going to be a designer"?

I bet she said that to her girlfriends. Men and women [sat separately] in the synagogue. Men had to sit with men and women sat with [women].

When you were making puppets and things like that, were you interested in performances? Did your family take you to the theater and ballet?

We had regular trips to the ballet and theater before I went to high school. They took us on birthdays and once a month we got out to some wonderful thing or a movie. It was a big thing, for instance, to be taken to the Ziegfeld to see *Funny Girl* or something.

You were at Yeshivah [of Flatbush], but not a great student. You were caught sketching fashions in the prayer books. You would impersonate rabbis.

I would also impersonate women. It was not the thing you would be the proudest of if you were the mother of a female impersonator. I didn't do makeup and hair. I didn't do drag, but I did these unbelievable impersonations of Judy Garland, whom I was obsessed with, and Streisand. Before my voice changed, you wouldn't believe how much I sounded like these ladies. I used to draw crowds at the beach club, on the corner in Brooklyn, at Yeshivah.

Your mother had to change outfits to plead your case to keep you from being suspended.

She was kind of glamorous—always very well put together—and her hair was always big. But on days when she was going to plead my case, she would take it all off and go with her hair in a bun, looking very bedraggled so you'd feel bad for her.

Tell us about your Bar Mitzvah and what you wore.

My custom-made suit, powder-blue wool shantung, and Pierre Cardin white patent leather shoes with big buckles. Remember those socks that had the ribs going this way? They were sheer and had sort of an ottoman knit-in stripe. I wish I had those socks today.

Your father gave you an interesting gift for your Bar Mitzvah.

Oh, the scissors are you talking about? Yeah, such a [phallic] thing to give your son, a big pair of scissors.

With your name engraved.

With my name inscribed. They were huge. I still have them. I actually have my grandfather's scissors, too, which is really [fun].

They put his name on those?

I don't think there's any name, but they're ancient and I keep them in the same drawer as those [Bar Mitzvah] scissors.

That year, you switched to the High School of Performing Arts. Why?

Yeshivah was really torture. We talk a lot about bullying and how we have to get to the root of that and stop it. This was bullying on a whole other level, because it wasn't even my peers. It was rabbis. Maybe that's why I don't believe in God, because when you're bullied by a rabbi at the age of seven or ten, you tend not to believe a word they say.

And you were a little overweight then?

I was very overweight. The great thing was that it got me to trust my feelings. If people are bullying you or saying you're wrong to feel something, it doesn't make any sense.

And then you lost seventy-five pounds, how?

I didn't eat for three or four months. And when you're that age, you lose twenty-five pounds a month if you don't eat. Seriously. And my body transformed.

So you liked being at that school? You were studying performance? Dance?

Left to right: Fashion designers Isaac Mizrahi, Marc Jacobs, Todd Oldham, Anna Sui and Byron Lars attend the *Women's Wear Daily* roundtable to discuss fashion on January 30, 1993 in New York

I loved it. I was studying acting, much to the chagrin of my music teacher, who wanted me to study music. But I majored in acting, and it was the greatest.

At fifteen, you also started your first label, IS New York.

That's right. Wow. I started making clothes with my parents' friend, Sarah [Haddad] Cheney. She was a good deal older than me. She's still a good deal older than me.

And she invested?

We both invested.

With Bar Mitzvah money?

I don't know how I did that. I remember this. I went to Cugnasca fabrics—but that's just a word that flew into my crazy, Xanax brain. It was this beautiful line of Italian prints. I went into that showroom and ordered these prints. They were like [graffiti] prints, and I made beautiful clothes. We made samples and we sold them to Charivari, and we sold them to this other store called Off Broadway.

So you and Sarah, without a business plan, started a business.

Her husband was also in the children's wear business, so we used his factory in Brooklyn.

Do you remember how long it lasted?

Maybe a year and a half.

While you were in high school you took classes at Parsons on the nights you didn't go to Studio 54.

Right. It was like this nice Yeshivah boy gone mad.

Did you graduate from the High School of Performing Arts?

Yes. I will say that going to an arts high school is more important than going to an arts college. At least in my case it was. Because I feel like the exposure to Bach—I took piano lessons so I was exposed to [music]. And then to be doing *King Lear* when you're twelve and half years old—if you're not afraid of that, you're not afraid of anything. And also to have diction classes and all those great movement classes, yoga classes, it was really something.

Then you decided to go to Parsons and study design

I worked on costumes for *A Midsummer Night's Dream*. I didn't design them, but I helped and I was so thrilled. I had already been sketching, and I met Mrs. Fishman, who sent me to Parsons night school.

She was one of your critics, but you didn't let anybody know you knew each other.

Right. It was so clandestine. So I decided to go to Parsons. It seemed, for someone who likes New York so much and likes being here so much, like a better career path.

Who were some of your classmates at Parsons?

Narciso Rodriguez, Marc Jacobs. Okay—I'm just saying, I don't know how that happened, but you go on his Wikipedia page, and he has changed the date of his birth.

You can't believe anything on Wikipedia. What was the most important thing you learned at Parsons?

I don't remember exactly, but I do remember the first year I was out to sea. It was such a rigorous, great program. It was like being at med school where you're just kind of thrown into this thing that keeps going. We were always doing crazy things like pulling grain threads on muslin and thinking, why doesn't Brooke Shields pull grain threads out of muslins? What are we doing wrong? It was full-on immersion. I didn't quite get it. Then the second year, I don't know what happened in my brain, it just went like, "Oh, that's what this is about."

During your junior year, you landed an apprenticeship with Perry Ellis. Now it would be called an internship, right?

No, darling. It was called a job. Now an internship means someone comes to your office for two weeks for a few hours a day for three days a week, and they don't do anything and you give them a party at the end. And it's usually someone whom you can't offend, like a producer's daughter.

Then they put on their resume that they designed the whole collection.

Exactly.

So how did you get the job at Perry Ellis?

It was right before the summer, and [Ann Kaegi] sent me out on a job interview to Milo Moreau, who ran the costume shop at the New York Shakespeare Festival. It was this room full of sewing machines. The costumes were stored [overhead]. It was a double-high ceiling, so you had to look up and see the hems of all these beautiful Elizabethan dresses and suits of armor. It was fabulous. But I didn't take that job because I was offered one at Perry Ellis.

You were named Outstanding Student Designer when you graduated in 1982. Then you got a full-time job with Perry. That was the same year your father died.

That's right. Wow, Fern. You know what? My shrink is ninety years old. I think, when I finish with him, I think I'm going to just come straight to you.

It might be a new business. I'll think about that. Did your father die before you graduated? Did he have a sense of your success?

No. It was the first year that I was on my own in my apartment on West End Avenue. Another kind of culture shock, a fabulous thing to be living by myself.

You worked for Perry for almost two years. Why did you leave?

I felt it was a very closed situation in the design world there. I was included, but I got that I was not going to go much further with Jed Krascela and Patricia Pastor in place. They were unbelievably talented people. And you've seen the Perry Ellis book, which is so great.

By Jeffrey Banks.

That's right.

When you were ready to leave, Jeffrey was actually looking for an assistant, and he called Parsons and asked them who they would recommend, and they suggested you. You and he apparently met at the Rockefeller Center ice-skating rink early in the morning because you didn't want to be seen by anybody. Do you remember that?

Yes. I do, now that you say it.

It was Frank Rizzo who set you up with Jeffrey.

Wow, that's true.

And Jeffrey is here. He's sitting with Ellie.

Oh hi, Jeffrey Banks. [CHUCKLING] Who else is out there?

He loved your portfolio, but he didn't want to poach you from Perry because he was a good pal of Perry's.

Do you know what Perry said when I told him I was leaving him for Jeffrey Banks? He said, "Darling, you're leaving me for a black woman?"

Then after you worked for Jeffrey for about two years, you left?

Jeffrey was reorganizing his business at that point, so it was a good opportunity for me. I thought I was going to go out on my own. I just took time off. And then all of a sudden I

started having money problems. I remember going to my interview with Calvin [Klein]. I was wearing these beautiful cobalt-blue bull pants that I [had] made. I remember going into the subway, and a bag lady came up to me and asked, "Why do you scare people in those pants?" And I thought, I can't go on my interview now. So I had to go home and change. I was late to the interview because of that lady.

Did you tell Calvin that you changed your pants for the interview?

Do you know what? He kept me waiting anyway. I was half an hour late and then I waited for him for forty-five minutes.

You worked for him when he was in his prime. Did his aesthetic influence your style?

Yeah. Yes. Boy, he was great, too. I think so. He really understands tailoring. And I think that is probably the hardest part of our business: knitting and tailoring.

Are you a good knitter?

Here's how my mother taught me: That's not how you knit. This is how you knit. So for the rest of my life, I've been chasing the elusive technique.

Then you left Calvin and Sarah Haddad Cheney came back in your life and funded a new business with you called Isaac Mizrahi New York in a loft in SoHo.

That's right. And my dad, unbeknownst to me, had left me a trust fund. It wasn't much at all. It was like fifty thousand dollars.

That was a lot of money.

She had fifty thousand dollars, I had fifty thousand dollars, so we just threw it together. You can't believe how inexpensive those [SoHo] lofts were [back then]. I think it was under two thousand dollars a month for this giant loft.

Describe your collection and what made it special.

I made clothes for a year before I had any show. I was making the things that I had always wanted to make. When you work for designers like Perry and Jeffrey and Calvin, you can only impose [your own vision] so much. They're all strong people, so they're going to do what they want to do. This was my opportunity to do exactly what I wanted to do, which is glamour with a raw—

Twist?

Yeah. I do hate the word "twist." It's like I hate when people say, "pop of color." I literally fired someone once for saying that.

How would you describe it, then? Other than a pop of color, what would you say?

A really gorgeous color, or something. A pop of color just means there are, like, other pops of color or something, and it's on one of the horrible cages in a showroom and they go, "Pop of color," and you want to vomit, right? So a twist. "It's also like a twist." Really? Irony. I don't know why. I just hate that "twist." It's just everybody defaults to the word "twist." They also default to the word "decadent" when describing chocolate cake, and I want to kill those people. There is nothing decadent about food, unless you literally can't get out of bed because you're so huge and you're going to die. "Decadent" is a whole other Weimar Republic thing.

Back to your business, Isaac Mizrahi New York, which started in 1987. Two years later, you won your first CFDA award, at the time named for Perry Ellis and presented to you by Liza Minnelli. How did that feel?

[Liza] was a friend by that point. The clothes were at Bergdorf for a year before I had a show. And [Bergdorf] called and said, "Guess who just bought your clothes?" She got my number and called and said, "I'm coming down."

She wanted it wholesale.

She came in and it was this kind of bomb. She had such incredible energy and generosity and kindness. Then we started to hang out. Then CFDA asked, "Who would you like to give you the award?" So she showed up and I was backstage and I was so nervous [and] she gave me the best advice. She said, "What's your favorite thing to eat?" I said, "Ice cream." And she said, "Picture that this is all over in two hours and you're sitting in your bed eating a giant bowl of ice cream. No matter how bad it is, if people start throwing things at you onstage, two hours later you will be eating ice cream."

Something to look forward to.

It just made so much sense to me, you know?

Do you still think of that advice when you perform?

Absolutely. And the other thing I think about is Liza herself and what an inspiration she is—the way she does what she does, her commitment.

The following year you got another CFDA award for Designer of the Year. And in 1990 you collaborated with Twyla Tharp for the American Ballet Theatre with tartan costumes.

Now, wait a minute. Back up, hold on there. Because I forgot to tell you, that year that I was making clothes before I had my show was really formative. There was an unbelievable woman in my life called Julie Britt. Does anybody remember the great and fabulous Julie Britt? She discovered me and brought me to Avedon to make clothes for sittings, because I guess they couldn't get anyone to do that. I made clothes for these wonderful sittings with fabulous women, like Audrey Hepburn. That's how I met Twyla Tharp. Dick [Avedon] said to Twyla, "Oh, he just did the Scottish collection," because she was about to make a beautiful Scottish ballet. The next thing I knew I got this call, which was destiny.

That was your first collaboration with costume and dance professions. And the following year you won another CFDA award, so you were really on a roll. The following year Chanel came on board to back you financially. Then you started working with Mark Morris. Tell us how you met and began to collaborate. Because he's an important part of your life.

Mark, hmm. Well, Anna Wintour set us up on a date. She's the biggest yenta in the world. Are you kidding? She loves a good match. We were at a dinner party and he was sitting on one side and I was sitting on one side and she said, "Mark, you should get Isaac to do costumes." Right? And Mark said, "Oh, I only work with artists." And then I said, "Well, I don't like fat dancers anyway, so it's good that I'm not an artist." And then we went on a date.

A match made in heaven?

We went on a few dates, and then we decided it wasn't about that, [we were] just really good friends. Then he called because he was doing this solo with beautiful Gershwin music. And I made the first costume and I went mad because it was double cast. I made clothes for [Mikhail] Baryshnikov, and that's how I met Mr. Baryshnikov.

Nice.

It's weird, when I met him it was a whole combination of feelings and things for this person. Anger and sexual attraction and hatred and love. Really, I love this man so much.

A year or two later came *Unzipped*, which I think is the best documentary about the fashion runway, done by your then-boyfriend, Douglas Keeve. Tell us how that came about. Who had the idea to do that?

There was a culture in my studio. Ellen Saltzman can attest to that. It was a fun place to be. There were loads of fabulous women in and out. People used to come over for tea for no reason. And fittings were always happening. Douglas and Nina [Santisi] and I agreed that it would be really funny if we captured that whole energy. At the same time, I was approached by AIDS Project Los Angeles to do their annual benefit. The year before Calvin [Klein] had done it.

At the Hollywood Bowl. Tina Turner danced and sang.

It was a big act to follow.

So you were going to make a movie to be part of [the benefit].

Yes. And I said, "I'm probably not going to do this unless you can get Grauman's Chinese Theatre, because I love that place." And they said, "Okay, we got that." So we had to make this movie and Douglas just started shooting.

I was running the tents at that time in Bryant Park, and I remember the discussions in our office about the scrim we needed to find [for your show]. It was a huge screen that had to be transparent so when the lights went on—

It's not the hardest thing in the world to find a scrim.

Right, but we happily had to redesign a lot of stuff for you.

I will tell you this, Fern. I was not a big proponent of the tents. What is a fashion show if not an individual statement of somebody's work? So [I said to people], "I'm sorry I have to drag you to this crazy location."

I got dragged to one of your shows in SoHo when the power went out and there were a thousand people sitting in the pitch black. We had to wait thirty minutes for the backup generators. And nobody would leave because it was an Isaac show.

Right, and by the way, the lighting designer left. He was at his next show at the tents. [I felt] like, I was forced to do my show at the tents.

It was like twisting your arm?

It kind of was, yes. I thought, okay, how do I set this apart? The other thought I had was that fashion was becoming very deconstructed. But it was a moment that I just didn't exactly understand, like how we were supposed to be looking at women. I thought the only way I

Clockwise, from top: Naomi Campbell, Isaac Mizrahi, and Linda Evangelista featured in *Unzipped*, 1995; "The Adventures of Sandee the Supermodel," created by Isaac Mizrahi and illustrator William Frawley; Isaac Mizrahi and models backstage behind a sheer scrim during his Fall 1994 ready-to-wear collection, the subject for the documentary *Unzipped*. Following spread: Isaac Mizrahi after his Fall/Winter 2011 show

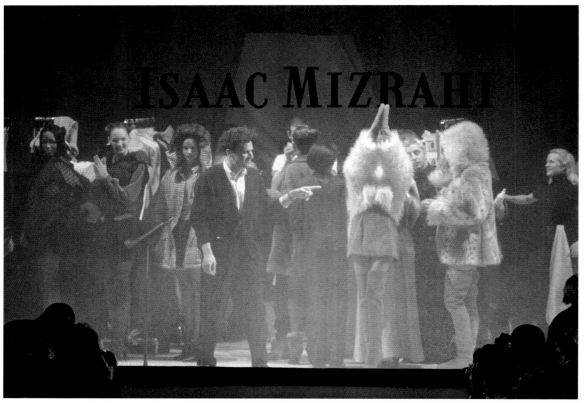

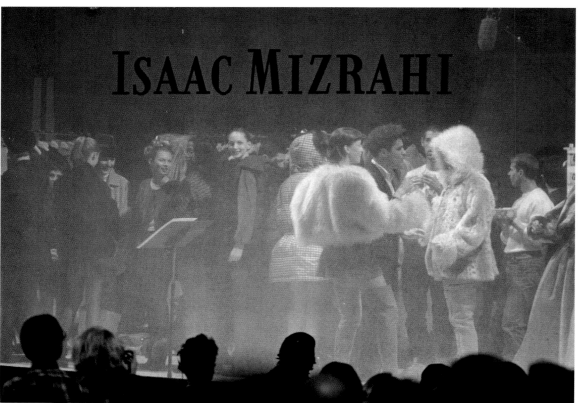

can make these really glamorous clothes and make them even more relevant is to involve people in the process. The idea was that the audience gets to see the girls changing.

Did you have to convince the girls—Naomi, Cindy, Linda, all the big names—to participate in this?

Yes, I did.

So we were watching them get undressed—

I thought, doesn't everybody want a picture of the backstage more than they do the front stage? And I was right about that, I have to tell you, because it became this crazy obsession of photographers backstage, and after two or three seasons it was like, "No, no, you people, you have to take pictures of the runway, please."

Has everybody in this room seen *Unzipped*? [APPLAUSE] I think it started a trend.

I know it did. I'm so happy it did.

Then you did your first comic book series, *The Adventures of Sandee the Supermodel*.

With the fabulous William Frawley. He's a great illustrator. It was supposed to become a movie but it never did, sadly. It might. There's still time.

Then Chanel pulled out [as a financial backer of your business].

I've never told that story and I think I should. It was a moment when they had a proposition for me. If you lose this number of millions of dollars a year, you can't go on forever. I didn't like that. I'm not feeling this. So I think I'm going to close. I didn't understand the repercussions. I just thought, eh, I'll do something else.

Do you know what you did that night? Do you remember?

I do. I remember I went with Mark Morris and Anna Wintour to see Matthew Bourne's *Swan Lake*. Is that what you were going to say?

Yes. I had organized a special performance for CFDA members. Then you were in Woody Allen's movies. What was that about?

I just got a call and they said, "Would you be in this movie? And can you grow a beard?" And I said yes, because what are you going to say? And they sent me two pages of dialogue, because they don't send the [full] script. Guess who was in that movie? It was Charlize Theron. Nobody knew who she was. All I remember was that she hated her makeup, so she went to her trailer and redid her own makeup.

And then you created Les Mizrahi, your cabaret act.

I did. I did. I did. I did. [LAUGHTER] I thought it was a good time to do something else. But I had been working on it for a long time. It was a lot of writing and a lot of stories. People would look at them and edit them and give me ideas. I worked with a number of really talented directors, like Moisés Kaufman and Joe Mantello and a lot of good directors who ended up hating the show and hating me.

How long did it run?

It ran for about six months, but it could have run indefinitely. Let me tell you something about shows. They're really hard and it gets dull to do the same thing every single day. So after six months, you go, yeah, maybe Isabella Rossellini wants to do this show. Maybe Brooke Shields wants to step in for the second cast. So I workshopped the show at Joe's Pub and all these wonderful cabaret venues. And then finally it felt like it was coming to an end, but my darling friend Wendall Harrington—a great lighting designer whom I met through Stephen Sondheim—was like, "No. You should meet the people at the Drama

Department, [including playwright] Douglas Carter Beane," and they produced my show.

You then hosted your own talk show on Oxygen. Was that fun?

It was really fun. I wonder if anybody else has this experience. Someone asks you if something was really fun, you [say] yeah, that was really fun. But if you actually remember what it was like, it was hell. But somehow you look back on it fondly. It's like when someone says, "Oh, it's so relaxing to cook." Are they crazy? What are they cooking? Frozen dinners? It's hell to cook. But when you look back on it, you think, ah, what a great cake I baked. It was lovely—it's like, "Oh it's so relaxing to practice the piano." I guess for a three-year-old. To play the piano, it's not relaxing.

What is relaxing to you?

Bathing. I like to bathe. I love my dogs.

Then you got your Drama Desk Award, did the costumes for Claire Boothe Luce's *The Women* at the Roundabout, appeared in *Sex in the City*, and then the next *Hollywood Ending*, another Woody Allen movie.

There was a third Woody Allen movie, I can't remember the name, but I remember playing a scene with Tracey Ullman, and I was a chef.

Then you made news in 2003 when you inked a big deal with Target. And you simultaneously did your couture label, IM to Order, with your business partner, Marisa Gardini. How did you guys get together? On this stage we've talked a lot about how important having a partner is to being successful in business.

Really important. Marisa was an employee at my company that was formed in 1986. She was working in a lot of different capacities including public relations and—oh, what do they call that, some kind of resource to do with humans—

Human resources.

Human resources, exactly. She worked in human resources. And then we became friends. And then when all of that went away, we maintained our friendship. She just got everything. She just got me. She got the clothes. She got my sense of humor. She got my sense of theater. We had all these crazy feelings for each other. She was the one who said, "Oh you know, there was this call from Target. Maybe we should call them back." Okay, go ahead. Do what you want. I'm busy. She convinced me of that idea.

Your collection with Target started a whole trend. You opened the doors for designers to make cool and fashionable mass clothing at affordable prices.

I know. I know. I know. And the first fashion show we had was so fabulous.

Bergdorf Goodman did it with you at Cipriani.

That's right, I wanted to call it "Obsessive Compulsive Shopping Disorder," like you'd buy anything, [whether] it [cost] twenty-five grand or twenty-five dollars. That was the joke. Of course Target was like, "Maybe we shouldn't call it that. How about 'High/Low'?"

Then you had another TV gig, *The Isaac Show*, a fashion advice show on the Style network. That led to you doing the red carpet commentaries—for which you got in trouble. Why were you feeling people's breasts?

I was feeling underwire, not breasts. If you're a designer, you feel a lot of things.

But not on TV on the red carpet with a celebrity.

Who knows? If you're working with someone and they're giggling and you're talking about underwear and underwire—

You were asking everybody what their underwear was?

Yes. I think that is what fashion is really about. As Christian Dior said, there is no fashion without foundation. Right? That's the truth. It's the underwear.

When the contract with Target was up, you became designer and creative director of Liz Claiborne. But ultimately that was a short-lived collaboration.

We did this giant launch. It was gorgeous. I redid the whole showroom, the old Perry Ellis space, which is so ironic. And I redid this beautiful collection. Then it was like 2008 [the start of the recession], so nobody bought anything.

That was a bad year.

Exactly. And suddenly they announced that they were doing this J.C. Penny line, so that was it. I honestly thought that was kind of funny.

You then made another incredible deal in 2009 with QVC: The Isaac Mizrahi Live collection. They were also selling Liz Claiborne for a while.

Marisa keeps making these deals. We're very lucky about that.

So you're on TV talking to millions of women all over the country and getting instant feedback about what's working and what's not. Do you enjoy that?

I really do. I do more and more because I love the product.

And you broadcast in Pennsylvania. So you like talking to Shirley in Omaha.

I do. I like people. Sometimes they say things like, "I have cancer and I love watching you because you're funny."

That's touching. They open up to you.

Yes, they do. I really love them. I like most people. You have to be pretty god-awful for me not to like you.

Are there new items and collections every week? That's a lot of merchandise.

Yes, for the most part. But we also do another collection that is sold at retail, and there are another fifty licenses.

When you launched QVC, that was the year that you and Kelly Rowland and I were on _The Fashion Show_ on Bravo.

That was fun. Here's what was fun about that. Being in really close proximity to Andy Cohen because he's so cute.

Do you think you could've been as successful as Michael Kors in judging those shows? Would you have wanted to do that longer?

I liked the critical dialogue. My work is talked about a lot. Why not talk about other people's

This page, left to right: Isaac with his dog Harry at a doggie luncheon, Tribeca Grand Hotel; Isaac on QVC. Page 386: Isaac Mizrahi with his husband, Arnold Germer, at the twelfth annual ASPCA Bergh Ball "RESCUE ME," the Plaza Hotel, New York

work? But there were angry Tweets [saying], "Who do you think you are?" There was often this comparison to Michael Kors and *Project Runway*. I wasn't prepared for that.

There's room for lots of those shows.

No, there isn't. That's what we learned. We did it for two seasons and we learned the hard way. It was like, if it's not *Project Runway*, they don't want to see it. And yet there are hundreds of Food Networks.

In 2010, you dressed First Lady Michelle Obama, who wore your dress to the State of the Union. Did you know she would wear it?

I knew at the last minute. She likes my clothes.

But that's a big moment.

Yeah. It was a big moment. But there was also a picture of her on the cover of the *Times* in a purple dress. Did you ever see that? You missed that? Now, if you were my shrink, I'd be really upset.

Were you watching the State of the Union and saw her come out? Were people calling you, saying, "Oh my God, Isaac, it's your dress"?

I was out in a restaurant and the fabulous Jayne Harkness called.

Then you had your first directorial debut in St. Louis with Stephen Sondheim's *A Little Night Music*. Is directing the ultimate trip?

Yeah. And there's a wonderful guy called James Robinson who runs that festival, which gets amazing artists and a lot of attention.

Then you sold your brand to XL Brands. And now you're licensing everything—footwear, denim, handbags, accessories, and even fragrances—under the name Fabulous. How did you get that name? It wasn't already [in use]?

I asked for it and they gave it to me. You have to ask for things.

Your collections are sold in Bloomingdale's, Nordstrom. Where else?

Lord & Taylor. I love my store in Southampton. We're planning to open more stores soon.

In 2011, you also celebrated another very special event. You married your boyfriend of twelve years, Arnold Germer. Why did you decide to marry?

I'm ten years older than Arnold. My generation was sort of anti-marriage—that's what straight people do. We didn't really understand. We trained ourselves to believe that it wasn't a good thing. Then I just thought, being a gay fashion icon, I should somehow represent and do this thing to make someone happy.

You made me happy.

I want to make Rachel Maddow happy. It's like, who would be really happy that I got married, right?

Arnold. So where and how did you do it? I read that you announced it on *The Wendy Williams Show*. And your mother had to call to say congratulations.

We went to city hall with Marisa.

Was your mother there, too?

No, she was in Florida. We just wanted me and Arnold and Marisa, as a witness. We didn't really tell anybody, but we didn't keep it a secret.

Did you go to lunch somewhere fancy?

We went to Sant Ambroeus. And then we went to Bridgehampton that night and went to this restaurant in Sag Harbor called Il Capuccino, with Chianti bottles and gingham table-

cloths, like *Lady and the Tramp*. It was like the craziest cliché.

Have you gone back since?

Yeah, we go back every anniversary. There's something so magical and sweet about marriage that you don't get until you actually are married. I remember when I got my dog. Immediately I loved the dog, and then for a few hours I felt trapped, like, oh my God. What have I done? A dog. He depends on me. He needs me.

Are you comparing getting a dog to your wedding?

No, but there is a moment where you feel like, "Oh Jesus, what did I do? Now I'm trapped." But when I got married I never felt that for one second. It was like this magical thing once we were married and we had this license. It must be all of the episodes of *Leave It to Beaver* that I grew up watching. Or all those Douglas Sirk movies I watched, where you had to be married in order to have validation.

Not to get too personal, but you and Arnold have separate bedrooms?

We do. I don't sleep well so I feel like it's mean to inflict that on anybody. I want to spare Arnold. When we travel we share a room. That makes it really difficult, if we travel together.

I read Arnold is a very good cook. And you have TVs in how many rooms?

We have so many TVs. I really like TV.

What are you obsessed with watching?

I love any [of the] *Real Housewives* [series]. Any Andy Cohen. I love Coven. It's the gayest thing in the world. It's like all these crazy actresses. It's the most florid, ridiculous thing. They're all overacting their heads off. It's great.

Are you and Arnold interested in having children?

What do you think? I'm not kidding. What do you think?

I think not.

I know. So far I have not exactly felt it but… it might still come. I think about it a lot.

Because he's a younger man, you said—

That's the thing. I think if we both agree then maybe it will happen. I'm not sure.

Okay, well, I think you both have to agree on that. Are you developing a new TV show?

I'm developing a few shows. I'm excited about the idea of becoming a TV producer, too. Not everything that I develop has to be a thing for me to be in. I'm [also] writing a movie, which doesn't mean anything. Everybody's writing a movie.

Did you like Tom Ford's [foray into] moviemaking?

I didn't see it.

You never saw it?

Nope, I promise you I did not see it. The thing I'm most excited about is *The Magic Flute*.

Will it be anywhere besides St. Louis?

Probably not. I did the *Peter & the Wolf* show at the Guggenheim, right before Christmas. It was so good, with all these crazy people in it and a beautiful choreographer that I work with now called John Heginbotham.

What theater directors or designers have you learned from?

When I was at the High School of Performing Arts, I had all these friends in ballet. I went to City Ballet all the time. Half the time I didn't know what I was looking at, and I hated it. But then the other half of the time I loved it. I really acquired a taste from Merce Cunningham. I always think I learned more from those shows than anything else—everything about design,

everything about stage, everything about legs. It was a good education.

How often do you go to the theater now?

Whenever I can. I love live theater, love it.

Is there advice you would give a young designer?

I don't really have advice, because you can't tell [people] to love what they're doing. If they don't, it's never going to work.

Where do you get nourished and recharged?

In my house in Bridgehampton. I really love [that] house. A lot. And it's not the best house—it's like a little shack.

Are you mourning the closing of Loehmann's?

Yes. That is the end of the world, honey. That is like global warming.

What's your favorite fashion movie? Who's your favorite supermodel?

There's a wonderful fashion show sequence in *The Women*. I think that's my favorite. Everybody thinks it's wrong because it's in color, but I think it's great that it's in color. My favorite supermodel is probably Christy Turlington. I used to say if I could look like Christy Turlington for ten minutes, you wouldn't recognize me when I came back.

This is an audience question: "I love to wear heels, but not on city streets. But I'm now schlepping a big bag. How do you wear nice shoes to go out and not look like a bag lady?"

You don't have to wear heels. You don't have to wear anything you don't want to wear. You can wear a strapless cocktail dress and Uggs and it'll look fine. It's more interesting to do that, don't you think? When I was a kid, it was much better to wear flip-flops with evening dresses than it was to wear those big shoes. I don't think it's very chic now, but too bad, it's better. It bespeaks an actual personal style, not a stylist's style. It bespeaks a kind of confidence that you don't have when you're wearing those giant shoes that you can't run in. I never liked those big shoes. You're trapped in those shoes.

Are you very involved with social media? Do you do your own Tweets, Instagram?

I like Twitter a lot. I don't really get Instagram, but I'm on it. I'm not on Facebook. I like Twitter because it's short, it's clever, and you can un-follow people.

Do you know how many people follow you?

No, I don't. Like fifty thousand people or something?

Last question. What's on your bucket list? And don't ask "What's a bucket list?"

I know what a bucket list is. Oh yeah. I do want to write a television series.

What would it be about?

I don't know. There are a number of things. I want it to be good. That's what I want it to be, really good.

Absolutely. Funny? A comedy?

Probably. Yes, absolutely.

Whom would you want to cast in it?

A lot of people. Allison Janney. I love her. Don't you? Yeah, that's who I want to cast on my show, just me and Allison Janney.

So create a show with her in mind. Sometimes that's the inspiration.

Totally, totally. You're so right about that.

Isaac, this has been a pleasure. Thank you all. Thank you, Isaac.

Thank you. Thank you, thank you, you're the best. [APPLAUSE]

JOHN VARVATOS

If I were ever to agree to have a blind date again in my life, I can tell you that if the door opened and the man was wearing John Varvatos, we'd be off to a great start. Today, in this country and actually in all the fashion capitals, menswear is at an all-time high. There are many terrific young men's designers, and the attention paid to men's fashion and style has never been more intense. Quite frankly, it's almost more exciting than the women's fashions these days. One of the designers most responsible for bringing this attention and great design to the men in our lives is one really nice, very likable, very cool guy who hails from Detroit. John Varvatos never set out to be a designer. He did what I've always urged every aspiring young designer to do. He worked in retail and worked for a few iconic designers, and he learned the business of fashion. And then he was off and running. His Detroit roots also kicked in when he made music an integral element to communicate his philosophy and designs to the world. He listened to music growing up to escape his family of five siblings and two parents in a tiny house of approximately seven hundred square feet with one bathroom. And now the music has come full circle in his life and business, with inspiration coming from every genre. He now hangs out with the musicians he grew up idolizing. He's collaborated on marketing campaigns with the likes of Willie Nelson, Joe Perry, Chris Cornell, Iggy Pop, Alice Cooper, Jimmy Page, Robert Plant, ZZ Top, Velvet Revolver, Lenny Kravitz, Peter Frampton, Dave Stewart, Dave Navarro, The Roots, Green Day, Ringo Starr, and tons more. And he shook up everyone in Milan when rock legends Kiss walked the runway with him. His extensive photography collection continues to inspire him with images of Jimi Hendrix, the Rolling Stones, MC5, and The Who. You can see many of these valuable photos hanging in his stores or in his book John Varvatos: Rock in Fashion. He was a key judge for two seasons of NBC's Fashion Star. John Varvatos's London store sits close to Hermès, Burberry, Prada, and Louis Vuitton, and additional stores are in Houston, Beverly Hills, Mexico City, and Bangkok. John has also launched John Varvatos Records, in partnership with Republic Records. He serves as a curator and president, spearheading the signing of new acts and the release of high-profile reissues and compilations. He's looking to find the next Guns N' Roses, and he should know about how to do that. He has forty thousand songs on his iPod, owns fifteen thousand albums, and goes to at least seventy-five concerts a year. Ladies and gentlemen, let's give a nice rock-and-roll welcome to the man GQ described as Sinatra meets Slash, John Varvatos.

JOHN VARVATOS: I like that Sinatra-meets-Slash thing.

FERN MALLIS: I know. That works. So, John, thank you for joining me tonight. And thank you for the Jimi Hendrix Collection John Varvatos jacket.

Excited to be here. You know it says "Einstein" up on the wall there, so we're in the presence of great minds.

Good company. We always start at the beginning at these talks. And I mean the real beginning. You were born on August 8, 1955. That makes you how old?

Oh geez, too old.

How old do you feel?

Oh, I don't feel half my age for sure. I always say that I think I have more energy than all the young people who work around me. Some people kind of have the slow walk, the slow pace, and for me, I've always got a lot of energy.

You were born in Michigan. In Detroit?

Yeah, in Detroit.

You're a Leo, a lion. Leos are confident, ambitious, generous, loyal, and encouraging, but also pretentious, domineering, stubborn, and vain. Any or all of that true?

I'd throw some of those out. I don't really think the "vanity" part of it as much. "Stubborn" fits in perfectly.

Leos are independent, but need something to control and someone to admire and appreciate them. People are attracted to Leos' zestful life and their warm spirit. They are the ultimate friend. They don't hold grudges and are very forgiving.

I believe that's true.

They're also excellent leaders in their kingdom. They can delegate and give orders, but they can't take them. And they won't settle for second best.

I believe all of that's true as well.

Tell us about your parents. They were Greek American. What were their names?

My father is George John, and I'm John George. And they grew up in Detroit.

Did they meet in Detroit?

They met in Detroit, two first-generation immigrants from Greece. My mother's name was Catherine, and they were born in 1925, 1926—around there. My father died when he was in his early fifties, of leukemia. And my mother, about ten years ago.

How long were they married?

Oh geez, before my father passed away? Probably twenty, twenty-four years maybe.

And he was an accountant.

Yes, it was a very kind of lower-middle-class environment. I grew up in quite a small home, as you mentioned, with one little bathroom and seven people running around to get ready in the morning. But it was all about the kids. My mother was a stay-at-home mom with five kids and had her hands full. And my father worked six days a week. He had a job on Saturdays in a shoe store, to earn extra money.

The five kids were brothers, sisters?

Two brothers and two sisters. I'm the second oldest.

Are they all still with you? Are you all [still] close?

Yeah. Three of them live in Michigan and one of them lives in Chicago. And my youngest brother lives in the house that my parents raised us in.

The house with the one bathroom?

Yep.

So describe that. What was the family dynamic like?

Crowded. It was a very crowded dynamic. First of all you have those five kids that are a year and a half to two years apart, so it's very tight. I shared a small bedroom with two brothers. When you're really young, you don't really notice it that much. That's just how your life is. As you are exposed to other people and you see how other people live, you learn that things

Clockwise from top right: John as a young boy; John with his sisters Elaine and Christine and brothers Dennis and Evan; John as a teenager

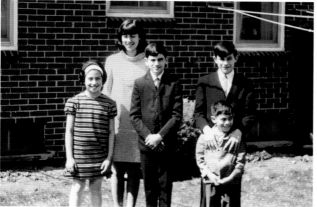

Rock band MC5,
circa 1970

are a little smaller in your world. But it was a very close, loving family, all of those positive things, which made life easier. But the space got small, and I used to go down in our basement and put headphones on and listen to music, and it was kind of like my little boy cave.

What did you listen to?

I guess it was rock and roll. At the time, I was never as much of a Beatles fan. It started with the Rolling Stones and The Who and some of the Detroit bands at the time. And there was a little record store in our town—when I was old enough to really be able to buy records from my paper route or cutting lawns—called Sam's Jams. I used to go there and spend my three dollars on a vinyl record.

At twelve, you also went to your first concert. Who was that?

I went to see one of my all-time favorite bands. I had a friend whose brothers were in bands in the Detroit area, so we shuffled along to shows with them, helping them carry their equipment and that type of thing in a place called [the Grande] Ballroom. And we saw the MC5, which are the Motor City Five, a very famous band in Detroit, at least in my generation.

Did you want to be a rock star then?

From the time I first saw the Rolling Stones on Ed Sullivan or whatever, I wanted to be a rock star. I didn't have the ability. I never really took lessons. We also didn't have the resources in my family for lessons or equipment. But yeah, I was so influenced by musicians in so many ways. Everybody has icons they look up to, and for me it was musicians.

I read that you wanted to grow your hair long but your parents forbade it.

Until I went to college, where they really couldn't say as much. My parents were pretty strict, you know. They were great, and I kind of appreciate some of it now that I have kids. But at the time, of course, being a rebellious kid, it was not always fun. But they didn't really get the long-hair thing.

But you did play in a band in high school, the Golden Sound? Did weddings and school events?

Yeah. I wouldn't really call it "playing" that much, but somehow we got by. It was my cousin Tim on drums.

And your uncle Gus was the manager. Tell us about Uncle Gus.

My uncle Gus was a character among characters. I actually miss my uncle Gus a lot. He grew up in a time of jitterbugging, that kind of dancing. I had two cousins from my uncle Gus. One of them played drums and he was a real character. And he [Uncle Gus] thought that we were going to take him and us—

Right to stardom.

Exactly, right to stardom. I remember before we played this wedding and he had this electric blue sharkskin suit on. A lot of the people on my design team know about my uncle Gus, because certain times when we're looking at colors and fabrics, we go, "That's an Uncle Gus fabric right there."

I think there should be a little Uncle Gus Collection, a little Rock and Roll Gus.

Put me out of business.

But then didn't you create a small band, Sweet Wine, with your cousin?

It evolved into Sweet Wine when we were old enough to sneak wine, because that was the kind of wine we drank. I don't like to talk about it much because when you really think about how bad you were at the time…

You went to Allen Park High School in the Allen Park section of Detroit. And you secretly shopped in the hippie neighborhood?

San Francisco had Haight-Ashbury, and Detroit had its version of it. We were about ten minutes away from central downtown Detroit. Even by bike it was—by Schwinn bike [although] I didn't have a Schwinn, they were kind of expensive; I had a Rollfast—still only fifteen or twenty minutes. I had to sneak those kinds of things into my closet.

Describe the sweater that you wore that made an impression on a girl for the first time, and you realized the power of fashion.

I think I was in seventh or eighth grade, and I really started to think about girls at that point in time. And yes, I am a straight designer. My wife is here someplace. And so I started to think about clothes a bit, and I had this sweater with a star on it. I wore it to class one day, and one of the girls whom I had a crush on really got into it and told me how much she liked it. And from that moment, every day I had to really think about what I wore to that class. And it was the impulse for me to eventually get a job in a men's store so I could get a clothing allowance. You know, it was like rock musicians' talk—it's all about the girls? At that point in time, it was all about the girls for sure.

That's as good a reason as any to work in a store. To get the discount.

Exactly. It's the only reason.

That was Hughes & Hatcher. And you started in the layaway department and worked your way up to sales clerk.

I had a lot of funny stories in the layaway department because there were a lot of characters in Detroit. A lot of people don't even know what layaway is today, but people would come in and buy a leather jacket or a suit. They'd put two dollars a week down, and sometimes it'd take them years to pay for it. I remember one time I was working in Ann Arbor, Michigan, where I went to the university. And a guy came up to me and I was selling him a leather jacket, and he said, "I want to put it up." And I was like, "Where do you want to put it?" He went, "I wants to put it on layaways." And so he gave me five dollars, and it started his payment on that four-hundred-dollar leather jacket.

And you still have the leather jacket that you bought for yourself in those days.

There was a band that I grew up with that is probably my favorite—well, not probably—is my favorite and most influential band for so many reasons: the Stooges with Iggy Pop. At the time, they were just the Stooges. When I bought their first album and looked at the pictures of them and the way they looked in black leather jackets and kind of skinny jeans with little flares at the bottom, it was very against what was happening in the market at the time. It was much more of a hippie movement, and they were not hippies at all. I love that whole aura. I had a gatefold of an album called *Fun House*. And I would look at that gatefold of them lying on an oriental rug in the recording studio, and I wanted to be those guys for sure. In the Downriver area, where I lived in Detroit, there was a very famous motorcycle jacket company that I didn't know was famous at the time. I learned about it later. I just knew they made these really amazing, simple motorcycle jackets. I actually almost wore it tonight, because it is my most favorite piece that I've ever owned.

Okay, you got a degree in education. You were going to become a science teacher. What happened?

Well actually, it's even worse than that. I actually went into pre-med. About three years in I said, "I don't really want this." Was I going to be a doctor? Was I going to be a vet? What was I going to do? Like a lot of young people, you go to college and you're not really clear on what your path is going to be. So I don't think I thought that much about my path when I was in college. I was just kind of getting by. I never missed class. I listened in class and took notes so I could cram really well. But I didn't have a real vision at that time. In the end it came back to a science teacher because I had taken so much chemistry, physics, biology. And when I did graduate—

From the University of Michigan.

I did teach science. A chemistry lab at Eastern Michigan [University], which was great because I was twenty-two or twenty-three years old, and the girls in the class were twenty-one or twenty-two years old. And they all needed help. But I was still working in retail, and I was making significantly more [than in my teaching job]. Back then, a full-time teacher was making fifteen thousand, seventeen thousand, and we still don't pay teachers anything that they deserve. And so I was working in retail. My parents didn't really have money to send me, so I worked my way through college and took student loans and then tried not to pay them back but had to when the government came after me.

You became a partner in the Grand Rapids men's store, Fitzgerald's. How did you become a partner in the store?

I heard about a guy who wanted to open up a store in Grand Rapids, in a luxury center that his family owned. I went to Grand Rapids to visit him, which was about three hours away from where I lived, in a beautiful but very conservative community. I thought it was a great opportunity for me. He wasn't going to be a working partner in the store. He was really looking for someone to run the store, and he felt there was something missing in the community. So it gave me my own little stage to do my own thing. That was my start of a men's store. The wife of the guy had already decided that it should be called Fitzgerald's. So that's what it was, even though there wasn't anybody called Fitzgerald.

And Polo Ralph Lauren was a big brand that they carried, right?

Yeah, this was in the early 1980s, so before Ralph really blew up. We were a unique Polo account because we weren't just about the polo shirt and the basic kind of things. We really

Clockwise from top: Portrait of
John Varvatos, 2009;
John Varvatos and Iggy Pop;
The Stooges in the studio while
making their second album,
Fun House, 1970

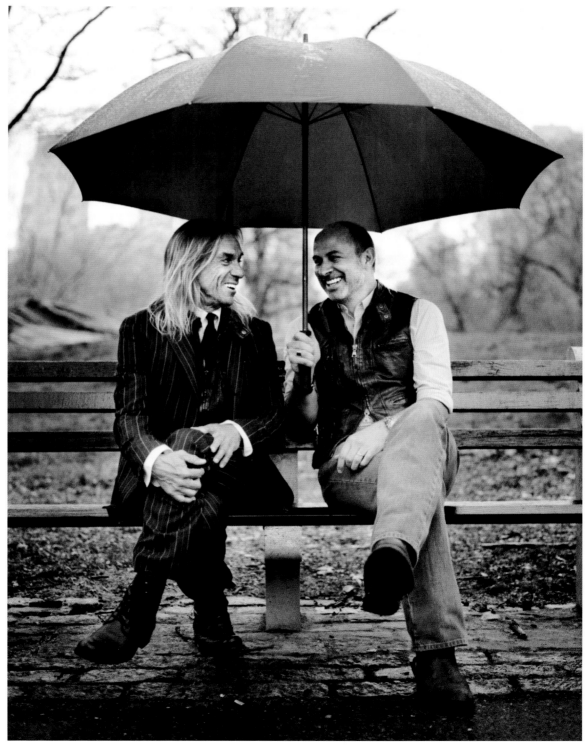

carried the whole lifestyle in the store. And the people from Ralph Lauren loved what we did, and that's actually how I ended up connecting with them later.

Were there other designer lines that you remember?

In menswear there was Calvin Klein and maybe Geoffrey Beene, but that wasn't a real men's line. That was just a name that they put on something. So Calvin was really the only other. The designer world didn't blossom until the later 1980s, early '90s.

I read that you sold so much Polo Ralph Lauren that they hired you to be their Midwest regional sales manager out of Chicago.

Something like that. They loved our store. Even the president of Ralph Lauren had been out to visit our store to find out what everybody was talking about and what was unique about it. So when I started to have a bit of a falling out with my partner, the president of Ralph Lauren contacted me and asked me if I'd be interested in taking over the Midwest region for them. It was just really starting to accelerate.

And then you did so well, they brought you to New York.

I'm still in my twenties at that point, and about a year out of Chicago, they asked me to come to New York to take over the sales for the men's company.

Was that like, "Oh my God, I've made it"?

That's the year I said that I'm going to be retired by the time I'm forty to forty-five.

It's a dream job.

Yeah, it was really. I worked like a dog. It's not so glamorous. But I learned more in my first month at Ralph Lauren than I learned in my entire career. I call it Polo University. I wanted to be the biggest sponge in the world. I wanted to suck up every single bit of information and knowledge about everything. I felt like if I was really going to be successful, that would be the way I was going to do it.

Do you remember anything that you specifically learned from Ralph?

Oh, so many things I learned from Ralph. The first thing I learned was that the bar is never raised high enough, that you always have to raise the bar. And there was never a designer that created a lifestyle before Ralph Lauren. People designed clothes or furniture, but they didn't design a whole lifestyle brand before him. I wanted to live that life, to some degree. I didn't necessarily want to have polo horses and all those things, but you wanted to have that life that was grand and special. And I learned how to be a better businessperson. We had to teach ourselves, because we were all learning when the company was growing. There weren't things in the stores like shop-in-shops. We started that whole shop-in-shop thing when I was there. Coordinators and merchants that were out in the department stores, those weren't in existence. So we all had to fall down and get scars on our knees and put Band-Aids on them because there wasn't a rulebook. I'm actually kind of proud now that I'm sitting here, and I think that I was part of developing that rulebook. Ralph and a few of his senior people, especially Ralph, were really the vision for where that brand would go and still is. He's still the visionary there.

Where was your first place you lived when you came to New York?

I lived in Westport, Connecticut, because I had two young kids.

When did you get married?

I got married when I was twenty-five. When I moved here I was twenty-nine or something, and I went out to Westport. I love New York. But my wife at the time was not that enamored

with the whole thought of uprooting and moving and everything. And so going out to Connecticut was a little easier, especially with kids, John Jr. and Lyndsey.

And they are now twenty-seven and twenty-nine. What are they doing?

My daughter, who's twenty-seven, graduated from one of the Florida universities with a degree in criminology, and she's bartending. She had an opportunity in Washington, D.C., and that FBI kind of thing, but she didn't want to pursue it so she's bartending in Key West. So if you're down there, check her out. She's really very cute, actually.

There are a lot of criminals at the bar.

And my son, who's been in school and out of school and film school and different things, is now back in school in his late twenties, on track with a vision of what he wants to do, in Chicago. So that's what they do, and they're happy kids.

So he's studying film?

He actually is working to be a drug rehab counselor.

So maybe the drug rehab counseling and the criminologist daughter can work together. Okay, so back to 1990. You left Ralph Lauren to go to Calvin Klein as president of men's design. How did Ralph react to that?

Not really well at the time. But it happened very quickly. I wasn't the most senior member of the team when I was there. I think that Ralph and other senior members were kind of disappointed, but that's life and you move on.

At Calvin, you oversaw the launch of the CK brand, the famously successful underwear business. And I read that you cut up a pair of long johns and gave birth to the boxer briefs. Is that right?

Something like that. When I went to join Calvin, the real draw to me was that he had had a brand where his business was in jeans—and a little bit of underwear because it had kind of fallen apart a bit—and, actually, all of his businesses were much smaller [then]. It was more in licensed kind of things. And he wanted to take it all back because he had lost control of a lot of the things in licensing. He had a women's collection, which he had had for a number of years. which was successful, and he wanted to start a Calvin Klein men's collection. So that was really the first call to order and the first call to duty for me, to come in and create a Calvin Klein men's collection with him. When that was happening, the whole thought of doing something that was more accessible but designer came about with CK. And then there was this dormant thing sitting over to the left there, this underwear business, which was at the time I think doing $30 million dollars.

That was the dormant business, $30 million?

Yeah, it was about $30 million dollars. And when I left about four years later—[and this was] not all because of me—the spark of the boxer brief and Mark Wahlberg, Marky Mark, wearing it everywhere was—

The billboards [were crazy].

The billboards, the planes—when I left, it was a $400 million-dollar underwear business. So it just shows you, when things catch on, they really can catch on. I call that the Dow Chemical explosion of things happening.

What would you say was the biggest difference between working for Calvin versus working for Ralph?

Completely different guys, and their personalities were completely different. Very, very smart

guys, both of them. Ralph was all-American, Ivy League, preppy, lifestyle, beauty, beautiful people, that type of thing. Calvin wanted to be edgy, push the envelope constantly. Both great marketers, but completely different marketers. Ralph was definitely more of a product-vision person. Calvin, a lot of what he built was branding. He was an amazing brand builder. It wasn't that he didn't love product, but it was really the sex and everything else that he created around it. And for me it was a complete left turn, which was amazing because it was modern. I went from preppy, which wasn't me but I knew how to do it really well, to something that was really on the edge and had no walls on the box. We could create the box and push it out as far as you want, and so that was an amazing experience.

When you think back, it's an extraordinary experience that you had the opportunity to work for those two legends and those two extraordinary companies.

Two of the greatest names in fashion history. I consider them both unbelievable mentors, and [we] continue to be great friends.

And now you see all these young people starting a business from scratch, without having any of the foundations of working for those kind of people and learning everything.

I was blessed to be in both of those places, for sure.

Okay, so why in 1993 did you leave Calvin to go to London Fog, as vice chairman and EVP of design and merchandise?

It's one of those things that we don't even want to talk about. I didn't even remember it until you just mentioned it. I haven't talked about it in ten years. I've completely eliminated it from my history. It was one of those bad moves that, you know, was really about money, and, honestly, it was about a big opportunity from that end of it. And it was a wrong move.

Okay, so then you went back to Ralph Lauren in 1995. With an opportunity to head up the entire men's design division. You were in charge of all the Polo Ralph Lauren brands, including Polo by Ralph Lauren, Polo Sport. [You] helped create the Polo Jeans line.

Purple Label, Black Label, all those brands were there. I think I was there for four years.

And then you realized you had a vision that was your own, and I read that you also saw seas of black nylon everywhere and thought, I have to do something about this.

Yeah, I went back to Ralph and it was like coming home. I knew Ralph quite well. And I knew a number of other senior people who were still there. There were a lot of new people in the company because when I first worked there in the 1980s, we were in a brownstone, 40 West 55th Street. And we ran up and down the stairs between all the floors because each one of the floors was an apartment. So there was one design room in one apartment. There was a sales room in another apartment. When I came back, it was this big spacious place on Madison Avenue above Crate & Barrel. Maybe there were fifteen hundred employees, and when I left the first time around, maybe we had a hundred and fifty people in the building. So it was a very different, different world. And it was a different way of working then, too. There were so many more people involved in the decision-making process. But it was fantastic. It was like coming home. I knew the groove. I knew the brand and I knew Ralph and I had a fun relationship with him. So it was like you had a fight with your parents and you came home and they treated you great. And Ralph treated me like a king. We did good things together. But in 1999, I was walking through Barneys on a Sunday and seeing what was happening for the fall season. And it was the year all these European designers were really exploding. It was Prada, Gucci, Jil Sander, Helmut Lang. There was a lot of black,

but it was black nylon, and Prada was really big with that type of thing. And then there were the people who were doing versions of them, the Hugo Bosses, who weren't really designers but were brands. And then the sub-brands. And I said to myself, wow, what a time to really do something different, to really shake it up here. Even though I had a lot of respect for all those names I mentioned, there were a lot of pieces I felt I could just change the label on them and I really wouldn't know what was what. I had been courted for a number of years by some people to create my own brand. And the next morning, I went into my office to make a call to say, "Let's talk about it." And on my phone was a voicemail from the person that I was going to call, saying, "Just thinking about you over the weekend. If you're ever interested, we're still here waiting for you." And that week, I put the whole thought process together on what I was going to do. And then the big thing had to happen, which was sitting down with Ralph to talk to him about it.

Leaving again?

That was a three-and-a-half-month to four-month process. I actually did tell him right off the bat that I was leaving and why I was leaving, but he wouldn't accept it. And finally, I think three months into it, I went in and said, "I'm really going to leave and this is what I'm going to do." And he said to me, "You can do anything you want here." In fact, he even expressed interest in backing me. But then I thought about it for a moment and said [to myself], will it be like your father, who's going to look at everything that you do? And will I really be able to do it the way I want to do it? I was so flattered. But I said to him, "I really believe that this is something that I need to do and want to do." The light bulb went off. And I was trying to explain that to him, and he said to me, "If you really, really believe that you have something new to say, you have my support and you should do it. But if you don't, you can do anything you want here and you can sail into the sunset with your career here." I'll never forget that.

Extraordinary.

When I won my first CFDA award, and even one time up against Ralph, he said to me, "You're really doing it. You really are doing what you said you were going to do. You're doing your own thing. You're not following. You have your own message and your own view." I wanted to make sure I stayed as far away from the Ralph and Calvin thing and just dialed into my own DNA.

It's a great story. When you left them, your business was financed with Nautica. But you weren't designing for Nautica; they were just behind you for the John Varvatos brand.
Yeah.

I read that you didn't want to have your name on the label. Why?

When I was trying to figure out what I was going to call the brand, I just never thought about my own name. I never thought about it as being a viable name on a label, for some reason. I don't know why. Now it seems like the right thing to do, but at the time it never really clicked. And I was coming up with all these names—

Like what? Do you remember any of them?

I don't. But none of them were registrable, or there was confusion with other registrations. It was getting to the point where I had to have labels woven to get into samples to open my collection. I sat down with a graphic person and started laying out a label and started showing it to a few of my close friends and marketing people. They were like, "What are you

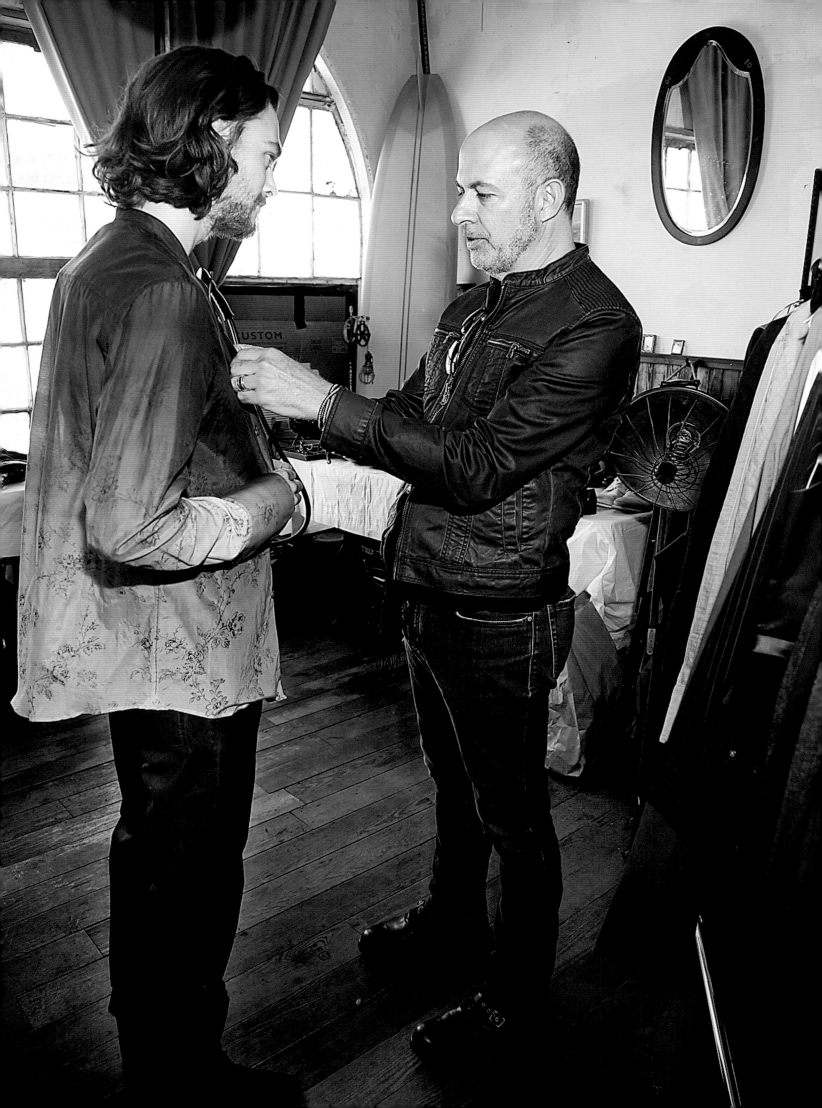

talking about? There's only one choice and it's your name." There was a little bit of humility in that I didn't feel so comfortable possibly putting my name on the label at the time.

That's kind of sweet.

I'm sweet. Sometimes.

You started right out of the gate with a complete collection. It included tailored clothing, sportswear, outerwear, accessories, and shoes. That's pretty ambitious, right from the gate.

A lot of things I do too big. But the only way I can think, though, is to really go for it. And I feel like in life you have to be able to tell your message, and you have to tell your message well. So when we launched the collection, we launched from head to toe, including footwear and leather accessories and everything. I'd look at some other designers that would show on the runway, and they'd be doing an apparel collection but they're using somebody else's shoes, and I'm like, how could I do that? How could I use someone else's shoes? Plus I can't find anybody's shoes that I want to tell my story with. And so that was the impetus for doing that, as well.

So your first show was in 2000. You also opened a store in SoHo, which was very ambitious. And you were then picked up by Bergdorf's, Saks, Barneys, and Neiman's. So you were off and running.

Yeah, it was an exciting time. When we launched the brand, we launched on the runway in New York and in the tents with Fern in January 2000. About a month before, I previewed with the head of Barneys and the head of Bergdorf's and the head of Neiman's. And I think maybe Saks, and also *Women's Wear Daily*. It was exciting to get such unbelievable response in the previews because we didn't even have everything. But we had enough to really tell the story. We already had serious commitments from those stores before we even showed, so it made the nervousness of doing your first show a little easier, even though I was still very nervous.

There was an extraordinary buzz about this show: "He worked at Ralph and he worked at Calvin and now he's doing his thing." It was very much the talk of the season. Okay, then three years later, Nautica was bought by VF Corp. How did that affect your brand?

I always describe my life as going to California. I'm not intending to go there, but I'm just using it as a story. One day I'm up in Canada getting there, the next day I'm down in Texas to get there. Life's a journey. I had a partner, Nautica [Enterprises], and then one day the chairman, who was my original partner, walked in. It was Harvey Sanders. He was going to think about selling the company to VF Corporation. He wanted to give me a heads up because my partnership and contract and everything was tied into all of that. And here, all of a sudden, you go from a much more commercial brand, Nautica, but they weren't involved in my business, to thinking about being involved with America's biggest apparel corporation, VF Corporation. It started out as Vanity Fair Corporation and then was changed to VF. And it was a little bit scary to me, especially being a designer. I'm not knocking them; they have an amazing business. They were Lee and Wrangler and they had North Face and Vans. But it was really out of my vocabulary in terms of what our brand was about. They were great at what they did, but it's kind of like joining a hockey team when you're a baseball player. It's a different kind of a viewpoint.

So what happened?

Long story short is that the chairman and the president of the company wanted us to go with them, and I didn't really want to go. We had a period of time to put the right deal together to buy out their interest. I wasn't able to put the right deal [together] for me because I had to think about somebody whom I was going to live with. And it was a short timeframe, and deals don't come together in a few months. So they basically gave me an ultimatum and said, "Either you stay with us or we're going to shut it down." Which was a tough thing to hear, even though the chairman Eric Wiseman today is one of my close friends and one of the people I respect the most in the industry. It was—excuse my expression—shit or get off the pot. We're not going to wait around, because we're spending money and you're spending money and all this is going on. So it actually turned out to be a very good learning experience from a business standpoint, because they ran an amazing business. But there was no synergy. It just never connected from sourcing to distribution. We didn't have any accounts that crossed over because I was selling to Neiman and Saks and Barneys and they were selling Dillard's and Walmart and Target and different people like that. After five or six or seven years into it—but a good relationship, a really good working relationship—I finally just said, "We're just not going to get to the finish line for both of us to where we really want this to be. You want me to be more commercial, to really blow it up in a big way, and I want to be true to who I am." And I then said, "I'd really like the opportunity to buy your interest out of it." And they gave me the opportunity and we did find the right partner then. At that point, the brand had high recognition and brand equity. And so we had a lot of people courting us, and we found the right partner. We're a private company today.

And that's the way you want to keep it?

And that's the way we want to keep it. It just makes it simple, too. When you're part of such a big company [and you] have forty thousand employees or something, it's a committee. Even the most high-powered people in the company don't make decisions on their own; they have to have boards, and other people make decisions. The great thing about being private and simple is that you can be quite nimble about what you do.

Was it during that time that you started your very lucrative and very exciting collaborative relationship with Converse?

No, I actually started with Converse in 2002. We met the Converse people when I was only a year and a half in business, and they had been bought at the time by a private equity firm. And it was nothing what Converse is today. They were really on the verge of going out of business. And they had an interesting marketing guy there who approached me and said, "I love your DNA. I think you're the future here. We've never done a collaboration, and we'd love to do something with you for the next year. We'd like to do two seasons with you." Now we're twelve years into it and just signed another agreement to continue. It's the largest, longest-running collaboration, maybe in our industry, but for sure in the footwear industry.

How many do you sell?

How many millions of pairs? I don't know. We still only sell them in the best places in the world. We never took it down to a lower level. But the great thing about it is [what] Converse had, part of the spirit of what Converse turned into—not when it was first a basketball brand, even though I love the whole Chuck Taylor story—[but] what I grew up with as a kid and that type of thing after basketball players [stopped] wearing those. Because it's funny when you think about guys like Lew Alcindor and the basketball players even into the

1970s, you see these pictures of them way up in the air and they're wearing Converse shoes with no support or anything, and they were amazing players. And they didn't break their ankles. And today you're wearing all these things and all these guys have injuries, so, I don't know what that says. But it's been an amazing collaboration because it's two like-minded companies that both want to approach things in a rebellious kind of way. And I've always worn Converse from the time I could ever remember, maybe three, four, five years old. There were always Converse in my closet.

How many pairs do you have now?

A lot. Because we do so many. But I think the whole thing that's interesting about it is it gets back to where my brand evolved with rock and roll. That was a part of the dynamic from Elvis Presley in the 1950s. He wasn't rock and roll but an icon for me, like James Dean all the way through The Who. And you think about the punks in the 1970s and early '80s. And every generation has embraced that brand, so for me, it was the most amazing thing to collaborate with.

So let's talk about those musicians and rock bands. I think it was about 2005 when you first decided you are going to use music as part of your branding and marketing.

Yeah, when we started the company in 2000, we did what I would consider beautiful, romantic advertising. We won awards for it. But then I was—let's say 2005—picking up *Vogue*, *Vanity Fair*, *GQ*, and there was actually a lot of other beautiful, romantic advertising in those magazines at the same time, which made it feel a little less your own thing. I think when we started it, it was more of our own thing. I'm not saying that everybody copied us, but there just seemed to be more of it out there. And so in 2005, we were going to have a marketing meeting with our creative director to talk about another beautiful, romantic advertising campaign, and I just walked into the meeting and said, "It's not what I want to do anymore." I threw out the ideas of musicians and that type of thing. And the conversation was, "Well, the Gap uses the musicians too." And I'm like, "No, no, I'm not talking that. I'm talking about owning something. I'm talking icons. I'm talking about shooting it in an iconic way. I'm talking about branding." And we created something in that year, in 2005, that has now become something synonymous with our brand and a global thing in the way people

Page 400: John Varvatos preps a model at a shoot, 2013. This page: John Varvatos in Converse by Clay McBride

John Varvatos store, the former CBGB's on the Bowery New York

look at it. We have Kiss in our ad campaign today, which is kind of a crazy thing because when I did it, there were a lot of questions about it. I think it's so cool, but some people might hate it. But I love that, the whole disruptiveness of it. And maybe that was a little bit of my learning through Calvin—do something disruptive.

So who was the first big one when you felt like this was working? Was it Iggy Pop?

Yeah, Iggy Pop. First of all I grew up with him. He was like an icon. And he's so recognizable to so many people. And so the whole getting to know him, for me, was like a dream. He's such a great guy and such a fun guy. On stage he's a lion but, you know, he's really a pussycat. Then we took these amazing pictures in Central Park with him, with umbrellas and everything, and just opened up the doors. Everybody wanted to be in the campaign then. And it's not a campaign that we spent a million on. We spent the money on marketing and paid advertising,

You're not paying these guys.

No, it's really a little bit of clothes, what we call "favored nations." Models make more than what we pay. It's really a relationship kind of thing. They have to want to cross-pollinate and not only have mutual respect, but also mutual growth from it, as well. So it was really Iggy. Iggy put us on the map. It was Iggy who ignited it all for sure.

And then you were ahead of the curve when you went to see an empty space on the Bowery that was previously CBGB. What happened?

That was, again, a moment that you don't plan. People think that it was so planned out. CB's was closed for two years before I even thought to look at the space, and I stumbled onto it by mistake. I was a big fan of CB's from the late 1970s, driving over from Ann Arbor—

To see the Ramones?

To see the Ramones and those kind of bands. So going there in a hot, sweaty room and just the whole scene in the Bowery—it was derelict at the time, which I loved. It was all those punks with their leather jackets and piercings. It wasn't me, but I so got into the whole visual of it. So here we are, 2005 or 2007, I guess. The fall before, I was in the Bowery looking at another space. Someone wanted me to do a bar club with them. I was having a meeting more out of courtesy, and it wasn't really something that I wanted to do at the time.

They had taken over the lease on CBGB and hadn't been able to lease it, and I said, "Can I just take a look to see what it looks like when it's empty?" There was one bare bulb—really, only one bare bulb in the whole place. It smelled bad, because it was CB's, for sure, but it smelled even worse because there was a sewer pipe that was broken in the basement. I think I saw Cujo running around down there, as well. But the light bulb went off in my head, and I said, "You know, what are you going to do with this place?" "Oh, we're talking to a bank and we're talking to this and we're talking to that." And I'm like, "Are you kidding me?" I mean, this is CB's, you know? And the neighborhood still was underdeveloped, there's no doubt about it. It's so much more developed right now. So I came back to my office that day, and I was all excited. I was dreaming all night about what we could do with this thing: a store, a club, a music venue, a cultural space—all these things. And so I got my little management team together; I got this idea to do live shows. It's going to be a cultural space, and we're going to keep some of the history going in the Bowery. And everybody said, "Great."

And, "What are you smoking?"

So I took them over. We all went over to the Bowery and we walked the space and it still smelled. And they went, "Yeah, this is great." And so we came back the next day or the day after. My most senior person in the company said to me, "We all talked about it and we don't think it's a good thing. We think that it's very treacherous to go over there right now. And from a business standpoint, there's nobody doing retail over there. It's underdeveloped. It's ten blocks from our SoHo store, which is so successful. We don't want to cannibalize." And—one of those terms you said that I was as a Leo that you were right about—I sat there and [thought], I've got to bite my tongue right now, which I don't do very often. The weekend went by and the Monday after, I came in and said, "I'm going to pull a filibuster here. We can't always be democratic. We're going into the Bowery." And then I had to go to my partners, the ultra-conservative VF guys. They said the same thing my team told me—ten blocks from the SoHo store, underdeveloped, five years away from being developed, all that kind of stuff, which just even fueled me to want to do it even more. Which showed how good my relationship was with VF. I said, "Guys, I've never done this to you before but I'm laying down on the railroad tracks right here. We're going to do this. It's the right thing for the brand. I have it in my gut. I promise you it's going to work." And thank God it really turned out to be probably the best thing we ever did for our company. It changed the whole culture of the company. It thoroughly engrossed and embroiled us in the music world. And we earned a whole other [kind of] respect for both what we were doing in our marketing and what we [were giving] back to the music community and young artists. We basically take our profits from that store and promote young musicians and shows. We have never charged for one show in that store since we've been there—I don't know, a hundred and some shows, so a hundred and some artists have performed there over time, from Guns N' Roses to young up-and-coming artists. In so many of those shows where I'm there, I am just a kid again. I don't feel I'm in a store; I'm in a club. And I get goose bumps. It's an amazing feeling.

And all those business guys wish they bought the buildings. Wasn't there a real negative community reaction? The local guys there really objected to you coming?

It was split a little bit. I think that there are people that lived in the neighborhood who thought, here comes a designer. The whole neighborhood's going to be gentrified. Before we built, they're thinking we're going to build a Madison Avenue–looking store. But we

really kept the history there. And I think there were some people in the neighborhood that were very unhappy with us, but there were also a lot of supporters in the music industry because they knew me. We had an opening concert that had thirty-five acts or something who performed for seven hours. It was totally incredible. And it really was a show of strength there. But we did have some negative feedback. Even the *Village Voice* wrote a crappy thing about us. But when we opened, they said, "We hate to say it, but it's good." We have an amazing marketing team, but I said, "We're not really going to market this. We have to let it be organic. We have to let it bubble up on its own. The minute it smells that we're marketing this, even though there's always a little bit of that in your background, people will sniff it out and it's not going to be successful." So it's just turned out to be something that is so much fun and such a great thing for the culture of the company.

Weren't some of the pieces of CBGB in the punk exhibit at the Met?

Yeah, sure.

Can you share with us any fabulous stories from some of those shoots and relationships and marketing experiences working with Willie Nelson or Iggy Pop?

If I told you. You can imagine a Willie Nelson one. I have pictures. Donna Faircloth, who's my senior vice president of marketing and communications, she's been at all of those shoots with me. Donna's gone from tears to tears of joy. We just look at ourselves and say, "This is our job? How lucky." As I said, the fashion industry is not nearly as glamorous as everybody thinks, and ninety-nine percent of what we do is not. But at those moments, we just feel so blessed to be amongst these amazing icons who treat us like we're the stars. Every one of the shoots we have so many laughs and so much fun. The Kiss campaign was just crazy. We shot it in Brooklyn last year. And all these people were up in their windows looking out, and the streets were packed. And of course, we wanted to keep it under cover, so we didn't want people to know that it was for us, and we made everyone, including the guys from Kiss, tell everybody that we were shooting for a Japanese magazine, because they're such big stars over there.

Describe the Kiss moment in Milan at your runway show.

When I watch the video, I get kind of emotional about it. The campaign was going to be announced the day of our runway show in Milan. Throughout the show, maybe the fifth model in, we had a star on one of the guy's eyes, painted like a Paul Stanley kind of thing. And then a little while longer, it was the Cat. And so it went through the show, until the last four guys came out, and they were in full Kiss makeup. No hair, but full makeup, perfectly done, in full-tailored elegant suits, and they looked amazing. People loved it. In kind of a stiff world sometimes, that was a great, fun thing. I came out to do my bow, and I did my bow, and I kind of went to do it again, and all of a sudden Kiss comes out in full makeup and hair, but in our suits, the exact clothes from the campaign. And that was the announcement of our campaign, and we walked the runway. I never really walk the runway. I usually just stick my head out and wave. But I walked the runway with them, and then the kind of stiff fashion crowd lost their minds. They were climbing over people, knocking people down. And I would say that three quarters of them missed the next show that they had to get to because they wanted to stay and take pictures or have pictures taken with Kiss. It was a really memorable moment. It wasn't something where we said, "You guys have to come to Milan." They wanted to fly to Milan. They flew twenty hours or nineteen hours from L.A.,

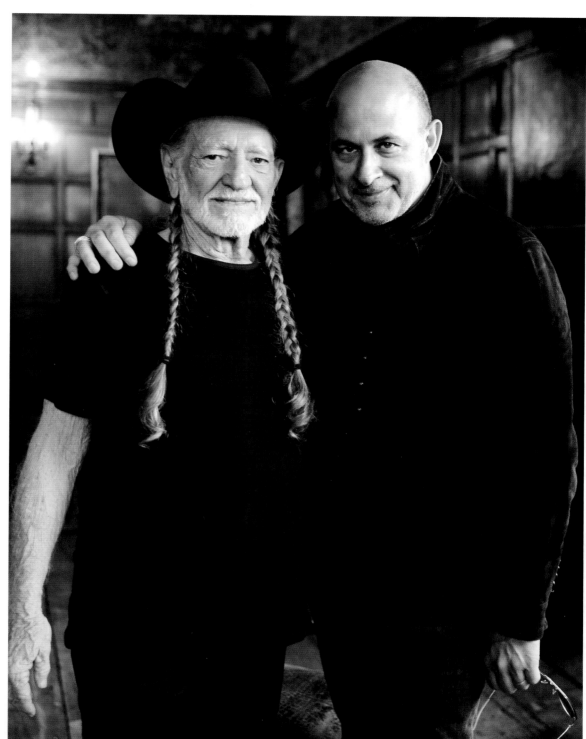

Clockwise from top right:
John Varvatos and Willie Nelson;
John Varvatos and Ringo Starr;
John Varvatos and Steven Tyler.
Following spread: John Varvatos
and members of the band
Kiss walking the runway of his
Fall 2014 Menswear show at
Milan Fashion Week

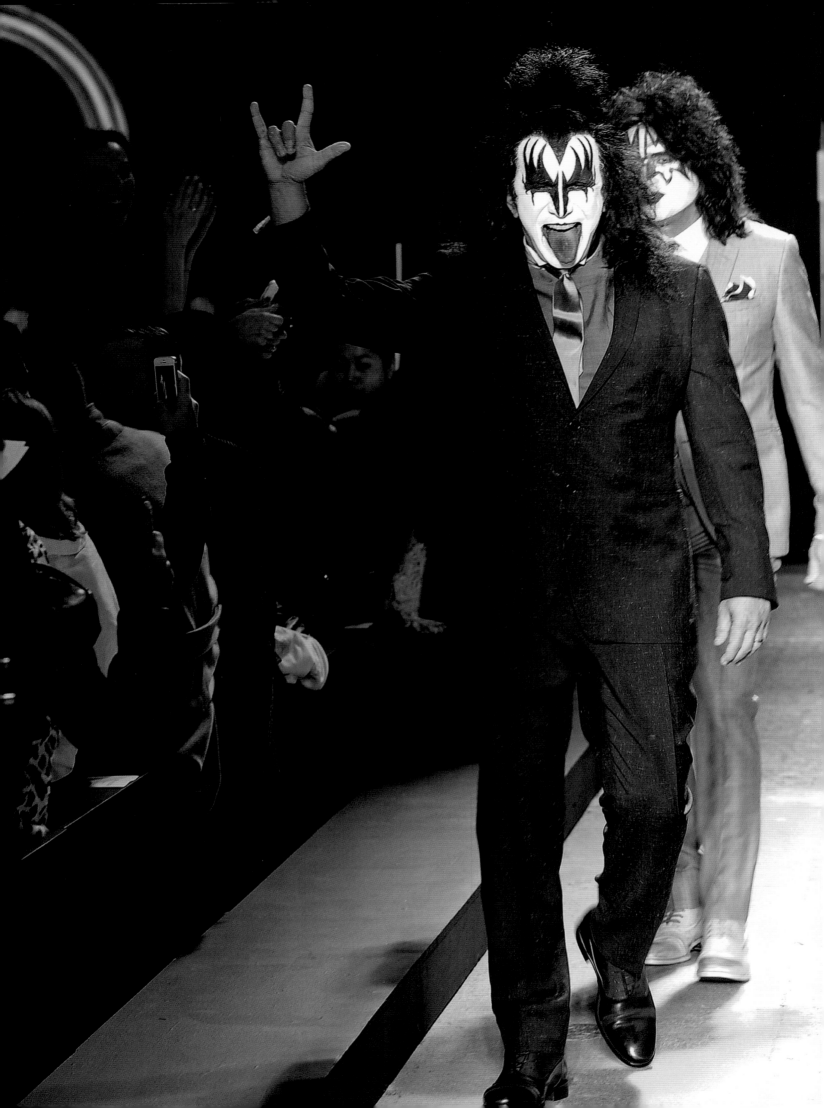

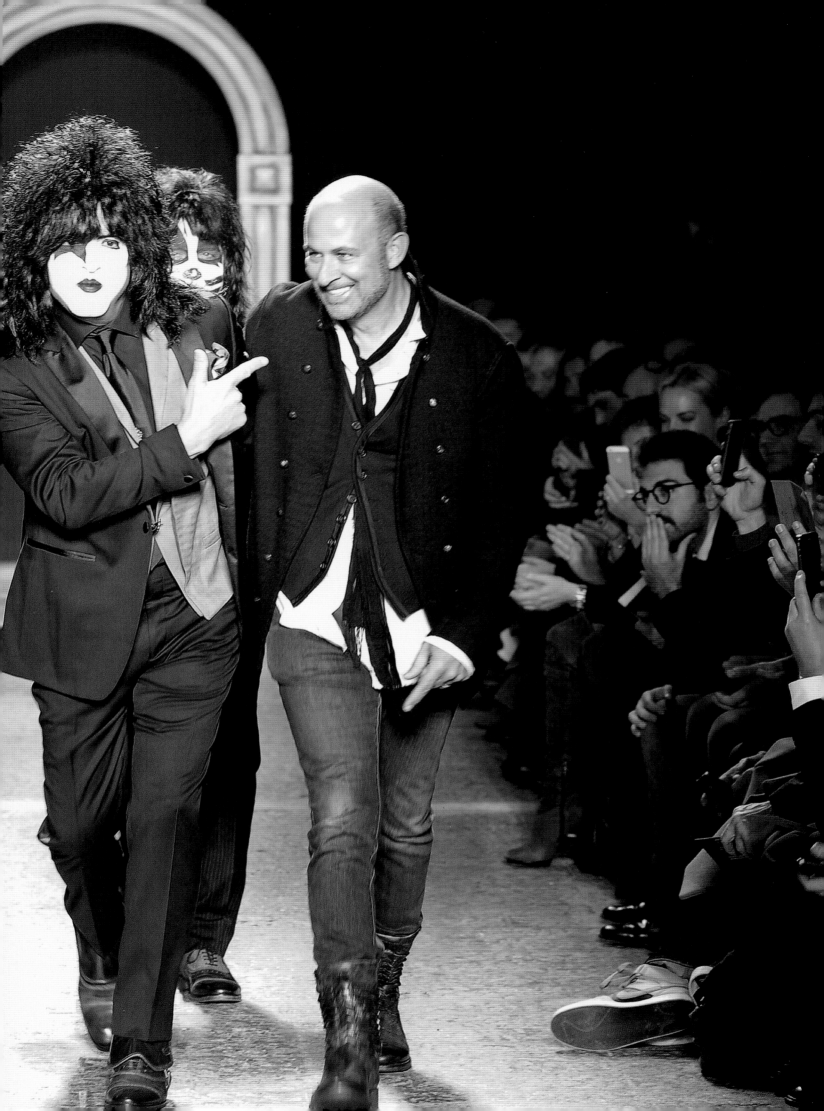

with the time changes—that's nine hours' time difference—and stayed for a day and a half and flew right back. And it was just such an incredible thing.

You couldn't plan that. If you tried to make that happen, it wouldn't be authentic.

Yeah, it was just such a moment. We really let it happen organically. We didn't even figure out exactly what we were going to do until it was all coming together there, even what I did with the faces. On the plane going to Milan, to get ready I started to think about it but it wasn't this well-thought-out strategy, and I think that's also why it felt much more fun.

Fantastic. Okay, let's pull back a little bit. It's hard to move on from Kiss, but another great Detroit collaboration you've been doing is with Chrysler.

You know I grew up in Detroit, and I actually also do a radio show like Fern on SiriusXM, on the Spectrum Channel.

On the first Monday of every month. What time?

It's 10:00 p.m. I started it six years ago. It actually started when the Bowery store was opening. People heard that we were going to do this big event in the Bowery store, and when they started hearing all the major artists that were going to perform, they wanted to broadcast it on SiriusXM. Of course, they didn't want to pay anything to help set it up. They just wanted a broadcaster. I have to say that—I hope they're listening.

This interview will be on SiriusXM.

Yes, exactly. Scott Greenstein, the president of Sirius, called me and said, "I love what you do. Can you come in and do an interview with us and talk about what you're doing?" And when I got there, I thought someone was going to be interviewing me and I was going to tell what we were going to be doing. I was supposed to just get on the air and do my own show. They didn't communicate that I was supposed to go there and play music, so I had to create this show right off the cuff, on the spot. And it was an hour show that was going to lead into broadcasting the show live from the Bowery. So, long story short, it was a big hit. I was funny. And they asked me to do kind of a permanent show, and I decided to call it Born in Detroit. I always love to do things to promote Detroit. I think that city needs so much help. And I love what they're doing right now, even though you read all this bad stuff about what's going on there and it's filing [for] bankruptcy and everything. I was there with the president of my company, and we were so excited and enthusiastic and blown away by all the great stuff that's going on in that city. So Chrysler approached me.

Chrysler.

Eminem did this amazing ad at the Super Bowl about Detroit and rebuilding it and lifting yourself up and all that type of thing. It was a spectacular, from-the-gods kind of ad. It only aired once, at the Super Bowl, and it's the largest-viewed advertisement ever on YouTube. Eighty million people saw it all over the world. I guess about a month or two after that, I got a call from Chrysler—or their agency, I don't really remember. They wanted to talk to me about doing a follow-up ad about a Detroiter talking about never forgetting your roots, never forgetting where you're from, and that you can make it in this world. And I was so honored by the idea of doing that, a television commercial pushing Detroit. So I did a commercial that followed up Eminem, of all people, which was amazing. About six months after that, they asked me if I would do a car for the New York [International] Auto Show. And I said, "Absolutely." I never ask about how much, I just say yes. So I went to Detroit a number of times and worked with a design team; I started doing all these things, and then they said,

"We can do it, but it only can be for the show. It's going to have to be a one-off." But the chairman of the Fiat Chrysler was at the show and saw the car and said, "This is the best car we've ever built." He's thinking we're producing it. So they came to me right after and said, "The chairman wants to produce this car, and it's going to be really complicated." We found a way to keep ninety-eight percent of what we wanted. So we limited it to a couple thousand cars last year, which sold out like that, which was fantastic. And we did another car for 2014.

Do you drive one?

I drive one. I drive only American vehicles right now, Chrysler vehicles. I have a Jeep as well. And I am so proud, honestly, to drive American.

Let's talk about John Varvatos Records.

Well, we're just starting. Shortly after we started the Bowery store, I started getting calls from different record executives wanting to know if we wanted to do a label. And every time I sat down with somebody to hear their pitch, I would feel that it sounded like a vanity thing. I'm such a record junkie and a music junkie, but I really don't like what the record industry looks like today, because it's all about pop music and the next single, and it's not about developing artists and nurturing them. Which it used to be when I was growing up. There were artists that weren't doing that well, but there was something really great there, and the word hadn't gotten out, the music hadn't gotten out. And so the label would stay behind them for two or three albums. Now if you don't get out right away, they drop you. They may drop you before you even finish recording your album. Over the last few years, I've had dozens of meetings with some of the top names in the record industry. And I really didn't have an affinity toward the relationship. And then I had a meeting with the guys from Republic Records, which is owned by Universal—Republic now is the largest record company in the United States, and I think the second largest in the world. And what's amazing about that is that they don't have a back catalogue. They're only fourteen years old. When you think about Columbia and Electra and Atlantic, they live on all these back catalogues of Bob Dylan and Bruce Springsteen or The Who and Led Zeppelin, and all these kind of things. So I was really impressed with the way they've built their business, even though [they're] a bit more pop. And then I knew another guy, who used to be president of Epic, who went to work with them and who was a friend of mine. So I sat down and had a meeting, and it was kind of like-mindedness, but I decided it would be very slow dating. After a while, we figured out the right path, and so we announced that we were launching John Varvatos Records. I'm in the process of collaborating with a number of artists whom I'm considering putting on the label and launching. And I'm really going after young, up-and-coming artists. I don't want it to be that we have fifty artists on the label. I want artists that I totally believe in. I don't want it to be anybody just because they look cool or I think they can be a hit. I want it to be somebody that I'm really passionate about.

And then we'll hear them playing at the CBGB store.

That's for sure. That may be the biggest place they ever play, but hopefully not.

Okay, so a quick detour back to your personal and romantic life. How and when did you meet your current wife, Joyce? When did you get married?

I met her in the spring of 2001 at a [Condé Nast] party or something. And she's better at telling this story. But I met her at a party. I was separated at the time. We had a dinner with some friends afterward. She was at the dinner. There was something going on there, but I

never pursued it. November of 2001, I was walking out of my office to go to a meeting and she was coming up in the elevator. We were having a friends-and-family sample sale, and she heard about it and was going to buy her boyfriend a Christmas gift. There were immediate sparks flying. One of my partner's best friends was a good friend of Joyce's, and I said, "Can you get her information?" I ran into her like the next night at a party at a store in the city. She was stalking me, I think. Not really. Maybe.

Whatever. It worked.

I loved it. And, honestly, from that night, we almost were inseparable, really. We went out late at night and had a dinner, and we went on a real date. And really it's been pretty unbelievable. I have a five-year-old with Joyce.

What's her name?

Her name's Thea. And it's been a magical part of my life.

Let's talk quickly about the book *John Varvatos: Rock in Fashion*. I love that the chapter names are all fashion: "Scarf It Up," "Rock and Roll Shoes," "Suits," "Blues," "Marching On," "Second Skin," "Gypsies, Divas, and Tomboys." Anybody come to mind from those categories you want to mention?

There's Patti Smith for "Divas and Tomboys." There's "Wham Bam Thank You Ma'am." There's the New York Dolls and Mark Bolan from T. Rex and all the glam people from that period. I had fun with it. But the book really was about my growing up and how music had a real influence on me, and how it seeped into me to have an influence on my fashion. It shows the kind of cross-pollination and the incestuousness of fashion and rock and roll. It still inspires me. I really love certain people's style. I love that scarf, so I want it to look like that. And then I love that guy's boots, so I want to find a boot like that. And I love the way the guy's jeans fit. It was never one look, and somehow that evolved into my own style.

Well, your three easy pieces actually are a boot that goes from night to day—not day to night, but night to day, which I like—and a good-fitted jean and a leather jacket.

Yup.

There might be a scarf, a fourth piece.

Every guy needs it in his wardrobe, for sure.

This page, left to right: John with his wife, Joyce Varvatos, at the 2013 CFDA Awards; John Varvatos by John Aquino, 2011. Page 414: John Varvatos at the finale of his Fall/Winter 2011 Menswear show at Milan Fashion Week

Will you do a women's collection?

Maybe.

Okay. If you weren't a designer, what would you be?

You know, if you asked me this ten years ago, I probably would have said an architect, because I still dream of being an architect. But I now know that if I wasn't a designer, I would be in the music industry. I love music so much and I'm so connected with it that it's something I'd want to pursue.

And whose clothes would you wear?

Oh boy. Vintage.

Oh, that's a safe answer. That's very diplomatic. Okay, being not so diplomatic: are there any of the young, new crop of designers whom you admire or you're watching and impressed by?

You know, I love what's happening in America, especially in design. I love what's happening on the West Coast. And I love what happened with the whole kind of premium denim thing in this country. I'm hoping that it evolves to another level. I love that there's a next generation that's coming up. But I see the sparks of it. And there're a lot of them, without mentioning one. There're a lot of them I'm really impressed with—and I think that's part of it. I think that it's not easy. In today's world, it's even more difficult because everything is so expensive to do, so to promote yourself, to market yourself, to do a runway show, whatever it is, it's so expensive. But we are in a digital age, and that is amazing. If you can do something interesting and get viral with it, you can get out there a lot quicker. So if you're smart about using today's youth to get it out there, you have a whole different avenue that we never had, even in 2000, when I started. The Internet was not the Internet today. Digital communication was not the same. You know, Tweeting, Instagram, any of those things, weren't around, and that sort of thing—

It's a whole new vocabulary.

There're a lot of tools that if you use right are great tools.

All right, so I guess that pulls together some of the advice you would have for young designers starting out.

Yeah, and I think the biggest advice I always say is that my company is not just about me. We have a lot of great young guys and girls on my design team. I think we have more girls. But my thing is that they all want to be a designer right out of the box and they all think they got it right. And there's always going to be that one in a million. But you ask me who I like, there's not that one in a million right there at the moment. Sometimes I wish I would have started younger. But I didn't even take design classes until I was twenty-nine years old. And we didn't even talk about that.

I had it in here, FIT for two years.

That whole thing I said about being a sponge and really learning and being exposed, I was lucky that I got exposed to amazing brands and I saw things that I felt were the right direction and things that I felt were the wrong direction, and on top of it all, learning every aspect of building a brand and business. You can be super creative, whether you're a musician or a designer or whatever, but if people don't see you or hear you, or you can't execute, that doesn't really mean anything, because execution is what it's all about.

Otherwise you get executed.

Exactly.

What's on your bucket list? Is there anything?

The number one word on my bucket list is "focus" right now. I feel like I have a lot going on, the brand has a lot going on. I want to focus on the things that we're doing really well and take them to another level. And the things that we need to improve, I want to focus on those.

So your bucket list doesn't have jumping off a building or anything.

No, the number one personal thing on my bucket list is spending more time with my family. No doubt about that.

We like that.

It's hard in this industry, with the crazy hours that we keep.

Okay, a couple of audience questions. Where do you get inspiration?

Inspiration comes from so many different places.

Well, you talked about the music and all that, but is there a muse?

I don't really have a muse. Every designer will tell you, it can come from people on the street. I say it comes from architecture, it comes from books, it comes from movies. It comes from organic things like fabric and dreaming. Dreaming is a great place to be, a great way to get inspired. We have to be better at managing our time because we need more time to dream. Because the dreaming is what got us here and the lack of dreaming will be what stymies our ability to grow.

Dreaming is important. And Arianna Huffington was just here at the [92nd Street] Y and talked about sleeping more. You need to sleep more so you can dream more.

I'd like that, too.

What was the most influential advice you were ever given? Would you say it was one of Ralph's comments?

Yeah, it was definitely one of Ralph's things: Whatever you do, don't follow. Lead. Be true to yourself. Follow your own path. And I've tried to stay as close to that path; even though sometimes I'm up in Canada or down in Texas, I've tried to stay close to that path all along.

What does success look like to you?

Wow. That's a good question, actually.

[TO AUDIENCE] I would say it looks just like him.

There's a bit of comfort in success, meaning that you feel some achievement. For me, success feels that you've built a team that really works. And when there's rumbling in the team, you feel like there's something that isn't as successful. I was just having a conversation with one of my team members this morning about how great I'm feeling about our design team, for example. We are having such a good time. First of all, our business is really great and we're doing great product right now. We're having such a great time with it, and I get the little butterflies when I talk about that kind of thing because that's the emotional part of it. The other success for me will be, as I said earlier, finding a way to spend more time with my family and my friends. Because that means that I've built this great organization that [doesn't] need me for every little thing.

So the lion will let a few more people in the jungle to take care of things.

Yeah, exactly.

Talking about having fun, I think we had fun. A pleasure talking to you tonight.

Thank you. [APPLAUSE]

BILL CUNNINGHAM

It's schooltime, summer's over, and I can't think of a more exciting way to kick off Fashion Week than talking to the enigmatic, very private New York Times fashion photographer extraordinaire, a chronicler of our culture, from ordinary and extraordinary people on the streets to glamorous and generous glitterati who basically run our city and fund the thousands of charity galas and benefits happening every night and are documented by the legendary Bill Cunningham. I think everybody whom he's ever photographed, if you are like me, on a Sunday, the first thing you do when you get the New York Times is open the Style section to see if you made the cut.

Bill was not an easy "get." I have been begging him for years, since this series started. And in his lovable, friendly way, he would always nod a little, act kind of interested, and then before we could have a real conversation, run off and dismiss me by taking somebody's picture. But I kept asking. Then about eight months ago, he told me he sent me a letter explaining why he wouldn't do this. I asked him where he'd sent the letter. He couldn't remember. The next time I ran into him, he came up to me and he said, "I sent the letter to the 92nd Street Y." So I emailed everyone here at the Y and asked [them] to keep an eye out for this letter. Sure enough, a few weeks later I got it. Beautifully handwritten in his cursive handwriting and it could not have been sweeter. He told me that he was unhappy about the documentary of his life, which he has never seen, and how it prevents him from doing his job, which is to be invisible. All he wants to do is get the picture and not have all sorts of people who don't know him talking to him. So I thanked him, and said that's it, I'll lay off. I respect and love him too much to be a pest. But recently, I had just arrived back from Mumbai at 5:00 a.m. and that evening I was in a saffron-colored chiffon caftan-type dress at the CFDA Awards at Lincoln Center. I was talking to Bill at the cocktail party, and as he wrote down a name on his pad—because he doesn't have one of those cameras where he records the names and he writes everybody down—he inadvertently knocked my arm and my vodka and soda spilled all over me. Bill was horrified. He had never done this in forty years of taking pictures. He was so visibly upset. I think the jetlag kept me calm. The true gentleman he is, he wouldn't stop apologizing and he offered to buy me a new dress, which wasn't possible. I had just come back with it from India. Then he wanted to pay for the cleaning. I said, "It's vodka, it will dry." Of course, I would have killed him if it was red wine. I said, "Bill, take your pictures. I'll be fine. It will dry." He looked so sad and serious and said, "I'll do anything you want." I said, "Will you sit for me at the Y?"

What can I say about this living legend, the man whom Anna Wintour says we all dress for? He has been described as humble, stubborn, independent, gentle, kind, childlike, curious, simple, complex, private, charming, inspiring, helpful, generous, charitable, and protective. He calls grown men and women "child" and his younger pals "muffin." He says, "I'm not interested in celebrities with their free dresses, I'm interested in the clothes." And "Fashion is the armor to survive everyday life." And "I let the streets speak

to me." And "I eat with my eye." And when receiving the Legion d'Honneur in Paris from the Minister of Arts and Letters in 2008 he said, "He who seeks beauty will find it." According to Harold Koda at the Met Costume Institute, "Bill's photos are a fascinating manifesto of another era in this city. He was the original trend spotter, long before the age of digital photos, blogs, tweets, and front-row ostentation. He is a true egalitarian, but that doesn't mean he isn't aware of cultural division and hierarchies. He just treats it all the same." Billy Norwich wrote in a very funny article in 2002 about how he tried to be Bill for a day and got the funniest and best advice on how to get the picture: "You really, really, really have to love New York a lot to do his job. Call it fashion or chiffon sociology, dress his mission up and down any way you like, but Bill's beat is first and foremost a seven-day-a-week purgatory in what passes for urban progress, over-crowded sidewalks, smokers in exile, busses' whooping coughs, sirens, cell phone deadheads, kamikaze in-line skaters, forgotten manners, facelifts, and bad shoes—and that's just one street corner responding." As Dan Shaw, a former colleague from the New York Times, wrote, "Bill's photographs are actually valentines. They are how he shows his affection for the people of New York, who love and revere him in return." Ladies and gentlemen, let's show Bill Cunningham how much we love and revere him.

BILL CUNNINGHAM: Boy, I hope you get your money's worth out of this.

FERN MALLIS: I think we already did, just having you here.

Okay, shoot, kid.

My first and most important question is: why don't you wear a bike helmet?

None of your business. It's freedom to wear what I want. When it's the law, I'll wear a helmet.

Can we all make that a law somehow? So we can protect this man?

Oh, baloney.

We always start at the very beginning. You were born on March 13, 1929. That makes you how old?

I'm going on eighty-six. [APPLAUSE] But the important thing is that I'm still enjoying what I do.

How old do you feel?

I never even think about it, child. You know? I never think about it. It doesn't mean a damn thing. It's like Iris Apfel. She just had a birthday in her nineties. My friend Suzette. She just had a birthday. She wouldn't tell me how old she is. And I've known her sixty years.

You're a Pisces. Do you follow astrology?

Everyone says it's a fish going each way. I don't believe in that stuff.

Well, I'm going to tell you what I found out from somebody about Pisces. Pisces is the twelfth and final sign of the zodiac. It rules artistic inspiration and is often associated with photography, film, or music. They are also shy, actually very sensitive, and put on a protective skin. They observe everything and are very aware of the complexity of life. But they are observant and respectful. They don't want to change what they see; they just allow it to be what it is and they don't interfere.

All that's right.

You were born in Boston. Tell us about your parents.

Oh well, gee. My mother was of Scottish descent and very strict. When you see me very shy,

Bill in action on
the street

then you know it's my mother. My dad was very outgoing. He was in the wool business. And with the Depression, that collapsed. To keep the family in a house, he took a civil service job. They were just normal people.

They have been described as a hard-working Catholic family.

Oh, they didn't think that way. They were religious but the family came first. We went to church on Sundays. It was just what you did. If they didn't like something you did, you got kicked around. I had marvelous parents.

Marvelous parents make marvelous children.

As a matter of fact, my mother's father abandoned the family when she was a young girl. They'd have a fit if they heard me now. But the only story I remember her telling—and I don't know how she ever did because she didn't drink—but as young girls they would walk along the train tracks, this would be the 1900s, 1890s, something like that, and they'd fill their aprons with the coal that fell off the train so their mother could bake pies.

You said that you're a family of four. So you have siblings?

I had one brother. He was all into sports and very smart. And I had two sisters. All normal people grow out of normal families. I guess until I was strange. My being in fashion—oh boy, that never went over big.

Did you stay close with them all through your life?

Oh, yeah. They're your family, you know. We were close but we never kissed.

There are a lot of families like that, though. Do you remember what your house looked like growing up? Was there anything in there that was creative or inspiring? Art books, photographs, music?

No, no. Nothing like that. We never even had a fashion magazine in our house. I didn't even know that they existed. I always had fun building little religious scenes, when it would come Easter, putting flowers around. It was probably a childish, stupid thing.

Not stupid. You were very crafty. That probably led to you making hats.

In school I took up things to work with my hands. I didn't work so well with my head. That's why my eyes do better.

I know you fell in love with the Isabella Stewart Gardner Museum in Boston. What is it about that museum you love so much?

Every single inch of that museum is an inspiration. Every single inch is beauty. To this very day, when I'm feeling really low, I go up there and spend the day. I mean, it's just so beautiful. Did you see last Sunday's column? It was a weekend of balls and tea parties in Newport and Boston. I got twelve dancers to dress in full regalia, circa 1900, and we went and photographed them in the museum. Now I know the kids say, ugh, that old stuff again. We want all the cool stuff. Well, maybe what isn't so cool is now cool. Besides that, I just think that every inch of that museum, put together by Mrs. Gardner, all the purists hate it because they want to put the pictures on a white wall. But she broke every rule. She's right up my alley, boy.

You told me that you went on a special midnight tour there, with just a flashlight. Tell us about that.

One of the guards gives a midnight tour [to] only one person at a time. I thought there'd be candles or something. There weren't. All I could think was, how the hell did those thieves steal the twelve art works in the biggest art robbery in the world? They made off with what,

Views of the Isabella Stewart Gardner Museum in Boston

three major Rembrandts, a Vermeer? You couldn't see your hand in front of you. Who would know where the light switches were? So anyway, going through the museum, they say the moon comes through the skylight over the court. Oh, I thought, how romantic. Wouldn't that be wonderful? Are you kidding? The moon would have to be sitting right on top of the skylight, and you still couldn't see. I remember in the 1960s the students from Harvard would come over, and it was open one night a month, and they'd bring a torch so they could see the pictures. But the candles were lit. Well, this was nothing. Oh, it was marvelous because the flashlight brought out all the colors. Oh, it was so beautiful. If you've never been, get there before you die.

Not to be morbid, but speaking of which, your assistant John Kurdewan told me that no matter what it takes, he's going to bury you in the garden at that museum.

I don't think they allow things like that. I wouldn't want to disrupt. Mrs. Gardner made the most extraordinary will that no one can break and no one can move a thing. It's absolutely heaven. All the itchy fingers from Yale and Princeton and Harvard, all the know-everythings, they can't do a damn thing. I mean, thank God for small favors. You go back and it's like an old friend is right there. *The Titian Europa*, just where you saw her last. Oh, it's marvelous.

Were you a good student? Did you like school?

Well, I'm a visual person. So no, I can hardly spell my own name.

You had several jobs growing up. The first one was delivering newspapers. Was that the *Boston Globe*?

I can't remember what it was. Whatever the paper was at that time. You get up at five in the morning, your mother made you eat some oatmeal, and you got on your bike and you folded the papers and flung them.

That was the beginning of your career on a bicycle.

Well, growing up in the suburbs, like every kid. You all had bicycles. But it worked out. You know.

And you went to Harvard?

I was working for Bonwit Teller, who opened a store in Boston. And they decided, "We're going to educate him." They enrolled me in classes there and after a couple of months, I

said oh, come on. I'm the wrong guy here. I don't belong in this place.

At Bonwit's a woman gave you some advice about observing people?

Yes, Roslyn DeHart. She came from Neiman Marcus. She must've sensed that I like fashion. She said, "At lunchtime, go outside and watch the customers coming in, and in your mind, redress them the way you think they should be." And that really, that woman was—I often think of her. I used to do that when I came to New York and worked at Bonwit's there. I'd go at lunchtime and study how people were dressed and how I thought they could improve themselves or leave something off or—you know.

So you left Harvard after a semester?

It was four months maybe. Someone should've thrown me out before. They never figured out, what the heck is this guy doing here? This dummy.

I think they're sorry they didn't keep you longer. You moved to New York and lived with your aunt and uncle. Where was the apartment?

Just down the street on Park Avenue.

And your uncle was in advertising?

He was an executive at one of those big ad agencies.

Then you got a job at Bonwit Teller in New York. You met some very influential women: Nona Parks, Sophie Shonnard, and Alisa Mellon Bruce—the owners of Chez Ninon.

They had a leased custom-made department in Bonwit's. It was the best clientele in New York. They dressed every Vanderbilt, every Astor you could think of. And yeah, that's how I got to know all those people.

This was a custom dress shop that also made copies of European designer clothes: Chanel, Givenchy, Dior. Describe those ladies. What did you do for them?

Oh, gee. What did I do for them? Well, I did a lot of odd jobs. They were very wellborn. Mrs. Shonnard came from a very distinguished family in Georgia. And Nona Parks was Nona McAdoo. Her father was [President] Wilson's Secretary of the Treasury. Her father then married Mr. Wilson's daughter in the White House. Their third and silent partner was Alisa Mellon Bruce, Andrew Mellon's daughter. These kinds of people were around me all my life. Maybe they had a couple of million dollars, but we didn't think of that. It was the same with

Jackie Kennedy. She used to come to Chez Ninon before she married the president and we didn't pay any attention. I remember Nona and Sophie were interviewing a cook for their apartment. Nona said to me, "Bill, who's that in the stock room?"—which was across from the office. I said, "Oh, that's Jackie." And they looked at each other and they kept interviewing the cook, because the cook was more important than Jackie. That's the way they felt, and Jackie loved that. She was treated like a normal person, instead of everyone bowing and jumping around.

Speaking of that, I read that in the 1970s, when Chez Ninon was closing, you rescued some important letters and documents from their trash.

I remember when I came in that day, I asked the secretary, "What's all that stuff doing out there, that trash?" She said, "Oh, they've cleaned the files and they're throwing everything out." She said, "Half of it is down on Park Avenue." So I went down and I pulled open a couple of drawers and I looked. Oh my God. All the files on the Mellons, the Astors, and the Vanderbilts. And I said this is ridiculous, this is history. It should be in a fashion school. So I saved what I thought was important. I think history should be preserved and passed on to other generations.

There were lots of personal Kennedy letters as well.

A lot of Jackie stuff—by then she was in the White House.

Okay. I have to ask you this. Is there any truth to the story that after President Kennedy was assassinated, Jacqueline Kennedy, who was, as you say, a regular client at the salon, flew the red Balenciaga suit she had bought at Chez Ninon to New York for you to dye black, and that's what she wore to the historic funeral?

Yeah. Was it Balenciaga? I think it was Dior. It was a red suit. And yes, because there wasn't time to get the fabric and to make a new suit, so overnight we dyed it black. Yup. It's a terrible misconception that Jackie was extravagant. Mrs. Kennedy was very cautious. She didn't have that money. We'd make her clothes at cost.

Back to 1949–50, you moved out of your aunt and uncle's apartment to your own place, which you found by looking at empty windows.

I started in the advertising department in New York Bonwit's, and my aunt and uncle thought that was all right, we are in safe territory. But when they heard I was making hats—whoa, no man in that family was going to be in the fashion business making anything. So, I had to get out. And it's sad. I suppose I was a greenhorn, very naive. I was walking between Park and Fifth Avenue from 57th Street down, and I got to 52nd Street, a little house, and I looked up and saw what I thought were empty windows. A young secretary at the door said, "What do you want?" I said, "You have empty windows. Do you have a place I could rent? I want to start a millinery salon." She looked like, "This one's really a loony bin. We've got to call for a straitjacket." But she said, "Come back tomorrow." So I went back the next day and she said, "The two men that own the house have an advertising business and need someone to clean it. Tell them that you'll clean it for the rent. There's an empty room on the top floor." And that's where it started.

And you named the business William J.

Oh yeah. Because my family would be embarrassed [if I used our surname] and I wouldn't do that to them.

So that's where you started the hat business. And client referrals came from Chez Ninon.

Oh yes. Then they were terrified because it was a speakeasy in the 1920s, but it had a charming garden in the back.

You did a fashion show in that garden and the *Times* fashion editor Virginia Pope came.

That's exactly right. That was my first show. This was the leading fashion editor at the time. She sat through the show because it was her rule always to go to the first exhibit of any new designers. And I've always followed that practice. Except now there are so many new designers. Look at the schedule for this coming [Fashion Week]. There are three different shows every hour, on the hour, all in different locations. In one day I counted seven shows in the same hour. So it's all changed.

Back in those days one of your hat models was Audrey Smaltz.

Audrey invited me to give a show up at the Hotel Theresa in Harlem. I went often. We had a marvelous time.

To pay your bills you worked at the corner drugstore. You stopped making hats at lunchtime to deliver lunches.

Where'd you find all this out? Oh boy, Sherlock Holmes. Leave it to Fern. Old Fern's got the thing down, kids.

And at night you were the counterman at Howard Johnson.

That's right, across from Radio City Music Hall.

And both of those places fed you, so you at least had meals for lunch and dinner.

Yeah, the summers were terrible. Many times I wouldn't eat for a week.

So then in the 1950s you opened a William J. hat store in Southampton.

No, I opened one before, on 57th Street and Lexington. My backer was a woman who came to me for hats. She was this lovely woman and she was fun and it was nice to make her hats. She was the wife of William Hale Harkness.

Rebekah Harkness.

Yes. And Mr. Harkness's father was the original lender of money to John D. Rockefeller to found Standard Oil. Well, what's it matter? They were buying a hat and they looked great and that's all that counted. Mrs. Harkness lent me maybe three thousand dollars, which was a lot of money at that time. And then the draft call came, and she and her lawyers must have spent ten thousand dollars trying to keep me out of the army. I said no. For heaven's sakes, what do you think I'd feel like, thirty or forty years later, if I didn't do my duty to the country? So I went, and then when I came back out I reopened the shop.

And this shop was on Jobs Lane. The white stucco building across the street from the old Parrish Art Museum.

Yeah, because the summers, there was no business. Madison Avenue, the month of August, every shop was closed. It's not like today. The department stores, when the temperature hit ninety [degrees], they closed down because air conditioning was rare. So no. I went out and found this shop just for the summer. No one bought any hats, but it didn't matter.

And you lived in the corner tower in Shep Miller's building.

Up at the head of Jobs Lane. The dog loved it. I'd take her down to the surf every night, run in the beach. I hated it. Boy, I wouldn't want to die there. I want activity.

Is that where you designed your famous cabana hat for Judy Peabody? I heard it was a big hat that unrolled so you could change [your clothes underneath it].

It was fringe. All fringe. It hung down. It was just silly nonsense. We used to do a collection of

fun hats for the beach. At that time people wore beach hats.

Because they didn't have 50 SPF sunscreens.

Southampton at that time was different from today. If anyone was buying a straw hat for the beach, they went to the dime store. They didn't come to me. Everyone out there didn't spend a dime. They were still reeling from the Depression, and they were so afraid they wouldn't have anything left. It wasn't until the beginning of the 1960s that they realized they could spend some money and still have some left.

But they had very big houses, nevertheless.

Yeah, but they were tearing the wings down because they couldn't get the help. They couldn't get people to come out because the gasoline rationing from the war. And many people moved into the former servants' quarters, because of the taxes, the cost of upkeep.

I can't believe this… I read that you had an old Rolls-Royce and drove women friends out to Southampton. Is that true?

Yeah. It was parked in front of the Metropolitan Club. And it had a "for sale" sign, for heaven's sakes. The chauffeur was in it and I asked him [about it] and he said, "Come tomorrow morning." So I went down the street on 54th to the garage and he said, "If you'd like it, it's yours for five hundred dollars." It was a custom-made 1934 with a Brewster body and a Rolls-Royce chassis.

You bought a Rolls-Royce for five hundred dollars. You save all [your] old pictures. Did you save the car?

No. It was either I'm going to have to move out of where I was living or sleep in the car. You know, you couldn't have both. But it was fun. I'm always buying a white elephant.

I also read that the widows invited you to take their late husbands' clothes, so you'd always have a tuxedo.

People were very generous. Hannah Troy was that way. She was a manufacturer on Seventh Avenue. That's when women manufacturers ruled. Boy, they were shrewd, tough, and wonderful people. Adele Simpson, Hannah Troy, Maddie Talmac. And when their husbands died they said, "Bill, you look like you would fit into the clothes." Listen, I have a whole new wardrobe, it was marvelous. People were wonderful that way. Americans weren't wasteful,

Page 425: Bill on the job. This page, left to right: Carnegie Hall on 57th Street and Seventh Avenue, New York, 1986; Bill Cunningham with Carnegie Hall Studios friend and photographer Editta Sherman, circa 1970s

like today. Throw it all out and buy new stuff. I don't believe in that.

We know, I can tell.

What'd you say? You pulling one over on me? No, but you know what I mean. Everything's too easy, too much money now. And that's not healthy.

I agree. So you still had your shop in New York City, and Diana Vreeland used your hats in her exhibitions at the Met. When we had Simon Doonan here he told us about waiting for a peacock hat for the Costumes of Royal India exhibition and you came at the last minute with some dead bird from Central Park.

I did find the beak of a dead bird. I was riding my bike and I thought, oh, for heaven's sake, that's wonderful. Pick it up and use it. I knew Mrs. Vreeland from when she was at *Harper's Bazaar* in the late 1940s. One time her secretary called and said, "Rush over with the hats. Mrs. Vreeland wants to look at them." So I was down the street, and I ran over. Mrs. Vreeland ran the photo sittings—Carmel Snow never looked at anything—and then she said to the secretary, "Have you got a scissor?" Now listen, I hardly had money to eat. And suddenly she picked up the scissor, she's cutting the brim of the hat down to the size she wanted, and she said, "Oh, maybe I cut a little too much off. Just add it back on." I mean, oh man, that was it for me. At the Met she was a marvelous woman, and full of energy and ideas and open to young people with ideas.

So you loved working with her.

Oh, yeah. I just documented everything her hand touched.

She was hands-on literally.

She was one of the best. Oh, Mrs. Vreeland was tip-top. Everyone at the museum wouldn't agree with me, but I watched every move she made. And incidentally, her sister was exactly the opposite.

We never hear about her sister.

Oh, in fact, she came to the shop all the time. Plain, simple.

After you came back from the Korean War, you reopened your shop and did a fashion show in 1956. You couldn't get on the fashion calendar so you did a nighttime post-show dedicated to My Fair Lady.

Oh yes, yes. Eleanor Lambert and her group decided I was not their client. Hey, listen, I couldn't pay anyway. So they were badmouthing it. So I said, well, they're going to see *My Fair Lady*, I'll have the show after that. So the cast of *My Fair Lady*, they loved the idea and they came and the press came and it was a huge success at midnight. Jayne Mansfield, her boyfriend the muscle guy, Jean Kennedy Smith, Rex Harrison all came.

When and how did you move to the Carnegie Hall studios?

When I first came to New York, a young woman I knew said, "Bill, you want to photograph your hats, my sister's husband is a photographer. And my sister is a well-known model and they'll photograph them for you." So I went up to Carnegie Hall and met Ray Solowenski, lovely people, so real and genuine. At that time my aunt and uncle didn't want me around. They would've done anything if I had gotten out of the fashion business. Ray said, "If you build props for me you can sleep here because I've got my family in New Jersey." So that was my introduction to Carnegie Hall. And then, gee, it went on for years. When did I move in permanently? It must've been around 1958.

In the 1950s tenants in that building said they saw Ginger Rogers, Joan Crawford,

and Marilyn Monroe coming to see your hats.

Yeah, they used to come. But more exciting than that was the actors' studio down the hallway. The actresses would come in and play with the hats when they weren't at acting class. I remember one time Marilyn Monroe came in. Katharine Hepburn came in. She'd be waiting for her voice teacher when she did the show Coco. Frankly, I didn't know who they were. I vaguely knew, but I wasn't into theater people.

Then John Fairchild asked you to write a column for *Women's Wear Daily* in the 1960s. Did you consider yourself a writer?

No. As Gloria Emerson at the *Times* said, "He's hopelessly, hopelessly illiterate. Get him out of the building." As a matter of fact, she said, "I'll teach him the English language." I went up to her apartment, and she brought out the books and we were studying. Gloria Emerson was a National Book Award winner, wrote a book about Vietnam called *Winners and Losers* that everyone in Washington had hidden in their desks. They were terrified of her because she was six foot five inches tall. At any rate, we were having this lesson to teach me the English language. [After] a half hour, she stood up and said, "Get your coat and get out of here. You are a hopelessly functioning illiterate." And that was it. And she was a powerhouse. At Dior, one time, at the couture show—now that's before they did ready-to-wear—she represented the *Times*, and everyone's in. I mean we're talking, this is big time, you know the audience was going to be two hundred people. Not like today. And the two silk sofas, pearl gray, one on each side, was empty. And the French, very nervous, running around, they couldn't start the show until whoever was coming, obviously V.I.P., were there. So Gloria was writing to deadline and again, she stood up and she said, "Where's the merchandise?" And the French all ran and hid and the show started. Then in came the buyers from Magnin and sat on the sofas.

Tell us about working for John Fairchild, when you were at *Women's Wear Daily*.

John didn't know me, but he knew that I was crazy about fashion, and that Nona and Sophie, the ladies from Chez Ninon, were desperate to get me away from fashion. They thought it was a hideous thing for a man to be involved in. They'd never speak to the press. They were just in a very small business. They convinced him to hire me. They thought now he'll be in a respectable profession. So John figured, "Oh, I'll hire him then he'll give me the lowdown on Jackie Kennedy and everything she bought and all their clients." He didn't realize that I was trained to the point where you didn't speak about the clients. So it lasted about nine months.

John was quoted as saying he hired you because you had pep and energy and lots of grace. And you knew everybody. You didn't sit in an office and talk. You went out and got the best stories. And everyone at the paper was jealous of you.

I don't think they were jealous of me. As a matter of fact they were furious at me because Fairchild would come back from lunch and tell everybody to throw everything we have out of the paper and do what Bill's telling us to do. You can imagine what the art department thought. Oh, they could've put poison in my coffee.

I read three different things about why and how you left *Women's Wear*. One was about a column you wrote about Courrèges and not Saint Laurent, which Fairchild wanted you to write. Another was that something negative about the wife of the president of Saks was your undoing. Or that there was an "In and Out" column in *WWD*

Bill Cunningham and Antonio Lopez, New York City, 1978

comparing women on the street to other women using your pictures and you felt betrayed so you left. Are any of those stories true?

Yeah, all of them are true. But these were business people. I think by that time, in nine months, they realized they had hired someone very naive. A woman I know told me she had lunch once with Peggy Siegal, a press agent here in New York who said I was the only one she was afraid of. And the woman said, "What are you talking about? He's the only one you can trust." She said, "That's the problem. He's dumb and he's honest. And that is lethal." [APPLAUSE]

It's nice to hear that Peggy's afraid of somebody though.

For the wrong reasons.

Then you did a short stint working for the *Chicago Tribune* for Eleanor Nangle.

Oh yes, wonderful, wonderful. She was there with Colonel McCormick before the Depression. Those women were as straight as an arrow. Oh, they were marvelous. You asked a question, you got a straight answer. You mightn't have liked it, but you got it. And they always paid for whatever they ordered. When I'd go to dinner, with photographer Harold Chapman and his wife, we had no money and we went to tiny little places in Paris. And we would always say, instead of "Thank you, Lord," "Thank you, Colonel McCormick."

I read that you were also with her at an Oscar de la Renta show when you heard there were antiwar protestors on the street and the two of you bolted from the show.

Yeah, Eleanor Nangle… That was in the early 1960s and she said, "Bill, we're leaving. The news is out on the street." We got up and left and sure enough, there was a demonstration. All the hippies and yuppies. Oh it's wonderful. You've got to follow the news. That's why you have to stay free and independent and you don't fall into the traps of the rich. So when the news comes, you follow the news. Hey, that's why I paid my own way to Paris. It's not that the *Times* wouldn't pay it. Of course they would. But then I'd have to do what they want. This way I do what I want. [APPLAUSE]

So how did you become good friends with the great illustrator Antonio Lopez?

Oh, those kids were adorable. I remember meeting them once and I just thought they were terrific, there's such talent. And they were free of all the intrigue of the fashion world. They

weren't involved in that. Neither was I. I mean, I'm a zero so no one cared. I moved out of my B studio in Carnegie Hall and gave it to them. And then I brought them down and introduced them to Charlie James. And Charlie thought, "Ah, now I have someone to draw and document my life's work."

It was Antonio who introduced you to his friend David Montgomery, who bought you your first Olympus Pen D half-frame camera and told you to use it like a notebook.

Yup. Oh, it was wonderful. He said it was simple as sin, you don't need to know anything. And it was wonderful because each roll of film was half-frames. So you got seventy-two pictures. And being as thrifty and chintzy as I am, I thought that was terrific.

Speaking of thrifty, when did you discover your blue Parisian street jackets?

The street sweepers wore them originally. I like them because they used to be only twenty dollars. And they were made of very heavy cotton, and they had pockets to put everything. It was marvelous and they were so inexpensive.

How much are they now?

Now they're fifty, fifty-five dollars. And dishcloths. The worst garbage you can imagine. So the French are no worse than the Americans, believe me. Or the Americans aren't any worse than the French.

Now we're somewhere near the 1970s. You're freelancing for several papers. You had pictures published in the *Daily News* and you worked with Marylou Luther for the *L.A. Times*.

Marylou was a protégée of Eleanor Nangle. This was a newspaper woman, but so charming, no hard edge. It's hard to explain. There aren't people like that today. So gentle but so smart. I mean, different world.

A different world. That describes Marylou as well.

I think of her every day and thank God I met her and she crossed my path. What a great influence. As a matter of fact, women have always been an enormous influence on me: My mother, Isabella Stewart Gardner…

Another one of those women, Bernadine Morris, was a friend of yours and spoke to Abe Rosenthal at the *Times* about using your pictures of street fashion to fill space. Does that sound familiar?

Absolutely. Bernadine and Enid Nemy, both of them. Mr. Rosenthal had just started the special sections. It was Friday, the first one. And they said, "Bill can fill it for you." Enid Nemy—I can still hear her—said to Mr. Rosenthal, "Listen"—and Enid can be tough, she was marvelous. She was a gentle lady. She said, "Listen, Abe, he can write it, he can photograph it, and he's got what you need the most: ideas." Boy, did she give it to him. I mean those women were tough, like Gloria Emerson and Bernadine Morris, always straight as an arrow.

I read that in '78, it was actually Mimi Sheraton, the restaurant critic, who showed your work to Arthur Gelb, the legendary editor. There was a picture of a woman in a fur coat crossing 57th and Fifth Avenue. And that turned out to be?

It was the cut of the shoulder. The coat was nothing. It was the shoulder, my dear, the way it was set in. I looked at that and I'm studying it and I'm taking pictures and then suddenly the woman puts up a newspaper. Then I noticed a woman crossing the street, and she's staring at the lady, and suddenly I thought, you dummy, it's Greta Garbo. That's how stupid I am about celebrities. What interests me is if someone is wearing something terrific. That's

why I got involved. I love the job I'm doing.

Then Gelb asked who else you had photographs of. And you had Cornelius Vanderbilt Whitney, the king and queen of Spain carrying plastic bags, Patricia Lawford Kennedy in a fur coat, and Farrah Fawcett. And the next day you got a column with a half page of pictures in the Metropolitan section, which also included photos of Stanley Marcus, Gloria Vanderbilt, and Paloma Picasso—just a day on the street for Bill Cunningham.

Those people I knew—Paloma, Stanley Marcus—[they walked]. People walked everywhere then. It's not like today. See, there were no paparazzi. It was just *WWD* people and it just wasn't the same thing. Today, people don't have any manners or respect for someone's privacy. Some people think I'm sneaky with taking pictures. Well, I never thought of that. I'm trying to be discreet so I don't disturb or frighten a woman on the street.

Arthur Gelb said your street photography was a breakthrough for the *Times*, and the first time the paper had run pictures of well-known people without getting their permission.

That's true. That's what Bernadine was telling them, and Enid Nemy hit them right on the head with it.

So it's true that you own all the negatives and images that you shot for the paper?
Yeah.

Then you worked with Charlotte Curtis, the Women's page editor, and then the Op-Ed page editor. She called you to come to Central Park because there was a fashion revolution going on—
Oh, what a fabulous woman.

And she called you—I can't believe she reached you on the phone somewhere—and she said to come to Central Park because there was a fashion revolution going on.

It was Easter Sunday. I had been photographing on Fifth Avenue. I came home probably to go to the loo, and the phone rang and I picked it up. Charlotte Curtis said, "Take your camera and get right up to the Sheep Meadow." She said, "There's a Be-In." What the hell is a "Be-In"? I'd never heard of that. So I jumped up and got on my bike and went. And there were all of the hippies and yuppies and flower children. That was the breaking of everything on Seventh Avenue. The first thunderbolt of the revolt that would end with Seventh Avenue telling the public, "Do your own thing," which undid the fashion world, but that's another story.

Your photographs gave voice and validation to many layers of our culture that had not been covered by the *Times*, or other papers for that matter. In 1979 the *Times* Style editor Suzy Slesin took you to Fire Island Pines to cover an infamous party called Beach. If anybody has seen the movie *The Normal Heart*, that party is very briefly in the opening scene. Your pal Scott Bromley designed that party.

Oh boy, what a talent he is. An architect, oh marvelous. It was the last party before the terrible AIDS epidemic. The party was fantastic. It was to raise money for Fire Island to buy a fire engine. The kids took white gauze and banners and sails and everything on the beach was this beautiful sight of white. I mean, you couldn't believe it. They even took the black inner tubes of big truck tires and wrapped them in white gauze for people to sit on. It was— all the guests were invited to wear white. Who will ever forget that kid with a great feathered white Indian headdress? Oh, what an evening. It was marvelous. This one here [Fern] with

Scott Bromley, and others that I didn't know, this woman, Fern, was the one. What a team. Talent, kids. Talent.

You gave that party almost a full page of coverage in *The New York Times*. That was probably the first time the *Times* had covered a gay event in Fire Island.

But we didn't think of it as a gay party. It was a charity.

Yep.

They were raising money for something they needed. They needed a fire truck. [So] we didn't think of it that way. It was just people having a marvelous social event raising money for something they needed.

You didn't, but other people did. Your contribution to that era was very important because you covered events that nobody else was covering, and no one could tell you what to cover. You covered every gay pride parade, every AIDS walk, Wigstock parties, amfAR and DIFFA benefits, Stopping AIDS Together benefits in Bellport. Nobody was reporting about those in the *Times*, but you were covering all the events. [APPLAUSE]

The publisher Mr. Sulzberger and the managing editors, Mr. Topping, Mr. Greenfield, and Mr. Rosenthal especially, wanted to cover and give exposure to charities that were raising money for people, libraries, buildings, hospitals. The *Times* was the paper for the world. It was never meant to be a page chasing celebrities. I mean, my God, that's the last thing I think of. The *Times* is not a frivolous paper.

But you selected the parties and charities that you wanted to go to. They didn't tell you which ones to go to.

No. But I try to mix in tiny little ones that never get exposure, just so they get some coverage, some exposure, and people know what they're doing. Look at the people. That's what's great about America. The Europeans relied on the government to put up the money. In America, you've got to get your butt off the seat, get out and raise the money, and that's what people do here.

We're raising money tonight for the 92nd Street Y.

I hope you get your money's worth, oh boy—I'll have a guilty conscience.

No guilty conscience for you. In 1982 you hooked up with Annie Flanders at *Details* magazine. What was that like? You produced a thirty-eight-page fashion shoot for her.

Well, they were starting out and they had no one to cover. And I loved what they were doing. *Details* was a platform for all the young designers, mostly downtown, to show their work. Uptown, they were all covered. And I loved what they were doing. So in my free time, when I went to Paris or New York, I would lay out the pictures for them of those collections and cover all the young designers whom I adored. The kids—hey, listen, the kids have the ideas of the future.

She said you were the first to cover Azzedine Alaïa and Jean Paul Gaultier.

Yeah, Jean Paul Gaultier, I might have been one of the first. Azzedine, yes. I remember seeing a woman walking down the street in Paris—and the shoulders. Marvelous. The pads they wore, they were skinny, little—and the perfection. I thought, "Oh, this is marvelous." I rarely speak to people because I don't want to embarrass or frighten them. But I did ask her about her jacket and she mentioned Azzedine Alaïa, and then I saw one of the French fashion editors had a jacket like that. And she told me [his name], and so I

Top: Beach party, Fire Island, New York, 1979, with (from left) Ron Martin, Mike Schaible, Robin Jacobsen, Fern Mallis, and Scott Bromley; above: setting up before the party

went and found him. He's probably, at this moment, the last functioning couturier in the world, except Ralph Rucci here. Not to get off the subject, but as the big mass-marketing people transform Fifth Avenue with their glittering stores, there's an opening for people who want special clothes. Not exactly a return to custom-made, but something similar. Because custom-made I wouldn't wish on anyone. The customers can be very difficult. Boy, I don't know how you get the money out of them. At any rate, there's a market now [for] special designs, not ones that you lend to celebrities to wear on a stupid red carpet. I mean, the fashion world killed itself by lending clothes and giving away them and paying the celebrities to wear them. Who the hell is going to buy anything when you pay them to wear it? That's loony bin.

You nailed that one. Annie also said that at *Details* you never took a check. You would rip them up, and that when the magazine was sold to Condé Nast, she told Si Newhouse you had a stake in the magazine that needed to be honored. By then it was worth a lot of money. And she doesn't think you ever collected it.

I didn't take money [from *Details*] because I had too much fun and I'm terrified of taking money because then they own you. And I'm not into that. I get along just fine.

You could've taken that money because the magazine was over… it changed direction.

Wait a minute, I'm not that dumb. Finally, Mr. Newhouse—I mean, there's a family, like the Sulzbergers, tip-top. Straightforward. And he said, "Bill, if you don't take it, it just goes back into some fund." He said, "Take it, put it away, you may need it when you retire." So I did. I don't remember how much it was. I'm not good at money. I know I can eat and the basic things. But Annie was right. She looked out for everyone. We had such a fantastic time at that magazine.

The documentary about your life was released a few days after your birthday. You took pictures at the opening but then left to go to an Anne Bass event.

Well, I was frightened. The fellows who made that documentary had been after me for eight years. I wouldn't get involved. Finally, they went to the publisher and talked him into it because they knew if he asked me I wouldn't refuse, because I think he's terrific. Of course I have the right not to go and see it, which I didn't. When all the other art departments in

the *Times* just gave up on me, when they figured "This guy is hopeless," the man who runs John Kurdewan's department said, "Come here, have a desk and John will put the pictures where you want them." And it's been marvelous. I write with pictures. Do you think I know what I'm photographing when I'm out there? Of course I don't. I let the street talk to me. That's how you find out what people are wearing, what's new, what's happening. There's nothing hocus-pocus about it. You just go out on the street and do it. At night I see what people are wearing and aren't wearing, all the people who support these charities and buy tickets. You walk in Westchester, all the money in the world. No one dresses like you see in the magazines. They would be horrified. That's how Mainbocher came into business. He realized the thing to do was dress [people] so they wouldn't be noticed. That's what people want. They don't want to be noticed.

In your apartments, first in Carnegie Hall and now on Central Park South, you have tons of fashion and art books. Did you buy them all?

Yes, of course. It's too dangerous to accept anything free. I'd rather buy it, like I'd rather buy my own lunch. Why sit at a table and have some chicken dinner? I go out to a deli.

What's your perfect meal at the deli?

Oh, salads or something. I'm not into food. I'm barbaric about food. And besides, I dine with my eyes on the street.

Tell me about your move from Carnegie Hall to Central Park South.

Talk about getting hit with a rainbow or a pot of gold. My friend Suzette has an apartment there, and we were in Carnegie Hall. They kept telling us for years, you've got to fight for it, you should be under rent control. I was working and I couldn't have cared less. Well, Carnegie Hall was evacuating the building to redo the studios and turn them into a [music] school and office. Oh, it's fantastic what they've done. Really, I mean, a school for music—that's what it should be. I loved being there, but believe me, this is the way it should be. And they came along with Mr. Sandy Weill and the other people who had the affluence to make this great change and shove it right into the twenty-first century. Anyway, the city auditors came and checked the books and said we should have been under rent control. Sure enough, they gave us a retroactive payment of two years. Then they gave us an option to take a buy-out, near two million dollars. What the hell was I going to do with that? The government would only tax it. The other option was an equivalent apartment. So I found this building with a view of Central Park. I'll take it. I mean God, you know I'm not that dumb. I said, "First get the air conditioner out of the window, it's blocking the view." And I said, "Take out the refrigerator so I can put in file cabinets." They were in a state of shock. But who needed that? The point is to live simply.

So you have no refrigerator?

There is a refrigerator, a little box one. I used to keep film in it. Now I keep a quart of milk for when my stomach gets nervous.

How many file cabinets do you have?

Oh my God, maybe thirty. And boxes. You know the things the paper for the Xerox machine comes in? There must be a hundred of those [boxes], with all the photographs by seasons in Paris and New York. The only nightmare I have [is] what to do with the damn stuff. There's a fireplace and I thought well, that might be the way to keep warm.

Don't you dare.

I have a fear of giving away the files. The fear is other people using a picture that might be unflattering to someone.

Can you give them to a museum or historical society?

I wouldn't want that. That really terrorizes me. You take lots of bad pictures. You don't publish them, for heaven's sake.

You don't. Other people do.

Well, that's what I'm afraid of. I would hate to know that that's what happened.

But there're so many incredible images and pictures.

There are very few celebrities.

It's not about the celebrities. You've documented culture and style. One of the schools or museums would love to have that.

Listen, there was a young fellow from *Women's Wear* who asked me earlier tonight, "What would your legacy be?" Legacy? Is he crazy? Who thinks about a legacy? I'm a worker in the factory. All I'm concerned about is what we're doing today. Never mind a legacy. That's baloney.

Whether you like it or not, you have a legacy.

I don't believe that. I don't mean to be immodest, but what we do, what I do, any photographer will tell you, it's really deeply minor work. What we should focus on in America is people who do things, doctors, and scientists. I mean the world needs desperately all this stuff. Yes, this is a lovely diversion. We get dressed every morning. It's very important how we feel. That's why I go out photographing at eight thirty. It's marvelous on the streets of New York at eight thirty. Oh, you see everything. People, how they really live and how they really dress. And I think the fashion world, if they thought "do your own thing" ended badly and they're afraid of H&M or M&H—whichever the heck it is—and all the rest of those places, I think what they should really think about and be fearful of is the high tech and the high-tech kids. They're no longer dressing the outsides of their heads. This generation are dressing the insides of their heads and—

But explain that a little bit more, what you mean by their dressing the inside of their—

I think the fashion world has got to come to grips with reality. I mean, it'll land on its own. I don't know when or how. But the reality is, look, you have the whole country electronically connected. They're educating the insides of their heads, as they should do, not the outside with a fancy hat or a dress. Simple clothes—I think that's the key.

Speaking of technology, you don't have a cell phone—or a television.

No. I'm an old hag. I'm out at night. When would I watch the darn thing? I'd rather go out and see the real thing than watch it on television. But I'm all for the high-tech world, the electronic world. My God, it's shaping everything. Newspapers are going on it. Everything is changing. Many people look at the street and say, "Oy vey, what a mess. People look terrible." They don't look terrible. They look clean. They're neat. And some people look absolutely marvelous. They have taste. But what they're doing is dressing the insides of their heads with all of this knowledge. I mean, look at the lines waiting to get into that Apple store on Fifth Avenue and 59th Street. Do you see a line waiting to get into Bergdorf or Saks? Because if you don't dress the inside of your head like you've been dressing the outside of your body, you're in trouble. And the future belongs to this generation, and the high-tech electronic is it. There's no question there will always be fashion. It's like the

designers—we're about to go to see their shows. I mean, people should think, seriously, we're invited to see the work of great artists, not to talk about the one across the way [who] is sleeping with so and so, or where we are going to dinner. Think about what they're showing. Look at the clothes. Look what they do for the body. Look how they help the woman. That's the thing to go and study. These are really very great artists who are showing us their exhibitions. Granted, the audience is huge but you have to concentrate and pay attention to what you're looking at.

And you do that more and probably better than most people in the industry.

Well, listen, I'm so appreciative that people invite us to look. You think I'm going there to discuss someone's sex life? No. I look at the clothes and I think, now who's going to wear it? What's their lifestyle? Where are they going to wear it? What does it do for their body? Go right back to Garbo's coat. The set of the sleeve of that nutria coat, I mean, marvelous. I think it was from the furrier at that time—the best—Maximilian.

Can we answer some audience questions? We've gone way over time.

That's fine. But you've got to ask me first, Fern, what was the most exciting fashion show I've ever seen?

Okay, that's the question.

I'll make it quick. If I'm taking too long, yell, "Shut up you old goat." But the greatest fashion show I ever saw was in 1973 and it took place at Versailles in France. It was a benefit for the Château de Versailles, to put on a new roof. There were five French couturiers and five Americans. Oh, but everyone's saying, how could that be? You have couturiers and you have the ready-to-wear. They're not the same thing. The French side—organized by Baroness Elaine de Rothschild—was Givenchy, Saint Laurent, Cardin, Ungaro, and Dior. I photographed it all. There were great floats, something from the era of Louis XIV. You can't imagine what they were like. [They] overpowered the clothes, such grandeur and gilding. It just knocked your head off. They had Nureyev leaping, Josephine Baker singing. They had every damn thing you could think of, drag queens and everything. And then came intermission. And everyone was kind of let down—people came back in and thought, oh, the Americans are never going to make it, the poor, pathetic little things. Well, I tell you what it was. A theater woman, a dancer, Kay Thompson, she choreographed it for the Americans. There were no sets. Joe Eula attempted an Eiffel Tower—they got it out of there. It was a plain black backdrop. Kay Thompson choreographed the models. Bill Blass did very classic, cool, understated Americans at the racecourse, the landed gentry as he fantasized. Next was Anne Klein, with sportswear. Now, you've got to remember, this is the world of couture. There was no ready-to-wear of any consequence. Saint Laurent had just started. And Lagerfeld was working for Chloé. I mean there was nothing. And the French saw this realistic, cotton sportswear. I mean, you had to see them. All the principessas from Italy. The Comte de Paris and his seven daughters, the princesses of Paris. Everyone was there. You couldn't imagine. Then came Oscar de la Renta. And wonderful. No set. But they were in charmeuse floating pastel-colored caftans. And Billy Blair led them out of the wings across the stage—they all had long scarves. It was beautiful, the flowing of the fabric. It was just dazzling, and so simple. Women no longer wanted to go for nine fittings. They wanted something they could put on in thirty seconds and that's what the Americans were showing. Then came Halston, with very beautiful shapes, structures. I mean, Halston at

Le Grand Divertissement at the Château de Versailles, November 1973. Clockwise from top: Josephine Baker singing; Liza Minnelli performing; Alva Chinn; John Fairchild and C.Z. Guest running backstage after the show. Following spread: Models Bethann Hardison and Romona Saunders at the Versailles show wearing Stephen Burrows

one time was very influenced by Charlie James.

But they had Liza Minnelli.

Oh my God, am I crazy? Liza opened the show—came out in a red Halston sweater set, Ultrasuede jacket, singing "Bonjour, Paris." She was marvelous. It was so American. It was so simple. Next came a replacement. Jimmy Galanos felt, apparently, that he was slighted, for whatever reason. He declined and at the last minute they invited Stephen Burrows. Aha, Stephen, as you know, is a black designer, wildly creative. I can still see him. The show is beginning and he's pulling the flews off peacock feathers, so the single ivory-colored bone went through the knot of the girl's slicked-back hair. It was marvelous, like a Brancusi sculpture. At any rate, the lights went down and the audience was already hopped up by what they had seen—the simplicity. And Stephen's models were almost all black. And at that time, the Europeans had been reading of the riots in Watts in California, in Newark, the burning, the looting, the killing. And out came these extraordinary, these marvelous black models. Each one looked like an empress of Africa. And they were in Stephen's brilliant colors, like you couldn't imagine, with his signature lettuce-leaf hems. Each one came out on the stage: Billie Blair, Pat Cleveland. Each one was more majestic than the one before. The French were stunned. They had all the televisions showing madness in America [and] here were the Americans in the fashion world. But the last one came out. It was Bethann Hardison. She was wearing a saffron-yellow silk jersey dress, typical Stephen. And she had the bone of the peacock feather through the bun in her hair. There was a savagery, an empress attitude. And she crossed the stage on the diagonal, and she shot the fiercest look she could possibly have at the crown heads of Europe. They didn't know what hit them. I mean, it was almost unbelievable. They were terrorized. Here was this beautiful, magnificent creature—a whole stage filled with them. These weren't the people they saw on the television screens at Watts in California and Newark. This was the real America, the America they hadn't seen. And with that they went offstage and out came Liza Minnelli, and she sang "Bonsoir, Paris, au revoir Paris." And the audience, wow, that did it, kid. And out came all the American models. At that moment, in the Royal Opera House of Louis XIV, the programs were flying in the air. People were going mad. They had just seen a revolution: The end of the couture and the beginning of the ready-to-wear. [APPLAUSE] It was like pandemonium hit the Royal Opera House. I can still see them. I can see John Fairchild and Mrs. Winston Frederick Churchill Guest, C.Z., running out of the opera's backstage, the Comtesse de Ribes and all her grandeur in the French couture, running backstage to get one of Oscar's caftans. The women didn't know which way to run, they all wanted to grab the stuff. And I felt bad for the—really lovely woman—the Baroness Elaine de Rothschild because there was no way they couldn't feel what had happened. And then there was a great dinner afterward in the Hall of Mirrors. That was the greatest fashion show, the greatest night I'd ever seen. [APPLAUSE] And it was due to what America does best, not imitation but the simplicity, the honesty of the clothes. That's what we've got to get back. That's what made America great and made the fashion world great. That's what we've got to get back. So, that's it.

So, on the eve of New York Fashion Week and American designers showing, I can't think of a better story to end this wonderful evening with. [SUSTAINED APPLAUSE AND STANDING OVATION]

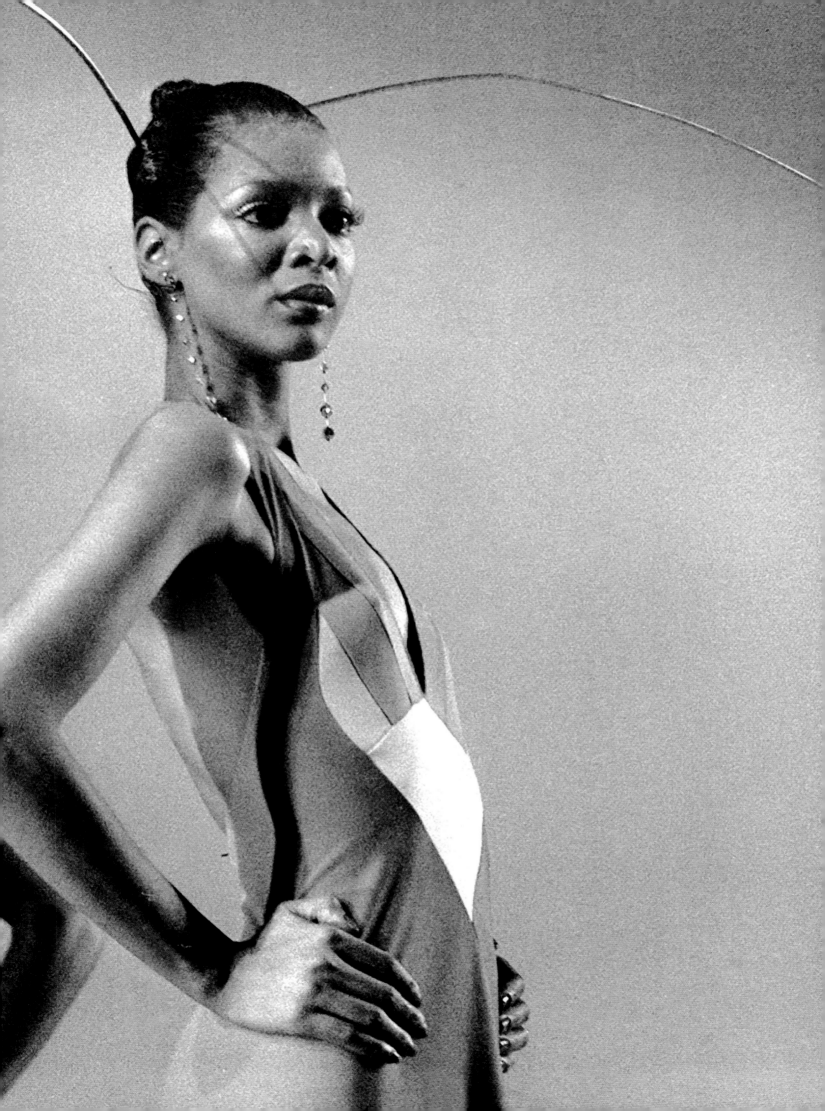

AFTERWORD

It has been the 92nd Street Y's enormous privilege to partner with Fern Mallis on her remarkable series. Fashion—like any industry—thrives on the constant flow of new ideas and perspectives, and through her series, Fern has brought some of the most important designers to our stage for the liveliest, most fascinating, relevant, irreverent, and downright interesting talks on fashion.

As a nonprofit cultural institution, part of the 92nd Street Y's mission is to convene people over the arts and ideas. Throughout our history we've been a magnet for pioneers in every field on both sides of the podium, creating communities where enthusiasts meet, learn, and share their passions. Each year, more than three hundred thousand people come through our doors—and more than five million more join us online. We provide arts education to ten thousand children in thirty-six New York City public schools each year, and more than one million dollars in scholarships for children's and adults' programs.

Why are Fern's interviews so good? I think it boils down to a question of trust. Fern is the ultimate insider's insider—but it's really because of her generosity, and her belief in, love of, and dedication to fashion. The audience trusts her to always deliver important, challenging, and revealing things they won't hear anywhere else.

Fern's commitment to our community goes so much further. A year after the series launched, Fern joined the advisory committee of the 92nd Street Y's newly established NYC Fashion Fellows program, founded in partnership with the New York City Economic Development Corporation to provide mentorship and career enhancement opportunities for twenty rising stars in fashion each year. Her insights mean so much to us.

We are deeply indebted to Fern for her commitment to our community and for enabling us to access a whole new industry. In the four years this series has been running, Fern has brought us some of fashion's biggest names, contributing to the great tradition of dynamic conversation at 92Y. Her contribution to our community is enormous—and we all dress a little sharper when Fern is on stage. **— Henry Timms, Executive Director/92nd Street Y**

FASHION ICONS
WITH FERN MALLIS

92|Y

NORMA KAMALI - September 15, 2011

CALVIN KLEIN - October 17, 2011

DONNA KARAN - January 12, 2012

TOMMY HILFIGER - March 8, 2012

TOM FORD - May 8, 2012

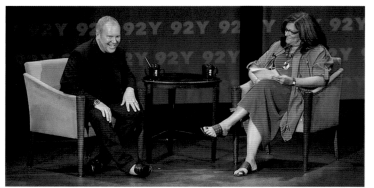

MICHAEL KORS - June 6, 2012

DIANE VON FURSTENBERG - September 12, 2012

POLLY MELLEN - December 12, 2012

MARC JACOBS - January 9, 2013

BETSEY JOHNSON - January 16, 2013

VERA WANG - February 19, 2013

OSCAR DE LA RENTA - June 6, 2013

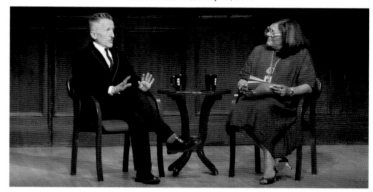

SIMON DOONAN - September 16, 2013

ANDRÉ LEON TALLEY - October 8, 2013

BRUCE WEBER - November 13, 2013

KENNETH COLE - December 11, 2013

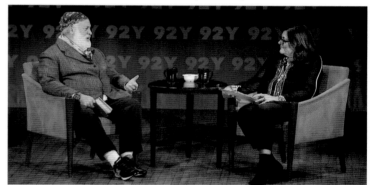

ISAAC MIZRAHI - February 4, 2014

JOHN VARVATOS - March 27, 2014

BILL CUNNINGHAM - September 3, 2014

ACKNOWLEDGMENTS

There are so many people to thank who have been a part of my life and career, and who have had a role in getting this book to publication. Some have labored with me on it for many months, and many have been on board since the interviews began, over three years ago. I never realized how many moving parts there are in getting a book published. I've called in many favors and cashed in lots of chits, and I appreciate every consideration that has been extended. I hope you all will enjoy reading *Fashion Lives* and be as proud of it as I am. Special thanks must go to the following:

First and foremost, my friend, the brilliant photographer and filmmaker Timothy Greenfield-Sanders, who introduced me to Betsy Berg, who introduced me to Susan Engel at the 92Y... where it all began.

Hedi Kim, my manager, who works behind the scenes at every *Fashion Icons* interview to make it smooth and flawless, and has overseen every aspect of creating this book. She's always had my back. To her go my heartfelt thanks and gratitude.

Sam Woolf, my assistant, who had no idea what he was getting into when he started working for me and became, among other things, a photo clearance expert. His Aussie accent and calm demeanor have also been a huge help.

Mae Mougin, my great friend, helped me edit every interview, decoded all the "inaudibles," and gave me good advice.

Alexandra Metcalf, aka Xela Flactem, my supremely talented niece who created the illustration of me on the back cover.

Ralph Lauren for writing the foreword—and I have not given up on the possibility of his sitting with me for an interview.

Sam Shahid, a dear friend and brilliant art director, the only person I ever wanted to design this book. I loved every minute of working with him and the creative and patient Dan Lori. I respected and trusted every decision made at Shahid & Company.

Everyone at 92Y: Susan Engel for her constant enthusiasm, Henry Timms, Alyse Myers, Sidney Burgos, Sarah Morton, house photographer Joyce Culver, Kevin Green and the security staff, Andrew Dainoff, Lester Baptiste, Nancy Kito, Jim Finn and the ushers, Felix Rodriquez, Monique Miller and the box office staff, Roz Rosario, Anna Carhart, Walt Taylor, Sean Fogarty, Anthony Lombard, Heather Jakub Matos and Joey Ortiz for 92Y Fashion Fellows, Jennifer Lam, Catherine Pollack, Paolo Mastrangelo, Andrew Krucoff, Rivkah Rothschild, Carrie Oman, and Kristopher Simmons.

The stellar team at Rizzoli: Charles Miers, who greenlit the book and provided invaluable advice; managing editor Anthony Petrillose, who oversaw every detail as the book grew and grew with an ever-changing page and photo count; and editors Caitlin Leffel, who knows every word of these interviews, Gisela Aguilar, who helped Sam navigate the photo clearances, and Elizabeth Smith, Suzanne Farrell Smith, and Keith Meatto, Rizzoli's indispensible copy editors.

My loyal "Friends of Fern," who came to every interview cheering me on—I heard their whistles, laughs, and claps and felt the love: Scott Bromley, Tony Impavido, Jeffrey Banks, Stan Herman, Mickey Ateyeh, Cindy Lewis, Steve Gold, Ron Roberts, Lisa Silhanek, Dan Scheffey, Mae Moughin, Lucy Suarez, Victoria Lampley and Michael Berens, Judy Agisim, Gary Van Dis, Charlotte Neuville, Skip and Susan Levy, Ty and Kathy Yorio and Brandon Sun (thank you for always bringing flowers), Jane Hudis, Terry Schaefer, Ricki Roer, Paula Friedman, Ruth Finley, LaVelle Olexa, and Marylou Luther. Knowing they were there at every interview means more to me than they will ever know.

Journalist Rubina Khan helped with research all the way from Mumbai.

My good friends Lois Herzeca, Donna Nadler, Bill Galvin, Jeremy Steinberg, and Margaret Braithwaite, who gave me invaluable advice and support: thanks for always looking out for me.

Keri Ingvarsson and Joey Hutchins of the King Collective, who assisted us with our VIP receptions. Steve Abrams and Magnolia Bakery, who

generously provided mini cupcakes and banana puddings for every post-interview reception.

The sponsors supporting this series and receptions: Moët & Chandon, Paul Goerg, Belvedere, Martini & Rossi, DiSaronno, Pampelonne, Peroni, VOSS, Perrier, Fiji, Boxed Water Is Better, and Vente-Privee.

The photographers who covered the interviews and our receptions: David Prutting and the Billy Farrell Agency, the Patrick McMullan agency, Alex Geana, and Sonny Norton.

Holly Palmieri, my executive producer at SiriusXM, who effortlessly shadows me every Fashion Week with microphone and equipment. She attends every interview and records them to broadcast on *Fashion Insiders with Fern Mallis* on the Stars channel. Nothing rattles her and she edits perfectly to the second.

WWD's Ed Nardoza for his support and for introducing us to Leigh Montville, associate director of Condé Nast Licensing & Permissions, who has been beyond cooperative and generous in assisting with so many photo clearances: you are both angels. And Rosemary Feitelberg, who has always reported on the *Fashion Icons* interviews.

The many photographers, agents and agencies who were beyond generous and supportive of this book: Bruce Weber, the Richard Avedon Foundation, Juergen Teller, Bob Colacello, Sante D'Orazio, Donna Cerutti for Deborah Turbeville, Arthur Elgort, Roxanne Lowitt, Mary Hilliard, Steven Klein, Patrick McMullan and his team, Anita Antonini, Ava Grumberg, and Ashley Collins, Billy Farrell, James Neiley, and Stephanie Ketty at BFA. Bara Botto and Butch Vicencio of Getty Images also deserve a very special thanks, as do Raja Sethuraman and Magnus Andersson of Gloss Studio for their retouching work.

Ken Sunshine, whom I was thrilled to run into outside the SiriusXM, studio when Barbra Streisand was there and I needed permission to include her wedding photo—done! The same goes to Brooke Shields, whom I saw at Carine Roitfeld's *Harper's Bazaar* Icons party while

trying to secure her famous photo in Calvin's jeans; SCAD's Michael Fink, who expedited a photo of ALT's exhibition in Savannah; and Bloomingdale's Anne Keating. Timing is everything! Thank you all.

The phenomenal PR teams and support staff for all my *Fashion Icons* guests: Jill Simpson, Jamie Gaudio, John Esposito & Keith Guidalian, Patti Cohen, Sheila Parham, Valerie Gelicame, Virginia Ritchie, Ben Wymer, Katelin Jones, Zach Eichman, Tiffin Jernstadt, Abbey Daughtery, Cori Galpern, Cliff Feiser, Sara Alvarez, Mary Fontamillas, Julie Beynon, Natalie Newman, Andrew Van Sant, Lance LePere, Lauren Davenport, Jacqueline Menda, Lisa Pomerantz, Michael McLaughlin, Kristen Ronan, Bethany Freund, Franca Dantes, Leslie Bell, Kate Waters, Chelsea Turner, Daniel Plenge, Reese Pozgay, Marshall Vickness, Billy Daley, Brandon Aldridge, Priya Shukla, Irina Binder, Alice Daniels, Monique Smith, Natasha Cowan, Aaron Sciandra, Erika Bearman, Gabrielle Katz, Martha Botts, Adam Kuehl, Nan Bush, Nathaniel Kilcer, Hillery Estes, Eva Lindemann, Jeanette Shaheen, Samantha Cohen, Donna Peda, Kristin Maher, Robert Genovese, Lauren Ray, Tessa Millman, Sam Morgan, Nikola Barisic, Jessica Driscoll, Belinda Arnold, Jennifer Moore, Erika Stair, Meghan Horstmann, Shanleigh Philip, Donna Faircloth, Diego Louro, Joyce Varvatos, James Schuck, Sasha Smith, Ivan Bart, Brandon Fox, John Kurdewan, Kim Skalecki, and Mary Randolph Carter. We couldn't have done it without you—neither the interviews at the 92Y nor this book. Your assistance and support were greatly appreciated.

The journalists, bloggers, and social media fans who Tweeted, posted, Facebooked, and Instagrammed from these interviews.

Finally, all the designers and fashion icons who shared their stories with me and the rest of the world: thank you to Norma Kamali, Calvin Klein, Donna Karan, Tommy Hilfiger, Tom Ford, Michael Kors, Diane Von Furstenberg, Polly Mellen, Marc Jacobs, Betsey Johnson, Vera Wang, Oscar de la Renta, Simon Doonan, André Leon Talley, Bruce Weber, Kenneth Cole, Isaac Mizrahi, John Varvatos, and Bill Cunningham. Without all of you, this book would not have been possible. I love you all and will be forever grateful.

John Aquino/Fairchild Archive: **p. 378** (middle row, left), **412** (right); John Varvatos Personal Archive: **p. 391**; Joyce N. Boghosian/White House/Handout/CNP/Corbis: **p. 141** (left); © Joyce Culver: **p. 6, 8, 30, 50, 74, 92, 122, 144, 160, 180, 226, 246, 270, 290, 322, 354, 366, 388, 416**; Juergen Teller: **p. 197** (left); Kenneth Cole Productions, Inc.: **p. 357, 358** (bottom), **361** (top left and bottom right), **362, 364**; Kyle Ericksen/Fairchild Archive: **p. 142** (right), **191** (left), **375** (left); Larry Rivers: **p. 328**; Nick Machalaba/Fairchild Archive: **p. 260** (Oscar with hands on hips), **301** (right); Marc Hispard: **p. 58**; Mary Hilliard: **p. 419, 425**; Mary Hilliard/*Vogue*/© Condé Nast: **p. 264** (left); Melissa Moseley/The Weinstein Co.: **p. 113** (bottom); © Michael John Murphy: **p. 353** (right); Courtesy of Michael Kors: **p. 124, 126, 143**; © Michael Roberts/Maconochie Photography: **p. 304**; Mikoto Arai/Fairchild Archive: **p. 36-37**; Mitra/Fairchild Archive: **p. 372**; Neilson Barnard/Getty Images: **p. 194** (top right); Photograph by Nic Lehoux/Isabella Stewart Gardner Museum, Boston: **p. 421** (left); Nina Leen/The LIFE Picture Collection/Getty Images: **p. 255**; Images provided by Norma Kamali: **p. 14, 17**; Oberto Gili: **p. 264** (right); Oscar de la Renta Personal Archives: **p. 249-250, 260** (top and bottom left); Photo Courtesy of OWN: Oprah Winfrey Network: **p. 114**; Courtesy of Parsons The New School for Design: **p. 54** (right); Pasha Antonov/Fairchild Archive: **p. 204-205**; Patrick Demarchelier/*Vogue*/© Condé Nast: **p. 26** (top right), **242**; © Patrick McMullan: **p. 12, 383** (left), **386**; Peter Lindbergh: **p. 59, 72** (top and bottom left); Piero Cristaldi/Fairchild Archive: **p. 404**; Pierre Schermann/Fairchild Archive: **p. 33** (bottom); Pigiste/AFP/Getty Images: **p. 422** (right); Piotr Redlinski/Corbis: **p. 220-221**; Polly Mellen Personal Archive: **p. 162-164, 167**; Courtesy of QVC: **p. 383** (right); Reginald Gray/Fairchild Archive: **p. 263**; Reuters/CORBIS: **p. 219**; © Rex USA: **p. 191** (right), **378** (top); © The Richard Avedon Foundation/Photographs by Richard Avedon: **p. 39** (Brooke Shields, Calvin Klein Ad, November 1980), **172-173** (Nastassja Kinski, actress, Los Angeles, June 14, 1981), **174** (Polly Mellen, fashion editor, New York, August 21, 1975); Photography by Richard Phibbs: **p. 395** (top); Robert Fairer/*Vogue*/© Condé Nast: **p. 308** (bottom left); Roger Prigant: **p. 54** (right); Rose Hartman: **p. 54** (left); Roxanne Lowit/*Vanity Fair*/© Condé Nast: **p. 296**; Russell James/Bryan Bantry Agency: **p. 68**; Russell Morrison: **p. 433**; © Sam Shahid: **p. 442**; Sante D'Orazio: **p. 83** (left); Photograph by Sean Dungan/© Isabella Stewart Gardner Museum, Boston: **p. 421** (right); Shareif Ziyadat/FilmMagic: **p. 308** (top); Simon Doonan Personal Archive: **p. 273, 276** (top, bottom left, bottom right), **284**; Slaven Vlasic/Getty Images: **p. 266-267**; Stefanie Keenan/Wireimage: **p. 113** (top); Steve Eichner/Fairchild Archive: **p. 142** (left), **188** (top and bottom right), **198, 268** (left), **412** (left); Steve Landis/Fairchild Archive: **p. 22-23**; Steven Klein: **p. 178**; Simon Perry: **p. 103** (bottom); Simon Perry/*W Magazine*/© Condé Nast: **p. 119**; Terry Richardson/Art Partner: **p. 106** (top right and bottom), **194** (top left), **361** (top right and bottom left); Thomas Iannaccone/Fairchild Archive: **p. 40** (bottom left), **183, 378** (bottom); Tom Ford/*Out Magazine*: **p. 103** (image of Tom kissing Richard); Tom Ford Personal Archive: **p. 95, 99, 103** (top right); Tommy Hilfiger Personal Archive: **p. 77, 80-81**; Tullio M. Puglia/Getty Images: **p. 414**; Underwood & Underwood/Corbis: **p. 422** (left); Vera Wang Personal Archive: **p. 231**; Victor Virgile/Gamma-Rapho via Getty Images: **p. 136**; *Vogue*/© Condé Nast: **p. 100**; Wayne Maser: **p. 148** (top right); *WWD*/Fairchild Archive: **p. 400**

First published in the United States of America in 2015 by
Rizzoli International Publications Inc.
300 Park Avenue South, New York, NY 10010
www.rizzoliusa.com

© 2015 Fern Mallis

Distributed in the U.S. Trade by Random House, New York.

Printed in China.

ISBN: 978-0-8478-4480-7
Library of Congress Control Number: 2014957376

2015 2016 2017 2018 / 10 9 8 7 6 5 4 3 2 1

DESIGNED BY SAM SHAHID

In recognition of their ongoing partnership, a portion of the book's proceeds are
being donated by Fern Mallis to support the 92nd Street Y.